HEROES

MORTALS AND MYTHS IN ANCIENT GREECE

EDITED BY
Sabine Albersmeier

WITH ESSAYS BY
Michael J. Anderson
Jorge J. Bravo III
Gunnel Ekroth
Guy Hedreen
Ralf von den Hoff
Jennifer Larson
Jenifer Neils
John H. Oakley
Corinne Ondine Pache
H. A. Shapiro

THE WALTERS ART MUSEUM BALTIMORE

DISTRIBUTED BY YALE UNIVERSITY PRESS NEW HAVEN AND LONDON

Heroes: Mortals and Myths in Ancient Greece has been organized by the Walters Art Museum, Baltimore, in cooperation with the Frist Center for the Visual Arts, Nashville, the San Diego Museum of Art, and the Onassis Foundation, New York.

The planning and implementation of this exhibition have been generously supported by grants from the Samuel H. Kress Foundation. The exhibition catalogue received a leadership grant from the Alexander S. Onassis Public Benefit Foundation (USA). The presentation in Baltimore has been made possible by the Women's Committee of the Walters Art Museum and several generous individual donors.

The exhibition is supported by an indemnity from the Federal Council on the Arts and the Humanities.

This publication accompanies the exhibition *Heroes: Mortals and Myths in Ancient Greece.*

EXHIBITION DATES:

The Walters Art Museum, Baltimore
October 11, 2009–January 3, 2010

Frist Center for the Visual Arts, Nashville
January 29–April 25, 2010

San Diego Museum of Art
May 22–September 5, 2010

Onassis Cultural Center, New York
October 5, 2010–January 3, 2011

Measurements are given in centimeters. Unless otherwise indicated, height precedes width precedes depth. For vases, "diameter," unless otherwise indicated, is the diameter of the body measured at its widest point.

Library of Congress Cataloging-in-Publication Data

 Heroes : mortals and myths in ancient Greece / edited by Sabine Albersmeier ; with essays by Michael J. Anderson . . . [et al.].
 p. cm.
 Catalog of an exhibition.
 Includes bibliographical references and index.
 ISBN 978-0-300-15472-6 (hardcover) — ISBN 978-0-911886-73-3 (softcover)
 1. Hero worship—Greece—History—Exhibitions. 2. Heroes—Greece—History—Exhibitions. 3. Mythology, Greek—Exhibitions. 4. Art, Greek—History—Exhibitions. 5. Greek literature—History and criticism—Exhibitions. 6. Heroes in literature—Exhibitions. 7. Heroes in art—Exhibitions. 8. Greece—History—To 146 B.C.—Exhibitions. 9. Greece—Religion—Exhibitions. I. Albersmeier, Sabine. II. Anderson, Michael J. (Michael John), 1967–
BL795.H46H46 2009
292.2'13—dc22 2009022481

Published by the Walters Art Museum, Baltimore
Copyright © 2009 The Trustees of the Walters Art Gallery, Baltimore

The Walters Art Museum
600 North Charles Street
Baltimore, Maryland 21201
www.thewalters.org

Distributed by Yale University Press, New Haven and London
www.yalebooks.com

Designed by Jeff Wincapaw
Proofread by Laura Iwasaki
Color management by iocolor, Seattle
Produced by Marquand Books, Inc., Seattle

CONTENTS

FOREWORDS

Modern media and society are quick to attach the label of hero or heroine to a broad array of outstanding men and women: protagonists from television, movies, or literature, soldiers at war, the policemen and firemen of 9/11, athletes, or ordinary people who rise to heroic status through their deeds or personal qualities. We are equally quick to denounce our heroes when they display human flaws. The ubiquity of heroes and heroines in our daily lives, as well as the diversity of their forms, underscores an inherent human need for heroes that can be found in most cultures and time periods. Since ancient times, heroes have created norms, defined trends, and shaped behavior, but there is scant consensus today on what constitutes a hero. *Heroes: Mortals and Myths in Ancient Greece* examines what made somebody a hero or heroine, what was expected of them, and how they were worshiped and portrayed in the arts of one of the world's oldest and most influential cultures. By providing a greater understanding of the past, *Heroes* gives us insight into our own present-day attitudes about who achieves heroic stature in our personal lives and why.

The Walters Art Museum holds one of the largest and finest collections of ancient and classical Greek art in the United States. The museum has a distinguished history of presenting landmark exhibitions and publications on ancient and Byzantine Greek art and culture. *Heroes* draws upon the Walters' permanent collection, supplemented by important loans from U.S. and European collections, including the National Archeological Museum in Athens, that support the intellectual integrity of the exhibition and this catalogue. This exhibition also continues the longstanding collaboration with the large Greek community in the Baltimore-Washington area.

A project of this scope and ambition could not have happened without the generous support of many institutions and individuals.

On Ms. Albersmeier's behalf, we thank H. A. Shapiro and the members of the scholarly advisory committee for their fruitful discussions on the subject and continued support of the exhibition: Megan Cifarelli, Ralf von den Hoff, Sandra E. Knudsen, Jennifer Larson, and Corinne Ondine Pache. Ms. Albersmeier also acknowledges the contributors to the catalogue: Michael J. Anderson, Jorge J. Bravo III, Jacquelyn H.

Clements, Helene A. Coccagna. Gunnel Ekroth, Richard A. Grossmann, Guy Hedreen, Sandra E. Knudsen, Angeliki Kokkinou, Jenifer Neils, John H. Oakley, Jocelyn Rohrbach, Sarit Stern, and Allison Surtees. She would like to extend many thanks to her research assistant for *Heroes*, Helene Coccagna, as well as to the following individuals and institutions and their staff for their support of the project: the Baltimore-Piraeus Sister City Committee in the Baltimore City Mayor's Office of International and Immigration Affairs, Bernard Andreae, Frederic A. Cooper, Sara Dayton, Zoe Emer Dolan, Jerome Eisenberg, Nikolaos Kaltsas, Marilyn Scher, Kleanthis Sidiropoulos, Victoria Napoli, Anna Pappas, Petros G. Themelis, and Andrew Ward, and all the staff members at the venues for the exhibition and at the lending institutions, who have been instrumental in securing the loans for the show.

At the Walters, we acknowledge for their instrumental roles as members of the exhibition team associate curator for ancient art Sabine Albersmeier, senior objects conservator Meg Craft, development director Joy Heyrman, manager of school programs Amanda Kodeck, head of exhibition project management Annie Lundsten, public relations manager Amy Mannarino, chief technology officer Jim Maza, chief registrar Joan Elizabeth Reid, and associate exhibition designer Laura Yoder. Staff members Danielle Bennett, Johanna Biehler, Jackie Copeland, Betsy Dahl, Paul Daniel, Gill Furoy, Jeff McGrath, Dylan Kinnett, Mike McKee, Julie Lauffenburger, Marietta Nolley, Kathy Nusbaum, Asa Osborne, Susan Wallace, Sarah Walton, Terry Drayman-Weisser, Nancy Zinn, and many others contributed in numerous and crucial ways to the enhancement of the exhibition. Special thanks for their work on the catalogue and exhibition go-to editor Charles Dibble, publications assistant Jennifer Corr, photographer Susan Tobin, and photo and digital imaging coordinator Ruth Bowler.

We are very grateful to the Hellenic Ministry of Culture as well as the Minister of Culture and his staff for supporting this exhibition so generously with loans from the National Archaeological Museum in Athens. His Excellency Alexandros P. Mallias, Ambassador of Greece, and Mrs. Mallias offered their gracious hospitality and enthusiasm for the exhibition. Dr. Zoe Kosmidou, Expert Minister Counselor for Cultural Affairs and

U.S. Representative of the Hellenic Foundation for Culture at the Greek Embassy in Washington, D.C., embraced the project early on and helped to move it forward in many ways.

Gary Vikan, *Director, The Walters Art Museum*

After closing at the Walters Art Museum, the exhibition travels to the Frist Center for the Visual Arts, Nashville, Tennessee. The Walters enjoys a long-standing relationship with the Frist Center, where *Realms of Faith: Medieval and Byzantine Art from the Walters Art Museum* and *Bedazzled: 5,000 Years of Jewelry from the Walters Art Museum* were presented. *Heroes* is the Frist Center's first exhibition devoted to the art of ancient Greece. The exhibition is particularly significant to Nashville, the home of a full-scale replica of the Parthenon, originally built for the Tennessee Centennial Exposition in 1897. As early as the 1850s Nashville was called the "Athens of the South," by virtue of its numerous institutions of higher learning and for being the first southern city to establish a public school system. Every student in Metro Nashville visits the Parthenon. Building on that introduction to Greek culture, *Heroes* offers unprecedented educational opportunities for all Nashvillians, while fulfilling the Frist Center's mission to present the art of the world, from all time periods, all cultures, and in all media. The installation and interpretation of the exhibition have been coordinated at the Frist Center by curator Katie Delmez and curator of interpretation Anne Taylor.

Susan Edwards, *Executive Director and CEO, Frist Center for the Visual Arts*

The San Diego Museum of Art (SDMA) is delighted to be the only west coast venue for this tremendous exhibition. *Heroes* represents the first of what we hope will be many collaborations with the Walters Art Museum, the Frist Center for the Visual Arts, and the Onassis Cultural Center. At SDMA, we have benefited greatly from the superb curatorship of Sabine Albersmeier and the organizational leadership of the Walters staff, foremost among them Nancy Zinn, associate director for collections and exhibitions, and Annie K. Lundsten, head of exhibition project management. The exhibition at SDMA has been expertly curated by James Grebl, SDMA librarian, assisted by designers and registrars led by Scot Jaffe, associate director for exhibitions and collections. SDMA's deputy directors Vas Prabhu (education and interpretation), Katy McDonald (external affairs), and Julianne Markow (operations and finance), and their teams have all contributed greatly to the success of the exhibition. In bringing to San Diego these spectacular objects of the art and culture of ancient Greece from world-renowned museums, *Heroes* not only affords southern Californians access to some of the most famous works of art from antiquity but also allows for deep consideration of the fundamental connections between the ancient world and our own.

Julia Marciari-Alexander, *Deputy Director for Curatorial Affairs, San Diego Museum of Art*

On behalf of Mr. Anthony Papadimitriou, President of the Onassis Foundation, I extend my deepest congratulations to the Walters Art Museum, the exhibition's curator, and all the people who made this exceptional catalogue and remarkable exhibition possible. In addition, I acknowledge the dedication and creativity of the following people who contributed to the presentation of the exhibition at the Onassis Cultural Center: Amalia Cosmetatou, director of cultural affairs of the Onassis Foundation (USA), Dan Kershaw, exhibition designer, and Sophia Geronimus, graphic designer.

Ambassador Loucas Tsilas, *Executive Director, Alexander S. Onassis Public Benefit Foundation (USA)*

PREFACE

The Onassis Foundation is proud to participate in the exhibition "Heroes: Mortals and Myths in Ancient Greece" and to offer the Onassis Cultural Center in New York as one of the four venues of this magnificent endeavor to better understand the concept of the Hero through the study of mythical and godlike figures in ancient Greece.

Throughout history, human societies have always set up role models and tried to emulate their values and personalities through veneration or outright worship. In the human quest for improvement, even perfection, heroes as beacons will always shine a light on the right path to follow.

The present exhibition, in showing us heroes that have galvanized and enchanted the imagination and upbringing of human generations for thousands of years, satisfies an important need of our contemporary society in the philosophical, academic, and social sense.

Our warm congratulations and appreciation go to the Walters Art Museum, and the curator, for organizing this major exhibition and composing this magnificent catalogue, which we are pleased to underwrite.

Anthony S. Papadimitriou
President, Alexander S. Onassis Public Benefit Foundation

LENDERS TO THE EXHIBITION

American Numismatic Society, New York
Badisches Landesmuseum Karlsruhe
Joslyn Art Museum, Omaha, Nebraska
Kunsthalle zu Kiel, Antikensammlung
Mr. Christian Clive Levett
Los Angeles County Museum of Art
The Metropolitan Museum of Art, New York
Mount Holyoke College Art Museum, South Hadley, Massachusetts
Museum of Fine Arts, Boston
Museumslandschaft Hessen Kassel, Museum Schloss Wilhelmshöhe
National Archaeological Museum, Athens
Royal Ontario Museum, Toronto
Staatliche Museen zu Berlin, Antikensammlung
Toledo Museum of Art, Toledo, Ohio
University of Pennsylvania Museum of Archaeology and Anthropology,
 Philadelphia
The Walters Art Museum, Baltimore
Worcester Art Museum, Worcester, Massachusetts

CATALOGUE CONTRIBUTORS

Sabine Albersmeier (SA), The Walters Art Museum
Jacquelyn H. Clements (JHC), The Johns Hopkins University, Baltimore
Helene A. Coccagna (HAC), The Johns Hopkins University, Baltimore,
 and the Walters Art Museum
Richard A. Grossmann (RG), Museum of Fine Arts, Boston
Sandra E. Knudsen (SK), Toledo Museum of Art, Toledo, Ohio
Angeliki Kokkinou (AK), The Johns Hopkins University, Baltimore
Jocelyn Rohrbach (JR), Washington University, St. Louis, Missouri
Sarit Stern (SS), The Johns Hopkins University, Baltimore
Allison Surtees (AS), The Johns Hopkins University, Baltimore

RECOVERING THE PAST

THE ORIGINS OF GREEK HEROES AND HERO CULT

Jorge J. Bravo III

Sing, goddess, the anger of Peleus' son Achilleus
and its devastation, which put pains thousandfold upon the Achaians,
hurled in their multitudes to the house of Hades strong souls
of heroes, but gave their bodies to be the delicate feasting
of dogs, of all birds, and the will of Zeus was accomplished. . . .
— Homer, *Iliad* 1.1–5, trans. Lattimore

Homer's bold opening to the *Iliad* makes a fitting starting point for an investigation of the ancient Greek hero. For here already, among the earliest surviving words of Greek literature, we encounter a form of the very Greek word that gives us "hero" in English: *hērōs*. It is the souls of heroes (*psychas / hērōōn*, lines 3–4) that descend to Hades as the numerous victims of Achilles' wrath. But what is a hero? In modern usage the word carries with it a positive valorization, describing anyone who accomplishes great feats and inspires admiration and emulation.

For the ancient Greeks, at least by the Classical period, the designation applied to a broad spectrum of figures that included not just the well-known warriors of Homeric epic and other early legends but also more shadowy figures, about whom, to judge by our ancient sources, the Greeks themselves knew only the slightest details. When narratives about the heroes' lives are available, it is clear that moral excellence was no prerequisite, and while many heroes engaged in deeds of great valor, others are known only for having been killed under extraordinary circumstances.[1] With the goal of comprehending the Greek heroes, scholars for more than a century have tried to sort them into categories according to different criteria such as nature, function, narrative pattern, or location of cult.[2] Thus we can speak of heroes who were ancestors of families and clans, eponymous heroes who gave their names to landmarks and territories, heroes sharing sanctuaries with Olympian gods, child heroes, and epic heroes, just to name a few. The ancients, however, clearly felt no need to dissect their heroes in this way.

What does unite the heterogeneous lot of Greek heroes is first a belief that they were, in fact, mortals, not gods; they lived and died, whether in the remote past or in recent times. Moreover, although now dead, they are believed to have a power over the living, and as a consequence they are worshiped alongside the gods. When the Greeks emerged victorious in the battle of Salamis in 479 BCE, as Herodotos tells us, Themistokles gave credit to the gods and heroes for their success.[3] Shrines dedicated to heroes were ubiquitous in ancient Greece.[4] It is this phenomenon of hero cult that especially distinguishes the ancient Greek sense of hero. The origin of hero cult in particular remains a matter of great debate, one aspect of which has been the question whether the word *hērōs* itself always possessed its cultic significance.

A PREHISTORY OF HEROES?

Attempts to trace the concept of the Greek hero back into prehistory have met many obstacles. The etymology of the word *hērōs* is disputed and far from certain; scholars cannot even agree whether it is Indo-European in origin.[5] What is interesting,

however, is that the many theories that have been put forth all attempt to link it in origin with the name of the goddess Hera.[6] One theory, for instance, regards *hērōs* and Hera as derived from pre-Hellenic, non-Indo-European words signifying "lord/master" and "mistress." Another assigns them an Indo-European pedigree, derived from the root for "year" or "spring," so that Hera is explained as originally a goddess of the seasons and the yearly cycle, and the hero in turn as her consort, a "man of the season," marked by a short life. A third theory, advanced by D. Q. Adams, sees them instead as related to an Indo-European root signifying youth and vitality.[7] Arguably there are elements in the portrayal of the heroes in epic that can be viewed as lending support to any of these theories.[8] A common linguistic origin with Hera, even if true, still does not prove that the concept of *hērōs* in the Bronze Age or in the time of Homer connoted divinity. It does not even necessarily prove that the hero was in origin a divine figure.[9] As a result, a consideration of etymology alone gives us little that we can confidently deduce about the meaning of *hērōs* in its earliest attestations in Greek.

There are, however, some tantalizing bits of evidence for the concept of a hero as a recipient of cult already in Bronze Age Greece. Among the many recovered documents written in Linear B are two clay tablets from Pylos that mention a figure called *ti-ri-se-ro-e*. In both instances the figure is a recipient of an offering from the central palace. The lengthier tablet, PY Tn316, provides more of a context for the offering (fig. 1). Inscribed on both sides, it records the sending of various precious objects and people to the shrines of different deities; several of them are clustered in a district near the palace known as *pa-ki-ja-ne*, interpreted as *Sphagianes*, or the Place of Slaughter. A gold vessel is sent to *ti-ri-se-ro-e*, whose shrine also appears to be in this district.[10] The name has been interpreted as representing what in alphabetic Greek would appear as **trishērōs*, that is to say, *hērōs* with the prefix *tris-* ("three times, thrice"); hence it is commonly translated as "Thrice Hero." The fact that no such compound of *hērōs* is attested in ancient Greek is problematic, yet there has been no serious consideration of any alternative to this reading of the Linear B. Appearing in the company of other recognizable deities, *ti-ri-se-ro-e* is likely to be one as well. In light of the possible etymological connection with Hera, however, it is worth noting that Thrice Hero is not paired with her on the tablet, although she is attested in Linear B and indeed appears on the other side of the tablet along with Zeus.[11]

In a recent essay C. M. Antonaccio draws upon the frequently noted similarity between this divinity's name and the Tritopatores, whose cult is attested in historical times in Athens and elsewhere and who represent a sense of collective ancestors.[12] In the context of the cult at Pylos, she proposes that Thrice Hero represented the ancestral lineage of the *wanax*, the king in Mycenaean society. After the collapse of Bronze Age society, she suggests, the leading men of the more fragmented societies of the Early Iron Age adapted a cult for the heroic ancestors of the *wanax* into cults for their own heroic ancestors in order to bolster their claims to power. It is an intriguing hypothesis, but in the absence of more secure knowledge about the meaning of *ti-ri-se-ro-e*, it remains a highly speculative one. Furthermore, even supposing that *ti-ri-se-ro-e* does embody some limited sense of hero as a deceased mortal with power

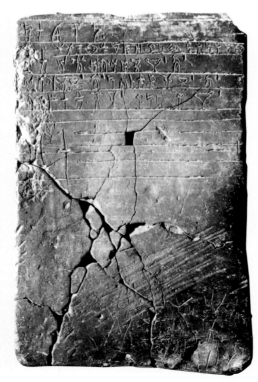

FIG 1 Linear B tablet, PY Tn316, recto

over the living, scholars remain unable to point to any secure archaeological evidence for the practice of hero cult in the Bronze Age as it later appears in the historical period of ancient Greece.[13] Our knowledge about heroes and hero cult in the Bronze Age remains tenuous.

The picture of the Greek hero begins to come more into focus in the first four centuries of the first millennium BCE. During this period, we can place the formulation of elaborate poetic expressions of the hero, which in turn inspire the representation of heroes in art. In addition, the Greeks begin to engage in ritual practices, leaving traces in the archaeological record, that suggest the widespread development of hero cult. Despite this surge in available evidence, questions linger about the original significa-tion of *hērōs*, the timing of the development of hero cult, and the factors that brought it about. Let us consider the issues from a philological perspective first and then turn to a consideration of the archaeological evidence for hero cult.

HEROES IN EARLY GREEK POETRY

The earliest Greek poems that survive in written form preserve stories that had been in circulation as oral traditions, both poetic and nonpoetic, throughout the preced-ing centuries.[14] The result of this creative process is a world populated with heroes, many of whom are fleshed out with full-blooded lives. Achilles and Odysseus number among them, and their complex characterizations permit us to see how different the qualities of an epic hero can be. They do not share a common mold.[15] There is no room here to explore the issue of the historicity of the epic tradition, but few scholars would now entertain the notion that the heroes represent some recollection of specific individuals of the Bronze Age past.[16] The origins of these heroes are tied to the origins of the epics in which they move, and while Greek heroes bear the undeniable stamp of the culture that described them, they share qualities with characters of other cultural traditions (for instance, Gilgamesh), so that we must also account for external impulses and influences in the shaping of their identities.[17]

As the opening lines of the *Iliad* exemplify, epic poetry abounds in heroes. In both of the Homeric poems, the term *hērōs* is applied to individual males as well as to larger groups. On the battlefield of Troy in the *Iliad*, for instance, many of the Greek champions, including Agamemnon (6.61 and elsewhere), Achilles (23.824), Menelaos (3.377; cf. fig. 2), and Odysseus (11.483), are so named, as are many Trojan champi-ons, such as Aeneas (5.308) and Paris (13.788).[18] Collective references to *hērōes* in the plural, however, demonstrate that the word applies more extensively to all the troops. To the opening lines of the *Iliad*, with its reference to the souls of heroes, we may add later references to the Greek army as Achaean or Danaan heroes (e.g., 12.165, 15.733), and even references to both armies together (e.g., 13.346). *Hērōes* can also describe men beyond the context of war, such as the Phaeacians (*Odyssey* 7.44). Moreover, as H. Van Wees points out,[19] *hērōs* is used not just in narration but also in the speech of the heroes themselves to refer to one another both indirectly and in direct address: "Come now, tell me this, hero Eurypylos, cherished by Zeus . . . ," says Patroklos to the injured warrior on his way back to the ships (*Iliad* 11.819).

In his analysis of the semantics of *hērōs*, M. L. West acknowledges the elusiveness of an exact meaning, arguing that "warrior" is "in several places the most suitable meaning," while noting some instances in the *Odyssey* of this meaning being difficult to maintain, for example, when it is used of the singer Demodokos (8.483) and the herald and attendant Moulios (18.423).[20] Other scholars regard *hērōs* as a more general term of respect, meaning something like "noble." The scholarly consensus, at any rate, is that the term is entirely secular in meaning and bears no trace of the religious meaning that *hērōs* comes to have in the context of hero cult.[21]

Consistent with this impression is the usage of *hērōs* in the surviving fragments of the poems of the Epic Cycle, which complement the Homeric poems in recounting the surrounding events of the expedition to Troy and the heroes' returns, in addition to recounting other early Greek legends such as the Theban War. The poems have been regarded as post-Homeric and derivative, but J. S. Burgess has come to their defense, maintaining that the Homeric and Cyclic traditions remained fluid into the Archaic period and that the Cyclic tradition may in many respects preserve early elements of Greek legend that the Homeric poems do not.[22] Among the extant passages of these poems, one encounters *hērōs* applied not only individually to great men but also collectively to those who died at Troy.[23]

Hesiod likewise uses the word for individuals as well as collectively, but without doubt the most noteworthy occurrence of *hērōs* is in *Works and Days,* where it designates the fourth of the five races in his well-known account of the history of mankind (106–201).[24] Probably adapted from a Near Eastern source, Hesiod's account is distinguished by the insertion of a race of heroes into a more traditional tale of a sequence of human races associated with metals of declining value: gold, silver, bronze, and iron.[25] After the death of the race of bronze men, relates Hesiod, Zeus created another, a "divine race of men who were heroes" (*andrōn herōōn theion genos,* 159). Better than their predecessors, the men of this fourth race are also called "demigods" (*hēmitheoi,* 160) and constitute the race before Hesiod's own beleaguered race of iron. The lines that follow make it clear that the race of heroes encompasses all the men who fought in the Theban and Trojan wars.

What, however, does Hesiod mean by calling them a "divine race" and "demigods"? West explains that the phrases relate to the divine descent and parentage of the heroes of legend rather than to a semidivine status, which presumably would imply worship.[26] They reflect, in other words, a general belief that the heroes of the past were descended, within a few generations at most, from the matings of gods and mortals.[27] There is, in addition, another layer of significance to the use of *hēmitheoi.* The term, which always appears in the plural, is used in poetry to refer collectively to a group of men who lived in the past and are distinct from the present time of the poet's audience.[28] The effect is striking in the sole instance when the word appears in Homer, as G. Nagy has shown: In book 12 of the *Iliad,* Homer temporarily steps outside the course of the narrative to describe the future events of the Trojan War and ultimately recount the demolition of the rampart that the Greeks had built to hold off the Trojans from their ships.[29] In the midst of this, Homer describes the fallen (and those yet to

fall) as "the race of men who are demigods" (*hēmitheōn genos andrōn*, 23). It is only from the distanced perspective of the audience that the word *hēmitheoi* appears in Homer. Accordingly, within *Works and Days*, not only does *hērōs* occur in its most inclusive sense in early Greek literature, but in its pairing with *hēmitheoi* and in relation to the succeeding race of iron, it designates explicitly men who died some time ago, in contrast to its usual usage in epic, in which it functions within the narrative present of the world of the living heroes themselves.[30]

Although the usage of *hērōs* is secular in epic poetry, still scholars have noticed passages that may indicate some awareness of a special status after death, for certain figures at least; a few passages even seem to refer to special rituals performed for the dead that are less like ordinary funerary ritual and more like hero-cult practices.[31] One of the most convincing is the description of the cult of Erechtheus, the legendary king of Athens (*Iliad* 2.546–51). He is said to reside in Athena's temple, and young Athenian males propitiate him with yearly sacrifices of cattle and sheep.[32] Another description of ritual associated with the dead is found in book 11 of the *Odyssey* when Odysseus offers libations and pours the blood of black sheep into a pit in order to summon up the dead and enable them to speak (23–36; cf. 10.516–29).[33] Several passages, in addition, mention specific tombs of the long dead in contexts that intimate reverence, although no attendant ritual is described.[34] Finally, while the dominant picture of the fate of the heroes after death is that their souls flitter down to a meaningless existence in Hades—again the opening lines of the *Iliad* are exemplary—there are, nevertheless, some figures who enjoy a kind of immortality after death, which can be variously expressed as living on Olympos, in Elysium, on the Isles of the Blessed, or even under the earth.[35]

In the poetic tradition of the Epic Cycle, the notion of immortality is more explicit. According to the summaries of the epics written by Proklos, several mortals, both men and women, gain it.[36] So, in the *Cypria*, the twins Kastor and Polydeukes, as well as Agamemnon's daughter Iphigeneia, are given immortality. Memnon receives this gift from his mother, Eos, in the *Aithiopis*, and similarly Thetis removes Achilles from his pyre and takes him to the White Island (*Leukē nēsos*). In the last poem of the Cycle, the *Telegony*, Kirke confers immortality upon Telegonos, her son by Odysseus, as well as upon Telemachos and Penelope. Setting aside these general references to immortality in the Cyclic tradition, it is possible to see further indications of hero cult in regard to Achilles. In the *Aithiopis*, for instance, the reference to the White Island as his afterlife destination may reflect an actual cult for him on a real island, called "White Island" by the Greeks, in the Black Sea. Despite his translation there after death, Achilles still has a tomb in the Troad, and references in the Cyclic tradition to Achilles appearing after death in the Troad and demanding the sacrifice of the Trojan princess Polyxena at his tomb may be further allusions to another hero cult in his honor.[37]

Turning back to Hesiod's account of the races of man in *Works and Days*, we can observe that it too reveals signs of an extraordinary status after death for some of the past races, but these are clearest for the gold and silver races, not that of the heroes.[38]

Men of the gold race, we are told, became *daimones* after their deaths (122). The word connotes divine power, especially the power to affect the fortunes of the living, and Hesiod subsequently signals this power by calling them *ploutodotai*, bestowers of wealth (126).[39] The afterlife of the silver race is different, but still there are elements suggestive of a cultic status. Whereas the men of gold reside on the earth after death (*epichthonioi*, 123), the men of silver come to dwell underground (*hypochthonioi*, 141), which recalls the local character of later hero cult, often bound to the hero's burial place.[40] Moreover, Hesiod calls them "blessed mortals" (*makares thnētoi*, 123). As mortals they are distinguished from gods, and yet the qualification "blessed," an adjective that by itself may designate the gods, may here indicate some divine power. Finally, they receive honor (*timē*) from Zeus, which may also imply receiving cult from mortals.[41]

There is no question about the afterlife of the bronze race; these men go to Hades after death and remain nameless and unsung (153–54). The race of heroes, on the other hand, has a different destination; some or all of these men pass on to live at the edge of the world on the Isles of the Blessed (*en makarōn nēsoisi*, 171).[42] There they become fortunate heroes (*olbioi hērōes*, 172), living in a land of abundant produce. The passage lacks any overt reference either to divine power or to cult for the heroes on the Isles (let alone those heroes who died in war, if line 166 belongs), and West maintains that Hesiod uses *hērōs* in the same way that Homer does, without any religious significance.[43] Nagy, on the contrary, explains that the Isles of the Blessed represent another expression of immortal existence, analogous to Achilles' White Island or Elysium, the place where Menelaos will end up, according to the *Odyssey*. Furthermore, the idea of the hero's removal to the edge of the world is not incompatible with the idea of hero cult.[44]

In various ways, therefore, the poems of Homer, Hesiod, and the Epic Cycle intimate ideas about certain mortals transcending ordinary death and even receiving cult from the living. Yet direct evidence for hero cult is lacking. Consider, for instance, that while both the Greeks and the Trojans in the *Iliad* on several occasions make sacrifices to the gods, pray to them, and vow future sacrifices and offerings to them, not once do they perform any ritual for a dead mortal. Why would early poetry not refer more explicitly to hero cult, if in fact hero cult existed? One answer, provided by M. L. West, has to do with geography. He argues that in Ionia, where the epics were developed, the concept of the *hērōs* was strictly secular, in contrast to the mainland, where the concept of *hērōs* developed independently of epic in association with "the honoured dead and more loosely with terrestrial *numina* resident in a district."[45] By his reasoning, hero cult was alien to the land where the epics originated, and the indirect references in the poems only result from the infiltration of the mainland concept of *hērōs* into the poetic tradition as it circulated there. Nagy offers another answer, having to do with the nature of the genre of epic poetry. In his view, Homeric epic strives to be pan-Hellenic in appeal, reflecting "the ideology of the polis in general—but without being restricted to the ideology of any one polis in particular." To the extent that hero

cult is by nature a very localized phenomenon, the epic tradition cannot embrace it. "What results is that the central heroes of this epic tradition cannot have an overtly religious dimension in the narrative."[46]

Although different in their reasoning, both answers accept that cult for the powerful dead already existed, at least on the Greek mainland, and both equate this with hero cult, that is to say, cult for *hērōes*. With regard to the word *hērōs*, however, there is more to be explained than just Homeric reticence about cult. Even when that reticence is overcome and we do find passages referring to a special existence after death or even cult ritual, the word *hērōs* is still not used in association.[47] Consequently, it may be worth considering the possibility that, while cult practices oriented toward the powerful dead did exist at the time of the formation of the poetry of Homer, Hesiod, and the Epic Cycle, these practices had not yet come to be articulated by the Greeks as cult for *hērōes*, or hero cult.[48]

If we search for literary evidence that explicitly attaches cult practice to the word *hērōs*, we find it only in such later genres as elegiac, iambic, and epinician poetry.[49] A fragment of Mimnermos, which refers to a hero Daites worshiped by the Trojans, seems to be the earliest. Outside of the realm of poetry, if the testimony of Porphyry is accurate, we learn that the seventh-century Athenian lawgiver Draco passed a law bidding the Athenians to worship the gods and heroes in accordance with ancestral practices.[50]

Artistic interest in the heroes of Greek legend becomes detectable at the end of the eighth century BCE and more common in the seventh.[51] Painted scenes, such as Menelaos fighting Hektor over the body of Euphorbos, become more recognizable with the addition of painted inscriptions to identify the heroes (fig. 2). The circulation of epic poetry doubtless had some effect on art, but surprisingly, scenes from the Homeric poems begin to appear in art later than scenes pertaining to the episodes recounted in the Epic Cycle poems. Other mythic traditions as well appear in early art, such as scenes of Herakles.[52] The relative independence of the artistic tradition should caution us against assuming that early Greek thought about these heroes found full expression in the earliest surviving literature.

One final observation to be made about the hero in literature is the late development of a vocabulary to describe female heroines. In early poetry, as all the examples that have been cited demonstrate, *hērōs* describes a man, just as the plural form refers to a group of men. Many times the plural form is coupled with the word for man (*anēr*) to reinforce the association, as in *Works and Days* (159). Of course women figure prominently in early poetry, and we have already observed that two of them, Iphigeneia and Penelope, received immortality in the Epic Cycle, suggesting that at least some women could attain a special status after death. Moreover, as will be seen below, one of the most certain and earliest archaeological examples of hero cult for epic heroes is the cult of Helen and Menelaos in Sparta. Nevertheless, distinct words for heroines, which are formed by adding feminine suffixes to *hērōs*, are not attested before the fifth century BCE.[53]

FIG 2 Menelaos fighting Hektor over the corpse of Euphorbos, Rhodian black-figure plate, ca. 630–610 BCE. London, British Museum, 1860,0404.1 (A 749)

HERO CULT IN THE EARLY ARCHAEOLOGICAL RECORD

Both West and Nagy understand hero cult to exist at the time that early poetry receives its fixed form. For more precision about the origins of this distinctively Greek belief in the cultic role of heroes, scholars rely on the findings of archaeology. Unfortunately, pinpointing the earliest examples of hero cult in the archaeological record has proved to be a challenge, which has generated conflicting scholarly opinions and ongoing debate. Moreover, the interpretations of the motivation for these early instances of hero cult are varied as well.

The earliest candidate for hero cult in the archaeological record is also, arguably, the most extraordinary. On Toumba Hill at Lefkandi on the island of Euboea, excavators unearthed the remnants of an apsidal building dated to the tenth century BCE (fig. 3).[54] Some fifty meters in length, the size of the building alone makes it exceptional for its time. Within its central room were discovered two burial shafts, one containing a cremated male in a bronze amphora placed next to an inhumed female, the other containing four inhumed horses. The burial goods included iron weapons and, adorning the female, fine jewelry of gold, electrum, and bronze; but what makes them especially stand out is the fact that the bronze amphora holding the cremated male was made in Cyprus, probably in the twelfth century BCE, and one gold necklace was apparently made in Babylonia about a millennium beforehand. The nature of the activity within the building is difficult to interpret, but before long, the building was demolished and concealed beneath a large earthen tumulus. For more than a century thereafter, the complex served as the focal point for a cemetery that developed immediately to the east, in front of the now buried building.

FIG 3 Plan of the Toumba building and cemetery at Lefkandi, Euboea. From M. Popham and I. Lemos, *Lefkandi III: The Toumba Cemetery* (Athens, 1996), pl. 4

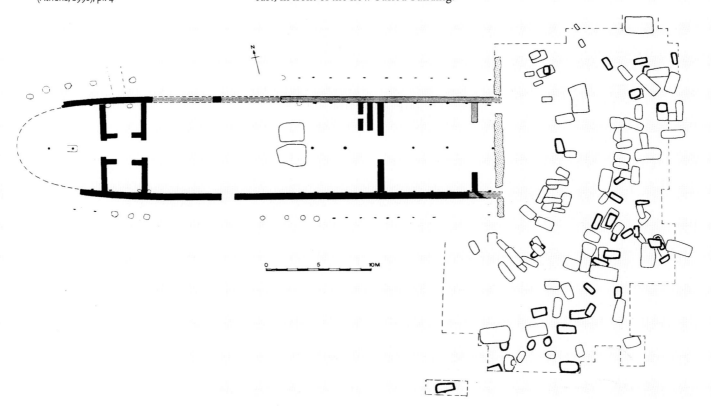

Aspects of the burials have prompted some scholars to interpret the building as a *heroön*, or hero shrine, in honor of the deceased. Features such as the cremation of the male, for instance, as well as the use of an elaborate metal vase to hold the remains and the burial of the horses, recall the elaborate funeral rites for the heroes of Homeric epic.[55] Even assuming that the similarity is genuine and was intended, is this sufficient to prove hero cult? Given the uncertainty in the philological evidence for hero cult, we should be careful to allow for the possible distinction between a social ideology that valorizes the deceased by assimilation into the great men of the legendary past and a religious ideology that regards some of the dead as retaining a power over the living community and therefore requiring cult.[56] I. Morris advocates more strongly for the Toumba complex as "the earliest known example of a ritual package which was to define heroic status for more than a millennium."[57] Not only does he note the similarities between the Toumba remains and epic funerals, but he also sees evidence in the burials for the conception of a past race of demigod heroes expressed in Hesiod's *Works and Days*. He posits that this conception, and with it, hero cult, originated in the eleventh century BCE as a way for the Early Iron Age elite to account for their deteriorated circumstances and at the same time, through the institution of hero cult, to deal with the potential threat of men who manage to surpass them.[58] It is an ingenious idea, but not without difficulties and in need of corroboration. With regard to hero cult specifically, we note that, like the appeal to Homer, the appeal to Hesiod rests on the assumption that hero cult is implicit in his description of that fourth race, but as we observed earlier, the references to cult are diffuse and more easily discerned in connection with the races of gold and silver.

Apart from the danger of using Homer and Hesiod to claim that there was hero cult at Toumba, there are other problems. For instance, uncertainty surrounds the chronological relationship of the supposed shrine to the burials within it. It is unclear whether the building preceded the burials, perhaps serving as the couple's dwelling, or was erected afterward as a shrine for the burials, or converted from the former to the latter.[59] Most problematic for the shrine interpretation is that there is no material evidence for the worship of the deceased, such as votive offerings or the remains of sacrifice, either within the building before its demolition or after the construction of the mound above it.[60] Antonaccio finds this last point decisive for the question of hero cult and instead focuses on the relationship between the buried structure and the cemetery to the east, arguing that the cremated male was regarded as a founding ancestor for the people subsequently buried in the cemetery.[61] Ultimately it is the uniqueness of the astounding remains at Toumba that precludes any certainty about their interpretation.

Another phenomenon of the Iron Age that has been claimed to represent early hero cult is the sporadic activity at Bronze Age tombs. Generally described as tomb cult, the activity is usually short-lived and encompasses a range of practices, from modest offerings to the reuse of the tomb for subsequent burial.[62] Examples of this activity have been found in the material record across Greece but are especially concentrated in Attica, the Argolid, and Messenia. Observing that most of them are dated to the

late eighth century BCE, J. N. Coldstream proposed in 1976 that the practices represent early hero cults, established under the sway of the Homeric epics, which became popular and widely performed in this same period.[63] His thesis has been criticized on two grounds: for claiming that these activities represent hero cult and for attributing them to the influence of epic. With regard to the latter, scholars have objected that some examples of tomb cult are known from earlier periods before the epics became familiar and that the forms and burial practices of the revisited Bronze Age tombs bear no resemblance to the poetic depictions of cremations buried under great earthen mounds. Moreover, the fact that Homer's poems already show an awareness of some form of hero cult proves that they could not be the cause of hero cult. Lastly, there is no evidence from any of the tombs to suggest that the occupants were identified with epic heroes.[64] Many scholars, accordingly, accept this Iron Age phenomenon as an early form of hero cult but prefer to seek alternative explanations.[65]

Other scholars have disputed that the activity at Bronze Age tombs constitutes hero cult at all. J. Whitley, for example, argues that it was directed instead to the men of the silver race as described in *Works and Days*, although he does allow for the possibility that in time they came to be reckoned "generic" (i.e., anonymous) heroes, as distinct from epic heroes.[66] This last point deserves emphasis, for it suggests that early beliefs about the powerful deceased may have been in flux and only later crystallized as one part of the complex of hero cult.

Antonaccio argues more strenuously for a distinction between tomb cult in the Iron Age and hero cult, based on a number of observations. These include the short duration of the activity at the tombs, as compared with the recurrent activity at hero shrines; the absence among the tombs of metal and stone dedications; and the rarity of later, more secure examples of hero cult located at Bronze Age tombs. In her view, the activity at the tombs is more comparable to contemporary burial practices, and for this reason she regards tomb cult as a form of ancestor cult, in which the living commemorate dead ancestors, whether fictional or real.[67]

A less categorical approach might allow that some instances of tomb cult do constitute hero cult. While most of the activity at Bronze Age tombs is of short duration, a few notable exceptions exist. For example, the excavation of the entry corridor (*dromos*) of a tholos tomb at Menidi, in Attica (fig. 4), yielded evidence for nearly three centuries of activity, beginning in the late eighth century BCE and continuing until the middle of the fifth. The finds included plenty of votive material in terracotta such as models of shields, painted plaques (although the paint was no longer preserved), and figurines of horses from chariot groups along with solitary horses with riders. There was an abundance of broken pottery as well, representing a variety of shapes such as oil bottles, drinking cups, wine service vessels, and basins for holding bath water (*louteria*).[68] The finds may be interpreted as evidence of a hero cult for the presumed occupants of the tomb (the tomb itself was not breached in antiquity, and most of the material was located at the end of the dromos opposite the tomb entrance), although the nature of the finds themselves does not prove beyond doubt that there was a hero cult here.[69] Antonaccio, noting the funerary character of much of the material,

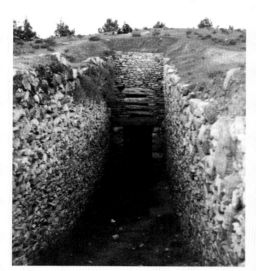

prefers to consider it another, albeit exceptional, instance of ancestor cult at a Bronze Age tomb.[70]

Claims of hero cult have also been made in connection with activity at graves of the Iron Age. Archaeologists have brought to light several examples of structures built over or near the graves and preserving evidence suggestive of ritual. A. Mazarakis Ainian offers a concise survey of the sites and notes the difficulty of distinguishing between the ordinary cult of the dead, ancestor cult, and hero cult. What is more, the division between cemetery and settlement was not so rigid in the Iron Age as in later times, which allows for the possibility that the activity at some sites was purely domestic. In the majority of cases, concludes Mazarakis Ainian, the activity should not be interpreted as hero cult.[71]

An important exception to this general conclusion is the West Gate Heroön, a complex of finds recovered near the West Gate of Eretria on the island of Euboea. There, Swiss excavators unearthed a cluster of sixteen rich burials dated from the late eighth and early seventh centuries BCE.[72] The earliest burial was also the richest: a male cremation buried in a bronze cauldron together with weapons and other objects of gold, silver, and bronze. The remaining burials, comprising men, women, and children, may represent his kin. Shortly after the last burial, a distinctive, triangular stone monument, measuring more than nine meters per side, was erected over the area (fig. 5). Features in the immediate vicinity, including a pit filled with ritual debris, the remains of two buildings associated with ritual dining, and a possible altar, suggest that a hero cult was established in honor of the deceased and continued for some two centuries. Scholars have sought to explain the institution of this hero cult as a function of the developing ideology of the polis of Eretria, although the identities of the deceased and their symbolic value for the developing polis remain matters of debate.[73]

The attempt to account for the social and political factors behind the West Gate Heroön is indicative of a larger trend in scholarship to find similar explanations for tomb cult (whether regarded as hero cult or ancestor cult) in general. In part it is a reaction to the view that epic poetry was so influential. Thus A. M. Snodgrass, in response to Coldstream's thesis about the cult activity at Bronze Age tombs, espoused the idea that tomb cult arose from the need of small landholders to defend their claims to land in the face of competing claims; through tomb cult they could invoke the protection of the anonymous heroes who had power over the land.[74] Subsequently, scholars have offered more complex accounts that show variation not only from region

FIG 4 Dromos of the Menidi tholos tomb in Attica, 1932

FIG 5 Aerial view of the triangular monument of the West Gate Heroön at Eretria, Euboea

to region but also among the competing social groups within a given region.[75] What unites these explanations is the concept that a social group, however large, incorporates a figure of the past, whether ancestor or hero, legendary or real, into its own sense of identity, status, and empowerment with respect to all others.[76]

Returning to the basic question of whether the activity at Bronze Age and later tombs constitutes hero cult, we should note that even if it does not, the phenomenon does not lose all relevance to the question of the origin of hero cult. It may be possible to trace the origin of at least certain forms of hero cult back to the cult of ancestors—after all, many Classical heroes were considered to be the legendary ancestors of particular clans and families. Such a relationship does receive some support from the archaeological record. Important in this regard is the evidence of a shift from ancestor cult to hero cult on the island of Naxos. Excavation at Metropolis Square in the town of Naxos uncovered a series of graves of Late Protogeometric date. Above them a sequence of constructions, including circular pebble platforms known from other funerary and tomb-cult contexts, and related finds point to the veneration of ancestors by aristocratic families or clans. Such activity lasted into the Late Geometric period, at which time the entire area was buried under a tumulus of mud brick and transformed into a more communal hero cult.[77] The example of Naxos thus encourages us to reflect on how ancestor cult could have been adapted to fit changing social realities and needs, resulting in hero cult in at least some instances.

There is an additional point of connection between tomb cult and hero cult in the form of the cult of the founder of a colony. A wave of colonial ventures began in Greece in the second half of the eighth century BCE, resulting in new settlements in South Italy, Sicily, the Black Sea region, and elsewhere around the Mediterranean. Crucial to the enterprise was the direction of a leader, the oikist (Greek *oikistēs*), who organized most aspects of the settlement process such as the division of land and designation of the locations of new sanctuaries.[78] After his death the oikist received an elaborate burial by the new community, and his tomb, located in the agora of the new polis, became the focus of a hero cult replete with annual sacrifices and athletic

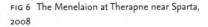

FIG 6 The Menelaion at Therapne near Sparta, 2008

competitions.[79] The value of the cult for the new polis lay both in serving as "a focus of this new political identity" and in asserting a claim to the new territory in the face of the surrounding native inhabitants.[80]

The later ancient sources are clear about the cult of the oikist, but the question lingers whether this kind of cult originated with the earliest colonial foundations or was introduced in later times. I. Malkin contends that the practice did begin in the late eighth and early seventh centuries and compares the contemporary development at the West Gate Heroön of Eretria. He further suggests that the innovation of oikist cult in the colonies in turn inspired mainland cities to establish cults for their own founders.[81] The material record is less certain, however. The earliest examples of oikist cult that have been identified archaeologically are the tomb of the oikist of Megara Hyblaea in Sicily and the tomb of Battus at Cyrene in Libya. Of these two, the remains at Cyrene are more certainly identifiable, but the earliest phase belongs to the sixth century BCE.[82] In the absence of earlier evidence for the cult of the oikist, it is difficult to prove that it contributed to the early development of hero cult, but the possibility cannot be excluded.

We turn at last to the cult of those heroes with whom we began the essay, the heroes of the epic poems and early myth. Assessing the earliest evidence for this type of hero cult entails another set of difficulties. One of the earliest and most securely identified shrines to an epic hero is the Menelaion, a shrine of Helen and Menelaos crowning a hilltop at Therapne near Sparta (fig. 6). The earliest material associated with the shrine documents the start of the cult in the late eighth or early seventh century BCE, and a bronze aryballos inscribed "to Helen, wife of Menelaos" can be dated to the second quarter of the seventh century BCE (fig. 7).[83] Thus we can be confident that Helen at least was the focus of worship from this date. Nevertheless, some scholars have cast doubt on the classification of the Menelaion as a hero shrine on the grounds that the Spartans, according to ancient testimony, considered Helen and Menelaos gods, not heroes. In addition, some regard Helen alone as the original recipient of cult and consider her a goddess in origin, only later identified with the epic figure of Helen.[84] These objections are not insurmountable, however; there are parallels for heroes being called gods, and the inscribed aryballos shows that Helen was addressed as the wife of Menelaos, not as a solitary goddess, in the early years of the cult.[85]

Different doubts surround another early instance of epic-hero cult, the shrine of Agamemnon at Mycenae. Located near a Mycenaean-era bridge at the Chaos ravine outside the citadel of Mycenae, the fragmentary remains of the Agamemnoneion attest to ritual activity beginning in the late eighth century BCE and persisting into the Hellenistic period, when the shrine was renovated.[86] The identification of the shrine is based primarily on a few fragmentary inscriptions preserved on pottery of Classical and Hellenistic date; the name "Agamemnon" can be restored on them, although the name is nowhere preserved in full. Earlier material from the shrine features a range of pottery, terracotta figurines, and a few metal objects. On the basis of some of the finds, in particular a substantial number of seated female figurines, some scholars argue instead that the shrine was devoted to the goddess Hera at first, with Agamemnon added to

the cult some time before the end of the Classical period, as evidenced by the later inscribed material.[87]

The Cave of Odysseus at Polis Bay on Ithaca is another disputed example of an early hero cult devoted to an epic hero. Systematic excavation of the cave by S. Benton in the 1930s revealed that the cave had functioned as a shrine from the Geometric period to the Roman period.[88] Benton identified the cave as a shrine of Odysseus in part because of the discovery within it of a series of at least thirteen Geometric bronze tripods. Their presence in a bayside cave recalls the account of Odysseus's return to Ithaca with the gifts of the Phaeacians in Homer's *Odyssey* (13.345–70). Athena appears to him on the shore and tells him to take the gifts, which include a number of bronze tripods, and leave them in a nearby cave of the Nymphs. Also supporting the identification is another find, a late Hellenistic terracotta mask bearing a dedicatory inscription to Odysseus.[89] On the other hand, many of the finds point to other deities worshiped in the cave. Inscriptions mentioning Athena, Hera, and the Nymphs came to light, and a number of votive terracotta masks bear images of Artemis and the Nymphs. The Geometric tripods, moreover, were recovered from layers associated with a fourth-century BCE refurbishment of the interior, and it has been suggested that they were moved to the cave from another sanctuary at that time. As at the Agamemnoneion, therefore, some scholars think that the hero cult of Odysseus was a later addition to the cult practiced in the cave at Polis Bay.[90]

Another correspondence with Homer's *Odyssey* lends support to a hero cult of Phrontis at Sounion. When Menelaos was returning to Sparta from Troy, we learn, his helmsman Phrontis was killed by Apollo just as their ships were passing by Sounion. Menelaos then stopped to give Phrontis proper burial there (3.278–85). Some scholars see in these details the reflection of a real hero cult for the helmsman, and they have sought confirmation of the cult among the finds of early votive deposits at Sounion.[91] Among them is a fragmentary terracotta plaque depicting a ship with armed men and a larger figure of a helmsman (fig. 8). The emphatic rendering of this last figure suggests that he represents the hero Phrontis, and the plaque has been considered a votive dedication in his cult.[92] If this interpretation is correct, then the plaque, which is dated to the late eighth century, constitutes the earliest known representation of a hero in the context of his cult. Some other votive material may pertain to the cult, and Abramson proposes that a small rectangular structure and enclosure wall near the Temple of Athena belong to the shrine of Phrontis.[93] To many, however, the case for a cult of Phrontis at Sounion appears weak.

As the preceding examples demonstrate, determining the earliest hero cults for the well-known heroes of myth and epic proves to be no easier than doing so for other forms of hero cult. The total number of archaeologically attested examples that originate before the Archaic period remains small, even when we assume that all such claims are true.[94] The circulation of the epic poems may have contributed somewhat to their development, but surely it did not trigger widespread worship. Like other forms of hero cult, the growth of cults of epic heroes is more likely to result from changing sociopolitical circumstances.[95]

CONCLUSION

Certainty about the origins of hero cult in the archaeological record proves elusive, however, as no early example of hero cult is free of dispute. While some scholars still search for the origins of hero cult in the Bronze Age and Early Iron Age, others are willing to consider hero cult a much later phenomenon commencing even as late as the seventh century BCE. For the centuries in between, debate continues about various practices detected in the archaeological record. As for the reasons for the development of hero cult, most scholars are now content to conclude that hero cult developed largely independently of Homer and other early epic poetry. Instead, they increasingly focus on the social needs that the worship of heroes served, worship that allowed groups and communities of varying size to lay claim to the past. The evidence of archaeology suggests that the expectation of some grand unifying theory of origin to explain the nature of Greek heroes and hero cult is unrealistic. Rather it suggests that the contributing factors were complex and diverse, but diverse origins make sense for a category of worship that in later times demonstrably entails a wide spectrum of heroes, not just those celebrated in early poetry.[96]

Furthermore, the complexity of the material record has a parallel in, and may even contribute to, the representation of the powerful dead in Homer, Hesiod, and the Epic Cycle. The early philological evidence attests to the dead achieving a special status in the afterlife and even receiving honors from the living, but the notion is expressed in varying terms. In addition, it does not seem anchored to the Greek word *hērōs*, which instead describes great men of a past age. Thus, even though the worship of the dead may have developed along any number of routes in earlier times, this still does not necessarily mean that the Greeks had begun to think and speak of worshiping *heroes*, as they did in later times.[97] An exact answer to the question of the origins of the Greek hero and hero cult is wanting, but if scholars do ever agree on one, it is likely to be as multifarious as the heroes themselves.

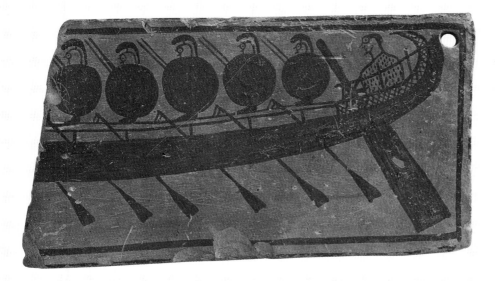

FIG 8 Fragmentary terracotta plaque from Sounion, perhaps representing the hero Phrontis, ca. 700 BCE. Athens, National Archaeological Museum, 14935

NOTES

1 For more discussion of the ancient Greek hero as a model of behavior, see the essay by Michael J. Anderson in this volume (144–73).

2 E.g., Farnell 1921; Brelich 1958; Kearns 1989.

3 8.109.3, cited by Burkert 1985, 205.

4 Consider that for Attica alone, Kearns 1989 catalogues more than 180 heroes. See the essay by Gunnel Ekroth in this volume (120–43) for more on the nature of hero cult in the Archaic and Classical periods.

5 O'Brien 1993, 113–16, provides a more detailed review of the theories summarized here. See also Barrigón 2000, 1–2.

6 O'Brien 1993, 113–19.

7 Adams 1987, 177.

8 O'Brien 1993, 116–19, finds support for the connection with seasonality in the Homeric poems; and Nagy 2005, 87, regards this idea as an integral part of the *hērōs* in ancient Greek. The idea of youthful vitality also approximates the Homeric meaning of (young) warrior proposed by West 1979, 370–73; see further discussion below.

9 In Homeric epic, as O'Brien 1993, 117–19 and 156–66, discusses, Hera is a patron goddess to the mortal Argive heroes. This may represent a semantic shift, at some unknown time in the past, from an original conception of Hera and Hero as divine consorts (cf. Morris 2000, 233). Is it not also possible, however, that the original linguistic bond represented divine and mortal aspects of a shared concept?

10 The tablet is a valuable document in the study of Mycenaean religion in many respects and has received attention for many reasons, not least of which has been the early interpretation, now rejected, of references to human sacrifice. See the thorough treatment of the tablet in Palaima 1999. The other tablet, PY Fr1204, records sending rose-scented oil to *ti-ri-se-ro-e*, although the reading of the name is not certain, according to the transcription printed in Bennett and Olivier 1973, 155. For *pa-ki-ja-ne* as Sphagianes, see Palaima 2008, 349.

11 Noted as well by Antonaccio 2006, 383.

12 Antonaccio 2006, 384–85. Against the similarity, García Tejeiro and Molinas Tejada 2000, 113, assert the difference in meaning between the ordinal prefix *trito-* and the intensifying prefix *tris-*. Antonaccio also admits that Thrice Hero is a single figure, whereas the Tritopatores are plural, but she does not regard this as a serious problem.

13 Antonaccio 1995, 245.

14 Burgess 2001, 3–5.

15 Nagy 2005, 71 and 78–79. For more on these two heroes, see the essays by Guy Hedreen (39–48) and Ralf von den Hoff (57–65) in this volume.

16 This does not exclude, on the other hand, the possibility that some elements of the epic tradition were being formulated within Greece during the Bronze Age. Another obsolete idea is that the epic heroes represent faded gods, a dim recollection of once powerful and revered divinities of the distant past: Farnell 1921, 280–85.

17 Burgess 2001, 1–2; see also Nagy 2005, 71–76, who proposes a composite methodology for understanding these external factors, one that examines basic typological patterns across cultures, inherited linguistic traits, and the historical mechanism of cultural contact and exchange.

18 For more extensive lists of citations from the Homeric poems, see Van Wees 2006, 368–69, with notes.

19 Van Wees 2006, 367–68.

20 West 1978, 370. Van Wees 2006, 369 and n. 18, notes problematic instances in the *Iliad* as well.

21 Chantraine 1968, 417; Kearns 1989, 2; Barrigón 2000, 2. Van Wees 2006, 366–70, challenges the consensus view and argues to the contrary, that *hērōs* has no other meaning but the one that it comes to have in later Greek, namely, a mortal who is worshiped after death. The basis of his reasoning is his belief that *hērōs* is applied too widely in Homer and Hesiod (see below) to have any discrete, secular meaning. He also makes the tendentious claim that *ti-ri-se-ro-e* in Linear B proves that *hērōs* already had a religious meaning in the Bronze Age. The entire argument is problematic and does not persuade me.

22 Burgess 2001.

23 The relevant fragments from the edition of Bernabé are *Little Iliad* 2.2 (Achilles); *Cypria* 1.7 (those who died at Troy) and 15.4 (Lynkeus); and *Thebais* 2.1 (Polyneikes) and 4.1 (Amphilokhos). See also Barrigón 2000, 3–4, although she mistakenly reads *hērōs* in the *Little Iliad* passage as referring to Odysseus.

24 Other passages include *Theogony* 970 and 1009, in relation to Iasion and Ankhises, the mortal mates of Demeter and Aphrodite. Occurrences among the fragments of the *Catalogue of Women* edited in Merkelbach and West 1967 include 25.11, 70.33, 193.13, 195.19, 200.9, and 204.119. Cf. the remarks of Barrigón 2000, 2.

25 West 1978, 173–74; at 176–77, he suggests that the tale originated in Mesopotamia and was ultimately transmitted to the Greeks through trade contact during the eighth century BCE. Morris 2000, 231–32, on the other hand, argues that the transmission occurred much earlier, in the eleventh century, for reasons related to his interpretation of the remains at Lefkandi (discussed below).

26 West 1978, 191, commentary on lines 159 and 160. West does not actually speak of worship here, but surely this is what he means by "semi-divine status," given his preceding remarks denying a religious meaning for *hērōs* in this same passage.

27 Against this genealogical sense of *hēmitheos*, Van Wees 2006, 364–66, contends that the word can only mean semidivine in a sense referring to cult. His argument is based on two faulty propositions, in my view. First, he maintains that the genealogical meaning can refer only in a strictly literal sense to children with one divine parent and one mortal parent. Second, he argues that since the total population at the time of the Trojan War surely included "pure mortals" and other mortals of mixed ancestry as well, then to call all of them a race of *hēmitheoi* makes no sense unless *hēmitheoi* has some other meaning. Against the first, it seems reasonable to

extend the meaning of *hēmitheoi* beyond the immediate offspring of gods and mortals. Cf. Nagy 2005, 84, who also understands the word in these broader genealogical terms. The second proposition applies too strict a logic and denies the poet the ability to focus on the most significant part of the population and let that represent the whole race in a manner of synecdoche. Compare Hesiod's description of the fourth race as a race of male heroes; as West 1979, 190, observes, this ignores women, who certainly existed as well. A last point is that there is no explicit, positive evidence in favor of connecting *hēmitheoi* with cult worship. It seems unlikely, in my view, that the term functions to designate someone as a recipient of cult.

28 West 1978, 191; Van Wees 2006, 364. Calame 2004, 73–86, especially 80–81, draws attention to the shifting verb tenses in the story of the five races as Hesiod moves between a historical perspective describing the past and the present perspective of the context of the performance. Such a shift takes place when Hesiod switches to a present-tense verb to say that the heroes (of the past) *are* called *hēmitheoi* (in the present time of the poetic performance), thereby emphasizing the difference of perspectives.

29 Lines 12–73; Nagy 1979, 159–60. At 159 he writes, "As the time frame expands, the perspective shifts from the heroic past to the here-and-now of the Homeric audience."

30 Cf. Barrigón 2000, 2 n. 6. One can also compare the parallel usage of *hēmitheoi* and *hērōs* in the account of Zeus's plans to destroy humanity in the *Catalogue of Women* (Fragment 204, Merkelbach and West 1967). As in the *Cypria*, he plans to instigate the Trojan War in order to eliminate mortals, but in this poem his reasoning is different. He wants to destroy the lives of the *hēmitheoi* so that men and gods in the future would be distinct. Once again *hēmitheoi* is being used to designate a collection of men, in this case all the descendants of the unions of gods and mortals since the time of Deukalion and Pyrrha, the very subject of the poem. Moreover, in the context of their planned destruction, the *hēmitheoi* are sharply separated from the performative present of Hesiod's audience, when gods and mortals indeed no longer mingle. Several lines later, the poet reprises Zeus's intention, but in starker terms: "the bronze would tear away for Hades the many heads of heroes who would fall in battle" (118–19).

31 T. Price 1973 collects these passages and argues strongly that the Homeric poems show a familiarity with hero cult. She has persuaded many, e.g., Kearns 1989, 131; Burgess 2001, 168.

32 T. Price 1973, 136. Some scholars have sought to dismiss this on the grounds that Erechtheus is being described as a god rather than a hero, but as Price notes, the idea is hard to reconcile with the later tradition of Erechtheus, in which he is assuredly a hero, indeed one of the eponymous heroes of the ten Cleisthenic tribes. Van Wees 2006, 371–72, revives the objection to Erechtheus and generally denies that any passage in Homer reflects hero-cult ritual—a paradoxical stance, given his claim that *hērōs* in all instances indicates the expectation of cult.

33 T. Price 1973, 134–35.

34 Specifically the tomb of Ilos, the eponymous ruler of Ilion (mentioned at *Iliad* 10.415 and elsewhere), and the tomb of Aepytos in Arkadia (*Iliad* 2.604): T. Price 1973, 137–40.

35 T. Price 1973, 133–35; cf. Van Wees 2006, 372. On the Isles of the Blessed, see below. Burgess 2001, 167, following Nagy 1979, 190–97, also includes references to heroes being carried off by gods or winds as further evidence of an idea of immortality and then notes that "the motif of a paradisiacal abode of afterlife for the dead dates back at least into the second millennium in Mediterranean culture." Nagy 2005, 81, 84, regards the immortality of heroes as an implicit theme in the Homeric poems.

36 Burgess 2001, 167; Nagy 2005, 81. Burgess 2001, 168, wonders whether the expressions of immortality in both the Homeric poems and the Epic Cycle necessarily presuppose hero cult. In contrast, Nagy 1979, 174–210, maintains that they do.

37 Burgess 2001, 164–65, 168.

38 Kearns 1989, 5; Whitley 1995, 53. Nagy 1979, 152–54, argues that Hesiod's depiction of the gold and silver races together circumscribes the concept of the hero as a recipient of cult.

39 West 1978, 182–83; Nagy 1979, 154; Calame 2004, 76 n. 15. Both West and Nagy note that in Hesiod's *Theogony*, the word *daimōn* is explicitly applied to the mortal figures Ganymede and Phaethon, both of whom are taken by gods to have an immortal existence: see further, Nagy 1979, 191–93, who sees a specific reference to cult in the description of Phaethon. Following *ploutodotai* in line 126, Hesiod states that the gold race obtained this kingly privilege (*geras basilēion*), which may again allude to worship, but there are other ways to interpret the phrase: West 1978, 183.

40 Accordingly, West 1978, 186, associates these men with the archaeological evidence for activity at Bronze Age tombs in the Geometric period and later. This evidence will be discussed below. The designation *epichthonioi* for the gold race is intended to distinguish them from the gods who reside in heaven: West 1978, 182. See also Nagy 1979, 153–54.

41 West 1978, 186–87. Calame 2004, 77, comments how, with respect to the afterlife of both races, the switch in verb tense from aorist to present brings their status in closer relation to the present time of the poetic recitation. On *timē* as a word for cult, see Nagy 1979, 152.

42 At issue is whether line 166, which some papyri and manuscripts omit, belongs in the text. It indicates that some heroes simply died at Troy and Thebes rather than going on to the Isles; without it, all the heroes go there. West regards the line as authentic: West 1978, 192. On the name of the Isles, see West's commentary on line 171.

43 West 1978, 190, commentary on line 190. Whitley 1995, 53, interprets the passage to indicate that the heroes live "apart from the rest of humankind" and thus "are not recipients of cult."

44 The *Odyssey* passage about Menelaos is 4.561–69. See Nagy 1979, 167–68, 189–90.

45 West 1978, 370–73 (quotation at 373).

46 Nagy 1979, 69–210 generally, and especially 114–17 (quotations at 116).

47 Noted by West 1970, 370.

48 This idea has been expressed before and deserves more reflection: Price 1973, 133; Snodgrass 1988, 21, 26; Boehringer 2001, 28. West 1970, 370, does consider the possibility and dismisses it on the grounds that the shift in meaning of *hērōs* to the religious sphere would be artificial and difficult to explain. Since, however, the word in epic already signifies respect and, from the perspective of the audience, applies to dead men of the past, the application of *hērōs* to the religious context of showing respect (honor, *timē*) for the powerful dead does not seem impossible.

49 Barrigón 2000, 3–14.

50 *De abstinentia* 4.22. The Mimnermos fragment is preserved by Athenaios, *Deipnosophistae* 174A. Both passages are cited by Barrigón 2000, 4.

51 Burgess 2001, 35–43, 53–114, surveys scenes from the Trojan War tradition appearing before 600 BCE.

52 Burgess 2001, 35, 43 with n. 129: "That we do not know of early Greek epics that can account for [Herakles'] popularity in artwork leads to the conclusion that epic poetry in general was not a prime source for early Greek artists or even a dominant force in early Greek mythology."

53 Chantraine 1968, 417; Larson 1995, 21–24; Barrigón 2000, 13. The resulting terms for heroines include *hērōis*, *hērōinē*, and *hērōissa*.

54 See Popham et al. 1993 for an account of the excavation and full publication of the architecture and finds. Antonaccio 1995, 236–40, and Morris 2000, 218–19, provide useful summaries of the principal features.

55 Popham et al. 1993, 100. As Popham notes, however, there are significant differences as well. There is no parallel in Homer for the burial of an entire building, and while the erection of the grave mound is an integral part of the Homeric burial, the construction of the tumulus at Lefkandi was a later, secondary development. For a more general discussion of attempts to identify Homeric burials in the material record, see Antonaccio 1995, 221–43.

56 The difference is clear when we consider, for example, aristocratic Athenian burial practices in the Kerameikos cemetery in the Archaic period. These families changed their burial practice to resemble epic burials, but not because they were establishing hero cults and expecting worship; rather, they were creating "metaphors for heroic courage and prowess" for themselves: Whitley 1995, 59.

57 Morris 2000, 235.

58 Morris 2000, 228–37. To the extent that the race of heroes is distinct and distant from the present race of iron, Morris sees a reference to it in the inclusion of burial goods of such antiquity and eastern origin, which likewise distance the deceased from his contemporaries. For an alternative reading of the symbolism of the burial goods, see Antonaccio 2006, 391–92.

59 Popham et al. 1993, 99–101. Possible Iron Age parallels for the burial of the dead in or near a dwelling

place have been noted at Thermon, Nichoria, Eretria, and Eleusis, although the evidence is not in every case clear. See Mazarakis Ainian 1999, 25–33; Morris 2000, 222–28.

60 Popham et al. 1993, 100.

61 Antonaccio 2006, 389–94; in the course of making her argument, she also points out problems with Morris's interpretation. Cf. Antonaccio 1995, 241.

62 Antonaccio 1995, 11–143, 245–46.

63 Coldstream 1976. Cf. Burkert 1985, 204: "The worship of heroes from the eighth century onwards must therefore be derived directly from the influence of the then flourishing epic poetry."

64 See, e.g., Snodgrass 1982, 114–15; Snodgrass 1988, 23; Whitley 1988, 174–75; Whitley 1995, 54–56. In relation to the earlier examples of tomb cult, one cannot altogether exclude the possibility that the oral tradition that culminated in the epic poems may have been a factor: Mazarakis Ainian 1999, 33. The argument about the lack of evidence among the finds with which to identify the recipients of the offerings as epic heroes is problematic since most of the activity at the tombs is restricted to periods too early to expect inscribed dedications.

65 Boehringer 2001, who offers the most recent study of the various examples of tomb cult from Attica, the Argolid, and Messenia, maintains that they represent early hero cult.

66 Whitley 1995, 58. In making a connection with the silver race, he follows West 1978, 186. Cf. Morris 1988, 754–75, 758.

67 Antonaccio 1993, 48–55; Antonaccio 1995, 6, 245–53. Malkin 1993, 229–30, follows her view.

68 Hägg 1987, 94–96; Antonaccio 1995, 104–9; Boehringer 2001, 48–54, 94–102.

69 Hägg 1987, 94; Kearns 1989, 130; Boehringer 2001, 130. While Hägg admits that the individual types of objects found in the dromos deposits are not exclusive to hero-cult sites, he does suggest that the relative quantities of such objects may allow us "to speak of a 'heroic character' of a certain deposit": Hägg 1987, 99.

70 Antonaccio 1995, 246. Other examples comparable to the Menidi tomb include Tomb I at Thorikos and a tomb at Solygeia: Antonaccio 1995, 110–12; Mazarakis Ainian 1999, 11; Boehringer 2001, 54–57, 89–93.

71 Mazarakis Ainian 1999, 18–25.

72 The principal publication is Bérard 1970. See Antonaccio 1995, 228–36, and Polignac 1995, 130–34, for summaries of findings and subsequent bibliography.

73 For discussion of these questions, in particular the identity of the male buried in the earliest grave (Tomb 6), see, e.g., Bérard 1982; Malkin 1993, 232; Antonaccio 1995, 234–35; Polignac 1995, 131–34; Mazarakis Ainian 1999, 25.

74 Snodgrass 1982.

75 E.g., Whitley 1988; Morris 1988; Boehringer 2001. See further discussion of social and political factors in Kearns 1989, 131–32; Malkin 1993; Polignac 1995, 128–49 (with relation to the development of the polis); Antonaccio 1995, 254–63; Mazarakis Ainian 1999, 33–36.

76 Cf. Burkert 1985, 206: "[T]he hero cult is a centre of local group identity." See also Kearns 1989, 133–34.

77 Lambrinoudakis 1988; Antonaccio 1995, 201–2; Polignac 1995, 136–37; Mazarakis Ainian 1999, 22, 35–36.

78 Malkin 1987, 3.

79 Malkin 1987, 189–240.

80 Malkin 1987, 200–203 (quotation at 203); Malkin 1993, 231; Antonaccio 1999, 116.

81 Malkin 1987, 261–66. Some scholars have understood Malkin to claim that hero cult in general originated in the colonies (see, e.g., Antonaccio 1999, 111 and n. 5), but he has denied this claim outright in at least one place: Malkin 1993, 232 n. 27.

82 Malkin 1987, 213–16; Antonaccio 1999, 119–20.

83 Antonaccio 1995, 155–66, summarizes the complicated excavation history and findings from in and around the Menelaion.

84 Whitley 1995, 54; Polignac 1995, 139; Ratinaud-Lachkar 2000, 250–53. The earliest inscribed dedications to Menelaos are indeed later in date (from the sixth and fifth centuries BCE), but as the total number of inscribed dedications is small, it is not necessary to conclude that he was a latecomer to the cult.

85 For heroes called gods, see Kearns 1989, 125.

86 Cook 1953; Hägg 1987, 97–98; Antonaccio 1995, 147–52; Boehringer 2001, 173–78, 200–203.

87 Whitley 1995, 54; Ratinaud-Lachkar 2000, 254–57.

88 Antonaccio 1995, 152–55; Malkin 1998, 99–100; Ratinaud-Lachkar 2000, 257–60. Earlier strata of Bronze Age date were also recorded but are unrelated to the later use of the cave.

89 Malkin 1999, 94–119, offers the most vigorous defense of the association of the cave with the cult of Odysseus.

90 Antonaccio 1995, 154–55; Whitley 1995, 54; Ratinaud-Lachkar 2000, 260–62.

91 Abramson 1979; Kearns 1989, 49–50, 131; Antonaccio 1995, 166–69; Boehringer 2001, 64–66.

92 Burgess 2001, 37–38, follows suit.

93 Abramson 1979.

94 We have treated here only the most discussed and most plausible candidates for early cult devoted to epic heroes. For others, see Antonaccio 1995, 169–97; Mazarakis Ainian 1999, 11–14.

95 See, e.g., Mazarakis Ainian 1999, 14, who holds a less skeptical view of the earliest examples of epic-hero cult and attributes them to the formation of the polis.

96 As Kearns 1989, 131, writes in relation to her study of the heroes of Attica, "There is really very little overlap . . . between the heroes celebrated in the epic and those worshipped in Attica."

97 Kearns 1989, 133.

FOUR PARADIGMATIC HEROES

THE SINGULARITY OF HERAKLES

Jennifer Larson

Herakles is both the most emblematic and the most singular of Greek heroes. The list of his exploits includes such paradigmatic deeds as slaying the great serpent called the Hydra; battling the forces of chaos in the form of Centaurs and Amazons; founding cities and sanctuaries throughout the Greek world; sacking Troy a generation before the better-known exploits of Agamemnon's army; even overcoming Death. Among the Greek heroes and heroines, only Herakles achieved immortality and the status of an Olympian god, with Hebe (Youth) as his divine consort (no. 9). The power of Herakles, who brought victory and warded off evils, could not be reserved to or controlled by one city, like that of other heroes. He was certainly the earliest of the heroes to achieve pan-Hellenic fame, and this universal popularity predates the formation of the Greek city-states and the dissemination of the Homeric epics. Even the earliest strata of Herakles' myths are embedded in more than one part of Greece. The first six of Herakles' famous labors were performed in the Peloponnese, and the center of this cycle is Tiryns, the home of Herakles' mother, Alkmene, and stepfather, Amphitryon. Thebes in Boeotia was the site of his birth and early exploits, and the hometown of his first wife, Megara. He is said to have warred against Peloponnesian kings, including Neleus of Pylos and Augeias of Elis, while his marriage to Deianeira, his death, and his apotheosis occurred around Trachis and Mount Oita in southern Thessaly.

Heroes and heroines were memorialized in the landscape of every Greek city through association with Mycenaean tombs and other ancient monuments. Herakles is unlike other heroes in that he is credited with the actual transformation of the landscape through his matchless physical strength. He is said to have changed the course of rivers, drained swamps, and flooded plains. Some of these efforts seem to be related to actual Bronze Age hydraulic works. That many myths of Herakles are rooted in the Mycenaean past was ably demonstrated by Martin Nilsson, who pointed out the correspondence between the settings of the Herakles myths and the great centers of Mycenaean power: Tiryns (and the entire Argolid), Thebes, Pylos, and Orchomenos.[1] The far-flung trade contacts of the Mycenaeans provided an opportunity for the integration of motifs from the Near East (a canonical series of triumphs over beasts is achieved by Sumerian Ninurta, who brings the trophies back to his temple at Nippur just as Herakles conducts various beasts to Tiryns) and Egypt (Amphitryon's impersonation by Zeus is drawn from the Theban myth of Amun's visit to the queen in the guise of the pharaoh). A second period of mingling and rapprochement between Herakles and his Mediterranean neighbors from the eighth through the sixth century gave rise to the identification of the hero with the Phoenician god Melqart in Cyprus, Sicily, and Spain: the Pillars of Herakles are also the twin pillars of Melqart's temple in Cadíz.[2] Among the Etruscans, he became Hercle; among the Romans, Hercules. Herakles is the only Greek hero who boasts not only pan-Hellenic but also pan-Mediterranean popularity.

Herakles transcends all the conceptual boundaries in Greek thought, for he is at once king and slave; beast, man, and god; lawless transgressor and vanquisher of the uncivilized. Even his hypermasculinity is offset by two minor episodes of cross-dressing.[3] More profoundly, Herakles shares in the experience of the feminine as the Greek male imagination defines it. That is, masculinity consists of power and self-control, while submission and physical or mental loss of control are attributes of the feminine. Herakles is twice enslaved and in each case voluntarily accepts this lot; he is maddened and kills his own children, experiences that are normally the province of women in Greek myths; and he suffers physical agony as a result of the poisoned shirt unwittingly sent by Deianeira.[4] Herakles' vulnerability to the extreme sorrows and pains of human existence, which he shares with such tragic heroes as Oedipus and Philoktetes, is complemented by his comic capacity for the pleasures of food and drink. Although the gods enjoy their nectar and ambrosia, Herakles' stupendous appetites for wine and meat, celebrated in Athenian satyr plays and comedies, are decidedly human.[5] Perhaps it was this essential humanity that contributed to the post-Classical popularity of portraits of Herakles as a youth, as an adult weary from his diligent labors, or as an elderly, drunken man (nos. 4, 35, 38). Herakles' identity as an Everyman also facilitated his encounters with various allegorical figures throughout his career, including Virtue and Vice, Death, Old Age (fig. 9), and Youth.[6]

HERAKLES AND HOMER

In the *Iliad*, the poet assumes detailed knowledge of the Herakles myths, including the hero's conception and birth at Thebes, his servitude to Eurystheus and a set of "tasks" assigned to him, his attack on Pylos, and his sack of Troy. Throughout the poem, tales of Herakles are used to foreshadow or counterpoint aspects of the main narrative; Herakles' conflict with the Trojans, imagined as having taken place in the generation immediately before that of Agamemnon and Achilles, is an obvious example.[7] Herakles the grim warrior is emphasized over the monster slayer; he punishes the Trojan king Laomedon for cheating him (*Iliad* 5.638–51, 20.144–48), while at Pylos he kills all the sons of Neleus except Nestor (*Iliad* 11.690–93). Herakles is also the model for Diomedes, the hero who, with Athena's help, dares to battle with gods. Herakles himself, we are told, once shot both Hera (under unknown circumstances) and Hades (at Pylos), painfully wounding them both (*Iliad* 5.392–97). But most significant is the conflict between Zeus and Hera engendered with the birth of Herakles, whose name ("Glory of Hera") seems to point ironically to the triumph of Hera over Zeus in the divine battle of the sexes.[8] Hera deceives Zeus when Herakles is about to be born, thus ensuring that Zeus's dearest son will serve her, not Zeus (*Iliad* 19.95–133). The tasks set by the Argive king Eurystheus redound to the glory of Hera. She ceaselessly hounds her heroic stepson, taking the opportunity to beguile Zeus in an unwary moment after Herakles' sack of Troy. Sleep and the North Wind are suborned to drive Herakles far from home to Kos (*Iliad* 14.242–68), and only with difficulty does Zeus ensure that he returns to Argos again. The terrible punishment he devises for Hera, hanging her from Olympos with anvils tied

FIG 9 Herakles encounters the allegorical figure of Old Age. Attic red-figure pelike by the Geras Painter (name piece), ca. 480–470 BCE. Paris, Musée du Louvre, G 234

to her feet, is intended to demonstrate Zeus's absolute power over the other gods (*Iliad* 15.18–30). Yet even this chastisement does not subdue her. Instead, she again seduces and deceives her spouse using the magic belt of Aphrodite, with the result that Hektor is wounded during Zeus's postcoital slumber (*Iliad* 14.153–223). Thus Hera's scheming in the matter of Herakles becomes a paradigm for her continued (and ultimately successful) efforts to assist the Greeks at Troy, contrary to the wishes of Zeus.

From the perspective of the Homeric heroes, Herakles belongs to a past age when great feats, beyond their own capabilities, were performed. Odysseus is willing to compete with any of the Phaeacians (*Odyssey* 8.223–25), but he insists, "I am unwilling to strive against the men of former days, Herakles, and Eurytos of Oichalia, who challenged even the immortal gods with the bow." Yet the Herakles of the Archaic period, whose deeds earn him immortality, is not "heroic" in the sense created and promoted by the poet of the *Iliad*, which requires that the distinction between mortal heroes and gods never be blurred. Achilles had to choose between dying with glory in battle and living a long and peaceful life in obscurity. Only if death is permanent and unambiguous does his choice have meaning. The brevity and contingency of the heroes' lives make their courage and the greatness of their deeds all the more poignant; they will be immortal, but only in song. Thus the logic of the *Iliad* demands that Herakles himself, as the paradigm of greatness for Achilles, must meet the same ultimate end (*Iliad* 18.117–19): "For not even mighty Herakles escaped death, though he was dearest to the son of Kronos, Lord Zeus, but Fate and the grievous anger of Hera overpowered him."

THE LABORS

Herakles' labors (in Greek, *athloi* or *erga*), which he performed in subjection to the Argive king Eurystheus, are the most familiar of his exploits. Twelve labors were depicted on the metopes of the temple of Zeus at Olympia (completed in 456 BCE), but the canon remained fluid until post-Classical times. Some deeds that were never included among the labors, such as the battle with Ares' son Kyknos, nevertheless gained great popularity in literature and art. The narrative framework for the labors was always the same: because of her hostility toward the son of a rival, Hera cheated Herakles out of his rightful place as king of the Argives. The core of the myth is the story of a superlative man who chafes under the unjust rule of his inferior (in this case, Hera's favorite, Eurystheus). This theme gives the story its emotional weight and is a basic ingredient in other mythic cycles: Achilles is a better man than Agamemnon; Jason is a better man than Pelias.[9] Perhaps Herakles originally performed a set of three labors, like Bellerophon, who was sent to battle the Amazons, the Solymoi, and the Chimaira. Yet Herakles' early exploits do not take place in the distant and fantastic lands explored by Bellerophon, Jason, or Odysseus. Instead, they are set in the familiar territory of the Peloponnese. The first six labors (Nemean lion, Lernaian hydra, Keryneian hind, Erymanthian boar, Augeian stables, and Stymphalian birds) form a coherent group. In performing the Peloponnesian labors, Herakles functions as the

Greek answer to various Near Eastern gods and kings who battle lions with their bare hands, wear lion skins, carry a club or bow, and slay many-headed serpents. These and the other labors involving the mastery of animals again confirm the roots of the Herakles myth in the Bronze Age, when the iconography and ideology of kingship was closely tied to the hunt.[10] By subduing the Nemean lion and other creatures, Herakles demonstrates his worthiness to be king. His overlord Eurystheus, by contrast, was depicted in Attic vase painting as cowering inside a large bronze jar at the terrifying sight of Herakles returning with the Erymanthian boar (no. 14).

Following the Peloponnesian labors is a series of tasks with a wider geographical scope: retrieving the mares of Diomedes in Thrace, capturing the Kretan bull, and winning the belt of the Amazon queen. Like punishing brigands and subduing dangerous beasts, fighting the Amazons was a stock assignment for Greek heroes, including Bellerophon, Theseus, and Achilles. A race of warlike women in Asia Minor, the Amazons were in many ways "anti-Greeks" in their monstrous inversion of Greek social norms. Among the Amazons, only women ruled and fought, having dispensed with males except for reproduction. By battling Amazons, Greek heroes put their patriarchal values to the test in the most active and literal sense, enacting male physical superiority over the female and asserting the primacy of the civilized, Hellenic way of life over the perceived deviance of barbarian customs (nos. 24, 49, 50–53). Although the erotic possibilities of these battles were often explored in later adumbrations of the Amazon myth, as in Theseus's capture of an Amazon who became his concubine, the earliest accounts probably focused on the Amazons as fierce and worthy opponents. One of Herakles' labors was to retrieve the zostēr, or war belt, of the Amazon queen. As used by Homer, the word zostēr refers to an indubitably masculine garment.[11] Its removal by Herakles was symbolic not of sexual relations but of the stripping of spoils from a vanquished foe. In the sixth century, Attic vase-painters delighted in representing Herakles battling Amazons (no. 53), often accompanied by Ajax's father, Telamon. In later versions of the myth, Herakles obtains the belt through peaceful negotiations (no. 51).

Each of the last three labors is symbolic of Herakles' march toward immortality, for the cattle of Geryon, the apples of the Hesperides, and Kerberos (nos. 15, 28) must all be sought in lands associated with the afterlife: the far west and the underworld realm of Hades. The story that Herakles stole the cattle of Geryon, a triple-bodied personage who lived on the island of Erytheia across the river Okeanos, is of particular interest (fig. 10). It appears to be a reflex of an Indo-European myth in which the hero battles a three-headed monster for the possession of cattle.[12] At the same time, the location of the cattle on an island across the river on the edge of the earth indicates that Herakles is battling a lord of the Otherworld, perhaps a god of the dead. The journey to Hades to bring back the multiheaded Kerberos may be a doublet of the Geryon myth, for Geryon too has a monstrous, two-headed watchdog, Orthos. In Apollodorus's account of the Kerberos labor, Hades owns a herd of cattle, one of which Herakles appropriates for a sacrifice. The herdsmen of both Geryon and Hades, whom Herakles must fight, are identically named Menoites (Apollodorus, *Library* 2.5.10, 12).

FIG 10 Herakles and the herdsman Geryon. Chalkidian black-figure neck amphora attributed to the Inscription Painter, ca. 540 BCE. Paris, Cabinet des Médailles, 202

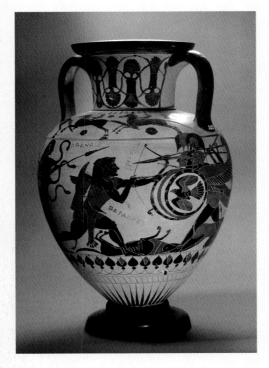

Because of its setting in the west, the Geryon myth was of special interest to Greek colonists in Italy and Sicily. After taking possession of the cattle, Herakles had to drive them back overland from Spain to Greece, and this journey, filled with subsidiary adventures and attempts by bandits to steal the cattle, afforded the colonists a chance to stake their own claims to Herakles and to advertise their Greek identity. Diodorus Siculus's account of Herakles in Sicily says that his activities there left "imperishable reminders of his presence" in the landscape. Near Argyrion, where a major annual festival of Herakles was held, the rocks preserved the impressions of Herakles and the cattle as they passed. Herakles' victories over the hostile king Eryx and the Sicani of the interior were supportive of Greek claims to Sicilian lands, and scarcely a Greek city in the west failed to mint coins showing Herakles. In Italy, the city of Kroton hailed Herakles as its founder, while the slaying of the monster Cacus, localized at Rome and originally attributed to the hero Recaranus, was attracted into the orbit of "Hercules" and eventually immortalized in the poetry of Virgil, Propertius, and Ovid. The Romans revered the god Hercules in his temple near the Forum Boarium, and it was the custom to dedicate a tenth of one's property to him in exchange for the promise of a happier life.[13]

HERAKLES THE HERO-GOD

A passage of the *Odyssey* (11.601–26), perhaps a late interpolation, insists upon Herakles' apotheosis, though his simulacrum (*eidōlon*) is said to reside in Hades while he himself feasts on Olympus. Most scholars interpret this passage, taken together with the lines in the *Iliad* that speak flatly of Herakles' death, as evidence that the idea of his divinity was an innovation of the seventh or sixth century. But it is also true that the early identification of Herakles with various Near Eastern and Egyptian deities (e.g., Tyrian Melqart, Anatolian Sandon, Egyptian Bes) set him apart from other heroes and affected the development of his myths and cults. For example, the local legends of the early Herakles sanctuaries at Thasos and Erythrai emphasized ties to the Melqart cult at Tyre.

Archaic poets and artists depict a Herakles who interacts on equal terms with the gods and shares their propensity for conflict with one another; at different times he is said to have attacked or threatened Hades, Poseidon, Ares, Helios, and Hera herself.[14] One story of this type was a favorite in Greek art: the battle with Apollo for the Delphic tripod (nos. 41, 42). Herakles went to the oracle at Delphi to be purified after the murder of his children, but the oracle refused to answer him.[15] Therefore he made off with the Delphic tripod in order to set up his own oracle. Apollo came after him and a tug-of-war ensued, to be ended only by the intervention of Zeus. The story must postdate the concept of Herakles' divinity, for it depicts Herakles and Apollo, both sons of Zeus, as coequals and recapitulates the plot of the Homeric *Hymn to Hermes*, in which the newly born god Hermes gains recognition among the immortals only after he picks a fight with Apollo by lifting his cattle.

The first firmly attested cults of Herakles appeared during the seventh century, when the Greek city-state had already emerged. Developing city-states announced

THE SINGULARITY OF HERAKLES

their identities through the promotion of local festivals and the construction of monumental temples for their patron deities, but little of this energy was expended on Herakles, perhaps because he belonged to every city—and none. Only Thasos, itself founded in the seventh century, and a few other colonial cities claimed Herakles as a principal civic god. Yet his cults required no state sponsorship to ensure their propagation. By the sixth century, both the worship of Herakles (nos. 62–64) and the doctrine of his apotheosis were ubiquitous. The popularity of Herakles' cult in Attica, in spite of the fact that none of his early myths are set there, illustrates the "horizontal" spread of religious ideas in Greece and provides an analogue to the later and equally speedy dissemination of the healing hero Asklepios's worship. The Athenians created new myths of Herakles' reception in Athens: he was the first foreigner admitted to the Eleusinian Mysteries; Theseus aided Herakles or the children of Herakles when they were driven out by Eurystheus; the Athenians were the first to worship Herakles as a god.[16]

Pindar (*Nemean Odes* 3.22) calls Herakles a hero-god (*hērōs theos*), and this term sums up the conundrum faced by the Greeks when constructing rituals for him. Should they treat him as a god or as a hero? While both modes of worship involved animal sacrifice, hero cult was adapted from the rites for the dead and had a different set of conventions for the handling of the victim's blood and meat. Cults of Herakles tended to resemble those of the Olympian gods more than those of the heroes, but the great geographical scope of Herakles' worship ensured variety in his rituals. Herodotos approvingly states (2.44) that some communities established a dual rite according to which Herakles received two sacrifices, one heroic and one divine. Often there was an emphasis on meat consumption (beef was a preferred food) and male commensality, which might involve the exclusion of women from the ritual.[17] The physical arrangement of sanctuaries also varied, but especially in Attica, a particular type of monument was associated with Herakles: four columns were set upon a base and joined by four beams (no. 62).[18] This roofless shrine could be covered with branches in order to provide a shady spot for dining or for the display of Herakles' image.

As a powerful hero-god, Herakles fulfilled many roles, but the most important are correlated with his mythic achievements. Before he could walk, Herakles strangled two serpents sent by Hera to attack him and his twin brother, Iphikles, in their crib (no. 2). This popular story of his childhood points to Herakles' cultic role as a protector of the household. Just as Herakles fought monstrous beasts, cruel highwaymen, and other adversaries during his lifetime, the hero-god protected his worshipers and their homes from all dangers material and metaphysical, including disease and misfortunes caused by malevolent spirits. People wore rings and other jewelry with Herakles' image in order to avail themselves of the god's protection (nos. 16, 17, 33, 37) and painted verses with his name over the doorway. This Herakles, often called Alexikakos (averter of evil), was rather illogically depicted wielding both club and bow simultaneously (figs. 11, 12).[19]

During his lifetime, Herakles was supreme in battle, the invincible veteran of many famous campaigns, and he was said to have founded the games at Olympia, so

he also became a patron of warriors and athletes. Many sanctuaries of Herakles were located outside the city walls and were large enough to accommodate athletic competitions and military training. Armies on campaign regularly camped in Herakles' sanctuaries, and he was credited with assistance against the Persians during the battles of Marathon and Thermopylae.[20]

THE SONS OF HERAKLES

The unsurpassed prestige of Herakles, favorite son of Zeus and greatest of the Greek heroes, made him a desirable ancestor. Apollodorus (*Library* 2.7.8) lists sixty-seven children of Herakles, all sons. A single daughter, Makaria, appears in Athenian mythology.[21] Among these offspring were the progenitors of aristocratic and royal families in Thebes, Thessaly, Sparta, Macedonia, Epiros, and Lydia.[22] Although Herakles is not in origin a Dorian hero, the Dorian people who moved into the Peloponnese during the early Iron Age appropriated him as an ancestor and promulgated the myth called the Return of the Herakleidai, which helped to establish their territorial claims. According to this account, Herakles was the rightful ruler of all the districts in the Peloponnese either by birth or by conquest, having overcome Neleus of Pylos, Augeias of Elis, and Hippoköon, the usurper who temporarily wrested Sparta from Tyndareus. When Herakles died, his sons (known as the Herakleidai) were persecuted by his old enemy Eurystheus and driven away to the district of Doris in northern Greece. In the third generation, they returned as conquerors, and their people were the Dorians. The Spartan kings, too, traced their line to Herakles and used this genealogy to legitimize their rule.

FIG 11 Cult statue of Herakles as the averter of evil. Detail of an Apulian red-figure bell-krater attributed to the Eton-Nika Painter, ca. 385–360 BCE. London, British Museum, 1867,0508.1327 (E 505)

FIG 12 Herakles as the averter of evil, ca. 525–500 BCE. Bronze, height 12.8 cm. New York, The Metropolitan Museum of Art, Fletcher Fund, 1928, 28.77

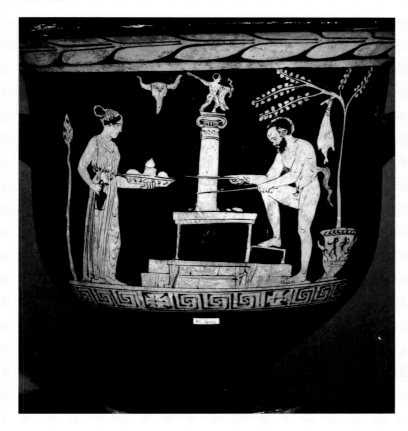

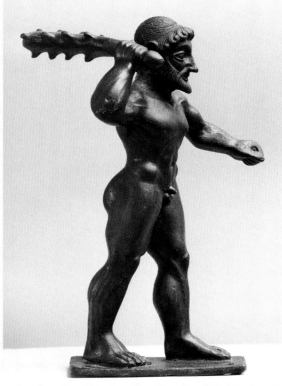

By the fifth century, Herakles had been remodeled from a legendary but brutish strongman to an exemplar of virtuous and heroic feats, who cleansed the earth of monsters and bandits, earning through his labors the reward of immortality. An allegory by the sophist Prodikos, which represented Herakles choosing between virtue and vice personified as two lovely women, illustrates this view of the hero.[23] For Pindar above all, Herakles was the ultimate warrior, hunter, athlete, traveler, founder, and dispenser of justice. Herakles' voyage to the ends of the earth was symbolic of the limits of human achievement (Pindar, *Isthmian Odes* 4.11–12): "by their manly deeds, unrivaled, they have set out from home and grasped the Pillars of Herakles." This image of Herakles was to dominate the succeeding centuries, during which the hero-god lost none of his popularity. He had been adopted as a putative ancestor by the Argead ruling dynasty in Macedonia during the late fifth century, and when Alexander the Great began his conquests, his achievements seemed to parallel those of Herakles in geographical scope and impact (nos. 101, 102).[24] Alexander made no secret of his admiration for Herakles and actively promoted the comparison: both were reputed to have been fathered by Zeus, and both were destined to achieve immortality through their deeds.

NOTES

1 Nilsson 1972, 181–86; Salowey 1995, 114, 141, 147, 155; Knauss 2004.

2 Amun: Burkert 1992, 122–23; West 1997, 459, 467–69. Melqart: Bonnet 1988, 219–20.

3 Cross-dressing: in Lydia with Omphale (e.g., Ovid, *Heroides* 9.53–118) and on Kos (Plutarch, *Greek Questions* 58). See Bonnet 1996; Llewellyn-Jones 2005.

4 Loraux 1995, 121.

5 Galinsky 1972, 81–100; Scarpi 1996, 135.

6 Stafford 2005b.

7 Galinsky 1972, 9–21.

8 Herakles' name has engendered much discussion; see, e.g., Farnell 1921, 99–101; Nilsson 1972, 189–92.

9 Nilsson 1972, 209–10; Galinsky 1972, 13.

10 West 1997, 460–62.

11 Gantz 1993, 398.

12 Lincoln 1976, 46–48.

13 Sicily and Kroton: Diodorus Siculus 4.17.1–4.24.7. Cacus: Virgil, *Aeneid* 8.185–275; Propertius 4.9; Ovid, *Fasti* 1.543–84. Tithe: Diodorus Siculus 4.21.3. See Bradley 2005.

14 For conflicts with Poseidon, Apollo, and Hades, see Molyneux 1972. Ares: Pseudo-Hesiod, *Shield of Herakles* 359–67; Janko 1986, 49. Helios: Page 1962, fragment 185.1 (Stesichorus). Hera: *Iliad* 5.392–97.

15 Hyginus, *Fabulae* 32; Servius on *Aeneid* 8.300. Or for the murder of Iphitos: Pausanias 10.13.8; Apollodorus, *Library* 2.6.2.

16 On Herakles in Attica, see Woodford 1971; Shapiro 1989, 157–63.

17 Hero or god: Lévêque and Verbanck-Piérard 1992; Stafford 2005a. Women: Loraux 1995, 119.

18 Woodford 1971, 213–14.

19 "Herakles lives here; let nothing evil enter." See Diogenes Laertius 6.50; Burkert 1992, 112 with n. 8. Alexikakos: Woodford 1976.

20 Salowey 1995, 160–63; Bowden 2005; Larson 2007, 184.

21 Herakles' maiden daughter is an unnamed character in Euripides' *Herakleidai*. Pausanias (1.32.6) calls her Makaria.

22 For primary sources, see Vollkommer 1988, 88.

23 Prodikos in Xenophon, *Memorabilia* 2.1.21–22.

24 Nicgorski 2005, 105–7.

ACHILLES BEYOND THE *ILIAD*

Guy Hedreen

The story of Achilles that has most vividly captured our imagination is that of Homer's *Iliad*. The best of the Achaeans to fight at Troy was a demigod, the child of an immortal sea creature and a pious man. When his sense of superiority was insulted by the lesser warrior who happened to lead the expedition, Achilles withdrew, and the predictable result was rout. When the Trojans finally reached the Achaeans' last retreat, its fleet, Achilles yielded—but only a little. He made the tragic error of allowing his dear friend Patroklos to join the battle in his place, while the Trojan's champion, Hektor, and the city's patron deity, Apollo, were still on the field. Patroklos was killed, and gods and men were treated to a superhuman display of grief and anger. Achilles pursued his enemy even though his mother and his immortal horse foretold that his own death would soon follow Hektor's. Vengeance would cost him his return to his father and his home. But the death of Hektor was not sufficient to sate the anger of Achilles, who dragged the body of his enemy daily around the tomb of Patroklos. The hero acknowledged the necessity of subordinating his personal grief to the needs of the human community only when King Priam himself came to the hero's tent and took the hand of the man who had killed his son.

For many modern readers, the importance of Achilles as a hero lies in his capacity for action in the full knowledge of its fatal consequences to himself, his questioning of the system of values or reward informing his martial culture, his understanding of the personal price of fame, his devotion to a friend or partner, and his discovery of empathy. Moving from the individual to the social perspective, the story of the *Iliad* highlights the tensions between the needs of the social group and those of the individual, and the different forms of *philia* (friendship) that facilitate social cohesion or social action. From a theological point of view, it exemplifies the manner in which the gods shape human decision making so as to serve their interests, the manner in which humans struggle to make choices in the face of unmoving, inscrutable, seemingly impersonal yet all too petty forces.

For the ancient Greeks, Achilles played additional mythological, artistic, political, and religious roles. In this essay, I explore some of those roles by examining poetic and visual representations of Achilles beyond the *Iliad*.

SIMONIDES' HYMN TO THE HEROES OF PLATEIA AND THE WORSHIP OF ACHILLES

A measure of the stature of the hero Achilles in the Greek imagination is his place in Simonides' relatively recently recovered elegy celebrating the heroes who fought and fell at the Battle of Plateia. The culmination of the Greeks' struggle to maintain their independence from Persia, this battle was central to Classical Greek self-definition. The poem introduces the achievements of the historical individuals with an account of the accomplishments of the Achaeans who fought long ago at Troy—and Achilles is preeminent among them. Although the text is fragmentary, the main lines of the

narrative are clear: in the "proem," Achilles is cut down by Apollo: "[and you fell, as when a larch] or pine-tree in the [lonely mountain] glades is felled by woodcutters."[1] The Achaeans grieve and press on, executing the gods' justice by sacking the city of Troy. The narrator bids farewell to Achilles and then invokes the aid of the Muses to prepare a song for the men who saved Greece from the Persians.[2] The introduction emphasizes the role of the heroes of the Trojan War as heroes of poetry: the city of Troy is *aoidimon* (singable); the heroes who fought there "are bathed in fame that cannot die, by grace [of one who from the dark-]tressed Muses had the tru[th entire,] and made the heroes' short-lived race a theme familiar to younger men." Surely this is an allusion to Homer himself. As such, the Homeric heroes are paradigms for the heroes of Plateia, insofar as they will be similarly immortalized by Simonides: "I [now summon] thee, i[llustriou]s Muse, to my support . . . [fit ou]t, as is thy wont, this [grat]eful song-a[rray] [of mi]ne, so that rem[embrance is preserved] of those who held the line for Spart[a and for Greece]. . . ."[3] But the main subject of the introduction is the hero Achilles; this is shown by the farewell to the hero, in the vocative case: *"chaire* [thou son] of goddess glorious [daughter] of Nereus." Dirk Obbink has argued that the direct address to Thetis and/or Achilles, together with the probable allusion to the funeral of Achilles, characterizes the opening lines of the poem as an address to a figure revered in cult as well as poetry. The basis for Simonides' comparison of the veterans of Plateia to the heroes of Troy may be not only literary (comparing his own poetic tribute with Homer's poetry) but also cultic. His comparison of the fallen at Plateia with recipients of hero cult would be especially pertinent if his poem were performed at the site of Plateia in an annual festival honoring the heroes of that battle.[4]

Achilles exemplifies the ancient practice of worshiping heroes as forces that transcend death. As in many hero cults, one focus of cult activity in Achilles' honor was the location of his burial. Well known since the dissemination of Homer's *Odyssey* is the site of the hero's tomb near Troy, overlooking the Hellespont. In the underworld, the ghost of Agamemnon visualizes the monument for the ghost of Achilles: "Your white bones . . . mixed with the bones of Patroclus. . . . Over your bones we reared a grand, noble tomb—devoted veterans all, Achaea's combat forces—high on a jutting headland over the Hellespont's broad reach, a landmark glimpsed from far out at sea by men of our own day and men of days to come."[5] The hero's cult at Achilleion, the putative location of his interment in the Troad, played an important role in the struggle between Athens and Mytilene for control of the strategic area at the mouth of the Hellespont. As Herodotos tells it (5.94), Athens cited its participation in the Trojan War as grounds for holding on to the shrine of Achilles. The anecdote illustrates both the importance of the grave as a locus for hero cult and the role played by such cults in inter-polis politics as well as polis self-identification.

The cult of Achilles is particularly interesting in this respect, because the most famous site of cult activity in his honor was probably not the burial mound. Philostratos claims that the Thessalians of northern Greece sent an annual expedition to Achilleion in the Troad to worship Achilles. Upon arrival, the Thessalians sang a hymn to Thetis that explicitly acknowledged the preeminence of a different cult of Achilles:

"however much [of Achilles] is mortal Troy retains, but however much he drew of your [sc. Thetis's] divine nature, the Pontos holds."[6] The Pontos, or Black Sea, was the location of perhaps the busiest and most celebrated cult of Achilles in antiquity. The cult originated in the sixth century BCE, if not earlier, and was still in existence in the third century of our era. The worship of Achilles was an important part of the religion of the Milesian colony of Olbia on the northern shore of the Black Sea, where the cult is well attested archaeologically. Ceramic disks, of a sort familiar from other hero cults, bearing inscribed dedications to Achilles, have been found in the earliest settlements of the colony. By far the most famous Black Sea site of Achilles worship, however, was Leukē, the White Island. This is a real island, located in the northern Black Sea, fifty kilometers southeast of the Istros (or Danube) River. It is attested in numerous literary references, but the earliest attestation is an inscription on a black glazed lekythos (oil jar) of the fifth century BCE, which reads: "Glaukos, son of Posideios, dedicated me to Achilles, lord of Leuke." The significance of the White Island as a cult center is rooted in the belief that Achilles dwelled on the island as an immortal. The idea goes back to the epic tradition, according to the Roman-era scholar Proklos (*Chrestomathia* 2). An epic poem titled the *Aithiopis* recounted the death and funeral of Achilles. According to Proklos, prior to the cremation of the body, "Thetis snatched her son from the funeral pyre and carried him to the White Island." We know that Achilles dwelled there as an immortal, since many ancient writers report that sailors claimed to have seen Achilles darting around the island in his armor, or heard the hero singing or riding horses, as they approached Leuke.

The cult of Achilles appears to have come to the Black Sea region with Milesian colonists in the Archaic period. In this way, the worship of Achilles exemplifies the use of hero cult to enhance the collective identity of colonists in a new land. It is important to note, however, that there is no evidence that Achilles was worshiped at Miletos itself. The colonists appear not to have brought the hero with them so much as to have found him in their new northern home. Different explanations of the hero's association with the Black Sea region have been offered. A fragment of an early Archaic poem by Alkaios, which reads simply "Achilles, lord of Scythia," has been taken to refer to a mythological tradition in which Achilles was the leader of the Scythians during the Trojan War.[7] All the known sites of cult activity in honor of the hero in the Pontos fall within the boundaries of Scythia. Such an ethnic and geographical association contradicts the Homeric tradition, which associates the hero with Thessaly. For that matter, the ongoing presence of Achilles on the White Island, so far from the site of his burial, not only contradicts the Homeric tradition, which firmly associates him with the underworld, together with virtually all other heroes and heroines of his age; it also contradicts ordinary cult practice, according to which a hero's powers after death are intimately associated with his physical remains.

PINDAR'S SIXTH PAIAN, ACHILLES AND APOLLO, ACHILLES AND ODYSSEUS

The death of Achilles at the hand of the god Apollo is a fundamental theme of the hero's mythology, first fully articulated in surviving poetry in Pindar's sixth paian, a poem roughly contemporary with Simonides' Plateia elegy. In the paian, the murder of Achilles (and that of his son Neoptolemos) functions as a tribute to Apollo's pre-eminence. Pindar says:

> Taking the mortal form of Paris, the god Apollo, skilled in archery, shot the forceful child of the blue-haired sea-goddess Thetis, and in that way the god put off for a time the destruction of Troy. The failsafe defense of the Greeks Apollo killed in cold blood. How the god clashed with the goddess of the lovely skin, Hera, matching his unbending strength against her, and against Athena as well! Before serious hardships had been suffered, Achilles would have captured Troy, had Apollo not been standing watch. But Zeus, sitting amidst the golden clouds, the highest heights of Mount Olympos, overseer of the gods, did not dare to undo fate. For the sake of glamorous Helen, it was necessary for the gleam of blazing fire to consume lofty Troy.[8]

Pindar's pocket edition of the story of Troy articulates one traditional concept especially well: the idea that Apollo was the only figure involved in the Trojan War able and willing to stop Achilles. Apollo's support of the Trojans is accounted for in the *Iliad* (7.452–53; cf. 21.441–57) through a story in which Apollo, together with Poseidon, built the walls of Troy. In Archaic Athenian vase-painting, Apollo's concern for the fabric of the city is given visible form through the inclusion of Apollo's distinctive attributes (tripod or palm tree) in the Trojan sanctuaries of Zeus and Athena.[9] The only Achaeans who posed a genuine threat to the security of the walls of Troy, who had to be physically neutralized by Apollo, were Achilles and, in the *Iliad* (16.698–709), his temporary battlefield double, Patroklos. Once Achilles and Patroklos were eliminated, no other Achaean ever threatened the physical integrity of the city's walls. The Achaeans managed to circumvent the fortifications only through trickery, through the ruse of the wooden Trojan Horse.

FIG 13 Achilles holding his horse. Black-figure kantharos fragment attributed to Nearchos, ca. 575–525 BCE. Athens, National Archaeological Museum, 15166

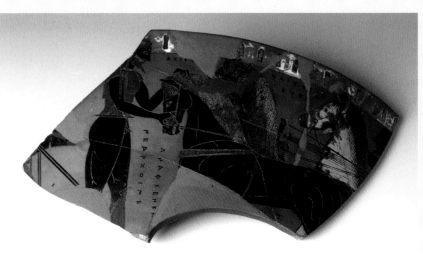

The Trojan Horse was the brainchild of Odysseus, a different sort of hero from Achilles. As Gregory Nagy has shown, Achilles, the hero of the *Iliad*, exemplifies one form of *aretē* (excellence): *bios*—that is, might or martial excellence in direct physical combat. Odysseus, as described in the *Odyssey*, exemplifies a different form of excellence, *mētis* (cunning), which was also highly praised by the Greeks. In Athenian vase-painting (fig. 13), one not infrequently sees Achilles depicted as arming for battle, preoccupied with military action. On this fragment of a kantharos, Achilles is already wearing his cuirass and greaves. His helmet, shield, and spears are brought to him by a Nereid, but he has turned to assist in the harnessing of his chariot, "holding the head of the trace-horse to keep it quiet," as Beazley nicely observed.[10] The outcome of the Trojan War implicitly validated the approach of Odysseus over that of Achilles, just as the *Odyssey* allows its hero to achieve two things that were mutually exclusive to Achilles in the *Iliad*, *kleos* (fame) and *nostos* (homecoming).[11] The Roman poet Horace gave concrete expression to the contradiction between Achilles' commitment to direct military confrontation and the necessity of employing artifice to penetrate the god-built walls of Troy: Achilles would not have tried to take the Trojans through trickery, "would not have hidden within the horse that feigned sacrifice to Minerva" (*Odes* 4.6.13–16, trans. Bennett); he would have attacked them openly. Achilles and Odysseus, *Iliad* and *Odyssey*, represent two different conceptions of heroism.

After the death of Achilles, the shift in initiative from infantry to "special ops" was effected by the dispute over who was best of the Achaeans after Achilles, and therefore who was entitled to inherit the hero's god-given armor. Both Ajax and Odysseus claimed the prerogative of receiving the armor. The fight between them is the subject of several fine Athenian vase-paintings, such as one by Douris, in which the armor of Achilles lies in a heap on the ground between the two heroes, who draw their swords against each other.[12] An episode from the lifetime of Achilles widely popular in Athenian vase-painting but unattested in any extant literary account suggests how Achilles might have settled the dispute had the decision been up to him: it shows Achilles playing a game with Ajax (no. 39). The most famous instance of this scene, and possibly the first ever, occurs on an amphora or wine jar made by the artist Exekias (fig. 14).[13] In some representations, the scene is part of a larger narrative in which the Achaean camp is overrun by the Trojans while the two best Achaean fighters are preoccupied with their game.[14] The images nicely suggest that Ajax alone was on a par with Achilles—that Ajax alone was capable of playing at the same table, so to speak, even if subtle details in Exekias's vase-painting suggest that Ajax will lose the game.[15] Indeed Homeric epic, Pindar, and other sources suggest that it was Ajax who was best of the Achaeans after Achilles (*Iliad* 2.768; *Odyssey* 11.550–51; Pindar, *Nemean Odes* 7.27). And it was Ajax who played the most important role in recovering the body of Achilles from the battlefield, according to the vase-painters.[16] But the question of who should inherit the arms of Achilles was decided differently: as vase-paintings show, the matter was put to the Achaeans for a vote, and Odysseus prevailed, thanks to the adroit campaign management of Athena.[17] In a sense, it was necessary that a different set of military values prevail were Troy ever to be sacked, because the vigilance of

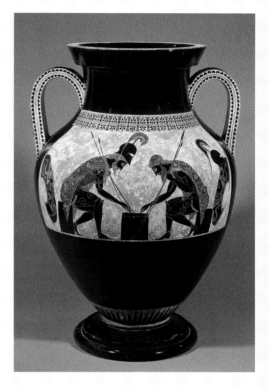

FIG 14 Ajax and Achilles playing a game. Attic black-figure amphora signed Exekias, ca. 540–530 BCE. Vatican State Museums, Museo Gregoriano Etrusco, 16757

Apollo meant that the walls he built would never be breached by direct assault. The only way in which the Achaeans would ever enter the citadel of Troy was if the Trojans let them in. But the triumph of Odysseus over the heroic values represented by Ajax or Achilles was a source of bitterness to some, such as Pindar, who wrote "I believe that Odysseus' story has become greater than his actual suffering because of Homer's sweet voice, for upon his fictions and soaring craft rests great majesty, and his skill deceives with misleading tales. The great majority of men have a blind heart, for if they could have seen the truth, mighty Aias, in anger over the arms, would not have planted in his chest the smooth sword" (*Nemean Odes* 7.20–27, trans. Race; cf. *Nemean Odes* 8.23–34, *Isthmian Odes* 4.34–36).

Pindar wrote that ode, and very likely the sixth paian, under Aiginetan patronage. In a bold rewriting of Homeric tradition, the Aiginetans claimed that Peleus and Telamon, the fathers of Achilles and Ajax, were the sons of Aiakos, the autochthonous son of Aigina and the island's first inhabitant. In the epinician poetry of Bacchylides and Pindar, as well as the magnificent Early Classical pedimental sculptures of the temple of Aphaia, the Aiginetans popularized a mythology in which their ancestors were central to the Trojan War effort.[18] So, for example, perhaps the most beautiful extant account of Achilles' childhood occurs in a poem written by Pindar for an Aiginetan victor: "But fair-haired Achilles, while living in Philyra's home, even as a child at play would perform great deeds; often did he brandish in his hands his short iron-tipped javelin and, swiftly as the winds, deal death in battle to wild lions and kill boars. He would bring their gasping bodies to the Centaur, Kronos's son, beginning at age six and for all time thereafter. Artemis and bold Athena marveled to see him slaying deer without dogs or deceitful nets, for he overtook them on foot" (*Nemean Odes* 3.43–63, trans. Race). Both the point of departure and the conclusion of this description focus on Achilles' Aiginetan ancestor Aiakos. Among the very early representations of Achilles in Greek art is a representation of his father bringing the hero as a young child to Cheiron for schooling, on a Proto-Attic vase from Aigina dating to the mid-seventh century. As Beazley noted, attached to Cheiron's branch are the young lion, bear, and perhaps wolf that will constitute the strengthening diet of the young hero.[19]

In view of the emphasis in the *Iliad* and later poetry on Achilles' prowess in open combat, it is noteworthy that perhaps the most popular type of Athenian vase-painting of the hero depicts him engaged in the sort of dirty, covert operation one associates with Odysseus (fig. 15).[20] In art, the ambush of Priam's youngest son, Troilos, at a water source outside the walls of Troy is most often part of a compound narrative. On this black-figure amphora of around 560 BCE, Troilos rides a dark-colored horse and leads a white horse toward a fountain to water them after exercise. Achilles crouches in ambush behind the fountain, fully armed. The compound nature of the visual narrative lies in the presence of a girl fetching water from the fountain; as we know from another vase, this is Polyxena, the sister of Troilos. The encounter between Achilles, Troilos, and Polyxena had fatal consequences for all three: after the war, prior to embarking for home, the Achaeans slaughtered Polyxena on the tomb of Achilles, the ghost of Achilles having demanded this sacrifice. On another amphora from the same time

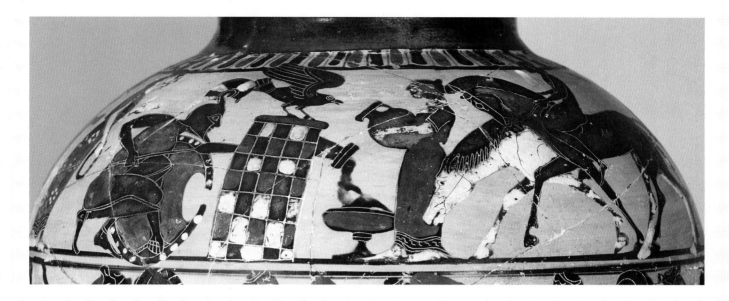

FIG 15 The ambush of Troilos. Detail of an Attic black-figure amphora attributed to the Painter of London, ca. 560 BCE. New York, The Metropolitan Museum of Art, Rogers Fund, 1945, 45.11.2

period, Polyxena is held horizontally by three Greek warriors so that Neoptolemos, the son of Achilles, may slit her throat over a low grave mound with a fire burning on top.[21] The ambush of Troilos was the fateful moment in the life of Polyxena when Achilles first laid eyes on the girl and developed his morbid fascination for her. Troilos was dispatched more quickly: although he had the advantage of being on horseback, he was no match for Achilles, who ran him down in spite of being on foot. This is beautifully captured on the important early sixth-century Athenian black-figure vase known as the François Vase: Troilos gallops toward the safety of the citadel of Troy, jumping his horses over the water jug abandoned by his sister; Achilles is in close pursuit, running so fast that neither of his feet touch the ground.[22] Troilos never reached the safety of the city walls: Achilles killed the boy on an altar of Apollo outside Troy. In some visual representations, the sacrilege seems deliberate: Achilles drags the boy to the altar before beheading him.[23] One can be sure that such desecration would not have gone unpunished; on the François Vase, the god gestures knowingly and angrily toward the crime unfolding in the center of the image.

The myth of the ambush and murder of Troilos in vase-painting exemplifies the idea that the mythology of the hero Achilles was not uniform in antiquity. The Troilos myth provides an alternative explanation of why Apollo killed the hero to that contained in Pindar's sixth paian: in the paian, Apollo acted against Achilles to prolong the existence of Troy whereas in the visual tradition, it was to punish the hero for his horrifying desecration of Apollo's sacred place.

BOYS AND GIRLS: ACHILLES AND PATROKLOS, ACHILLES AND BRISEIS

In the *Iliad*, the relationship of the greatest narrative and characterological importance is that between Achilles and Patroklos. Although the plot is set in motion by the disruption of Achilles' relationship with the captive girl Briseis, the tragic turning point of the story is the loss of his friend Patroklos. The relationship between Achilles and Patroklos is characterized as homosexual in nature in a famous passage of Plato's *Symposium* (179e–180b). Phaidros describes Patroklos as the *erastes*, Achilles as the *eromenos*, in a pederastic relationship. Phaidros claims that Aeschylus characterized the relationship as pederastic as well (although, Plato argues, Aeschylus misunderstood its dynamic in making Achilles the older, and Patroklos the younger

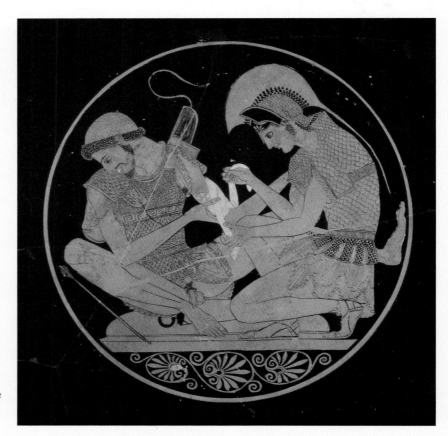

FIG 16 Achilles binding Patroklos's wounds. Detail of an Attic red-figure kylix attributed to the Sosias Painter, ca. 500 BCE, Staatliche Museen zu Berlin, Antikensammlung, 2278

partner). Several fragments of Aeschylus's lost play *Myrmidons* seem to be relevant. It is unclear whether other Greek auditors understood the relationship between Achilles and Patroklos to be homosexual.[24] On a famous cup by the Sosias Painter (fig. 16), however, the concern of Achilles, who bandages the arm of the wounded, slightly older Patroklos, seems deep and intimate.[25]

If Plato's influential reading of the Homeric relationship between Achilles and Patroklos has encouraged a belief that Achilles placed a higher value on pederastic relationships than on heterosexual ones, the visual tradition tells a somewhat different story. As noted already, Archaic visual representations of the ambush of Troilos regularly feature the visual encounter between Achilles and the Trojan princess Polyxena more prominently than the encounter with Troilos (e.g., fig. 3). Although Achilles' interest in Troilos was characterized as homoerotic by the Hellenistic poet Lykophron, it is purely as professional assassin that he interacts with Troilos in Athenian vase-painting. Another series of vase-paintings depicts Achilles' encounter with the Amazon princess Penthesilea.[26] Several Archaic and Early Classical examples have plausibly been interpreted as visualizing an erotic interest in the warrior heroine on the part of Achilles. That idea is developed thoroughly in later literature, to the point that it is argued that Achilles' infatuation with women, irrespective of their Trojan allegiance, repeatedly imperiled the community of the Achaean army, that he was comparable in this respect to none other than Paris of Troy: "Achilles, you perverted man, what power has beguiled your spirit for the sake of a wretched Amazon, whose only desire for us was every conceivable evil? . . . [Y]our accursed mind has no concern at all for glorious deeds of valor once you catch sight of a woman. . . . Surely you know how great has been the cost to Troy of lust for women."[27]

The earliest surviving positively identifiable visual representation of Briseis grants her a stature, compositionally, that seems larger than what one would expect from the

Iliad (figs. 17a, 17b).[28] A red-figure amphora of around 510 BCE by the Athenian artist Oltos depicts a single figure on each side, equal in visual prominence, Achilles on one side and Briseis on the other, both identified by inscriptions. A similar composition occurs on the name piece of the high Classical artist known as the Achilles Painter.[29] On one of the most celebrated of all ancient visual representations of the hero, Achilles competes for attention on equal footing, visually, with a depiction of a girl who appears to be Briseis. A third example of this scheme may have been painted by the late-Archaic Kleophrades Painter, a vase-painter with a deep interest, it seems, in the Trojan War.[30] The vase-paintings do not necessarily amount to narratives counter to the Homeric tradition. But the prominence of Briseis, the absence of the figures one might expect to see in the company of Achilles, and the degree to which the hero acknowledges the girl do not correspond closely to the subsidiary, pawnlike role she plays in Homer. As Casey Dué concluded, "this kind of scene [in the vase-paintings] is reminiscent of narratives about local girls falling in love with Achilles when he come to sack their town, a kind of scene that falls outside of the confines of the *Iliad*."[31]

In Wolfgang Petersen's 2004 film *Troy*, the murder of Agamemnon by Briseis is both a gratifying resolution to their relationship, as it is defined in the movie, and also, to readers of the *Iliad*, utterly foreign. The prominent role played by Briseis in the deaths of both Agamemnon and Achilles is perhaps the film's most radical departure from the ancient narrative tradition about the Trojan War. In Petersen's *Troy*, the final moments of Achilles' life bear a close resemblance to the manner in which the story of Achilles and Polyxena is told in later ancient literature. In the late antique tradition, Achilles goes to the temple of Apollo outside of Troy to meet Polyxena, and there he is assassinated by Paris. Achilles' interest in advancing the Achaean military objective is eclipsed by his love for an enemy girl. In the film, the identity of the hero's beloved is not Polyxena but Briseis, and the time and place of their final encounter is a sanctuary within the citadel of Troy during the city's last moments. Two of Achilles' traditional female love interests are rolled into one, and Achilles' ethical choice of love over spoils is vividly conveyed through the contrast between his desperate attempt to find his beloved before the city burns to the ground and the violent looting carried out by his fellow Greeks. Of course, a further motivation for the remarkable increase in the importance of Briseis in the Trojan War, as the film recounts it, was the imperative to eliminate any trace of homoeroticism or homosexuality from the biography of Achilles. The filmmakers made him a "man's man" in the modern, rather than the Greek, sense of the expression. But in so doing, the filmmakers paralleled narrative lines and interpretive debates about the character of Achilles that go back to the Archaic period in literature and the visual arts.

FIGS 17A AND 17B Achilles and Briseis.
Attic red-figure amphora by Oltos (painter),
ca. 510 BCE. London, British Museum,
1836,0224.126 (E 258)

NOTES

1 Lines 1–3. The divine identity of the hero's killer is emphasized in lines 7–8. As Alessandro Barchiesi (2001, 256–57) has persuasively suggested, this account may have been the model for Horace's account of the death of Achilles at the hand of Apollo: "He, like a pine by axes sped, Or cypress sway'd by angry gust, Fell ruining, and laid his head in Trojan dust" (Horace, *Carmine* 4.6.9–12, trans. Conington).

2 For the text, see West 1998, 118–20, frag. 11; trans. after West 1993, 168–69.

3 Rutherford 2001, 38, 44.

4 Obbink 2001, 67–73.

5 *Odyssey* 24.76–84, trans. Fagles. In Simonides' proem, the reference to Patroklos may be part of a similar, if much briefer, account of the burial of Achilles.

6 Philostratos, *Heroicus* 53.10, a new translation in Maclean and Aitken 2001. Further on the cult of Achilles in the Black Sea, see Hedreen 1991.

7 Pinney 1983; Ferrari 2003.

8 Lines 78–98; Rutherford 2001, 298–338, for the text and a recent comprehensive commentary. The reference to the hero by naming his mother, Thetis, recalls the manner in which Simonides refers to the hero in the Plataian poem. The allusion to what Paris did to Helen, the reference to the destruction of Troy, and the idea that the city's demise was mandated by justice also seem to have occurred in both poems.

9 Hedreen 2001, 67–88.

10 Athens, National Archaeological Museum, 15155, kantharos fragments; *ABV* 82,1, Nearchos; Beazley Archive, no. 300767; Beazley 1986, 37.

11 Nagy 1979, 22–24, 40, 42–63. See also Edwards 1985a.

12 Vienna, Kunsthistorisches Museum, 3695, cup; *ARV²* 429,26; Beazley Archive, no. 205070.

13 Rome, Vatican, 16757, amphora; *ABV* 145,13, Exekias; Beazley Archive, no. 310395. For the series, see Woodford 1982.

14 Cf. Robert 1923, 2:1126–27.

15 For the subtle details, see Moore 1980.

16 For the images, see *LIMC* 1 (1981), s.v. Achilleus A, 185–93 (A. Kossatz-Deissmann); Woodford and Loudon 1980.

17 For the vase-paintings, see Williams 1980, 137–45.

18 See Burnett 2005, 13–28 and passim; Hedreen forthcoming.

19 Berlin, Staatliche Museen, Antikensammlung, A 9; *CVA* Berlin 1, pl. 5; see Beazley 1986, 9–11, with pl. 9,3–4. See also Robertson 1940.

20 New York, Metropolitan Museum of Art, 45.11.2, hydria; *ABV* 85,2, Painter of London, B 76; Beazley Archive, no. 300791.

21 London, British Museum, 1897.7-27.2; *ABV* 97,27, Timiades Painter; Beazley Archive, no. 310027.

22 Florence, Museo Archeologico, 4209, volute-krater; *ABV* 76,1, Kleitias and Ergotimos; Beazley Archive, no. 300000.

23 E.g., Perugia, Museo Archeologico, 89; cup; *ARV²* 320,8, Onesimos; Beazley Archive, no. 203224.

24 For the relationship between Achilles and Patroklos in the *Iliad* and beyond, see most recently Davidson 2007, 255–84. For the fragments of Aeschylus and Plato's account of them, see Michelakis 2002, 43–53. In the Classical period, Aischines (*Against Timarchus* 149) argued that Homer did not explicitly claim that Achilles and Patroklos were lovers. See also Laguna-Mariscal and Sanz-Morales 2005.

25 Berlin, Staatliche Museen, Antikensammlung, F 2278; *ARV²* 21,1; Beazley Archive, no. 200108.

26 For the iconography, see *LIMC* 7 (1994), s.v. Penthesilea, 296–305 (E. Berger).

27 Quintus of Smyrna 1.723–735, trans. James. On the story of Thersites' accusations against Achilles, see Rosen 2003.

28 London, British Museum, E 258; *ARV²* 54,4; Beazley Archive, no. 200436. On the pictorial conception, see Klinger 1993.

29 Rome, Vatican, 16571, amphora; *ARV²* 987,1; Beazley Archive, no. 213821.

30 Basel, Antikenmuseum und Sammlung Ludwig, 424, amphora; *ARV²* 183,8; Beazley Archive, no. 201661. On the painter's interest, see Boardman 1976.

31 Dué 2002, 33.

HELEN HEROINE OF CULT, HEROINE IN ART H.A. Shapiro

No other female figure in Greek mythology—goddess, heroine, or mortal woman—fascinated and puzzled the ancient Greeks as did Helen of Troy. Her continuing fascination, for writers, artists, and thinkers of all kinds up to the present day is exemplified by such figures as Christopher Marlowe, Goethe, and Richard Strauss. Even Helen's status as mortal or immortal was not always clear to the Greeks and may have varied at different times and in different parts of the Greek world. Scholars have often assumed that she was in origin a minor fertility goddess, as there is evidence for early cult worship in her Peloponnesian homeland.[1] Yet by the time we first encounter Helen in Greek poetry, in Homer's *Iliad*, she seems to be fully mortal, on the same plane as the epic's other characters, including her husband, Menelaos of Sparta, and her lover, Paris, the Trojan prince. She is admired by many for her beauty and grace but also scorned by others for the infidelity that supposedly caused this great war. What is perhaps most remarkable about the Helen of the *Iliad* is how "humanized" she is, with all the conflicting emotions of a woman in her peculiar situation: regret, self-doubt, occasional defiance, and gratitude for the gentle treatment she receives from Trojan "enemies" like Priam and Hektor.[2]

It is only with the Helen of the *Odyssey* that we begin to glimpse a figure who may be beyond the merely mortal.[3] We first meet her in book 4 when Telemachos, young son of Odysseus, on a journey in search of news of the father who was been gone from home nearly twenty years, fetches up at the court of Menelaos in Sparta. Helen is back by her husband's side as the sovereign queen, all the bitterness and pain of the war at Troy now only a distant memory, almost like a bad dream. Indeed, when unhappy memories threaten to dampen the mood, Helen (who clearly possesses magic powers) slips a potion into the drinks to bring forgetfulness (4.219–30). This is our first inkling that Helen is no ordinary mortal, nor would we expect any child of Zeus to be "ordinary."

All our sources agree that Zeus was Helen's father, but there are different accounts of her mother and of the circumstances of her conception and miraculous birth. Interestingly, however, whether the mother was a mortal—Leda, wife of King Tyndareus of Sparta—or the goddess Nemesis, it was in the form of a swan that Zeus coupled with Helen's mother and from an egg that she was born (no. 1). In the visual tradition of this myth, which starts only in the last third of the fifth century BCE, it is always the version set in Sparta that is shown, with Leda and her family watching in amazement as the egg, set upon an altar, is about to hatch (fig. 18).[4] In one rare instance, on a vase probably made in Sparta itself, Helen has begun to emerge from the huge egg, as the eagle symbolizing her divine father hovers above her (fig. 19).[5] Clearly, this extraordinary birth portends great things—for good or ill. The religious aura of the occasion is enhanced by the altar and, in some scenes, by other indications of a setting in a sanctuary of Zeus, Helen's unseen father (see fig. 18). Also important is the presence of Helen's brothers, the Dioskouroi, the twins Kastor and Polydeukes, as they will

FIG 18 Birth of Helen. Attic red-figure bell-krater attributed to Polion, ca. 430 BCE. Akademisches Kunstmuseum Bonn, 78

FIG 19 Helen emerging from the egg. Detail of a Laconian red-figure olpe, ca. 420 BCE. Athens, National Archaeological Museum, 19447

later figure in other stories of Helen's early life and will be closely associated with her in cult worship.

The alternate version, in which Helen's mother was the goddess Nemesis, whose name means something like "retribution" and is the origin of our current idiom ("she's my nemesis"), goes back to a different layer of the Epic Cycle than the one known to Homer.[6] What makes this important for Helen's later status as a cult heroine is the role of local geography and the process by which historical and political considerations could lead the Greeks to promote cult figures in specific times and places.

The Archaic source had reported the setting of Zeus's rape of Nemesis as Rhamnous, a small village near the eastern coast of Attica, the large city-state (polis) whose leading city in the Classical period was Athens. At the time the story originated, however, Attica was a loose association of autonomous towns, and Nemesis could have been worshiped in Rhamnous as a local divinity. It was only with the political reforms of Kleisthenes at the end of the sixth century that all of Attica was unified into a political entity, with each deme, like Rhamnous, having representation in the council and assembly that governed from Athens.[7] Coincidentally, the first Persian invasion of mainland Greece, in 490 BCE, landed at Marathon, not far up the coast from Rhamnous, where the armies of Darius were beaten back by a vastly outnumbered Athenian army. Recalling the name of the goddess Nemesis, the Athenians came to believe that she embodied the punishment of the invader, the retribution inflicted on the Persians for their hubris in crossing the immutable divide between Asia and Europe and trying to enslave a free people. To make the image even more concrete, they spread the story that the Persians had brought with them a large block of marble, intending to use it to set up a carved victory monument (Pausanias 1.33.2). This very stone would later be used to fashion a colossal cult statue of none other than Nemesis herself, thus turning the tables on the Persians, and the previously local shrine would be built into a major sanctuary, graced with a proper temple.[8]

What part could Helen play in all this? Just as she had once been the instrument of Nemesis, the cause of Troy's destruction at the hands of the Greeks, so might she now help the Athenians overcome the Spartan enemy with whom Athens would soon be at war. We are fortunate to know quite a lot about the Temple of Nemesis and its

cult statue, which was the masterpiece of the sculptor Agorakritos of Paros, a protégé of Pheidias. Pausanias, the traveler and guidebook writer of the second century CE, saw and described the statue (1.33.3–7), and adaptations of it were recognized in statues of the Roman period. Then, in the 1960s, the Greek archaeologist Giorgios Despinis identified some fragments of the original statue in the storerooms of the British Museum.[9] These confirmed that, unlike larger and more imposing cult statues of gold and ivory, such as the Athena Parthenos inside the Parthenon or the Zeus of Olympia, the Nemesis of Rhamnous was about life-size and was carved in marble, perhaps from the very block left behind by the Persians (fig. 20). Nevertheless, the statue did share an important feature with the two more famous, chryselephantine cult statues, in that each of them stood on a rectangular base that was adorned with figures carved in high relief. Once again we are fortunate in having the collocation of a description by Pausanias with portions of the actual frieze (fig. 21). But without Pausanias, we would have no idea of the subject: "The Greeks say that Helen's mother was Nemesis," he writes, "while Leda only brought her up. . . . Pheidias represented Leda leading Helen to Nemesis" (1.33.7–8; Pausanias follows a minority tradition, that the statue was not by Agorakritos but by his teacher, Pheidias). The subsidiary figures on the frieze named by Pausanias include various family members, such as Tyndareus and his children (probably meaning the Dioskouroi); Menelaos and Agamemnon; and Pyrrhos, a son of Achilles who would marry Helen's daughter, Hermione.

Recent studies have shown that the many figures were disposed in small groups on three sides of the base (unlike, for example, on the Athena Parthenos, where all the figures depicting the birth of Pandora were lined up along the front of the base),[10] though just how they were grouped and what, if any, particular moment was depicted have

FIG 20 Reconstruction of the cult statue of Nemesis at Rhamnous. From *Deutsches Archäologisches Institut, Athens, Archaische und klassische Griechische Plastik* (Mainz, 1986), vol. 2, 92, fig. 2

FIG 21 Head of Nemesis from the base of the Nemesis of Rhamnous, ca. 430 BCE. Neg. D-DAI-Athen Hege 1144

FIG 22 Excerpt from the principal scene on the Nemesis base (Roman adaptation). Marble, 54 × 50 cm. Stockholm, National Museum, Sk 150

been much discussed (fig. 22). One recent and attractive theory suggests that the occasion is the wedding of Hermione and Neoptolemos (also called Pyrrhos) in Sparta.[11]

In any case, it is clear that one of the focal points of the composition was the group with Helen, since this group also included Nemesis, who was honored in the temple and loomed over the base in all her glory. To understand the prominence given to Helen here, we need to consider the temple's historical context. At the same time that it harked back to a specific military victory, over the Persians, it was erected in the years about 430 BCE, just as the Peloponnesian War was beginning.[12] Much of the family depicted on the base, including Helen herself, belongs to the myth-history of Sparta. Greeks of the Classical period were very conscious of their descent from heroes (and sometimes gods) of the distant past, heroes who to us are mythological, but to them were their very real ancestors, and they were eager to call on these ancestors for help. Later in the war, when the Spartans invaded Attica, they would invoke the memory of an earlier invasion by the Dioskouroi (Herodotos 9.73), an episode to which we shall return below.

The Spartans would no doubt claim Helen as one of their own, too, but here at Rhamnous the Athenians seem to be staking a counterclaim, on the grounds that Nemesis, Helen's "real mother" (as Pausanias expresses it), conceived the child in Attica. The egg was later brought to Sparta, where Leda kept it warm until Helen was ready to break out. In this manner, the Athenians could also claim Helen as a local heroine, and her worship was no doubt incorporated into that of Nemesis in this sanctuary. In fact, Helen's worship in Attica was more widespread still, for a sacrificial calendar of the fourth century BCE, carved on stone in the deme of Thorikos in southern Attica, includes sacrifices to her together with her brothers, Kastor and Polydeukes.[13]

It is Helen's close association with her twin brothers that leads us into the most salient aspect of her persona: her irresistible attractiveness to men. The affair with Paris that gave her the nickname Helen of Troy was preceded, some years earlier, by an erotic adventure that is portrayed by our sources in a very different light. The Athenian hero Theseus came to Sparta when Helen was still a young girl and, overcome by her beauty, abducted her to Attica.[14] There are good reasons to think that this is a very old myth, yet the first continuous narrative that survives, in Plutarch's *Life of Theseus*, written around 100 CE, has been given a strong moralizing spin that was surely alien to

the Archaic myth. All of Plutarch's biographies hold up their subjects as both positive and negative *exempla* of behavior. Since this *Life* will see Theseus come to a bad end, first overthrown by a usurper and driven into exile, then treacherously murdered, there must be flaws in his character that foreshadow his comeuppance. Thus in Plutarch's improbable version of the story, Theseus is already a reckless middle-aged man of fifty, while Helen is a girl of seven (*Life of Theseus* 31, citing the fifth-century historian Hellanikos as his source). To keep the story from becoming even more shocking, Plutarch is at pains to point out that the abduction was not sexually consummated (which would make it a great rarity in Greek myth). Instead, Theseus left the girl with his mother, Aithra, for safekeeping, at the town of Aphidna in northeastern Attica, while he went off on other, equally foolish adventures. The Dioskouroi, avenging the honor of their sister, promptly mounted an invasion of Attica to bring her home. The reason this has been thought to be a very old story is that, in the *Iliad*, Aithra is named as a handmaid of Helen's in Troy (3.143–44). The only logical explanation for this is that, in rescuing their sister, the Dioskouroi had also taken Theseus's mother hostage, and she ended up accompanying Helen to Troy.

Doubts about the authenticity of Plutarch's version of the story arise when we compare it with the visual tradition of Theseus's abduction of Helen, which stretches in Athenian art from the late sixth to the late fifth century BCE. The scene is always shown as an abduction by chariot, but neither of the protagonists matches Plutarch's description (fig. 23). Rather, Helen is a beautiful—and fully grown—young woman, and Theseus is most often a beautiful, beardless youth, like the idealized bridegroom in Athenian wedding scenes.[15] It is not hard to guess at why the story might have become distorted in later retellings that eventually came down to Plutarch. It might, for example, have seemed unacceptable were Helen not still a virgin when, after being courted by all the greatest heroes of Greece, she was awarded to Menelaos. But in Archaic mythmaking, heroes' abductions of women almost invariably lead to offspring, and in fact, the Archaic poet Stesichoros, as quoted by Pausanias (2.22.7), wrote that none other than Iphigenia was born to Helen and Theseus, then given up to Helen's older half-sister, Klytaimnestra (daughter of Leda and Tyndareus), to raise. If Stesichoros's account was known to the Athenians of the sixth and fifth centuries, as seems likely,[16] this would have been yet another way of tying the figure of Helen more closely to Attica. For Iphigenia was also the recipient of cult worship in an Attic sanctuary, at Brauron, where she had ended her life as the first priestess of the goddess Artemis (Euripides, *Iphigenia among the Taurians* 1462–67).[17]

All of the myths just discussed—Helen's conception at Rhamnous by Zeus and Nemesis; her abduction by Theseus and rescue by the Dioskouroi; her daughter, Iphigenia—were promoted (and, in some instances, perhaps invented) in the political context of Athens's rise to preeminence in the Aegean world in the aftermath of the Persian wars and the creation of a defensive alliance of Greek city-states in the 470s and 460s that quickly evolved into an Athenian empire. In an era when so much of the rivalry among Greek cities was played out with reference to one's heroic ancestors, Athens was at a distinct disadvantage for having had such a minor role in the defining

FIG 23 Helen abducted by Theseus. Detail of an Attic red-figure stamnos attributed to Polygnotos, ca. 430 BCE. Athens, National Archaeological Museum, 18063

event of the Heroic Age, the Trojan War. It is true that Homer mentions a small contingent of ten Athenian ships, but they are under the command of the obscure hero Menestheus (*Iliad* 2.552). Theseus, who would later become the Athenian national hero par excellence, belongs to an earlier generation of heroes, while his two sons, Akamas and Demophon, appear at Troy only at the tail end of the war, in stories that may have been told in a sequel to the *Iliad*, a part of the now-lost Epic Cycle.[18] By the time we get down to Plutarch, Menestheus has turned into a villainous figure, the usurper of Theseus's throne, though in the Classical period he was still a glorious hero and role model for the Athenian youth,[19] just not one whose name resonated throughout Greece, like Agamemnon or Odysseus or Ajax.

The continuing relevance of the Trojan War and its various heroes and heroines to interstate relations in Greece received a tremendous boost with the two Persian invasions of 490 and 480 BCE. Greek writers, starting at least with the tragedian Aeschylus (himself a veteran of the Battle of Marathon), immediately recognized a parallel between the Persians under Darius and Xerxes—unimaginably wealthy and autocratic rulers from the East—and the Trojan kingdom of Priam as described by Homer and then reimagined by Aeschylus and others in extravagant imagery of oriental splendor and decadence.[20] In this new context, the stories of Helen and Menelaos and, most especially, of the Trojan Paris were reimagined as well, a process we can follow most vividly in Attic black- and red-figure vase-painting. In early depictions of the judgment of Paris, for example, the Trojan prince, though supposedly living as a young shepherd on Mount Ida, is depicted as a regal Greek gentleman greeting the god Hermes, who escorts the three goddesses. A century later, Paris looks more appropriately rustic and boyish, but after the middle of the fifth century, he will take on a radically different look, that of the elegantly dressed and effeminate oriental prince (fig. 24).[21]

The same style also characterizes Paris in a scene that becomes especially popular in the last years of the fifth century BCE and the early years of the fourth: his first encounter with Helen at Sparta.[22] Whereas this key moment had earlier been shown in an interior, domestic setting, with Menelaos and others present, it has now moved into an idyllic landscape in which the future lovers are mostly alone (no. 11). The entire mood and meaning of the story have been reinterpreted for a new audience that may have included large numbers of Athenian women, since many of these vases are small perfume vessels that would have been used by women in life and accompanied them into their tombs.[23] With Paris's youthful beauty and oriental finery, the sometimes lush setting, and Helen's demure yet overtly erotic demeanor, the moment takes on an intensely romantic cast, eliding all that this fateful moment portends and instead expresses a new vision of romantic love between handsome young women and men not seen in earlier Athenian art.[24]

We can witness a somewhat analogous development taking place over a period of a century in the scene of Helen reunited with her husband, Menelaos, on the night that Troy fell to the Greeks. In the Archaic black-figure tradition (no. 28), Menelaos is a grim, faceless warrior who brutally seizes his wayward wife and contemplates

FIG 24 The judgment of Paris. Detail of an Attic red-figure hydria by the Painter of the Karlsruhe Paris (name piece), ca. 410–400 BCE. Badisches Landesmuseum Karlsruhe, B 36 (259)

dispatching her on the spot. She is an utterly passive figure.[25] But in red-figure a century later (no. 27), the moment has taken on a far more dynamic and psychologically complex aspect. As Helen flees toward the sanctuary of an altar, she turns to look back, making eye contact with her husband. He in turn loses his murderous resolve at the sight of her beauty, as indicated by the dropped sword. The later literary tradition, as if not content with this charming reversal of fortune, added one vulgar detail: a wardrobe malfunction in which Helen's breast was exposed at the crucial moment. But the vase-painters do not seem to know (or care) about this detail,[26] and it is not surprising that by the later fifth century, some painters could even travesty this melodramatic moment (no. 26).

It is interesting to imagine how Helen and Menelaos got from this harrowing moment of emotionally fraught reconciliation to the scene, some ten years later, when Telemachos finds them a happy and serene middle-aged royal couple who can reminisce with fond nostalgia about the events of a distant war and an earlier life. Though philosophers and intellectuals would continue to debate Helen's character until the end of antiquity—Was she to blame for her actions, or was she the innocent victim of Aphrodite? Was she a whore who betrayed her family or a pawn in the games of the gods?—the verdict of the Classical period is clearest in the visual imagery that consistently depicts Helen as a sympathetic figure of beauty and romance. That she was worshiped as a heroine and daughter of almighty Zeus made such intellectual exercises beside the point for the average Athenian, and most of all for the Athenian girls and women who longed to identify with her life of glamour and romance. If she was occasionally a "bad girl," that would only have added to her appeal.

NOTES

1 Clader 1976. For the early cult of Helen at the Menelaion in Sparta, see Larson 1995, 66–67, 79–81; Antonaccio 1995, 155–66.

2 On Helen's character in the *Iliad*, see Austin 1994, 23–50.

3 Austin 1994, 71–89.

4 For scenes of the birth of Helen, see *LIMC* 4 (1981), s.v. Helene, 503–4 (L. Kahil).

5 Athens National Museum, 19447. See Karouzou 1985 for the full publication.

6 Kypria (Fragment 7 Davies). For other sources, see Stafford 2000, 78–81; Shapiro 2005.

7 On the Kleisthenic reforms and the unification of Attica, see Anderson 2003.

8 See Stafford 2000, 82–88, for the role of Nemesis, and Miles 1989 for the Classical Temple of Nemesis.

9 Despinis 1971.

10 See the studies of the Rhamnous base by Kallipolitis 1978; Petrakos 1986; and Shapiro-Lapatin 1992. For the base of the Athena Parthenos, see Leipen 1971.

11 Palagia 2005, 68, who comments, "At the heart of Sparta, Helen is revealed to be an Athenian."

12 For the dating of the temple, see Miles 1989, 221–42.

13 Daux 1984, 149.

14 For the sources, see Shapiro 1992.

15 On these scenes, and the mythological role models, see Sutton 1997–98.

16 On the reception of Stesichoros in Athens, see Burkert 1987b. The notion that Helen and Theseus not only consummated their affair but were even briefly married was spectacularly confirmed by the recent discovery of an Attic vase, dated to ca. 400 BCE, depicting their wedding: see Shapiro 1992.

17 See Ekroth 2003, who stresses the role of Euripides in promoting, and perhaps inventing, this cult.

18 These stories do seem designed to shore up Athens's minor role at Troy, as well as the glory of Theseus's family. In one, Akamas and Demophon rescue their aged grandmother Aithra during the chaos of Troy's fall, and in another, they make off with the ancient cult image of Athena in Troy, the Palladion, and establish it in Athens. For the former episode, see the sources and representations in *LIMC* 1 (1981), s.v. Aithra, 420, 426–27 (U. Kron); for the story of the Palladion, see Tiverios 1988b.

19 The best evidence for Menestheus's positive reputation in the Classical period is his mention in an epigram commemorating Kimon's victories over the Persians in the 470s: see Plutarch, *Life of Kimon* 7, and Osborne 1985.

20 For the parallels between Persia and Troy, see Erskine 2001; and for Aeschylus in particular, see Hall 1989.

21 For the iconography of the judgment of Paris, see Clairmont 1951; *LIMC* 1 (1981), s.v. Alexandros, 498–500 (R. Hampe).

22 See *LIMC* 4 (1988), s.v. Helene, 515–20 (L. Kahil); Shapiro 2005.

23 Shapiro 2000.

24 On this shift in attitude, see especially Sutton 1997–98.

25 See the classic study of these scenes, Kahil 1955.

26 For the sources see *LIMC* 4 (1988), s.v. Helene, 499–500 (L. Kahil).

We all know Odysseus. His ten-year odyssey on the Mediterranean Sea was beset with many dangers and setbacks, yet, through his own cunning and the support of others, he survived it. His voyage brought him back from Troy to his wife, Penelope, who had remained faithful for more than twenty years. Homer's epic poem *The Odyssey*, probably dating from the early seventh century BCE, tells of these travels. The poem has made Odysseus into a positive tragic figure, yet one of human proportions, a hero who adheres to his objective no matter what the obstacle or how great the peril. For many he represents an archetype in the history of ideas and *mentalité* in the West.

Despite all that, Odysseus has no real biography. Homer tells us almost nothing of his childhood or his youth apart from the fact that he came from the western Greek island of Ithaca. We learn that King Laertes was his father, Penelope his wife, and Telemachos his son. When the Greeks set up camp and prepared for action outside the gates of Troy, he distinguished himself, unlike Achilles, by using his intelligence to serve the interest of his companions. The Trojan Horse that launched the conquest of the city was his idea. Homer's *Odyssey* depicts the subsequent ten-year homeward journey of the long-suffering (*polytlas*) hero: shipwrecks and sustained wanderings mark his route as he crisscrosses the Mediterranean. This unreconstructible voyage presents us with the experiences of the Greeks as seafarers. It takes Odysseus to the limits of human civilization: to the one-eyed giant Polyphemos; to the cannibalistic Laestrygones; to Kirke the enchantress; to the Sirens whose songs bewitch sailors; and through the straits of Scylla and Charybdis, where he loses six of his men. Naked, scarcely any longer a man—not to say a king—Odysseus is finally washed ashore on the island of the friendly Phaeacians. They take him in and initiate a kind of resocialization. He then returns to his homeland, where the men of Ithaca and neighboring islands, coveting the throne, have been plaguing his wife for years. Disguised as a beggar and recognized only by a trusted few, he murders the suitors in vengeance. In his fury, Odysseus nearly becomes a second Achilles.

In this relatively self-contained story of a blameless downfall and a reentry into the human community, Odysseus emerges as the embodiment of the hero to an extent matched by few others. Yet, however little we know about what preceded these Homeric events, we know just as little about what happened afterward. Odysseus is a truly epic figure as Homer defines him, but he also lacks certain elements of Greek heroism. Thus, outside Sparta and possibly Ithaca itself, no distinct cult grew up around him. On the other hand, artifacts purportedly associated with Odysseus were preserved in many locations. Numerous cities claimed him as their founder. The endowment of sacred shrines and temples to Athena, his tutelary goddess, was traced back to him. Odysseus was much praised. In the tragedies known to us from fifth-century Athens, he appears as Homer describes him: the epitome of the "ever-ready"

Translated from the German by Linda Parshall

(*polymetis*), "inventive" (*polymechanos*), and "much-traveled" (*polytropos*) man. This is how the authors of other texts represent him as well. In tragedy and in the later poetry, however, when Odysseus uses his cunning and unscrupulous trickery to pervert the truth, it is perceived as a problem. Over time Odysseus evolves as a tragic figure to become a more human character with his own ups and downs. Beyond his epic endurance and craftiness, in the later tradition it is the image of a hero with a human face that dominates.

In classical antiquity Odysseus was a presence not only in poetry but also in the visual arts. This is all the more important because, in the cultures of ancient Greece and Rome, images played a role that can hardly be overstated. They appeared in domestic interiors, in shrines and city squares, at feasts, and in rituals. And yet, although Odysseus was much praised in the ancient world, it was Herakles, and after him Achilles, who drew the most attention from artists. That the Greeks and Romans were relatively uninterested in representations of Odysseus is all the more remarkable given that he is the protagonist of an epic composed by Homer, the "teacher of the Greeks." The disparity is especially conspicuous in Athens, where Odysseus often appeared as a character on the stage. We are led to ponder the relationship between Odysseus in pictorial representations and in Homer's epic poem, and in particular to consider which aspects of the man and his deeds served to ignite the visual interest of antiquity.

FROM MYTH TO PICTURE; OR, IMAGE VERSUS NARRATIVE

In contrast to the later period, Odysseus was a popular figure in the seventh-century world of images; he was in essence a locus for the visualization of Greek myth. Luca Giuliani's *Bild und Mythos* (2003) undertakes a fundamental investigation of this phenomenon. Let us consider the example of one of the best-known tales from the *Odyssey*, the Cyclops adventure, which Odysseus himself narrates at the court of the Phaeacians (9.105–566). As the story goes, his ships reach the land of the "lawless" Cyclops, where, along with a dozen of his men, Odysseus discovers the cave of a dairy farmer. Its inhabitant, the giant Polyphemos, refuses them hospitality, instead devouring two of the men the first evening and another two the next morning. He then departs with his livestock, closing off the cave with an immense boulder. Odysseus, trapped with the remaining eight members of his crew, devises an escape. In the cave he finds a post of olive wood as big as the mast of a ship (9.320). From this he chops off an *órgyia* (9.325)—nearly two meters, a fathom's length—which he sharpens to a point and hides under a heap of dung. Lots are drawn to determine which four of his men will assist Odysseus in blinding the one-eyed Cyclops. After the giant has returned in the evening and closed the cave from inside, Odysseus amiably offers him a bowl of wine and, when asked, declares his name to be "Nobody" (*outis*, 9.366). The first bowl of pure wine becomes three, too much for the Cyclops, who is accustomed to drinking only milk. Intoxicated, he falls over backward, vomits, and goes to sleep. Now Odysseus holds the point of the stake in the fire, and once it is red-hot, he and his men thrust it into the Cyclop's eye. They twist it up and down like the movement of a shipbuilder's bore, with the crew in front and Odysseus at the back of the stake. There

is the sound of sizzling like in a blacksmith's shop. Blood spurts forth, and Odysseus and his men scuttle away. Screaming, Polyphemos wrenches the stake from his eye and from the cave calls to his brethren for help. But when they hear that "Nobody" has attacked him, they decline to come to his assistance and simply advise him to pray. The ruses of the wine and the false name have succeeded, and the Greeks are able to escape from the cave, as we shall see, beneath the bellies of the giant's sheep.

Around 670, shortly after the *Odyssey* was composed, representations of Homeric tales began appearing on clay vessels in many locations around the Mediterranean. Already on the earliest known example, a large amphora from Eleusis (fig. 25), we see the giant holding a wine vessel in his right hand and, with his left, grasping a stake that bores into his open eye. The stake is guided by three men, two represented in black and in front of them the third, whose body is emphasized by having been painted over in white. This is Odysseus. Hence, inconsistent with Homer's text, Odysseus appears in the foreground as the main figure. Polyphemos, however, is not supine, and he holds the wine cup in his hand, as if Odysseus dared to attack him while he was awake. (His open eye seems to support this reading, although in the seventh century, closed eyes meant the figure was dead, and hence the giant's eye had to be shown open, to indicate that he was still alive.) Furthermore, Polyphemos seems to hold the cup very calmly, even while his mouth is agape with a scream. This image is not a snapshot from the epic tale. Rather, the wine cup is placed at the center of the action because it is the key element in Odysseus's trick. The painter has brought something new to the illustration: narrative. There is a recognizable before—the inebriation—and an indication of the after. In the *Odyssey,* once he is blinded, Polyphemos rips the stake from his eye, and here we see him already reaching for it. Thus the image joins various moments together in a single frame and by this means tells the story—something unprecedented in earlier representations in Greek art.

There are similarities to be found in other seventh-century portrayals of the blinding of Polyphemos in which we find narrative texts translated into pictures in ways that are typical of the period. There is no attempt to capture just a single moment in the narrative continuum of the Homeric story, even when the blinding is presented as central. Neither is the goal to represent Homer's tale in exact detail. Instead, the vase-painters were seeking to enrich their "standing pictures" with narrative elements. They were not aiming for an illusion of Odysseus's actual presence but were compensating for the static nature of images by enhancing them with motifs capable of their own narration. Thus, in some respects, these images were meant as "living representations," like the automatons of the god Hephaistos as they appear in Homer. This interest in epic imagery stands at the beginning of the representation of heroes in Greek art, and it was inspired by, in fact may have competed with, the literary works of the same period.

The idea of synthesizing separate temporal and spatial elements into a single image in order to increase narrative capacity remained fundamental to the storytelling technique of Greek art until well into the fourth century, and it continued to evolve in various ways. On a late sixth-century oinochoe in the Musée du Louvre, one can see

FIG 25 Odysseus and his companions blinding Polyphemos. Detail of a Proto-Attic black-figure amphora, seventh century BCE. Eleusis, Archaeological Museum

at the left the stake being heated in a fire in preparation for the blinding, while to the right another vignette shows the blinding itself (p. 168, figs. 95a, 95b). By this point, the images are focused more on single moments in the story that can be followed in sequence. The conflict between synthetic accounts incorporating different moments and discrete accounts operating like snapshots resulted in a new scheme for visual storytelling: the sequential, comic strip–like pictorial narrative.

Over the course of the fifth century, interest in representations of the Polyphemos episode both declined and changed. On a krater from the latter part of the century (fig. 26), Polyphemos is shown asleep and with his single eye closed. An animal pelt and his enormous genitals identify him as an uncivilized being. Next to him is the drinking vessel along with a wineskin. He is about to be blinded from above. So far the scene corresponds to the *Odyssey*. But the figure of Odysseus does not: he stands to the right and directs the action. This and the fact that two satyrs take delight in the event have led to the assumption that the scene is actually an illustration of Euripides' *Cyclops*, a satyr play, which shows that by the late fifth century, pictorial narration had become more episodic, focused on one moment of the action and adhering more closely to the textual tradition. Thus it has become more literal at a period in the cultures of Greece and South Italy when reading was playing a decisive role.

In the Late Classical and Hellenistic eras that followed, the practice of bundling events together to illustrate a narrative moment reached its high point. This is most evident in a first-century BCE statuary group of the blinding of Polyphemos from the grotto of a villa in Sperlonga, on the western coast of Italy (fig. 27). Similar sculptural groups must have existed elsewhere as well (nos. 18, 45). Here the setting alone—an actual cave—places the viewer directly within the story. Three Greeks guide the stake toward the eye of the sleeping Polyphemos, who, in his drunkenness, has dropped the wine cup. At the right, a fourth conspirator takes to his heels, his flight raising our anticipation of the danger that will follow the blinding. Yet the focus is on the dramatic moment preceding the act, and the viewer shares in the tension. This group has not abandoned the power of the epic-narrative so highly valued by earlier Greek artists, but here it is overshadowed by the illusionistic power of a true re-creation of action. The advantages of a text, namely the ability to narrate consecutively and epically, have been superseded by the strengths inherent in an image: a direct, sensory encounter with an action. The tale of Odysseus in Polyphemos's cave thus offers a paradigmatic demonstration of the transition from text to image *and* from image to text illustration. It especially demonstrates the competition between the two media, that is, between heroic imaging and heroic narrative. From the seventh century onward, the effectiveness of heroic images was tested through the example of Odysseus.

FROM THE IMAGE OF THE HERO
TO THE CONSTRUCTION OF HEROIC IMAGES

What was it about images of the blinding of Polyphemos that proved so compelling? In seventh-century representations of the event, three aspects are especially striking. First, they do not portray a victory over an inhuman monster but over an immense

FIG 26 Odysseus and his companions blinding Polyphemos. Detail of Lucanian kalyx-krater by the Cylops Painter (name piece), late fifth century BCE. London, British Museum, GR 1947.7-14.18

FIG 27 Odysseus and his companions blinding Polyphemos. Reconstruction of the statue group in the cave at Sperlonga, first century BCE. Bochum, University Collection

man. Second, the emphasis falls on the trickery involved—the excessive wine, the gigantic stake. Third, the images depict a collective action; Odysseus is not the mastermind but at most *primus inter pares*, and to that extent a socialized being. This is also true for the other episode from the Polyphemos story that began to appear in seventh-century illustrations: the escape from the cave beneath the bellies of sheep. As Homer tells it, the flock leaves the cave and the blinded giant feels only the backs of the sheep, thus failing to discover the Greeks carried beneath. Early images always include a number of sheep bearing the escapees; it is not clear which figure represents Odysseus, for he is not singled out. In Homer's account, only Odysseus clings to the fleece with his own hands, whereas each of his men is tied beneath the middle sheep of three that are lashed together. The pictorial representation thus takes the similar rescue of all, not Odysseus's individual feat, as its subject.

In sixth-century scenes of the escape, Odysseus is sometimes identified by an inscription, but we often find just a single sheep bearing a single Greek (no. 19). Is this Odysseus? Possibly, but it was apparently not essential that we know. By this point one could concentrate on the individual, yet the fact that Odysseus outperformed his companions is made less prominent than the cleverness of the escape itself. And, in addition to the scenes of the blinding and the escape, we now find images of Kirke and the Sirens. According to Homer, Kirke used a magic potion to turn Odysseus's crewmen into pigs before he had the chance to intercede. However, sixth-century images portray the men transformed into various different kinds of animals. Here again the intervention of Odysseus is not the focal point of the story: rather, the subject is the danger of drinking the magic potion. Kirke's miraculous power continued to be of interest in later periods (cf. nos. 29–31). Also dating from the sixth century is the earliest surviving depiction of Odysseus lashed to the mast of his ship and listening to the song of the Sirens (no. 20). He has plugged the ears of his crewmen so they cannot be lured off course. Here the large size of the Sirens, their varied instruments, and their prominent placement in the image all show that the painter was primarily

intent on highlighting their dazzling musical skills. Odysseus's cunning is inherent but receives little attention.

Beginning around 500 BCE we can observe a change in this pattern. Odysseus appears more prominently in the narrative of the escape from Polyphemos's cave, for instance, shown driving the sheep from the cave by himself. The vase-painters are now striving to put this exceptional hero and his accomplishments in the limelight. He becomes more visibly active in the Kirke adventure as well; Kirke is shown fleeing from the heroic Odysseus. It was scarcely possible to depict his success in outwitting the Sirens, given that he is bound and inactive. Yet the painter of a vase now in London (fig. 28) attempted to convey Odysseus's power by showing one of the Sirens plunging from the cliff to her death in an act of despair over the hero's ability to resist her. The might of Odysseus, before which the Siren yields, becomes the central issue. None of this is present in Homer.

At about the same time, two new groups of Trojan subjects were introduced to Athenian vases. On one side of the vessels we find Odysseus and Ajax preparing to fight each other for the armor of Achilles while their companions restrain them in an attempt to mediate the quarrel. On the other side we are shown a decision being reached through a vote. This combination of scenes suggests that the real subject is the conflict and its resolution. Odysseus appears here as part of the Greek electorate. This was an appropriate role for a hero in early fifth-century Athens, which was gradually moving toward democracy. It is thus not surprising that he is also shown speaking at the Agora: Odysseus as politician. Elsewhere we see him depicted together with other

FIG 28 Odysseus and the Sirens. Detail of an Attic red-figure stamnos by the Siren Painter (name piece), fifth century BCE. London, British Museum, 1843,1103.31 (E 440)

figures in the embassy to Achilles; their goal, as related in the *Iliad*, is to persuade
Achilles to set aside his anger and return to battle (9.197 ff.). Whereas Achilles is por-
trayed deeply veiled and utterly self-absorbed, Odysseus is his opposite. Wearing a
traveling hat—a sign of his mobility—he teeters uneasily on his stool, hands clasped
in front of his knees. These are pictorial conventions for restlessness and pensive-
ness. Odysseus is pursuing the discussion with Achilles in order to resolve the con-
flict; this is not the cunning deceiver but the persuasive arbiter. At a time when the
political order in Athens was up for negotiation, painters were deploying the figure of
Odysseus to play out the conflicts and procedures of contemporary political life. But
at the same time, they were using Odysseus to weigh the role of the extraordinary indi-
vidual, the victor. Both subjects seem to have occupied the Athenians to an unusual
degree. Elsewhere—for instance, in private votive offerings (fig. 29)—we also now
find Odysseus disguised as the elderly beggar who returns to his mourning wife, a
symbol of faithfulness.

 In the second half of the fifth century, the emphasis shifts to other dimensions of
the hero. He appears on the Phaeacian coast as a naked, broken man, accompanied
for the first time by Athena: now Odysseus too needs the protection of a god. On
a pair of skyphoi that may have been intended as pendants, the Penelope Painter
represented two subjects (figs. 30, 31)—faithfulness in the *oikos* and vengeance. One
of the vessels shows Odysseus back at home with his nurse Eurykleia and the loyal
Eumaios; Penelope and Telemachos appear as well on the other side—in other words,
the whole family. The second vessel depicts the hero taking his murderous revenge
on the suitors; standing behind him are two of the disloyal female slaves who will also
soon face a terrible death of their own. Here loyalty and vengeance, the roots of human
conflict, are set in contrast. Thus, in the fifth century, the Odysseus who acts with bold
self-determination is augmented by the conflicted Odysseus who needs protection.
The depths of human existence are plumbed in this figure, and contemporary tragedy
centering on the politically minded, crafty Odysseus bears a similar implication.

 We could extend our survey to the fourth century, when images adhered more
closely to the Homeric models, although depictions of Odysseus continue to reflect

FIG 29 Plaque with the return of Odysseus,
Melian, ca. 460–450 BCE. Terracotta. New York,
The Metropolitan Museum of Art, Fletcher
Fund, 1930, 30.11.9

FIG 30 Odysseus, Eurykleia, and Eumaios. Attic red-figure skyphos by the Penelope Painter (name piece), fifth century BCE. Chiusi, Museo Archeologico Nazionale, 62705. From A. Furtwängler and K. Reichhold, *Griechische Vasenmalerei*, vol. 3 (Munich, 1932), pl. 121

FIG 31 Odysseus slaying the suitors. Attic red-figure skyphos by the Penelope Painter, ca. 440 BCE. Staatliche Museen zu Berlin, Antikensammlung, F 2588. From A. Furtwängler and K. Reichhold, *Griechische Vasenmalerei*, vol. 3 (Munich, 1932), pl. 138

contemporary preoccupations until the late classical period. For instance, in the third century CE, the owner of a house in Dougga in present-day Tunisia had a mosaic laid out showing Odysseus bound to the mast of his ship and, to the right on cliffs above a sea teeming with fish, the Sirens (figs. 32a, 32b). Except for their talons, the Sirens now resemble female figures, some exposing their torsos in Venus-like fashion. On the left a fisherman proudly displays a crayfish, a detail absent from the myth. It is true that the text of the *Odyssey* lies behind the image, but it has been adapted to fit the particular wishes of a wealthy patron of the third century: in his villa, the proprietor of a fishery chose a tale of Odysseus the hero to celebrate female beauty and the bounty of the sea.

Overall, Homer was not especially popular in the pictorial repertoire of the Greeks and Romans. But the images of Odysseus, like the stories about him, provided a means for the ancient ways of *Arbeit am Mythos* (work on myth). Only there, in these different media, did the hero really exist, and through these representations the possibilities for portraying heroes were tested. As in our own day, each phase of antiquity constructed its own image of Odysseus, sometimes stressing one characteristic, sometimes another. As is true for all Greek heroes, we come to know him through the variations of the myth; Homer's *Odyssey* was, after all, no inviolable "sacred text." Rather, the ancient heroes were constituted of the tension between the narrative core of a myth and the variations played upon it, and this same tension makes it possible

for us to discover the ancient imagination that survives there. The Greeks became especially preoccupied with Odysseus's role as a social being entangled in issues that were political and collective, whereas for the Romans it was Homer's Odysseus, the hero of a *Bildungskanon* (canon of knowledge) and the protagonist of fascinating tales, who caught their attention. Thus from out of Homer's Odysseus arose, step by step, a succession of images in which we learn more about the *mentalité* of an audience than we do the biography of a hero.

FIGS 32A AND 32B Ulysses and the Sirens. Details of a Roman mosaic from the House of Dionysus and Ulysses in Dougga, third century CE. Tunis, Musée national du Bardo

NOTE
An overview of the visual material on Odysseus is found in Touchefeu-Meynier 1968; Brommer 1983; *LIMC* 6 (1992), s.v. Odysseus, 943–70 (O. Touchefeu-Meynier); Buitron 1992; Andreae and Parisi Presicce 1996; Andreae 1999; and Latacz et al. 2008, 221–44, 406–37. The first part of this essay is based largely on Giuliani 2003, which is now being translated into English.

CHILD HEROES IN GREEK ART

John H. Oakley

Children do not spring immediately to mind when the word "hero" is first mentioned, but child heroes existed in antiquity, as they do today.[1] One difference is that many of today's child heroes are real people, while most of those from antiquity are mythological. Typically, modern child heroes are those who save the life of another, overcome some form of hardship such as disease, abuse, or physical deformity, or perform a public service. The last type did not exist in antiquity but is a purely modern construct that in the United States has blossomed in the last decade. Fictional child heroes have long been a staple of American popular literature, and for those raised in the twentieth century, Nancy Drew, the Hardy Boys, the Boy Allies, and the comic strip Little Orphan Annie spring to mind. Today's children prefer their fictional child heroes to have special powers, Harry Potter being by far the best example, although some, like Alex Rider, a fourteen-year-old sleuth, have none—just special abilities.

Another modern parallel with antiquity are the quasi-historical actions attributed to heroes when they were children. George Washington's admission to his father that he had chopped down a cherry tree exemplifies his honesty. Alexander's taming of his horse Bucephalos after the failure of all Philip's men to do so (Plutarch, *Alexander* 6) exemplifies his precocious physical and mental prowess. Some heroes are distinguished by their childhood deeds, although the childhoods of many heroes are unrecorded. Those whose childhoods are recounted are often the best-known and most important Greek heroes. Some of their early deeds are rendered in Greek art.

HERAKLES' PRECOCITY

Herakles, then and now, is among the most famous of Greek heroes. His most celebrated childhood deed occurred when Hera, his constant tormenter, sent a pair of snakes to kill him and his twin brother, Iphikles, in their bed.[2] In another version of the story (Pherekydes FGrH3 F 69), Herakles' stepfather, Amphitryon, sent the snakes as a test to distinguish his son from that of Zeus since he had been cuckolded by the god. The story is first depicted on several Athenian vases dating between 480 and 450 BCE, including a remarkably well-preserved Attic red-figure hydria by the Nausicaa Painter.[3] The two boys are shown kneeling atop a short *kline* (a bed or dining couch), which occupies the center of the picture. Iphikles, on the right, extends his two hands toward his mother, Alkmene, for help. Awoken by his cries, she flees to the right, her hands raised up to either side. (Fleeing figures like this are commonplace at this time in mythological scenes, and we should understand her pose as indicating surprise rather than fear.) The baby Herakles, meanwhile, calmly strangles a snake with each hand while looking toward Amphitryon, who prepares to strike the serpents with the sword he holds over his right shoulder, just as Pindar describes the episode in his first Nemean ode (44–53). Filling out the middle of this balanced composition is the standing figure of Athena, who rests on her spear as she looks toward Amphitryon. Herakles' patron goddess is often either present or not far away.

After the middle of the fifth century BCE, the infant Herakles is most often represented alone holding the snakes; this was all that was now needed to indicate the story. The image appears most frequently on coins and gems, whose picture fields were

perforce limited, as well as on pottery with relief decoration, and the theme persisted into Hellenistic sculpture. Normally Herakles is depicted either seated or kneeling, as on an early fourth-century BCE silver stater from Kyzikos (cf. no. 2), on which he holds one snake down toward the ground with his left hand; the other is wrapped around his raised right arm. Kyzikos was one of eight cities belonging to a maritime alliance that used this image-type on their coins along with the letters ΣΥΝ, an abbreviation for *synmachikon* (alliance). Some scholars believe that this alliance was opposed to Sparta and connected with the Athenian Konon's defeat of the Spartans at Knidos in 394 BCE; under this interpretation the snakes represent the two kings of Sparta. Others associate the league with other events and people, including the Spartan king Lysander in 405–404 BCE, interpreting the snakes as an allusion to the tyrannical city of Athens.[4] On a general level, however, the story of Herakles and the snakes and images deriving from the myth are meant to indicate the young hero's premature strength and to foreshadow his later encounters with various beasts and villains. This precocious display of a heroic quality is exactly what is found in the stories of Washington and the cherry tree, and Alexander and Bucephalos.

Two other moments in Herakles' life as an infant are illustrated in Greek art, each on a single vase. Hera is depicted suckling Herakles on an Apulian red-figure squat lekythos (ca. 360 BCE) from the Suckling-Salting Group (fig. 33).[5] The flower held by Athena, standing before Hera, may refer to the "field of Herakles." Diodorus Siculus (4.9.6) tells us that Athena had encouraged Hera to pick up the baby who had been abandoned there by Alkmene and that he sucked so hard that Hera, in pain, cast him away. On the far left sits Aphrodite, who is about to be crowned with a wreath by Eros. Iris stands on the right, talking with another seated woman (probably Alkmene). In the picture, unlike in Diodorus's account, Hera and the infant Herakles appear content with each other, as indicated by their shared gaze. Suckling scenes are not common in Greek art, but the subject of Hera suckling Herakles also appears on several Etruscan mirrors and a Faliscan red-figure calyx-krater, although in these instances Herakles is shown no longer as a baby but as either a young or mature man.[6]

In another version of the story (Pausanias 9.25.2; Eratosthenes, *Katasterismoi* 24; Schol. Art. 469; Hyginus, *Poetic Astronomy* 2.43; and others), Hermes is reported to have carried the infant to Olympos, where Zeus himself placed the babe at Hera's breast. The child, we are told, sucked so hard that Hera cast him down, and a spurt of milk shot out across the sky and became the Milky Way. On one side of a black-figure amphora (500 BCE) from the Dot Band Class (fig. 34),[7] the god is depicted flying to the right and carrying the infant Herakles in his left arm. Both are labeled, as is Cheiron, the Centaur, who, accompanied by a dog, occupies the other side of the vessel and extends his right hand. Both pictures have been understood to represent Hermes bringing the young hero to Cheiron for his upbringing, but some scholars have been uneasy about connecting the two images, because Hermes, who looks back, appears to flee the Centaur rather than approach him. We might do better to see the two images as referring to separate events in Herakles' childhood. In the case of Hermes, he is bringing the baby Herakles to Olympos, while the picture of Cheiron

FIG 33 Hera suckling the baby Herakles. Apulian red-figure squat lekythos from the Suckling-Salting Group, ca. 360 BCE. London, British Museum, 1846,0925.13 (F 107)

refs to the baby's upbringing, for this Centaur was one of Herakles' teachers, as he was for a number of other heroes.

EDUCATION

The literary sources recount that Herakles was taught a variety of skills by various teachers: Kastor taught him fencing, Eurytos archery, Amphitryon driving a chariot, Eumolpus singing, and Autolycus wrestling and boxing. Among these, visual representations are limited to scenes of Herakles and Linos, and appear exclusively on Attic red-figure vases dating between 490 and 450 BCE. From Diodorus (3.67.2) and Apollodorus (2.4.9) we learn that Linos struck Herakles for being a poor student and that the hero retaliated and killed him in anger. While it demonstrates the young hero's strength, the story also shows the dark side of the hero who is unable to control his temper, a common problem for adolescents. Excess remained a problem for Herakles throughout his life, so once again the childhood story foreshadows the character of the adult hero. The immediate prelude to the deed is shown on a single masterfully rendered skyphos signed by the potter Pistoxenos and decorated by the Pistoxenos Painter (fig. 35).[8] On one side Iphikles and Linos sit facing each other, each holding a lyre. A phorminx hangs on the wall between them, and a phormiskos and a cross-shaped object of uncertain use can be seen behind Linos. The old man, with white hair and long beard, instructs the youth in lyre playing. On the other side of the vessel stand Herakles, arriving for his lesson, and his Thracian nurse, Geropso. Wrapped in his mantle, he holds a long arrow upright with his right hand and looks on almost bug-eyed, while his heavily tattooed nurse carries his lyre and a crooked stick—the latter complementing her crooked physique and haggard appearance. Herakles does not appear particularly eager to go to school.

The most famous depiction of the murder is on a cup by Douris (fig. 36).[9] Herakles raises a broken *diphros* (backless stool) over his head and is about to strike Linos, who holds a lyre above his head and extends his left arm outward to protect himself. Four other agitated and fleeing youthful students fill out the scene. The writing slate and stylus hanging from the wall define the school setting, and the other half of the broken *diphros* is visible on the ground behind the victim. The unrest continues on the

FIG 34 Hermes carrying the baby Herakles. Attic black-figure amphora from the Dot Band Class, ca. 500 BCE Munich, Antikensammlungen und Glyptothek, 1615A

FIG 35A Linos instructing Iphikles in lyre playing. Attic red-figure skyphos by the potter Pistoxenos and attributed to the Pistoxenos Painter, ca. 470. Schwerin, Staatliches Museum, 708

FIG 35B Herakles and Geropso. Attic red-figure skyphos by the potter Pistoxenos and attributed to the Pistoxenos Painter, ca. 470 BCE. Schwerin, Staatliches Museum, 708

FIG 36 Herakles slaying Linos. Attic red-figure cup by Douris, ca. 480 BCE. Munich, Antikensammlungen und Glyptothek, 2646

other side of the cup, where three pairs of youths and men are in animated discussion about what has happened. Linos sometimes appears seated in other depictions; one vase includes a nathex, the fennel staff that teachers sometimes used for punishment; this is very likely the instrument with which Linos beat Herakles.[10]

The theme of education is reflected as well in vase-paintings depicting the young Achilles. His primary teacher was Cheiron (sometimes assisted by Cheiron's mother, Philyra, and wife, Chariklo), who taught Achilles lyre playing, singing, hunting, riding, reading, writing, and medicine as well as moral virtues such as piety, fairness, and the aristocratic way. The hero's childhood is represented exclusively by scenes depicting the young Achilles being entrusted to the Centaur. The earliest depiction of the episode is a Proto-Attic amphora by the Painter of the Ram Jug from around the middle of the seventh century BCE, considerably earlier than the first mention of it in the literary sources (Pindar, *Nemean Odes* 3.43–58; *Pythian Odes* 6.21–23). Peleus is shown holding out his son on one side of the vase to the Centaur standing on the other. Cheiron extends his right hand to receive his student and, in his left, carries a branch over his shoulder from which to hang dead prey.[11]

The subject is most popular on Attic black-figure vases, although there are several Attic red-figure examples, in addition to a Corinthian plate and Boeotian Kaberiote skyphos.[12] A good black-figure example is a neck-amphora of about 520–510 BCE in Baltimore (no. 6). The civilized Centaur, draped in a mantle, stands to the right holding the child close to him, apparently with his left arm, while gesturing with his right hand to Peleus, who stands opposite him. The fawn in the background between them indicates the rustic setting on Mount Pelion, where the action takes place. Peleus, dressed in a chlamys and carrying a staff in his left hand, grasps the mantled child with his right hand, while Achilles reaches out toward his father in a manner typical of children. In other vase-paintings, Achilles is shown as a youth standing before the Centaur with or without

Peleus in attendance; sometimes Thetis, Chariklo, or Hermes is present. The courtship of Achilles' parents is shown on the other side of the Walters vase: Peleus wrestles with Thetis, and a sister Nereid flees on either side. Zeus has chosen Peleus to be the husband of Thetis, but she does not accede willingly to the mortal's advances, turning herself successively into fire, water, and different beasts in her attempt to break free, before relenting. The couple's wedding was one of the great social events of myth, attended by all the Olympians. The seeds of the Trojan War were sown at it.

THE DANGERS OF CHILDHOOD

The baby Herakles' encounter with the snakes demonstrates the hero's exceptional strength and foreshadows his future labors, but it also illustrates one of the many dangers faced by children—a recurring theme in Greek art. Unwanted, deformed, or sick newborns were regularly abandoned and left to die in ancient Greece. Since nature killed them, in the Greek mentality there was no blood guilt involved. Probably the most famous case in Greek myth was that of Oedipus. His father, King Laios of Thebes, had learned from an oracle that any child born to him and Queen Jokasta would murder him. Therefore, when Oedipus was born, he pierced and bound the child's feet and ordered that he be abandoned on Mount Kitharon, where he was rescued by a shepherd and brought to Corinth to be raised by King Polybos and his wife, Periboia. A unique picture on an Attic red-figure neck-amphora by the Achilles Painter (fig. 37)[13] shows a burly outdoorsman, labeled Euphorbos, carrying the baby Oedipus, who clings to him for protection, resting his head on the shepherd's shoulder. One can sense how close the boy came to death as well as his vulnerability. The shepherd's dark, unkempt, and stringy hair contrasts with the baby's golden short hair. Interestingly, Oedipus's dangling feet show no sign of the swelling from which his name was derived. Only one other depiction of the boy's childhood survives in Greek art, and that is on a Hellenistic relief bowl, where Polybos is shown seated with the infant on his lap as Periboia looks on.[14]

A unique scene on an Apulian red-figure volute-krater of about 330 BCE by the Underworld Painter (fig. 38)[15] shows Hellen, the hero from whom the Greeks (Hellenes) got their name, standing before a herdsman (so labeled as BOTHP) who holds the twin sons of Poseidon and Melanippe, Aeolus and Boeotos. The action is ambiguous: either the herdsman has found the babies and brought them to their grandfather, or the grandfather has given them to the herdsman with orders to expose them. They are wrapped tightly in cloth and wear the pointed bonnet typically worn by infants. Melanippe and an old nurse (ΤΡΟΦΟΣ) look on anxiously from the right, while on the left Melanippe's father, King Aiolos, stands watching. Behind him, Kretheus, probably Melanippe's son, crowns a horse that may well be Hippo/Hippe, Melanippe's mother, who was transformed into the animal to serve as an oracle. A group of gods, including Poseidon, occupies the upper register. The outcome in this case is a happy one, for the boys live to adulthood. *Melanippe the Wise*, a lost play by Euripides, appears to be the source for this picture.

Exposure is also the theme in the one event depicted from Perseus's childhood. King Akrisios of Argos had learned from an oracle that the son of his daughter Danae

FIG 37 The shepherd Euphorbos holding the baby Oedipus. Attic red-figure neck-amphora by the Achilles Painter, ca. 450–445 BCE. Paris, Cabinet des Médailles, 372

FIG 38 A herdsman holding the twins Aeolus and Boeotos. Apulian red-figure volute-krater by the Underworld Painter, ca. 330 BCE. Atlanta, Michael C. Carlos Museum of Emory University, 1994.1

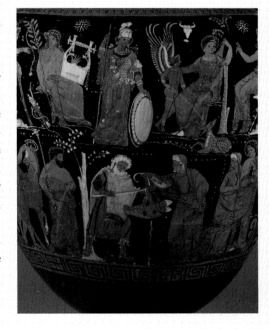

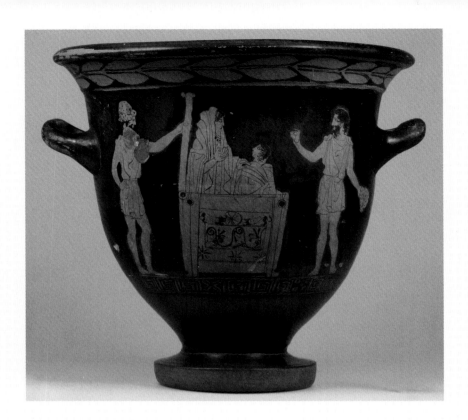

FIG 39 Danae and Perseus on Seriphos. Attic red-figure bell-krater, ca. 440 BCE. Syracuse, Museo Archeologico Regionale "Paolo Orsi," 23910

would kill him. To prevent the birth, he locked Danae in a chamber, but Zeus came to her in the form of golden rain and impregnated her. Akrisios, hearing the baby's cries, learned of Perseus's birth and proceeded to place mother and son in a wooden chest and set them out to sea. They washed up on the Cycladic island of Seriphos, where they were discovered by a fisherman and brought to King Polydektes.

The story is depicted only on red-figure vases. A lekythos of about 470 BCE in Toledo by the Providence Painter shows the mantled child in the chest. He raises his right hand toward his mother, who stands beside the chest on the left of the scene.[16] She bends slightly toward her helpless son, an alabastron in her raised left hand. The vessel, like the lekythos, held oil or oil-based perfume and should be understood in this context as a grave good. King Akrisios stands on the right and extends his right arm outward in a gesture of command. With his left hand he holds a scepter by his side. The simple and balanced composition is appropriate for the size of the picture field on a lekythos. The child's helplessness is underscored by the contrast between his small body and the cavernous wooden chest.

Other depictions of the episode elaborate the story,[17] adding figures, including the carpenter who manufactured the chest, a nurse, or other women. On a lekythos in Providence, Danae and Perseus are shown in the chest encircled by birds and adrift on the water.[18] Four vases show their arrival on Seriphos, including an unattributed Attic red-figure bell-krater of about 440 BCE (fig. 39).[19] A fisherman stands on the left behind the chest, holding open its lid to reveal its contents. The child looks back to his mother for reassurance, which she gives by placing her left hand on his shoulder while gesturing with her right hand to another fisherman, who has taken off his hat (a rustic *pilos*, typically worn by fishermen and other outdoorsmen) and greets her with raised right hand.[20] Mother and child have landed safely and will soon be led to King Polydektes. Back home, the two are presumed dead, as suggested by a unique scene of Akrisios seated on a grave/cenotaph for Perseus on a white-ground lekythos of about 450 BCE.[21]

Violence by parents or other adults against children was a persistent theme. Euripides' tragedy *Telephos* tells how the wounded Telephos, on Klytaimnestra's advice, seized the baby Orestes and threatened to kill him unless Achilles cured Telephos's wound. We see the child being used as a pawn, as children often are in disputes between adults, on several Attic and South Italian red-figure vases. The earliest representation of the hostage scene is on the reverse of a Lucanian calyx-krater of about 400 BCE (fig. 40).[22] The wounded Telephos, a bandage around his right thigh, kneels with his left leg upon an altar (see fig. 47). He holds the boy in his left hand and threatens him with a sword that he wields with the right. The baby Orestes holds out both arms pleadingly to his parents, who advance from the right. Agamemnon is about to pull his sword from its scabbard, while Klytaimnestra runs forward with arms extended. Euripides' play may have been the source for the picture. This story will have a happy outcome, as Achilles agrees to heal Telephos's wound. This is not the case with the scene on the other side of the vase, where we see the bodies of Medea's dead children strewn across an altar.

The baby Erichthonios, a future king of Athens, was also abused by adults. He was born from the earth after Hephaistos's seed had been spurned by Athena. Athena placed the infant in a basket and gave it over to daughters of King Kekrops for safekeeping, with the instruction not to open the basket. Curiosity got the better of them, and when Athena returned to Athens and discovered what had happened, she pursued the guilty parties, who fell to their deaths from the Acropolis.

The birth of the child with Ge (Earth) handing the baby over to Athena is known from several Attic black- and red-figure vases.[23] The outside of a cup by the Kodrus

FIG 40 Telephos threatening to kill the baby Orestes. Lucanian red-figure calyx-krater by the Policoro Painter, ca. 400 BCE. Cleveland Museum of Art, Leonard C. Hanna, Jr., Fund, 1991.1

FIG 41 The Birth of Erichthonios. Detail of an Attic red-figure kylix by the Kodrus Painter, ca. 430 BCE. Staatliche Museen zu Berlin, Antikensammlung, F 2537

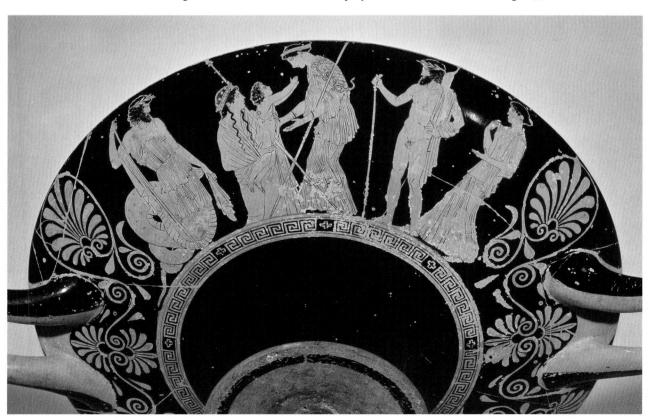

Painter in Berlin (fig. 41) shows the elaborately bejeweled Ge rising from the ground holding the baby, who reaches out with both arms toward Athena.[24] The goddess leans over gently to receive the boy, who is nude except for a protective string of amulets strapped across his chest. She has turned her snaky aegis around so that Erichthonios will not be frightened by it. The crossed scepter of Ge and lance of Athena draw the viewer's attention to this event. Framing the three are King Kekrops on the left, identifiable by his serpentine lower body, and the boy's father, Hephaistos, on the right. The advancing figure of Herse, one of the Kekropides, links the scene with that on the other side of the vessel, where Herse's sisters, Aglauros and Pandrosos, are shown along with two other Athenian kings, Erechtheus and Aigeus, in addition to Pallas, the brother of Aigeus.

The punishment of the Kekropides is also depicted on several Attic and one Apulian red-figure vase.[25] The essential elements of the tale are given on a lekythos in Basel by the Phiale Painter (fig. 42).[26] An angry Athena storms in from the left and reaches out to grab one of the fleeing girls, most likely Aglauros, who holds up her hands in fright. Between them is the falling basket from which a snake pops out—a chthonic guardian appropriate for the child of the Earth. Several black- and red-figure vases show the boy in Athena's care, notably the name piece of the Erichthonios Painter, a pelike of 440–430 BCE in the British Museum (fig. 43).[27] The future king is shown seated in the lower half of a cylindrical basket perched atop a rock and guarded by two

FIG 42 Athena pursuing one of the Kekropides. Attic red-figure lekythos by the Phiale Painter, ca. 435–430 BCE. Antikenmuseum und Sammlung Ludwig, Basel, BS 404

FIG 43 Athena and Erichthonios. Attic red-figure pelike by the Erichthonios Painter (name piece), 440–430 BCE. London, British Museum, 1864,10-7.125 (E 372)

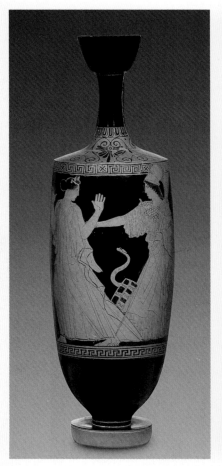

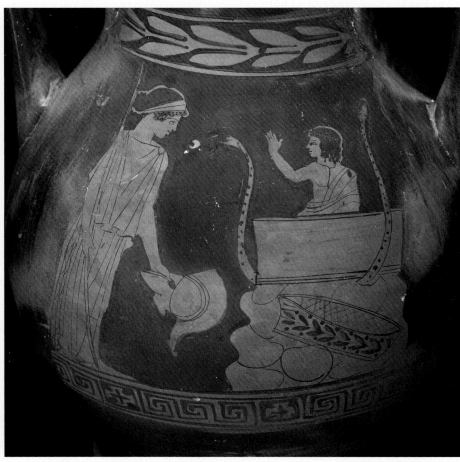

FIG 44 The snake devouring Opheltes. Paestan red-figure calyx-krater fragment by Python, ca. 360 BCE. Bari, Museo Archeologico Nazionale, 358. Neg. D-DAI-Rom 01480

snakes. The upper half of the container rests below on the rocks, and Athena stands on the left holding her spear and helmet while looking at her ward, who gestures to her with raised right hand.

The happy ending of Erichthonios's fraught childhood is far from the norm; more often, child heroes perished before they reached adulthood, and cults were established in their honor. Shrines to child heroes existed all over mainland Greece and in two cases are associated with the founding of pan-Hellenic games (the Isthmian Games and the Nemean Games). The child hero Opheltes, the son of King Lykourgos of Nemea and Eurydike, is represented only on South Italian red-figure vases and by several Hellenistic figurines. An oracle had warned Lykourgos not to place his son on the ground until he could walk. Ignoring (or ignorant of) the oracle, the boy's nurse, Hypsipyle, put the child down by a spring in order to help the Seven against Thebes find the water source. A large snake that lived there attacked and killed the young hero. Amphiaraos saw the event as a bad omen for the Seven's expedition, so they gave the child a new name, Archemoros (instigator of doom) and instituted the Nemean Games in his honor. For the Greeks, a horrific premature death alone was sufficient cause to heroize a child. The first certain literary reference to this foundation myth is contained in an epinician by Bacchylides (9.10–14) that may have been written after 466 BCE, but the earliest detailed account of the story appears about half a century later, in Euripides' tragedy *Hypsipyle*.[28] The artistic depictions, in turn, emerge about half a century after Euripides' play.

The vases show four different moments: the snake attacking Opheltes; Opheltes dead at the spring and the Seven killing the snake; Opheltes dead on his mourning mother's lap or in her arms; and Opheltes lying in state on a kline.[29] The earliest is a fragmentary Paestan red-figure calyx-krater by Python of about 360 BCE (fig. 44).[30] A huge snake with bulging eyes emerges from behind an altar and devours the right arm of the kneeling Opheltes. The infant reaches out with his left hand toward the fleeing Hypsipyle. Only parts of her drapery and the hydria that has fallen from her hand remain.

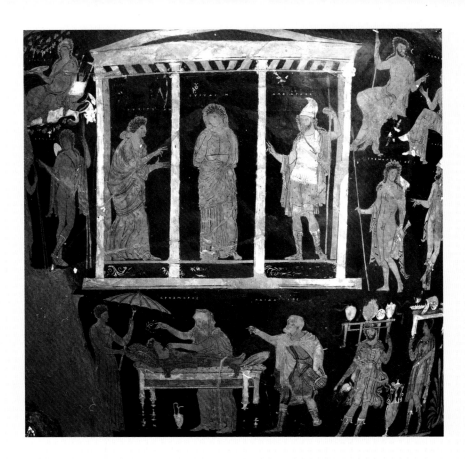

FIG 45 Archemoros lying in state. Apulian red-figure volute-krater by the Darius Painter, ca. 340 BCE. Naples, Museo Archeologico Nazionale, 81394 (3255). Neg. D-DAI-Rom Singer 1971.0439

The visual contrast between the huge serpent and small boy underscores the helplessness of his situation.

The most complex narrative image was made some twenty years later on a volute-krater by the Darius Painter (fig. 45).[31] As typical of large South Italian funerary vases, there are several levels of figures. The architectural frame in the middle has three standing figures placed between columns: Hypsipyle (Opheltes' nurse), Eurydike, and Amphiaraos. The nurse gestures to the other two, apparently pleading her case; Eurydike appears despondent, while Amphiaraos motions back to the nurse. The scene may be based on Euripides' *Hypsipyle,* for his account appears to have been the first to include Eurydike in the story.[32] To the left of the naiskos stand the sons of Hypsipyle, Euneos and Thoas, with Dionysos, the grandfather of Hypsipyle, reclining above them, while to the right stand Parthenopaios and Kapaneus, two members of the Seven against Thebes. Above them sit Zeus and the personification of Nemea. The boy hero, labeled Archemoros, is shown dead and lying on a kline in the partially preserved frieze below. He is attended by an old nurse who prepares to place a wreath on him, while a younger servant holds a parasol over his head. A *paidagogos* (guardian and tutor) advances from the right followed by a bearded man and a youth who carry funerary offerings atop tables. A loutrophoros, a ritual vase placed on the tombs of those who had died unmarried, stands between them. The event shown is the *prothesis,* a standard part of the Greek funerary ritual and a subject that is rendered already on Mycenaean larnakes and Geometric vases.[33] Females are normally shown by the bed with the males off to the side, as here. The prothesis—an appropriate subject for funerary vases—is also known from a contemporary Campanian bell-krater by the Painter of B. M. F 229 and in South Italian tomb painting. The pain caused by the premature death of the boy hero is keenly demonstrated here. Tragedy was possibly the inspiration behind all the vase-paintings with Opheltes/Archemoros, who is depicted either as a baby or as a youth, depending upon the setting.

Young Greek heroes were also subject to violence at the hands of their parents. The most famous example is the tale of Medea's children, as recounted in Euripides' tragedy, in which the sorceress kills her progeny to exact revenge on her husband, Jason, who has abandoned her for another woman. Once again fourth-century BCE South Italian red-figure vases—many of which likely were influenced to some degree by Euripides' drama—are our primary visual source. Medea contemplating killing her children, the actual murder, and her escape are the moments shown, sometimes in combination with other elements of the story.

The simplest picture is on a Campanian red-figure amphora by the Ixion Painter (fig. 46), on which Medea is shown stabbing one of her children.[34] She grabs the child by the hair with her left hand while applying the weapon with the other. The boy reaches back with both hands, the left in an attempt to free Medea's grasp, the right in a gesture of supplication. Her oriental blouse indicates that she is not Greek. Two columns and a small statuette—most likely depicting Apollo—atop a base in the background suggest that the action takes place in the palace's courtyard or a sanctuary. Medea's stern, relentless attack contrasts with the twisted pose and slipping mantle of the boy, who is clearly physically overmatched. His helplessness reflects well how powerless children are against violence directed toward them by their parents.

The most spectacular picture of Medea is on the obverse of the Lucanian red-figure calyx-krater in Cleveland (fig. 47) whose reverse (see fig. 40) shows Telephos and the baby Orestes.[35] She rides a multicolored, snake-drawn chariot in the center of a nimbus in the upper middle of the scene. The latter is a clear reference to

FIG 46 Medea slaying one of her children. Campanian red-figure amphora by the Ixion Painter, 340–330 BCE. Paris, Musée du Louvre, K 300

FIG 47 Medea and her dead children. Detail of a Lucanian red-figure calyx-krater, ca. 400 BCE. Cleveland Museum of Art, Leonard C. Hanna, Jr., Fund, 1991.1

her grandfather Helios (the sun), in whose chariot she escapes. She is more ornately dressed than the Medea on the Campanian amphora, including a Phrygian hat. Below her on the right, her two dead boys are strewn across a Corinthian-style altar rendered in a three-quarter view. The image situates the action in a sacred space, thereby heightening the seriousness of an already terrible crime.[36] The pathos is further augmented by the kneeling old nurse, who mourns the two children with both hands raised to her head. Her tattoos indicate that she is Thracian, the preferred ethnicity for Greek nurses. Behind her, looking on, is the *paidagogos*, who raises his right hand to his head in a gesture of mourning. An angry and dejected Jason stands on the lower left glowering at the escaping Medea. The two hook-nosed, ugly winged figures sitting in the top left and right corners of the picture are probably best identified as Erinyes, the avengers of blood guilt. The horror of the sorceress's deed is vividly rendered here. The final scene in Euripides' drama may well be the source of inspiration behind this vase-painting, although in the play Medea takes the children with her, thereby denying Jason the right of burying them. Both sides of this vase, then, appear to have been inspired by Euripidean dramas.

Itys was another child to die at his mother's hands as an act of revenge. Tereus had raped Philomela, the sister of his wife, Procne, and cut out her tongue so that she could not name her attacker. Philomela, however, wove the story into a tapestry, which Procne eventually saw. To avenge the crime, Procne killed her son Itys and fed his severed parts to the boy's father in a stew. Six certain depictions of the myth are known on Attic red-figure vases dating between 510 and 430–420 BCE; a marble statue of the episode on the Acropolis is generally attributed to the fifth-century sculptor Alcamenes.[37] These artifacts show various episodes in the murder of Itys: the preparations for the murder; the murder itself; the banquet and subsequent pursuit of the women. A seventh-century BCE metope from Thermon may show the preparations for the feast.[38]

The brutality of the slaughter is rendered on a fragmentary cup by Onesimos (fig. 48) of about 500 BCE.[39] The nude boy, labeled ITYΣ, hangs between the two sisters (only traces of Philomela survive), blood spurting from his body. Procne has sunk her sword into him, and his legs kick in the throes of death. The pose of Procne and Itys is closely paralleled on a slightly later cup by the Magnoncourt Painter.[40]

Violence against children is also associated with fathers. Herakles' children by Megara are a prime example, for the hero killed them while struck with a fit of madness. The details of the story—the cause of Herakles' madness, the precise manner of the children's death, their age, gender, and number—vary in the literary sources, but their deaths and the foundation of a cult at Thebes in their honor are constants.[41]

Only one depiction of this well-known story is documented in ancient Greek art: a magnificent Paestan red-figure calyx-krater signed by the painter Asteas (*Assteas egrapse*) on the lower border of the main picture (fig. 49).[42] Herakles, clad in a diaphanous chitoniskos, chlamys, feathered helmet, and greaves, holds a pleading infant in his arms at his waist as he moves left to cast it into a blazing fire that consumes a large pile of household objects, including a *klismos* (backed chair), tables, and a *kalathos*

FIG 48 The death of Itys. Attic red-figure cup by Onesimos, ca. 500–490 BCE. Basel, Cahn Collection, HC 599

(wool basket). The fallen hydria between his legs appears elsewhere as a motif in scenes of violence against children (see, e.g., fig. 47) and underscores the suddenness and unexpectedness of the attack.[43] The presence of metal vases in the pile suggests that Herakles in his madness has gathered anything at hand.[44] On the far right, Megara flees toward a door; her right hand is already upon her head in a mourning pose that anticipates the child's death and indicates her panic. In the architectural niches above are the busts of Mania (the personification of madness), Iolaos (nephew and companion of Herakles), and the white-haired Alkmene (mother of Herakles). The last two gesture in conversation with each other, while Mania holds a whip, an instrument that can be used to stir things up. The depiction is likely based on a lost tragedy, but not Euripides' *Herakles Mainomenos*, for in that play Herakles shoots the children with arrows. Both Pherekydes (*FGrH* 3 F 14) and Apollodorus (2.4.12) preserve a tradition in which Herakles throws the children into a fire, apparently the version shown on this krater. The frenzy of the Dionysiac thiasos depicted on the reverse of the vase complements the scene of Herakles' madness on the obverse.

The aftermath of Herakles' slaughter is depicted on a group of Apulian vases from 340–320 BCE, in which Megara and her children are shown in the underworld.[45] Some of these vases may go back to the same prototype, most likely a wall-painting. On a krater in Naples,[46] Megara is shown seated in the top left corner talking with her two boys, one of whom has a bandage around his chest (probably a reference to Euripides' account of the myth). Below in the middle the hero is depicted performing the labor in which he brings the dog Kerberos back to earth. Other familiar underworld figures in this scene include Hades, Persephone, Orpheus, Sisyphus, Hermes, the Danaides, and three underworld judges, Triptolemos, Aiakos, and Rhadamanthys.

Herakles later had more children with Deianeira, daughter of King Oineus of Calydon. An Attic red-figure lekythos of 460 BCE in Oxford shows her seated and holding the baby Hyllos, who reaches out to his father.[47] The hero extends his right hand to touch the boy. This tender family moment between father and son is an everyday domestic scene that has been raised to a heroic level.

The children of Deianeira and Herakles were orphaned after their parents' deaths, and in Euripides' *Herakleidai* they go to Marathon to seek refuge from the persecutions of King Eurystheus of Argos. Only two Lucanian red-figure vases of about 400 BCE,

FIG 49 The mad Herakles killing one of his children. Paestan red-figure calyx-krater signed by Assteas, ca. 350s BCE. Madrid, Museo Arqueológico Nacional, 11094 (L 369).

FIG 50 Iolaos and the children of Herakles. Lucanian red-figure pelike, ca. 400 BCE. Policoro, Museo Nazionale della Siritide, 35302

both found in the 1960s near Herakleia, are known to depict them. Both images appear to be connected with the play, but they differ in composition and details. The moment is the supplication scene at the start of the play. On a pelike in Policoro (fig. 50),[48] the elderly Iolaos stands atop an altar holding a walking stick and a suppliant's laurel branch. Five boys surround him, two of whom grab his clothes, just as he instructs them to do in the play when they see the agent of Eurystheus approaching (lines 48–49: "Children, children come here—take hold of my robes"). The agent comes in the form of a herald, standing and eyeing the children on the left side of the image. He is balanced by the figure of Athena looking on protectively from the right. The statuette of a young male atop a column is best identified as Apollo, suggesting that the sanctuary belongs to that god rather than to Zeus, in whose sanctuary the Herakleidai in Euripides' tragedy take refuge. (Vase-painters did not normally try to illustrate all the details of a play exactly but were generally influenced by it, so the details of the play and image often do not match precisely.)

The other depiction is on a column-krater.[49] Here the herald has already placed his hand on Iolaos, who sits atop the altar on the left of the scene. The kings of Athens, Demophon and Akamas (sons of Theseus), are shown riding in to the rescue from the right. Alkmene, holding a small image of Zeus, sits on the far left. In the play, she waits with the female children in the Temple of Zeus. Only two boys are shown with Iolaos standing in front of the altar. The plight of orphan children would have been apparent in Athens during the Peloponnesian War of the last thirty years of the fifth century BCE,[50] the time when this play was written, and the Policoro pelike is a particularly effective depiction of their helplessness.

War destroys families, and this was certainly the case in Greek myth as well. Probably the most famous and moving example in Greek art of a child suffering its effect is the murder of Astyanax during the sack of Troy.[51] The young son of Hektor is often depicted as he is about to be slammed upon the dead or dying King Priam. This composition appears to be the result of the vase-painters effectively combining two different episodes in the story as told in the literary sources: Astyanax being cast from the battlements of Troy and Priam being killed by the altar of Zeus Herkeios.[52] An Attic black-figure amphora by the Bucci Painter of about 525 BCE effectively illustrates the essential elements (fig. 51).[53] Neoptolemos strides in from the right, holding up the boy by the lower right leg. Strewn across the altar before the warrior is Priam, the boy's grandfather, his right hand raised over his head to avert the impending blow, while supplicating with his extended left arm. The child's powerlessness in this situation is emphasized by the way his arms and hair hang limply. In other depictions of the *Ilioupersis,* the child is shown off to the side near his mother or dead on Priam's lap.[54] Besides the Attic black-figure and red-figure vases dating between 560 and 460 BCE, bronze shield bands from Olympia of about 580–570 BCE and a relief pithos on Mykonos from the third quarter of the seventh century BCE may also possibly show the murder.[55]

Although some children survive the effects of war, their lives are often permanently altered. A good example is Ascanius, the young son of the Trojan hero Aeneas,

FIG 51 Neoptolemos throwing Astyanax upon the body of Priam. Attic black-figure amphora by the Bucci Painter, 520–510 BCE. Paris, Musée du Louvre, F 222

who along with his grandfather, Anchises, and his father safely escaped from Troy. After wandering, they settled in Latium, near the site where the city of Rome would be founded. The family's flight from Troy with Ascanius is rendered on a large group of Attic black-figure vases, several red-figure vases, and a metope of the Parthenon (North 28). The subject is very popular in Roman art, since Aeneas's descendents will later found the city of Rome. The core of the composition is composed of Aeneas fleeing and carrying Anchises on his back. Ascanius is often shown fleeing with the pair. Other figures sometimes include Aphrodite (Aeneas's mother), a second child, Trojan warriors, hoplites, and Kreoussa (the boy's mother), who perished during the flight.

A black-figure amphora in Würzburg gives a playful air to the scene (fig. 52).[56] Aeneas, holding Anchises on his back before a building (likely part of Troy), gently grasps the upper right arm of Ascanius. The old man turns to look back at the building they leave behind, while the boy's attention is directed at a dog that runs eagerly toward

FIG 52 Aeneas, Anchises, and Ascanius fleeing Troy. Attic black-figure amphora from the Class of Cambridge 49, ca. 520–510 BCE. Martin von Wagner Museum der Universität Würzburg, 218

a man squatting on one of the florals that decorate the area underneath the handle on the right. The man holds out both hands to the dog, almost as if a family with their beloved pet have returned home safely. A dog, but not the squatting man, appears in other examples of the scene. He may be intended to indicate the happy ending of the story when the boy and his father safely arrive at and make their new home in Italy.

Other child heroes who lost parents did not fare as well. Alcmaeon as a boy saw his father, Amphiaraos, go off to war to his death, having been forced to do so because his wife, Alcmaeon's mother, Eriphyle, had accepted a bribe. Adrastus, her father, had given her the necklace of Harmonia on the condition that she compel Amphiaraos to join the expedition against Thebes, even though as a seer Amphiaraos knew he would perish there. He made his children swear to avenge him, so that later Alcmaeon was forced to commit matricide, a heroic deed of an unsavory nature. Once again this was a situation in which a child suffered because of his parents' animosity toward each other and a situation brought on by war.

Alcmaeon and his siblings are often shown as children in scenes of Amphia-raos's departure for Thebes. The fullest and most famous of these is a Late Corinthian column-krater of 560 BCE in Moscow (fig. 53).[57] On the left, in front of the palace, the family bids farewell to the departing hero. Alcmaeon stands closest to his father,

FIG 53 The departure of Amphiaraos. Late
Corinthian column-krater. Formerly Staatliche
Museen zu Berlin, Antikensammlung. From
A. Furtwängler and K. Reichhold, *Griechische
Vasenmalerei*, vol. 3 (Munich, 1932), pl. 142

beseeching him with raised arms not to go, as do all the others except Eriphyle; the tragedy of their loss is emphasized by the chorus of raised limbs. She stands at the back of the group, unveiling herself with the left hand in the gesture known as the *anaka-lypsis* while holding the necklace of Harmonia in the other. Amphiaraos takes a long stride forward as he mounts his chariot and appears to turn his head back to glower at her, a stare that she appears to return; there is, evidently, no love lost between the two. Between them, from left to right, stand Ainippa with Alcmaeon's younger brother, Amphilochus, perched on her shoulder, Damovanassa, Eurydika, and Alcmaeon. The charioteer Baton stands ready in the vehicle before the palace's entranceway, Leontis and Hippotion stand by the chariot, and the seer Halimedes sits on the ground in front of it. The mourning gesture he makes with right hand to head indicates that he has foreseen the family's disastrous future. Animals of various types—hedgehog, lizard, hare, owl, scorpion, snake, lizard, and a bird of prey—fill out the scene. The subject is known also on Attic black-figure, Attic red-figure, Chalcidian, and Etruscan Pontic ware, as well as from an ivory group of about 580 from Delphi.[58] Some of the vase-paintings, along with the depiction of the scene on the chest of Kypselos, known only from a literary description (Pausanias 5.17.7–9), were once thought to derive from a wall-painting, but the differences among the various compositions are now thought to be too great to associate them with one source. Alcmaeon is not always shown or clearly identified: he might be shown seated on Eriphyle's or a nurse's shoulder or receiving the sword of vengeance from his departing father. One Attic red-figure hydria of 440–430 BCE depicts him seated on his mother's lap suckling her exposed breast as Amphiaraos looks on from the left and his sister Demonassa from the right.[59] This is a household scene that takes place sometime before the heroes' fateful departure. The fighting cocks that Eriphyle observes evoke her inner conflict and foreshadow the future problems in the family.

This concludes our survey, and, as we have seen, there are depictions of a great variety of child heroes in Greek art, a fact heretofore not fully recognized and therefore unappreciated. There are also many child heroes of whom there are no known images,

including Linos, Demophon, Kharila, and Hippasus (Plutarch, *Greek Questions* 38).[60] Most of those who are depicted are either major pan-Hellenic heroes, such as Herakles, Achilles, and Perseus, or Athenian heroes, such as Erichthonios and Itys. The latter is due primarily to the large number of Athenian vases with mythological depictions and the Athenians' interest in their own myths and heroes. Vase-paintings are the single most important source for depictions of child heroes, and although Attic and South Italian painted vases constitute the vast majority of these, other fabrics, such as Corinthian and Boeotian, depict child heroes, as do a wide range of other media, including sculpture (in relief and in the round), gems, coins, terracotta figurines and reliefs, bronze shield bands and statuettes, and wall-paintings.

Child heroes are not uncommon in Archaic art, but the largest number with the greatest diversity of subject dates to the Classical period. This is contrary to what one might expect, for art of the Hellenistic period attests to a great interest in the different stages of life, so one might expect that it would be during this period that child heroes were most commonly depicted. One cause for the presence of children in Athenian art of the Classical period may be the increased interest in the family, as reflected in art, literature, and Perikles' citizenship law of 451 BCE, which stipulated that in order for a child to be a citizen, both parents had to be citizens. The more important role that children played in Athenian art and literature was likely also a reaction to population losses in Athens during the Peloponnesian War.[61] Children were seen as the future of the city, compensating for those who had died fighting on behalf of the city or in the plague that twice hit Athens between 430 and 425 BCE. The increased interest in children is also evident in their greater presence as subjects and characters in Athenian tragedy during the last thirty years of the fifth century BCE, which in turn is reflected in the scenes influenced by tragedy on Greek vases, particularly South Italian red-figure vases.

Some of the child heroes depicted display their heroic qualities at an early age, foreshadowing their adult powers, virtues, or weaknesses (Herakles and the snakes). Other young heroes receive an aristocrat's education (Herakles and Achilles). The majority of pictures, however, show the various dangers that children confront: violence at the hands of parents or other relatives (Medea's children, Perseus, and Itys), the death of parents (the Herakleidai),[62] dangerous animals (Opheltes and the snake), war (Astyanax and Ascanius), adults' neglect (Opheltes and Erichthonios), violence by individuals outside the family (Orestes), and exposure (Oedipus, Melanippe's children, and Perseus). Sometimes the outcome for these child heroes is a happy one (Orestes, Perseus, and Ascanius), but in other instances, their end is tragic (Medea's children, Itys, and Astyanax). As in real life, there is much variety as to the nature of the outcome. Various moments in many of the stories can be shown—before, during, and after—and the age of the child hero depicted diverges from that given in the literary sources; the age of the same hero can also vary significantly from representation to representation. Particularly striking is the relative absence of child heroines. (Representations of the Herakleidai are limited exclusively to males, although Herakles had sons and daughters.) Helen is the exception, as scenes of her birth

and abduction as an adolescent by Theseus exist. Male children are what mattered in antiquity, for they allowed the *oikos* to continue, and male babies in general are much more often depicted than female ones.

We started this essay by briefly discussing modern child heroes. As we have seen, some Greek child heroes are remembered for the adversities they have overcome, just as is the case with modern child heroes. Others, however, do not perform the types of deeds that modern children do in order to become heroes, nor are they considered heroes for the same reasons. To the Greeks, a horrific premature death alone was worthy of heroization. Why this was, is impossible to say for certain, but it may well be that the Greeks felt that the spirit of the unfortunate child needed to be propitiated, just as those who had died never having been married received special treatment—a precaution, perhaps, against the spirits behaving badly. The remembrance of these lost child heroes might also have been a form of atonement for an interrupted life, which also made some sense out of a meaningless death. Greek child heroes were revered and remembered, just as their modern counterparts often are, and the pictures of them in Greek art help to remind us of how important they were.[63]

NOTES

1 I use the term "hero" in the broadest sense of the word and do not limit myself to those who were honored by a cult.

2 For the literary and artistic sources for Herakles' childhood, see in general *LIMC* 4 (1988), s.v. Herakles, 827–38 (S. Woodford), and Ganz 1993, 374–79.

3 New York, Metropolitan Museum of Art, 25.28. *ARV²* 1140, 41; *BAdd²* 330; Neils and Oakley 2003, 70, 212 no. 10. For the iconography, see Woodford 1983; *LIMC* 4 (1988), s.v. Herakles, 828–32, nos. 1598–1664 (S. Woodford).

4 See Karwiese 1980 for the image on coins and the various interpretations of it.

5 London, British Museum F 107: *RVAp* I 395, 1, pl. 137,1; Vollkommer 1988, 31, no. 29; 33, fig. 40.

6 Rasmussen 2005.

7 Munich, Antikensammlungen und Glyptothek, 1615A: *ABV* 484,6; *Paralipomena* 221; *BAdd²* 122; *CVA* Munich 9, pls. 29,3; 31; 34,3; *LIMC* 3 (1986), s.v. Cheiron, 246, no. 100, pl. 196 (M. Gisler-Huwiler); *LIMC* 4 (1988), s.v. Herakles, 832, no. 1665, text fig. (S. Woodford).

8 Güstrow, Palace (Collection of the Staatliches Museum Schwerin), inv. 708: *ARV²* 862,30; *Paralipomena* 425; *BAdd²* 298–99; Simon and Hirmer 1976, pls. 180, 181.

9 Munich, Antikensammlungen und Glyptothek, 2646: *ARV²* 437,128 and 1653; *Paralipomena* 375; *BAdd²* 239; Buitron-Oliver 1995, 83 no. 173, pl. 96; *LIMC* 4 (1988), s.v. Herakles, 833, no. 1671, pl. 557 (J. Boardman). For the scene in general, see *LIMC* 4 (1988), s.v. Herakles, 833–34 (J. Boardman), and 810–11 for Herakles and music.

10 Paris, Cabinet des Médailles, 811: *ARV²* 829,45; *BAdd²* 294; *LIMC* 4 (1988), s.v. Herakles, 833, no. 1668, pl. 557 (J. Boardman).

11 Berlin, Staatliche Museen, Antikensammlung, 31573 (A 9): *LIMC* I (1981), s.v. Achilleus, 45, no. 21, pl. 58 (A. Kossatz-Deissmann); Beazley 1986, 9–10, pl. 9,3–4; Morris 1984, 123 no. 3, pl. 12, left.

12 *LIMC* I (1981), s.v. Achilleus, 40–47, 53–54 (A. Kossatz-Deissmann); Shapiro 1994, 99–105.

13 Paris, Cabinet des Médailles, 372: *ARV²* 987,4; *Paralipomena* 437; *BAdd²* 311; Oakley 1997, 115, no. 4, pl. 5.

14 Paris, Musée du Louvre MNC 660: Sinn 1979, 106 MB 44 pl. 21,3; *LIMC* 7 (1994), s.v. Oidipous, 3, no. 4, text fig. (I. Krauskopf).

15 Atlanta, Emory University, Michael C. Carlos Museum, 1994.1: *RVAp* Suppl. 2 162 no. 283d; Taplin 2007, 193–96, no. 68 (with earlier bibliography).

16 Toledo Museum of Art 69.369; Neils and Oakley 2003, 203, 213–14, no. 13. For different readings of his gesture, see Oakley 2005, 193–94.

17 *LIMC* I (1981), s.v. Akrisios, 449–52 (J.-J. Maffre); *LIMC* 3 (1986), s.v. Danae, 331–34, 336–37 (J.-J. Maffre); *LIMC* 7 (1994), s.v. Perseus, 337–38 (L. J. Roccos); *Praktika tes en Athenais Archaiologikes Hetaireias* 149 (1994), pl. 135A.

18 Providence, Rhode Island School of Design, 25.084: *ARV²* 697,18; *BAdd²* 280; *JdI* 100 (1985) 53, fig. 14e; *LIMC* 3 (1986), s.v. Danae, 332, no. 53, pl. 247 (J.-J. Maffre).

19 Syracuse, Museo Archeologico Regionale, 23910: *LIMC* 3 (1986), s.v. Danae, 332, no. 55 (J.-J. Maffre); *AJA* 86 (1982), pl. 13,4; *LIMC* 7 (1994), s.v. Perseus, 337, no. 84, pl. 287 (L. J. Roccos).

20 See most recently for these hats, Pipili 2000.

21 Geneva, Musée d'art et d'histoire, HR 299: Oakley 1997, 156, no. N 10, pl. 163; Oakley 2004, 105–7, fig. 66.

22 Cleveland Museum of Art, 1991.1: Neils and Oakley 2003, 217–18, no. 17, and Taplin 2007, 207 (both with earlier bibliography). For the scene, see also *LIMC* 7 (1994), s.v. Telephos, 866–68, 869–70 (M. Strauss). See now also a Campanian red-figure amphora on the art market: Schauenberg 2008, 46–48, 165, figs. 118a–d. An Apulian bell-krater in Würzburg (H 5697) depicts a parody of the scene, probably inspired by a scene in Aristophanes' *Thesmophoriazousai*: see, most recently, Taplin 2007, 14, fig. 6. Scenes connected with sexual violence involve adolescents, such as Ganymede, Kephalos, and Chrysippos, for which reason I do not consider them here.

23 It is also on electrum coins from Kyzikos, a Melian relief, and possibly in relief sculpture: see Kron 1976, 55–67, 90–92, 249–51; *LIMC* 4 (1988), s.v. Erechtheus, 931–32, nos. 23, 24 (U. Kron).

24 Berlin, Staatliche Museen, Antikensammlung F 2537: *ARV²* 1268,2 and 1689; *BAdd²* 356; Reeder 1995, 258–60 (with earlier bibliography).

25 Kron 1976, 67–72 and 252–53; *LIMC* I (1981), s.v. Aglauros, Herse, Pandrosos, 288–89, nos. 15–19 (U. Kron), and *LIMC* 4 (1988), s.v. Erechtheus, 932–33, nos. 29–31 (U. Kron).

26 Basel, Antikenmuseum und Sammlung Ludwig, BS 409: Oakley 1990a, pl. 84; Reeder 1995, 252–53, no. 66 (with earlier bibliography).

27 London, British Museum, GR 1864.10-7.125 (E 372): *ARV²* 1218,1; *BAdd²* 349; Kron 1976, 72–75 and 254–55; Reeder 1995, 257–58, no. 69 (with earlier bibliography).

28 Most recently Pache 2004, 95–134, for the literary sources and artistic depictions.

29 *LIMC* 2 (1984), s.v. Archemoros, 473–74, nos. 2, 8–10 (W. Pülhorn). A Gnathian calyx-krater possibly by the Darius Painter shows Hypsipyle walking and carrying the corpse of Archemoros in her arms. Both figures are labeled. *QNAC* 37 (2008), 125–26, fig. 10.

30 Bari, Museo Archeologico Nazionale, 3581: Trendall 1987, 144, no. 242, pl. 93a (with earlier references); Pache 2004, 118, fig. 20.

31 Naples, Museo Archeologico Nazionale, 81394 (3255): *RVAp* 496, no. 42; Pache 2004, 121, fig. 22; Taplin 2007, 212, fig. 79. See also Carpenter forthcoming.

32 Taplin 2007, 211–14.

33 See most recently Oakley 2004, 76–87, and Brigger and Giovanni 2004. For the krater, see Schauenburg 2003, 33–36, figs. 87 and III–IV; for tomb painting,

Bennett and Paul 2002, 134–37, and Andreae and Schepkowski 2007, 88–101, 146–47.

34 Paris, Musée du Louvre, K 300: *LCS* 338, no. 786, pl. 131,1; Trendall and Webster 1971, 97, no. III,3,36; Pache 2004, 32–33, fig. 7.

35 See above, note 22; Pache 2004, 27–28, fig. 2; Taplin 2007, 122–23, no. 35.

36 Pache 2004, 28.

37 *LIMC* 7 (1994), s.v. Prokne and Philomela, 527–29 (E. Touloupa); see also recently March 2000, 123–34, who questions the connection of the vases with the myth; Ajootian 2005, 225–37.

38 Athens, National Museum, 13410: *LIMC* 7 (1994), s.v. Prokne and Philomela, 527, no. 1, pl. 418 (E. Touloupa); March 2000, 126, fig. 7.3.

39 Basel, Cahn Collection, HC 599: *LIMC* 7 (1994), s.v. Prokne and Philomela, no. 3, pl. 419 (E. Touloupa); March 2000, 132, fig. 7.5; Ajootian 2005, 229, fig. 18.

40 Munich, Antikensammlungen und Glyptothek, 2638: *ARV²* 456,1 and 1654; *BAdd²* 243; Schefold and Jung 1988, 43, figs. 32A, 32B; March 2000, 124, fig. 7.1.

41 See most recently Pache 2004, 49–57.

42 Madrid, Museo Arqueológico Nacional, 11094 (L 369): Trendall 1987, 84, no. 127, pls. 46 and 47; Pache 2004, 57–58, fig. 15; Taplin 2007, 143–45, no. 45.

43 Pache 2004, 8, 28, 42, 57–58, 61, 65, 118, 134.

44 Oliver Taplin astutely queries whether Herakles may have thought that he was sacking a city: Taplin 2007, 145.

45 *LIMC* 7 (1997), s.v. Megara, I 828–29 (S. Woodford); Pache 2004, 59–61.

46 Naples, Museo Nazionale, 81666 (3222): *RVAp* 430–31, no. 82, pl. 160,2; Pache 2004, 60, fig. 16.

47 Oxford, Ashmolean Museum, 1890.26 (322): *ARV²* 627,1; *BAdd²* 271; Woodford 2003, 156, fig. 119.

48 Policoro, Museo Nazionale della Siritide, 35302: *LCS* 55, no. 283, pl. 25,5–6; Trendall and Webster 1971, 86, no. III,3,20; Taplin 2007, 126–27, no. 37.

49 Berlin, Staatliche Museen, Antikensammlung, 1969.6: *LCS* Suppl. 2, 158, no. 291a; *LCS* Suppl. 3, 20, no. 291a; Trendall and Webster 1971, 87, no. III,3,21; Taplin 2007, 128–30, no. 38.

50 Perikles in his funerary oration (Thucydides 2.46) says the state will take care of the children of the Athenians who died fighting on behalf of Athens.

51 Some of the depictions of the death of Troilos are equally moving. See, e.g., *LIMC* 1 (1981), s.v. Achilleus, 87, no. 360, pl. 93, and 88–89, no. 370, text fig. (A. Kossatz-Deissmann); for the subject, see recently Hedreen 2004, 120–81.

52 Hedreen 2004, 64–68.

53 Paris, Musée du Louvre, F222: *ABV* 316,4; *Paralipomena* 137,7 bis and 138; *BAdd²* 85; *LIMC* 2 (1984), s.v. Astyanax I, 932, no. 12, pl. 683 (O. Touchefeu).

54 E.g., *LIMC* 2 (1984), s.v. Astyanax, 931, nos. 4 and 5, pl. 682, and 932, no. 19, pl. 684 (O. Touchefeu).

55 *LIMC* 2 (1984), s.v. Astyanax, 934, no. 27, pl. 686, and 935, no. 34, text fig. (O. Touchefeu). A late Attic Geometric shard from the Agora has also often been thought to depict the murder: *LIMC* 2 (1984), s.v. Astyanax, 933–34, no. 26, fig., pl. 685 (O. Touchefeu).

56 Würzburg, Martin von Wagner Museum, 218: *ABV* 316,2; *BAdd²* 85; *LIMC* 2 (1984), s.v. Aineias, 387, no. 69, pl. 301 (F. Canciani); Sinn and Wehgartner 2001, 64–65, no. 25.

57 Formerly Berlin, Staatliche Museen, Antikensammlung, F 1655: FR III pl. 121; *LIMC* 1 (1981), s.v. Amphiaraos, 694, no. 7, pl. 555 (I. Krauskopf); Amyx 1988, 263, no. 1571, and 572, no. 66.

58 *LIMC* 1 (1981), s.v. Amphiaraos, 694–97 (I. Krauskopf); Oakley 1990b; Schefold 1993, 280–85; Papadopoulou-Kanellopoulou 2001.

59 Berlin, Staatliche Museen, Antikensammlung, F 2395: *LIMC* 1 (1981), s.v. Amphiaraos, 697, no. 27, pl. 559 (I. Krauskopf); *CVA* Berlin 9, pls. 26 and 58,2.

60 For Linos and Demophon, see Pache 2004, 66–83; she also discusses the few depictions of the child hero Melikertes-Palaimon (135–80), which I do not here, as they are few and fragmentary.

61 Oakley forthcoming.

62 Arkas, the eponymous hero of the Arcadians, was orphaned when his mother, Kallisto, was changed into a bear. The child was then rescued by Hermes and entrusted to the care of his mother, Maia. The baby Arkas is shown with Kallisto on several Apulian vases and silver coins from Arcadia, and is depicted being transported by Hermes on silver staters from Pheneos. All the depictions date near to the founding of the Arcadian League in 370 BCE. See *LIMC* 2 (1984), s.v. Arkas, 609–10 (A. D. Trendall), and *LIMC* 5 (1990), s.v. Kallisto, 940–44 (I. McPhee). See now also an Attic red-figure oinochoe by the Washing Painter with Hermes peering at a bundled baby, probably Arkas, nestled in a rocky landscape: Lezzi-Hafter 2007.

63 Pache 2004, see in particular 1–8 and 181–83.

THE HERO BEYOND HIMSELF

HEROIC DEATH IN ANCIENT GREEK POETRY AND ART

Corinne Ondine Pache

In all those stories the hero
is beyond himself into the next
thing, be it those labors
of Hercules, or Aeneas going into death.

I thought the instant of the one humanness
in Virgil's plan of it
was that it was of course human enough to die,
yet to come back, as he said, *hoc opus, hic labor est.*

That was the Cumaean Sibyl speaking.
This is Robert Creeley, and Virgil
is dead now two thousand years, yet Hercules
and the Aeneid, yet all that industrious wis-

dom lives in the way the mountains
and the desert are waiting
for the heroes, and death also
can still propose the old labors.
—Robert Creeley, "Heroes"

HEROISM AND DEATH

The modern mind likes its heroism served with death. "They died heroes" begin news reports of death in battles and disasters, man-made or natural. Altruism, self-sacrifice, and disregard for danger define the modern hero, both in life and in death. Sometimes heroes are defined by the fact of their survival: war heroes return home after enduring the trauma of battle, captivity, or torture. Regardless of individual circumstances, to be a modern hero entails joining a community of individuals defined by the same essential qualities of selflessness and courage: to be a hero is to be willing to sacrifice oneself and risk one's life for a greater cause, and to be remembered as much for how one faced death as for what one accomplished in life.

Heroism and death are also closely linked in ancient Greece, but for a rather different reason. In contrast to their modern counterparts, Greek heroes are not defined by who they were or what they did during their lifetimes (indeed some heroes, as we will see below, are remarkable more for their failings than their virtues). In ancient Greece, mortals become heroes not because of selflessness or kindness, or as the culmination of a life well lived, but because, having experienced mortality, they are made to transcend it: to become a *hērōs*, in the Greek context, is to continue to exist beyond death.

Starting in the Archaic period, some individuals were posthumously honored as objects of worship and recipients of animal sacrifice. Traditionally, the connection between worshiper and hero was established through ritual, and the relationship between hero and worshiper was conceived as reciprocal, mediated by cult. The

reciprocal bond between the living and the dead was based on offerings and sacrifices: the hero was conceived as a "deceased person," in Walter Burkert's formulation, "who exerts from his grave a power for good or evil and who demands appropriate honour."[1] Hero cult in the Archaic and Classical periods was thus a highly ritualized form of worshiping the dead, conceived as powerful beings who could, for good or ill, exert their influence in the world.

The ritualized aspect of the relationship between the living and the dead in heroic cult was central to the Greeks' understanding of death and heroism. The classicist Jean-Pierre Vernant once described epic poetry not simply as a literary genre but as one of the institutions, alongside the funeral, developed by the Greeks "to give an answer to the problem of death in order to acculturate death and integrate it into social thought and life."[2] This definition extends to the institution of hero cult, which responds to the problem of death and extinction by keeping the memory of specific mortals alive through art and ritual. Epic poetry and cult, however, differ fundamentally in that epic poetry strives for universal significance, while ritual tends to be localized and significant to a restricted community. Poets sought to present narratives that were pan-Hellenic, whose interest carried beyond the inhabitants of a local area. We know that Homeric heroes such as Odysseus and Achilles were the objects of localized cults: votive gifts were dedicated to Odysseus in a cave sacred to the Nymphs on the island of Ithaca, while Achilles was venerated at his burial mound near Troy as well as in other locations throughout the Greek world.[3] Because of the local nature of most hero cults, which centered on the hero's tomb, allusions to ritual practice tend to be implicit rather than explicit in early Greek poetry. While Homer is silent on the local cults honoring Achilles and Odysseus, Homeric heroes acquired a pan-Hellenic importance through poetry. This explains why allusions to hero cult per se are scarce in Greek poetry, although heroes themselves, their deeds, lives, and deaths, are central to Homeric epic and its successors.[4]

For all the differences among ancient heroes and heroines—their deeds and status, their choices, their manner of dying—all are alike in transcending death by becoming immortalized.[5] "[Death] also can still propose the old labors," writes the poet Robert Creeley: everybody dies, but what is it about the deaths of heroes that allows them to continue to intercede in the affairs of the living, and thus to transcend their own deaths and become the objects of cult and art? The answer must take into account the fact that the ancient Greeks made no distinction between the realm of the divine and the realm of the beautiful, the world of art and the world of the gods. The ancient Greeks had no word for "religion"; they conceived of religious activity in terms of ritual (*drō-mena*, "things done") and words (*legomena*, "things said"), and the boundaries between poetry and cult were fluid and indistinct. The historian Herodotos recounts that the poets Hesiod and Homer "taught the Greeks the births of the gods, and gave the gods their names, and determined their spheres and functions, and described their outward forms" (*Histories* 2.53.2). Myths and rituals in honor of heroes thus not only fulfilled important religious functions; narratives of heroes' deaths also provided a source of aesthetic pleasure derived from the literary and visual representations to which they

gave rise. Death, poetry, and heroism were thus inextricably intertwined in the ancient Greek imagination, and becoming a hero or a heroine meant to remain "alive" in cultural memory. Artistic representations and cultic gestures—vase-paintings and statues, poetry and inscriptions, sacrifice and libations—sustained the memory of the hero. As a consequence, heroes enjoyed an afterlife inaccessible to other mortals. The difference hinged on personality and individuality. When Odysseus travels to the land of the dead to question the departed seer Teiresias, most of the "shades" he encounters there are just that: mere shadows of their former selves, without self-consciousness and without memories. Yet when he encounters the great heroes of the Trojan War, Agamemnon, Achilles, and Ajax, he finds them with their personalities, and their memories, intact: Agamemnon is still an imperious leader, Achilles an impetuous warrior, and Ajax remains angry at Odysseus for their quarrel over which of the two would obtain the weapons of Achilles, a quarrel that ends in Ajax's suicide. Poets describe heroes enjoying the afterlife in the paradisial Elysian Fields or on the Isles of the Blessed.[6] The fact of mortality thus links heroes and other mortals, yet heroic death by definition sets heroes apart. The difference between heroes and ordinary, nonheroic mortals is emphasized by, and is to some extent the consequence of, the moment and manner of the hero's death. This emphasis can be seen in the fascination among poets, painters, and sculptors with the moment of the hero's transition from the visible world into the realm of cultural memory.

HEROIC DEATH IN EPIC: ACHILLES AND ODYSSEUS

Heroic death comes in all forms, including battle, murder, suicide, sickness, accident, poison, fire, and old age. A particularly fruitful approach to defining the concept of the hero in antiquity is to take up particular cases. There is no better place to start than with one of the most ancient and greatest of all heroes, Achilles, hero of the *Iliad* and "the best of the Achaeans." The *Iliad* tells of the hero's wrath after the leader of the Greek army, Agamemnon, takes the captive Briseis from Achilles. It covers a period of some forty days of the ten-year war, during which Achilles withdraws from the fighting to spite Agamemnon but eventually returns to the battle to avenge the death of his closest friend, Patroklos, killed by the Trojan prince Hektor. In his grief and rage, Achilles kills Hektor and—shockingly, for his age as well as ours—mutilates his body. The *Iliad* ends with a truce between Achilles and Hektor's father, Priam, in which Achilles movingly agrees to return Hektor's body to his father. The last lines of the poem focus on the funeral in honor of Patroklos's killer, Hektor, "breaker of horses."

The conclusion of the *Iliad* leaves both the sack of Troy and the death of Achilles untold. Yet the death of Achilles is, in a very real sense, the subject of the *Iliad:* the poet, the audience, and the characters in the poem all know that Achilles is "short-lived" and that his death is imminent. Achilles' death is the poem's absent center, and it is implicit in virtually every scene depicting the hero and present even in a number of scenes that pointedly do not represent the fair-haired, swift-footed Achilles. Far from recoiling from the carnage of war, Homer seems almost to revel in it; his is a poetry of

violence. His descriptions of suffering and death are unparalleled in their vivid, almost exultant imagery, yet he is always careful to emphasize the youth and beauty of the bodies he asks us to imagine being pierced by arrows, swords, or spears. Using one of those puns that work better in their language of origin than in translation, Vernant contrasts the "beautiful death" ("la belle mort") and the "beautiful dead" ("le beau mort").[7] The *Iliad* provides numerous depictions of the "beautiful death" of the young warrior at his peak, whose lifeless body becomes the "beautiful dead," an object of spectacle and admiration:

> Gorgythion the blameless, hit in the chest by an arrow;
> Gorgythion whose mother was lovely Kastianeira,
> Priam's bride from Aisyme, with the form of a goddess.
> He bent drooping his head to one side, as a garden poppy
> bends beneath the weight of its yield and the rains of springtime;
> so his head bent slack to one side beneath the helm's weight.
>
> —Iliad *8.303–8, trans. Lattimore*

Gorgythion and other young warriors cut down in the prime of their youth are described in imagery that evokes vegetation and bloom. This comparison, which after Homer becomes a mandatory stopping point for war poets such as Virgil, pointedly evokes the absent center of the poem.[8] Here is the goddess Thetis's account of the childhood of her son, Achilles:

> Ah me, my sorrow, the bitterness in this best of child-bearing,
> since I gave birth to a son who was without fault and powerful,
> conspicuous among heroes; and he shot up like a young tree,
> and I nurtured him, like a tree grown in the pride of the orchard.
>
> —Iliad *18.54–57, trans. Lattimore*

Even the "pride of the orchard," we infer along with Thetis, must fall. The implication is further emphasized by its context: Thetis speaks these words at the moment her son learns of the death of his companion Patroklos and makes his fateful vow to avenge his friend, a decision that both Achilles and his mother know will lead to his eventual death. Earlier in the poem, in book 9, when the Greeks, pressed by the Trojans, go to Achilles' tent to beg the hero to return to the battle, Achilles refuses and reveals the prophecy that causes his mother so much sorrow:

> For my mother Thetis the goddess of the silver feet tells me
> that I carry two sorts of destiny toward the day of my death. Either,
> if I stay here and fight beside the city of the Trojans,
> my return home is gone, but my glory [*kleos*] shall be everlasting;
> but if I return home to the beloved land of my fathers,
> the excellence of my glory [*kleos*] is gone, but there will be a long life
> left for me, and my end in death will not come to me quickly.
>
> —Iliad *9.410–16, trans. Lattimore*

The Greek term *kleos,* often translated as "glory," has no exact equivalent in English. *Kleos* means both "glory, fame, that which is heard" and "a poem or song that conveys glory, fame, that which is heard." *Kleos,* in other words, is a way of immortalizing heroes through epic poetry.[9] At this point in the narrative, Achilles sees the choice as between two sorts of destiny, both of which end, of course, in death. Either he can die young and gain everlasting *kleos* in the form of epic glory, or he can go home and enjoy a long life. Achilles is impelled to return to battle by his grief at Patroklos's death and by his desire for revenge, but as both Thetis and he himself know, his decision entails an earlier death and the compensation of the everlasting glory conferred by epic song.

I have referred to the death of Achilles as the absent center of the *Iliad.* Every member of the poem's original audiences would have been as aware of Achilles' eventual death as we are now of the eventual fate of John F. Kennedy. Yet within the *Iliad* proper, there seems to be a taboo against directly describing Achilles' death; instead, the death of the hero is evoked, as it were, laterally—through the death of others (including those that he himself kills, foremost among them Hektor). But the best example of the displaced presence of Achilles' death is to be found in the poem's representation of the death of Patroklos, which comes about as a result of his resemblance to Achilles. When Achilles allows Patroklos to go into battle wearing his armor, he sets off the chain of events that will lead to his own death. Paradoxically, Patroklos dies from breaking the taboo against representing the death of Achilles and in so doing causes that death.

The death of Patroklos occurs in three distinct stages: first, the god Apollo, "shrouded in a deep mist," stands behind the hero and strikes his back and his shoulders "with a flat stroke of the hand so that his eyes spun." This direct intervention of a god in a mortal's death is unprecedented in the *Iliad* and foreshadows the role played by the god in Achilles' death as we know of it from other traditions, such as the *Aithiopis.*[10] Apollo's blow causes Patroklos to lose both corselet and helmet:

> Apollo now struck away from his head the helmet
> four-horned and hollow-eyed, and under the feet of the horses
> it rolled clattering, and the plumes above it were defiled
> by blood and dust. Before this time it had not been permitted
> to defile in the dust this great helmet crested in horse-hair;
> rather it guarded the head and the gracious brow of a godlike
> man, Achilleus; but now Zeus gave it over to Hektor
> to wear on his head, Hektor whose own death was close to him.
> —Iliad *16.793–800, trans. Lattimore*

At the moment when Patroklos is shaken by Apollo's blow, the poet evokes Achilles, whose armor Patroklos is wearing when he dies, another ominous sign. The helmet of Achilles is defiled, for the first time, by dust and blood.

In the second stage, a Trojan ally, Euphorbos, stands behind Patroklos and strikes him in the back, now unprotected because of Apollo's intervention, with his spear.

Euphorbos, however, is too cowardly to fight Patroklos, and snatching his spear from the wounded man's body, he runs away, hiding in the crowd of soldiers. When Hektor arrives on the scene, he thus is the third character to strike Patroklos, but he gives the fatal blow, and Patroklos falls "thunderously, to the horror of all the Achaean people." With his last breath, he prophesizes that Hektor will encounter his own death shortly at the hands of Achilles:

> and the soul fluttering free of his limbs went down into Death's house
> mourning her destiny, leaving youth and manhood behind her.
>
> —Iliad *16.856–57, trans. Lattimore*

As several scholars have observed, the death of Patroklos is depicted as the killing of an animal in sacrificial ritual: the victim is first stunned by a blow, then struck a second time, and finally killed and dedicated to a god. Patroklos's funeral in book 23 of the *Iliad* also evokes sacrificial ritual. Here we see Achilles wrap the body of his companion in the fat of animals he has just sacrificed and arranged on the funeral pyre. The fat around Patroklos's body may have a practical purpose in helping the fire to consume it, but it also strikingly evokes the archetypal animal sacrifice described in Hesiod's *Theogony,* in which the Titan Prometheus convinces Zeus to choose the portion of sacrifice that consists of bones wrapped in layers of fat, while mortals are allotted the flesh of the sacrificed animal. Patroklos's body is thus cremated on a funeral pyre in the same way that animal sacrifices are burnt as offerings to gods. That the Greeks

FIG 54 The death of Achilles. Attic red-figure pelike attributed to the Niobid Painter, ca. 460 BCE. Kunstsammlungen, Ruhr-Universität Bochum, S 1060

themselves read the tripartite death of Patroklos as evocative of an animal sacrifice is also attested by a vase-painting depicting two warriors fighting over a dead ram labeled Patroklos.[11] Structurally, Patroklos's death also prefigures that of Achilles: Achilles, like his friend, is killed through Apollo's intervention.

Just as Homer is reluctant to recount the death of Achilles directly, vase-painters seem reluctant to depict it. One exception is a fifth-century BCE pelike attributed to the Niobid Painter depicting Paris, on the left, aiming his arrow at Achilles, on the right (fig. 54). In the center stands Apollo, who directs one of the arrows toward Achilles' heel, according to some traditions the only vulnerable part of the hero's body. (Homer, however, is completely silent on this topic.) There is no physical contact in this scene between god and mortal, yet Apollo's action is nonetheless depicted as essential to the result. Moreover, Achilles is killed by Paris's arrows, just as Euphorbos's wounding of Patroklos is part of a sequence of events that ends in the death of Achilles' comrade. The killers of Patroklos and Achilles are depicted as essentially deluded: Hektor and Paris kill their antagonists, but, in both cases, they are able to do so—though they may not realize it—only because of a god's direct intervention.

The death of Patroklos is also causally linked to the death of Achilles: it is because of the death of his comrade that Achilles goes back into battle, knowing that this action will entail his own death. The poet emphasizes this connection by portraying Achilles as if he were already a dead man when he learns of his friend's death:

> In both hands he caught up the grimy dust, and poured it
> over his head and face, and fouled his handsome countenance,
> and the black ashes were scattered over his immortal tunic.
> And he himself, mightily in his might, in the dust lay
> at length, and took and tore at his hair with his hands, and defiled it.
> —Iliad 18.23–27, trans. Lattimore

Achilles reacts with a series of gestures typical of mourning: strewing dust over his head and tearing his hair. But when the poet describes the hero lying on the ground as *megas megalōsti*, "mightily in his might," he uses language that conventionally describes the body of a dead warrior. Earlier, indeed, the phrase arises in just such a context, recounting the death of Patroklos's last victim: Hektor's charioteer, Kebriones (*Iliad* 16.775–76). Even more important, Agamemnon uses the same words in a passage in the *Odyssey* to describe Achilles' death. The scene takes place in the underworld, where Agamemnon addresses Achilles and describes how he and the other Achaeans fought over the hero's dead body at Troy: "and you in the turning dust lay / mightily in your might, your horsemanship all forgotten" (*Odyssey* 24.39–40, trans. Lattimore). This sense of the body of Achilles being, as it were, not alive but rather not-as-yet dead, is reinforced by the description in the same scene in the *Iliad* of Thetis and the Nereids. Having heard, from the depths of the sea, Achilles crying, Thetis leads the Nereids in a dirge that resembles nothing so much as a lament for her son, although he is not of course yet dead. Driven by her proleptic grief, Thetis eventually leaves her sea cave and, accompanied by the other Nereids, goes ashore

to her son. In another moment that unmistakably evokes a funeral, Thetis stands by
the body of her son, and "[cries] out shrill and aloud, and [takes] her son's head in
her arms" (*Iliad* 18.70–71). These Iliadic scenes also echo the description of Achilles'
funeral in the underworld scene in the last book of the *Odyssey*, an episode depicted
on a sixth-century BCE hydria (fig. 55). The image on the vase, in which Thetis, sur-
rounded by the Nereids, cradles her son's head, resembles the scene as described by
Agamemnon in the underworld:

> your mother, hearing the news, came out of the sea, with immortal
> sea girls beside her. Immortal crying arose and spread over
> the great sea, and trembling seized hold of all the Achaians.
>
> . . .
>
> . . . Around you stood the daughters of the Sea's Ancient,
> mourning piteously, with immortal clothing upon them.
> And all the nine Muses in sweet antiphonal singing
> mourned you, nor would you then have seen any one of the Argives
> not in tears, so much did the singing Muse stir them.
> For ten and seven days, alike in the day and the night time,
> we wailed for you, both mortal people and the immortal.
>
> —Odyssey 24.47–49 and 58–64, trans. Lattimore

Both the *Iliad* and the *Odyssey* circle around the unrepresented event of Achilles'
death: it is always about to happen or already past. Although the *Odyssey* lovingly
portrays the funeral rites for Achilles, here too the narrative stops short of depicting
the moment of his death: Agamemnon describes the dead body of Achilles, "mightily
in his might," but not the circumstances of the hero's death. In many ways, the *Iliad*
can be understood as an extended mourning song in honor of the dead hero, echoing
the themes we find in Thetis's lament for her living, yet doomed, son:

Hear me, Nereids, my sisters; so you may all know

well all the sorrows that are in my heart, when you hear of them from me.

Ah me, my sorrow, the bitterness in this best of child-bearing,

since I gave birth to a son who was without fault and powerful,

conspicuous among heroes; and he shot up like a young tree,

and I nurtured him, like a tree grown in the pride of the orchard.

I sent him away with the curved ships into the land of Ilion

to fight with the Trojans; but I shall never again receive him

won home again to his country and into the house of Peleus.

—Iliad *18.52–60, trans. Lattimore*

The *Odyssey*, by contrast, playfully redefines heroism in a way that makes an unheroic death a precondition of its hero achieving epic glory: to achieve *kleos,* Odysseus must return home, live a long life, and die in his own bed.[12] Odysseus is an atypical hero in many ways, but particularly so in his unheroic death. While neither narrative depicts its hero's death, both the *Iliad* and the *Odyssey* emphasize the heroes' foreknowledge of how their lives will end. Achilles learns of his two destinies from the prophecy given to him by Thetis; in the *Odyssey*, the dead seer Teiresias prophesies in the underworld that death will come to Odysseus in his old age:

. . . Death will come to you from the sea, in

some altogether unwarlike way, and it will end you

in the ebbing time of a sleek old age. Your people

about you will be prosperous. All this is true that I tell you.

—Odyssey *11.134–37, trans. Lattimore*

The death of Odysseus lies well beyond the confines of the narrative that tells the story of his homecoming from Troy to Ithaca, but Teiresias's prophecy, which Odysseus repeats in the first person to Penelope after their reunion (23.282), points to an unusual heroic death. It is not by chance that so many of the passages we have been examining evoke the underworld scene in the *Odyssey*. Death is of the essence. Just as the *Odyssey* radically redefines epic glory and heroism, it also redefines the hero's death. While the mystery of precisely how Odysseus's death comes "from the sea" is never fully explained, Odysseus is the exceptional hero in that his death is perfectly ordinary and in many ways enviable: having lived a long life, he dies gently, surrounded by friends and family.[13]

Neither the *Iliad* nor the *Odyssey* depicts the death of its respective hero, yet both Achilles and Odysseus know a great deal about their own deaths. Achilles is given a prophecy by his mother, while Odysseus learns of his own death through Teiresias. In both cases, death can also be understood as the direct result of a god's antagonism toward the hero, a common pattern in heroic death. Apollo sets Achilles' death into motion, while the death that comes from the sea for Odysseus can be read as a consequence of Poseidon's enmity toward Odysseus, caused by the blinding of his son, Polyphemos.

THE MYSTERY OF HEROIC DEATH: OEDIPUS

The mortality of heroes is often presented as a mystery, in the sense either of being beyond normal understanding or, more literally, requiring initiation into the mysteries of the hero in order to be understood. Heroes, as we have seen in the cases of Achilles and Odysseus, are often given signs (*sēmata*) warning them of their impending deaths, and the living who survive them are similarly given clear indications that they have witnessed an event of extraordinary and abiding significance. Oedipus, in our post-Freudian age, does not strike the modern reader as particularly heroic. Yet he was a hero to the Greeks.[14] Sophocles' *Oedipus at Colonus*, written shortly before the playwright's own death, focuses on the mystery of Oedipus's death. Unlike Achilles and Odysseus, Oedipus is known not for his skills in battle or his cunning; his fame is due to the (unwitting) crime of killing his father and marrying his mother and to his mysterious death. Sophocles' earlier play *Oedipus the King* tells the story of how Oedipus discovers the meaning of his past actions. While attempting to evade Apollo's prophecy that he will kill his father and marry his mother by leaving those he believes to be his parents behind, Oedipus commits the very wrongs the prophecy has foretold: the stranger he kills in self-defense is his father, and Jokasta, the Theban queen whom he marries as a reward for solving the Sphinx's riddle, is his mother. Yet the play itself, which is more often alluded to than read, focuses not on the events themselves but on Oedipus's discovery of their significance. Intent on finding the cause of the plague suffered by the people of the land he rules, Oedipus discovers that he himself is the source of the pollution. By the end of the play, his mother/wife has committed suicide, and Oedipus himself, the solver of riddles and truth seeker, has understood the danger that attends an excess of knowledge and plucks his eyes from their sockets with the golden brooch that held the dead Jokasta's garment together. Although Oedipus's crimes are committed unconsciously, his actions are nevertheless the source of pollution and horror, both personal and political. Nonetheless Oedipus becomes a hero and the object of worship after his death.

Oedipus at Colonus focuses on the death of Oedipus. Sophocles' play is unique in representing Oedipus as already a powerful figure of cult during his lifetime. In contrast to the heroes of Homeric epic, Oedipus is a mortal who already exerts supernatural powers before his death. Yet, tragedy is as reluctant as epic to depict the actual moment of death. In *Oedipus at Colonus*, we find Oedipus, sometime after the events depicted in *Oedipus the King*, being led by his daughter Antigone as they arrive at a sacred shrine dedicated to the Furies—the goddesses of vengeance, nicknamed the Eumenides, literally the "kind ones"—near Athens. Oedipus remembers a prophecy of Apollo that he will die in a place sacred to the Eumenides and become a blessing to the land that receives his body for burial. Nevertheless, the inhabitants of Colonus are understandably troubled to find the elderly man there and even more so when they discover his identity: to them, Oedipus is a murderer, a cursed figure to be shunned or driven away. Oedipus defends his innocence: he is morally innocent, he tells them, since he did not know the identity of his parents and acted in self-defense against his father. Moreover, he adds, he has come as a holy (*hieros*) and pious man, who will

bring great benefit to Colonus; Oedipus convinces the Colonians to allow him to stay and to summon the king of Athens, Theseus. Theseus recognizes the benefits brought by Oedipus, as does the new king of Thebes, Kreon, who subsequently attempts to take Oedipus back to Thebes by force. Whichever city gets the body of Oedipus after his death, the kings both recognize, will be protected by his spirit. In the event, Oedipus, with Theseus's help, remains at Colonus.

Toward the end of the play, Oedipus hears thunder and recognizes it as a sign of his impending death. Oedipus tells Theseus he will initiate him into mysteries (*exagista*, "holy things," 1526) that he alone will know until the approach of his own death, at which time Theseus must initiate his son, as his son will in turn initiate his own son.[15] Oedipus, his daughters, and Theseus walk offstage, and the chorus of old men from Colonus sings a hymn to Hades, the god of the underworld. The play continues with a messenger's account of the death of Oedipus, although he did not witness it directly: according to the messenger, a mysterious voice called to him, "Oedipus, why do you delay us from going?" and Oedipus asked his daughters and the messenger to leave. When the messenger looked back a moment later, all he saw was Theseus:

> . . . and from afar we saw
> that man no longer present anywhere, but just
> our lord, and he was holding up a hand before
> his face to shade his eyes, as if some dread and fearful
> thing had been revealed, unbearable to see.
> But then, a little later and without a word,
> we saw him bowing down in worship to the earth
> and at the same time to Olympus of the gods.
> But by what doom he perished, there's no mortal man
> can tell, except Theseus. For no fiery bolt
> of thunder from the god destroyed him, nor a tempest
> stirred up from the sea at just that moment; no,
> the gods sent him some escort, or the underworld,
> the earth's unlit foundation, being well-disposed
> to him, gaped open. For the man was not sent off
> with weeping, or distressed by sickness, but in some
> amazing way if ever any mortal was.
> —*Sophocles,* Oedipus at Colonus *1648–64, trans. Blondell*

The death of Oedipus is presented as a mystery, something full of wonder (literally "to be wondered at," *thaumastos,* 1665), and only the man who is initiated—in this case, Theseus—can witness it. The messenger does not see what happens, but he depicts the disappearance of Oedipus in terms of its effects on Theseus: something at once dreadful and miraculous, which causes Theseus to cover his eyes and immediately offer a prayer to both the gods below the earth and the Olympian gods above. While the messenger is unable to describe Oedipus's death in detail, a reluctance,

as we have seen, that is typical of literary sources, he offers a taxonomy of typical wondrous heroic deaths: thunderbolts, storms that snatch people away, and mystical disappearances.

DEATH IN SACRED SPACE: OPHELTES/ARCHEMOROS AND THE SERPENT

While Oedipus is aware of his own status as hero, and indeed seems already to exercise heroic powers in life, many heroes do not have foreknowledge of their deaths. Let me turn to another death that happens in sacred space but one that is depicted as purely accidental. One of the foundation myths for the Nemean Games, a pan-Hellenic festival on the model of the athletic competitions held every four years at Olympia, tells the story of the death of the infant Opheltes, who enters sacred space with fatal consequences: left on the ground by his nurse, Hypsipyle, so that she can find water for the Seven against Thebes, who happen to pass by Nemea, the baby is attacked by the serpent guarding the spot. An Apulian volute-krater depicts the moment immediately following the discovery of Opheltes' dead body (fig. 56). The child lies on the ground, while Hypsipyle runs toward him from the left. A female figure, perhaps the eponymous nymph of Nemea, stands on the right. On the upper register, the serpent coils around a tree in the center, as two warriors attack it from the right side, one with a rock, the other with a javelin that is about to pierce the serpent's throat. On the left side, another warrior approaches holding a short sword. A fourth man, perhaps Amphiaraos, stands on the upper left, looking toward the center. The scene depicted on the amphora encapsulates both the story of the death of Opheltes and his future as an object of cult. The story was also told in the epinician poetry of Bacchylides, who described how the first Nemean Games came to be held after the child's death:

> There, the demigods with the red shields,
> the choicest of the Argives, were the first
> to compete in the athletic games in honor of Archemoros,
> who was killed while sleeping by a monstrous yellow-eyed serpent,
> a sign of the ruin to come.
> —*Bacchylides 9.10–14, author's translation*

Bacchylides glosses the child's posthumous name, Archemoros, "the beginning of doom," as referring to the fate of the Seven against Thebes: Amphiaraos will later experience his own form of heroic death when he and his horses are swallowed by the earth after Zeus strikes the ground with this thunderbolt (his companions, for their part, all die in battle, a story dramatized in Aeschylus's *Seven against Thebes*).[16] But Archemoros also alludes to the child's own death and his new status as a hero. The cultic status of the child is evoked on the Hermitage amphora by the triangular perimeter that surrounds the space guarded by the snake, denoting not only the sacred space guarded by the serpent and transgressed by the child, but also the sacred space of hero shrines such as the sacred perimeter for Pelops at Olympia, which Pausanias describes

FIG 56 The death of Opheltes. Apulian red-figure volute-krater attributed to the Lykourgos Painter, ca. 350 BCE. Saint Petersburg, State Hermitage Museum, Б1714 (St. 523)

as a triangular perimeter. While Opheltes' death, like that of Oedipus, takes place in sacred space, Opheltes does not disappear as Oedipus does. The Seven institute the Nemean Games as funeral games in his honor, and the body of the child hero is thus central to his cult at Nemea.[17]

THE DISAPPEARING ATHLETE

Whether the hero's body is present or absent, heroic death is always understood as a transformation. Let us turn to a tale of a heroic disappearance, which we find in Pausanias's *Periēgēsis*, a second-century CE guide to Greece. In an aside to a passage describing the votive offerings made by victors at Olympia, Pausanias tells the story of a certain Kleomedes, from the island of Astypalaia, who killed his opponent in the boxing competition at Olympia in 484 BCE. Kleomedes was denied his victory because of the accident. Driven out of his mind by the loss, the athlete went home to Astypalaia and attacked a school in which sixty boys were studying. Inside the school, Kleomedes overturned a pillar that held the roof, and the building caved in, killing all the boys. Kleomedes escaped and, when the people of the city pursued and attempted to stone him, took refuge in a sanctuary of Athena, where he hid inside a chest, pulling the lid down on himself. The Astypalaians tried to open the chest without success and, in frustration, broke open the wood only to find the chest empty: "not finding Kleomedes either living or dead." Puzzled by the disappearance of the body, the townsmen sent an envoy to the oracle of Apollo at Delphi to ask what had happened to Kleomedes and received the following oracle:

> Astypalaian Kleomedes is the last hero,
> honor him with sacrifices: he is no longer mortal.
>
> —*Pausanias,* Guide to Greece *6.9.8, author's translation*

And from this time forward, Pausanias concludes, the Astypalaians have honored Kleomedes as a hero. By any measure, Kleomedes is not a good person, yet he becomes a cult hero, one of the many vengeful hero-athletes who become objects of worship and recipients of cult.[18] Kleomedes' crimes, like those of Oedipus, make him an object of fear and revulsion among his townsmen. While the circumstances of Kleomedes' crime are of course very different from Oedipus's situation, and there are no redeeming or exculpatory factors in Kleomedes' behavior, both men are seen as potential sources of pollution but ultimately find refuge in sacred space, bringing a cult and commensurate benefits to the places in which they disappear. The reluctance to depict heroic death that we saw earlier in epic poetry is echoed in the narratives of Oedipus and Kleomedes. In both cases, the disappearance of the heroes' mortal bodies remains a mystery at the core of the cults in their honor. In the case of Kleomedes, it is precisely the disappearance of his body that is a sign of Athena's favor, a divine sign confirmed when the oracle calls Kleomedes "the last hero."

SNATCHED AWAY: KEPHALOS

Another typically heroic way of dying, also mentioned by the messenger in *Oedipus at Colonus*, involves disappearance caused by tempests or storms. The term used by the messenger, *thuella* ("storm, hurricane"), is often used in describing supernatural abductions, and more specifically abductions of mortals by gods. In the *Odyssey*, storms are personified by the Harpies, by whom Telemachos fears his absent father, Odysseus, has been snatched.[19] Semantically, to be snatched away by a storm (*thuella* or *Harpuiai*) is thus equivalent to being abducted by a god, as is Ganymedes by Zeus, for example, or Oreithyia by Boreas, and the many beautiful youths snatched up by the goddess of dawn, Eos. As Gregory Nagy has shown, the abduction of mortals alludes to patterns of immortalization: mortals are "snatched up" (by the gods or by gusts of wind) as a prelude to death and immortalization through heroization.[20]

Such abductions are usually caused by the mortal's irresistible beauty, and Eos seems to be particularly susceptible to the good looks of certain young mortals. The tale of her abduction of the young hunter Kephalos, for example, was extremely popular in Attica, where Kephalos was a cult figure. A number of Attic vases from the fifth century BCE depict Eos's abduction of Kephalos.[21] For purposes of classification, the scenes portrayed on the vases can be divided into three broad categories, each of which focuses on a different moment: pursuit, contact, and abduction.[22] The first category depicts the goddess pursuing a young man. A red-figure stamnos with Eos and two youths, 480–450 BCE, in the collection of the Walters Art Museum (fig. 57) exemplifies the contact motif, in which Eos touches the object of her desire. The third category, abduction, is the most relevant for our present purposes.

On the tondo of a fifth-century kylix (fig. 58), Eos cradles a youth's body in her arms and rushes to the right; both Eos and the young man, identified by an inscription

FIG 57 Eos and two youths. Attic red-figure stamnos attributed to the Painter of the Florence Stamnoi, active ca. 480–450 BCE. Baltimore, The Walters Art Museum, 48.2034

FIG 58 Eos stealing Kephalos. Attic red-figure kylix attributed to the Kodros Painter, ca. 440–430 BCE. Staatliche Museen zu Berlin, Antikensammlung, F 2537

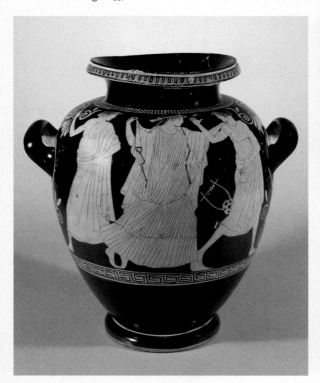

as Kephalos, look to the left, toward what they are leaving behind. Kephalos looks small and young, and wears a laurel crown over long hair. The goddess and her mortal prey seem suspended between different realms. Images of Eos and Kephalos stress not only the goddess's desire and predatory power but also the extraordinary beauty and special status of her lover. In pursuit and contact scenes, the young man is a mortal who is singled out by the goddess's desire. He usually reacts to the encounter with fear and reluctance, sometimes fighting the goddess off with a rock or with his lyre. The young man's fear of the goddess in these images can be better understood in light of the complete transformation brought about by abduction, which is a prelude to death and heroization. On the Berlin vase, the young man no longer attempts to resist but embraces the goddess by wrapping his arm around her neck. There is no return from being abducted by a goddess or a god: when Eos takes the mortal in her arms and transports him into her divine domain, the man leaves the mortal realm to become a hero. Death, the precondition of heroization, is depicted as disappearance rather than as physical process.

As the goddess of dawn, Eos is also connected with the transition from life to death in the context of funeral rituals for ordinary mortals. For Emily Vermeule, "Eos the Dawn is the end of normal sleep, and in many myths she signals not just a new day but the beginning of a new life with the gods." The apparition of Eos completes the process of death and marks the end of funerals, both in epic and in classical Athens. In later periods, accounts of the death of a young man are often cloaked in a vocabulary that verges on the erotic. Whenever a well-born and beautiful young man dies, his death and dawn funeral procession are often described as an abduction resulting from Eos's desire.[23] These funerary associations are also found in the myth of the death of Eos's own son, Memnon, who is killed by Achilles toward the end of the Trojan War.[24] Vase paintings depicting Eos carrying off the dead body of her son (fig. 59) are remarkably similar to those showing her abducting young men. Just as abducting a mortal lover points to an essential transformation from mortal to hero, carrying off the body of Memnon signifies the transition from life to death. The scene resembles depictions of Eos abducting mortal lovers, yet there can be no question of mistaking one scene for the other: the body of Memnon lies on a horizontal plane, lifeless, with limbs and head slumping down. Memnon is also portrayed as bearded, and therefore older than the smooth-faced young men who typically are captured by Eos.

THE HERO AMONG THE GODS: THE CASE OF HERAKLES

By way of conclusion, I turn to the death and apotheosis of Herakles. Herakles differs from other heroes insofar as he is both heroized and deified after death. When Odysseus meets Herakles in the underworld, he observes the hero's unique standing:

> After him I was aware of powerful Herakles;
> his image, that is, but he himself among the immortal
> gods enjoys their festivals, married to sweet-stepping
> Hebe, child of great Zeus and Hera of the golden sandals.
> —Odyssey 11.601–4, trans. Lattimore

FIG 59 Eos with the body of her son, Memnon. Attic red-figure kylix attributed to Douris, ca. 490–480 BCE. Paris, Musée du Louvre, G 115

Herakles' image (*eidolon*) is present in Hades, but his true self enjoys a divine existence on Olympos with the other gods. Herodotos, writing in the fifth century BCE, notes the paradox of Herakles' ambivalent character, devoting a section of his *Histories* to his status as *herōs kai theos* ("both hero and god," 2.43–45). Associated with the foundation myths of three of the pan-Hellenic competitions—at Isthmia, Nemea, and Olympia—Herakles is also a model for aspiring athletes. Young men competing in these contests think of themselves as undergoing trials, which they describe with the same Greek word, *athloi,* used to describe Herakles' labors; what Herakles experiences in myth, the athletes, as they perform in the contests at the sacred festivals, experience on the level of ritual. While it may be tempting from a modern vantage point to see Herakles' special status as a compensation for his extraordinary sufferings, Herakles in many ways encapsulates the paradoxical nature of ancient heroes: a natural leader, who brings civilization to his people, he is also an Everyman who endures the greatest humiliations and the most painful ordeals during his lifetime. He is at once a savior and an enraged killer who slaughters his own children, an ideal ruler as well as a drunken reveler.

FIG 60 Philoktetes, Athena, and Herakles. Fragmentary red-figure calyx-krater attributed to the Achilles Painter, 450–445 BCE. Malibu, Calif., The J. Paul Getty Museum, Villa Collection, 77.AE.44.1

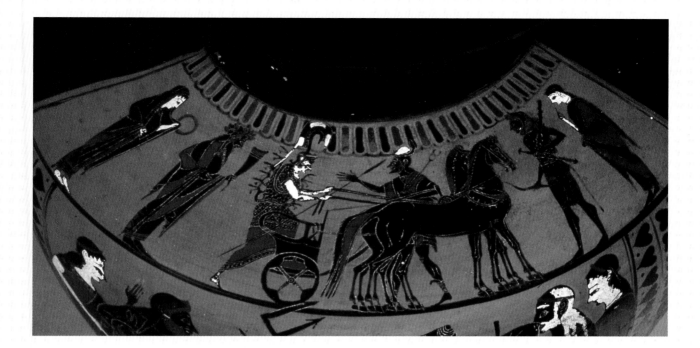

FIG 61 The apotheosis of Herakles. Detail of an Attic black-figure hydria attributed to the Painter of Vatican G 43 or the Lysippides Painter, ca. 540–530 BCE. Toledo Museum of Art, 1956.69

Herakles' greatest *athlos* is his death, the fatal result of a chain of events that starts when the Centaur Nessos attempts to rape Herakles' second wife, Deianeira. Herakles shoots him, but before dying, the Centaur has time to give Deianeira some of his blood, telling her that it is a powerful love philter. When Deianeira ("man destroyer") later learns that her husband is infatuated with another woman, she decides to use Nessos's love charm on a shirt she sends to Herakles as a gift. Nessos's blood is, of course, no aphrodisiac, but instead a powerful poison that causes Herakles such unbearable pain that the hero immolates himself on a pyre. A life of bravery, sufferings, and violence thus ends in a funerary conflagration.

No extant vase depicts the moment of Herakles' death on the pyre, but a fifth-century example shows him lying on the pyre just before it is lit, handing over his quiver to Philoktetes, who, in some traditions, lights the fire. In another version of the story, the goddess Athena hands over Herakles' weapons to Philoktetes (fig. 60). The literary sources often stress the events preceding Herakles' death. Sophocles' *Trachinian Women*, for example, describes Herakles' sufferings and his plea that his son, Hyllos, build and light his funeral pyre, but Sophocles ends his play before Herakles' death. Vase-painters often combine two different scenes: the funeral pyre, on which lies Herakles' breastplate, and another scene depicting Herakles himself being welcomed by the gods. Sometimes the latter scene appears alone.[25]

A vase in the Toledo Museum of Art depicts Herakles' apotheosis (fig. 61). On the right stands a woman, with her hand raised, behind Herakles, who wears his lion skin and holds his club and bow, facing the horses leading the chariot driven by Athena. Behind the horses, between Athena and Herakles, stands Hermes, who seems to be guiding the hero. On the other side, behind the goddess, stands Dionysos, wearing a wreath of ivy and holding a horn-shaped vessel. Another woman stands on the far left, holding a wreath in her left hand. While the pyre is not depicted on this vase, the arrival of Herakles on Olympos is clearly shorthand for both his death and his subsequent deification.

The complete consumption of Herakles' body by the funeral pyre partly explains why, unlike the deaths of other heroes, that of Herakles results in his apotheosis and deification. The Herakles myth emphasizes the importance of the gods' intervention,

and some versions explain it as a reward for his help in the fight between the gods and the giants. Another way to look at it is that Herakles is such an influential figure throughout the Greek world that he transcends his local heroic status to become a god, a transformation represented as being brought about by the gods themselves.

CONCLUSIONS

Death's "old labors," the ability to defy death, distinguishes heroes from other mortals. The supernatural powers posthumously attributed to heroes are thus directly linked to the mystery of their deaths. The moment of death itself is often taboo and therefore unrepresented: the *Iliad* stops before Achilles' death; the *Odyssey* alludes to Odysseus's eventual death but far into the future, well beyond the bounds of its narrative; Oedipus mysteriously disappears from the gaze of witnesses who, because they are uninitiated, can neither express nor understand what they see; Kephalos is snatched away by a goddess; and Herakles emerges from the funeral pyre as a god. Poets and artists allude to the mystery of heroic death but do not represent it directly. Ancient heroes cannot be consistently defined by their actions during their lifetimes: a few may be admirable, but some are undeniably monstrous or morally corrupt, and others are too young to have ever accomplished anything. Unlike their modern counterparts, most ancient heroes do not necessarily offer models of behavior. Ancient heroes instead are understood as heroic in terms of their death and subsequent transformation into objects of cult. Their deaths remain a mystery that cannot be fully described, understood, or represented. We encounter heroes either before their deaths, as mere mortals with all their foibles, or after, as figures who have transcended mortality. As the worshiped object of cultic practice and the abiding subject of poetry and the visual arts, the hero remains mysteriously yet vividly alive: worshipers, poets, and artists keep alive the memory of heroes who have transcended mortality and come back from death, beyond themselves.

NOTES

"Heroes," from *The Collected Poems of Robert Creeley, 1945–1975*, by Robert Creeley, is quoted by permission of the University of California Press. © 1982, 2006 Regents of the University of California. Published by the University of California Press.

1 Burkert 1985.

2 Vernant 1991.

3 On the cult of Odysseus on Ithaca, see Malkin 1998; on the cults of Achilles, see Hedreen 1991 and herein, 39–48.

4 On the implicitness of hero cults in epic and the pan-Hellenism of Homeric poetry, see Nagy 1999 and "The Sign of the Hero: A Prologue" in Maclean and Aitken 2001; on the implicitness of hero cult in drama, see Henrichs 1993.

5 On heroine cults, see Larson 1995 and Lyons 1997; on baby and child heroes, see Pache 2004.

6 On how poets imagine the afterlife of heroes, see Nagy 1999.

7 On the notion of "la belle mort" and "le beau mort," see Vernant 1991.

8 For Virgil's use of this simile, see *Aeneid* 9.436.

9 On the notion of epic *kleos* as a mode of heroization, see Nagy 1999.

10 The *Aithiopis* survives only in summary form. For more on the relationship between the death of Achilles in the *Aithiopis* and the *Iliad* and the *Odyssey*, see Edwards 1985b.

11 For the death of Patroklos as an animal sacrifice, see Lowenstam 1981. For the story of Prometheus deceiving Zeus, see Hesiod, *Theogony* 535–57. For the vase, Basel, Antikenmuseum und Sammlung Ludwig, inv. BS 477 (*ARV²* 361.7), see Griffiths 1985 and Griffiths 1989.

12 On the definition of *kleos* in the *Odyssey*, see Segal 1994.

13 The *Telegony*, which survives only as a summary, records a tradition of Odysseus's being killed by his son by Kirke, Telegonos, who comes to Ithaca in search of his father and unwittingly kills Odysseus.

14 For the cult of Oedipus, see Edmunds 1981.

15 The play alludes frequently to the Eleusinian Mysteries and consistently depicts Oedipus as if he were an initiate in the mysteries; see Calame 1998.

16 For the story of Amphiaraos's engulfment, see, e.g., Pindar, *Nemean Odes* 9.24–25.

17 For more on Opheltes and other child heroes, see Pache 2004.

18 For more on stories of vengeful hero-athletes, see Fontenrose 1968; see also Ekroth herein, 120–43.

19 *Odyssey* 1.241. On this passage and on the iconography of Harpies, see E. Vermeule 1981.

20 On the link between being snatched up by the gods and by gusts of winds, see Nagy 1990.

21 See Stewart 1995, table 1, "Divine pursuits and abductions," which catalogues vases depicting abductions of mortals by gods. See also the discussion "Eos and Kephalos, Eos and Tithonos" in Reeder 1995. In a forthcoming book on nympholepsy in ancient Greece, I examine in more detail the motif of Eos and her lovers. Allusions in tragedies (e.g., Euripides, *Hippolytos* 451–58) suggest that the story of Eos and Kephalos was already well known in the fifth century BCE.

22 My categories are similar to those in Lefkowitz 2002: "(1) approaching the mortal, (2) catching hold of him by his hand or arm, or (3) carrying him away." For a catalogue of representations of Eos and her lovers, see Kaempf-Dimitriadou 1979.

23 See E. Vermeule 1981; see *Iliad* 23.226–27 (funeral of Patroklos) and 24.788 (funeral of Hektor). For the attribution of beautiful young men's deaths to Eos, see Herakleitos, *Homeric Problems* 68 (first century CE), rationalizing the myth of Eos and Orion in terms of funeral practices.

24 The death of Memnon, like that of Achilles, was included in the *Aithiopis*.

25 For the iconography of the death of Herakles, see Carpenter 1991, and especially fig. 229 for Herakles on the pyre handing over his quiver to Philoktetes.

BELOVED OF THE GODS

IMAG(IN)ING HEROES IN GREEK ART

Jenifer Neils

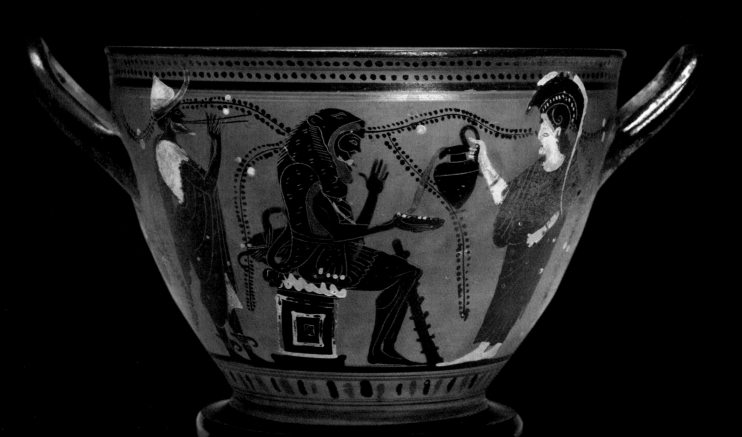

The trials and tribulations of those exceptional semi-humans whom we call heroes are a central concern of the earliest surviving Greek literature. The same is true of the earliest Greek representational art, which precedes Homer's epics by over two hundred years. Throughout its long history, Greek narrative art remained preoccupied with the image of the hero, from his often miraculous birth to his inevitable tragic death. By about 600 BCE, artists had established a canonical iconography for most heroes—their major adversaries, their specific attributes, their patron deities—while later Greek artists often exhibited an interest in the more psychological aspects of a hero's character. Artists met the challenge of distinguishing a hero from an ordinary mortal in various ways, such as increased scale, special dress or weaponry, and proximity to the gods. This essay explores the diverse modes of representation used by painters and sculptors in bringing heroes of the remote and shadowy past to life, and considers specifically their intimacy with the gods as represented in Greek art.[1]

REPRESENTING THE INDIVIDUAL HERO

Artists of the so-called Geometric period (900–700 BCE) imagined the hero for the first time, and while the subject and iconography of these representations might have been clear to their audiences, it is often difficult for us to pin down a hero's identity.[2] A case in point is the late Geometric bowl from Thebes (fig. 62), on which a nude male is grasping the wrist of a draped female as he boards an oared ship. The large size of these two protagonists would seem to indicate their status as epic figures, although some scholars believe they are mere mortals, a man bidding farewell to his wife as he departs for a sea voyage. More likely they represent some hero and his lady-love; whether Paris abducting Helen, Jason departing with Medea, or Theseus eloping with Ariadne remains open to debate. The artist has provided an attribute for each (shield and wreath), but they are too generic to offer much assistance. The same problem pertains to sculpture of the period. A small bronze group of a man fighting a Centaur now in New York (fig. 63) is surely heroic but nonetheless difficult to identify as either Herakles or Theseus, both of whom battle these hybrid beasts. Compounding the

FIG 62 Hero (?) abducting woman. Attic Late Geometric spouted krater from Thebes, ca. 730 BCE. London, British Museum, GR 1899,0219.1

FIG 63 Man and Centaur. Late Geometric figurine, ca. 750 BCE. Bronze, height 11.10 cm. New York, The Metropolitan Museum of Art, gift of J. Pierpont Morgan, 1917, 17.190.2072

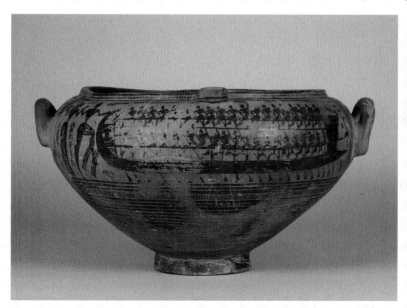

problem of identification is the fact that both the hero and the monster wear the same type of headgear. Abducting beautiful women and slaying fabulous monsters were the primary claims to fame of heroes in Greek mythology. Hence, these earliest narratives in Greek art may perhaps be deliberately generic, serving as vehicles for telling the tales of various mighty men of the past, of what the poet Hesiod (late eighth to early seventh century) called "the fourth generation" or "the divine race of heroes who are called demigods" (*Works and Days* 160).

In the next century (700–600 BCE), Greek artists, inspired by the more advanced figural traditions of the ancient Near East and Egypt, produced more specific narratives. The body of the famous Proto-Attic amphora of Eleusis (fig. 64) already shows an identifiable hero, Perseus, with his monstrous adversaries, the Gorgons, and his patron deity, Athena, holding her staff (but not yet with her characteristic armor). On the broad neck of the vase is the scene of the blinding of Polyphemos, in which the hero Odysseus is distinguished from his nonhero comrades by being painted white.[3] Both heroes move to the canonical right, the auspicious direction that handily serves in Greek art to indicate the victor. Already at this early date, the juxtaposition of two monster-slaying heroes may indicate that the artist intended a contrast or comparison: the young Perseus, who needs the aid of the gods to accomplish his deed and is shown running off, presumably with the head of his female victim (this portion of the vase is lost), versus the older but wiser Odysseus, who uses a stratagem of his own devising to maim the male giant Cyclops. Both actions are also forerunners of even more demanding adventures: the rescue of Andromeda and the escape from the cave.[4] (This juxtaposition of the feats of two different heroes is a technique used as well by later Athenian artists, who often show Theseus and Herakles on opposite sides of a vase or even on the Doric friezes of temples and treasuries.) Even the seemingly mundane image on the shoulder of the Eleusis amphora of a lion attacking a boar—the animal combat motif beloved of Archaic artists—may allude to heroism. Because Homeric

FIGS 64A AND 64B Perseus, with the Gorgons and his patron deity, Athena, holding her staff. Proto-Attic black-figure amphora, ca. 670–660 BCE. Eleusis, Archaeological Museum

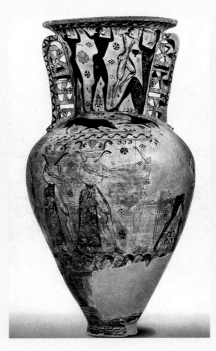

similes frequently employ the image of an attacking lion to describe the aggressive hero in combat, this animal confrontation serves metonymically for the valiant acts of heroes.[5]

Beyond Attica, the miniature ceramic art of Corinth and the carved ivories of Sparta supply some of the earliest detailed narratives of heroes, and if textiles were extant, they would no doubt preserve rich imagery of heroic deeds. Another medium of this period, terracotta reliefs applied to large pithoi (storage jars), provides a venue for a series of related scenes involving heroes, such as the fall of Troy with its massacre of the innocents and recovery of Helen on the example found on Mykonos.[6] Bronze shield straps and tripod legs also afforded rectangular panels for series of two- or three-figure compositions. The now-lost wooden chest of Kypselos at Olympia, described by the traveler Pausanias (5.17–19), had numerous friezes and several dozen panels depicting the actions of heroes as diverse as Idas and Melanion.[7] In the realm of performance, there were almost certainly enactments of the legendary acts of heroism, as indicated by terracotta masks of youthful males and wrinkled monsters found at religious sanctuaries.[8]

One major monument with a series of heroic actions that thankfully is extant because it was placed in a princely Etruscan tomb near Chiusi is the exceptionally large volute-krater signed by Kleitias and Ergotimos (figs. 65a, 65b).[9] Known as the François Vase and dated around 575 BCE, it is exceptional in having six bands of figurative decoration on each side. While the main zone at the top of the bowl is devoted to the gods who proceed in their chariots to the wedding of Peleus and the sea nymph Thetis, five others are concerned with heroes: Meleager and his band fighting the Kalydonian boar; the chariot race in honor of the slain Patroklos; Achilles' ambush of the Trojan prince Troilos; Theseus and his fellow Athenians celebrating their victory over the Minotaur; and Theseus's fight with the Centaurs at the wedding of Peirithoos. It is a virtual mythological compendium, with all the figures, mortal and immortal, carefully labeled. The lowest figural zone of the krater's body shows a series of animal combats, no doubt reinforcing the heroic themes of the other registers. While some scholars have viewed this vase as an extended encomium of the hero Achilles, from the wedding of his parents to his death (on the handles), the episodes with Theseus are difficult to reconcile with this scenario.

Might there again be a deliberate juxtaposition of heroic deeds, but in this instance with a nod to their amorous subtext? Meleager is the hunter par excellence, while Achilles shows off his athletic prowess as a runner (hence his epithet "swift-footed"), and Theseus is the civilized leader playing his lyre at the head of the choral dance. His confrontation with Ariadne is echoed by the pairing of Atlante with her lover, Melanion, in the boar hunt, and perhaps by the Trojan princess Polyxena in the scene of Achilles' ambush. The inclusion of these maidens, who are not absolutely necessary to the various narratives, accords with the wedding images elsewhere on the vase and may underscore the interpretation of this vase as a nuptial gift, albeit one with an Athenian agenda given the prominence of the local hero Theseus. If this vase can be associated with the marriage in about 575 BCE of the Athenian aristocrat Megakles

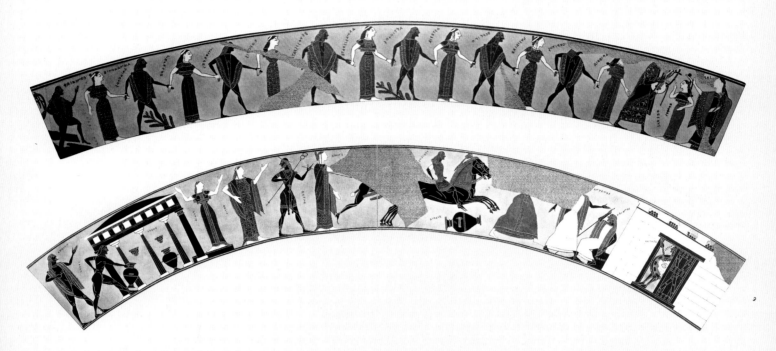

FIG 65A Theseus and Ariadne. Detail of an Attic black-figure volute-krater from Chiusi (François Vase), signed by Ergotimos (potter) and Kleitias (painter), ca. 575 BCE. Florence, Museo Archeologico Etrusco, 4209

FIG 65B Troilos pursued by Achilles. Detail of an Attic black-figure volute-krater from Chiusi (François Vase), signed by Ergotimos (potter) and Kleitias (painter), ca. 575 BCE. Florence, Museo Archeologico Etrusco, 4209. From A. Furtwängler and K. Reichhold, *Griechische Vasenmalerei*, vol. 1 (Munich, 1909), pls. 11/12, 13

with the daughter of the tyrant of Sikyon Kleisthenes recorded by Herodotos, then a politicization of Theseus may be the intent of the imagery.[10] This hero could in some way reference the Alkmaeonid faction in Athens, just as John Boardman has suggested that Herakles did for Peisistratos in the latter half of the century.

The heyday of heroes in Greek figurative art was the Archaic period (600–480 BCE). From the sculpted pediments of stone temples to the minutest carving on gemstones, the exploits of heroes were celebrated in all media. At the beginning of the sixth century, artists often crammed onto a single large vase as much imagery as possible (as we have seen with the François Vase), while at the end of the century exceptional painters like Exekias concentrated on the drama of a single figure, as in his moving portrayal of the suicide of Ajax.[11] Heroes emerge as distinct types, if not personalities: Herakles as an old-fashioned archer who bears a rustic club and lion skin; Theseus as a youthful, *palaistra*-trained swordsman; Odysseus with his traveler's cap (*pilos*); and Bellerophon mounted on his winged horse, Pegasos. Heroes are also readily identifiable by the distinctive hybrid monsters they alone encounter and overcome: the Nemean lion wrestled to death by Herakles; the Kretan Minotaur killed by Theseus; the Sirens and Scylla outwitted by Odysseus; the Gorgon named Medusa beheaded by Perseus; the Chimaira slain by Bellerophon; and the Theban Sphinx encountered by Oedipus. While Achilles is often portrayed in the fury of battle, he is also shown in much quieter moments, putting on his armor or bandaging the wounds of his comrade, Patroklos. These scenes are more revealing of his particular story (the role of arms in his life, from the ruse on Skyros to the allotting of them to Odysseus instead of Ajax) and his persona (his dedication to his fellow Myrmidons). And in fact one great vase-painter, Douris, can evoke the absent warrior simply by the careful arrangement of his famous armor forged by the smith god Hephaistos (fig. 66).[12]

However, not all heroic imagery derives from old tales sung by poets and recited by generations of mothers to their sons. Some exploits, like those of the Athenian

hero Theseus, were newly invented in a deliberate attempt to give the local hero a fuller *vita* in emulation of Herakles. These "new" deeds were advertised on a special vehicle created for this purpose, the cycle cup. These Attic red-figure kylixes emerge around 510 BCE and combine several of these exploits on the exterior with another in the tondo, usually his canonical deed, the slaying of the Minotaur. Some, like the later example in London attributed to the Kodros Painter (fig. 67, and p. 171, fig. 96), show six of the new deeds both inside and out. In the realm of public art, these new deeds of Theseus are featured on the metopes of the Athenian treasury at Delphi as well as the Temple of Athena and Hephaistos in the Agora. Some are clearly modeled on the labors of the older Herakles, such as the Krommyonian sow, which resembles the Erymanthian boar (with a sex change), or the bull of Marathon, which is in fact the Kretan bull (with a change of location). Obviously the new Athenian democracy felt a need for a hero with a more ample résumé and had no compunction about fabricating one.[13]

In the Classical period (480–330 BCE) interest in the monster-slayings of heroes diminishes in favor of their romantic entanglements: Greeks subduing beautiful Amazons, Kadmos rescuing Harmonia from the dragon at Thebes, Herakles marrying Hebe, Menelaos reclaiming Helen, Odysseus encountering the young Nausicaa, Perseus rescuing Andromeda—even Medusa is transformed from a hideous monster to a beautiful woman. Instead of slaying their opponents, heroes often stand beside them as if in conversation, as in the case of Theseus's meeting with the rogue Sinis. Rather than lashing him to a pine tree as he does in Archaic art, Theseus now calmly confronts him (fig. 68). Likewise artists also exhibit a greater interest in the childhood of heroes, and their relationships with the gods become more intimate.

This increasing passivity, if one may call it that, of heroes in Greek art is best illustrated by an enigmatic vase of the mid-fifth century BCE in the Louvre. The name piece of the Niobid Painter, it is famous for its unusual arrangement of figures on

FIG 66 The arms of Achilles. Detail of an Attic red-figure kylix by Douris, ca. 480 BCE. Vienna, Kunsthistorisches Museum, 3695

FIG 67 Six youthful deeds of Theseus. Exterior of an Attic red-figure kylix attributed to the Kodros Painter, ca. 440–430 BCE. London, British Museum, 1850,0302.3 (E84)

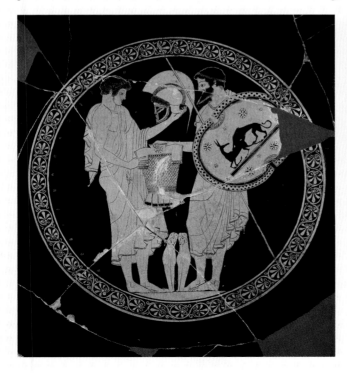

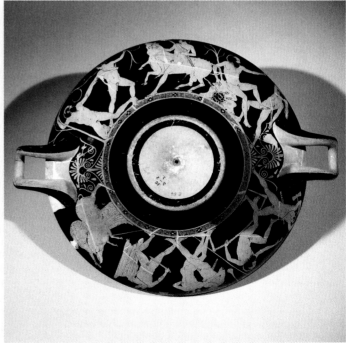

FIG 68 Theseus's meeting with the rogue Sinis. Attic red-figure Nolan amphora attributed to the Oionokles Painter, ca. 460 BCE. Paris, Cabinet des Médailles, 369

FIG 69 Herakles and other heroes. Red-figure calyx-krater by the Niobid Painter (name piece), ca. 460–450 BCE. Paris, Musée du Louvre, G 341

different groundlines, suggesting influence from a major wall painting (fig. 69).[14] The obverse shows a group of heroes congregating in a rocky landscape; both their identities and the story with which they are associated are much debated. The only clearly identifiable figures are the goddess Athena standing at the left and Herakles with his lion skin and club in the center. Theseus may be the warrior lounging at the lowest level; the figure directly above him may be his comrade Peirithoos, who tugs at his knee; hence one plausible identification of the scene is Herakles' rescue of Theseus from Hades, during which his friend, who attempted to abduct Persephone, could not be unstuck from his seat. Other heroes stand around at the sides, looking more like a group of statues than an attempt at a mythological narrative.

Statues of heroes standing together in groups on a single long base did in fact emerge in this period in the form of commemorative victory monuments or, in the case of Athens, as civic monuments of the democracy's ten eponymous heroes who gave their names to the new tribes. Ten Attic heroes, along with Athena and Apollo, graced the monument dedicated by the Athenians at Delphi following the Persian wars, while the ten actual *eponymoi* stood in a row on the monument set up before 424 BCE in the Agora. This monument no doubt inspired the relief carvings of the ten, divided into groups of six and four, who flank the gods on the eastern frieze of the Parthenon. They provide some idea of how the Athenians perceived their heroes—as beardless youths or bearded men, wearing mantles and leaning relaxedly on their staffs.[15] We will return to these heroes shortly.

While later Classical architectural sculpture tends to run to tried-and-true themes like the Amazonomachy and the Trojan War, vases, produced in quantity in South Italy during the fourth century, show a preference for episodes popularized by Attic drama. The largest of these vases, the immense Apulian volute-kraters, often display the plays' dramatis personae arranged in registers on dotted groundlines. The gods are shown lolling about, seated or standing, in the topmost register, while the protagonists enact their roles in the areas below. Some of these divinities are the *dei ex machina*, who fly to the rescue aided by mechanical cranes, not unlike Peter Pan or Mary Poppins, at the end of many Greek dramas.[16]

An early Apulian vase inspired by two Euripidean tragedies, but not literally depicting scenes from them, is a stamnos in Boston, the name-piece of the Ariadne Painter (figs. 70a, 70b).[17] One side shows the hero Bellerophon about to depart on Pegasos, a scene probably inspired by the prologue to Euripides' early play *Stheneboia*. King Proitos sees the hero off, giving him the falsely accusing letter of his treacherous queen, who lurks in the doorway. The other side again shows a departure, in this case by ship. The hero Theseus also has orders to leave, in this instance given by the goddess Athena, who sits in the upper level and gazes down at him. Ariadne lies nearby, fast asleep, and torso bared as if to allude to her seductive nature. This specific scene may have been described in the epilogue delivered by Athena to Euripides' early play *Theseus*. On both sides the heroes are portrayed frontally and larger than the other characters and thereby draw the viewer's attention to themselves. They are both escaping the clutches of besotted females who might otherwise impede their progress toward fame and glory.

On a krater made in the vicinity of Paestum (fig. 71), an episode from Aeschylus's *Eumenides* is depicted.[18] The hero Orestes is shown kneeling before the tripod at Delphi, seeking refuge from the avenging Furies. He is flanked by divinities who have come to his defense: Athena at the left and Apollo at the right. Even the goddess Leto is shown looking on from the upper left. While Apollo stares down one of the Furies, Athena is making direct eye contact with Orestes, as if to reassure him of a positive verdict when he goes on trial for matricide in Athens. On a related Paestan vase, the entire family gets into the act, with Apollo purifying Orestes with the blood of a piglet, while Leto and Artemis stand nearby with offerings.[19] This third play of Aeschylus's trilogy was unusual in having the gods actually appear in the action of the play, as opposed to performing the prologue or *exodus*.

In actual staged drama, heroes were readily recognizable by their costumes and in particular their masks. Occasionally actors are pictured on vases holding their masks,

FIG 70A AND 70B Bellerophon departing with Pegasos / Theseus abandoning Ariadne. Early Apulian period red-figure stamnos by the Ariadne Painter (name piece), ca. 400–390 BCE. Museum of Fine Arts, Boston, Henry Lillie Pierce Fund, 00.349

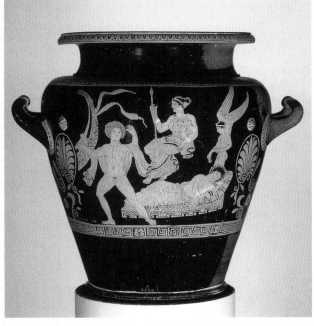

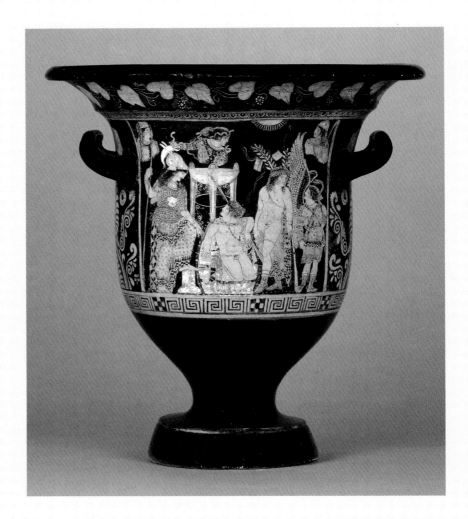

FIG 71 The purification of Orestes at Delphi. Paestan red-figure bell-krater attributed to Python, ca 350–340 BCE. London, British Museum, 1917,12-10.1

as in the famous case of the Pronomos Painter's krater in Naples.[20] While Herakles is identifiable by his club and lion skin, his mask is also distinctive, with its curly hair and trim beard. Such portraitlike masks may have given rise to specific physiognomies for the heroes, for in the sculpture of the fourth century, heroes like Herakles can be recognized even without their attributes. The miniature head of the bearded Herakles on the silver tetradrachms of Kamarina (ca. 415–405 BCE) looks remarkably like that of the so-called Weary Herakles attributed to Lysippos (see no. 35). There are not enough extant sculptures of other heroes to determine how pervasive this trend was, but attempts have been made to identify Theseus, for example, in the so-called Ares Borghese on the basis of his distinctive "drippy locks" hairstyle.[21]

PROXIMITY TO THE GODS

However, it is proximity to the gods that most clearly distinguishes heroes from mortals in Greek art as well as literature. While in literature the gods can either help or hinder heroes, in art they are largely helpmates, and their presence usually indicates a positive outcome for the Greeks. The tone is set by Homer's epics, in which warriors like Achilles and Odysseus are not only aided and counseled by the gods (especially by Athena, who is a patron goddess of heroes par excellence) but are actually privileged to be in their presence. On Attic vases these epiphanies manifest themselves as deities standing on the sidelines as heroes encounter their foes. Thus, for example, on a famous red-figure kylix attributed to Douris, Athena watches as Jason is disgorged from the gaping maw of the dragon guarding the Golden Fleece (fig. 72).[22] Athena is

portrayed most often at the side of Herakles. An early cup from Argos (ca. 580 BCE, now lost) shows Herakles backed by Athena in his encounter with the Hydra of Lerna, while Hermes accompanies him to the underworld on the other side.[23] Both gods often in fact appear in scenes of the hero's capture of Kerberos, which entailed the tricky descent into the underworld (nos. 15, 28). Athena can take up arms in defense of her favorite, as when she attacks Ares, whose son Kyknos has been struck down by the hero.[24] She drags him into the presence of Zeus or drives him by chariot to Olympos. She even waits on Herakles, pouring out wine (or nectar?) for him as he stands, sits or reclines in her presence (nos. 43, 44).[25]

In sculpture Herakles also enjoys the patronage of Athena and Hermes. The twelve metopes of the Temple of Zeus at Olympia (ca. 470 BCE) show the hero aging as he progresses through his onerous labors. On the first metope, Athena looks caringly on as the still beardless hero slumps with exhaustion over the dead lion. On the third metope, he delivers the Stymphalian birds to a demure Athena seated on a cliff (fig. 73). Athena actually assists in his tenth labor, helping Herakles hold up the heavens while Atlas arrives bearing the apples of immortality. Hermes (now largely missing) simply stands by in the eleventh labor as the hero drags Kerberos from the underworld. In the last labor, cleaning the stables of Augeias, Athena directs the earth-moving operation with her spear. On these last two metopes, god and hero are literally standing toe to toe, a subtle detail that illustrates the hero's familiarity with the gods.[26]

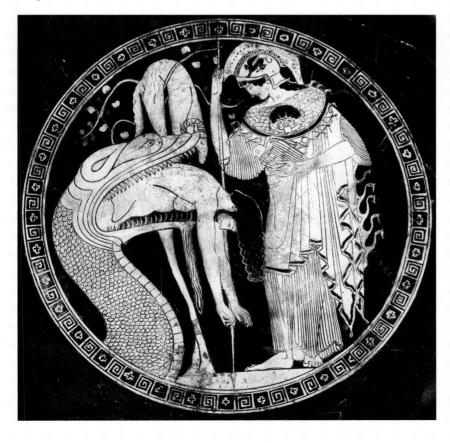

FIG 72 Jason disgorged by the dragon with Athena. Interior of Attic red-figure kylix attributed to Douris, ca. 500–450 BCE. Vatican, Museo Gregoriano Etrusco, 16545

FIG 73 Herakles delivers the Stymphalian birds
to Athena. Metope 3 from the Temple of Zeus
at Olympia, ca. 470 BCE. Paris, Museé du Louvre,
M 717

FIG 74 Athena at the side of Theseus as he faces
the Minotaur. Attic black-figure band cup signed
by Archikles and Glaukytes, ca. 550 BCE. Munich,
Antikensammlungen und Glyptothek, 2243

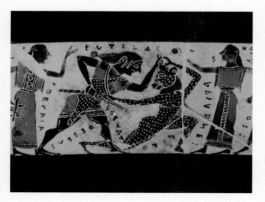

The Athenian Theseus is an exceptional hero in that he enjoys the patronage of two major gods, and, as we have seen, his narrative evolves as the city of Athens asserts itself as an Aegean-wide power. In some of the earliest images of the hero, Athena is at his side; for instance, she holds his attribute, a lyre, as he faces off with the Minotaur on an Attic black-figure band cup signed by Archikles and Glaukytes (fig. 74). On metope 5 of the Athenian Treasury at Delphi, she greets him as he arrives in Athens after successfully ridding the Megarian coast of a series of rogues. She even accompanies Theseus to the bottom of the sea to visit his father's consort, Amphitrite. At the same time, images of Theseus with his divine father, Poseidon, begin to appear on Attic red-figure vases; these take the form of a *sacra conversazione* in which an enthroned or standing god greets his son with a gesture or handshake. This meeting represents both an assertion of his divine paternity as well as an affirmation of Athens' newly founded naval empire.[27] Even after his death, Theseus comes to the aid of the Athenians, when he appears as an apparition at the plain of Marathon in 490 BCE, as depicted in the famous painting of this battle housed in the Stoa Poikile in Athens. Here he is in the company of the goddesses Hera, Athena, Demeter, and Persephone as well as the hero Herakles.[28]

The Olympians can also act collectively in determining the destiny of heroes. On the sculpted eastern frieze of the Siphnian Treasury at Delphi, they deliberate the fate of their favorites as Achilles and Memnon fight over the body of the slain Antilochos at Troy. A similar group of seated gods watching a battle involving Theseus is depicted on the eastern frieze of the Hephaisteion in Athens.[29] Finally and perhaps most strikingly, the twelve Olympians appear on the eastern frieze of the Parthenon, flanked by the ten eponymous heroes of Attica. Here they witness a contemporary event, the Panathenaic Festival held every four years in honor of Athena, and its culminating ritual, the presentation of a peplos by the citizens of Athens. So as individual gods in earlier art served to identify the rank of heroes, here on the Parthenon in mid-fifth-century Athens they as a group have a propagandistic function, to enhance the status of the citizenry of Athens. Scholars have seen this reading as too hubristic on the part of the Greeks and would like to locate the gods in some other realm. However, if Athena can be shown descending to the potter's workshop to crown a vase-painter,[30] then why should not the Olympians come to attend her renowned festival? In contemporary vase-painting, the Athenians are likewise heroized by having the god Hermes escort them in depictions of their wedding processions or of their journeys to the underworld, just as he led Herakles in his quest to retrieve Kerberos.[31] Heroes derived much of their power and ability to perform valiant deeds from their nearness to the gods—and so too did Athens, a city that was once termed the most devout of all.

NOTES

1 For another approach to early Greek mythological narrative, see Neils 2007. See also Shapiro 1994.

2 See Ahlberg-Cornell 1993.

3 See Boardman 2001, 34, figs. 34.1–2.

4 The Oresteia krater in Berlin (A 32) may be another example of deliberate juxtaposition, in this instance as punishments for hubris: Orestes killing Aigisthos on one side and Apollo and Artemis slaying a missing figure (Tityos? Niobids?) on the other.

5 See Markoe 1989.

6 See Boardman 2001, 41, figs. 46.1–2.

7 See Schefold 1966, passim.

8 See Carter 1987.

9 For the François Vase by Kleitias and Ergotimos (Florence 4209), see Boardman 2001, 52–53, figs. 62–64. For a thorough discussion of the iconography of this vase, see Stewart 1983.

10 I have argued elsewhere (Neils 1987, 150) that the François Vase may be a wedding gift to the Alkmaeonid Megakles and his bride Agariste, as recorded by Herodotos (5.67–68). The date of the vase is close to that of the famous wedding, ca. 575 BCE.

11 For the scene by Exekias of Ajax's suicide (Boulogne 558), see Boardman 2001, 63, fig. 82.

12 For these and other images, see Schefold 1992.

13 See Neils 1987.

14 See Denoyelle 1997.

15 On Attic heroes, see Kron 1976.

16 For the gods' roles in Greek tragedy, see Mastronarde 2005. He writes (321–22): "Visible gods on stage are partly analogous to the gods who appeared in contemporary sculpture and vase-painting, such as the Athena who stands by Heracles or Theseus in the depiction of their labors, the Apollo who extends his arm over the battling Lapiths and Centaurs, the observing gods [sic] who witness the preparations for Pelops' chariot race, and the gods who appear on the margins of vase-painting scenes or in a higher band (and divine participants and observers must also have been shown in lost large-scale paintings)."

17 Museum of Fine Arts, Boston, 00.349, Apulian stamnos by the Ariadne Painter, ca. 400–390 BCE. See Trendall and Webster 1971, nos. III.3, 45, and 51.

18 British Museum, 1917,12-10.1, Paestan bell-krater by Python, ca. 350–340 BCE. See Trendall and Webster 1971, no. III.1,11.

19 Trendall and Webster 1971, no. III.1,12.

20 Naples, Museo Archeologico Nazionale, 3240 (inv. 81673), Attic volute-krater by the Pronomos Painter, ca. 400 BCE. See Trendall and Webster 1971, 28–29, no. II,1; Taplin 2007, 31, fig. 12.

21 Neils 1988.

22 See Boardman 2001, 91, fig. 124.

23 Schefold 1966, 68, fig. 23. For Athena actually assisting Herakles by holding a jug to collect the poisonous blood of the Hydra for the hero's arrows on a Corinthian aryballos (Basel BS425), see Boardman 2001, 47, fig. 57.

24 For the depiction of this scene on a krater by Euphronios, in a private collection, see Boardman 2001, 87, fig. 120. For the same on a cup by the Kleophrades Painter in London (British Museum, E 73), see Boardman 2001, 184, fig. 205.1.

25 For a seated Herakles, see Boardman 2001, 65, fig. 85; for a reclining Herakles, see Boardman 2001, 81, figs. III.1–2; for a standing Herakles, see Boardman 2001, 89, fig. 122.

26 For the metopes of the Temple of Zeus at Olympia, see Ashmole and Yalouris 1967.

27 Neils 1987; LIMC 7 (1994), s.v. Theseus (J. Neils). For Theseus and Poseidon, see also Shapiro 1982.

28 See Stansbury-O'Donnell 1999, 142–44.

29 See Barringer 2008, 124–25.

30 For example, on the Caputi Hydria in a private collection in Milan, see Boardman 2001, 147, fig. 178.

31 For a wedding with Hermes on a pyxis in London (British Museum, 1920.12-21.1), see Boardman 2001, 233, fig. 255. The funerary scenes appear on Attic white-ground lekythoi; see Boardman 2001, 232, fig. 254.

THE CULT OF HEROES

Gunnel Ekroth

How does one venerate a figure who is neither a man nor a god? The concept of hero cults is paradoxical from a contemporary perspective, for no phenomenon in modern society directly corresponds to the ancient Greek conception of heroes. Some scholars maintain that Christian saints constituted a development of Greek heroes, but the analogy is flawed. To qualify as a saint, one had to behave in an exemplary fashion and to be a paragon for other believers. To qualify as a hero in ancient Greece, one had to be extreme, in every sense of the term, in life or death; virtue was not necessarily a qualification. A telling example is the athlete Kleomedes from Astypalaia, who killed his opponent in the *pankration* (an event blending wrestling and boxing) at Olympia, was disqualified, and in anger razed a school, taking the lives of sixty innocent children. Barely escaping a lynching, he took refuge in a stone chest in a sanctuary and miraculously disappeared. The oracle at Delphi declared him a hero, since he was no longer mortal.[1]

Greek heroes encompassed a plethora of characters. Most heroes known from ancient sources have no attested cults, but this is probably due simply to lack of evidence, as every hero seems to have been a potential candidate for some form of worship. On the other hand, a number of heroes are documented only in cultic contexts, and no details of their biographies are known.

The reasons for worshiping a hero and for initiating a hero cult were also diverse. Many hero cults were directed to male warriors or kings known from myth and epic, such as Achilles, Menelaos, and Theseus, giving rise to our modern usage of the terms "hero" and "heroic." These figures performed extraordinary deeds and were venerated as founders of cities and sanctuaries, as ancestors of distinguished families, or as inventors of ingenious things or devices. Female heroic figures encountered in epic and myth were also the object of cult, often in the guise of virgins who had given their lives to save their cities, families, or husbands.[2] Paired heroes, such as the Dioskouroi or Helen and Menelaos, or anonymous male-female couples were venerated together (nos. 65, 67–69).[3] Mythic children and even babies could receive hero cult, and their deaths were often related to the institution of the cult, as was the case with the infant Opheltes (Archemoros) at Nemea.[4]

The appearance of a hero as an active helper in a decisive moment might also give rise to a cult. When the Greeks confronted the Persians at Marathon in 490 BCE, Theseus, Herakles, and Marathon (the eponymous hero of the region) were reported to have fought on the Greek side, as did Echetlaeus, in the guise of a peasant who killed the enemy with his plow.[5] The accidental discovery of a prehistoric tomb might have called for ritual actions, presumably to placate the disturbed heroic figure resting there, as might have been the case with the nine fifth-century black-figure lekythoi deposited in a Mycenaean chamber tomb under the later Temple of Ares on the Athenian Agora.[6] Bronze Age remains could also be connected with heroes and might have stimulated the institution of a cult. The sanctuary of Agamemnon at Mycenae was situated along the Chaos ravine upstream from a huge Mycenaean bridge or dam, while the cult of Helen and Menelaos at Therapne outside Sparta was located near a ruined Mycenaean mansion.[7] Finally, historical and quasi-historical figures, such as founders of colonies

(*oikistai*), soldiers killed in battle, former enemies, athletes, doctors, poets, and writers, also became the object of hero cults due to their extraordinary achievements and contributions.[8]

Though many heroes were worshiped as helpers and their cults instituted as thanks for their rescue of a city or a person, some had a dangerous and threatening aspect, and their cults were introduced to appease their anger. Heroes were counted among the *ahoroi* or the *biaiothanatoi*, those who had perished by murder, execution, plague, suicide, or, in the case of virgins or small children, simply before their time.[9] The institution of cults to such figures often sought to resolve some kind of crisis, usually related to injustice or violent death. Pausanias, our eternal source for hero cults and their origins, tells the story of the children of Kaphyai, who pretended to hang the statue of Artemis and were stoned to death in retribution by the angry inhabitants of the city (8.23.7). When the women of Kaphyai began to miscarry, the town's inhabitants consulted the oracle at Delphi, who decreed that the children had died unjustly and had to be buried and receive a cult. The institution of a hero cult was often preceded by violent death and deprivation of burial, which had unfortunate consequences for the entire society; after the consultation of an oracle, usually the Pythia at Delphi, the institution of a cult transformed the vengeful hero into a benevolent defender and protector.[10]

RECOGNIZING HERO CULTS

Archaeological investigations have documented sanctuaries and cult sites for heroes in a surprising variety of forms throughout ancient Greek territory.[11] The diversity of these cults is attested by the rich terminology for hero-cult places provided by the written sources.[12] Terms such as *sema*, *mnema*, *theke*, and *taphos* all underscore the fact that the hero with whom they were associated was dead, although the same terms were also used to describe conventional burials. *Heroön* (pl. *heroa*) is often used for more elaborate cult places, with the implication of a tomb's presence at or near the site. Some heroes were worshiped at sites explicitly said to lack a burial, for example, the empty mound, *kenon erion*, that Pausanias (6.20.17) describes as the site for sacrifices to Pelops's charioteer, Myrtilos, at Olympia. Even the terminology for the sanctuaries of the gods could be applied to cult places for heroes, for example, *temenos* and *hieron* (a holy place or a precinct), *naos* (temple), or *alsos* (sacred grove).

Most archaeological remains recognized as hero cults have been identified on the basis of one or more inscriptions at the site or have been connected with a hero cult mentioned in literary texts: Pausanias's description of Greece alone refers to more than a hundred monuments to heroes and constitutes an invaluable source for modern scholars. Identifying a hero cult solely on the basis of archaeological evidence is, on the other hand, a difficult task. A cult place for a hero is often indistinguishable from that of a minor god. From the Hellenistic period onward, it can also be difficult to distinguish a hero-cult installation from the substantial burial monument of an ordinary person.[13] In the absence of literary or epigraphic sources, we are often left with pure speculation; small shrines or cult installations are sometimes identified as hero cults simply due to

their relatively inconspicuous size and appearance. Furthermore, even *heroa* explicitly mentioned in the written sources may be difficult to match convincingly with the excavated remains, as is the case with the tomb and *mnema* of Neoptolemos situated somewhere to the north of the Temple of Apollo at Delphi and the *temenos* of Phylakos near the Sanctuary of Athena Pronoia, also at Delphi.[14]

Archaeological criteria for distinguishing a hero cult are fluid.[15] Since a hero was supposed to have a grave, a cult place located on or near a burial or burials might suggest the presence of a hero cult, though such an association presumes that these burials were known to those founding the cult in antiquity, which may not in fact be the case. A link between cult place and burials is clearly distinguishable at the so-called West Gate Heroön at Eretria on Euboea.[16] The cult centered on the graves of six cremated adults and nine inhumed children, made between the late eighth and the early seventh century BCE. The richest cremation included an exceptional number of weapons: four swords and six spear points, one of which was bronze, perhaps an heirloom from the Mycenaean period, a further indication of this warrior's high status.[17] At the beginning of the seventh century, a triangular structure composed of massive stone slabs, perhaps once covered by a tumulus, was placed above the graves. Later in the same century, a series of buildings, presumably used for the cult, was constructed around the monument; an oblong structure with five rooms to the southeast might have served as a dining facility. A large pit to the southeast of the triangular structure contained ashes, animal bones (including the heads of ten sheep), female figurines and figurines of male riders, lamps, and fragments of pottery vessel types used for libation and dining. The religious use of the site probably continued until the end of the sixth century BCE.

The setting of a grave as well may indicate a hero cult. The graves of the ordinary dead were impure and for that reason were segregated from the living. A burial located within the city walls or in a sanctuary might suggest a hero cult, for the tombs of heroes were not considered to be a source of pollution.[18] On the other hand, the relation between a hero cult and the hero's grave was a complex matter, even though a fundamental characteristic of a hero was the fact that he was dead.[19] Many hero shrines have no traces of graves either within them or in their environs, a fact that accords with the testimony provided by the written sources that a tomb was not a prerequisite for the founding or maintenance of a hero cult. Some heroes explicitly declined any form of posthumous cult. Eurystheus pledged to protect Athens from his grave on the condition that the Athenians refrain from offering him sacrifices or libations.[20] There was also a tradition that some heroic tombs were to be kept secret and hidden, especially in the event of war, to prevent enemies from exploiting the cult's power. An interesting example is found in a fragment of Euripides' *Erechtheus*.[21] After Erechtheus's daughters have given their lives to save the city, Athena instructs their widowed mother, Praxithea, (and the Athenians as well) that the maidens are to receive sacrifices from the Athenians before battle but that their shrine, an *abaton*, must be guarded so that the enemy cannot sacrifice there and secure victory.

Identifying a hero cult on the basis of the votive material is even more difficult, for what were deemed "heroic" accoutrements or furnishings seems to have varied from

place to place. Among the objects claimed to be specific for dedications to heroes are certain types of figurines, such as horses and riders, or pottery shapes, such as kraters, drinking cups, or large bowls for hero's ablutions, or objects, such as miniature shields.[22] A more comprehensive look at these offerings, however, often demonstrates that they were part of a regional votive tradition and could be dedicated to the gods or used as funerary gifts.[23]

Certain types of votive reliefs seem frequently to have been dedicated to heroes, however. These objects, made of stone or terracotta, depict a horseman, a seated male figure or a male-female couple, or a reclining and banqueting figure, often accompanied by a large snake, which is sometimes depicted as drinking from a cup.[24] In some of these reliefs, a group of worshipers is seen approaching the hero, and the procession may also include a sacrificial animal and be directed toward an altar (nos. 62, 67). Other hero reliefs show a heroic couple, the male figure leading a horse, making offerings at an altar or performing a libation (fig. 75; see also no. 67). Worshipers may also be included in these scenes.

BONES, BELONGINGS, AND CULT STATUES

Death being an indispensable attribute of heroes, their bones as well as their graves were the object of cult. The enormous size of the bones is often noted, in accordance with the notion that heroes were literally larger than life. The bones of Theseus, rediscovered on Skyros by Kimon, were recognized by their gigantic size and by the presence of bronze weapons in the grave.[25] The display of the hero's bones seems not to have been particularly common, however. Although the ivory shoulder blade of Pelops was kept in the Temple of Hera at Olympia, when Pausanias visited the sanctuary in the mid-second century CE, it had been lost; the remainder of the hero's bones were

FIG 75 A hero and heroine libating at a mound-shaped altar. Votive relief from Thasos, ca. 350–300 BCE. Archaeological Museum of Thasos, inv. 31

reportedly housed in a box in a sanctuary in the countryside.[26] Much of the hero's power resided in the bones; for that reason, it was essential that a city or sanctuary have possession of the bones and keep them at a particular location, often hidden so that they could not be stolen. On the other hand, there is no tradition of individual bones of heroes being used to perform miracles or healing in the manner that relics of Christian saints were.

The power of the hero's bones also accounts for the fact that hero cults could be transferred from one locality to another. Several instances are recorded of a community acquiring bones in order to strengthen its political position relative to that of its neighbors. Such hero cults were clearly propagandistic, as when the bones of Orestes were acquired by Sparta.[27] Transferrals of cults were facilitated by the fluidity of myth, which allowed for the adoption or elaboration of different versions of the hero's history; this might explain why Agamemnon could be worshiped both at Mycenae, where Homer places him, and at Sparta, where he took on the guise of Zeus-Agamemnon.[28] But a hero cult could also be discontinued for political reasons. The most famous instance concerns Kleisthenes of Sikyon, who in his war with Argos sought to end the Sikyonian cult of the Argive hero Adrastos.[29] When the Pythia at Delphi disapproved of this action, Kleisthenes invited Adrastos's sworn enemy—the hero Melanippos from Thebes—to come to Sikyon; the sacrifices and festivals previously performed for Adrastos were now performed for Melanippos.

Apart from the bones, numerous kinds of objects associated with heroes were displayed and venerated in sanctuaries all over Greece, often at locations that did not house the tomb or the bones of the particular hero.[30] Such objects might include spears, shields, and other weaponry, but also ships, chariots, furniture, musical instruments, clothing, and jewelry. The egg hatched by Leda and from which the Dioskouroi, Helen, and Klytaimnestra emerged (see no. 1) was kept in the sanctuary of the Leukippides at Sparta.[31] Some of these objects were venerated, as were the scepter of Agamemnon at Chaironeia, which was presented with daily sacrifices as well as with a table laden with meat and garlands, and Ajax's panoply, which was honored in the same manner on Salamis.[32] Certain items, predominantly weapons, were brought out in wartime to frighten the enemy and ensure victory for those who possessed them.[33]

Many depictions of heroes are known, but cult statues, in the sense that we encounter them in the cult of gods, do not seem to have been as common and are found mainly in sanctuaries of important, well-known heroes, who often had substantial precincts, such as Helen at Therapne near Sparta, the Heros Ptoios at Akraiphiai, and Amphiaraos at Oropos.[34] Ajax had a shrine on Salamis, where, according to Pausanias, his ebony statue was displayed.[35] Statues of heroes were important cult objects, however, and Pausanias enumerates several heroic images that performed miracles.[36] One particularly engaging story concerns the cult of the athlete Theogenes from Thasos.[37] Theogenes was a champion in boxing at the great pan-Hellenic games at Olympia, Delphi, Nemea, and Isthmia, and he was honored posthumously with a bronze statue in his hometown. Each night, an envious and hateful local came to flog the statue. Eventually the statue punished the attacker by falling on him and killing him. The

dead man's sons prosecuted the statue for murder, and the statue was punished by drowning in the sea. When Thasos was cursed with crop failure, the oracle at Delphi ordered the Thasians to bring back all those who had been exiled from the island. After all the island's expatriated citizens had returned, the earth was still barren; the Pythia, in response to a second consultation, observed that the Thasians had forgotten Theogenes. The statue was recovered and rededicated on the agora at the same spot where it had stood earlier, and the Thasians thereafter regularly offered sacrifices to it.[38]

The cult of Theogenes has been connected with a round base found on the agora of Thasos, probably that of an altar, as suggested by the presence of a large iron ring fastened to one of the lower steps, where sacrificial animals could be tethered. A *thesauros*, a marble strong box for keeping the payments made in connection with sacrifices, was recovered nearby, bearing an inscription cautioning that those who did not deposit at least an obol when sacrificing to Theogenes would be cursed, probably sound advice to heed given the hero's power.[39]

CULT PLACES

Like the cult places of the gods, hero cults could be located anywhere: in the remote countryside, along roadsides, at city gates, or on the agora, where the cult often evoked the hero's role as the community's founder or protector. Many heroes had an intimate relationship with a god, and consequently the hero's tomb and cult were located within a god's sanctuary. These heroes were often described in myth as the institutor of the cult, the founder of the sanctuary, or its first priest or priestess. At the major pan-Hellenic sanctuaries, the cult of a hero was often connected with the games, as was the cult of Pelops at Olympia and that of Opheltes/Archemoros at Nemea.[40]

The variety of installations that could serve as hero-cult places is not surprising given the diverse character of the heroes themselves;[41] indeed, one of the distinguishing features of hero cults is their heterogeneity.[42] The local character of heroes often informed the layout of their cult places, and local conditions and traditions seem to have figured more prominently at the sanctuaries of heroes than at those of the gods.

Many installations connected with heroes consisted of nothing more than a tomb, a statue, or a stele, and both written and archaeological evidence attests that these monuments were not necessarily the focus of sacrifices or offerings. A monument commemorating Glaukos, one of the Parians who colonized Thasos in the late seventh century BCE, has been found at the eastern corner of the city's agora (fig. 76).[43] It consists of a simple two-stepped stone construction of poros stone, gneiss, and marble blocks, one of which bears the inscription: "I am the monument (*mnema*) of Glaukos, Leptinos's son. The sons of Brentes dedicated me."[44] The monument occupied a prominent position in the public area of the agora, at the crossroads of two important routes, and was visible from all directions. When the surroundings changed, the monument was still preserved and venerated, raised in the latter half of the sixth century and perhaps also moved. In the fourth century BCE, a stoa was constructed along the eastern side of the agora encompassing the Glaukos monument within and with the northern wall

of the building even traversing the monument.[45] This stoa was in use until imperial times, though the inscribed stone could apparently no longer be seen. Nonetheless, the location, if not the monument itself, seems to have been remembered and was probably venerated as a cult of a heroic founder of the settlement.

Even as modest an object as a boundary stone (*horos*) could define a site where a hero was worshiped.[46] Small precincts enclosed by a blind wall (*abata*) have been identified (albeit ambiguously) as hero-cult places, such as a number of triangular or semi-circular enclosures on Delos and on the Athenian Agora.[47] In the case of the so-called Leokorion in the Agora, offerings were dropped by the worshipers over the walls of the square enclosure onto a large, flat boulder in the center.[48] At Argos, an early hero cult to the Seven against Thebes was marked by a series of simple stone posts connected by wooden bars forming a fenced enclosure (fig. 77).[49] One of the posts carried an inscription, which can be dated to the mid-sixth century BCE, reading "Of the heroes fallen at Thebes." Interestingly, the stone posts were reused in the fourth century CE to surround a large pit, measuring 6.5 × 2.6 meters and approximately 60 centimeters deep, filled with ashes covering a layer of calcined logs. This late Roman installation probably also represents some kind of cult, perhaps even the hero cult described by Pausanias as the "Fire of Phoroneus."[50]

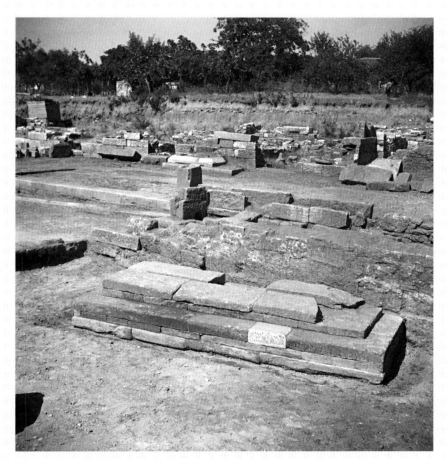

FIG 76 Heroön of Glaukos, Thasos, ca. 600 BCE

FIGS 77A AND 77B Inscribed stone post from the *heroön* of the Seven against Thebes, Argos, ca. 550 BCE. From A. Pariente, "Le monument argien des Sept contre Thèbes," *Polydipsion Argos* (BCH Supp. 22), ed. M. Piérart (Paris 1992), pl. 36 and fig. 2

FIG 78 Plan of the Heroön of the Cross-roads, Corinth, sixth century BCE. Drawing by C. K. Williams. From C. K. Williams, J. MacIntosh, and J. E. Fisher, "Excavations at Corinth," *Hesperia* 43, no. 1 (1974): 2

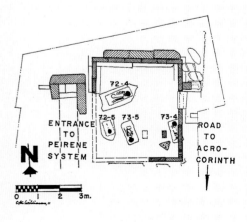

Many hero cults consisted of minor enclosures that contained an altar or an offering table, in which few worshipers could have been present during the rituals, as in the Stele shrine and the Heroön of the Crossroads at Corinth.[51] The latter shrine (fig. 78) was a rectangular peribolos of orthostats (3.77 × 4.48 m) erected in the sixth century above four Proto-Geometric tombs.[52] The entrance was to the east; supports for an offering table were found within the precinct, as well as a triangular stone slab with three cuttings, presumably a base for a tripod or a perirrhanterion. The finds were rich: pottery, such as amphorai and phialai, figurines of horses and riders, banqueters, small stelae with snakes, females holding doves, and seated females. Two round pits beneath the first floor of the shrine contained ash, some bone, and a little pottery. The recipient of the cult is unknown but must certainly have been of considerable importance, as the shrine was in use until the destruction of Corinth by the Romans in 146 BCE.

Several important and well-known hero cults were large, enclosed areas with little or no formal architecture. The heroön of Opheltes/Archemoros in the Sanctuary of Zeus at Nemea consisted of a pentagonal area surrounded by a low wall and entered by a simple propylon in the northeast (fig. 79).[53] Originally constructed in the early sixth century BCE around an artificial mound, the precinct was equipped with a wall of limestone orthostats in the early Hellenistic period (late fourth or early third century BCE). Within the enclosure was an oblong structure of boulders, filled with large amounts of ash, animal bones, and votives, perhaps functioning as an altar or to be identified as the tomb of the child hero. Some large cut blocks might have served as offering tables or altars. The simple appearance of this hero shrine may seem surprising, given its location within a pan-Hellenic sanctuary of a major god, but the Sanctuary of Pelops at Olympia had a similar, polygonal layout, although it was centered on an Early Bronze Age mound, presumably acknowledged as the burial tumulus of the hero, at least from the late Archaic period.[54] There are no traces of architecture within the Pelopion, but it was embellished with an elaborate propylon and a wall during the Classical period.[55] The cult place of the important local Delian hero Anios or Archegetes consisted of a walled courtyard with a peristyle, in the center of which was a heap of ashes, where the sacrifices were performed.[56] On Paros, the fourth-century heroön of the poet Archilochos was a templelike building with four columns in the front and a large entrance, whose elevation would have made it difficult to access.[57] Inside was placed an Archaic, mid-sixth-century Ionian column, presumably marking what tradition identified as the hero's grave.

The specific activities connected with the cult of the hero may also have informed the layout of the sanctuary, as when the hero was specifically associated with the healing of diseases. At Rhamnous, on a hill facing the fortress on the acropolis, a small cult place for a healing hero (fig. 80) may have been used as the hospital for the garrison.[58] The hero, originally called Aristomachos, was identified in the fourth century BCE with the more famous healing hero Amphiaraos of Oropos. An inscription from the last quarter of the third century BCE, which records an attempt by the hero's worshipers to collect money for the repair of the dilapidated sanctuary (the door was missing and the

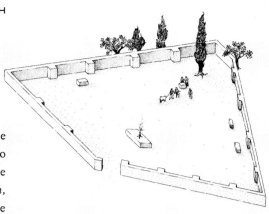

roof had collapsed) mentions an *oikos*, a statue of the divinity, an altar, a sacred table (*trapeza*), and a building called a *prostoion*.[59] The excavated remains extend over two terraces. The western structure can be identified as the *oikos*, where the hero's statue and table were housed, while the building to the east is presumably the *prostoion*, which served as sleeping quarters for the sick who visited the hero in order to be healed. The altar, of which no archaeological traces remain, was presumably situated in the middle. Among the finds are statue heads of a bearded male figure, presumably Aristomachos/Amphiaraos, and votive reliefs showing worshipers consulting the hero.[60] Such votive offerings were placed along the southern wall, toward the slope of the hill, on the evidence of the cut marks in the rock.[61]

Certain hero sanctuaries resembled those of a god, complete with a stone temple and auxiliary buildings. The Menelaion at Sparta, where Helen and her husband, Menelaos, were worshiped,[62] consisted of a massive, rectangular platform, measuring

FIG 79 Reconstruction of the heroön of Opheltes/Archemoros, Nemea, late fourth or early third century BCE. From S. G. Miller, ed., *Nemea: A Guide to the Site and the Museum* (Berkeley, 1989), 106, fig. 35

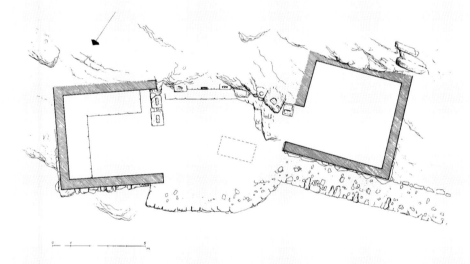

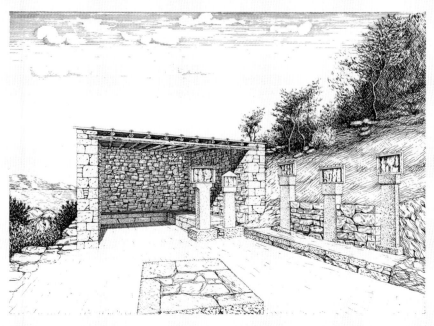

FIG 80 Plan and reconstruction of the healing shrine of Aristomachos/Amphiaraos, Rhamnous, fourth–third century BCE. From V. Petrakos, *Rhamnous* (Athens 1991), 52, figs. 36, 37

almost 15 × 20 meters and at least 5 meters high, accessed by a ramp (see p. 22, fig. 6). On the top there may have been an altar, statues, or even a small temple. The sanctuary of the less celebrated Heros Ptoios in Boeotia had at least two altars, a small temple (probably housing the cult statue), and a stoa, where the worshipers could eat and sleep and where votives might have been kept (fig. 81).[63] Along the access routes to the sanctuary were two rows of stone columns, dating from the late sixth to the mid-fifth century, supporting at least twenty-nine monumental tripods, some of which would have been between 1.5 and 2.5 meters high.[64] Similar elaborate architectural arrangements are found at the Sanctuary of Hippolytos at Troizen and at the Amphiareion at Oropos, graced by a large theater in addition to a temple as well as a large stoa, where visitors would have slept when consulting the hero.[65] The Herakleion on Thasos (fig. 82), founded in the seventh century BCE, was originally centered around a rock altar. During the Classical period, the sanctuary grew to include a five-room *hestiatorion* (dining hall) to the south, a gallery to the east, and a rectangular *oikos* to the north, which may originally have served as a dining room for the more prestigious participants; it was later transformed into a temple by the addition of a colonnade.[66]

CULT PRACTICES: DESTRUCTION OR CONSUMPTION?

The fact that a Greek hero was a person who had lived and died, whether in myth or in real life, and received some kind of posthumous religious attention clearly set him off from gods as well as from the ordinary dead. Gods were immortal and ubiquitous; in most instances, they were worshiped throughout Greece and Hellenic territory. The ordinary dead, on the other hand, were powerless shades of the underworld, locally confined and intimately connected to the families to which they had once belonged. Heroes stood between these two groups and had traits in common with both: they were dead but still divine. To what extent this informed the manner in which heroes were worshiped is a complex and much-debated issue.

Numerous scholars of Greek religion have maintained that heroes are very different from gods and more closely related to the dead, a distinction assumed to be attested by sacrificial rituals.[67] In hero cults, these rituals are thought to have consisted of holocausts on low hearth-altars, libations of blood poured into offering pits, and the presentation of various kinds of cooked food. Animal sacrifice concluding with a meal at which the meat was consumed has been considered a rare and exceptional feature of hero cults. The sacrificial actions, as well as the altars and installations used, had their own terminology, which was reserved for hero cults, cults of the dead, and the gods of the underworld.

Within the last several decades, however, this view of hero-cult ritual has changed substantially. The traditional notion of sacrifices to heroes was based almost exclusively on the literary sources, inscriptions being considered to a lesser extent and archaeological evidence only sparingly. This method is problematic, as texts from Homer to late Roman authors, as well as scholia and lexica, have been adduced as evidence with little or no consideration of any differences in the date and character of the various sources; the information gleaned from Roman or even Byzantine authors

FIG 81 Kantharos dedicated to Heros Ptoios from Ptoion, Boeotia, ca. 500 BCE. From J. Ducat and C. Llinas, "Ptoion, sanctaire du héros," BCH 88 (1964): 862, fig. 19

has been considered valid for conditions during the Archaic and Classical periods. Furthermore, the theoretical approach to heroes and their cults has been dominated by the understanding of Greek religion as divided into an Olympian and a chthonian sphere, viewed as opposites. According to this model, the gods of the sky were fundamentally different from the gods of the underworld, heroes, and the dead, a distinction particularly evident in ritual practices, terminology, and cult places.[68] This dichotomy, however, has increasingly been called into question, particularly with respect to sacrificial rituals, since this model seems too restricted to reflect the variations within Greek ritual practice and therefore risks creating a polarity that the ancient evidence does not in fact support.[69] Recent scholarship on hero cults has considered a broader range of evidence: literary texts, inscriptions, iconography, archaeology, as well as osteological remains. In addition, understanding the ritual practices of the Archaic and Classical periods requires a primary focus on contemporary sources. The conclusion of this reevaluation is that the sacrificial rituals of hero cults during these periods were very similar to those of the gods.[70]

MEAT BANQUETS

The principal ritual of hero cults was an animal sacrifice that concluded with a meal at which the worshipers consumed the meat. Sacrifices are described by the terms *thyein* and *thysia,* standard terms used in the cult of the gods.[71] A particularly explicit case is a mid-fifth-century Athenian decree of the cult association of the hero Echelos and his female (unnamed) companions.[72] This document stipulates a sacrifice of a piglet and two "full-grown" animals, probably sheep. The division of the meat is set down in detail. Members of the cult association who were present at the sacrifice were each to receive a full portion of meat, while their sons, wives, and daughters seem each to have been given at least a half-portion. A number of regulations governing hero cults outline the distribution of meat to various categories of worshipers, as well as the distribution of the perquisites for the priests; some cults even had a *hestiator*—a designated person in charge of the practicalities at the sacrifice and especially the handling of the meat.[73] The fact that meat from sacrifices to heroes had to be either consumed in the sanctuary or sold is further evidence that the destruction of the victims was not the standard ritual of hero cults.[74]

That dining constituted an important part of the ritual at a hero sacrifice is also evident from the presence of dining facilities. The Herakleion on Thasos was equipped with a series of dining rooms (see above and fig. 82), and the earliest architecture at this sanctuary, a broadroom structure dating to about 650–600 BCE, may in fact have been a *hestiatorion* and not a temple.[75] The pottery recovered in many cult places for heroes also makes clear that eating and drinking were a major feature of the cults, as do other finds, such as the *kreagra,* an instrument for lifting pieces of meat from the cauldron and distributing them to the worshipers, recovered at the Menelaion at Sparta (fig. 83).[76] A relief from the sanctuary of Pankrates in Athens shows two children or assistants grilling meat on spits on an altar or hearth (fig. 84).[77] The osteological evidence as well may elucidate the sacrificial practices of hero cults. Particularly

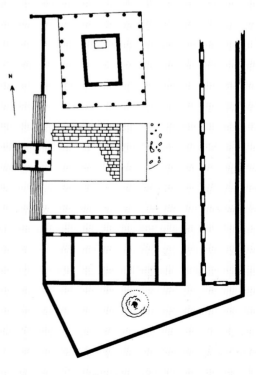

FIG 82 Plan of the Herakleion on Thasos, early/ mid-fifth to late fourth/early third century BCE. From B. Bergquist, *Herakles on Thasos,* Boreas 5 (1973): 46, fig. 7

FIG 83 Bronze *kreagra* (meat hook) with dedication to Helen from the Menelaion, sixth century BCE. Sparta Archaeological Museum, M 101

FIG 84 Worshipers grilling meat. Votive relief from the Sanctuary of Pankrates, Athens, ca. 310–300 BCE. Athens, Fetiye Camii, P 68. Neg. D-DAI-Athen 1993/1213

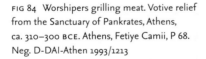

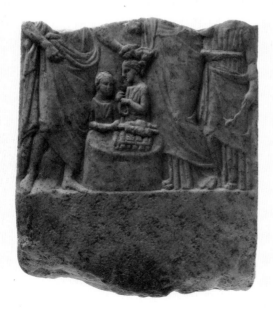

interesting are the bones recovered at the Herakleion on Thasos, which indicate that the animals sacrificed had been eaten in the sanctuary.[78]

The layout and furnishings of hero-cult shrines attested in the epigraphical material further emphasize the centrality of ritual meals. A lease regarding the property of Egretes, an Athenian hero known only from this unique inscription, describes the facilities of his precinct and offers an insight into the practice of his cult.[79] There was a *hieron* (cult building) and an unspecified number of *oikiai*, presumably dining rooms. When the members of the cult association performed their annual sacrifice to the hero, the tenant was to allow them use of these buildings as well as two structures designated *stege* and *optanion*, and couches and tables sufficient for two dining rooms (*triklinia*). The *optanion* must have been a kitchen, while the *stege* was probably a small stoa or portico where couches and tables could have been placed.[80] There would have been sufficient reclining space for twelve to thirty people, depending on how many used each couch, but if more members were present than could have been accommodated by the couches, some might have eaten their meal seated on the ground under the trees that grew within the shrine and that the tenant also had to take care of.

A LADEN TABLE AND A COUCH

Besides animal sacrifice of the *thysia* kind, heroes also received *theoxenia*: offerings of the sorts of food eaten by men. This ritual might consist simply of a table of offerings (*trapeza*) or a more elaborate version, in which, in addition to the table with cooked food, a couch was prepared and the divinity was invited to participate in the ritual as an honored guest at a banquet.[81] The objective of *theoxenia* has been extensively discussed, but the ritual's intent seems to have been to bring the object of cult closer to the worshipers by diversifying and increasing the range of offerings.[82]

When mentioned in calendars listing the costs for sacrifices to heroes, such tables are often priced inexpensively, an indication that the offerings did not include meat, as was the case for the *theoxenia* for the Dioskouroi in the Athenian Prytaneion, who were offered cheese, barley cakes, ripe olives, and leeks.[83] The hero Kylabras at Phaselis in Pamphylia received offerings of smoked or salted fish (*tarichos*), presumably also an indication of a *theoxenia* ceremony.[84] In minor cults and private contexts, *theoxenia* or the offering table alone seems to have been a popular, less expensive alternative to animal sacrifice. In some cults, the male, principal hero received an animal offering, while his female, anonymous companion or companions had to settle for just a table.[85] If the *theoxenia* took place in connection with a *thysia* sacrifice, portions of cooked meat were surely placed on the table as well, particularly in official hero cults, where *theoxenia* often functioned as a complement to a *thysia* and as a way of substantiating the latter ritual; such was the case in the cult of the hero Echelos, where the hero, in addition to offerings of animals, had a table prepared for him.[86] The presence of a major state festival on Thasos called the Heroxenia shows that the ritual could be performed on its own as well.[87]

Theoxenia required particular equipment, and some sanctuaries had elaborate permanent marble tables where the offerings could be deposited, as was the case at the

Amphiareion at Oropos.[88] A fourth-century inscription from the Athenian Agora lists the belongings of an unnamed hero, presumably to be used in such a ritual: a double-headed couch, a mattress, a bedspread, a smooth rug, four pillows, two kinds of cloths, and several silver vessels.[89] Herakles Diomedonteios, worshiped on Kos, also had his own *theoxenia* equipment, consisting of two lampstands, two lamps, a grill, a mixing bowl for wine and water, a rug, a table, three incense burners, and a couch, as well as five gilt wreaths for the statue and two clubs.[90] The setup of the ritual can be imagined from a second-century BCE relief from Larissa (fig. 85), which depicts the double-headed couch and the table covered with cakes and bread, while the Dioskouroi are seen riding by in the sky above.[91]

The popularity of *theoxenia* is also evident from the number of votive reliefs that show a hero reclining at a table laden with food (so-called *Totenmahl* reliefs), approached by worshipers, sometimes bringing an animal victim as well (nos. 68, 69).[92] The procession often ends with a female servant carrying a large basket (*kiste*), on

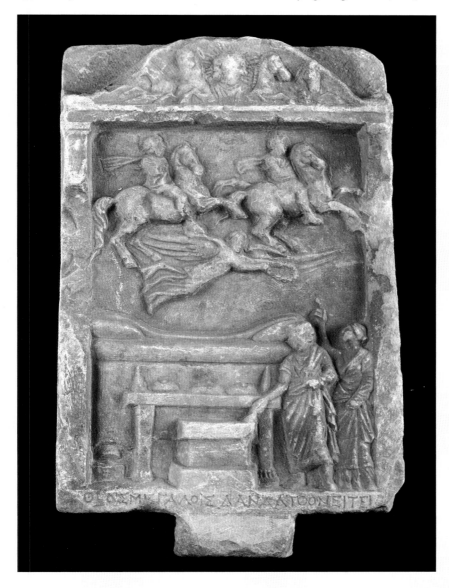

FIG 85 The Dioskouroi arriving at a *theoxenia* ceremony. Votive relief from Larissa, second century BCE. Marble. Paris, Musée du Louvre, M 746

her head, perhaps containing offerings such as cakes. It is noteworthy that the food on the table in these reliefs never seems to include meat of any kind—only cakes, bread, and fruit. Votive reliefs such as these were predominantly the gifts of private individuals or families, commemorating private sacrifices. Apparently it was felt more important to show the animal victim as alive and intact, thereby displaying the true magnitude of the offering, than to depict it cut up and transformed into food, although portions of meat eventually would have ended up on the hero's table.[93]

The iconographic evidence suggests that *theoxenia* was particularly popular in specific hero cults, such as that of Herakles. Numerous vase-paintings show Herakles reclining at a table from which huge slabs of meat hang down, perhaps a reference to the hero's legendary appetite but also attesting to the prominence of *theoxenia* in his actual cult.[94] A further indication of the link between Herakles and *theoxenia* can be found in votive reliefs and vase-paintings that show the hero next to a monument consisting of four columns placed on a stepped base and linked by a roofless architrave.[95] Such a structure, a *Säulenbau*, or tetrastylon, is clearly visible on a relief from Athens (no. 62), where we see the hero leaning against his club, while two worshipers approach him from the right bringing animal victims, an ox and a sheep. The tetrastylon would have sheltered the hero's table and couch during the *theoxenia* ritual performed on his behalf.[96]

BLOOD

An emphasis on the blood of the victim has commonly been regarded as an important aspect of the sacrificial practices for heroes. A closer look at the evidence, however, shows that libations of blood seem to have been of relatively minor importance. At regular *thysia* sacrifices to heroes, the blood was kept, prepared, and eaten, just as it was at animal sacrifices to gods.[97] In a few instances, the standard animal sacrifice to a hero was modified by a particular handling of the blood, usually by discarding it, an action that is designated by a specific terminology that emphasizes the technical aspects of this procedure.

The cult of Pelops at Olympia involved a bloodletting, according to our primary source, Pindar's first Olympian ode (90–93). The ritual described by the poet can be interpreted as consisting of a *thysia* sacrifice elaborated by a *theoxenia* element, but the entire ceremony was initiated by pouring out the blood of the victim(s). The term used is *haimakouria*, a very rare word; presumably this action took place on the prehistoric mound within the Pelopion, the shrine of Pelops, perhaps into a pit, a *bothros*, that had been dug for this particular occasion.[98] The act of pouring out the blood on this occasion, as well as in other instances when this action is attested, seems to have been intended as a vehicle for contacting and inviting the hero, perhaps also for invigorating him, and ensuring his presence at the sacrifice and in particular at the *theoxenia* ceremony.[99]

Most heroes for whom libations of blood are attested seem to have had a particular connection with war. The handling of the blood in these cults may have underscored this association by recalling the bloodshed of battle as well as the sacrifices

that took place on the battlefield, *sphagia*, at which the animal's throat was cut and the blood flowed freely in order to divine the outcome of the struggle.[100] An interesting inscription from Thasos enumerates the honors that are to be shown the citizens who died for their country, hereafter called the Agathoi, "the good men":[101] a public funeral, sacrifices, an official listing of their names, games, and financial contributions by the city for the care of their orphaned children. The sacrifices are called *entemnein*, which in this context is best understood as referring to a ritual at which the victims were killed and bled without the blood being kept. The blood may have been offered as a libation on the tomb of the Agathoi, while the meat was eaten at a public banquet to which the fathers and the sons of the fallen were invited.[102]

A late fifth-century silver coin from Syracuse (fig. 86) may allude to the ritual practice of discarding the victim's blood in a specific manner and at a specific location followed by the consumption of the meat.[103] The hero Leukaspis, naked apart from his helmet and a shield, advances with a spear in his right hand. Behind him is a burning altar, while on the ground a ram lies on its back, the throat slit so deeply that the head has been almost severed. The motif is intriguing, as scenes of animal sacrifice are almost never shown on Greek coins.[104] The presence of the altar excludes the possibility that a battlefield *sphagia* is intended, while the depiction of the animal dead on its back evokes a ritual different from a regular *thysia*, as the iconography of this ritual does not seem to have included the depiction of the dead victim near the altar. A particular sacrifice, such as a *thysia* modified with a blood ritual, may be what is depicted here. Leukaspis was a local Sicanian or Siculian warrior who was killed together with a number of other military leaders when defending their territory against the invading Herakles; they later were venerated with *heroikai timai* (heroic honors).[105] The coins depicting Leukaspis were apparently minted in connection with the Sicilian victory over the Athenians in the war of 415–413 BCE, an event at which it would have been appropriate to worship a local hero connected with war.

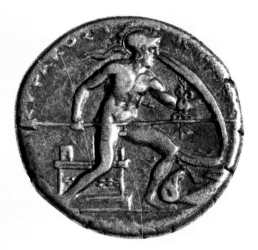

FIG 86 Recto of silver drachm of Dionysios I from Syracuse showing hero Leukaspis at altar and a slain ram, struck ca. 410–405 BCE. Munich, Staatliche Münzsammlung

DESTRUCTION BY FIRE

Though the handbook literature frequently claims that the victims sacrificed to heroes had to be entirely destroyed by burning, and that no part was to be consumed by the worshipers, as the meat was considered unclean and unfit to be eaten, such holocaust rituals for heroes are only rarely attested in Archaic and Classical sources.[106] It is noteworthy that complete or partial destruction of the animal victim by fire was practiced in the cult of the gods as well, in particular that of Zeus.[107] Rituals at which the victims were destroyed often seem to have been performed in times of crisis, when this extraordinary type of sacrifice would have been intended to remedy specific problems.[108]

Destruction sacrifices to heroes fall under the term *enagizein*, which is also used in the cult of the dead. This terminology seems to imply that the offerings were completely burnt, but it also emphasizes the dead and therefore impure character of the heroes receiving such sacrifices.[109] Herakles, for example, called both a hero and a god in the sources, could receive a combination of *thysia* and *enagizein* sacrifices in

recognition of his dual character as both an immortal god and a mortal hero.[110] In general, however, this "mortal" aspect of Herakles seems to have been relegated to myth and in cult Herakles was usually treated as a god.[111] The animal bones recovered at the Herakleion on Thasos are not the remains of holocaustic sacrifices but the leftovers from meals.[112]

In some hero cults, the *thysia* sacrifices that concluded with dining were modified by burning a quantity of the meat or of a particular victim, usually a portion smaller than the one that was to be eaten, a partial destruction that has been termed *moirocaust* by a modern scholar.[113] A particular kind of *moirocaust* specific to hero cults involved burning a ninth of the meat of the sacrificial victim. An extensive sacred law from Selinous on Sicily prescribes a sacrifice to the "impure" Tritopatores (the collective ancestors) to be performed "as to the heroes" and stipulates that a ninth of the meat is to be burnt.[114] This practice is also encountered on Mykonos according to a sacred law dated to around 200 BCE, which states that an *enateuein* (nine-part) sacrifice is to be performed to Semele; two inscriptions from Thasos use the same term regarding the cult of Herakles.[115]

The scarce evidence for destruction sacrifices in hero cults is less surprising if we consider the importance of heroes within the broader parameters of Greek cult. The actual number of sacrifices to heroes documented in our sources and the amount of money spent on these make clear that heroes fulfilled the same role as the gods within the Greek religious system. The prominence of heroes is particularly evident in the epigraphical evidence, and the Attic material serves as a case in point. In the four best-preserved sacrificial calendars, among the 170 or so sacrifices listed, 40 percent were directed to heroes, and the cost for the victims constituted 38 percent of the total budget.[116] If these sacrifices had not been of the alimentary kind, more than a third of all animals slaughtered by these communities or cult groups would literally have gone up in smoke. Considering the close connection between animal sacrifice and the distribution and consumption of meat, and the political and social structure of Greek society, such a waste of meat seems highly implausible.[117]

ALTARS: TEXT VERSUS IMAGE

The difficulties arising from interpreting the rituals of hero cults on the basis of the literary evidence alone, without consideration of its date and character, and from using the Olympian-chthonian model uncritically, become evident when the definitions derived from the texts are applied to the archaeological and iconographic evidence.[118] The shapes and appearances of altars in hero cults serve as a good example of these methodological concerns.

The Greek terminology for altars is rich, the most frequent term being *bomos*, but an altar could also be called *eschara*, *thymele*, or *hestia*. A prominent feature in the study of hero cults has been the assumption that heroes had particular altars, distinct from those of the gods, and scholars have tended to posit a clear distinction between *bomos* and *eschara*, the former being associated with the Olympian gods of the sky, and the latter with the chthonian gods of the underworld as well as with heroes.[119]

This distinction, based on the literary sources, has been perceived as applicable also to iconographic and archaeological evidence. Literary texts describe a *bomos* as tall, built up, and constructed of cut blocks. An *eschara*, on the other hand, is said to be low, of simple construction, or even a hole in the ground.[120] Consequently, tall square or rectangular altars, whether preserved examples or depictions in vase-paintings and reliefs, have been identified as *bomoi*, whereas low altars, either mound-shaped or constructed of heaps of fieldstones, have been termed *escharai*. Such identifications have been taken as additional support for the validity of the view of heroes as distinct from gods in accordance with the Olympian-chthonian model. Furthermore, the different kinds of altars have also been linked to different kinds of rituals, a *bomos* being an indication of alimentary *thysia* sacrifices, while an *eschara* evokes holocausts or libations of blood.

The problems with this construct are many, however. The textual sources that thus define *bomos* and *eschara* are mainly Roman or even Byzantine lexicographers and grammarians or the scholia—the often undatable comments in the margins of preserved manuscripts.[121] Closer scrutiny shows that this neat picture is not compatible with the evidence from the Archaic and Classical periods. In the literary sources and inscriptions from these periods, the usual term for an altar is *bomos*, in the cult of the gods as well as in hero cults.[122] *Eschara* could be used for the upper part of a *bomos*, where the fire was kept, often made of a different kind of material, such as a metal tray or a slab of fire-resistant stone, but there is no indication of the term implying any rituals other than alimentary *thysia* sacrifices.[123] In hero cults, the term *eschara* could also be used for a simple kind of sacrificial installation, perhaps no more than a spot of ash on the ground. A boundary stone from Porto Raphti in Attica bearing the inscription "The *eschara* of the Herakleidai" (the children of Herakles) could have marked such a location.[124] In the sanctuary of the hero Anios on Delos, a large ash altar of this kind was found in the structure, labeled *escharon*, a term that seems to have been a Delian equivalent for *hestiatorion*, that is, a building where ritual meals took place.[125] An *eschara* in a hero cult can therefore be taken as a sign of the simple nature of the altar but it does not imply any particular rituals.

The iconographic evidence does not support the traditional distinction between *bomos* and *eschara* derived from the literary sources. Most altars depicted on reliefs and vases are rectangular or square, or occasionally cylindrical, and seem to represent either monolithic cut blocks or constructions built of slabs of stone.[126] There is also a smaller group of mound-shaped altars, either low and flat or high and omphalos- or egg-shaped, as well as altars shown as constructed of loose, often large, fieldstones.[127] On the vases, both the mound-shaped and fieldstone altars, like the rectangular and square altars, are clearly rendered as being used for regular *thysia* sacrifices. That a *thysia* sacrifice is taking place is evident from the *osphys* (the animal's sacrum and tail) burning and curving in the fire on these altars, as this part was to be burnt for the gods at such sacrifices (fig. 87).[128] Furthermore, an Archaic black-figure amphora depicts a mound-shaped altar that is clearly labeled *bomos*.[129] On the votive reliefs, mound-shaped altars are shown in connection with both libations and preparations for animal

FIG 87 Bearded man pouring a libation. Attic red-figure Panathenaic amphora attributed to the Group of Polygnotos, ca. 420 BCE. Cambridge, Mass., Harvard University Art Museum/ Arthur M. Sackler Museum, bequest of David M. Robinson, 1960.371

sacrifice, the same kind of actions depicted as being performed at high, rectangular altars.[130] A votive relief from Tanagra (no. 67) showing a hero and a heroine libating at a rectangular, high altar, can be compared with a relief from Thasos (see fig. 75), in which we see the same action, although the altar is mound-shaped. Reliefs from the same sanctuary may also depict both the usual rectangular altars and the mound-shaped or fieldstone altars, as is the case at the sanctuary of Pankrates at Athens.[131]

Though altar shapes cannot be taken as an indication of a specific kind of ritual in hero cult, it is possible that they could have functioned as markers of a cult's particular setting or character. Perhaps the simpler mound-shaped altars or those constructed of fieldstones were considered as older and more venerable than the square altars, a hypothesis strengthened by the fact that fieldstone altars on the vases are found only in scenes showing sacrifices set in the mythic past.[132] It is also possible that the shape and appearance of these altars were meant to suggest that the cult did not take place in an elaborate, formal sanctuary. An ad hoc altar composed of a large boulder or a heap of stones accords with the character of hero cults, which, judging by the archaeological remains, often were housed in simpler settings than the cults of the gods and had simple sacrificial installations.

LOCAL HERO(ES)

The cult of heroes offered worshipers a means to express local traits and needs— social and political as well as religious—in a different manner than did the cult of the gods. The diversity of the heroes' mythical or historical backgrounds was an important element of their cult, and this heterogeneity is reflected in the variations in size and appearance of hero shrines. Hero cults had a flexibility that enabled them to be adapted to particular situations or needs; therefore the local perspective is an important consideration when looking at hero cults.

This local prominence of the hero cults is most evident in the rich epigraphic evidence from throughout Greek territory, and the sacrificial calendars from the Attic demes offer particular insights into the significance of these cults. In the calendar of the deme Thorikos, on the eastern coast of Attica, the most expensive offerings, two cows or oxen, were to be sacrificed to heroes: to the eponymous hero Thorikos and to Kephalos, who was intimately connected with the deme in myth.[133] The importance of these two heroes is further underlined by the fact that both also received a sheep on another occasion during the year. In the calendar from Marathon, the most expensive annual sacrifices were also given to heroes: Neanias and a hero whose name is only partly preserved ([]-nechos).[134] Neanias received a cow or an ox, as well as a sheep and a piglet, costing in total 105 drachmas, while the cow or ox and sheep sacrificed to the hero []-nechos cost 102 drachmas. The sacrifices to these two heroes constituted almost a third of the deme's annual sacrificial budget.[135]

However, the heroes' importance in cult is evident not only from the fact that they were given large and expensive sacrificial offerings but also from the specific local character of many of these heroes. Inscriptions document many examples of heroes who were so intimately connected to the local topography that they did not

bear personal names but were called "the heroes in the field," "the hero at Antisara," and "the heroines at Schoinos," to name a few.[136] Anonymous heroes and heroines are mentioned in dedications, sacrificial calendars, and sacred laws or depicted on votive monuments. These figures presumably were known and identified, and perhaps also named by the worshipers, but they were of little or no concern outside the context of their particular cults.[137]

It is possible that one of the attractions of hero cults, apart from their intimate connection to specific locations, was the fact that the heroes were perceived as being able to help on a local or personal level, since they had once been men or women who had led a kind of "human" existence. The importance of heroes as curers of disease and illness is evident; even the main healing god, Asklepios, was originally considered a mortal hero who was elevated to immortality by Zeus. But a hero's connection with his worshipers was also personal: he could be an individual whose anger once had threatened the community but had been appeased by cult and who now was a guardian and a protector.

In many cases, hero cults served to underline and strengthen the participation of a specific group of worshipers, be it a segment of the population, such as a tribe, a community, such as a deme, or a private cult association. The modest size of many hero-cult places indicates that they catered to needs of a particular group, as they could have been frequented only by a small number of people at any given time, a possibility confirmed by the epigraphic evidence for private cult associations focusing on heroes.[138] But an entire polis might have wanted to emphasize its coherence through hero cult by limiting access to those who held the status of "citizen," as was the case with in the cult of Anios on Delos, where the entrances to the hero's walled precinct carried the inscription "Foreigners (xenoi) are not allowed to enter."[139] Participating in the sacrifice to the hero and, most of all, in the consumption of the victim's meat clearly marked who belonged and who did not.

NOTES

1 Pausanias 6.9.6–9. Tereus, a similarly abhorrent hero, worshiped in Megara, raped his sister-in-law and cut out her tongue to prevent her from reporting the crime. As a punishment, he was served his son Itys for dinner, after which he committed suicide (Pausanias 1.41.8, 10.4.10).

2 Larson 1995, esp. 101–30; Lyons 1997.

3 See Larson 1995, 43–57. Several such pairs are evidenced in the sacrificial calendars of Attica. Some of these female figures are unnamed; they are called the heroine(s) of so-and-so. See *NGSL* 1, lines 28–30 and 48–51; *LSS* 20, line 14.

4 Pache 2004, 95–134, who also discusses other cases of heroic children receiving cult.

5 Pausanias 1.32.4–5; Jameson 1951.

6 Townsend 1955, 195–96 and 218–19. For the veneration of heroes at Mycenaean graves, see Antonaccio 1995; Boehringer 2001.

7 For Mycenae, see Cook 1953; Knauss 1997. For Therapne, see H. Catling 1976; H. Catling 1976–77. On tombs and Bronze Age remains as factors in the rise of hero cults, see Coldstream 1976; Antonaccio 1995; Boehringer 2001.

8 For these categories, see Malkin 1987; Clay 2004; Bohringer 1979; Fontenrose 1968; Visser 1982; Connolly 1998. For the heroization of historical figures, see Boehringer 1996; Currie 2005, 89–200.

9 Johnston 1999, 127–99; Larson 1995, 131–44.

10 This pattern is particularly clear at institutions of cults of athletes and former enemies; see Boehringer 1979; Fontenrose 1968; Visser 1982; Larson 1995, 131–44.

11 Ambramson 1978; Pariente 1992, 205–16; Deoudi 1999; Antonaccio 1995, 145–97; Boehringer 2001; Seifert 2005; *ThesCRA* 2:131–58, s.v. Heroisierung.

12 Kearns 1992, 65–67; Larson 1995, 9–13.

13 On monumental tombs, see Fedak 1990; Kader 1995; Schörner 2007; *ThesCRA* 2:151–58, s.v. Heroisierung. For the exceptional second-century heroön at Kalydon, see Dyggve, Poulsen, and Rhomaios 1934. On Hellenistic hero cults in general, see Hughes 1999.

14 Neoptolemos: Pausanias 1.4.4, 10.24.6; Heliodoros *Aethiopica* 3.10. For suggested identifications, see Pouilloux 1960, 49–60; Roux 1987, 141–43; Jacquemin and Laroche 1990; Bommelaer and Laroche 1991, 195 and 200 (no. 507); Funke 2000, 87–94.
 Phylakos: Herodotos 8.39; Pausanias 10.8.7; Bousquet 1963, 191–92. For suggested identifications, see Homolle 1901; Demangel 1926, 105; Vallois 1928; Widdra 1965; Le Roy 1977; Bommelaer and Laroche 1991, 52.

15 On the methodological difficulties in identifying a hero cult from the archaeological evidence, see Ekroth 2003, on the particular case of Iphigeneia at Brauron.

16 Bérard 1969; Bérard 1970; Auberson and Schefold 1972, 75–90; Ekroth 1998, 123; *Eretria* 2004, 172–75.

17 Bérard 1972.

18 For burials within cities, see Martin 1951; Kader 1995; Schörner 2007. For hero cults located within gods' sanctuaries, see Pfister 1909–12, 450–59; Vollgraf 1951; Kearns 1992, 77–93.

19 Regarding hero cults for living humans, see Currie 2005.

20 Euripides, *Heraclidae* 1026–36, 1040–43.

21 *TrGF*, fr. 370, lines 77–89.

22 Hägg 1987, 94–96.

23 The votive material from the Agamemnoneion at Mycenae, for example, has been adduced as evidence for the sanctuary belonging to Agamemnon, to Hera, or to both jointly; Cook 1953; Morgan and Whitelaw 1991, 89; Hall 1995, 601–3; Boehringer 2001, 201–2.

24 Salapata 1993, 1997 and 2006; Hibler 1993; van Straten 1995, 92–100.

25 Plutarch, *Theseus* 36.2; McCauley 1999, 87, 93. It is possible that the discovery of prehistoric bones or fossils lay behind some stories or may even have given rise to cults; see Mayor 2000, 110–21.

26 Pausanias 5.13.6, 6.22.1.

27 Herodotos 1.66–68; Boedeker 1993; McCauley 1999.

28 Hall 1999.

29 Herodotos 5.67.

30 For the evidence, see Pfister 1909–12, 331–39.

31 Pausanias 3.16.1.

32 Scepter of Agamemnon: Pausanias 9.40.11. Panoply of Ajax: scholia on Pindar, *Nemean Odes* 2.19 (Drachmann).

33 See examples given by Pfister 1909–12, 337–39.

34 Helen: Herodotos 6.61. Heros Ptoios, inscribed statue base: Perdrizet 1898, 243–45. Amphiaraos at Oropos, statue base in the temple: Petrakos 1968, 99.

35 Pausanias 1.35.3; Kron 1976, 172–73.

36 On Pausanias's comments on statues, see Pirenne-Delforge 2008, 271–89.

37 Pausanias 6.11.2–9; Pirenne-Delforge 2008, 254–55.

38 Pausanias (6.11.9) also reports that other statues of Theogenes were worshiped locally and cured diseases.

39 For the base or altar, see Chamoux 1979; Pouilloux 1994; Grandjean and Salviat 2000, 73–76. For the *thesauros* (second century BCE), see Dunant and Pouilloux 1958, 334 (no. 379),

40 For Pelops, see Mallwitz 1988, 86–89; Davidson 2003; Pache 2004, 84–94; Ekroth forthcoming a. For Opheltes/Archemoros, see Pache herein, 88, 107; Pache 2004, 94–134; Bravo 2006, 81–163. At Isthmia, Melikertes-Palaimon occupied a similar position; see Gebhard and Dickie 1999.

41 Ambramson 1978; Pariente 1992, 205–16; Deoudi 1999; Antonaccio 1995, 145–97; Boehringer 2001; Seifert 2005; *ThesCRA* 2:131–58, s.v. Heroisierung. For altars in hero cults, see Ekroth 1998.

42 On scholarly attempts to categorize Greek heroes, see Farnell 1921; Pfister 1909–12. See also Nicholas Coldstream's pertinent statement: "Greek hero-worship has always been a rather untidy subject, where any general statement is apt to provoke suspicion" (Coldstream 1976, 8).

43 Grandjean and Salviat 2000, 69–70, with previous literature.

44 The inscription has been dated to about 600 BCE on the basis of the letterforms; see Pouilloux 1955. Originally the base may have been crowned by a stele.

45 Grandjean and Salviat 2000, fig. 21.

46 See Lalonde 1980, for a small shrine, presumably of a hero, marked by a *horos* under the Middle Stoa in the Athenian Agora.

47 Delos: Bruneau and Ducat 1983, 144 (no. 32), 146 (no. 34), 191 (no. 63), 199 (no. 71). Athens: Lalonde 1968; Camp 1986, 78; see also Thompson 1978.

48 Shear 1973a, 126–34; Shear 1973b, 360–69; Thompson 1978, 101–2; Camp 1986, 78–82.

49 Pariente 1992. A similar fence surrounded the monument of the eponymous heroes on the Athenian Agora, see Camp 1986, 98–99; Kron 1976.

50 Pariente 1992, 196; Pausanias 2.19.5.

51 Stele shrine: C. Williams 1978, 5–12. For hero cults in the Corinthian Agora, see also Broneer 1942.

52 C. Williams and Fisher 1973, 2–12; C. Williams, MacIntosh, and Fisher 1974, 1–6; C. Williams 1981, 410–12.

53 Bravo 2006, 1–80, 210–34; S. Miller 1990, 104–10; S. Miller 2002; Pache 2004, 131–34.

54 Kyrieleis 2006; Ekroth forthcoming a.

55 Kyrieleis 2006, 58; Mallwitz 1972, 133–35. The Agamemnoneion near Mycenae, established in the Late Geometric period, had a similar layout; see Cook 1953, as well as Knauss 1997 on the relation to the Mycenaean dam to the south.

56 Bruneau 1970, 424–26; Bruneau and Ducat 1983, 200–201 (no. 74); Prost 1997, 785–89; Ekroth 2002, 36–39.

57 Ohnesorg 1982; see also LS 180 for the mid-third-century BCE oracle approving the institution of the cult.

58 Pouilloux 1954a, 93–102; Petrakos 1991, 52–53; *Praktika* 1981 (1983), 123–30. On healing heroes, see also Verbanck-Piérard 2000.

59 Pouilloux 1954a, 145–46 (no. 34); *Praktika* 1981 (1983), 123–26.

60 Pouilloux 1954a, pl. 43: 1–2 and 4–5; *Praktika* 1976 (1978), 56–57; *Praktika* 1986 (1990), 22–24.

61 The Amyneion at Athens, where the healing hero Amynos was worshiped, consisted of a pentagonal area with a small cult-building, a well, and probably a simple stoa, where those seeking treatment from the hero could sleep and receive the hero's advice in their dreams. See Travlos 1971, 76–78.

62 Wace et al. 1908–9; H. Catling 1976–77; Tomlinson 1992; Antonaccio 1995, 155–66.

63 Guillon 1943, 57–73; Ducat and Llinas 1964; Llinas 1965; Llinas 1966; Schachter 1994, 12–21; Ekroth 1998, 121–23, fig. 2.

64 Guillon 1943, 28–52. On the symbolic and cultic importance of these columns, see Papalexandrou 2008.

65 Troizen: Welter 1941, 26–27, 34–37; Pausanias 2.32.1. Oropos: Petrakos 1968, 62–109; Schachter 1981, 19–25; Travlos 1988, 301–5.

66 On the architectural development of the site, see Bergquist 1973, 13–62; see also Bonnet 1988, 358–66. For the suggestion that the *oikos* originally was a dining room turned into a temple in the Hellenistic period, see Bergquist 1998, esp. 71.

67 Deneken 1886–90, 2486–87, 2497–516; Stengel 1920, 138–44; Rohde 1925, 116; Farnell 1921, 95–96, 370; Meuli 1946, 192–97, 209; Nilsson 1967, 186–87; Rudhardt 1992, 251–53; Burkert 1985, 205; Bruit Zaidman and Schmitt Pantel 1992, 37.

68 Early twentieth-century scholars construed the differences even more strictly; see, for example, Deneken 1886–90, 2486–87; Stengel 1910, 126–45; Stengel 1920, 124–27, 138–52; Farnell 1921, 370; Rohde 1925, 116; Meuli 1946, 185–224. For a less categorical view, see Rudhardt 1958, 251–53; Burkert 1992, 199–203. See also Scullion 1994 and Scullion 2000, for recent attempts to modify and defend the validity of the Olympian and chthonian concepts for sacrificial rituals.

69 Schlesier 1991–92; van Straten 1995, 167; Clinton 1996, 168–69; Ekroth 2002, 310–25; Hermary et al. 2004, 62; Clinton 2005; *OCD*³, s.v. chthonian gods. See also the various contributions to the seminar *Greek Sacrificial Ritual, Olympian and Chthonian*, ed. R. Hägg and B. Alroth, 2005.

70 See Ekroth 1998; Ekroth 2002; Verbanck-Piérard 2000; *OCD*³, s.v. hero-cult; sacrifice, Greek; see also the fundamental article by Nock 1944.

71 Ekroth 2002, 140–69, 179–206, 293–301; Verbanck-Piérard 2000.

72 *LSS* 20, early third century BCE but preserving a mid-fifth-century part.

73 For meat portions and priestly perquisites, see Ekroth 2002, 140–45. For *hestiatories*, see LSS 20, line 12; *IG* II² 1259, lines 1–2.

74 The victims sacrificed to Amphiaraos at Oropos had to be eaten on the spot; see LS 69 (= *IG* VII 235), lines 31–32; see also seven instances in the sacrificial calendar from Erchia, Ekroth 2002, 156, table 25. Sale of meat from sacrifices to Neanias at Thorikos, see *NGSL* 1, commentary to lines 25–27; Parker 1987, 145–46.

75 Bergquist 1998. For possible dining rooms at the Archegesion on Delos, see Kuhn 1985, 227–37; at the Ptoion and the West Gate Heroön at Eretria, see Ekroth 1998, 120–29.

76 For the pottery, see, for example, Cook 1953 (Agamemnoneion); R. Catling 1992 (Menelaion); Callaghan 1978 (heroön of Glaukos, Knossos); Ducat and Llinas 1964, 856–60 (Ptoion). *Kreagra*: H. Catling and Cavanaugh 1976, 153–57.

77 Vikela 1994, 224–25, S 1 and pl. 32, late fourth century BCE.

78 Gardeisen 1996. The burnt bones from the heroön of Opheltes/Archemoros at Nemea consisted mainly of upper parts of back legs of sheep, a practice that accords with a typical *thysia* sacrifice, see Bravo 2006, 228–31.

79 *LS* 47, lines 27–30 (= *IG* II² 2499), 306/5 BCE.

80 Ferguson 1944, 80.

81 On the *theoxenia*, see Jameson 1994a; Gill 1991; Bruit 1989, 19–21; Ekroth 2002, 136–40, 177–79, 276–86; Bruit Zaidman 2005, 38–42.

82 See Jameson 1994a, 53–57; Bruit 1989, 17, 21; Bruit Zaidman 2005, 41–42; Ekroth 2008, 95–104. Gill 1991, 136–37, suggested that the food offerings were meant to increase the god's otherwise meager share of the sacrificial victim.

83 In the sacrificial calendar from Marathon, *LS* 20 B, lines 3–4, 23–24, 25, the *trapezai* cost one drachma each, to be compared with the cheapest animal victims, piglets, costing three drachmas apiece. Offerings for the Dioskouroi, see Chionides fr. 7 (*PCG* IV, 1983); Jameson 1994a, 46–47.

84 Heropythos *FGrHist* 448, F1.

85 As in the sacrificial calendar of the deme Thorikos, see *NGSL* 1, lines 16–19, 28–30, 48–51. On the lesser status of heroines in the Attic sacrificial calendars, see Larson 1995, 26–34.

86 *LSS* 20, lines 14–16; see also Ekroth 2002, 137–39.

87 *LSS* 69, line 3.

88 Gill 1991, 78 (no. 62), pl. 27, third-century BCE fragment of a *trapeza*.

89 Rotroff 1978, 196–97, lines 4–13.

90 *LS* 177, lines 120–30; Sherwin-White 1977, 210–13, ca. 300 BCE.

91 Relief from Larissa, second century BCE, now in the Musée du Louvre (MA 746).

92 Thönges-Stringaris 1965; Larson 1995, 43–50.

93 Ekroth 2002, 283–84; Jameson 1994a, 53.

94 Verbanck-Piérard 1992; Jameson 1994a, 52–53.

95 Woodford 1971; van Straten 1979, 189; Tagalidou 1993, 19–22, 27–32; *LIMC* 4 (1988), s.v. Herakles, 801–2, nos. 1368–80 (J. Boardman).

96 Also the cult of Pelops at Olympia included a *theoxenia* element; see Ekroth 2002, 178, 190–92; Slater 1989. The earliest phase of the Pelopion may have consisted of a tetrastylon; see Ekroth forthcoming a. Stafford 2005a has recently suggested that the tetrastylon was an allusion to a funerary aspect of Herakles' cult. For the tetrastylon as a marker of chthonian cult, see also Riethmüller 1999, 141–43; see, however, the objections advanced by Verbanck-Piérard 2000, 329–32.

97 For the use of blood at *thysia* sacrifice, see Ekroth 2002, 242–51.

98 Ekroth 2002, 171–72, 178, 190–92; for the use of *bothroi*, 60–74.

99 Ekroth 2002, 178, 265–68; on the importance of *theoxenia* in the cult of Pelops at Olympia, see Ekroth forthcoming a; Slater 1989.

100 Ekroth 2002, 257–62. For the *sphagia*, see Jameson 1991; Jameson 1994b.

101 *LSS* 64, lines 7–22, mid-fourth century BCE; Pouilloux 1954b, 371–79 (no. 141).

102 Pouilloux 1954b, 373–74, 377. Also the Spartan general Brasidas, who fell while defending Amphipolis against the Athenians and was venerated as a hero with games and sacrifices, which included both libations of blood and public consumption of the meat, according to Thucydides' account (5.11); see Ekroth 2002, 172, 184–86; Malkin 1987, 228–32; Hornblower 1996, 449–56.

103 Ekroth 2002, 259–61; Dunst 1964. For the coin type, see Raven 1957.

104 For numismatic evidence for altars and sacrifices, see Aktseli 1996, 50–54; Ayala 1989.

105 Diodoros Siculus 4.23.5.

106 In the sixth- to fourth-century epigraphic evidence, five cases are clearly attested by the use of the term *holokautos*: *LS* 18, col. II, lines 16–20, col. IV, lines 20–23, col. V, lines 12–15; *LSS* 19, line 84. A newly published fragment of a sacrificial calendar from the Attic deme of Axione may also refer to holocaustic sacrifices to heroes, as the officiating priest or priestess receives no portions of meat from the victims; see Ackermann 2007. In the literary texts, there are four instances of destruction sacrifices to heroes: Herodotos 1.167, 2.44; *De mirabilibus auscultationibus* 840a; *Athenaion politeia* 58.1.

107 *LS* 151 A, lines 32–34; *NGSL* 1, lines 13–15; Xenophon, *Anabasis* 7.8.4–5; see also Ekroth 2002, 217–18.

108 See Burkert 1987a; Ekroth 2008, 91–93.

109 On the use of *enagizein*, see Ekroth 2002, 74–128, 233–42.

110 See Herodotos 2.44; cf. Pindar, *Nemean Odes* 3.22, calling Herakles *heros theos*.

111 Verbanck-Piérard 1989, 44–49, 53; Lévêque and Verbanck-Piérard 1992; Ekroth 2002, 85–86, 98–99, 225–26, and 238–39; Henrichs 1991, 195–96.

112 Gardeisen 1996. The only osteologically documented case of a holocaust for a hero concerns Palaimon at Isthmia, as the sacrifices were performed after the Roman reintroduction of his cult in about 50 CE; see Gebhard 1993 and Gebhard 2005; for the osteological evidence, see Gebhard and Reese 2005. The increased use of the term *enagizein* suggests that holocaustic sacrifices to heroes seem to have been more frequent in the Roman period, perhaps because such rituals corresponded to the Roman conception of hero cult; see Ekroth 2002, 121–26. The famous holocaust of living animals to Artemis Laphria at Patrai (Pausanias 7.18.11–13) was apparently a Roman adaptation of a Greek cult; see Pirenne-Delforge 2006.

113 Scullion 2000, 165–66.

114 Jameson, Jordan, and Kotansky 1993, A lines 9–13; Bergquist 2005; Scullion 2000.

115 Mykonos: *LS* 96, lines 23–24. Thasos: *LSS* 63; *IG* XII suppl. 353; see also Bergquist 2005.

116 *NGSL* 1; *LS* 20 B; *LS* 18; *LSS* 19. Ekroth 2002, 150–69, esp. 153.

117 On the relation between animal sacrifice and Greek society, see Detienne 1989; Burkert 1985, 55–59; Rosivach 1994, 11–12, 65–67; Whitehead 1986, 205–8.

118 On the difficulties of distinguishing Olympian and chthonian categories in the archaeological evidence, see van Straten 1974, 187–89; van Straten 1995, 165–67; Antonaccio 2005; Gebhard and Reese 2005.

119 Deneken 1886–90, 2496–503; Pfister 1909–12, 474–75; Stengel 1920, 15–17; Farnell 1921, 95–96; Yavis 1949, 91–95; Rudhardt 1992, 250–52; Nilsson 1967, 78; Burkert 1985, 199; Rupp 1991a, 303; Bruit Zaidman and Schmitt Pantel 1992, 37; *OCD*³, s.v. altar.

120 See Ekroth 2002, 39–54, for the sources. This particular type of altar has further been linked to the term *bothros*, a pit into which offerings were made; see Ekroth 2002, 60–74, for the use and meaning of this term.

121 For the evidence, see Ekroth 2002, 39–34; Ekroth 2001, 116.

122 Pindar, *Olympian Odes* 1.93 (Pelops), 9.112 (Ajax), *Isthmian Odes* 4.62 (Herakleidai), Herodotos 4.35 (Opis and Arge). A sacred law from the Amphiareion at Oropos calls the altar of the hero *bomos;* see *LS* 69, line 26. For heroes sharing a *bomos* with a god, see *LSS* 19, line 93; *LS* 18, col. I, lines 46–68.

123 Ekroth 2001, 120–24; Ekroth 2002, 54–59. This use is understandable, as the basic meaning of *eschara* is "hearth" and "fireplace."

124 *IG* II² 4977; Ekroth 2002, 29–30.

125 Bruneau 1970, 424–26; Ekroth 2002, 120–21.

126 For reliefs, see van Straten 1995, figs. 57–65, 71, 75, 77, 80–82, 85, 86, 88–92, 96, 100, 101, 107, 108. Vases: Rupp 1991b; Aktseli 1996; Ekroth 2001.

127 Rupp 1991a, types I–III; Aktseli 1996, 18–19, 109–11; Ekroth 2001; Gebauer 2002, 522–24.

128 Ekroth 2001; Neils 2004.

129 Munich 1426; *LIMC* I (1981), s.v. Achilleus, 360 (A. Kossetz-Deissman); Aktseli 1996, pl. 8.3.

130 Machaira 2000; for mound-shaped or fieldstone altars, see van Straten 1974, 187–88, A5, A6, A8, A9; Tagalidou 1993, 252 (no. 46); van Straten 1995, R99. For the uses of high, rectangular altars, see van Straten 1995, figs. 57–65.

131 Vikela 1994, A1, A4, A5, A7, A9, A10, A15, A18, B2, B6, and B7 (square altars) and A16, A20, and B12 (fieldstone altars).

132 Gebauer 2002, 522–23; Hooker 1950; Ekroth forthcoming b. The mound-shaped altars still need to be investigated from this point of view.

133 *NGSL* 1, lines 28–30 and 54–56; Ekroth 2002, 158–59; Kearns 1989, 177.

134 *LS* 20 B, 20–21.

135 The sacrifices amounted to 354 and 366 drachmas in alternate years; see Ekroth 2002, 153, 159–60.

136 *LS* 2 C, lines 6–10; *LSS* 14, line 84; *LS* 18, col. V, lines 6–7.

137 For example, *LS* 20 B, lines 3–4; Hermary et al. 2004, 94–95.

138 Ferguson 1944, 80, 91, 117.

139 Butz 1994; Butz 1996. This may also have been the case with the cult of Pelops at Olympia during the Classical period, when he had become the national hero of the Eleans; see Ekroth forthcoming a.

HEROES AS MORAL AGENTS
AND MORAL EXAMPLES

Michael J. Anderson

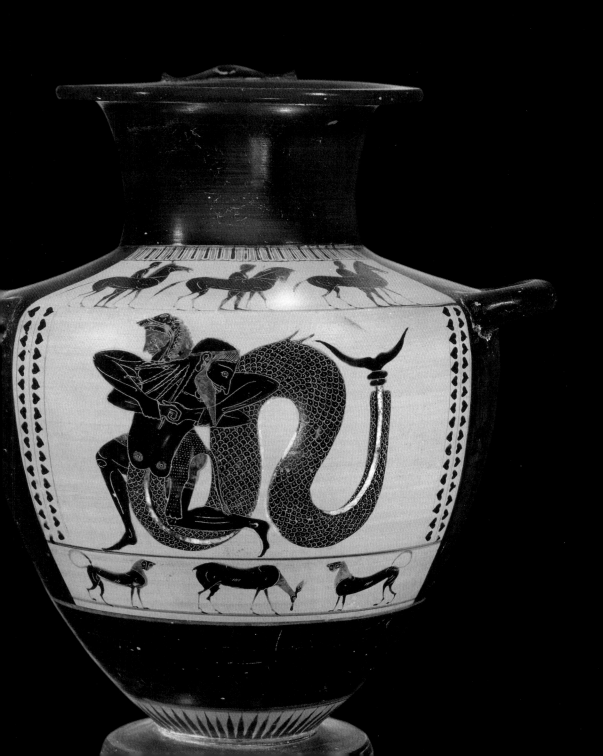

In Prodikos's tale of the choice of Herakles, preserved in Xenophon's *Memoirs of Socrates*, the young hero withdraws to a quiet place to consider what path he will follow in life, and there he is approached by two goddesses. Vice, or as she prefers to call herself, Happiness, promises Herakles an effortless and carefree route to soft beds and sensual pleasures. But Virtue exposes Vice's purported pleasures as transitory, empty, and shameful, and she insists that only the blessings earned by honest labor are worth enjoying.

> For of all things good and fair, the gods give nothing to man without toil and effort. If you want the favor of the gods, you must worship the gods: if you desire the love of friends, you must do good to your friends: if you covet honor from a city, you must aid that city: if you are fain to win the admiration of all Hellas for virtue, you must strive to do good to Hellas.
>
> —Xenophon, Memoirs of Socrates 2.1.28, trans. Marchant, 99

Nothing comes from nothing. Instead, mortal actions are part of a balanced system of give and take, in which labor earns rewards. Reciprocity of action governs friendship and civic alliances between men, and reciprocity governs the relation between gods and mortals. The same, she continues, is true for the farmer, the soldier, and the athlete, none of whom can succeed without effort. The philosopher, too, should be judged according to the same principle, as the dialogue framing Prodikos's tale suggests. Socrates, who recounts Prodikos's story, is an advocate and a model of self-control, practicing and preaching vigorous physical and mental training. The man to whom he recounts the tale, on the other hand, the hedonist Aristippos, feels no desire to exert himself for friends or country but looks only to the satisfaction of his own bodily desires. In the Athens of Xenophon's youth, his beloved teacher Socrates is Virtue, while Aristippos is either Vice or a pupil deaf to Virtue's teaching.

Prodikos's story, with its unusually contemplative Herakles, is an innovative product of fifth-century sophistic teaching. Yet the values and ideals it advocates were not entirely new; they had long been revered in Greek society and praised by Greek poets. Xenophon's Socrates is not the pioneering ethical theorist we encounter in Plato's writing but a much more traditional and pragmatic moralist. He prefaces Prodikos's tale by quoting ethical sentiments expressed by Hesiod some three hundred years earlier: though rough at the start, the poet had declared, the path of virtue is smooth at the end (Hesiod, *Works and Days* 287–91). While Virtue's lengthy and eloquent speeches define Prodikos's composition as a moral discourse rather than a traditional mythic narrative, the mythological component is much more than a thin veneer. Direct attention to Herakles himself is cursory—he speaks only once—but by presenting his hero with this general choice, Prodikos cleverly invites his audience to recall Herakles' entire heroic career. Xenophon's readers and Prodikos's original audiences would immediately have identified this moment as a prelude to the hero's endless toils, from his battle with the Nemean lion to his journey to fetch the golden apples of the Hesperides. They would have recalled that, in return for his ceaseless labor, Herakles was granted a unique reward, a place among the Olympian gods themselves. Ancient

audiences might also have recalled a different portrait of Herakles, the gluttonous Herakles of Athenian Old Comedy, a boisterous buffoon with insatiable appetites. And while it seems likely that the Herakles of this moral lesson would reject Vice in favor of Virtue, that a teacher of virtue would deny the mocking inventions of the comedians, Xenophon does not specify which path the young Herakles ultimately chooses. The only time Herakles speaks, in fact, is to ask Vice her name. Perhaps Xenophon wanted his readers to keep Herakles' legendary excesses somewhere in the back of their minds as a reminder of temptation's power to corrupt.

While adapting the Herakles legend to a new form of discourse, Prodikos does not introduce any radically new ethical values; rather, he elucidates the ethical concerns already inherent in the myth. The poets who preceded Prodikos and the sophists had for centuries recognized and explored the moral implications not only of the Herakles legends but of the entire corpus of traditional heroic tales. Insofar as myth reflects, questions, and transmits the traditional values of a community, it is inherently ethical, and the poets shaped and reshaped traditional myth to exploit its ethical potential. Sometimes they dictated unequivocal moral principles, praised the heroes' virtuous successes, and condemned their vicious errors. Elsewhere they confronted their heroes with complex moral dilemmas that resisted simple solutions and invited audiences to debate the merits of the heroes' actions. The poetic imagination did not restrict itself to posing moral questions and constructing moral lessons, but it is rare to encounter in Greek poetry a hero detached from moral responsibilities or moral limitations. The heroes' superior abilities and their often intimate association with the gods inevitably distance them from the mortals of the poets' own age, making them objects of awe and veneration. But no hero is so powerful as to be beyond good and evil, and no hero is so distant from the present age that his virtue cannot inspire emulation, or his vice deter it. Like Prodikos, who saw in Herakles' moral choice a lesson for all, masters and slaves alike, the poets often shaped their heroes' triumphs and failures as inspiration or caution for their audiences.

My goal in this essay is not to provide a comprehensive catalogue of specific virtues and vices illustrated in Greek heroic myth, nor to identify a set of fundamental ethical principles determining right and wrong. Instead, I wish simply to consider some of the ways in which Greeks poets and artists approached ethics, how they confronted their heroes with moral challenges, and how they provoked ethical inquiry in their audiences. I have selected several myths with distinctively ethical preoccupations and organized them into three broad categories. First are myths that, like Prodikos's tale, confront the hero with a choice, thereby highlighting the opposition between the heroic and the unheroic path, between right and wrong. Next are some examples of heroes who, once on the path of the hero, lose their way, transgressing against either the gods or their fellow mortals. Last come the righteous heroes, those who punish transgressions.

THE HERO'S CHOICE

The idea of moral choice illuminated allegorically in Prodikos's tale of Herakles manifests itself in various ways in the more traditional myths of the poets. The charming tale of Achilles' early visit to Skyros is one of the more amusing examples. When Odysseus was traveling through Greece enlisting warriors for the expedition against Troy, Thetis removed her son to the island of Skyros, for she knew that fighting at Troy would lead her son to an early death. There, disguised as a girl, he hid among the daughters of King Lykomedes. But Odysseus outwitted Achilles' protective mother. He arrived at the island with a cargo of trade goods, and while Lykomedes' daughters gathered around a caravan of fine clothing and jewelry, Achilles was detected admiring a display of weapons. Despite his mother's attempt to shelter him, Achilles' masculine inclinations toward heroic endeavors could not be repressed.[1]

Both of the monumental Homeric epics confront their principal characters with an unusual heroic choice between glory and immortality. As we learn in book 9 of the *Iliad*, Thetis has informed her son that two distinct courses of action lie before him. Either he may fight at Troy and die young, thereby winning imperishable fame, or he may return home to enjoy a long life but leave behind no lasting memory of achievement (*Iliad* 9.410–16). Whereas the typical hero understands that he must risk his life to win honor in battle, Achilles knows for a certainty that to win honor he must forfeit his life. At this point in the poem, having suffered grievously demeaning insults from Agamemnon, he questions the path of honor, and the possibility of a comfortable life of obscurity begins to look more appealing than a wretched life as Agamemnon's vassal at Troy. But once Hektor slays his beloved Patroklos, Achilles can no longer entertain the thought of inaction. Passion drives him to honor Patroklos by avenging his dearest friend's death, even if this course of action entails his own death:

> Now I shall go, to overtake that killer of a dear life,
> Hektor; then I will accept my own death, at whatever
> Time Zeus wishes to bring it about, and the other immortals.
> —Iliad *18.114–16, trans. Lattimore*

The specific achievements that constitute heroism for Achilles—to slay the Trojans and enslave their women—are not those that our more enlightened age of gentle values can applaud. But his pursuit of honor without fear of death was a choice even Plato's Socrates could commend (*Apology* 28b3–d5).

The other great Homeric hero faces an analogous choice in book 5 of the *Odyssey*. He has now spent seven years on the island of the beautiful nymph Kalypso, but he longs to return home. Despite her offer to make him immortal, to allow him perpetual enjoyment of her delightful home, Odysseus has long since made up his mind to return to the world of men. Though it means risking his life and forfeiting immortality, he would rather struggle to regain his kingdom and his family, to leave a mark on the world, than to live an obscure life on the edge of the world as the pampered pet of a spoiled goddess. It is noteworthy that once the Olympians have compelled Kalpyso to consent to Odysseus's departure, instead of building him a vessel, she provides him

with an axe and sets him to work building his own craft. His days of idle pleasures in the Golden Age paradise of the goddess are at last over, and he looks forward to returning to a world where success is earned with labor.

Other versions of the hero's choice highlight specific moral qualities. Achilles' son, Neoptolemos, for example, confronts a choice between honesty and deceit in Sophocles' *Philoktetes*. The youth has assumed his father's place in the Greek army, inheriting his father's armor and adopting his warrior spirit. He has already made the fundamental heroic choice to pursue honor and fame on the battlefield. But a new father figure now threatens to supplant the memory of Achilles and lead the young man astray. Odysseus, here characterized more as a conniving swindler than an honorable warrior, urges Neoptolemos to adopt guile as a weapon, to gain Philoktetes' confidence with false friendship and then steal from him the bow of Herakles. Achilles would surely have disapproved, Achilles, who had so adamantly declared his abhorrence of deception in the *Iliad:* "As I detest the doorways of Death, I detest that man who hides one thing in the depths of his heart, and speaks forth another" (*Iliad* 9.312–33, trans. Lattimore). Although Neoptolemos initially compromises his integrity, his compassion for Philoktetes eventually distances him from the wily Odysseus, and he distinguishes himself by choosing honor untainted by deceit, the path favored by his true father.

Another laudable heroic choice illustrates the deep bonds of love ideally uniting brother with brother. Kastor and Polydeukes were twins, born of the same mother. But while Polydeukes enjoyed immortality as a divine son of Zeus, Kastor was a mortal son of Tyndareus. Pindar draws attention to this distinction at the close of his tenth Nemean ode, when Polydeukes grieves at the death of his twin and asks Zeus to grant him death as well. In response to this request for death, Zeus reminds Polydeukes of his immortality and offers him a choice. Either he may dwell forever among the gods, or he may share his own immortality with his mortal brother, and together they may spend alternate days in the darkness of the underworld and in the splendor of Olympos. Without hesitation Polydeukes chooses the latter, privileging friendship and brotherly love above individual advantage. Honor, the quintessential heroic value, is for Polydeukes entirely dependent on the friendship and trust of his brother.

In contrast to the many instances of youths who eagerly embrace danger and adventure, Greek myth provides one very conspicuous example of an unheroic choice in the legend of Paris, the young Trojan prince who awarded the apple of discord to Aphrodite, thereby winning the love of Helen and precipitating the Trojan War. No early poetic account of the judgment survives, but there is much evidence to suggest that it was already widely known in the Archaic period. A brief reference to the judgment in the *Iliad* explains the relentless hatred that Hera and Athena direct against the Trojans (24.25–30). A fragmentary image of the scene appears below the handle of the Chigi Vase (Rome, Villa Giulia, 22679), an exquisite Corinthian olpe of the later seventh century, and it appears regularly on sixth-century Athenian black-figure vases. A red-figure kylix in Berlin (fig. 88), from the mid-fifth century, brilliantly captures the principal details of the event. At the left of the panel are Hera, Athena, and Aphrodite, the three goddesses vying for the distinction of being judged the most

beautiful. They had been celebrating the wedding of Peleus and Thetis, when Eris, goddess of discord, angered at not having been invited, threw into the crowd a golden apple inscribed "for the fairest." When Hera, Athena, and Aphrodite each thought that she herself merited the distinction, Zeus prudently declined to serve as judge and referred the case instead to the young Trojan. And now Hermes, identified by his herald's wand and winged cap, leads the three contestants toward this beardless, youthful judge. Some versions of the myth locate the judgment in the hills outside of Troy, where the foundling Paris tends flocks before being recognized as a Trojan prince. But here he sits within an architectural structure suggesting a palace, and he holds in his right hand a scepter, befitting his royal lineage and perhaps indicating that he is being groomed for leadership. The lyre dangling from his other hand may suggest an elite education in aristocratic pursuits, as well as perhaps a gift for aesthetic judgment. I think it also likely, however, that the lyre and the scepter reflect a contrast between business and pleasure. What type of career path, they invite us to ask, will Paris choose? As the three goddesses approach, each strengthens her case and complicates Paris's decision by offering to reward him with her own unique form of patronage. Aphrodite, at the head of the trio, extends a small, winged Eros before her, a symbol of sexual desire common in marriage iconography, and she holds a marriage garland in her other hand. Her offer is union with Helen, the most beautiful of women. Behind her follows the warrior goddess Athena, wearing the aegis, holding a spear, and extending a magnificent helmet before her. Her offer is military distinction. At the rear of the procession follows Hera, queen of the gods, with her offer of royal power, symbolized by the scepter in her right hand and the diminutive lion in her left.

The painter of this image, intrigued by the erotic elements of the scene, perhaps intended it to charm rather than to instruct. He has featured a similarly sensual meeting of Paris and Helen on the opposite side of the cup. Setting aside the aesthetic appeal of this cup, however, and viewing the myth from a safe distance allow us to consider two contrasting ethical readings of the myth. On the one hand, we might easily pity Paris for his awkward predicament, forced to select one goddess and thereby incur the wrath of the other two. Already the goddesses' determination to win has apparently motivated them to bribe the judge. So we might well wonder to what lengths the indignant

FIG 88 The judgment of Paris. Detail of an Athenian red-figure kylix by the Painter of F 2536 (name piece), 450–440 BCE. Staatliche Museen zu Berlin, Antikensammlung, F 2536

losers will go in their desire for revenge. Black-figure representations of the scene, in fact, sometimes depict Paris fleeing as the goddesses approach. No doubt he is startled by the sudden apparition of the divine, but he also has good reason to fear the task they impose. Zeus himself, after all, has declined to judge the contest. Paris, then, is just a pawn manipulated by the capricious divinities as they vie for honor among themselves. On the other hand, it is difficult to overlook the fact that the goddesses offer him a choice, and that in awarding the apple to Aphrodite he departs radically from the standard heroic course. The Berlin kylix characterizes him as a young man on the threshold of adulthood, a pupil, as the lyre may indicate, ready to choose a path in life. His situation resembles that of Prodikos's Herakles, confronted with a choice between honorable toil and dishonorable ease. But unlike Herakles, Paris chooses gratification of physical appetite above the arduous quest for honor. The Greek hero is by no means prohibited from enjoying the pleasures of marriage, but for the typical hero marriage comes as a reward for achievement. Perseus wins Andromeda as his bride by slaying a sea monster; Pelops wins Hippodameia by defeating her father in a chariot race; and Oedipus, albeit to his own misfortune, wins Jokasta by defeating the Sphinx. Paris, by contrast, does nothing to prove himself worthy. Instead, with Aphrodite's assistance he seduces Helen and steals her from her lawful husband.

A glance at the larger narrative to which the judgment belongs, the wedding of Peleus and Thetis, also helps us recognize Paris's choice as decidedly unheroic. When the gods forced Thetis to marry a mortal, they selected as her husband the hero Peleus, who had distinguished or soon would distinguish himself as one of the Argonauts. Rather than simply receiving Thetis as a gift, moreover, Peleus had to prove himself worthy and actively win his divine bride. The sea goddess resisted her suitor and transformed into all manner of beasts to thwart him, but Peleus took hold of her and maintained his grasp until she resumed her original form. By situating the contest of the goddesses at the marriage of Peleus and Thetis, the mythmakers implicitly contrast the characters of Peleus and Paris. The trial that Peleus endures to win Thetis is worlds apart from Paris's carefree choice of Aphrodite and Helen. Both men are offered beautiful wives by the gods, but Peleus earns his gift in advance of the marriage, while Paris postpones payment to a later date. Paris's primary motivation is not the love of contest and achievement, just acquisition and enjoyment.

It comes as no surprise that Homer rates Paris among the least valiant of the warriors in the *Iliad*. When we first meet him in book 3, he is strutting arrogantly before the Trojan army, challenging the Greeks to fight him. But upon catching sight of Menelaos, the man whose wife he has taken, he retreats sheepishly into the throng of Trojan troops. Homer immortalizes Paris's cowardice here with a vivid simile, comparing the fear-stricken fighter to a man who suddenly leaps back after almost stepping upon a snake, "cheeks seized with green pallor" (*Iliad* 3.35, trans. Lattimore). Only after his brother Hektor rebukes him in the harshest terms—"Evil Paris, beautiful, woman-crazy, cajoling, better you had never been born, or killed unwedded" (*Iliad* 3.39–40, trans. Lattimore)—does Paris agree to face the man he wronged. And even then, though he recognizes Hektor's rebuke of his cowardice as just, he acknowledges

no wrongdoing in his love for Helen: "do not bring up against me the sweet favors of golden Aphrodite. Never to be cast away are the gifts of the gods, magnificent, which they give of their own will, no man could have them for wanting them" (*Iliad* 3.63–66, trans. Lattimore). Paris's reverence for the gods and their gifts sounds hollow, and his argument exposes opportunism rather than virtue. He seems to deny that choice is always an option for mortals, whatever blessings and sorrows the gods may bestow. Has he forgotten that he chose to award the prize to Aphrodite before she granted him Helen? The duel that ensues in any case exposes Paris as barely fit for combat; he is soundly thrashed, surviving only because his patron goddess rescues him from the battlefield and deposits him in the safety and comfort of his bedroom. The battle and its aftermath form a delightful comedy, with the wronged husband left stomping around the battlefield while Paris plays with his unearned prize. But the comedy takes a deadly serious turn as the war develops further, and the comic duel between Paris and Menelaos is succeeded by the poignant confrontation between Hektor and Achilles.

Homer's typical warrior is driven by an overwhelming desire to achieve honor and glory on the battlefield, as well as by a sense of obligation to those he rules, an obligation to earn the privileges he enjoys. Sarpedon neatly summarizes the warrior's ethics in a famous passage in book 12. Reminding his comrade Glaukos that the men of Lykia honor them like gods, awarding them the finest food and the richest lands, he proclaims, "Therefore it is our duty in the forefront of the Lykians to take our stand, and bear our part of the blazing of battle" (*Iliad* 12.315–16, trans. Lattimore). And accepting death as a fact of life, whether it comes sooner or later, he urges his companion to charge into battle and risk life in return for glory: "Let us go on and win glory for ourselves, or yield it to others" (*Iliad* 12.328, trans. Lattimore). Hektor is another model of responsibility and valor. When Andromache pleads with him to remain within the safety of the city walls, he reminds her both of the shame he would feel were he not to fight in the front ranks and of his desire for success.

> Yet I would feel deep shame
> before the Trojans, and the Trojan women with trailing garments,
> if like a coward I were to shrink aside from the fighting;
> and the spirit will not let me, since I have learned to be valiant
> and to fight always among the foremost ranks of the Trojans,
> winning for my own self great glory, and for my father.
> —Iliad *6.441–46, trans. Lattimore*

Paris does not have this heroic spirit within him. More at home in the bedroom than on the battlefield, he tarries with Helen while the other Trojans fight the war he began. He lacks both the passion that drives the hero forward in pursuit of honor and the shame that prohibits him from holding back.

HEROES WHO TRANSGRESS

The temptations of leisure and illicit pleasures are not the only ethical dangers challenging the hero. The passionate spirit driving the hero toward success sometimes

carries him too far, as in the myth of Bellerophon and Pegasos. In his youth, Bellerophon was not only a model of bravery, the hero who slew the Chimaira, but also a model of moral virtue and self-control. When the wife of the king of Argos attempts to seduce him, he vigorously resists her advances. His descendant Glaukos, recounting Bellerophon's career in the *Iliad*, proudly lauds his self-restraint against sexual temptation: "Beautiful Anteia the wife of Proitos was stricken with passion to lie in love with him, and yet she could not beguile valiant Bellerophontes, whose will was virtuous" (*Iliad* 6.160–62, trans. Lattimore). As in other examples of the Potiphar's wife motif, which in Greek myth attaches also to Peleus and Hippolytos, the spurned woman retaliates by unjustly accusing the virtuous hero of rape and political intrigue. Proitos believes his wife's false accusations and sends Bellerophon to his father-in-law, Iobates, who attempts to kill him by assigning him perilous tasks. But when Bellerophon successfully completes each mission, even slaying the Chimaira, Iobates recognizes his merit and rewards him with his daughter's hand in marriage, together with half his kingdom (*Iliad* 6.191–93). Having slain the dragon and won the princess, Bellerophon has become a model of heroic success. Whether or not this success, following directly from his persecution by Anteia and Proitos, is to be regarded as a reward for virtue, the moral contrast between these two chapters of the legend is clear; after resisting the illegitimate temptation, with its implication of insurrection against the king, Bellerophon instead earns a legitimate wife and lawful succession to the throne.

Bellerophon's fabulous winged horse Pegasos, curiously omitted from Homer's account although known to the tradition from Hesiod forward, provides another moral dimension to the tale. Pindar's thirteenth Olympian ode recounts how Athena visited the hero in a dream, instructing him to sacrifice to Poseidon and then tame the flying horse with a magical bridle. Bellerophon successfully tames the horse and with him defeats the Amazons, the Chimaira, and the Solymi. This focus on Pegasos in Pindar's narrative underscores the role of the gods as Bellerophon's benefactors and implicitly commends Bellerophon for the reverence and gratitude he shows his patrons. He not only sacrifices to Poseidon but erects an altar to Athena as well. Pindar, moreover, summarizes the gods' indispensable role in Bellerophon's success with a generalizing aphorism: "The power of the gods brings to fulfillment—as if it were a trivial thing—even the deed no man would promise or expect" (Pindar, *Olympian Odes* 13.83–84, trans. Nisetich). The favor of the gods has enabled Bellerophon's success, just as their favor enables the athletic victories of Pindar's many patrons and the poetic achievements of Pindar himself. All in turn owe thanks to the gods.

Sixth- and fifth-century vase-painters were intrigued by the visual possibilities afforded them by the composite figure of Pegasos and his rider—horse, man, and bird—an image that symbolizes the close association of Bellerophon and the divine. We find this tripartite image frequently balanced with the three-bodied Chimaira—goat, lion, and serpent—as on an Athenian black-figure cup of the mid-sixth century in the Musée du Louvre (fig. 89). Here the painter has contrasted the elegant combination of Bellerophon and Pegasos, a model of control, with the wild Chimaira, whose destructive nature seems to burst forth from its misshapen composite body.

Bellerophon and Pegasos both look forward, and the tip of Pegasos's wing follows their gaze with its gentle curve to the left, as if cradling the hero. By contrast, the goat head emerging from the Chimaira's back faces away from the lion head, while the snake-headed tail twists menacingly at the rear. Pegasos's feathers are neatly arrayed along his tapered wing, the hairs of his mane spread evenly behind his neck. The Chimaira instead has a row of shaggy tufts of fur strung out along his back, and a rather large beard hangs from the head of the goat. Pegasos's graceful, bridled head faces the large, squat head of the lion, its mouth wide open in attack, perhaps suggesting the monster's roar. The Chimaira raises a heavy claw while Pegasos rears up slightly, his slender forelegs lifted as if he is preparing to spring into the air. In short, the Chimaira embodies violent disorder, while the hero who subdues him exemplifies the harmonious cooperation of man, animal, and the divine. The magical bridle, a gift of the gods, enables Bellerophon to tame the divine beast and soar to previously unknown heights of success.

This exceptional harmony is not to last, however. Despite the restraint he exercises in resisting Anteia, despite the favor shown him by the gods, at some point on the path of the hero Bellerophon takes a wrong turn. And when he no longer controls his own heroic ambitions, he loses mastery over Pegasos as well. Pindar again, in another ode, moralizes Bellerophon's fall:

> If a man gazes in the distance,
> he is too short
> to reach the bronze-paved
> home of the gods:
> winged Pegasos shook from his back
>
> Bellerophon, his rider, striving
> to enter the dwellings of the sky
> and join Zeus' company.
> Most bitter is the end
> of a sweetness not our right.
> For myself, O Loxias, I wish another
> flourishing garland, from your games at Pytho!
>
> —Pindar, Isthmian Odes 7.43–51, trans. Nisetich

FIG 89 Bellerophon, Pegasos, and the Chimaira. Athenian black-figure Siana cup attributed to the Heidelberg Painter, mid-sixth century BCE. Paris, Musée du Louvre, A 478

The gods themselves had distinguished Bellerophon by giving him this marvelous animal, and it was this gift that had enabled him to complete the tasks assigned by Iobates. But success has swollen Bellerophon's pride, and he now abuses the gift, employing it for an illicit purpose against the very patrons who had so generously given it. Despite having successfully resisted temptation as a youth, he eventually succumbs to this far darker desire for illicit honors. The gods, of course, prohibit him from crossing the boundary between mortals and themselves. Pegasos, perhaps recognizing Bellerophon's folly, throws his rider. The wings that had elevated Bellerophon above his fellow mortals cannot make him a god, and his plunge into the sea reminds Pindar's audience that they are all likewise bound to the earth and to mortality. But Pindar

offers Bellerophon's fall, accompanied by his characteristic universalizing aphorisms, not only as a lesson on the proper limits of human ambition, but also as a kind of consolation. Strepsiades, the uncle of the victor celebrated in this ode, had lost his life in battle. Rather than grieve endlessly over the brevity of life, or try to escape death as Bellerophon did, Pindar urges his audience to pursue with gratitude the kind of achievements made possible by the gifts of the gods. Like his athletic patrons, Pindar has achieved greatness, and he will continue to pursue and celebrate success, so long as the gods allow.

A fifth-century temple metope from Selinus (fig. 90) instructs its visitors with an analogous lesson on transgressive mortal ambitions: the death of the hunter Actaeon. The goddess Artemis, at the left of the panel, incites Actaeon's dogs to attack their master. The traces of a stag's head and antlers visible behind Actaeon's head indicate either that the goddess has metamorphosed him or that she has incited the dogs with hallucinogenic madness. Since the Hellenistic period, Actaeon has been remembered as the hunter who accidentally saw his patron goddess bathing naked. His transgression, though unintentional, was unforgivable, and hence the goddess's terrible reaction. Such is the tale as told by Kallimachos in his "Bath of Pallas" and by Ovid in the *Metamorphoses*, in which the goddess's wrath is viewed as either inscrutable to human understanding or simply perverse. Visitors to the temple at Selinus, however, probably saw in the metope a less innocent Actaeon and a more justified Artemis. The Actaeon known from Archaic and Classical verbal sources actively earned his punishment, either by proclaiming himself the equal of Artemis in the hunt or by rivaling Zeus as a suitor of Semele, perhaps even by pursing the virgin huntress herself.[2] In Euripides' *Bacchae*, for example, Kadmos cites Actaeon's fate as a didactic example to his impious nephew Pentheus:

> You saw
> that dreadful death your cousin Actaeon died
> when those man-eating hounds he had raised himself
> savaged him and tore his body limb from limb
> because he boasted that his prowess in the hunt surpassed
> the skill of Artemis. Do not let his fate be yours.
>
> —*Euripides*, Bacchae 337–41, trans. Arrowsmith

The last line, of course, anticipates the punishment Dionysos will inflict on Pentheus for having denied the god's divinity: dismemberment at the hands of his own mother and aunt.

It is impossible to say which of these alternative offenses inspired the scene depicted on the Selinus metope, or indeed to rule out the possibility that Actaeon's offense was accidental.[3] What is clear, however, is that the gods intended this ghastly punishment to humiliate Actaeon and to restore the inviolable boundary between gods and mortals, a boundary that can be crossed only when the gods themselves will it. The mutilation of Actaeon's body, a realization of the defilement with which Achilles threatens Hektor in the *Iliad*, means the denial of an honorable burial. We

FIG 90 Actaeon attacked by his dogs. Metope from Temple E at Selinus (Selinunte), ca. 460–450 BCE. Palermo, Museo Archeologico, 3921C

might compare the distraught Priam, who paints a similarly wretched image of his own dishonor at the fall of Troy, his naked corpse mauled by the dogs who formerly guarded his gates and ate from his table (*Iliad* 22.66–76). And Actaeon's debasement is compounded further by his transformation. Instead of dying in a hunting accident, bravely facing the charge of a wild boar, he is stripped of his role as hunter and made the prey of his own dogs. If indeed he actively and deliberately transgressed against the gods, then the myth has fashioned his crime as a fitting complement to his punishment. Artemis previously fostered his skill and promoted his success in the hunt, but she now turns the hunt against him. Having sought to equate himself with the gods, he is dehumanized and demoted to the status of wild beast, and the madness of his dogs as they attack their master reflects his own madness in disturbing the hierarchy of gods over mortals.

Pindar in his monumental first Olympian ode erects a moral diptych contrasting the wicked man who abuses the gods' gifts and the hero who employs them properly. On one side is Tantalos, a mortal son of Zeus justly famous for the punishment he received in the underworld. On the other is Tantalos's son Pelops, worshiped at Olympia as a model of mortal success blessed by the divine. Once so loved by the gods that they feasted with him at his home, Tantalos conceived a mad passion to test them. He dismembered his son Pelops, disguised the pieces in a stew, and served him to the gods in a short-sighted attempt to deceive them. The absurd self-destructiveness of Tantalos's action, murdering one's own child, reflects the degree of his blindness in attempting to outwit the gods. Perhaps it also marks his disdain for the mortal cycle of life and death to which he is bound, each mortal generation maturing to succeed the last. After briefly entertaining this story of Pelops's dismemberment, Pindar offers a

revised version of the myth and makes Tantalos guilty of a different alimentary crime, secretly sharing the nectar and ambrosia of the gods with other mortals, dispensing immortality without a license.

> If ever the watchlords of Olympos
> honored a man, this was Tantalos.
> But he could not digest
> his great bliss—in his fullness he earned the doom
> that the father poised above him, the looming
> boulder which, in eternal
> distraction, he strains to heave from his brow.
> Such is the misery upon him, a fourth affliction
> among three others, because he robbed
> the immortals—their nectar and ambrosia,
> which had made him deathless,
> he stole and gave
> to his drinking companions.
> —*Pindar*, Olympian Odes *1.54–63, trans. Nisetich*

Like Bellerophon, Tantalos was cherished by the gods, so cherished, in fact, that they shared with him the food and drink of immortality. But he abused their hospitality by supplying this immortal delight to others, repaying the gods' gift with his own thievery.

Pindar reaches the moral climax of his poem not with the crime and punishment of Tantalos but with the contrasting heroic achievement of Tantalos's son, Pelops. Though denied immortality because of his father's offense, the young man earns the heroic equivalent, honor and fame, by daring to confront King Oinomaos of Elis in a perilous chariot race for the hand of Hippodameia: win the race and he wins the king's daughter, lose and he forfeits his life. In the hero's bold request to Poseidon for aid, Pindar highlights the daring spirit driving Pelops toward this challenge:

> Great danger
> does not come upon
> the spineless man, and yet, if we must die,
> why squat in the shadows, coddling a bland
> old age, with no nobility, for nothing?
> As for me, I will undertake this exploit.
> And you—I beseech you: let me achieve it.
> —*Pindar*, Olympian Odes *1.81–85, trans. Nisetich*

The gods reward this kind of courage, and like Bellerophon, divinely assisted in his battles by the winged horse Pegasos, Pelops is granted a team of winged horses, a gift to be understood not as an unfair advantage over his opponent but as an indication of true merit. Pindar records Pelops's victory and his marriage to the princess with relative brevity, offering no account of the race itself, but he is careful to point out that the memory of Pelops's achievement is preserved forever at Olympia:

> Now in the bright blood rituals
> Pelops has his share, reclining
> by the ford of Alpheus.
> Men gather at his tomb, near the crowded altar.
> The glory of the Olympiads
> shoots its rays afar
> in his races, where speed
> and strength are matched
> in the bruise of toil
>
> —*Pindar*, Olympian Odes *1.90–96, trans. Nisetich*

The contrast between Pelops's achievement and Tantalos's crime is now evident. The tale recounted earlier in the poem is one of unrestrained mortal ambition, unmerited immortality, and gifts stolen from the gods, while Pelops's story tells of harmonious cooperation between mortal and divine, of undying fame earned with the gods' blessings. Tantalos's crime earns him everlasting punishment in the underworld, while Pelops's divinely sanctioned achievement earns him everlasting honor at Olympia. We might be tempted to detect magnanimity and benevolence in Tantalos's desire to share nectar and ambrosia with other mortals; he resembles Prometheus, stealing fire from the gods and bestowing it as a gift on suffering mortals. When Tantalos's theft is placed next to his son's accomplishment, however, it is clear that Tantalos makes a grave ethical error, choosing easy living rather than heroic struggle, possession rather than attainment. Stealing immortality from the gods, he robs men of the dignity accompanying exertion and the pride that follows earned success.

In addition to visiting the hero's tomb, visitors to the sacred precinct at Olympia could see Pelops's chariot race immortalized in stone on the east pediment of the great fifth-century Temple of Zeus (fig. 91), inspiration for the contemporary athletes gathered at the site to test their skills and earn rewards for their arduous training.[4] The heraldic design of the pedimental sculpture, still recognizable in the fragmentary remains, depicts the competitors as they prepare for the race. At the center stands Zeus, divine patron of the games, and to his left and right stand the bearded king and his youthful challenger. Next to these are female figures, probably Oinomaos's wife and the young woman Pelops is soon to marry. The competitors' chariots and horses flank the central group, and as no trace of wings has been found among the sculptures, it is impossible to know whether the sculptor specifically envisioned Pelops driving the divine team of Pindar's ode. Some viewers, in fact, have attempted to detect here an alternate version of the myth, according to which Pelops bribes a charioteer to replace the bronze linchpins in Oinomaos's chariot with wax copies, thereby causing the chariot to crash. Pelops later murders this same charioteer, but before dying, Myrtilos curses Pelops and his descendants—hence the fraternal strife of Atreus and Thyestes, and the evils that visit Agamemnon and Menelaos. According to this version of the myth, Pelops inherits his father's moral flaws rather than overcoming them. In the vicinity of the Olympic competition, however, where cheating was unforgivable,

FIG 91 Pelops and Oinomaos. Conjectural reconstruction of the east pediment of the Temple of Zeus at Olympia, second quarter of the fifth century BCE. Drawing by Candace Smith

so prominent an illustration of unfair competition would hardly be possible. Here, as in Pindar's ode, Pelops stands as an example of heroic excellence and an ethical model for the contemporary athletes who competed at Olympia.

Another form of transgression often explored in heroic myth is the violation of the ethical principles governing human society. While the gods themselves are not the direct targets of these ethical transgressions, they often retain some involvement in the myths, insofar as they are believed to oversee and uphold human ideals of right and wrong. This kind of ethical conflict frequently characterizes Greek tragedy, in which differing human visions of justice compete and in which mortals sometimes display an imperfect understanding of the divine moral laws governing their lives. A classic example, still commonly employed as an exercise in moral logic for today's youth, is Sophocles' Antigone, who violates the mortal decrees of her uncle Kreon lest she violate the sacred laws obligating her to bury her brother. The citizens of the democratic Athens, where public debate flourished throughout the fifth century and well into the fourth, must have relished the moral conflicts of their tragic heroes. And in a political environment that viewed eminent individuals both with admiration and with suspicion, that applauded achievements beneficial to the community while at the same time fearing the abusive power of the eminent few, the public must have recognized in the tragic heroes vague reflections of the successes and abuses of their own contemporaries.

The earliest canonical example of this ethical transgression, however, is not a specifically Athenian or democratic product but a work of pan-Hellenic appeal, Homer's *Iliad*. The hero of the poem, Achilles, repeatedly violates the ethical standards that govern the interactions of men, no doubt arousing considerable shock and even indignation among Homer's ancient audiences. But Achilles, we must remember, is no normal man, and no normal hero either. He enjoys a special status among the Greek heroes thanks to his mother, not simply because she is a goddess, but because she was destined to bear a child greater than its father. For this reason the gods forced Thetis to marry a mortal and bear a mortal child, lest her divine offspring grow powerful enough to rival Zeus and overthrow the Olympian hierarchy. Homer does not acknowledge this legend directly, but its implications are felt throughout. Having wedded Peleus against her will, Thetis now feels that she and her son are owed something from Zeus in return for her sacrifice, and Achilles shares his mother's sense of entitlement. At issue, then, in any ethical reading of the poem is how great a share of honor Achilles deserves, and how far may he go to secure it. In response to the humiliating insults that

Agamemnon hurls at Achilles in book 1, together with his threat to deprive Achilles of his prize concubine Briseis, the hero's instinct is to draw his sword and slay his fellow Greek, so great is his indignation, so fierce his desire for revenge. Even after Athena convinces him to restrain his violence, his retaliation is extreme. Instead of simply withdrawing from the war and allowing Agamemnon to recognize his folly, he prays that Zeus may "help the Trojans and pin the Achaians back against the ships and the water, dying, so that thus they may all have profit of their own king" (*Iliad* 1.409–10, trans. Lattimore)—a shocking betrayal of his former comrades. Echoing the plague that Apollo has recently inflicted on the Achaeans, Achilles' retaliation assumes divine dimensions. Is he entitled to this honor? Or should he recognize that, in the imperfect world of men, no one can enjoy absolute honor?

In book 9 Homer offers his audience a moral lesson on the dangers of unbridled emotions like the fierce indignation of Achilles. When Achilles rejects the compensatory gifts offered by Agamemnon and still refuses to return to the battle, his beloved mentor, Phoenix, attempts to rouse his young protégé to action by recalling the tale of the hero Meleager. Meleager too once withdrew from a battle. Nursing resentment against his mother, he shut himself in his chambers and refused to fight on behalf of his city against its enemy. Meleager's parents, his kinsmen, and the city elders in turn beseeched him to assist in the battle, promising rich honors, not unlike the gifts Agamemnon offers to Achilles. But still Meleager's resentment held him back. Finally, when Meleager's wife, Kleopatra, warned him of the horrors that befall a city captured in war—the men slain, the wives and children dragged away into slavery—the hero put on his armor and routed the invaders. But though he saved the city, his delay cost him the gifts of honor once promised.

Phoenix's narrative is one of the earliest examples of heroic myth used explicitly as an ethical paradigm in a didactic context. The tales of the heroes of old, Phoenix implies, have value as authoritative moral lessons for the youths of the present. Moreover, Phoenix underscores the moral value of his story by accompanying it with a brief moral allegory about folly and reconciliation; he invokes divine authority for his ethical advice. Some would therefore interpret Phoenix's advice as the moral key to the entire poem—Achilles is wrong not to heed his mentor's advice and will suffer the consequences: the devastating loss of his beloved companion, Patroklos.[5] This kind of reductive moralizing, however, vastly oversimplifies the ethical complexity of the poem.[6] I am inclined to read in Phoenix's failure not only a disturbing comment on Achilles' intractable heroic nature but also a tragic acknowledgment of the limited power of conventional didactic tools, their inability either to describe the hero's experience adequately or to sway the hero's extraordinary spirit. In emphasizing Meleager's loss of the promised gifts, Phoenix surprisingly misjudges Achilles' present contempt for the physical symbols of honor; he fails to perceive that a hero of Achilles' stature requires more than symbols. Phoenix does, however, at least point to the fundamental role played by emotion in the hero's ethics. Meleager returns to war, not because he understands that it is the right thing to do, but because he is moved by Kleopatra's compassion, because he is made to feel compassion himself. In Achilles' case, only his

intense hatred for Hektor and passionate desire to avenge his friend will bring him back to the battle, not the abstract understanding that it is the right thing to do.

Homer again privileges the ethical role of the emotions over abstract rules and principles when resolving the crisis over Hektor's body. Like his earlier wish for the deaths of his Achaean comrades, Achilles' infamous treatment of Hektor's corpse constitutes an unambiguous violation of the standards of human decency. Even in warfare, which can rarely be termed a civilized activity, it was customary to allow the enemy to bury their dead. But Achilles continues to vent his rage on his enemy in death, piercing Hektor's ankles, lashing the corpse to his chariot, and finally dragging it past the city toward the ships, in full view of the Trojans standing on the city walls. A black-figure vase from the late sixth century (fig. 92) features a highly animated depiction of the legend.[7] The chariot seems to have just sprung into motion; the swift-footed Achilles is leaping on board as the charioteer speeds away, and the three-leg device on his shield adds to the sense of movement. The horses' tails extend behind them as they lunge forward; the front half of their bodies has already left the picture frame. Hektor's corpse is suspended from the chariot by his legs, and the lower half of the body rises from the ground as the chariot advances, while the shoulders and head are pulled along the ground, arms trailing behind. Priam and Hekabe stand within a portico to the left, within the city of Troy and distant from the battlefield. Though stationary, their obvious emotional turmoil complements the agitated movement in the center of the scene. Priam extends an arm forward, pleading with Achilles to surrender the body, while Hekabe raises one arm to her head in a gesture of grief.

In the background to the right is yet another figure in rapid motion, the small, winged spirit of Patroklos rising above his burial mound. The presence of Patroklos's tomb suggests that the painter has given us a narrative collage rather than a snapshot of a single moment, since Patroklos has not yet been buried when Achilles' first

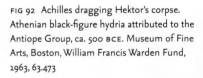

FIG 92 Achilles dragging Hektor's corpse. Athenian black-figure hydria attributed to the Antiope Group, ca. 500 BCE. Museum of Fine Arts, Boston, William Francis Warden Fund, 1963, 63.473

ties Hektor's corpse to his chariot. The prominence of the mound reminds us of the motivation for Achilles' monstrous act, his seemingly boundless grief over his beloved friend's death, and his overwhelming anger against the man who slew that friend. Even after the funeral of Patroklos in book 23 of the *Iliad*, Achilles continues to defile Hektor's corpse by dragging it around Patroklos's burial mound each morning. If we read the image with the *Iliad* in mind, then Patroklos's tomb evokes the persistence of Achilles' anger long after the initial act of vengeance. The funeral mound also reminds us that Achilles' goal is specifically to honor his dead friend by dishonoring his dead enemy. Homer's Achilles, vaunting over the dying Hektor, explicitly contrasts the honor he will accord to Patroklos with the defilement of Hektor's body: "the dogs and the vultures shall feed and foully rip you; the Achaians will bury Patroklos" (*Iliad* 22.335–36, trans. Lattimore). The magnificent funeral and the lavish games celebrated in Patroklos's memory in book 23 contrast sharply with the continuing abuse inflicted on the dead Hektor. The vase-painter captures this contrast visually in the opposition between Hektor's corpse, stripped of its armor and dragged through the dust, and the shade of Patroklos, gloriously armed and set in rapid motion, as if rushing to battle. Hektor's parents, deprived of the chance to lay their son to rest with the funeral honors due the Trojan champion, neatly balance the glorious tomb Achilles has erected for Patroklos. It is noteworthy that the only labels on the image are those of "Hektor" and the tomb "of Patroklos," as if the artist wished to draw attention to this contrast between tribute and degradation, to highlight the honor of which Hektor and his family are deprived.

The detail of the scene that carries the greatest ethical implications, however, is the gaze of Achilles himself. Iris, the winged messenger goddess, seems to confront the hero at the center of the scene. Her dynamic pose, one leg raised and bent forward to indicate swift movement, mirrors Achilles' leap into the chariot, while her raised arms seem to mimic the gestures of Priam and Hekabe farther to the left. In the *Iliad* Iris summons Thetis to Olympos, where the gods instruct her to inform her son that they disapprove of his behavior (*Iliad* 24.73–119). Zeus then sends Iris to Priam with instructions for him to ransom the corpse of his son from Achilles (*Iliad* 24.142–58). She represents divine oversight of the laws of humanity, and her intervention sets into motion the resolution of the poem, laying the groundwork for Priam's recovery of his son's corpse and the subsequent funeral. The balanced opposition of Iris and Achilles on the vase reminds us that gods condemn Achilles' behavior, while the goddess's speed and agitation convey an urgent appeal to rectify the offense. Despite her prominence, however, Achilles turns his face away from the goddess and looks instead at Priam and Hekabe. Ultimately, it will not be the divine injunctions that convince him to return Hektor's body to Priam. He is moved instead by the emotions Priam stirs within him, by his compassion for Peleus's impending grief over his own son's death, and hence by his compassion for the grief that Priam suffers now.[8]

The ethical questions raised in the closing books of the *Iliad* reemerge more ominously in the legends of the sack of Troy.[9] The victory of the Greeks, at last secured through the ruse of the wooden horse, is less glorious combat than bloodthirsty

rampage, the Greeks' fury, like Achilles' rage against Hektor, driving them to exceed the conventions of regular warfare. The scanty surviving sources of lost epics tell of infants and old men slaughtered, of women brutalized and enslaved—a grim picture, sadly reflective of actual military conquests ancient and modern. Myth offers some moral justification for Troy's defeat in the form of Paris's illicit abduction of Helen, but when Aeschylus's Agamemnon proudly boasts that the Argive army has obliterated a city for the sake of one woman (*Agamemnon* 823–24), surely we should recognize the imbalance in his conception of justice. The Archaic and Classical vase-painters who treat the sack typically depict not the valiant last stand of the Trojans but disturbing scenes of slaughter. And the episodes of the legend appearing most frequently, Neoptolemos's attack on Priam and Ajax's attack on Kassandra, not only foreground violence against the weak; they are both acts of sacrilege, attacks on victims who have sought refuge in sanctuaries.

These two scenes often appear side by side, a juxtaposition that emphasizes the common elements of brutality and sacrilege, as on the Kleophrades Painter's Vivenzio hydria (figs. 93a, 93b), of approximately 480 BCE. The central scene among the five featured on the vase's shoulder shows Priam seated at an altar of Zeus, hands grasping his head in despair, as blood pours from his head and shoulder. His grandson Astyanax, naked and wounded, lies sprawled across his knees or is perhaps falling to the ground beside him. Tradition records that this last descendant of Priam was hurled from the walls of Troy—assurance that the detested line would not revive and seek vengeance against the Greeks—and the vase-painters regularly conflate his death with that of his grandfather, oldest and youngest members of the royal family perishing together. The child's frontal face, a feature rare in vase-painting generally but relatively common for Astyanax, seems to appeal for compassion to the vase's viewers. Beside Priam stands Neoptolemos, poised to strike again, and at the feet of the Greek lies an armed Trojan warrior, clearly wounded and dead, an indication that a more heroic, evenly matched combat preceded this attack on the old man and the child. In a roughly contemporary depiction of the same episode (formerly J. Paul Getty Museum, 85.AE.362), the warrior at Neoptolemos's feet appears to be labeled as Deiphobos, the Trojan prince to whom Helen was awarded after the death of Paris. Thus the vase-painters perhaps hint that the Trojans themselves are not blameless, their defeat not entirely unmerited. Those who would wage war must accept the consequences of defeat, as we see them depicted here. Yet it is difficult not to view Neoptolemos's brutal attack on Priam against Achilles' very different meeting with the old man in the *Iliad*. There the memory of his father, Peleus, had stayed Achilles' anger. For Neoptolemos, by contrast, we may suspect that remembrance of his lost father drives him on. Achilles once showed mercy to Hektor's corpse and compassion for Priam, but here not even the altar of Zeus restrains Neoptolemos from his pursuit of Priam and Astyanax.

Ajax's attack on Kassandra, immediately to the left of the Priam scene (fig. 93b), is an analogous conflation of victory and violation. Again, a Trojan warrior lies dead at the feet of the Greek; the enslavement of the women, we are to understand, is the horrific but expected consequence of the men's failure in war. As in the Priam scene,

FIG 93A Neoptolemos and Priam. Detail of an
Attic red-figure hydria attributed to the Kleo-
phrades Painter, ca. 480 BCE. Naples, Museo
Nazionale Archaeologico, 2422

FIG 93B Ajax and Kassandra. Detail of an Attic
red-figure hydria attributed to the Kleophrades
Painter, ca. 480 BCE. Naples, Museo Nazionale
Archaeologico, 2422. From A. Furtwängler and
K. Reichhold, *Griechische Vasenmalerei*, vol. 1
(Munich, 1904), fig. 34

however, any justification Ajax may claim for his attack is invalidated by the pres-
ence of Athena's statue. Ajax attacks Kassandra in the temple of the virgin goddess,
as she clings to the very image of the goddess. And as the warrior drags the maiden
from the goddess's image, ignoring her plea for mercy—his victim's naked body
indicating his intent to rape—we can sense the goddess's displeasure in the statue's
stance. The shield of the goddess extends before Kassandra's head, and the spear is
aimed at Ajax. An attack on Kassandra alone is unlikely to have troubled Athena,
certainly no friend to the Trojans in the *Iliad* or elsewhere. But for this violation of
her temple, the goddess punished the Greeks by wrecking their fleet on their journey
home, and the blasphemous Ajax was finally condemned to a dishonorable death at
sea (see *Odyssey* 4.499–511 and Alcaeus fr. 298). The image of the crime contains
within it an image of the goddess's wrath, reassuring us that Ajax's punishment is soon
to follow.

HEROES WHO PUNISH

On the opposite end of the moral spectrum from these transgressive heroes are those who function as true agents of justice, defending the virtuous and punishing wrongdoing—heroes like Orestes, who slays Aigisthos to avenge the murder of his father, Agamemnon. A magnificent red-figure krater of the mid-fifth century (figs. 94a, 94b) displays Aigisthos's crime and the ensuing punishment back to back, highlighting the hero's role as the justified avenger.[10] On one side (fig. 94a) we see Agamemnon mortally wounded by his cousin Aigisthos. According to Aeschylus's roughly contemporary *Oresteia* trilogy, the king returns home from Troy after ten years of war and at last relaxes in the comforts of home, not suspecting his wife's treachery. But as he emerges from the bath, stripped of clothing and weapons, Klytaimnestra entangles her husband in a netlike robe and stabs him to death. The vase-painter depicts a similar scene, Agamemnon rendered helpless by the robe. But instead of Klytaimnestra, as in Aeschylus's drama, Aigisthos, the man who seduced Klytaimnestra, here wields the sword and lands the killing blow. Aigisthos extends his left arm, grasping Agamemnon's head, indicative of his power over the helpless victim. And while Agamemnon extends an arm forward in supplication, the blood pouring from his wound shows us clearly that it is too late for mercy. The other side of the vase (fig. 94b) tells the second chapter of the story—the ensuing murder of Aigisthos—and the clear visual similarities between this composition and its companion image invite the viewer to explore the thematic complementarity between the two episodes. In the second image, the criminal has assumed the position of his former victim; his punishment matches his crime. Now Aigisthos appeals for mercy while his attacker holds him firmly by the hair, blood already pouring from the wound. We might sense an indication of unfairness in the contrasting attire of the two men, as we do in the opposite image; Orestes is equipped

FIG 94A Aigisthos kills Agamemnon. Athenian red-figure calyx-krater attributed to the Dokimasia Painter, mid-fifth century BCE. Museum of Fine Arts, Boston, William Francis Warden Fund, 1963, 63.1246

FIG 94B Orestes kills Aigisthos. Athenian red-figure calyx-krater attributed to the Dokimasia Painter, mid-fifth century BCE. Museum of Fine Arts, Boston, William Francis Warden Fund, 1963, 63.1246

with helmet, breastplate, and greaves, towering above a victim armed only with a lyre. Rather than pity Aigisthos as a gentle patron of the arts, however, the painter is inviting us to recognize the contrast between the heroic young son of Agamemnon, the king who led the Greeks at Troy, and the idle usurper, the man who stayed home and played while Agamemnon fought.

The female figure positioned immediately behind Orestes and rushing forward, axe ready for action, is a brief allusion to a darker detail of the myth. This axe-wielding woman can be none other than Orestes' mother, Klytaimnestra, who in Aeschylus's drama calls for a "man-slaying axe" upon discovering Aigisthos's death. Her first impulse is to defend herself and avenge her lover's murder, but instead she herself will soon die at the hands of her son. In Aeschylus's dramatization of the tale, in which Klytaimnestra, and not Aigisthos, masterminds the plot and lands the death blow to Agamemnon, Klytaimnestra is the principal victim of Orestes' retribution, and the confrontation between mother and son forms the emotional climax of the trilogy's second play. Aigisthos has only a subsidiary role, both in the murder of Agamemnon and in the revenge of Orestes. Aeschylus, to be sure, does not condemn Orestes by foregrounding the matricide or suggest that his heroism is somehow diminished as a result. In fact, the dramatist actively alienates his audience from Agamemnon's devious, transgressive wife and aligns our sympathies much more closely with the young hero, who undertakes the murder of his mother, a grim and unwelcome duty, with reluctance and trepidation. But whereas Aeschylus addresses this dilemma head-on, grappling openly with the moral complexity of the myth, the vase-painter has instead ironed over the moral wrinkles by relegating Klytaimnestra to a subsidiary position. While offering a hint of the imminent matricide, the painter showcases instead a moment of unambiguous moral triumph, a moment of honor and glory for the young hero.

Perhaps no other work of ancient Greek poetry constructs so clear a distinction between right and wrong, between heroes and villains, as does the *Odyssey*. The unruly and unwelcome suitors waste their days in idleness in Odysseus's palace, consuming his stores. Their ambitions fixed on the throne rightfully belonging to the absent king, they harass his wife and plot to murder his heir. Conditioned by our modern values to feel compassion and clemency, we may recoil at the terrible punishment Odysseus inflicts on the suitors, blood drenching the palace as he vengefully slaughters all 108 of these would-be usurpers. But there can be no doubt that the poem approves of its hero's violence and endorses the suitors' punishment as justice. With the terrible mutilation of the treacherous Melanthios and the gruesome execution of the disloyal maidservants, a task assigned to Telemachos, the poet again confirms Odysseus's moral authority over those who have wronged him. And in all these punishment scenes he seems to offer his audience a kind of grim emotional satisfaction, quenching the fierce indignation we have been conditioned to feel toward these miscreants and villains. In contrast to the *Iliad*, in which moral ambiguity and confusion visit Greeks and Trojans alike and our sympathy is drawn to both sides, the *Odyssey* forges an unambiguous distinction between those who violate and those who uphold justice. The specific moral principles governing the world of the *Iliad* and the *Odyssey* are not inherently

different, but the characters and the world they inhabit have changed in the *Odyssey*—no longer a loose confederacy of rival kings tearing down an enemy civilization, but a solitary man determined to reestablish law and order in his own kingdom. The poem celebrates the hero's power to impose the necessary law and order in a crisis, not his willingness to compromise and negotiate.

The poet highlights his moral preoccupation with crime and punishment at the very start of the narrative, where Zeus cites Aigisthos as an example of human recklessness justly punished.

> Oh for shame, how the mortals put the blame upon us
> gods, for they say evils come from us, but it is they, rather,
> who by their own recklessness win sorrow beyond what is given,
> as now lately, beyond what was given, Aigisthos married
> the wife of Atreus' son, and murdered him on his homecoming,
> though he knew it was sheer destruction, for we ourselves had told him,
> sending Hermes, the mighty watcher, Argeiphontes,
> not to kill the man, nor court his lady for marriage;
> for vengeance would come on him from Orestes, son of Atreides,
> whenever he came of age and longed for his own country.
> So Hermes told him, but for all his kind intention he could not
> persuade the mind of Aigisthos. And now he has paid for everything.
> —*Odyssey, 1.32–43, trans. Lattimore*

Life may not always deal the cards evenly; some will suffer a greater share of misfortune than others, some will enjoy a greater share of delights. But mortals should not imagine that they live in a morally blind universe, a universe where the virtuous can suffer and the wicked are rewarded. Zeus emphatically denies this with the example of Aigisthos, who may have enjoyed his ill-won success for a time but soon met the punishment he deserved. By raising this issue in the assembly of the gods, Zeus implicitly assigns the gods a role in moral oversight and judgment of human behavior. They recognize the injustice of Aigisthos's intentions, and they even send Hermes to warn him not to seduce Agamemnon's wife or murder the king.

Despite Zeus's indignation, Homer does not simply reassure his audience with the comforting belief that the gods administer justice, dispensing punishment and reward as merited. For the system to work, the passage implies, the world needs mortal heroes like Orestes to serve as agents of divine will. While Zeus cites Aigisthos as the model for crime punished, Orestes stands as a model for the justified avenger. Athena, in fact, will soon inspire Odysseus's son, Telemachos, by recalling Orestes' heroic achievement:

> Or have you not heard what glory was won by great Orestes
> among all mankind, when he killed the murderer of his father,
> the treacherous Aigisthos, who had slain his famous father?
> So you too, dear friend, since I can see you are big and splendid,
> be bold also, so that in generations to come they will praise you.
> —*Odyssey, 1.298–302, trans. Lattimore*

A young man on the threshold of maturity, Telemachos confronts the traditional choice of the hero: sit idle or embrace action. As with Orestes, the heroic path offered to Telemachos leads not just to achievement but specifically to moral achievement, triumph over the unjust. And by eventually joining his father in dispensing punishment to the suitors, Telemachos will earn heroic fame rivaling that of Orestes and will himself become another model of retributive heroic justice.

Hearing Athena's unqualified praise for Orestes' heroism, one may well wonder whether the poet had the murder of Klytaimnestra somewhere in the back of his mind. It is difficult to imagine that Homer did not know of the matricide, when he certainly knew of Klytaimnestra's complicity in her husband's murder; the king's shade recalls with burning resentment how his treacherous wife cut down his Trojan concubine Kassandra and refused to perform his burial rites (11.421–34). Like the Boston krater discussed above, however, the *Odyssey* prefers not to blur the boundaries between hero and villain. It shrewdly suppresses the matricide and favors instead a more straightforward model of heroic behavior. The same tendency governs Homer's characterization of Odysseus himself. Why, we might ask, did Odysseus alone of all his crew survive the journey home? Is he not responsible for the men he led to Troy? Did Odysseus's quest for adventure endanger his men unnecessarily and eventually get them all killed? Yet the very opening lines of the poem forestall this question and absolve Odysseus of any blame: "he could not save his companions, hard though he strove to; they were destroyed by their own wild recklessness" (*Odyssey* 1.6–7). Another potential stain on Odysseus's moral record is his reputation for disguise and deception. Pindar, always a stern moralist, faults Homer in his seventh Nemean ode for exaggerating Odysseus's merits; the men who favored the crafty Odysseus over the mighty Ajax in the contest for Achilles' arms, Pindar tells us, were blind to the truth (lines 20–30). The tragedians sometimes painted Odysseus as an unscrupulous and unprincipled opportunist, as did Sophocles in his *Philoktetes.* Even in the *Iliad,* although his leadership skills surpass those of Agamemnon (see the opening of book 2), Odysseus's integrity is not beyond suspicion. Achilles expresses mistrust when Odysseus announces the gifts offered by Agamemnon, and his nocturnal raid on the Trojan camp in book 10, when Odysseus and Diomedes slaughter Rhesos's sleeping soldiers and steal his prize horses, forms a provocative contrast with the battlefield combat in which Achilles earns honor and fame. The *Odyssey,* by contrast, expels any doubts about the hero's moral character by fashioning his cunning into a powerful weapon of justice. His cleverness is a shield against the lawless violence of the lands he visits. And upon his return to Ithaca, his beggar's disguise enables him to witness and judge the suitor's wickedness and to test the loyalty of his servants and his wife. Cunning, moreover, is an indispensable moral weapon for Odysseus's wife as well. Unlike the treacherous Klytaimnestra, Penelope employs deceit to delay her impatient suitors (recall the secret unraveling of Laertes' shroud) and to confirm that the triumphant stranger is in fact Odysseus (recall the test of the bed in book 23). Both husband *and* wife demonstrate heroic endurance, employ heroic cunning, and earn heroic fame for their moral virtue.

FIG 95A AND 95B The blinding of Polyphemos. Athenian black-figure oinochoe attributed to the Theseus Painter, 500–490 BCE. Paris, Musée du Louvre, F 342

Odysseus's encounter with the Cyclops Polyphemos exemplifies the triumph of just cunning over lawless aggression. The well-known series of tricks Odysseus employs to defeat the monster—calling himself Nobody, intoxicating the monster and blinding him, and tying his men to the bellies of Polyphemos's sheep—not only provide defense and escape for Odysseus and his men. They constitute a stern punishment for the savage who recognizes none of the conventions of the civilized world. The blinding is a favorite scene among early vase-painters, and a fifth-century example on a black-figure oinochoe in the Louvre (figs. 95a, 95b) draws a particularly acute distinction between the savagery of the monster and the civilizing power of the hero. As in several similar depictions of the story, the monster of the wilderness is clearly differentiated from the humans by his enormous size and by his shaggy hair and beard. But here the painter, following Homer, has also emphasized Odysseus's technological superiority by including the fire in which he heats his weapon. And the finely pointed stake he produces, the perfect tool for blinding, contrasts with the knotty rustic club resting in the left arm of the drunken Polyphemos.

Among Polyphemos's many savageries, Homer highlights in particular his violation of the laws of hospitality, a crime for which the suitors too are notorious. As Odysseus begins to drug Polyphemos with the powerful wine of Maron, the monster asks his guest for his name so that he may give him a guest-gift, or so he claims. In heroic legends, a guest-gift, like the war belt and the cup exchanged by Oineus and Bellerophon (*Iliad* 6.216–21), is a traditional token of the sacred bond uniting guest and host, and Zeus himself oversees this bond. But the gift Polyphemos offers Odysseus is no gift at all, only the honor of being eaten last. Polyphemos has not only ignored the sacred status of the guest, eating Odysseus and his men instead of feeding them; he openly derides the very institution of hospitality with this perverted present. It is here, not coincidentally, that Odysseus gives his name as Nobody, the ruse that will deter Polyphemos's neighbors from assisting him. Odysseus responds to Polyphemos's subversion of human and divine law with his own subversion. He counters the monster's injustice with cunning.[11] And Odysseus himself proclaims the moral lesson of his achievement immediately after he escapes from the cave, as he calls back to declare

the righteousness of his act: "in the end . . . your evil deeds were to catch up with you, and be too strong for you, hard one, who dared to eat your own guests in your own house, so Zeus and the rest of the gods have punished you" (*Odyssey* 9.475–79, trans. Lattimore). Odysseus, so he claims, has acted as the agent of the gods, upholding the moral order they oversee.

It should not be forgotten, however, that the defeat of Polyphemos is not, in the end, an unequivocal victory for justice. At Odysseus's moment of glory, when he reveals his true name to Polyphemos and bids Polyphemos spread the fame of his deed—"if any mortal man ever asks . . . , tell him that you were blinded by Odysseus" (*Odyssey* 9:502–4, trans. Lattimore)—Polyphemos curses his enemy, calling on his father, Poseidon, to punish him. Hence Odysseus is condemned to wander for years and lose all his companions before finally reaching Ithaca. That the very moment of triumph is also the origin of Odysseus's suffering suggests some moral unease on the part of the poet over Odysseus's achievement or his subsequent boasting. We are perhaps reminded that the monsters of this outer world and the gods who sired them do not fit neatly into the strict moral order we seek to impose on the human world. This is especially true of the wrathful Poseidon, who follows the old ethic of helping friends and harming enemies. Like the families of the suitors, who wage war against Odysseus in the poem's final book, the god of the sea will not be limited by questions of moral guilt and innocence in avenging his son's wound. It is enough for him to know that Odysseus wounded Polyphemos, not why and whether with justification. Like the sea itself, its stormy god follows his own rules. On the other hand, it is difficult to escape altogether the suspicion that Odysseus has gone too far in his conceit, recklessly endangering his men by calling out to Polyphemos, and recklessly endangering himself by proclaiming his identity. When he lays aside his cunning disguise, exults in his victory, and allows the character of the hero to emerge unrestrained, he perhaps fails to observe the limits of heroic achievement, and humiliation is the price he must pay.

The only hero who seriously rivals Odysseus as the most zealous avenger of wrongs is Theseus, the unusually civic-minded champion of the Athenian people. Theseus first displays his sense of moral indignation while still in his teens, when he leaves his hometown of Troezen and journeys to Athens to reveal himself as the heir of King Aigeus. On the road, he is tested by a series of brigands who make a career of murdering travelers, men like Sinis, who uses pine trees as catapults to dismember his victims, and Prokrustes, who accommodates his guests on a one-size-fits-all bed, either by stretching their bodies or cutting off appendages. The development of this series of deeds in the late sixth and early fifth centuries, a series that forms an obvious parallel to the famed labors of Herakles, suggests that the Athenians of the age saw their national hero as a worthy rival to the preeminent Dorian hero. Some sculptural projects, in fact, depict the achievements of Theseus side by side with those of Herakles, as, for example, the early fifth-century Athenian treasury at Delphi and the temple of Hephaistos and Athena in Athens from the mid-fifth century. But while Herakles' labors pit him against a string of monstrous beasts and send him to the

ends of the world, Theseus's deeds show a more specific interest in local justice. Both heroes make the world a safer place, but Herakles does so by civilizing the wilderness, Theseus by punishing the wicked.

No detailed poetic narrative of Theseus's deeds survives from the sixth or fifth centuries, but vase-painting preserves a rich record. In the interior of a remarkable fifth-century kylix (fig. 96), the zone surrounding the tondo displays six of Theseus's labors side by side, five scenes from his journey to Athens together with his later capture of the bull of Marathon. In each of the engagements, Theseus is young and beautiful, a model hero, while his wicked opponents have unkempt beards and unflattering receding hairlines, visual indications of their degeneracy, no doubt. Several of the scenes follow the familiar moralizing pattern, according to which punishment comes in the form of the original crime. Axe raised and ready to fall, Theseus forces Prokrustes to lie in his own bed. Skiron, who kicked his victims down a cliffside, where they were devoured by a giant turtle, is here about to become the turtle's next meal. And Sinis, who bound his victims to bent pines, is now pulled toward the pine tree himself. The combination of several scenes on one surface allows the artist to display his skill exploring various compositions and giving Theseus various triumphant poses— chopping, dragging, and stabbing his adversaries. But two of Theseus's poses carry a special symbolic significance: the figure attacking Skiron, with the arm raised above the head and bent, and the figure confronting Phaea and her monstrous sow, with the left arm thrust forward and draped by a cloak. These two distinctive stances suggestively mimic the stances of Harmodios and Aristogeiton from a well-known statue group that once stood in the Athenian Agora. In 514 BCE Harmodios and Aristogeiton led a conspiracy against the tyrant Hippias and his brother, Hipparchos, and though they succeeded only in murdering Hipparchos, the Athenians remembered them forever after as the tyrant-slayers. Their statues, showing them in the moment of attack, stood in the agora as a testament to their heroic undertaking and as a monument to the city's democratic, anti-tyrannical values. The original statues, destroyed when the Persians sacked Athens in 480 BCE, were soon replaced, and in the aftermath of the Persian wars, the monument perhaps acquired a new significance, embodying Athenian defiance of another potential tyrant, the Persian king. Roman copies of the lost Greek statues depict Harmodios, the older man, striding forward, his cloak draped over his outstretched arm, and Aristogeiton, his young accomplice, with his right arm raised high, preparing to land a blow. The adoption of their famous poses in depictions of Theseus, both on the London cup and elsewhere, characterizes the legendary hero as another enemy of tyranny, indeed, as the paradigmatic enemy of tyranny.

The tondo of the London cup is reserved for the best-known and most daring of all of Theseus's exploits: his victory over the Minotaur in the Kretan labyrinth. Fifth-century vase-painters typically chose to show Theseus in combat with the monster, but there is little room left on the London cup to do justice to the moment of conflict itself, and the painter has instead depicted its aftermath: Theseus emerging triumphant from the labyrinth, dragging the corpse behind him. By positioning Theseus specifically at the threshold, the artist perhaps invites us to contrast the beast's gloomy lair

FIG 96 Six youthful deeds of Theseus. Interior of an Attic red-figure kylix attributed to the Kodros Painter, ca. 440–430 BCE. London, British Museum, 1850,0302.3 (E 84)

with the light of day, and to see the hero's glorious accomplishment in opposition to the shameful deeds that went before—the birth of the illegitimate monster and the sacrifice of the Athenian youths and maidens, demanded annually by King Minos. Theseus, displaying the monster's corpse, assures us that the terror is now at an end. The threshold might also make us think of Ariadne, Minos's daughter, whose gift of a ball of string assisted Theseus in escaping from the maze. This myth thus echoes a familiar pattern—the hero sets out on a journey and overcomes a monster, thereby wining a beautiful princess—but again in this myth we find an atypical emphasis on the hero's sense of civic duty. By defeating the Minotaur, Theseus liberates the people of Athens from a foreign oppressor. Moreover, Theseus was not among those selected by lot; he volunteered for the mission, actively choosing a heroic confrontation with danger in defense of his city.

The lyric poet Bacchylides was attracted to Theseus's moral virtue, and in his seventeenth ode, which recounts a portion of the journey of the youths and maidens to Krete, he highlights another example of the hero's moral superiority. When Minos makes improper advances toward one of the Athenian maidens, Theseus is overcome with indignation and quickly intercedes to protect her. He reproaches the king openly:

"the spirit in thy breast no longer obeys righteous control" (Bacchylides 17.20–23, trans. Jebb). And he warns that he will risk his life and fight the king rather than allow the abuse to continue: "I should not care to look on the fair light of divine Eos, after though hadst done violence to one of this youthful company: before that we will come to a trial of strength, and Destiny shall decide the sequel" (Bacchylides 17.41–46, trans. Jebb). Bacchylides' Theseus knows right from wrong, fiercely opposes tyrannical abuse, and is willing to die in the pursuit of justice.

This survey of moral excellence and moral shortcomings among the heroes is necessarily selective and limited in scale. It should not be forgotten that Greek myth, shaped and reshaped by generations of creative artists, rarely entertained a one-sided or static moral picture of any major hero for long. The Theseus of Euripides' *Suppliants* is a calm and benevolent proto-democratic king, while in the same poet's *Hippolytos* a rash and unjustified Theseus brings about the death of his own son. The cunning avenger praised for his justice in the *Odyssey* occasionally becomes a conniving scoundrel in Athenian tragedy. Then there are the heroes whose experiences defy or transcend purely moral interpretation, Sophocles' *Oedipus,* for example. And add to these the vengeful and feared heroes of cult worship, and we soon realize that no simple assessment of good and bad can accommodate the heroes as a group or individually. The moral elements of heroic myth are nevertheless evident even to the casual observer. These traditional tales provided an institutional foundation for ethical thought in early Greece, and the artists often shaped the tales specifically to address moral issues and pose moral questions for their audiences, as the preceding examples have shown. The achievements of the heroes lie beyond the realm of everyday experience, but the ethical choices they face make them apt models for the warrior, the athlete, and the ordinary citizen. Observing the heroes' transgressions helped the Greeks to recognize the boundary separating right from wrong while reminding them that this boundary is not always fixed and impermeable. And although the motivation for the heroes' successes is typically the individual reward of honor and glory, in their active pursuit of justice, maintaining sanctified ideals of moral order by punishing offenders, they demonstrate a cooperative spirit and exemplify the civic ideal of serving the community as well as the self.

TRANSLATIONS

Arrowsmith, W., trans. Euripides: *The Bacchae*, in D. Grene and R. Lattimore, eds., *The Complete Greek Tragedies: Euripides V*. Chicago and London 1959.

Jebb, R. C., ed., trans. *Bacchylides: The Poems and Fragments*. Cambridge 1905.

Lattimore, R., trans. *The Iliad of Homer*. Chicago and London 1951.

Lattimore, R., trans. *The Odyssey of Homer*. Chicago and London 1965.

Marchant, E. C., trans. *Xenophon: Memorabilia and Oeconomicus*. New York 1923.

Nisetich, F. J., trans. *Pindar's Victory Odes*. Baltimore and London 1980.

NOTES

1 This is the version of the tale provided by Ovid at *Metamorphoses* 13.162–70, and it is not in fact known whether it originates in the early Greek material. Achilles' visit to the court of Lykomedes, however, was known already to the early epic, and I suspect that some ruse involving armor was also known at an early date. For a detailed survey of the early evidence for this myth, see especially Gantz 1993, 580–81.

2 Gantz 1993, 478–81, provides a lucid assessment of the evidence and additional bibliography.

3 If Temple E is in fact a temple of Hera, a reference to Semele, mother of Dionysos and a detested rival of Hera, might seem out of place. On the other hand, the Actaeon myth and the Semele myth are linked by some provocative analogies. Semele, in asking Zeus to appear to her in his divine form, as he appears to Hera, implicitly attempts to equate herself to the goddess. And Hera's vengeance on her rival, the incineration of Semele's body in the blazing thunderbolt of Zeus, parallels to a degree the bodily mutilation suffered by Actaeon.

4 See Barringer 2008, 32–46, for a more detailed discussion of the pediment.

5 E.g., Bowra 1930, 17–19, and Hainsworth 1993, 56–57.

6 E.g., Redfield 1994, 106, and see Yamagata 1994, 40–60.

7 For a more complete description of the vase and a more detailed discussion of its relationship to the *Iliad*, see E. Vermeule 1965.

8 Emily Vermeule (1965, 44–45) observes that the image of Achilles looking back upon Priam and Hekabe reflects the conventional iconography of the warrior's departure from his home. If we were to speculate further, this borrowing might give the viewer the impression that Achilles, looking back on Priam, sees also his own father, Peleus, as indeed he does when he looks upon Priam in book 24. This kind of meaningful ambiguity, however, is unlikely to have been deliberately added to the scene.

9 For further discussion of the sack of Troy, see Anderson 1997, passim.

10 See E. Vermeule 1966, for a full description of the vase and further discussion of its relationship with Aeschylus's trilogy.

11 It is quite possible that the name "Nobody" conceals within it a pun on the word "cunning." The form of the name Odysseus gives to Polyphemos is *outis*, but when the neighbors say "if nobody is hurting you . . ." (*Odyssey* 9.410), they use the form *mētis*, which but for a slight difference in accent is identical to *mētis*, meaning "cunning."

HEROES IN MYTH

Greek heroes and heroines are known to us today primarily through the epics, which recount their lives and deeds. To the Greeks, however, they were not fictional protagonists invented by a storyteller; they were mortals who had lived, died, and were worthy of worship. While they were known universally through the epics, their cult was mostly local, often limited to their hometown or the place in which they had died.

The life cycles of four major figures in myth and the manner in which these heroes and heroines are represented in the arts suggest that the question of what defines a hero is not easily answered. Each follows a distinctly different trajectory and is characterized by very different qualities: Herakles, the strong hero-god; Helen, the eternal beauty; Achilles, the hot-tempered warrior; and Odysseus, the cunning traveler. The artists illustrate every aspect of a hero's life, from birth to death. In a large variety of scenes and media they highlight their greatest deeds, their failures, comical aspects, and private moments with family and friends. The deeds of a hero or heroine could be illustrated by artists in great detail or brought into focus as a single iconic image that summarized the whole story.

The noteworthy parentage and conception of heroes and heroines often presage their future glory. Many face obstacles in early childhood or perform their first heroic deeds in their early years. Scenes of marriage provide a glimpse into the private lives of the heroes, but many heroic marriages end unhappily or experience times of distress. Moments of respite for the heroes often carry a sense of foreboding. Agony and glory often occur side by side, as heroes overcome obstacles, sometimes relying on support from friends or gods. Many heroes are defined by their adversaries, the monsters or warriors they kill in battle. Finally, as Corinne Ondine Pache observes, death marked the point of transition: "For all the differences among ancient heroes and heroines—their deeds and status in life, their choices, their manner of dying—they are all alike in transcending death by becoming immortalized after death."

SA

1. THE BIRTH OF HELEN

Apulian red-figure pelike
Attributed to the Painter of Athens 1680,
ca. 360–350 BCE
Height 32.7 cm
Kunsthalle zu Kiel, Antikensammlung, B 501

PROVENANCE
Museum purchase, 1969

SELECTED BIBLIOGRAPHY
RVAp 1:243, no. 137; *RVAp* Supp. 2, 54; Raeder
1986, 92, 105; *LIMC* 4 (1988), s.v. Helene, 503,
no. 6 (L. Kahil); Schmaltz 1996, 102–6; Neils
and Oakley 2003, 209, no. 7

The lively scene on this South Italian pelike depicts the birth of Helen. At the center, an infant emerges from a large white egg that sits atop an altar. She reaches out to a frightened woman, who flees with her arms outstretched in surprise. The woman's flowing garments indicate her haste as she dashes to the left and looks back at the scene unfolding. Behind the altar is a young man, nude except for a mantle and sandals. With an expression of surprise on his face, he extends his right hand, which holds a knotty staff, toward the newborn. Hovering above the trio on a schematically rendered groundline is a winged Eros, who holds a large wreath in his right hand. The son of Aphrodite frequently appears in representations of Helen, alluding to the heroine's unrivaled beauty and appeal.

Helen's parentage was unclear even in antiquity; some myths maintained that she was the daughter of Zeus and Leda, while other accounts named Tyndareus as her father or Nemesis as her mother. The myth depicted here treats Nemesis as her mother. The goddess of retribution transformed herself into a goose to fend off the unwanted advances of Zeus, but he, undaunted, took the form of a swan and impregnated her. As a result of this odd conception, Helen was not born in the typical way but instead was hatched from an egg. According to the myth, Nemesis gave the egg to a shepherd, who in turn gave it to Leda. She served as surrogate mother and hatched the egg by placing it on a warm altar. The motif of Helen's birth from an egg is rare in Greek art; it is more common in South Italian vase-painting. The scene reinforces Helen's heroine status by highlighting her divine and remarkable origins.

On the opposite side of the vase are a young man holding a bunch of grapes and a young woman with a phiale. The phiale is a vessel used to pour libations, often onto altars, and perhaps alludes loosely to the scene on the opposite side.

HAC

2. THE INFANT HERAKLES STRANGLING SNAKES

Stater of Kroton, South Italian (Bruttium)
Mid-fourth century BCE
Silver; 7.61 g
American Numismatic Society, New York,
1955.54.42

PROVENANCE
Gift of Mrs. G. P. Cammann, 1955

SELECTED BIBLIOGRAPHY
SNG ANS 3 (1975), no. 386; Neils and Oakley 2003,
212, no. 11

Like many cities throughout the Greek world, Kroton (present-day Crotone), one of the principal cities of South Italy, boasted Herkales as its legendary founder, celebrating this heritage by placing images of the hero on a portion of its coinage.[1] This issue of silver staters, generally dated to the middle decades of the fourth century BCE, features a popular legend from Herakles' infancy as a reverse type, opposite a head of Apollo—another of the city's favored deities—on the obverse.

Herakles was the son of Zeus and Alkmene, a Mycenaean princess. Zeus's divine consort, Hera, angered by her husband's tryst with a mortal woman, had tried unsuccessfully to prevent Alkmene from giving birth. Later, as told by the poet Pindar (*Nemean Odes* 1:35–72) and others, Hera sent a pair of snakes to slay the infant Herakles and his (fully mortal) twin, Iphikles. Herakles, whose preternatural vigor was already evident, throttled the serpents.

The Kroton coins, perhaps more than others bearing representations of the same incident, seem to emphasize the naive playfulness with which the juvenile Herakles, nude and in a crouched position, regards his attackers.[2] Rather than being perilously encumbered, he extends both his arms away from his body, grasping each snake by the neck and peering into the face of one of them.

RG

NOTES
1 For the coinage of Kroton, see N. K. Rutter, ed.,
Historia Numorum: Italy (London, 2001), 166ff; for
the coin type illustrated here, see no. 2157.

2 The infant Herakles strangling snakes also appears
on roughly contemporary issues of Thebes, as well as
on the so-called ΣΥΝ coinage struck by several allied
cities in Asia Minor at the end of the fifth or beginning
of the fourth century BCE; see S. Karwiese, "Lysander
as Herakliskos Drakonopnigon," *Numismatic Chronicle*
140 (n.s. 20) (1980): 1–27.

3. HERAKLES AS A CHILD

Roman copy after a Hellenistic original
Bronze; 12.3 × 8 × 4.5 cm
Baltimore, The Walters Art Museum, 54.1002

PROVENANCE
Henry Walters, by 1931; Walters Art Gallery, by
bequest, 1931

SELECTED BIBLIOGRAPHY
Hill 1948; Hill 1949, 49, no. 100; *LIMC* 4 (1988),
s.v. Herakles, 788, no. 1253 (O. Palagia)

This small bronze statuette depicts a boy holding a club, which he rests upon his shoulder. His nude body is somewhat chubby and has the proportions of a child. His right hand is outstretched, and he may have once held something, perhaps an adversary or an animal. Striding to the left, his weight rests upon his left leg, while his right foot barely touches the ground. His hair is short and curly, held in place with a thick band.

Although we tend to think of Herakles as an archetypal hero, fully grown and muscular, he is often represented as an infant or a child.[1] The club, an attribute used in his deeds, confirms his identity. Herakles was unique among Greek heroes for having performed extraordinary deeds as an infant, strangling the snakes sent by Hera. Here, his weapon and active pose again suggest that this is no ordinary child; instead, he is imbued with the extraordinary strength of a hero.

JHC

NOTE
1 For a similar piece (a life-size bronze of 62.2 cm), see Neils and Oakley 2003, 204–5, no. 3.

4. HERAKLES AS A YOUTH (BELOW)

Roman copy after a Hellenistic original
Marble; height 30 cm
Staatliche Museen zu Berlin, Antikensammlung,
Sk 188

PROVENANCE
From Herculaneum; Friederike Sophie Wilhelmine,
margravine of Bayreuth (sister of Friedrich II [the
Great]), by 1758; formerly at Sanssouci, Potsdam

SELECTED BIBLIOGRAPHY
Conze 1891, 81, no. 188

COMPARANDA
LIMC 4 (1988), s.v. Herakles, 746, 761, nos. 305
and 650–51 (O. Palagia)

5. HERAKLES AS A CHILD (OPPOSITE)

Roman copy after a Hellenistic original
Marble; height 29 cm
Staatliche Museen zu Berlin, Antikensammlung,
Sk 153

PROVENANCE
From Herculaneum; Friederike Sophie Wilhelmine,
margravine of Bayreuth (sister of Friedrich II [the
Great]), by 1758; formerly at Sanssouci, Potsdam

SELECTED BIBLIOGRAPHY
Conze 1891, 68, no. 153

COMPARANDUM
LIMC 4 (1988), s.v. Herakles, 786, no. 1226
(O. Palagia) (possibly Eros as Herakles)

The Hellenistic period saw the development of a wide variety of artistic styles, including the decorative and lighthearted rococo style, a term borrowed from eighteenth-century French art.[1] Children, hitherto only rarely represented in Greek art, became a common subject in sculpture.

The extraordinary childhoods of many heroes were a natural subject for this new interest in portraying children. Herakles as a child was a particularly popular image, and he is most often shown performing his earliest deed: strangling the snakes that Hera sent to kill him in his crib. One of the heads from Berlin offers a distinctly anachronistic portrayal, showing Herakles as a child, a figure too young to have undertaken the great labors for which the hero was famous. And yet he is clearly identified by the lion skin—the fruit of his first labor—worn on his head and wrapped around his neck.

Whereas images of Herakles from the sixth and fifth centuries BCE typically show the hero as an older, bearded figure, the second sculpture depicts him as a beardless youth, a portrayal that became more common in the Hellenistic period. In both instances, the subject's identification as Herakles is entirely reliant on his main attribute.

AS

NOTE
1 Pollitt 1986, 127.

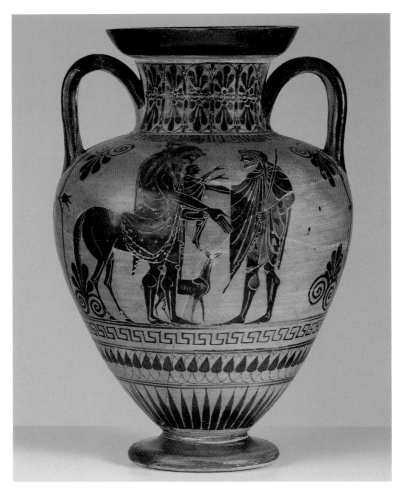

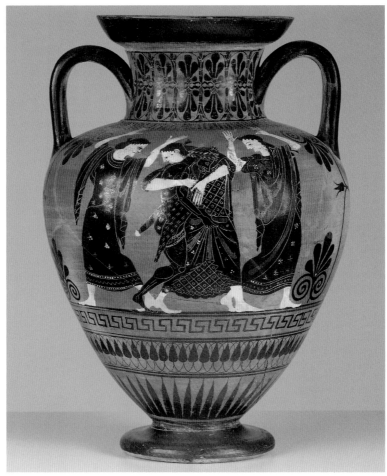

6. PELEUS AND THETIS / ACHILLES AND CHEIRON (OPPOSITE)

Attic black-figure amphora
Attributed to the Group of Würzburg 199, circle
of the Antimenes Painter, ca. 520–510 BCE
Height 40.6 cm, diameter 26.7 cm
Baltimore, The Walters Art Museum, 48.18

PROVENANCE
Don Marcello Massarenti, Rome, by 1897; Henry
Walters, 1902; Walters Art Gallery, by bequest, 1931

SELECTED BIBLIOGRAPHY
Massarenti 1897, 2:43, no. 203; Hill 1962; *ABV*
288, 13; Brommer 1973, 321, no. 18; *BAdd*² 75;
Krieger 1973, 27, 29, 42, 56, 58–59, 116, 159,
no. 39; *LIMC* 1 (1981), s.v. Achilleus, 45, no. 20
(A. Kossatz-Deissmann); *LIMC* 7 (1994), s.v.
Peleus, 259, no. 109 (R. Vollkommer); Neils and
Oakley 2003, 214–15, no. 14; Albersmeier 2008,
56–57, no. 14 (A. Kokkinou)

7. ACHILLES AND CHEIRON (BELOW)

Second–first century BCE
Red jasper, set in a modern gold ring;
width of bezel 1.3 cm
Baltimore, The Walters Art Museum, 42.1161

PROVENANCE
Chesterfield collection; Bessborough collection
(no. 31c); Tassie collection (no. 9207); Marl-
borough collection (no. 339); Henry Walters
(Dikran Kelekian as agent), by 1931; Mrs. Henry
Walters, 1931, by inheritance; sale, Joseph Brummer,
New York, 1942; museum purchase, 1942

COMPARANDA
LIMC 3 (1986), s.v. Cheiron, 242–43, no. 69
(M. Gisler-Huwiler); *LIMC* 1 (1981), s.v. Achilleus,
49, no. 57 (A. Kossatz-Deissmann)

NOTES
1 For the life and deeds of Peleus, see *LIMC* 7 (1994),
s.v. Peleus, 251–52 (R. Vollkommer).

2 For the myth of Thetis's abduction and marriage and
its depictions, see Krieger 1973; Schefold 1992, 208–11;
LIMC 7 (1994), s.v. Peleus, 251, 255–69, nos. 47–212
(R. Vollkommer); *LIMC* 8 (1997), s.v. Thetis, 6–9,
13–14 (R. Vollkommer).

3 For the myth of Achilles' education by Cheiron and
its representations, see Kemp-Lindemann 1975, 7–38;
LIMC 1 (1981), s.v. Achilleus, 41–42, 45–55 (A.
Kossatz-Deissmann); Schefold 1992, 211–14; *LIMC* 7
(1994), s.v. Peleus, 252, 267–69, nos. 214–27
(R. Vollkommer).

Both sides of the Walters amphora are decorated with themes concerning Achilles' conception and his accession to manhood. Side A refers to him indirectly, showing the encounter and the binding of his parents: the divine Nereid Thetis and the mortal hero Peleus, who was renowned for his many glorious deeds.[1] The union of supernatural and human resulted in Achilles, immortal through the efforts of his mother but for his vulnerable heel.

Peleus found Thetis with her sisters on a beach and managed to abduct and marry her despite her threatening metamorphoses. The hero wears a chitoniskos, an outfit commonly associated in the visual arts with heroes and hunters. The animal skin that he wears and his sword signal his heroic spirit. The wreath of olive branches on his head foretells the victorious conclusion of his exploit. The marine goddess does not show any indication of undergoing a transformation, as she often does in other representations of this episode.[2]

In the second scene, Achilles is a young boy. The episode is the entrusting of the hero to the wise Centaur Cheiron, a renowned teacher. Peleus is depicted as a mature and gentle father, unarmed, with a chlamys and a staff. He is handing his child over to Cheiron, who has already taken hold of his student with his left arm. The infant Achilles raises both arms toward his father in a tender gesture.[3]

The gemstone depicts Cheiron resting on his hind legs underneath a tree on the right. He has a long beard, and his hair is arranged in a thick roll around his head. A loose piece of cloth or animal skin hangs over his right shoulder. He reaches out to grasp the lyre that the nude boy holds in his right arm in order to instruct him. The musical education of Achilles by Cheiron is a particularly popular theme on gems. The first literary reference to the theme is Roman (Ovid, *Ars Amatoria* 1.11), but Achilles' lyre-playing is already mentioned in the *Iliad* (9.186–89).

AK / SA

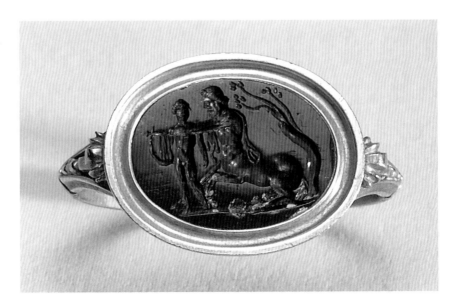

8. HERAKLES, NESSOS, AND DEIANEIRA

Tyrrhenian amphora
Attributed to the Castellani Painter, ca. 570–560 BCE
Height 40.7 cm, diameter 26 cm
Museumslandschaft Hessen Kassel, Museum Schloss Wilhelmshöhe, T 385

PROVENANCE

From Cerveteri; Calabresi collection, Rome; Edward Perry Warren, by 1899; gift of Edward Perry Warren, 1899

SELECTED BIBLIOGRAPHY

ABV 105.2; *BAdd²* 28; *CVA* Kassel, fasc. 1 (1972), 40–41, pl. 16,1–4, 18,1 (R. Lullies); Beazley 1971, 35; Yfantidis 1990, 121–23, no. 69; *LIMC* 6 (1992), s.v. Nessos, 839, no. 12 (F. Diéz de Velasco); Stansbury-O'Donnell 2006, 200–201, fig. 67

The central scene on the shoulder of the vase shows Herakles wrapped in the lion skin attacking the Centaur Nessos, who had assaulted Herakles' wife, Deianeira, while ferrying her over the river Evenus. The hero grasps the Centaur's right arm and threatens him with a large sword. Deianeira, dressed in a star-patterned peplos, anxiously looks back toward Herakles with both arms raised. The dramatic events in the middle are witnessed by three women in long garments and himation (probably Deianeira's servants), who raise their hands in agitation. The scene is framed by a Centaur on either side, each of whom carries a large rock on his back.

The friezes below the shoulder and on the neck of the vase are decorated with lotus-palmettes, while the two lower registers are animal friezes with deer, ram, boar, and panthers. The shoulder frieze depicts five dancers.

The Nessos and Deianeira episode foreshadows Herakles' death and apotheosis and also signifies the sad ending of Herakles' penultimate marriage. While he succeeds here in rescuing his wife and killing the Centaur, he nevertheless seals his fate. Just before his death, Nessos convinces Deianeira that his blood can win Herakles' attention back, should the hero's love for her ever wane. When Herakles becomes infatuated with Iole, the desperate Deianeira gives him a garment saturated with the supposed love potion, which turns out to be caustic and burns Herakles alive. The gods finally rescue him from the funerary pyre he erects for himself to end his suffering and bring him to Olympos, where he marries Hebe, daughter of Zeus and Hera.

SA

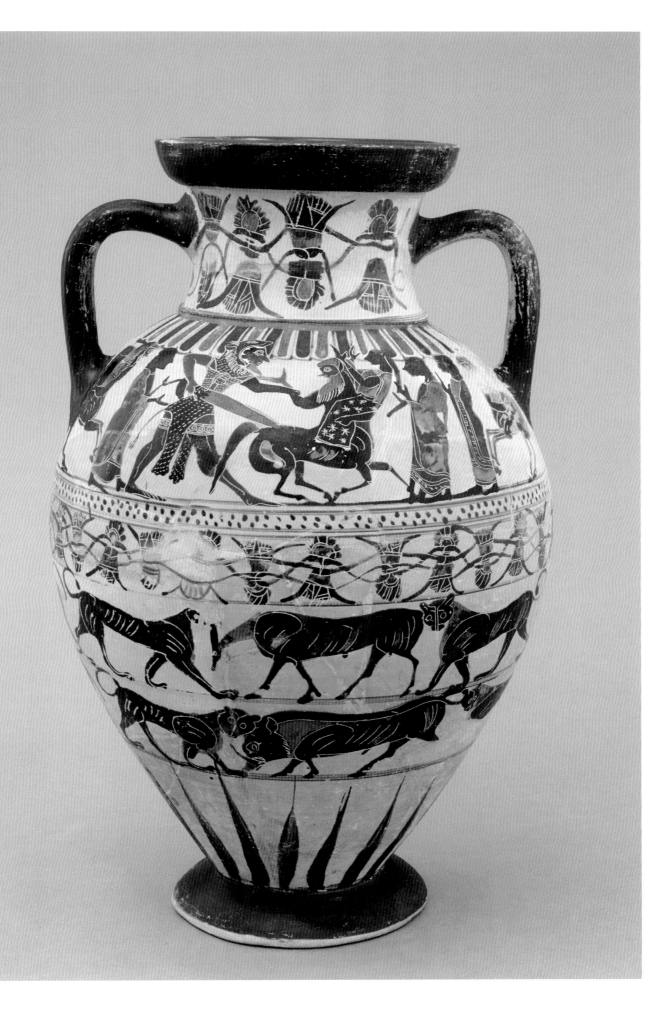

9. THE MARRIAGE OF HERAKLES AND HEBE

Attic red-figure pyxis
Attributed to the Meleager Painter, ca. 400–390 BCE
Height 7.9 cm, diameter 21 cm
Philadelphia, University of Pennsylvania Museum of Archaeology and Anthropology, MS 5462

SELECTED BIBLIOGRAPHY

Luce 1916; Vollkommer 1988; *LIMC* 4 (1988), s.v. Hera, 715, 474 (A. Kossatz-Deissmann); *LIMC* 4 (1988), s.v. Hebe 1, 458–64 (A.-F. Laurens); J. Neils, "Hera, Paestum, and the Cleveland Painter," in Marconi 2004, 77

The nude, youthful Herakles holds his club in his left hand; with his right hand he grasps the wrist of his young bride, Hebe, and leads her to the right. This gesture, known as *cheir' epi karpo*, is commonly used in Greek art to indicate a scene of marriage. Hebe wears a richly ornamented gown and jewelry. Floating behind her is an Eros who delicately adjusts her veil. The young husband is preceded by another Eros figure, carrying a torch as he leads the couple toward a small gathering of gods. Hestia, goddess of the home and hearth, greets the newlyweds. Behind her is Athena, who gazes over her right shoulder toward the approaching pair. Beyond Athena sit Zeus and Hera, who represent an earlier generation of divine marriage. Another Eros awaits the couple as he leans expectantly against the back of Zeus's throne. Two women behind Herakles and Hebe are the young bride's attendants; they carry a loutrophoros, a vessel used to transport water for a nuptial bath, and a box that likely contained the bride's jewels. Two doves, symbols of Aphrodite, flank the couple. Added white paint was used for Hebe's highly ornamental garment, on the flesh of the Erotes, and for the upper portion of Athena's clothing. Various details, including diadems, earrings, and necklaces, were gilded. The lid is encircled by an egg-and-dot motif that is repeated around the top of the frieze and around the handle.

Hebe, whose name means "youth," was the daughter of Zeus and Hera. Herakles' marriage to the young bride was believed to symbolize a reconciliation between the hero and Hera, while also granting him entry to Olympos and eternal youth (Hesiod, *Theogony* 950–55).

HAC

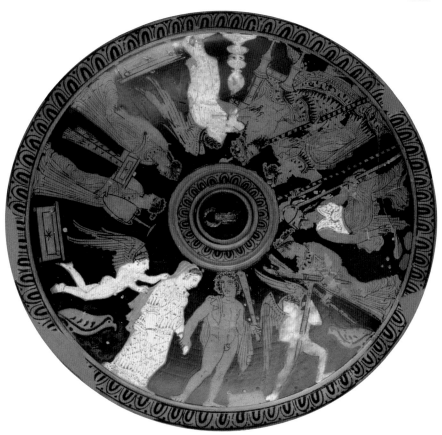



11. HELEN AND PARIS

Apulian red-figure pelike
Attributed to the Laodameia Painter, mid-fourth
century BCE
Height 48.3 cm, diameter 27 cm
Museumslandschaft Hessen Kassel, Museum
Schloss Wilhelmshöhe, T 723

PROVENANCE
Purchased in 1971 from Rosenbaum, Ascona

SELECTED BIBLIOGRAPHY
Kahil 1955; *CVA* Kassel, fasc. 2 (1972), pls. 74–76;
Schmidt, Trendall, and Cambitoglou 1976; *LIMC* 4
(1988), s.v. Helene, 521, no. 118 (L. Kahil); Yfantidis
1990, 260–61

In the center of side A of this pelike sits an enthroned young man wearing a Phrygian cap over his long hair and a knee-length, long-sleeved chiton that is held in place by straps that cross over his chest. His feet, in high-laced boots, rest upon a low footstool. In his right hand he holds a scepter. Above him floats an Eros, who crowns him with a wreath. This regal figure in eastern attire has been identified as Paris, the Trojan prince who abducted Helen and instigated the Trojan War. He looks toward a woman on his left—perhaps Helen, wearing a chiton with a long overfold, earrings, and a bracelet and standing with her back to the viewer, her right hand on her head and her hand propped on her hip. To the left of this pair stands a woman, perhaps a personification of Aphrodite, in a long, ornamented chiton, holding an oinochoe and phiale, vases typically used for libations. At the far right is a younger female figure in loose garments carrying a kalathos, or basket. Above this lower scene are two more women. On the left, a figure sits on a low box and holds a tympanum, or tambourine. On the right, another woman sits on a mantel and holds a mirror. A xylophone rests on her lap.

In the middle of side B, a nude youth stands in a relaxed pose, holding a wreath in his right hand. He looks at a woman seated on his right who wears a belted chiton and holds a wreath and a box. Beneath her is an egg and, in the left corner, an open box. Flanking this central pair are two women; the one on the left wears a chiton and mantle and holds a shallow vessel and a kithara. On the right of the couple stands a woman in a belted chiton holding a tympanum. All three women have the same hairstyle. In the background between the central couple is a tree that is framed by two Erotes in the upper field, each of whom holds a fillet. This image may also depict the infamous mythological pair or a more generic couple, alluding to the figures on the opposite side.

HAC

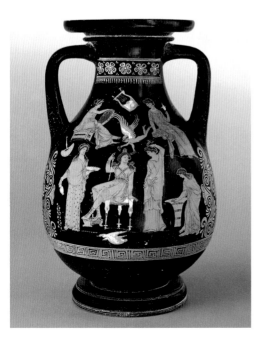

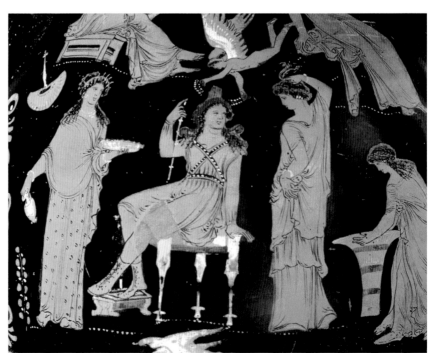

12. HELEN AND MENELAOS

Attic red-figure lekythos
Attributed to the Brygos Painter, early fifth
century BCE
Height 34 cm
Staatliche Museen zu Berlin, Antikensammlung,
F 2205

PROVENANCE
From Armento (Italy). Came to the museum in 1827
as part of the Bartholdy collection

SELECTED BIBLIOGRAPHY
Wegner 1973; *ARV²* 383, 202; *LIMC* 4 (1988), s.v.
Helene, 514, no. 62 (L. Kahil)

The man on this lekythos, depicted frontally with his head turned to the right, is identified by an inscription as Menelaos, the legendary king of Sparta; the woman is Helen, his wife, who was the direct cause of the Trojan War. Menelaos is wearing a helmet and a himation. In his right hand he holds a spear, and his left hand grasps Helen's wrist. Standing behind Menelaos, facing left, Helen wears a chiton and a himation that covers her head. The image of a man holding a woman's wrist has a strong nuptial connotation. It may depict the actual wedding, with the bride being led away by her new husband. The scene on this vase may represent the wedding of this famous couple, or, as one scholar has suggested, it may depict Menelaos leading Helen away after she was awarded to him in this famous contest (see Pindar, *Pythian Odes* 9.121–23).

As the daughter of Zeus, Helen was qualified by her lineage alone to be considered a heroine. When it was time for her to marry, suitors came to Sparta from all over the Greek world. Tyndareus, the husband of Leda, Helen's mother, commanded the suitors to support the man that he selected as Helen's husband and to offer assistance should another try to compromise the marriage. Their loyalty was put to the test by Helen's abduction.

SS

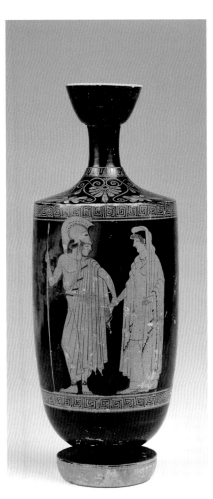

13. HERAKLES AND TRITON

Attic black-figure hydria
ca. 530–520 BCE
Height 40 cm
Museum of Fine Arts, Boston, Henry Lillie
Pierce Fund, 1899, 99.522

PROVENANCE
Reportedly from Vulci; Campanari Collection;
Rogers Collection, by 1856; Christie and Manson
(sale, 1856, lot 347); W. H. Forman, by 1899; with
Sotheby, Wilkinson & Hodge, London (sale, June
19–22, 1899, lot 284); Edward Perry Warren, 1899;
museum purchase, 1899

SELECTED BIBLIOGRAPHY
ABV 150, 7; *CVA*, Museum of Fine Arts, Boston,
fasc. 2 (1978), pl. 766; Glynn 1981; Russell et al.
1999, 217, no. 168; Kondoleon, Grossmann, and
Ledig 2008, 161

NOTE
1 Glynn 1981, 126.

On the body of this exquisite black-figure hydria is a scene of Herakles engaged in a tense struggle with the sea monster Triton. The hero, clad in a short chiton and his characteristic lion skin, straddles his opponent and is mostly hidden by the sea creature. Herakles' hands are clasped in front of Triton's bare chest. Triton's bearded face looks away from his adversary as his arms struggle to release Herakles' crushing grip. While the upper half of his body is human, Triton's lower body takes the form of a fish—his long, scaly tail forms a series of sinuous curves terminating in an upraised fish tail.

Two areas of subsidiary decoration frame the central panel. On the shoulder are three nude youths leading horses. Beneath the main scene is a frieze of panthers flanking a deer. The panthers and helpless prey resonate with the contest in the panel above.

In literature, Herakles' only recorded encounter with a sea creature was with the sea god Nereus, who was a fully human figure. The motif of Herakles wrestling the merman Triton appeared in black-figure vase-painting in the sixth century and was a popular motif. Despite the common sea origin of both Nereus and Triton, vase inscriptions have established that the men are two distinct figures.[1] The motif of Herakles wrestling Triton survives only in the visual arts. While we cannot know the exact details of the story that the painter had in mind, scenes of Herakles struggling with the fish-tailed Triton offered the artist an opportunity to illustrate the hero's superior strength while also demonstrating his skill at rendering the monster's sinuous tail.

HAC

14. HERAKLES AND THE ERYMANTHIAN BOAR

Attic black-figure neck-amphora
ca. 520 BCE
Height 42.7 cm, diameter 28.4 cm
Baltimore, The Walters Art Museum, 48.253

PROVENANCE
Joseph Brummer, New York, by 1925; Henry
Walters, 1925; Walters Art Gallery, by bequest, 1931

SELECTED BIBLIOGRAPHY
Bothmer 1954, 63; Brommer 1973, 48, no. 37;
Albersmeier 2008, 54–55, no. 13 (A. Kokkinou)

NOTES
1 Schefold 1992, 94; *LIMC* 5 (1990), s.v. Herakles,
5–6 (J. Boardman); Wünsche 2003, 56–57 (B. Kaeser).

2 Luce 1924, 296–98, 310–25; Vollkommer 1988, 6;
LIMC 5 (1990), s.v. Herakles, 43–48, nos. 2, 124
(W. Felten), 43–48, nos. 2, 124; Schefold 1992, 102–6;
Wünsche 2003, 99–103 (B. Kaeser).

3 For images of Dionysos with a woman and satyrs,
see Isler-Kerényi 2007, 107–24.

After Herakles, maddened by Hera, murdered his wife and children, he was ordered by the oracle at Delphi to perform a series of labors for Eurystheus, king of Tiryns, as penance.[1] Side A of this Attic amphora is decorated with the capture of the Erymanthian boar, a savage beast that ravaged the Erymanthos Mountains in the Peloponnese. Here, the final moment of this episode is depicted: the presentation of the boar to Eurystheus. Herakles carries the beast on his left shoulder, resting his left foot on the rim of a pithos, a large storage vessel that was usually buried halfway in the earth. He is ready to throw the animal on the king, who is hiding in the pithos with both hands raised in fear. Herakles' unusual outfit, a short chiton and a cuirass, associates him with warriors. Behind Herakles, his divine patron, Athena, carries his armor, a helmet, and a club. The other female attendant is probably the king's mother.[2]

The theme on the opposite side is not immediately related to the story on side A but complements the amphora's function as a symposium vessel. In the center, Dionysos with his characteristic drinking cup, the kantharos, and possibly his wife, Ariadne, stand facing each other. Two satyrs, members of the god's playful procession, dance at each side.[3]

The god and the famous hero had one characteristic in common: their love of wine. Dionysiac scenes and Herakles' labors were a favorite theme for vase-painters during the Archaic period.

AK

15. HERAKLES AND KERBEROS

Attic black-figure amphora
Attributed to the Edinburgh Painter, late sixth
century BCE
Height 45.7 cm, diameter 29.8 cm
Los Angeles County Museum of Art, William
Randoph Hearst Collection, 50.8.19

PROVENANCE
Marshall Brooks (d. 1944); sale, Sotheby's London
(May 14, 1946, no. 15); William Randolph Hearst,
1946; presented to the Los Angeles County
Museum, 1950

SELECTED BIBLIOGRAPHY
ABV 479, 4; *CVA* LACMA, fasc. 1 (1977), pl. 11;
LIMC 5 (1990), s.v. Herakles, 89–90, no. 2587 (V.
Smallwood); Levkoff 2008, 214, no. 96 (A. J. Clark)

Side A of this amphora depicts Herakles leading Kerberos out of the underworld in the presence of Athena and Hermes (see also no. 28). Herakles, who wears a short chiton and quiver, moves to the right but turns his upper body back to face the two-headed beast, who resists the hero. One of the dog's two heads looks up and snarls at Herakles. A thick mane with thick tufts of fur runs the length of the animal's back, and its sinuous tail forms a backward S-curve that terminates in a snake head. Towering above Kerberos is Athena, the crest of her helmet interrupting the tongue pattern above. She wears a chiton with incised stars, and her aegis, pinned at the neck, is bordered in curling snakes. In her right hand is a spear. She raises her left hand, perhaps to threaten the dog or to encourage the hero in his difficult feat. Behind Kerberos, at the left, is Hermes in a chitoniskos, chlamys, petasos, and winged boots. He extends his left hand toward Athena while holding his kerykeion in his right.

A much calmer, nonmythological scene decorates side B. In the center stands a hoplite who removes his Corinthian helmet with his right hand. In his left hand are his shield and two spears. He approaches a seated elderly man in a striped himation who holds a scepter and wears a fillet, suggesting that he is of royal status. The seated figure greets a dog that rests its front paws on the old man's knees. Behind the soldier is another man at the left wearing a striped himation. The figure holds a spear and looks back, away from the central scene.

HAC

16. HERAKLES WITH CLUB AND BOW
(TOP)

Greco-Phoenician, probably from Sardinia
Late sixth century BCE
Green jasper, gold; height of gem 1.5 cm
Baltimore, The Walters Art Museum, 42.158

PROVENANCE
Newton-Robinson collection (sale, 1909, no. 14);
Hoffmann collection; Dikran Kelekian, New York/
Paris; Henry Walters, 1909; Walters Art Gallery,
by bequest, 1931

SELECTED BIBLIOGRAPHY
LIMC 4 (1990), s.v. Herakles, 734, no. 19
(J. Boardman)

17. HEAD OF HERAKLES (BOTTOM)

Roman period, first–second century CE
Sard, set in modern gold ring; height of
bezel 1.6 cm
Baltimore, The Walters Art Museum, 42.511

PROVENANCE
Henry Walters, before 1931; Walters Art Gallery,
by bequest, 1931

COMPARANDA
Richter 1971, 61, nos. 281, 282; *LIMC* 4 (1990),
s.v. Herakles, 739, nos. 101, 110 (O. Palagia).

The jasper depicts Herakles moving toward the left with the lion skin pulled over his head and flying behind his body. He holds a bow in his right hand and the club in his left, raised over his head ready to strike. The sard shows a youthful Herakles in profile facing right. He has long, curly hair covered in part by the lion skin on his head, its paws tied on the hero's chest in the typical fashion, the so-called Herakles knot. Gems were used as seals but also as jewelry and could reflect mythological figures represented elsewhere in the arts, especially in sculpture.

SA

18. HEAD OF ODYSSEUS

Roman, first–second century CE
Marble; height of head 34.3 cm, with base
50.2 cm
Mr. Christian Clive Levett

PROVENANCE
Lord Bristol, Bury St. Edmunds, England, acquired
in the eighteenth century; Elderay Collection,
England, by ca. 1920; French collection; sale, 2008
(Royal Athena Galleries)

SELECTED BIBLIOGRAPHY
Royal Athena Galleries 2008, no. 17 (CBD 10)

The head shows Odysseus with his characteristic cap, the pilos, which is elaborately decorated. The base of the cap is ornamented with a wave pattern, surmounted by dancing Eros figures alternating with palmettes. The next frieze, separated from the figural scene by a raised band, is composed of rosettes inscribed in intertwined scrolls. The top is crowned by a tongue pattern and a rosette (restored). Odysseus has deep-set eyes and a slightly open mouth, which gives him a somewhat worried expression. The long, raised locks over his forehead and on both sides of his face and the shorter, straighter locks of the full beard accord with the depiction of a traveler instead of a well-groomed Greek living in the comfort of his house, but the hero is not characterized as an unkempt barbarian.

The German painter Johann Heinrich Wilhelm Tischbein (1751–1829) was a friend of Johann Wolfgang von Goethe, whom he met while he lived in Rome; the two traveled to Naples in 1787. A drawing in Tischbein's 1801 work on Homer, drawn after antiquities, shows this head, including details of the erotes on the pilos. The commentary by Christian Gottlob Heyne identifies the piece as a marble bust in the collection of Lord Bristol. Tischbein also included the head in other works, for example, as one of seven heads of Homeric heroes.[1]

The head must therefore have been restored in the eighteenth century, possibly by a well-known sculptor such as Bartolomeo Cavaceppi (ca. 1716–1799). Among the restored parts are the bust and the base, the nose, the left rear part of the face with the lower part of the beard, and part of the helmet.

SA

NOTE
1 Kunze 1999, 118, no. IV.11 (head of Odysseus), and 119–20, no. IV.13 (seven Homeric heroes); Grubert 1975, 222–23, no. HW 13. He also incorporated the head into a scene with Odysseus and the Sirens.

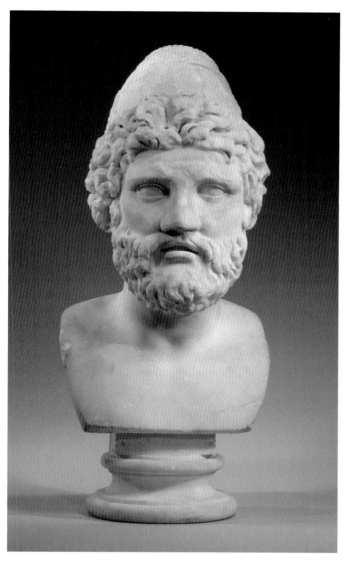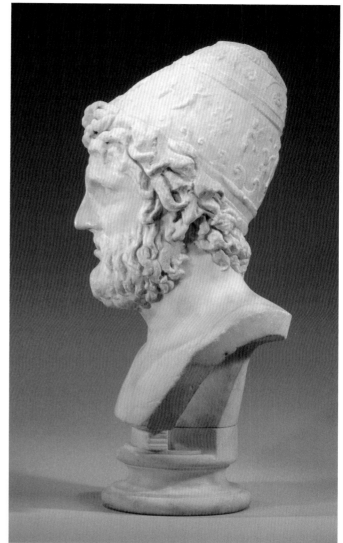

19. ODYSSEUS ESCAPING FROM THE CAVE OF POLYPHEMOS

Attic black-figure column krater
Attributed to the Sappho Painter, ca. 510 BCE
Height 34 cm
Badisches Landesmuseum Karlsruhe, B 32

PROVENANCE
Purchased in Italy in 1837–38 by Friedrich Maler (1799–1875) on behalf of the collection

SELECTED BIBLIOGRAPHY
CVA Karlsruhe, fasc. 1 (1972), 18, pls. 9.1–3; *ABV* 507, 57; *BAdd²* 126; *LIMC* 6 (1992), s.v. Odysseus, 958, no. 105 (O. Touchefeu-Meynier); Andreae and Parisi Presicce 1996, 131, fig. 2.22; Maaß 2007, 64–67; Latacz et al. 2008, 420, no. 174 (M. Maaß)

Vases often illustrate a myth in great detail, but Greek artists sometimes chose to reduce the narrative to a single emblematic image that captured the heart of the story, as in this exquisite depiction of the Polyphemos episode from the *Odyssey* (9.447–63). Odysseus and his men were imprisoned in a cave by the cannibalistic Cyclops Polyphemos. The cunning Odysseus set into motion a two-stage plan of escape: first, they incapacitated the one-eyed monster by making him drunk and blinding him with a stake; then they fled the cave by tying themselves to the bellies of the Cyclops's sheep. The blinding of Polyphemos was already a popular theme in the early sixth century BCE, while the escape appears on numerous vases of the later Archaic period. The scene is often reduced to a single sheep or ram, with Odysseus underneath leading the escape.

The Karlsruhe krater is a masterful rendering of this subject, which is found more often on smaller vessels. The ram moves slowly to the right, carrying Odysseus between its legs; he has tied himself to the ram's shoulders, belly, and hind legs with three red ropes wound twice around. Odysseus grasps the middle rope with one hand, while the other holds a drawn sword, directed forward. The torsion of his body, like the grimace on his face, aptly expresses the tension of the moment. Although Polyphemos is not shown, his presence is "understood"; the hero is about to find out whether his ruse will work. Although he does succeed, Odysseus makes one fatal mistake: he boastfully reveals his name and incurs the wrath of Polyphemos's father, Poseidon, who dogs his journey back to Ithaca.

The other side of the krater depicts a familiar scene—the departure for war—but with unusual protagonists. The warriors depicted departing for battle in a chariot and on foot are Amazons. Some are carrying helmets, Boeotian shields, and spears, like Greek warriors; others are represented as archers with trousers and Phrygian caps.

SA

20. ODYSSEUS AND THE SIRENS

Attic black-figure oinochoe
ca. 520 BCE
Height 22 cm
Staatliche Museen zu Berlin, Antikensammlung,
1993.216

PROVENANCE
From the collection of Frank Brommer, 1993

SELECTED BIBLIOGRAPHY
Brommer 1983, pls. 33b, 34; Höckmann 1985, 99,
fig. 72; *Quaderni ticinesi di numismatica e antichita
classiche* 15 (1986), 56 pl. 2.3; Krumme 1989, 40,
no. 253; Hofstetter 1990, pl. 9; Andreae and Parisi
Presicce 1996, 141 fig. 2.45; *LIMC* 6 (1992), s.v.
Odysseus, 962, no. 152 (O. Touchefeu-Meynier)

Odysseus, nude and bearded, stands in the middle of this black-figure oinochoe, tied to the ship's mast and facing right. Three of his men are in the ship, rowing between two rocks. Three Sirens, with human heads and birds' bodies, stand close together on the right rock, their wings forming a cascade of feathers. Odysseus extends one arm toward the Sirens, while another arm rests on his hip, bent behind his back; what seems to be a third arm is closer to his body but also drawn backward. This surplus of arms, according to one account, may indicate the hero's struggle to release himself from the mast and to join the Sirens, denoting motion in an inanimate medium.

When Odysseus leaves Kirke's island, she warns him of the dangers that will attend him on his journey home. The first of these is the island of the Sirens (*Odyssey* 12.37–54), whose sweet singing lures and enchants those who hear them. Kirke also tells him what to do—he must put wax in his men's ears so that they will not hear the Sirens' enthralling voices. Odysseus stops their ears, but not his own; he commands his men to bind him to the mast so that he can hear the song, ordering them not to release him under any circumstances.

And indeed, the Sirens call Odysseus, beckoning to him with promises of knowledge of the future. Upon hearing their songs, Odysseus orders his men to untie him, but they tighten his bonds. Only after leaving the area do they remove the wax from their ears and unbind Odysseus.

SS

21. RELIEF WITH SCENES FROM THE TROJAN WAR (TABULA ILIACA)

Roman, first half of the first century CE
Marble; 18.1 × 17.6 × 2.5 cm
New York, The Metropolitan Museum of Art,
Fletcher Fund, 1924, 24.97.11

PROVENANCE
Probably from Rome; Giovanni Fabiani, Rome;
museum purchase, 1924

SELECTED BIBLIOGRAPHY
Bulas 1950; Richter 1954, 116–17, no. 236, pl. 161d,
162 (with earlier bibliography); Sadvrska 1964,
37–40, pl. 2, 3

Series of carved stone reliefs called *tabulae iliacae* were produced to educate Roman students on the Trojan epics. They drew on several famous accounts of the war in addition to Homer's *Iliad* and *Odyssey*: the *Aithiopis* by Arktinos of Miletos, the *Ilioupersis* by Stesichoros, and the *Little Iliad* by Lesches of Pyrrha. More than twenty such tablets and fragments have survived, covered with scenes labeled in Greek that depict various episodes in the Trojan War. The back of this relief bears the signature of the artist—Theodoros—whose workshop produced most or all of the known *tabulae iliacae*, likely copying earlier versions in stone or on papyrus. Although Virgil's *Aeneid*, composed in the late first century BCE, was the classic Latin account of the Trojan War, Homer's epic was much admired and taught to students in Imperial times.

The central scene depicts the fall of Troy as recounted in the *Ilioupersis;* specific details can be identified by comparing this relief with other *tabulae iliacae*.[1] The upper register depicts the Greeks within the walls of Troy, leaving the Trojan Horse on a ladder. Below on the left, Priam is slain by Neoptolemos on an altar, while a Greek soldier leads Priam's wife, Hekabe, away and Aeneas carries his father, Anchises, on his shoulders through a gate. To the right, Menelaos is about to kill Helen at the Temple of Aphrodite but is overcome by her beauty. The scene below is badly damaged.

The surrounding panels start chronologically on the lower left. On panel 1, Thetis and another Nereid on the right offer Achilles his armor; he then departs in a chariot held by a servant. Panel 2 shows Achilles on the right attacking Aeneas, who is on his knees, while Poseidon intervenes. On panel 4, Achilles fights the overflowing river Skamandros with help from Poseidon and Athena. Panel 5 depicts Achilles dragging the body of Hektor around the walls of Troy with Hekabe, Priam, and others watching. On panel 6, Achilles observes the chariot race at the funerary games for Patroklos. Panel 7 (to the left of panel 6) is only partially preserved, but the title identifies it as the ransom for Hektor's body arriving on a cart drawn by mules in the presence of Achilles and Priam.

SA

NOTE
1 The best-preserved example and a close parallel to the Metropolitan Museum of Art's relief is in the Musei Capitolini most recently published in Latacz et al. 2008, 440, no. 199 (P. Blome).

22. PRIAM RANSOMING THE BODY OF HEKTOR FROM ACHILLES / WARRIORS DEPARTING

Athenian black-figure Type A amphora
Attributed to the Rycroft Painter, ca. 520–
510 BCE
Height 68.6 cm, diameter of rim 34 cm, diameter
of body 45 cm, diameter of foot 25.7 cm
Toledo, Ohio, Toledo Museum of Art, Purchased
with funds from the Libbey Endowment, Gift of
Edward Drummond Libbey, 1972.54

PROVENANCE
Nicolas Koutoulakis, Geneva; museum purchase,
1972

SELECTED BIBLIOGRAPHY
CVA Toledo, fasc. 1 (1976), pls. 4 and 5; Moon
and Berge 1979, 114 (cat. 65); *LIMC* I (1981), s.v.
"Achilleus," 149, no. 649, pl. 122 (A. Kossatz-
Deissmann); Moon 1985, 55 (no. 25), fig. 15;
Shapiro 1994, 41–42, fig. 24; M. Miller 1995,
450–52, fig. 28.4; Giuliani 2003, 175, 351 n. 34,
repr.; Baughan 2008, 63, fig. 17; Toledo 2009, 71

The aged king Priam of Troy visits the enemy Greek camp to beg Achilles for the body of his son Hektor. Many Attic vases illustrate this climactic episode in Homer's *Iliad*, with varying numbers of figures. This amphora, famous for its strong composition, large size, and intense emotion,[1] may echo a mural painting showing one or more attendants bearing tribute.[2] Two hundred lines of narrative are condensed into a compelling image, focused between the proud helmet at the top and the bloody corpse of Hektor along the bottom. Priam lurches forward to plead with Achilles, who carouses over Hektor's bleeding corpse. From the right, a woman brings wine—at one and the same time stoking Achilles' drunken wrath, representing the Greek army's tribute to its great hero, and offering hospitality. From the left, the god Hermes escorts a servant bearing gifts, symbolizing how the gods intervened to end Achilles' madness. The ransom includes a traditional Greek tripod and a stack of lobed phialai. Achilles drinks from the same type of metal cup. The cups are precious imports from Persia, and they emphasize the high rank of both Priam and Achilles, who are otherwise represented as Greeks.

Images from the *Iliad* became fashionable on Athenian vases from the last third of the sixth century until about 480. The popularity may have been related to contests for reciting Homeric poetry at the Great Panathenaic Games, introduced in 566 by the Peisistratos and supported by his successors for the moral education as well as the entertainment of the Athenians.[3]

On the other side of this amphora soldiers depart for war. The men at right wear Persian-style trousers, so the scene may represent Priam saying farewell for the last time to valiant Hektor, as he goes off to fight Achilles.[4] The old man and the young man are half-hidden behind the warhorses. Priam's piteous gaze stands for every father saying farewell to his son. The two paintings on the vase thus reflect Homer's and contemporary Greeks' empathy for the heroism and suffering of both Trojans and Greeks.

SK

NOTES
1 The attribution to the Rycroft Painter is by Dietrich
von Bothmer. The Rycroft Painter is named after a vase
now in the Ashmolean Museum, Oxford (inv. 1965.118).
He is recognized for two quirks: the unintentional
drawing of left hands as right (see both Achilles and
Hektor) and of reversed ears (see Achilles).

2 *LIMC* I (1981), s.v. "Achilleus," 159 (A. Kossatz-
Deissmann); M. Miller 1995, 451–52.

3 Johansen 1967, 223–41; Burkert 1987b, 46, 51;
Neils 1992, 72–75.

4 The inscription ΤΛΟΣ above the old man's head
on side B may be intended as ΤΡΟΣ (M. I. Davies,
personal communication, January 21, 1974).

23. ACHILLES AND MEMNON

Corinthian hydria
ca. 575–550 BCE
Height with pouring handle: 20.8 cm; depth
with pouring handle 22.7 cm; width with side
handles 29 cm
Baltimore, The Walters Art Museum, 48.2230

PROVENANCE
Hesperia Art, Philadelphia, by 1961; museum
purchase, 1961

SELECTED BIBLIOGRAPHY
Hill 1961; *LIMC* 6 (1990), s.v. Memnon, 448–61
(A. Kossatz-Deissmann)

In the center of the scene on the belly of this hydria, the Greek hero Achilles towers over his opponent, Memnon. The dueling figures are identified by inscriptions in the Corinthian alphabet. Both warriors wear armor and carry shields; Achilles' bears a frontal Gorgon face, while Memnon's slightly smaller shield is decorated with a swastika. The central pair is flanked by two chariots, with charioteers aboard, prepared to rush off the battlefield. Behind each set of horses is a woman with outstretched hands. These figures are usually taken to be Eos, the mother of Memnon and goddess of the dawn, and Thetis, Achilles' mother, who was a Nereid, or sea-goddess. The vase is particularly colorful, with white and purple used on the armor, chariots, and horses. Broad bands of ornate palmettes decorate the vessel's shoulder and lip.

Memnon, an Ethiopian prince, came to the aid of Priam in the Trojan War. He is mentioned only briefly in the *Iliad*, figuring more prominently in a lost epic titled *Aithiopis*. The prince incurred Achilles' wrath when he killed Antilochos, the son of Nestor. Memnon's final combat with Achilles and scenes of his body being carried away by Eos were favorite themes in Archaic and Classical vase-painting. The battle between these two semi-divine figures emphasizes the prowess and strength of the Greek warrior, Achilles, by pairing him with an equal.

HAC

24. AMAZONOMACHY (ACHILLES AND PENTHESILEA?)

Attic or Euboean black-figure amphora
The Omaha Painter (name piece), ca. 570 BCE
Height 35.9 cm, diameter 23.7 cm
Omaha, Joslyn Art Museum, 1963.480

PROVENANCE
Gift of Mr. and Mrs. Thomas C. Woods, Jr., 1963

SELECTED BIBLIOGRAPHY
Beazley 1971, 34, no. 2; *BAdd*² 9; *CVA* Joslyn
Art Museum (1986), 6–8, pl. 10–11. Stansbury-
O'Donnell 2006, 77–81, fig. 15

One side of this black-figure amphora is decorated with a battle scene: a Greek warrior, facing right, thrusts his spear toward a squatting Amazon, whose body turns away from him while her eyes meet his gaze. The warrior is nude and the Amazon is clothed; her clothes conceal her body, and her white skin is the sole indication of her gender. They both wear helmets and hold shields, but while the Greek warrior is using a spear, the Amazon is holding a sword. On each side of this battle scene stand three spectators, two Amazons and between them a Greek man.

The other side of the amphora depicts a banquet. Three men are reclining on klinai, banquet couches; each of them is accompanied by a hetaira, or courtesan. The two sides of the amphora shift between the realm of daily activity— the banquet—and the realm of the imagination, represented by the Amazons. In contrast to the hetairai, who act within conventional gender boundaries, the Amazons transgress those boundaries by being fearless warriors who arm themselves and fight men. Amazons were a popular theme in Greek art from around the early sixth century BCE. Elaborate battle scenes, or Amazonomachies, were common until the middle of the century; new and smaller vase shapes subsequently limited the complexity of the scenes.

Since the warrior lacks any attributes and there is no inscription to identify him, certain identification of the subject is not possible. The scene may depict Achilles killing Penthesilea, queen of the Amazons, falling in love with her at the very moment when their eyes met (Apollodorus, *Library* 5.1).

SS

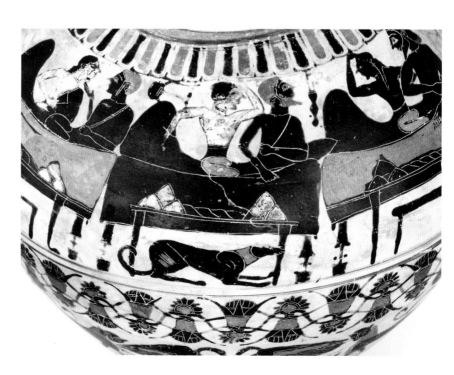

25. THE DIOSKOUROI

Red-figure bell-krater
Attributed to the Villa Giulia Painter, ca. 460–450 BCE
Height 42.6 cm, diameter of rim 48.6 cm, width with handles 52 cm
Badisches Landesmuseum Karlsruhe, B 40

PROVENANCE
Reportedly from Lokri (Calabria); purchased in Italy in 1837–38 by Friedrich Maler (1799–1875) on behalf of the collection

SELECTED BIBLIOGRAPHY
ARV[2] 619, 15; *CVA* Karlsruhe 1 (1951), 27, pl. 20 (G. Hafner); *LIMC* 3 (1986), s.v. Dioskuroi, 569, no. 3 (A. Hermary); *BAdd*[2] 270; Schefold and Jung 1988, 33–34, fig. 23; Maaß 2007, 90–91, no. 21

A faded inscription in white identifies the two protagonists on horseback as Kastor and Polydeukes, the twin brothers of Helen, called the Dioskouroi ("sons of Zeus"). The two are alike in appearance and even in posture. Each grasps the reins in his left hand, while holding a lance in his right hand toward the back of the horse. Each wears a petasos, a chlamys draped over his left arm and shoulder, and elaborate high-bound sandals. The twins are charging to the left, their horses prancing energetically in excitement; the horse on the right throws its head backward.

On the opposite side of the krater, an elderly bearded man with white hair stands holding a large staff or scepter in his right hand. He is surrounded by two women, who seem to be running away from him in either direction with arms raised in apprehension.[1]

According to some versions of the myth, Zeus fathered Helen's brother, Polydeukes, as well as Helen herself, by Leda. Polydeukes' twin, Kastor, was conceived by Leda with her mortal husband, Tyndareus. The inseparable brothers shared the immortality that only Polydeukes had received by birth from his divine father by residing alternately in Hades and on Olympos. The Dioskouroi appear in several myths involving groups of heroes, such as the Kalydonian boar hunt or the Argonautica. Their cults were closely associated with that of Helen, and they rescued their sister on several occasions, for example, when she was abducted by Theseus. They were also venerated as helpers in war and protectors at sea, and they are often depicted with horses, a tradition that carried on into Roman times.

SA

NOTE
1 Schefold and Jung 1988, 33–34, interpreted the aged man as King Leukippos and the women as his two daughters about to be abducted by the Dioskouroi and fleeing toward their father, but the women are clearly turning away from the man in the middle.

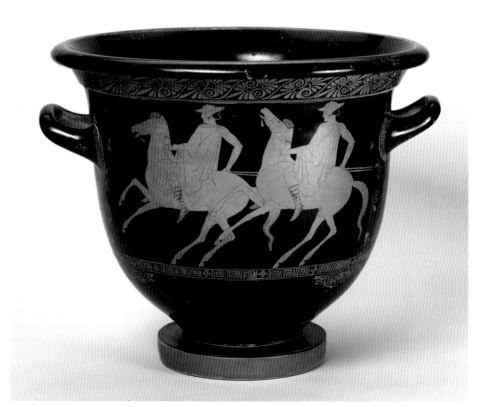

26. HELEN AND MENELAOS AT THE SACK OF TROY (BELOW)

Boeotian black-figure skyphos
Attributed to the workshop of the Kabeiros
Painter, ca. 420 BCE
Height 20.5 cm, diameter of rim 18 cm
Kassel, Staatliche Museen Antikensammlung,
ALg 18 (coll. Ludwig)

PROVENANCE
Ludwig Collection, purchased 1962

SELECTED BIBLIOGRAPHY
Berger and Lullies 1979, 86–88, no. 32 (R. Lullies);
Yfantidis 1990, no. 181; *Prestelführer Schloß
Wilhelmshöhe*, Kassel, 2000, 33–34 (P. Gercke);
LIMC 4 (1988), s.v. Helene, 543, no. 290
(L. Kahil); *LIMC* 8 (1997), s.v. "Ilioupersis," 653,
no. 18 (M. Pipili); *LIMC* 8 (1997), s.v. "Menelaos,"
841–42, no. 62 (L. Kahil); *Welt der Gefäße*, exh.
cat., Ludwig Galerie Schloß Oberhausen (2004),
112–13; Daumas 1998, 34–35; Walsh 2009, 81–82,
fig. 14a

27. HELEN AND MENELAOS AT THE SACK OF TROY / YOUTH DEPARTING (OPPOSITE)

Attic red-figure bell-krater
Attributed to the Persephone Painter, 440–
430 BCE
Height 32.5 cm, diameter of rim 37.5 cm, width
with handles 39 cm, diameter of foot 18 cm
Toledo, Ohio, Toledo Museum of Art, Purchased
with funds from the Libbey Endowment, Gift of
Edward Drummond Libbey, 1967.154

PROVENANCE
Reported to be from Etruria (Vulci?); Elie Borowski,
Basel, Switzerland

SELECTED BIBLIOGRAPHY
Riefstahl 1968, 43; Luckner 1972, 71, fig. 12; *CVA*
Toledo, fasc. 1 (1976) pl. 43; Kakrides 5 (1986),
33, fig. 21; *LIMC* 4 (1988), s.v. Helene, 543, no. 274
(L. Kahil); Carpenter 1991, 210, fig. 338, 232; Lyons
1997, 39–40, fig. 2; March 1998, 252–53, fig. 91

NOTES
1 *LIMC* 4 (1988), 537–52, nos. 210–372 (L. Kahil).

2 E.g., TMA 1923.3123, a black-figure amphora of about
540 BCE attributed to the Swing Painter: *CVA* Toledo,
fasc. 1 (1976), pl. 3; *LIMC* 4 (1988), s.v. "Helene," 548,
no. 320 (L. Kahil).

3 The attribution to the Persephone Painter is by
Dietrich von Bothmer.

4 Curiously, Menelaos wears a Thracian-style helmet,
perhaps something he picked up as booty.

What happened when Menelaos met up with Helen at the sack of Troy must have fascinated artists and patrons.[1] Helen not only survived but flourished. When, ten years after the war, Telemachos visited the court of Sparta in search of his father, Odysseus, Homer describes the queen as not only beautiful but also clever (it is she who penetrates Telemachos's disguise) and tactful (she slips an herb into the wine to ease the pain of reminiscence) (*Odyssey*, book 4).

Multiple visualizations of the meeting survive: Menelaos confronting Helen, Menelaos chasing her armed with spear or sword, and Menelaos seizing her by the hair or wrist or clothing.[2] On the primary side of this large vessel for mixing wine and water, the Persephone Painter renders a delightful tongue-in-cheek spoof.[3] Menelaos, elegantly clad in an embroidered short chiton, drops his sword and races in pursuit of Helen. She flees, arms outstretched toward an altar, behind which stands a tree.[4] Helen is gorgeously disheveled by her flight. Her facial composure, hairstyle, and jewelry seem unaffected, but her chiton has been loosened, presumably by her patron, Aphrodite, to offer enticing glimpses of her torso and legs. Menelaos, changing any thoughts he had about murdering his wayward wife, speeds toward her with an unmistakable leer on his face.

The cartoonlike sequence painted on the skyphos illustrates a burlesque of the sack of Troy, as drunken revelry literally under the cover of a grapevine. Helen scurries to the right, but her head turns to watch the lewd figure of the Achaean hero Ajax about to rape Kassandra, who kneels at the Palladion. Helen does not see that she is about to run into Menelaos. Her irate husband is shown beardless, naked except for helmet and baldric. His penis dangles between his striding legs. His sword is raised but his left hand reaches to clasp Helen's left hand in a parody of a dance as they are reunited. The silhouetted figures are rendered with grotesque, exaggerated features and gestures characteristic of the Kabeirion Group—a distinctive class of pottery, mostly skyphoi, like this example, many with comic illustrations of popular myths.

SK

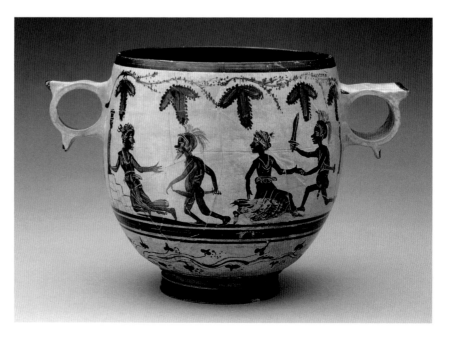

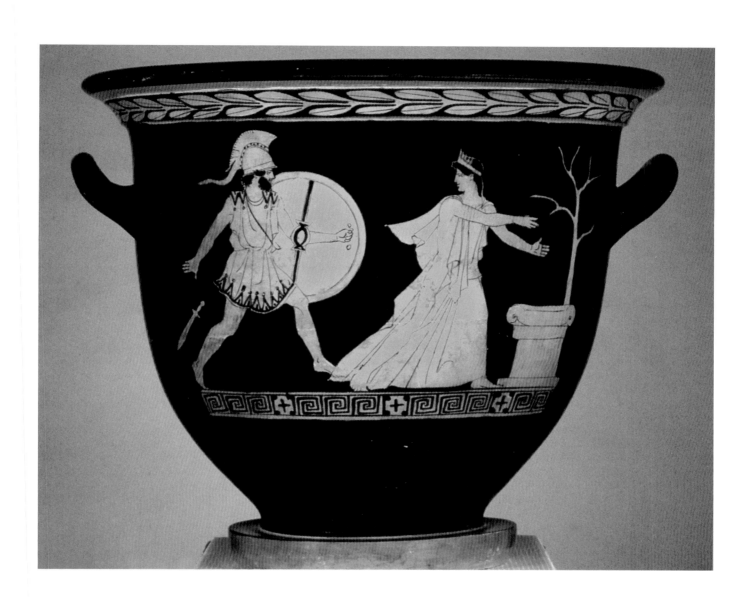

28. THE RECLAMATION OF HELEN / HERAKLES AND KERBEROS

Attic black-figure amphora
Attributed to the Circle of Exekias, ca. 540–530 BCE
Height 48.2 cm, diameter of rim 20.2 cm, diameter of body 32 cm
Baltimore, The Walters Art Museum, 48.16

PROVENANCE
Don Marcello Massarenti, Rome, by 1897; Henry Walters, 1902; Walters Art Gallery, by bequest, 1931

SELECTED BIBLIOGRAPHY
Massarenti 1897, 2:38 (no. 16); *ABV* 140, 1; Kahil 1955; *LIMC* 4 (1988), s.v. Herakles, 739, no. 118, and 742, no. 214 (O. Palagia)

One side of this black-figure amphora depicts an armed warrior drawing his sword on a veiled woman in the presence of two onlookers. This scene likely represents the reclamation of Helen by her husband, Menelaos, after the Trojan War. The wayward Helen, who had fled to Troy with Paris, incurred the hatred of many Greeks, who regarded her as the cause of the war. According to the lost epic *Little Iliad*, Menelaos intended to kill Helen when he recovered her from the Trojans but, upon seeing her, was overcome by her beauty and immediately forgave her and dropped his sword (see also nos. 26, 27). This moment of forgiveness perhaps marks the beginning of the couple's reconciliation; they subsequently return to Sparta, where they live happily into old age (*Odyssey*, book 4). In this scene, the painter chose to highlight a tense moment, just as Helen reveals herself to her husband but before he drops his sword. The theme of Menelaos's reclamation of Helen often stresses the power of her unequaled beauty, which literally disarms her husband and allows her to return to her former life as his respected spouse.

Herakles ushers the two-headed dog Kerberos out of the underworld on the amphora's obverse. The hero was sent on his mission by Eurystheus, who commanded him to bring back this frightening beast. Homer recounts that this labor was a particularly difficult one and that Hermes and Athena aided the hero in the mission (*Odyssey* 11.623–26).

HAC

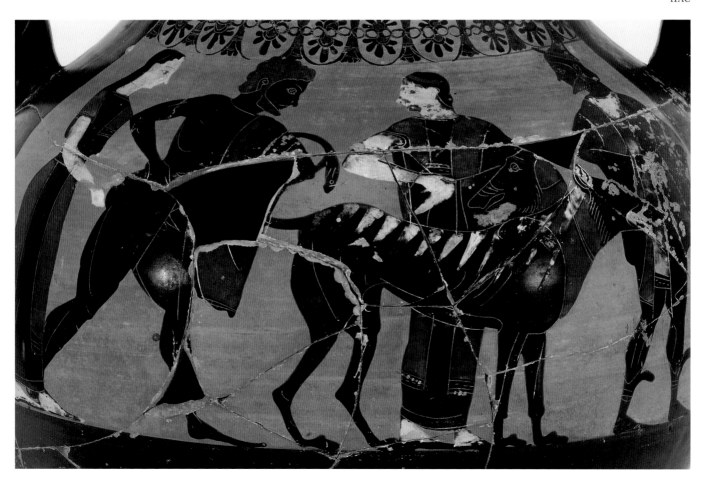

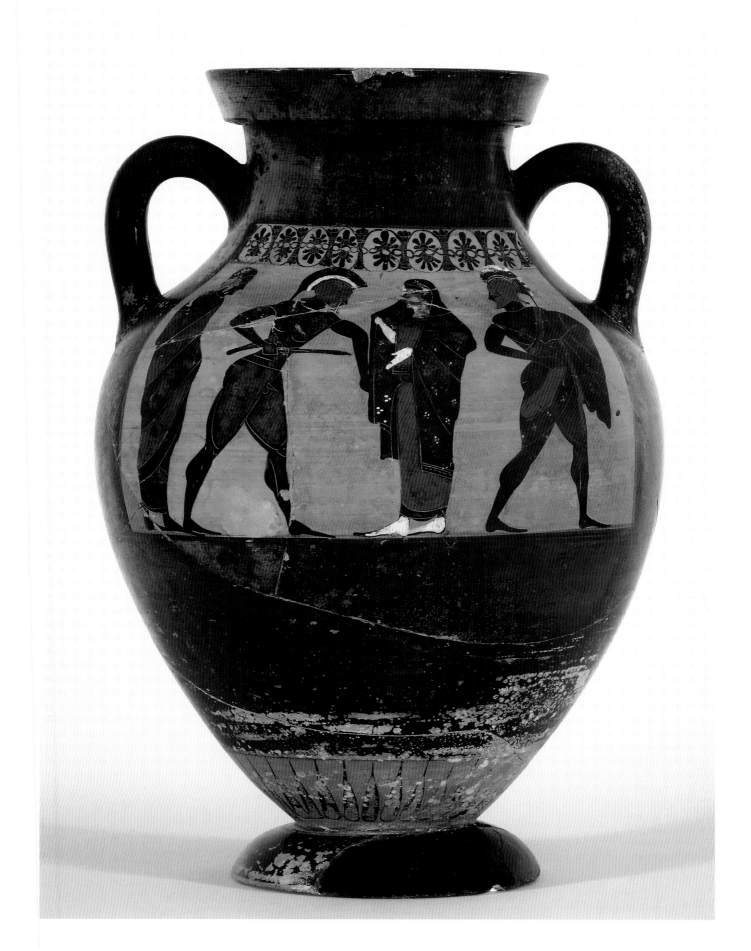

29. ONE OF ODYSSEUS'S MEN
TRANSFORMED INTO A PIG (BELOW)

Fifth century BCE
Bronze; 1.27 × 4.76 × 0.95 cm
Baltimore, The Walters Art Museum, 54.1483

PROVENANCE
Henry Walters, by 1931; Walters Art Gallery, by
bequest, 1931

SELECTED BIBLIOGRAPHY
Hill 1949; Touchefeu-Meynier 1968, 97, no. 190;
Andreae and Parisi Presicce 1996; Albersmeier 2008,
69, no. 19 (J. Oakley)

30. ODYSSEUS'S MEN TRANSFORMED
INTO PIGS (OPPOSITE LEFT)

Attic red-figure lekythos
Manner of the Bowdoin Painter, ca. 480–
470 BCE
Height 18.8 cm, diameter 4.7 cm
Athens, National Archaeological Museum, 9685

PROVENANCE
Reportedly found by Fossati at Vulci, 1828; Magnus-
Dorowschen Collection, Berlin, 1829

SELECTED BIBLIOGRAPHY
Perdrizet 1897, 36–37, fig. 6; ARV^2 693.3; Siebert
1990, 157, pl. 2.3; Andreae 1999, 390, no. 96, pl. on
p. 263

31. SCARAB WITH A PIG-MAN
(OPPOSITE RIGHT)

Etruscan, fifth century BCE
Chalcedony, set in modern gold ring;
Height of gem 1.5 cm
Baltimore, The Walters Art Museum, 42.847

PROVENANCE
Henry Walters, by 1931; Mrs. Henry Walters,
by inheritance, 1931; Joseph Brummer, New York,
1942; museum purchase, 1942

SELECTED BIBLIOGRAPHY
Buitron 1992, 84, 91, no. 26

NOTES
1 Buitron 1992, 77; *LIMC* 6 (1992), s.v. Kirke, 48–50
(F. Canciani); *LIMC* 6 (1992), s.v. Odysseus, 960–61
(O. Touchefeu-Meynier); Shapiro 1994, 56; Andreae
1999, 257–58.
2 Siebert 1990, 157; Buitron 1992, 78; *LIMC* 6 (1992),
s.v. Kirke, 58 (F. Canciani); Shapiro 1994, 56–59;
Andreae 1999, 258.

This lekythos is decorated with an episode from the *Odyssey*, the encounter of Odysseus and his comrades with the sorceress Kirke (10:133–574). When their ship reached her island home of Aeaea, Odysseus sent out an exploratory party of twenty-three men. The men, except for the hesitant Eurylochos, entered Kirke's palace, and Kirke transformed the visitors into pigs. After Eurylochos returned to the ship and reported the incident, Odysseus decided to go alone to the palace. With the help of the god Hermes, he avoided Kirke's magic and persuaded her to restore the men to their original form.[1]

The lekythos depicts Odysseus's comrades in a cavelike space: Kirke's sty, indicated by an uneven, wavy band in the color of the clay, with black circular and undulating lines to represent the projections of the rock. Two trees that spring from these rocks denote the outdoors. The constraints of the vase shape limit the field: only two men are represented, half swine, half human. In other depictions of the episode, such as the small bronze and the intaglio gem, the mutated crew is similarly represented, with an animal head or upper body and human lower part. Often departing from the Homeric account, Attic artists used a variety of animals for the metamorphosed sailors, such as lions, horses, bulls, rams, or wolves.[2]

Though Homer's account describes the men as entirely transformed into swine, the small bronze, like the lekythos, depicts the moment of transition into animal form. Appropriately, the point of this metamorphosis is at the figure's midsection, as the pig's bristles fade away down his back. Small plates under the figure's feet suggest it was once an attachment, perhaps the handle of a metal vase. Alternatively, the figurine may have been part of a group of other figures from the Kirke episode. The gem depicts one of Odysseus's companions balancing a kantharos on his knees; it likely contained the potion responsible for his transformation.

AK / JHC / SA

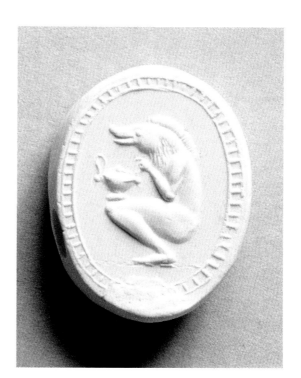
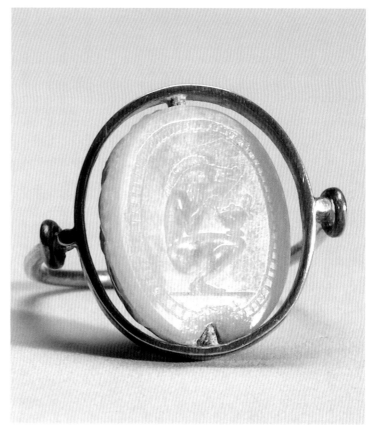

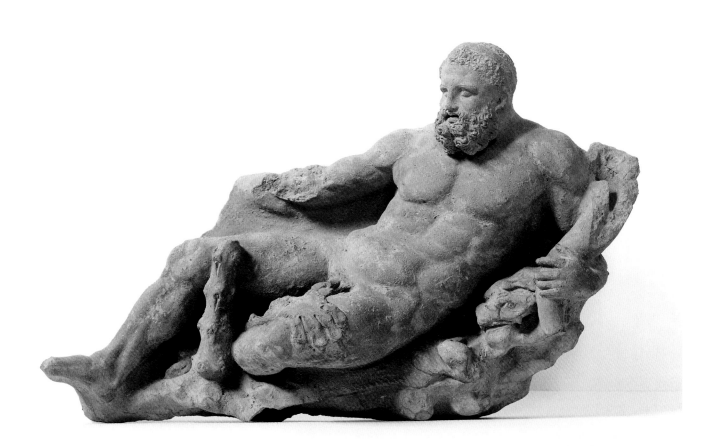

32. HERAKLES AT REST (OPPOSITE)

Probably late second century BCE
Terracotta; 30.4 × 50.8 cm
Museum of Fine Arts, Boston, museum
purchase, with funds donated by contribution,
01.7967

PROVENANCE
Reportedly found at S. Maria di Capua, by 1901;
Alfred Bourguignon; Edward Perry Warren;
museum purchase, 1901

SELECTED BIBLIOGRAPHY
Bieber 1945, 272–77, no. B 1, pl. 39,4; Scharmer
1971, 30, 37, no. 52, fig. 14; Gais 1978, 367, fig. 18;
C. Vermeule 1980, 85, 132, 264, fig. 111; *LIMC* 4
(1988), s.v. Herakles, 779, no. 1063 (O. Palagia)

33. HERAKLES AT REST (BELOW)

Etruscan, first half of fifth century BCE
Carnelian, gold; width of gem 1.5 cm
Baltimore, The Walters Art Museum, 42.494

PROVENANCE
Henry Walters, by 1931; Walters Art Gallery,
by bequest, 1931

NOTES
1 See *LIMC* 4 (1988), s.v. Herakles, 777
(J. Boardman, O. Palagia).
2 Gais 1978, 367.

Both objects show a bearded, naked, and somewhat older Herakles reclining in a relaxed fashion. On the terracotta relief, the hero reclines to the right. He seems to be resting on some rocks and uses his lion skin as a blanket; the impressive lion head is visible beside his left hip while a large lion paw rests on the hero's left thigh. His facial features are characterized by deep-set eyes, a full beard, and slight furrows. He wears a thick band around his head and has a full but muscular body. The hero holds a cornucopia in his left arm, while the outstretched right arm likely once was supported by the now missing upper part of the club standing between his knees.

The gem shows Herakles reclining to the left, again resting on the lion skin: The lion's tail is visible between the hero's legs, while fur and a paw appear behind his back and below his right leg. His right hand rests with the club on the ground next to him, while he raises a large kantharos with his left in front of him. A (palm?) tree behind the hero indicates scenery.

Depictions of Herakles reclining are attested as early as the sixth century BCE, but the sculptural type was introduced only in the fourth century BCE. It shows the almost always aged and bearded hero resting from his labors and as symposiast, associating him with the world of Dionysos. It became a popular and widespread theme in Hellenistic and Roman times.[1] The cornucopia as a symbol of fertility and abundance is a rare attribute and might point to Herakles' role as agricultural hero.[2]

SA

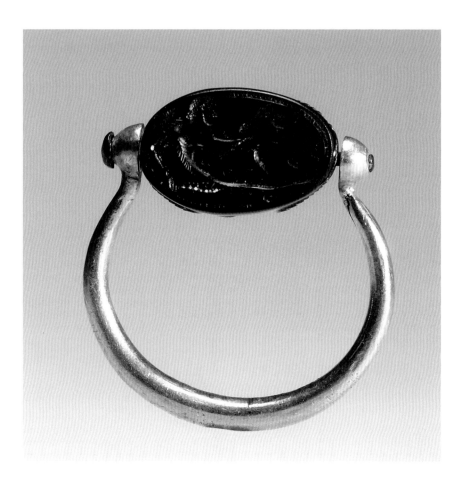

34. HERAKLES AND PHOLOS

Attic black-figure lekythos, with added white ground
Attributed to the Beldam Painter, ca. 500 BCE
Height 24 cm, diameter 7.6 cm
Baltimore, The Walters Art Museum, 48.229

PROVENANCE
Joseph Brummer, New York, by 1924; Henry Walters, 1924; Walters Art Gallery, by bequest, 1931

SELECTED BIBLIOGRAPHY
ABV 587, 3; Brommer 1973, 179, no. 30

The surface of this lekythos, a vessel for holding liquids such as oil or perfume, is covered with an assortment of lines and a meander pattern of red on the neck, shoulder, and base. It likely depicts a scene from Herakles' life that was parallel to his main labors. These side-adventures (*parerga*), were entertaining and provocative narratives of interest to artists.

Here we see a draped male figure, leaning against a rock, who can be identified as Herakles by the quiver and the club above his head. He looks to the left, and as our eye moves around the side of the vase following his line of vision, we encounter a Centaur, standing before a pithos and facing the hero.

This has been identified as the encounter of Herakles and Pholos, a Centaur who lived in the Peloponnese and dwelt in a cave on Mount Pholoe. While Herakles was in search of the Erymanthian boar, Pholos offered him hospitality. Despite Pholos's warnings, Herakles demanded wine. When Pholos opened the wine container, the other Centaurs nearby became agitated and attacked, causing Herakles to defend himself with his arrows. In some versions of the story, the wise Centaur Cheiron was wounded in this incident, whereas in other versions Herakles accidentally killed Pholos by dropping a poisoned arrow on his foot. The scene depicted here shows the last moment of calm before the storm: Pholos has his hand already above the pithos and is about to pour Herakles a drink.

JHC

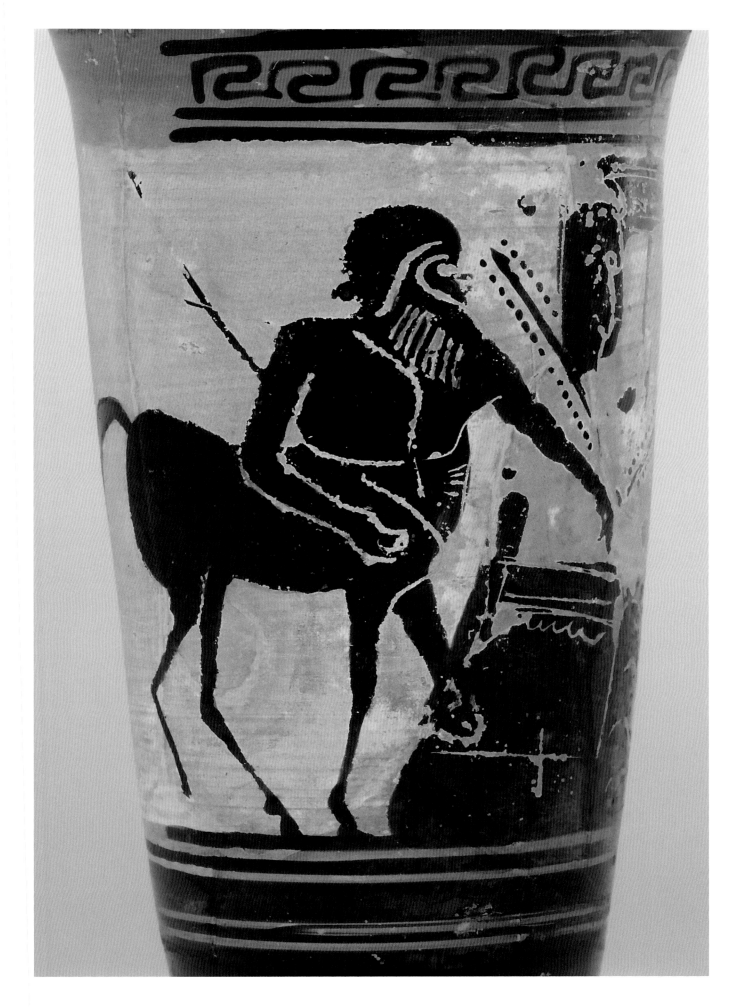

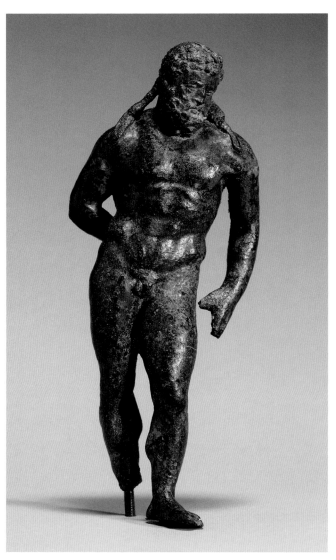

35. WEARY HERAKLES (HERAKLES FARNESE) (OPPOSITE LEFT)

Third century BCE
Bronze, solid cast; 15.4 × 6 × 3.9 cm
Baltimore, The Walters Art Museum, 54.1005

PROVENANCE
Said to be from Alexandria; Dikran Kelekian, New York/Paris, by 1925; Henry Walters, 1925; Walters Art Gallery, by bequest, 1931

SELECTED BIBLIOGRAPHY
Hill 1949, 47, no. 97, pl. 24; C. Vermeule 1975, 323–32 (esp. 325 no. 6); Reeder 1988, 126–27, no. 44; *LIMC* 4 (1988), s.v. Herakles, 764, no. 721 (O. Palagia); Albersmeier 2008, 156–57, no. 56 (S. Albersmeier)

36. BRONZE ARM OF A STATUETTE OF HERAKLES (OPPOSITE RIGHT)

Roman copy, first–third century CE, after a Greek original
Bronze, solid cast; height 14.6 cm
New York, The Metropolitan Museum of Art, Fletcher Fund, 27.122.13

PROVENANCE
Said to be from Rome; museum purchase, 1927, through C. A. Lambessis, Rome

SELECTED BIBLIOGRAPHY
LIMC 4 (1990), s.v. Herakles, 768, no. 808 (O. Palagia); *LIMC* 5 (1990), s.v. Herakles/Hercle, 201, no. 27 (S. J. Schwarz)

37. HERAKLES WITH THE APPLES OF THE HESPERIDES (BELOW)

Etruscan scarab, fifth century BCE
Carnelian; height 1.5 cm
Baltimore, The Walters Art Museum, 42.486

PROVENANCE
Henry Walters, by 1931; Walters Art Gallery, by bequest, 1931

The bronze statuette of Herakles is a small-scale version of the famous statue by Lysippos from the fourth century BCE depicting the hero nude, resting on his club covered by the lion skin. The attributes are lost in this version but they once were placed in the space underneath his left arm, providing him with support while he leans slightly forward with his weight on his left leg. Herakles is shown bearded, with an aged, tired face, and a full, muscular body. Around his head he wears a fillet with three rosettes whose long ends fall on his shoulders.

The motif is linked to one of Herakles' labors. He has retrieved the apples of the Hesperides, which he hides behind his back in his right hand. They are also lost in this statuette, but their former presence is indicated by the hollow space between the slightly closed fingers. Herakles is weary from his labors, likely from holding up the heavens for Atlas, who retrieves the apples for him in some versions of the story.

The motif of the Weary Herakles reveals the hero's vulnerability and the toll the labors took on him. It makes him accessible and stresses his human side, which at least partly explains the great popularity of this motif in Hellenistic and Roman times as well as in later centuries.

The bronze fragment belonged to a standing statuette of Herakles wearing his lion skin over his left shoulder. The detailed lion head is facing downward to the paws, which look as if they are resting on the ground facing to the right. The hero stretches his left arm out at the elbow and might have held the apples of the Hesperides in his wide-open left hand (as known from parallels). These statuettes, however, most often show the lion skin hanging over the lower left arm, not covering both arm and shoulder. This is better attested in similar statuettes of Herakles, in which the hero holds the lower end of the club in the outstretched left hand while the upper end rests on his shoulder. This type portrays him bearded with an offering bowl in his other hand.

The scarab depicts Herakles striding forcefully to the left with the club in his left hand behind him and three apples of the Hesperides in his outstretched right hand in front of him. He is bearded and wears a wreath around his head.

SA

38. AGED HERAKLES

First century BCE–first century CE
Bronze; 43 × 23.8 × 14 cm
Baltimore, The Walters Art Museum, 54.764

PROVENANCE
Reportedly from Caesarea, Cappadocia (?); Henry
Walters, by 1931; Walters Art Gallery, by bequest,
1931.

SELECTED BIBLIOGRAPHY
Hill 1949; Hill 1950b

This bronze statuette depicts a heavy-set Herakles in a rare moment of quiet. His shoulders are covered with a lion skin that gathers in a generous fold behind his neck. The drooping lion skin is a visual contrast to Herakles' fully muscled body. The rich curls of the lion's mane drape over the hero's left arm, but the head of the animal is now missing. Herakles' right arm is hidden beneath the skin. Similar examples of this statue-type indicate that his left hand held a club against the left shoulder. Herakles is heavily bearded, his facial hair rendered in thick curls reminiscent of the lion's mane. A gilded band encircles his head. The eyes are silver, and it appears that another material would have been used for the pupils.

This representation of Herakles is known from several examples, including a marble version in the Walters Art Museum (23.74). Both of the Walters' pieces are likely modeled on a famous Hellenistic statue of the hero as a wayfarer. Euripides' play *Alkestis* depicts just such a Herakles, who appears as a traveler and unannounced guest at the home of Admetos, whose wife, Alkestis, has just died. In the drama, the hero is initially unaware of the tragedy unfolding around him. Oblivious to his host's suffering, he advocates drinking wine to ease life's difficulties, revealing a less noble side of the hero. Once he finally recognizes the plight of the family, he reverts to his heroic self and succeeds in bringing Alkestis back to life. Unlike so many depictions of Herakles, this statuette captures the hero in a moment of rest rather than at the height of a challenge. The bulk of his body, his mature appearance, and his relaxed pose suggest that this is the hero later in life, well after the period of his famed labors.

HAC

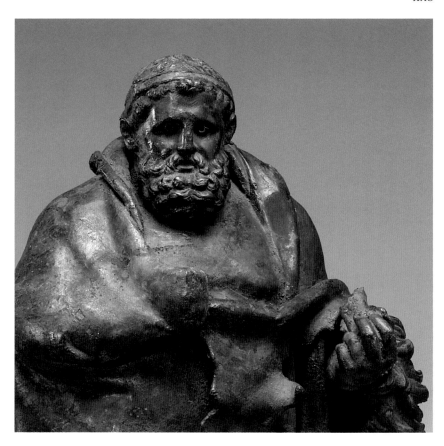

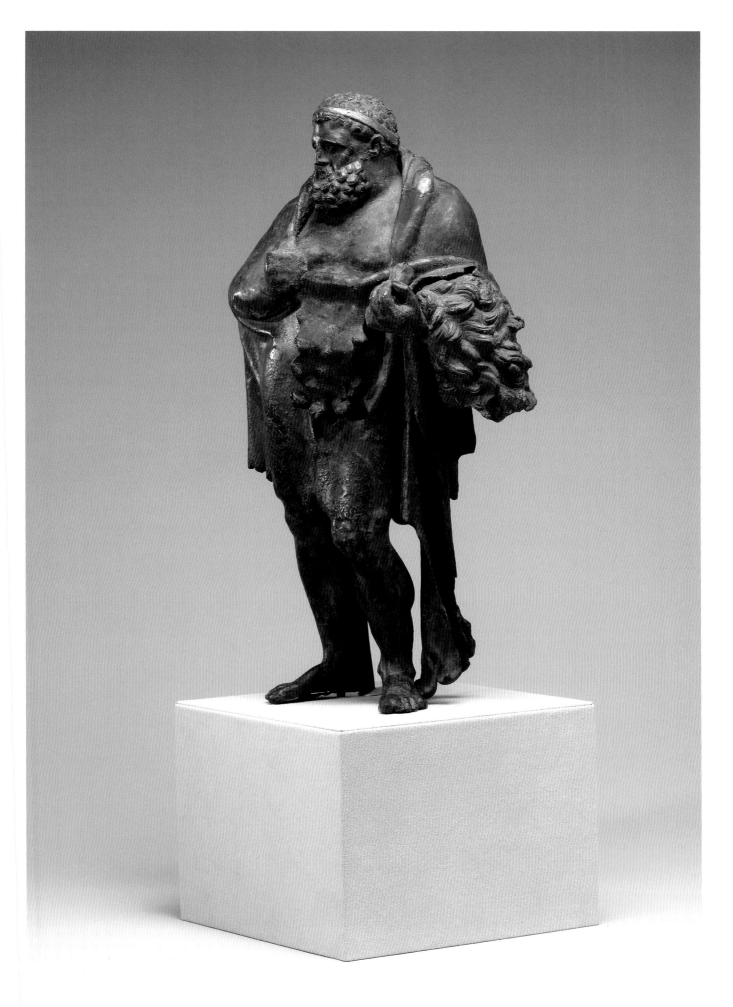

39. ACHILLES AND AJAX PLAYING A GAME / HERAKLES AND NESSOS

Black-figure amphora
Attributed to the Toulouse Painter, late sixth
century BCE
Height 22.2 cm, diameter 14.6 cm
Toronto, Royal Ontario Museum, 925.97

PROVENANCE
Reportedly from Vulci; Durand Collection; Joseph
Brummer, New York; museum purchase, 1925

SELECTED BIBLIOGRAPHY
Beazley 1971, 141, no. 2; Woodford 1982, 181, no. 6;
CVA Toronto (1981), 13–14, pls. 19.1 and 2, 20.1 and
2 (J. W. Hayes); *Add²* 87; *LIMC* 6 (1992), s.v.
Nessos, 840, no. 26 (F. Diéz de Velasco)

NOTES
1 For the various interpretations and bibliography, see
Mommsen 1980; Shapiro 1989, 156; Woodford 1982;
Woodford 1993, 59–64. See also the historical interpre-
tation by Boardman 1978, 21–24.

2 Woodford 1982, 178–79.

More than 150 vases depict this popular scene: the heroes Achilles (on the left) and Ajax engaged in a board game. They are sitting on blocks facing each other, leaning on their spears, with Boeotian shields and Corinthian helmets set up behind them. Achilles is pointing at the board, while Ajax has just made a throw. A bird flies above their heads. On the opposite side of this vase, Herakles fights the Centaur Nessos, who is defending himself with rocks. Deianeira and an old man witness the event.

The theme of Achilles and Ajax playing a board game was masterfully introduced around 540–530 BCE by the black-figure vase-painter Exekias, who labeled the heroes with inscriptions and therefore made them identifiable. The earliest vases show only the two heroes concentrating on the game, while later examples of the sixth century introduce a third protagonist: Athena, who is shown standing between the two heroes.

This scene is not reflected in any of the written sources dealing with the Trojan War known to us today. The version with Athena has led some scholars to posit a lost story, in which Achilles and Ajax were distracted by a game while on guard duty and had to be alerted of imminent battle by Athena.[1] But Athena does not appear on the earliest vases, and there is no evidence for this episode. The theme might go back to a lost epic or poem, but it also could easily be the invention of Exekias and obviously resonated with the Greeks.[2]

Although the scene is peaceful, the artists make it clear that battle is never far away: the weapons of the heroes are right at hand. This is a familiar scenario for soldiers at war in any time period or culture: the endless waiting periods, the boredom, and the anxiety before the next fight, which might break out at any time.

SA

40. HERAKLES AND IOLAOS FIGHTING THE LERNAEAN HYDRA

Attic black-figure on white-ground lekythos
Attributed to the Class of Athens 581, ca. 500 BCE
Height 17.7 cm, diameter 6.9 cm
Baltimore, The Walters Art Museum, 48.227

PROVENANCE
Joseph Brummer, New York, by 1924; Henry
Walters, 1924; Walters Art Gallery, by bequest, 1931

SELECTED BIBLIOGRAPHY
Baltimore 1939, 56, no. 4; *ABV* 499, 33; Bothmer
1954; *LIMC* 5 (1990), 38, no. 2034 (J. Boardman
et al.)

The second of Herakles' twelve labors required him to slay the Hydra, a serpent that lived in the swamps of Lerna near Argos. This was no ordinary serpent: it had multiple heads, usually reported as nine in number, eight of which were mortal and one that was immortal. To make matters even more complicated, each time Herakles cut off one of the heads, two more grew in its place. He was assisted by his nephew Iolaos, the son of Herakles' twin brother, Iphikles, who used a torch to cauterize the stumps so that no head could grow back. Herakles then buried the immortal head under a huge rock. Some accounts of this episode include a giant crab sent by Hera, Herakles' nemesis, as an added difficulty.

This black-figure lekythos illustrates the myth, popular in Greek art as early as the eighth century BCE. It is carefully decorated with a variety of patterns: sprays of vines on the white ground of the main scene and a pattern of dots located above the narrative scene. The shoulder of the vase is decorated with two rows of a teardrop pattern, and the mouth, neck, and lower half of the body are simply decorated with alternating bands of black and red. The body of the Hydra, too, is elaborated with small red dots.

Herakles wears his characteristic lion skin, which he had claimed as an attribute when he killed the Nemean lion. He grasps at two of the necks of the Hydra, in this version shown as a giant snakelike creature with eleven threatening heads. To the right of the Hydra stands Iolaos, who wears the helmet of a warrior and echoes the pose of Herakles as he reaches toward the Hydra.

JHC

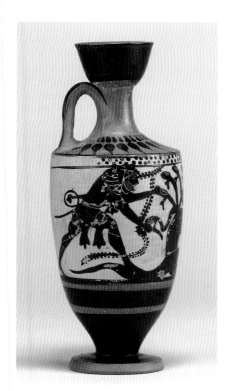

41. HERAKLES AND APOLLO FIGHTING OVER THE TRIPOD

Attic black-figure amphora
Attributed to the Circle of the Antimenes Painter,
near Group of Toronto 305, ca. 520 BCE
Height 41.5 cm, diameter 28 cm
Baltimore, The Walters Art Museum, 48.21

PROVENANCE
Don Marcello Massarenti, Rome, by 1897; Henry
Walters, 1902; Walters Art Gallery, by bequest, 1931

SELECTED BIBLIOGRAPHY
Massarenti 1897, 2:40, no. 21; ABV 284; LIMC 5
(1990), s.v. Herakles, 136, no. 2992 (S. Woodford);
Neer 2001

Athena, Herakles, Apollo, and Artemis appear on side A of this vase. Athena, striding right, is clad in an ankle-length peplos and helmet. She holds a spear and a shield. Rushing toward her is Herakles, who wears a short chiton beneath his close-fitting lion skin. He carries the Delphic tripod under his left arm and waves his club overhead in his right hand. He glances over his left shoulder toward Apollo, who closely pursues him. Apollo, who has long hair, wears a short chiton and animal skin and a quiver on his back. He grasps two legs of the tripod. Artemis follows her twin brother. She is clad in the same style of peplos as Athena and carries a bow.

When Apollo refused him an oracle at Delphi, Herakles threatened to carry off the tripod, which was used by the oracle's priestess, and to create his own oracle. Zeus intervened by casting a thunderbolt and resolved the dispute. Apollo kept his tripod, and Herakles received his oracle. One interpretation of this motif emphasizes the mediation of Zeus and the symbolism of the tripod. In epic, tripods were often the prizes offered in contests, but by the late Archaic period, they represented agonistic struggles, particularly between aristocrats. Under this interpretation, the theme is a metaphor for political disagreements.

Side B of this amphora depicts a maenad, Dionysos, and Hephaistos. The motif of Hephaistos on a donkey in the company of Dionysos typically represents the return of Hephaistos to Olympos. After the god of the forge was expelled from Olympos by his mother, Hera, Hephaistos crafted a chair with invisible bonds that he sent to his mother as an act of revenge. Unable to free herself from the chair, Hera called a counsel of the gods to determine how they might coax Hephaistos to return to Olympos. Ultimately, Dionysos gave Hephaistos wine and brought him back, drunk, to release Hera.

HAC

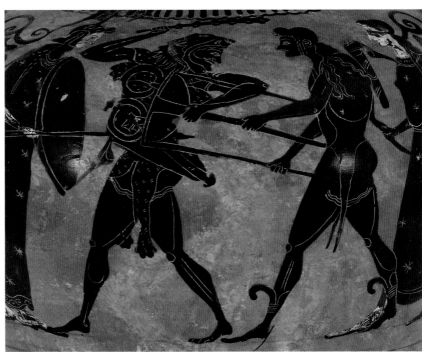

42. HERAKLES AND APOLLO FIGHTING OVER THE TRIPOD

Roman, first–second century CE
Marble; 75.6 × 60 × 5 cm
Baltimore, The Walters Art Museum, 23.164

PROVENANCE
Musée Nani, Venice; M. J. Ferroni, sale, Sangiorgi, Rome, 1909 (no. 279); Henry Walters, 1909; Walters Art Gallery, by bequest, 1931

SELECTED BIBLIOGRAPHY
Smith 1961, no. 224; Zagdoun 1989, 229, no. 81, pl. 25, fig. 97; LIMC 2 (1984), s.v. Apollon/Apollo, 418, no. 406c (E. Simon)

Herakles is easily identified in the left side of the relief by the lion skin covering his head and back and by the club that he holds in his raised right hand. He is equipped with a quiver and a bow, which he holds with his left hand. The hero has seized the sacred tripod and is walking away from the scene, but he turns his head back towards the god. Apollo is naked except for a short mantle that runs across his back and over his arms and the characteristic laurel wreath over his long hair. He also carries a bow (heavily damaged) in his left hand. With his right hand he has grasped the tripod by its ring to prevent its removal. The omphalos in the middle indicates the location of the episode, the Delphic sanctuary.[1]

The relief imitates the style of Archaic Greek art, seen mainly in the profile pose of the figures, the zigzag borders of Apollo's mantle, and the god's hairstyle. The subject flourished in Greek art in the late Archaic and Early Classical periods. After a period of decline, it was revived in the first century BCE, in this type and in archaizing style, in neo-Attic workshops that served a Roman clientele. It continued to be copied closely in Greek and Roman art until after the second century CE. Several replicas are known from other reliefs and candelabra.[2]

AK

NOTES
1 Luce 1930, 314–18; Bol 1989, 293–94, no. 93 (H.-U. Cain); Vollkommer 1988, 43; LIMC 5 (1990), s.v. Herakles, 133, 142–43 (S. Woodford); Schefold 1992, 153–54; Wünsche 2003, 250–55 (V. Brinkmann).

2 Fuchs 1959, 126–27; Bol 1989, 292–96, no. 93 (H.-U. Cain); Luce 1930, 320–21; LIMC 2 (1984), s.v. Apollon/Apollo, 418–19, 444 (E. Simon); Fullerton 1990, 9–10; LIMC 5 (1990), s.v. Herakles, 140, 142–43 (S. Woodford). Wünsche 2003, 255 (V. Brinkmann). For replicas of this type, see Fuchs 1959, 126–27; Stephanidou-Tiveriou 1979, 39, nos. 63–64; LIMC 2 (1984), s.v. Apollon/Apollo, 418–19 (E. Simon); Cain 1985, 100, 154, no. 19, pl. 21, 2; Tiverios 1988a; Bol 1989, 292–96, no. 93 (H.-U. Cain); Zagdoun 1989, 95–96, pls. 23–26.

43. HERAKLES, ATHENA, AND HERMES
(BELOW)

Attic black-figure skyphos
Attributed to the Theseus Painter, ca. 500 BCE
Height 17.8 cm, width with handles 29.5 cm
South Hadley, Massachusetts, Mount Holyoke
College Art Museum, purchased with the Nancy
Everett Dwight Fund, MH 1925.3.B.SII

PROVENANCE
Joseph Brummer, New York; museum purchase,
1925

SELECTED BIBLIOGRAPHY
LIMC 5 (1990) s.v. Herakles, 149, no. 3160
(J. Boardman)

44. HERAKLES AND ATHENA (OPPOSITE)

Attic red-figure amphora
Attributed to the Deepdene Painter, ca. 470–
460 BCE
Height 47.9, diameter 27.9 cm
Los Angeles County Museum of Art, William
Randolph Hearst Collection, 50.8.21

PROVENANCE
Sir William Hamilton (1730–1803), Naples, by late
eighteenth century; Thomas Hope (1769–1831);
by descent to Henry Francis Hope Pelham Clinton
(1866–1941), 1844; his sale, Christie's London,
July 23, 1917, no. 71; Marshall Brooks (1855–1944);
his sale, Sotheby's, London, May 14, 1946, no. 43,
pl. 2; William Randolph Hearst; presented to the
Los Angeles County Museum, 1950

SELECTED BIBLIOGRAPHY
*ARV*² 500.28; *BAdd*² 123; *CVA* LACMA, fasc. 1
(1977), 24–25, pls. 863, 23.1 and 2; Levkoff 2008,
216, no. 99 (A. J. Clark)

Athena is known for helping many of the Greek heroes, but she played a special role as Herakles' patron and protector, as attested by numerous artistic and literary sources. She assisted him in some of his labors and stood by him during some of his battles. Herakles in his turn came to Athena's aid when she summoned him to join the Gigantomachy, the battle of the gods against the giants.

The black-figure skyphos presents a very similar scene on each side. Herakles is sitting on a rectangular base, which may be interpreted as an altar. He is facing right, wearing his lion skin. His club leans on the ground, and he is holding it between his knees while his quiver is behind him. His left hand is raised, and in his right hand he extends a phiale toward Athena, who pours him wine from an oinochoe. The goddess is marked by her white skin color as well as by her Attic helmet. She is wearing a himation and a chiton and has a bracelet on each arm. Behind Herakles stands Hermes, with his winged sandals, playing the aulos. The same scene appears on the other side of the skyphos, with small decorative variations. A bearded goat is depicted under each of the handles.

Herakles' mythological connections with Hermes are not as strong as those with Athena; Hermes' role in this instance may be that of messenger god. However, both Hermes and Herakles are often depicted on vases. Both, along with all the gods, fought the giants, and Hermes led Herakles to the slave market, where he was sold to Queen Omphale.

Herakles and Athena are portrayed on one side of the red-figure amphora. The hero is looking to his right, holding a kantharos, and facing the goddess, who is presumably pouring him wine from an oinochoe. Both are depicted with their conventional attributes: Athena with a helmet and a scaly aegis featuring a gorgon's head and decorated with small dangling snakes, holding a spear as well, and Herakles with his lion skin. He also has his club, on which he leans with his other hand, and he is carrying a quiver, although a bow is nowhere to be seen. This scene is mirrored on the opposite side of the amphora, where on the left the god Dionysos, identified by his thyrsos and his ivy wreath, is holding his kantharos toward a maenad, one of his female followers, who pours him wine from her oinochoe. Both the oinochoe and the kantharos are closely associated with Dionysos, the god of wine, and it is possible that Athena and the maenad are giving libations to Herakles and Dionysos.

SS

45. HEAD OF POLYPHEMOS

Roman, first or second century CE
Thasian marble; height 38.3 cm
Museum of Fine Arts, Boston, museum
purchase with funds donated in honor of
Edward W. Forbes, 63.120

PROVENANCE
R. L. Ashman; Hesperia Art, Philadelphia, by 1957;
museum purchase, 1963

SELECTED BIBLIOGRAPHY
R. Hecht, *MAAR* 24 (1956), 137–45, pls. A–B;
B. Andreae, *Antike Plastik* 14 (1974), 64, 76–77,
no. C1, 79–71, pls. 60–63; Comstock and Vermeule
1976, 66–67, no. 105 (with earlier bibliography);
C. Vermeule and Comstock 1988, 109, no. 105;
LIMC 6 (1992), 155, no. 9 (O. Touchefeu-Meynier);
Rome 1996, 127, no. 2.12; Andreae 2001, 156–58,
no. 133; Kondoleon, Grossmann, and Ledig 2008,
68–69

This head of Polyphemos represents the Cyclops with a single, large, almond-shaped eye extending across the bridge of the nose below the ridge of the brow between two tightly clenched eye sockets. While this physical abnormality, as well as his shaggy hair and beard and heavy facial features, firmly locate him in the camp of giants, Centaurs, and other non-ideal creatures, this head portrays Polyphemos as more malformed than monstrous.[1]

Polyphemos appears in Greek and Roman art primarily as one of the many obstacles encountered by Odysseus on his homeward journey from Troy. It seems unlikely that this head, open-eyed and alert, belonged to a statue group, like that found at Sperlonga, depicting the scene from the *Odyssey* (9.371ff) in which Odysseus and his companions prepare to blind the drunken Cyclops with a fiery stake.[2] It has been suggested that this head could have belonged instead to an assemblage of figures representing the preceding episode (9.345ff), when Polyphemos reaches for the wine-filled vessel proffered by Odysseus as part of his plan to escape.[3] Yet the tranquil, even forlorn expression on the Cyclops's face may be more easily reconciled with another interpretive possibility—Polyphemos may be gazing at his unrequited love, the nymph Galateia.[4]

Some scholars have labeled this head, similar in style to the sculpture of Pergamon, as a Roman copy of a lost Hellenistic original of the mid-second century BCE. Both the "copy" status and the precise date of the sculpture are difficult to pin down. It seems at least equally plausible that this head was conceived and executed by a sculptor working in the first or second century CE for a Roman clientele, who considered the theatricality of the Pergamene style well suited to the subject of Polyphemos.

RG

NOTES
1 For a more exaggeratedly monstrous representation of Polyphemos, see, for example, the marble head in Torino (Andreae and Parisi Presicce 1996, 128, no. 2.13).

2 For a recent synthesis of scholarship on the sculptural program of the so-called Grotto of Tiberius at Sperlonga, see Ridgway 2000.

3 For the range of ancient representations of this episode, see Andreae 1999, 142ff.

4 A few wall-paintings from the area of Pompeii preserve depictions of Polyphemos pining for Galateia; cf. the fresco from the Villa of Agrippa Postumus at Boscotrecase now at the Metropolitan Museum of Art (MMA 20.192.17).

46. SIRENS

Attic black-figure kylix
Sixth century BCE
Height 11.5 cm, diameter of rim 23 cm,
width with handles 30 cm
Baltimore, The Walters Art Museum, 48.37

PROVENANCE
Don Marcello Massarenti, Rome, by 1897; Henry
Walters, 1902; Walters Art Gallery, by bequest, 1931.

SELECTED BIBLIOGRAPHY
Massarenti 1897, 2:47, no. 215; Buitron 1992;
Hofstetter 1990

Homer does not describe the physical appearance of the Sirens, but their tantalizing beauty and alluring song captured the interest of commentators throughout antiquity. The Sirens are depicted as composite creatures as early as the eighth century BCE. The earliest types, such as those seen here, are shown without arms or hands, simply with women's heads and birds' bodies. Sirens occur not only in narrative scenes with Odysseus and his men but also as decorative motifs (as do sphinxes); during the Classical period, they come to have associations with funerary iconography.

The two-handled vase shown here is a type of kylix known as an eye cup, which would resemble a mask when raised to the lips during the symposium. The simple, black-slip interior reveals several small holes around the handles that indicate repairs in antiquity. On the exterior, a similar composition dominates each side of the vase in a single band. Between two large eyes stands a Siren; on one side, the Siren faces frontally to the right, and on the other side, she turns her head, looking back. Their full wings are simply drawn, with bands of added red pigment. Beneath their feet runs a simple groundline of black glaze. Above each Siren are traces of an unreadable inscription.

JHC

229 FRIENDS, GODS, AND MONSTERS

47. SIREN WITH A KITHARA FROM A GRAVE MONUMENT

Second half of the fourth century BCE
Pentelic marble; 21.6 × 17.5 × 5.7 cm
Baltimore, The Walters Art Museum, 23.3

PROVENANCE
Joseph Brummer, New York, by 1924; Henry
Walters, 1924; Walters Art Gallery, by bequest, 1931

SELECTED BIBLIOGRAPHY
Andreae and Parisi Presicce 1996, 141, cat. 2.46;
Buitron 1992, 122, 132–33, no. 44; Ensoli 1996;
Hofstetter 1990; Meyer-Baer 1970, 245, fig. 122;
Woysche-Méautis 1982

This small sculpture of a Siren would have topped a grave monument, the lower portion of which is now lost. The heavy-lidded female plays an elaborate kithara, which she is holding in her left hand and balancing on her hip. Her hair, long and wavy, falls gently over her shoulders, and the round flesh of her nude body is surrounded by large, smooth wings, which were once most likely painted. Her long, sinuous torso would have terminated in bird's feet.

Her austere, still form gazes solemnly out toward the viewer of the grave monument, as if in quiet contemplation while she plays her kithara. This sculpture illustrates a tradition of the Sirens that seems almost an antithesis of Homer's account of their terrifying aspects. Here the Siren functions as a kind of protective figure that would have graced the top of the deceased's gravestone and offered consolation through music. The use of the Siren in funerary iconography became widespread in the Late Classical period. These Sirens occur in two types, those who stand in a gesture of mourning and others, such as this one, who play musical instruments.

Descriptions of Sirens in literary sources, including several funerary epitaphs, elucidate their close connections to death and the underworld. Euripides' *Helen* invokes the Sirens, "virgin daughters of Earth," to accompany her in lamentation (*Helen* 165–78), and Plato's description of the underworld in the *Republic* includes a description of the Sirens, to whose music the Fates sing (10.617b). In archaeological contexts, the discovery of statues of sirens within funerary precincts such as the Kerameikos in Athens further links these alluring figures to the world of the dead.

JHC

48. NEREID WITH ACHILLES' SWORD

Apulian red-figure kylix
Fourth century BCE
Height 10 cm, diameter 21 cm
Badisches Landesmuseum Karlsruhe, B 11

PROVENANCE
Purchased in Italy in 1837–38 by Friedrich Maler
(1799–1875) on behalf of the collection

SELECTED BIBLIOGRAPHY
LIMC 6 (1992), s.v. Nereides, 812, no. 377
(N. Icard-Gianolio and A.-V. Szabados); *CVA*
Karlsruhe, fasc. 2 (1972), 35, pl. 72, 1–2

This Apulian cup portrays a Nereid, one of the daughters of the sea god Nereus, carrying a sword, which, presumably, she will give to Achilles. She is not so much riding on the dolphin as leaning on it and holding it with her right arm. In her left arm she holds a sword in an ornamented sheath. The oceanic atmosphere is enhanced by small waves drawn in the background and a shell, as well as by the whorling hemline of the figure's dress and her floating headdress.

Achilles, slighted by Agamemnon's appropriation of Briseis, refused to fight for the Greeks but gave his armor to his companion Patroklos, who died in battle. When the Trojans seized Achilles' armor, Hephaistos, at the request of Achilles' mother, Thetis, forged Achilles a new helmet, breastplates, greaves, and a wonderful decorated shield. Vases depicting this episode elaborate on Homer's account, showing Nereids transporting swords or spears as well.

The theme of Nereids carrying weapons and armor, presumably on Thetis's behalf, is a common one. They are usually accompanied by a sea creature, either real ones such as dolphins, or imaginary sea beasts. Some vases, such as this example, depict a single Nereid; others portray a procession of several Nereids, usually carrying different pieces of armor and weaponry.

SS

49. HERAKLES FIGHTING AMAZONS / WARRIORS ARMING

Attic black-figure amphora
Attributed to the Antimenes Painter, ca. 520–510 BCE
Height 36.5 cm, diameter of rim 17.5 cm, diameter of body 26 cm, diameter of foot 13.8 cm
Toledo, Ohio, Toledo Museum of Art, Purchased with funds from the Libbey Endowment, Gift of Edward Drummond Libbey, 1955.225

PROVENANCE
Reported to have been found in Etruria; Mario Cellini, Rome (Pico Cellini, Rome)

SELECTED BIBLIOGRAPHY
Bothmer 1957, 61 (no. 233 bis), 62, 63, 225; Brommer 1960, 9 (no. 9), 12; Beazley 1971, 120 (no. 38 bis); Brommer 1973, 12 (no. 92); *CVA* Toledo, fasc. 1 (1976), pls. 7 and 8

Heroes defeat great adversaries—monsters and other heroes. Whether Amazons—the inhabitants of a mythical land of women warriors located vaguely on the shores of the Black Sea—were regarded by Greeks of the sixth century BCE as monsters or heroes, or a bit of both, is complicated by the dearth of early literature.[1] However, more than a hundred black-figure Attic vases show Greeks fighting Amazons, a subject that blossomed into popularity between 575 and 550 BCE and remained popular, with unmistakable adjustments of meaning through the fourth century (see no. 50).[2] Sometimes the hero depicted is Achilles killing queen Penthesilea. Sometimes the hero is Theseus, the companion of Herakles who abducted Queen Hippolyte to be his wife and then fought her compatriots when they invaded Attica.

On the front of this vase the hero is clearly identified as Herakles by his Nemean lion skin. For the ninth labor, King Eurystheus commanded Herakles to fetch the zostēr (war belt) of the queen of the Amazons. Herakles is here about to kill the queen.[3] The queen has no chance of winning this duel; nonetheless she seems to be withdrawing not to flee but to fight beside the Amazon on the right.

The other side shows warriors arming, presumably to depart on campaign. The hero in the center is muscular and tall (if he stood erect, he would be much taller than the other figures), with abundant red hair and beard. He slips on a greave. The woman facing him holds his two spears and a Boeotian shield with a device of two panther's heads. Who are they? Are they related to the Amazonomachy on the front, or does the scene represent a different epic, one in which the woman plays an important but more respectable, domestic role?

SK

NOTES
1 *LIMC* 5 (1990), 71–72, Labour IX ("Herakles and the Amazons," nos. 2455–59 (J. Boardman); Blok 1995, 236, 350.

2 The attribution to the Antimenes Painter is by Dietrich von Bothmer (Bothmer 1957, 61 [no. 233 *bis*]), where the accession number is mistakenly printed as 55.88). The Toledo vase belongs to Bothmer Group ε, the most common composition, in which the Amazon behind Herakles is an archer who retreats to the left but looks over her shoulder to the right.

3 Contrary to later literature, on sixth-century BCE Attic vases the most common name inscribed for the queen is Andromache ("battle of a man"): Bothmer 1957, 12–13. On the Toledo vase her shield device is a tripod, perhaps an echo of Herakles' famous duel with the god Apollo for possession of the Delphic tripod when the oracle was slow to respond to Herakles' request that he be purified after murder.

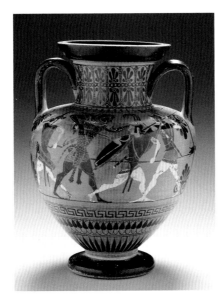
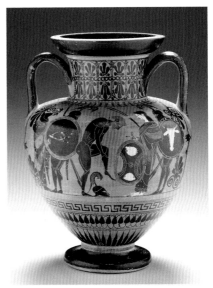

50. THESEUS (?) AND AN AMAZON

Attic red-figure hydria
Attributed to the Berlin Painter, ca. 500–
490 BCE
Height 41.3 cm, diameter 36.6 cm, width with
handles 42.8 cm
Baltimore, The Walters Art Museum, 48.79

PROVENANCE
Don Marcello Massarenti, Rome, by 1897; Henry
Walters, 1902; Walters Art Gallery, by bequest, 1931

SELECTED BIBLIOGRAPHY
Massarenti 1897, 2:37, no. 186; *CVA* Baltimore,
Walters Art Gallery, fasc. 1 (1992), 25–26, fig. 7.2,
pls. 28.3, 29.1, 29.2; Albersmeier 2008, 74–75
(J. Oakley)

Two figures stand on a groundline of meander on the shoulder of this hydria. At left, a young Greek soldier advances to the right, his legs and head in profile and his torso turned to present his back to the viewer. He wears a chitoniskos, chlamys, greaves, and an Attic helmet, its cheekpieces raised to expose his face. His left arm, obscured by his body, holds a shield and two spears. He extends his right hand toward the Amazon before him, and their gazes meet. The Amazon attempts to flee from the soldier: her legs are in profile moving right, while her torso is depicted frontally and her head turns back to look at her pursuer. Like the soldier, she is clad in a chitoniskos, though hers has a loose kolpos in front, and she wears a short mantle, a disk earring, and a pointed cap, from which small curls emerge around the forehead. Her weaponry includes a bow in her left hand, and a sagaris, or small axe, ineffectually pointing downward, in her right hand.

Several mythological heroes were said to have had encounters with the Amazons, but the identity of the figure represented here remains uncertain. The meeting of the figures' gazes is evocative of the story of Achilles and the Amazon Penthesilea, who were said to have fallen in love just as the warrior-hero plunged his sword into her chest. The scene might also depict Theseus, the Athenian hero who fought the Amazon queen Antiope.

HAC

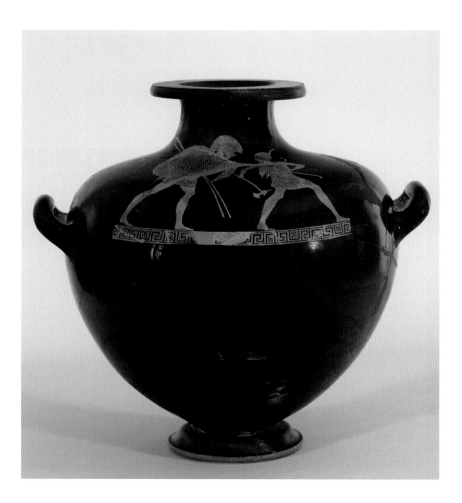

51. HERAKLES AND AMAZONS

Fragment of an Apulian volute-krater
Attributed to the Baltimore Painter, ca. 325–
320 BCE
Height 19.4 cm
New York, The Metropolitan Museum of Art,
Rogers Fund, 19.192.81.1

PROVENANCE
Purchased in 1919 from G. Allegrini

SELECTED BIBLIOGRAPHY
Schauenburg 1960, 6–7, fig. 5; Trendall and
Cambitoglou 1982, 867 (no. 31)

Like a scene in a play—perhaps literally—Herakles meets peacefully with a group of Amazons. He turns to speak to the Amazon leader at left. She leans on a spear while enthroned on a rocky outcrop. To the right a statuesque warrior wears a large and fancy belt, the clue that identifies this scene as the ninth labor of Herakles, the "girdle" of Hippolyte. King Eurystheus of Argos commanded Herakles to bring him the zostēr (war belt) of the queen of the Amazons. For this campaign, alone among the canonical labors, Herakles assembled an army of stalwart Greek heroes to fight beside him.[1]

The Baltimore Painter depicts a cosmopolitan world in which Greeks and exotic foreigners co-exist. The Amazons are strange but not necessarily enemies. This reflects a new way of thinking just after the death of Alexander the Great, a descendant of Herakles, who was often depicted on the coinage of the Hellenistic kings. On the neck of this krater Herakles poses, beardless and handsome, with his famous attributes—lion skin, club, and bow. The heads of all five Amazons turn toward him, perhaps stagecraft, perhaps admiration, perhaps suppressed longing. The painter lavishes attention on the garb and weapons of the mythical warriors—Persian-style trousers and loose cloth *tiara*-helmets, long-sleeved tunics of many patterns, heroic shields, and axes.

Only fragments are preserved of the rest of this volute-krater, but the body of the primary side was painted with a Gigantomachy. The Baltimore Painter is recognized for his complex mythological subjects,[2] many painted on the sides and necks of enormous volute-kraters found in tombs in northern Apulia, near Arpi and Canosa.[3]

SK

NOTES

1 Later versions of the myth turn on parley, with the queen either willing or tricked into promising the belt. "It was here [the mouth of the river Thermodon, near Thermiskyra, the legendary capital of the Amazons] that Melanippe daughter of Ares, having sallied out one day, was caught in an ambush by the great Heracles, though he let her go unharmed when her sister Hippolyte gave him her own resplendent girdle by way of ransom." (Apollonius of Rhodes, *The Voyage of Argo* 2.966, trans. E. V. Rieu).

2 The attribution to the Baltimore Painter is by K. Schauenberg (1960, 6).

3 For recent reappraisal of the center of Apulian red-figure vase-painting being not the Greek colony of Taras or Metapontion but Ruvo or Canosa, see Carpenter 2009; Thorn 2009.

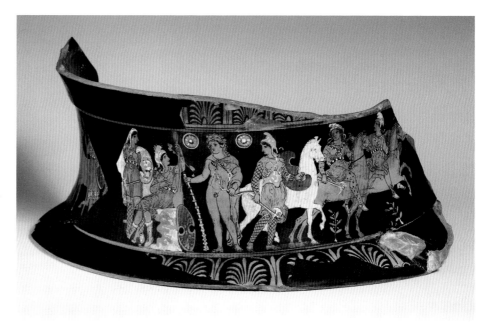

52. THREE AMAZONS

Attic black-figure lekythos
Attributed to the Beldam Painter, ca. 500 BCE
Height 20.5 cm, diameter 6 cm
Baltimore, The Walters Art Museum, 48.249

PROVENANCE
Joseph Brummer, New York, by 1924; Henry
Walters, 1924; Walters Art Gallery, by bequest, 1931

SELECTED BIBLIOGRAPHY
Bothmer 1957; *ABV* 587, 3

NOTE
1 Larson 1995, 111–16.

Three Amazons on this black-figure lekythos face right and appear to march one after the other. Their skin is white, and their facial features, eroded or rubbed away, are indistinguishable. Each wears a helmet, holds a long spear, and has a horizontal quiver. The middle figure holds both hands near her waist; the other two each have one hand raised.

Amazons are first mentioned in the *Iliad* (6.186) as allies of the Trojans; later authors emphasize their fearlessness and their status as foreigners. They were introduced on Attic vases in the early sixth century BCE and quickly became a popular subject. Early black-figure depictions of Amazons resemble Greek warriors, with one notable difference—their white skin color, which identifies them as women. In red-figure vases, the Amazons acquire more femininized features and bodies, and their foreignness is emphasized by their attire: Scythian or Thracian clothing and subsequently Persian garb.

In some places in Greece, Amazons were the object of cult. Jennifer Larson has suggested that despite the fact that they were considered hostile to the Greeks, their complete otherness from the Greek way of life also gave them protective powers and entitled them to be worshiped as heroines.[1]

SS

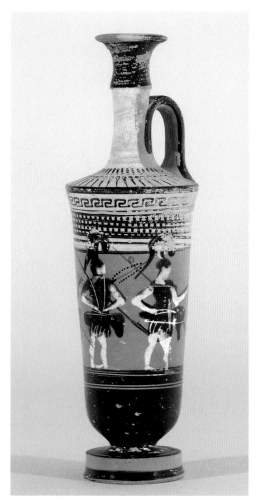

53. THREE AMAZONS AND HERAKLES

Attic black-figure lekythos
Attributed to the Haimon Painter, ca. 500 BCE
Height 27 cm, diameter 8.2 cm
Baltimore, The Walters Art Museum, 48.241

PROVENANCE
Joseph Brummer, New York, by 1924; Henry
Walters, 1924; Walters Art Gallery, by bequest, 1931

SELECTED BIBLIOGRAPHY
Bothmer 1957; *ABV* 548, 280

Herakles is depicted on this black-figure lekythos with his usual attributes, the lion skin and the club, which he holds in his right hand, and a quiver. He is facing right, grasping an Amazon who tries to escape from him, though she turns her head to face him. There is an Amazon on each side of this duel. One runs away from Herakles, while the other runs toward his captive, as if coming to her aid. All three are similarly dressed; two carry spears; one has no shield.

Herakles' ninth labor for King Eurystheus required him to retrieve the girdle of the queen of the Amazons. While the queen at first willingly acceded to Herakles' request, the goddess Hera spread a rumor among the Amazons that Herakles intended to kidnap their queen; when the Amazons attacked him, Herakles killed her and made off with her girdle. This theme was a common subject on vases depicting the Amazons, and one of the most frequently recurring subjects on vases portraying Herakles and his labors. In vase-painting, the Amazon queen is usually named Andromache (she is more often named Hippolyte in the literary evidence), and the girdle itself is not usually depicted until after the sixth century.

SS

54. OEDIPUS AND THE SPHINX (OPPOSITE)

South Italian red-figure oinochoe
ca. 350–335 BCE
Height 22.1 cm
Museum of Fine Arts, Boston, Henry Lillie
Pierce Fund, 01.8036

PROVENANCE
Alfred Bourguignon; Edward P. Warren, by 1901;
museum purchase, 1901

SELECTED BIBLIOGRAPHY
Trendall 1967; Moret 1984; Taplin 1993

**55. GEM WITH OEDIPUS AND THE
SPHINX** (BELOW)

Fourth–third century BCE
Green and white agate, gold; height of
bezel 1.2 cm
Baltimore, The Walters Art Museum, 42.465

PROVENANCE
Henry Walters, 1913; Walters Art Gallery, by
bequest, 1931

COMPARANDUM
LIMC 7 (1994), s.v. Oidipous, 4–5, no. 26
(I. Krauskopf)

This oinochoe, a vessel for wine, depicts the meeting of Oedipus and the Sphinx in a caricature, a common treatment of Greek myths on South Italian vases in the fourth century.

The Sphinx was a savage creature with the head of a woman, the body of a lion, and the wings of a bird, sent by Hera to plague the city of Thebes. Oedipus encountered her at the entrance to the city, where she allowed none to enter or leave until they had correctly answered her question: "What has one name and is four-footed, two-footed, and three-footed?" Only Oedipus was able to answer her riddle correctly: "man," who as an infant crawls, in the prime of life walks on two feet, and in old age carries a cane. The episode, likely part of a long oral tradition, is mentioned in Sophocles' *Oedipus the King* (lines 469 ff.)

The vase depicts a nearly nude Oedipus, leaning on a staff and wearing a hat that resembles a pilos, with a comically protruding stomach and an enormous phallus. He looks toward the Sphinx with apparent indifference as she crouches on a tall pile of rocks. The vase is richly decorated with patterned motifs and vegetation. Tall plants are interspersed between Oedipus and the Sphinx, suggesting an outdoor setting, with large palmettes along the sides of the vase and the back. The scene may depict a stage performance.

On the gem, the winged Sphinx with a lion's body and a large female head is seated on a high rock on the right. Oedipus faces the monster and raises his left hand to his mouth to address the Sphinx; he holds a sword in his right. He is nude except for sandals and a cloak tied around his neck.

JHC / SA

56. THE SPHINX ON A PEDESTAL (OPPOSITE)

Attic black-figure lekythos
Attributed to the Emporion Painter, ca. 500 BCE
Height 25.8 cm, diameter 8.4 cm
Baltimore, The Walters Art Museum, 48.238

PROVENANCE
Joseph Brummer, New York, by 1924; Henry
Walters, 1924; Walters Art Gallery, by bequest, 1931

SELECTED BIBLIOGRAPHY
ABV 585, 3 *BAdd*² 139

57. SPHINX EARRING (BELOW)

First century BCE
Gold, garnet; 4.9 × 1.7 × 1.6 cm
Baltimore, The Walters Art Museum, 57.1490

PROVENANCE
Henry Walters, by 1931; Walters Art Gallery, by
bequest, 1931

SELECTED BIBLIOGRAPHY
Walters Art Gallery 1979, 79, no. 245; Walters Art
Gallery 1984, 62, no. 43; Reeder 1988, 228, no. 126

The scene on this black-figure lekythos depicts an assemblage of four Theban men before the Sphinx, pondering her riddle. The Sphinx sits on a column, while two of the men facing her sit on folding stools and two stand upright.

In Greek art, the Sphinx is normally depicted with a lion's body, wings, and a woman's head, sometimes extended downward to include the breasts. Accounts vary as to why the Sphinx plagued the Thebans, but most traditions agree that her enmity was directed particularly at Theban males. The tradition of the riddle is described by the third-century BCE lyric poet Asklepiades (12F7a).

The hero Oedipus brings about the demise of the Sphinx either by solving her riddle or by force. Depictions of Oedipus in Greek art resemble those of the assemblage of Thebans on this vase: bearded, cloaked, and holding a staff. He either sits or stands facing the Sphinx on her column. Sometimes he wears a petasos, a brimmed traveler's hat. More rarely, Oedipus is represented killing the Sphinx.

The elaborate earring depicts a Sphinx with a female head, pronounced breasts, and a bird's body with raised wings seated on a trapezoidal base. She is heavily adorned, with a necklace, straps crossing between the breasts, and multiple garnets. The large, central stone of her headdress is missing, but above she is wearing the crown of the Egyptian goddess Hathor, consisting of a sun-disk inscribed in cow horns with two plumes above. Outside of the myths, the apotropaic character of the Sphinx as well as of other monsters such as griffins, sirens, and the Medusa transformed them into guardians and protectors, an appropriate motif for jewelry.

JR / SA

58. PEGASOS <small>(BELOW LEFT)</small>

Early fifth century BCE
Bronze; 10.1 × 3.3 × 11 cm
Baltimore, The Walters Art Museum, 54.882

PROVENANCE
Henry Walters, by 1931; Walters Art Gallery,
by bequest, 1931

SELECTED BIBLIOGRAPHY
Hill 1974

59. PEGASOS AND BELLEROPHON
<small>(BELOW RIGHT)</small>

Roman, late first century BCE–early first
century CE
Agate (?), gold; height of bezel 2.6 cm
Baltimore, The Walters Art Museum, 42.1317

PROVENANCE
Henry Walters, by 1931; Walters Art Gallery,
by bequest, 1931

COMPARANDUM
Boardman 2009, no. 329

This bronze horse head is an ornamental finial for the shaft of a chariot. The horse's head, neck, forelegs, and wings emerge from a tube, the opening of which would have fit over the shaft, which was attached to the chariot's carriage. The mane sweeps upward, and behind it a flange emerges. A serpent, entwined around the wings, faces the opposite direction from the horse. A projecting piece might have held a ring that secured the zugodesmon, a rope or strap that kept the tilted carriage level with the horses' backs by connecting the top of the chariot carriage with the shaft's terminus at the finial.

Semi-divine horses were associated with the cult of Poseidon, who sired Pegasos, according to one tradition. In association with Apollo, the horse symbolized intellectual enlightenment. Winged horses such as Pegasos are depicted in literature and art drawing the chariot of Helios and Eos. Certain winged horses, including Pegasos, were thought to have made springs burst from the ground as they galloped upon it.

Pegasos was the most famous of the mythological winged horses, and he was prominent in myth as friend, helper, and half-brother to the hero Bellerophon. In the literary and artistic tradition, Pegasos shares in Bellerophon's labors, performed at the behest of King Proteus of Tiryns, and the heroes are commonly represented together, with Bellerophon riding Pegasos.

The gem depicts the hero Bellerophon watering Pegasos, who stands beside and behind him. Bellerephon rests his weight on the horse's left leg and in his left hand holds Pegasos's reins. With his right hand, Bellerephon balances a staff on his shoulder.

JR

60. AJAX CARRYING THE BODY OF ACHILLES

Attic black-figure amphora
Attributed to the Antimenes Painter, ca. 520 BCE
Height 38.1 cm, diameter 27.9 cm
Baltimore, The Walters Art Museum, 48.17

PROVENANCE
Don Marcello Massarenti, Rome, by 1897; Henry
Walters, 1902; Walters Art Gallery, by bequest, 1931

SELECTED BIBLIOGRAPHY
Massarenti 1897, 2:36 (no. 183); Hill 1950a; *ABV*
271, 70; *BAdd*² 34

Depicted on side A of this amphora is Ajax carrying the dead body of Achilles off the battlefield. Although alluded to in the *Iliad*, the hero's death does not occur in this epic poem but was recounted in the lost epic *Aithiopis*. In the center of the scene, a fully armed Ajax bends slightly under the weight of the deceased hero. Achilles' limp body is balanced over Ajax's shoulder, with his feet hanging just above the ground. Both warriors still bear their shields and wear helmets. Achilles' upper body is obscured by Ajax's shield, with only the plume of his helmet visible over the shield's rim. At the right, behind the pair, are two similarly armed warriors who may serve to situate the scene on the battlefield. To the left is a woman, her flesh rendered in added white. She runs to the left, raising her arms in a gesture of alarm or mourning. This demonstration of Ajax's dedication to the memory of Achilles foreshadows Ajax's death at his own hands. After the armor of Achilles was awarded to Odysseus, Ajax was so enraged that he commited suicide (Sophocles, *Ajax* 812ff).

The theme of warriors recurs on side B, where two fully armored, mounted horsemen clash over a crouching warrior who appears to be trapped in the duel. Both horses rear up on their hind legs as their front legs entwine in the fight. The triangular effect of the horses is accentuated by the crossed spear shafts of the two warriors in the top center of the scene.

HAC

61. THE DEATH OF PRIAM

Attic red-figure amphora
Attributed to the Nikoxenes Painter, ca. 500 BCE
Height 45.7 cm, diameter 30 cm
New York, The Metropolitan Museum of Art,
Rogers Fund, 06.1021.99

SELECTED BIBLIOGRAPHY
*ARV*² 220, 4; *LIMC* 7 (1994), s.v. Priamos, 517,
no. 94 (J. Neils); Richter 1936; Christiansen and
Melander 1988

On side A of this amphora, Priam, the king of Troy, is seated on a volute altar, where he has fled to seek refuge from Neoptolemos, the son of Achilles. The king wears a chiton and mantle and holds one hand to his balding head, another to his chest. He looks down and averts his gaze from his armed aggressor, Neoptolemos, who approaches from the left. The warrior's face is covered by his helmet, which reveals only his eyes and lower beard. He bears a shield on his left arm and holds a spear in his hand, its tip pointed toward the frightened Priam. From the right, a woman with outstretched arms approaches Priam in a futile attempt to protect him.

The image on the reverse of this amphora depicts the same scene with slight variations that suggest that we are seeing the same scene just moments later. Neoptolemos lifts his spear in preparation to strike Priam, whose face now looks toward his attacker. To the right, Hekabe has turned, perhaps in flight, and her right arm gestures back to the horrific events unfolding on the altar.

The murder of Priam was recorded in the lost epic *Ilioupersis*. After the Greeks infiltrated the city of Troy through the strategem of the Trojan Horse, Priam sought refuge at the altar of Zeus Herkeios and was slain by Neoptolemos. Hekabe was then enslaved, and in Euripides' play *Troades*, she describes the slaughter of her husband at the hands of Neoptolemos.

The scenes on this vase portray the confrontation of two generations of heroes—the older, dignified king and the aggressive, vengeful son of Achilles.

HAC

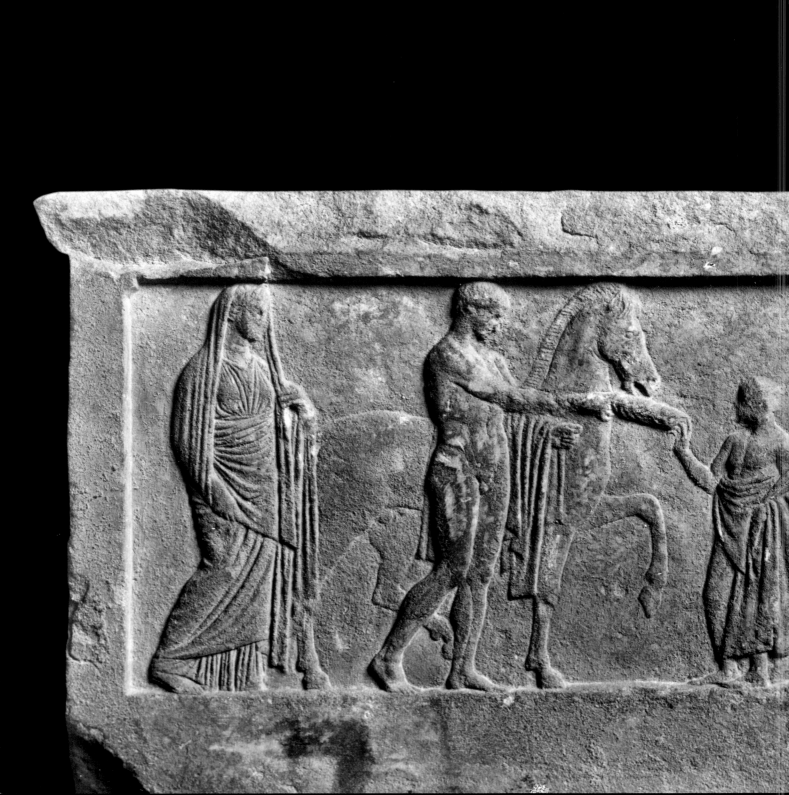

HEROES IN CULT

Heroes and heroines were worshiped locally throughout Greece. The reasons for the initiation of a hero cult and the form it could take were several. Heroes were regarded as ancestors of a heroic past, as founders, protectors, healers, or helpers, but also as dangerous and haunted revenants, who had to be appeased. Heroines who died for the greater good or who were worshiped along with male family members received cults, as did infant and child heroes whose violent deaths often instigated their worship. The Greeks held festivals in their honor, performed rituals and sacrifices, gave them offerings, and asked for favors such as protection, fertility, or healing in return. As the cults were local in character, they developed according to local traditions, which might account for the large variety of cult practices and unusual places of hero worship.

Votive objects like bronze and terracotta statuettes, armor, and vessels were placed at a hero's tomb or shrine. At excavated sites, these objects are often indistinguishable from funerary gifts or offerings for gods typical of the same region; offerings alone are not a reliable basis for identifying hero cults. Certain votive reliefs, however, can clearly be associated with hero worship. They most often depict a hero and/or heroine and a dedicant or a group of worshipers in various settings. Unlike the epic protagonists, many of the heroes and heroines depicted on these reliefs are unrecorded or unrecognizable by modern viewers. Some of the major epic heroes appear on these reliefs as well: Herakles is often depicted in front of a four-pillar shrine typical of his cult. The heroes are distinguished by their larger size relative to other figures depicted on the reliefs, and they are often accompanied by a horse or a snake, both characteristic elements in representations of heroes. The votive reliefs also introduce elements of sacrifice such as libations, offering vessels (e.g., a rhyton or a phiale), and sacrificial animals.

SA

62. THE WORSHIP OF HERAKLES

Fragment of a votive relief
Early fourth century BCE
Pentelic marble; 50 × 51 cm
Athens, National Archaeological Museum, 1404

PROVENANCE
From Ithome (Messenia), or from Athens

SELECTED BIBLIOGRAPHY
Svoronos 1903, 58, 352–53, no. 102, fig. 46, pl. 60; Kastriotis 1908, 246–47, 414; Stais 1910, 240, pl. on p. 241; Süsserott 1938, 104, pl. 14.3; Karouzou 1967, 93; *LIMC* 4 (1988), s.v. Herakles, 802, no. 1377 (J. Boardman et al.); Vollkommer 1988, 83, no. 549; Tagalidou 1993, 208–11, no. 18, pl. 10; Van Straten 1995, 88, 297–98, no. R92, fig. 94; Edelmann 1999, 235, no. U 66; Comella 2002, 122, 199, no. Atene III, fig. 122; Kaltsas 2002, 139, no. 266; Wünsche 2003, 318–19, fig. 55.16 (S. Lorenz)

This type of architecturally framed relief, depicting a supernatural being, usually in the presence of worshipers, is a common ex voto in hero cults.[1] In this case, the recipient of the offering is Herakles, depicted on the left side of the relief, young and nude but for his characteristic lion skin. In his left hand, he holds his main attribute, the club. In the background, a columnar building on a three-stepped crepis undoubtedly represents a construction related to his cult; it accompanies Herakles, with minor variations, in many representations.[2]

A group of worshipers—a family or an association, of whom only one is fully preserved—makes its way toward the hero's shrine to offer him a sacrifice. The individuals' significantly smaller proportions signal the group's status relative to the hero. The raised hand of the preserved worshiper is a gesture, common in votive reliefs, of adoration and respect. The sacrifice is impressive for a private monument and attests either to the wealth of the dedicator or, more likely, to the importance of the offering. The hero receives two animals, one of which, the cow or bull, would have been a rare and very costly offering.[3]

Such votive reliefs provide reliable information about private cult and ritual. They constituted a means of expressing personal faith, and they offer a visual description of the kind of ritual appropriate for a hero. Reliefs such as this, mostly private dedications, were offered mainly to heroes and lesser deities. Heroes, like saints in the Christian church, might have been more accessible than gods in matters of everyday concern such as protection from danger, illness, or war, the birth and rearing of children, or prayers for a successful harvest.[4]

AK

NOTES
1 Hausmann 1960, 57; Van Straten 1995, 58–100.

2 For the representations of this columnar shrine and the various theories about its meaning, see Frickenhaus 1911; Walter 1937; Woodford 1971, 213–14; Tagalidou 1993, 19–22, 27–32.

3 For the proportions of gods and worshipers, see *ThesCRA* I.2d (2004), s.v. Dedications (E. Vikela). For this gesture of adoration, see Van Straten 1981, 83; *ThesCRA* III.6c (2004), s.v. Veneration, 184–89 (A. Costantini). For the kinds and the prices of animal sacrifices, see Van Straten 1995, 171–86; Edelmann 1999, 147–53.

4 Nock 1944, 165; Hausmann 1960, 57; Van Straten 1995, 95. For the votive reliefs as a source of information for Greek cult, see Van Straten 1995, 53–54; Edelmann 1999, 175–81.

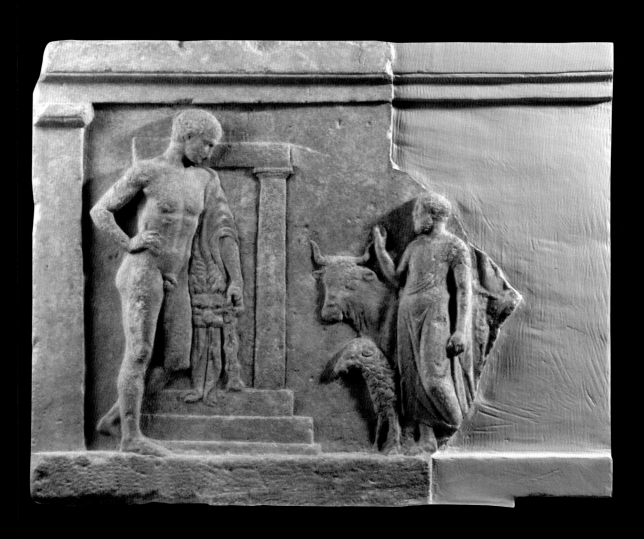

63. HERAKLES AND THE HERO OF ANTIOCHIS

Fragmentary Attic document relief, ca. 320 BCE
Pentelic marble; 62 × 36 cm
Athens, National Archaeological Museum, 3491

PROVENANCE
Discovered in the precinct of the Herakleion at Kynosarges

SELECTED BIBLIOGRAPHY
Karouzos 1923, 89–96, no. 2 fig. 2; SEG 3 (1927), 26, no. 116; Kron 1976, 191–93, 239, 279 no. An 5, pl. 28.1; LIMC 1 (1981), s.v. Antiochos, 852, no. 6 (E. B. Harrison); Meyer 1989, 25, 27, 69, 119–21, 149–50, 188–90, 304–5, no. A 139; Tagalidou 1993, 100–102, 219–21, no. 22, pl. 11; Lawton 1995, 8, 15, 34, 51–52, 150, no. 157, pl. 83; Kaltsas 2000, 238, no. 501

This fragmentary stele is a part of a document relief, a public record with figural decoration, known mainly from Attica in the fourth century BCE. Such reliefs recorded formal state proclamations, such as laws, regulations, and treaties, but also texts associated with smaller civic groups, such as demes, phylai, or ephebes.[1] The document in this instance is a decree issued by the members of the infantry of the Attic tribe Antiochis to honor their commander, the taxiarch Prokleides, for fulfilling his duties successfully.[2]

The figure on the right is readily identified as Herakles by his attributes: the lion skin, thrown over his left arm, and the club that he holds with his right hand and rests on a rock. He is unbearded and nude and stands in a relaxed contrapposto. On the left, a bearded man of the same proportions, dressed in himation and holding a staff, originally rendered in paint but now lost, looks toward Herakles. Figures of this type commonly appear in the company of gods and heroes, but the association of this decree with the Antiochis tribe suggests that he is Antiochos, the hero for whom the tribe was named after Kleisthenes' reform of the constitution of Athens.[3]

The presence of Herakles is explained by the fact that he was Antiochos's father and that his cult was significant for this tribe. The relief was discovered near the place where it had originally stood, the sanctuary of Herakles at Kynosarges, one of the many cult places associated with Herakles in Attica and the tribe's central sanctuary. The shrine may have contained a cult of Antiochos.[4]

The naming of social groups after a hero, the depiction of heroes in public documents, and the display of official records in heroes' sanctuaries reveal the importance given to them and the popularity of their cult.

AK

NOTES
1 Meyer 1989, 1; Lawton 1995, 1, 5–10, 19–22.

2 Karouzos 1923, 90–91; SEG 3 (1927), 26, no. 116; Meyer 1989, 188; Tagalidou 1993, 101–2, 220; Lawton 1995, 8, 34, 150, no. 157.

3 Karouzos 1923, 92–96; Kron 1976, 192; LIMC 1 (1981), s.v. Antiochos, 852, no. 6, (E. B. Harrison); Lawton 1995, 52, 150, no. 157.

4 Karouzos 1923, 92, 100–101; Woodford 1971, 215–16; Kron 1976, 191; LIMC 1 (1981), s.v. Antiochos, 852 (E. B. Harrison); Kearns 1989, 149; Meyer 1989, 188; Tagalidou 1993, 100–101; Lawton 1995, 15, 51–52, 150 no. 157. For the cult of Herakles at Athens, see Farnell 1921, 107–10; Woodford 1971; Kearns 1989, 166. For the presence of Herakles in decree reliefs, see Tagalidou 1993, 86–103.

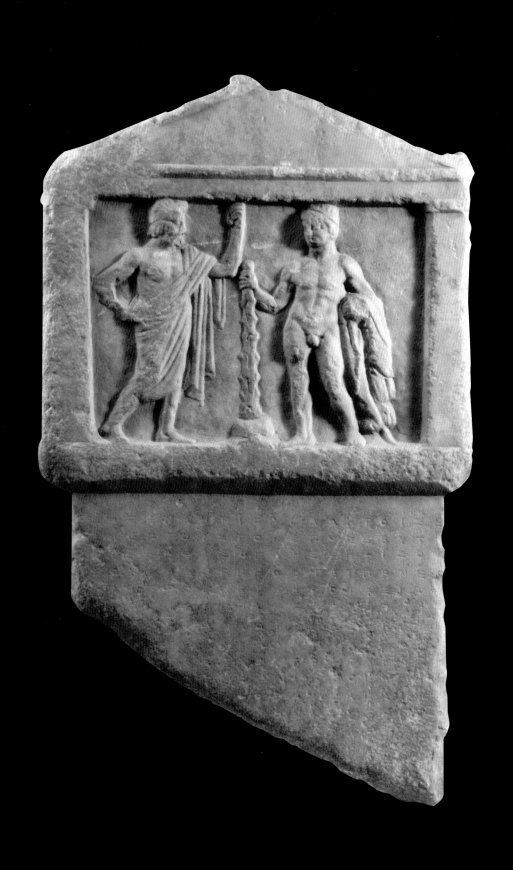

64. GRAVE RELIEF WITH A HERAKLES HERM

Second century BCE
Marble; 93.5 × 61 × 19 cm
Staatliche Museen zu Berlin, Antikensammlung,
Sk 784

PROVENANCE
Found at the maussolleion of Halikarnassos

SELECTED BIBLIOGRAPHY
Pfuhl and Möbius 1977, 86, no. 141, pl. 32; Wrede
1985, 24; *LIMC* 4 (1988), s.v. Herakles, 782,
no. 1114 (O. Palagia)

A herm of the hero Herakles is flanked by a nude young boy on the left and a tall man on the right. The scene is framed by a large palm branch, which arches to the right, terminating at the face of the deceased. The boy (probably a servant) gazes toward Herakles and holds a long object in his left arm, possibly another palm branch.[1] All three figures are carved almost in the round, standing out prominently from the background.

The bearded Herakles figure in the middle is a herm, composed of a half-figure tapering into a shaft below the hip that supports the statue. Although the face is damaged, the lion skin wrapped around his upper body clearly identifies the hero. The herm is placed on an altar, together with a small fruit on the altar's front right corner.

The man on the right lightly rests his right hand, grasping a folded fillet, on the herm's left shoulder. He has short curly hair, deep-set eyes, and a small mouth. He wears a chiton underneath his mantle, which is wrapped horizontally around his body and falls over his left arm.

Herms serving as cult image are often found in places under the special protection of the herm gods—a palaestra, gymnasium, hippodrome, or stadium. Its presence in this relief signals the location, while the fillet and palm branch identify the deceased as a victorious athlete. Herms of Herakles appear exclusively on grave reliefs from eastern Greece, particularly after the middle of the second century BCE.[2]

SA

NOTES

1 Another possibility would be two javelins, which appear on similar reliefs (cf. Pfuhl-Möbius 1977, 86, no. 40, pl. 32), but here the rods are slightly bent and seem to split into three parts at the very top.

2 Wrede 1985, 24, 38.

65. THE DIOSKOUROI AND A DEDICANT

Attic votive relief
Fourth–third century BCE
Marble; 34 × 45 cm
Athens, National Archaeological Museum, 1409

PROVENANCE
Discovered at Piraeus

SELECTED BIBLIOGRAPHY
Svoronos 1903, 357–58, no. 107, pl. 33.4; Kastriotis 1908, 248; Stais 1910, 242, 243 (fig.); Van Straten 1981, 97, pl. 39; *LIMC* 3 (1986), s.v. Dioskouroi, 577, no. 121 (A. Hermary); Kaltsas 2002, 277, no. 580

The decorated area of this fragmentary relief is dominated by the presence of the two twin heroes, sons of Zeus, the Dioskouroi, each dressed in a short chiton and chlamys. One of the brothers stands in front of the other, who is represented riding and holding his brother's horse. On the right, a much smaller nude youth stands on the prow of a ship and addresses the heroes with the characteristic gesture of adoration. The vessel is roughly represented, but the absence of an embolon, a pointed projection of the keel used in maritime combat, suggests that it is a simple sailor's boat and not a warship.

Dedications of sailors to the Dioskouroi are common. The twin heroes were considered protectors of seafarers, and offerings were given to them in thanks for rescue from danger at sea or as a supplication for protection on a maritime journey. Sailors occasionally named their ships after the brothers, a practice attested for marine divinities and other gods who served as protectors at sea.[1]

This representation attests to their presence as seafaring heroes in Attica. The port of Piraeus would have been a particularly appropriate location for a sailor's offering, if this findspot was also the original place of the dedication. In Athens, the Dioskouroi were more often known as the Anakes, and according to the tradition they came to Attica to rescue their sister Helen, who had been abducted and brought to the area by the hero Theseus. They had several cults in Attica: at Athens, in the area of modern Vari, and at Thorikos. The most important of their shrines was the Anakeion in the center of Athens, embellished with the famous lost mural of Mikon and Polygnotos.[2]

AK

NOTES
1 Van Straten 1981, 97; Köhne 1998, 26–28; Shapiro 1999, 106; Parker 2005, 411 n. 96. For the naming of ships after the Dioskouroi, see Casson 1971, 359; Morrison 1996, 209.

2 Farnell 1921, 210–11; Kearns 1989, 148; Köhne 1998, 108–10, 121–28; Shapiro 1989, 149–51; Shapiro 1999, 100–101.

66. HERO WITH A SUNKEN SHIP

Fragmentary grave stele
First quarter of the fourth century BCE
Pentelic marble; 70 × 45 cm
Athens, National Archaeological Museum, 752

PROVENANCE
Found before 1881

SELECTED BIBLIOGRAPHY
IG II² 11114; Kavvadias 1890–92, 361–62, no. 752;
Kastriotes 1908, 117; Stais 1910, 128; Diepolder 1931,
39; Karouzou 1967, 83–84; Morrison and Williams
1968, 177, no. Clas. 13; Stupperich 1977, 128, 179,
155, no. 18; Garland 1985, 15–16, fig. 5; Clairmont
1993, 316–17, no. 1330; Scholl 1996, 107–8, 194,
244–45, no. 70; Kaltsas 2002, 163, no. 320

This elegant grave monument, the bottom portion of which is missing, commemorates Demokleides, son of Demetrios, according to the inscription on a relief band on top of the figural scene. The stele's upper edge ends in an epistyle and a geison with palmette antefixes. The scene on the main portion was executed in relief and painted, but only the relief is visible today. In the upper right corner of the decorated area, an unbearded youth wearing a short chiton sits on the ground near a ship. His left arm rests on his knees; he holds his head with his right hand in a gesture of grief and despair.[1] The helmet and shield beside him suggest that he is a hoplite, or foot soldier. The piece of cloth on which he sits is probably his mantle. Only the prow of the ship is represented, a convention in the scarce depictions of ships during the Classical period. The only visible part of the vessel is the outline of its front profile; the rest would have originally been rendered in paint, as would the seawater beneath the ship. The embolon, the outermost protuberance of the keel, defines the vessel as a warship.[2]

The armor and warship imply that the youth suffered a heroic death in a naval battle. This stele might have decorated his cenotaph, if his body was lost at sea. His unburied body might be the source of his grief; a heroic death would otherwise have been a matter of pride.[3] Memorials commemorating a death at sea are rare in Attic art of the Classical period, and the manner in which the scene is represented, with the elements so extensively defined in added paint, makes this tombstone unusual.[4]

AK

NOTES
1 Diepolder 1931, 39, reads the figure's pose more broadly, as indicative of a "spirit of the age."

2 Clairmont 1993, 316–17. For depictions of ships during the Classical period and for the characteristic features of a warship, see Morrison and Williams 1968, 169–80; Morrison 1996, 255.

3 Johansen 1951, 50; Clairmont 1993, 317.

4 Stupperich 1977, 179.

67. VOTIVE RELIEF FOR THE HERO ALEXIMACHOS

ca. 360–350 BCE
Pentelic marble; 36 × 44 × 9 cm
Staatliche Museen zu Berlin, Antikensammlung,
Sk 807

PROVENANCE
From Tanagra; formerly Saburoff collection;
museum purchase, 1884

SELECTED BIBLIOGRAPHY
Blümel 1966, 67–68, no. 77, fig. 113 (K 112);
Langenfaß-Vuduroglou 1973, 49, no. 102; Mitro-
poulou 1975, 18–19, no. 7; LIMC 6 (1992), s.v.
Heros equitans 1027, no. 43 (A. Cermanovič-
Kuzmanovič et al.); Edelmann 1999, 206, D 39;
Comella 2002, 147–48, 225, Tanagra 3, fig. 151;
Schild-Xenidou 2008, 49, 122–23, 158, 192–96,
318–19, no. 86, pl. 34.

The relief shows the hero Aleximachos on the left next to a horse striding forward. He is wearing a belted chiton, a chlamys, and a petasos pushed back from his head. His slightly raised left hand grasps the once-painted reins of the horse, while his outstretched right hand holds an offering bowl, into which the heroine pours a libation from a jug. The heroine, equal in size to the hero, wears a chiton, and a mantle, and a himation, the bulk of which is draped over her left arm. Her hair is pulled back and knotted at the back. Between the heroic couple stands a simple altar.

Behind the group at the altar a family of worshipers, comprising a couple with two children, approaches, clearly distinguished from the heroic couple by their size; the adults are about a third smaller than the heroes. The bearded man, dressed in a himation that leaves his upper body exposed, raises his right hand toward the heroic couple in a gesture of adoration. His wife and the two children are identically dressed, their bodies entirely enveloped in their mantles, and each performs the same gesture.

The relief is framed by an architectural setting: pillars (antae) with simple capitals on either side, which support an epistyle with five antefixes. Together with the altar, they likely represent an actual shrine; the group of worshipers overlaps with the pillar on the right side as if they were entering the shrine. The dedicatory inscription on the architrave reads ΚΑΛΛΙΤΕΛΗΣ ΑΛΕΞΙΜΑΧΩΙ ΑΝΕΘΗΚΕΝ, "Kalliteles dedicated [it] to Aleximachos." Aleximachos was likely an ancestral hero worshiped by his descendants, here represented by Kalliteles and his family.

SA

68. BANQUET RELIEF

ca. 350 BCE
Pentelic marble; 44.5 × 57 cm
Athens, National Archaeological Museum, 3872

PROVENANCE
Discovered at Kalamaki in Palaio Phalero in 1940

SELECTED BIBLIOGRAPHY
Thönges-Stringaris 1965, 77, no. 58; Karouzou 1967, 153; Dentzer 1982, 317, 335, 590, no. R 194; Kaltsas 2002, 230, no. 483

This relief is framed by antae, epistyle, and cornice, common architectural features in classical Attic votive reliefs that probably allude to the sacred location of the scene. The rectangular projection at its bottom suggests that it was originally inserted in a base.[1]

The sculpture belongs to the category of banquet reliefs, or *Totenmahl*, depicting a hero, god, or heroized dead man attending a symposium. This type was introduced in the sixth century and flourished all over Greece from the fourth century BCE onward, primarily as votive offerings. Slightly different banquet scenes appear less frequently on funerary monuments.[2]

In this example, a bearded male figure with a polos on his head and a himation covering his lower body reclines behind a table laden with food. He holds a rhyton with his right hand and a phiale with his left. His female consort accompanies him in this symposium, which implies his supernatural character, since respectable women did not attend ordinary men's drinking parties. She has just taken incense from a box and is about to place it in the censer that stands on the table. In the left edge of the scene, a young nude servant holds an oinochoe and a phiale above a volute-krater, the wine container for the feast.

The reclining man is a hero rather than a god; in other banquet reliefs, a similar man wearing a polos, a head-covering signifying sacred character or political authority, is accompanied by a snake and a horse, all attributes of a hero. The rhyton is also appropriate for a hero; according to Athenaeus (*Deipnosophistae* XI.461b and 497e), this drinking vessel was intended only for heroes.[3] Banquets for heroes were an element of cult; some hero cult rituals prescribed a *theoxenia*, the preparation of a feast for the hero.[4]

AK

NOTES

1 Van Straten 1995, 59–61; Kaltsas 2002, 230, no. 483.

2 Thönges-Stringaris 1965, 2, 14, 24, 58–62; Van Straten 1995, 94; Ekroth 2002, 279–80; *ThesCRA* II.3.d (2004), s.v. Heroization, 143–44, 152 (I. Leventi).

3 Thönges-Stringaris 1965, 48–54, 56–58; Dentzer 1982, 316, 482–84, 490–93, 495–501; Hoffmann 1992–93, 134; Van Straten 1995, 95, n. 283; *ThesCRA* II.3.d (2004), s.v. Heroization, 153 (I. Leventi). For a similar relief, see Kaltsas 2002, 231, no. 487.

4 Ekroth 2002, 136–40, 177–79, 276–86, 304–305; *ThesCRA* II.4.a (2004), s.v. Banquet, 225–29 (L. Bruit and F. Lissarrague).

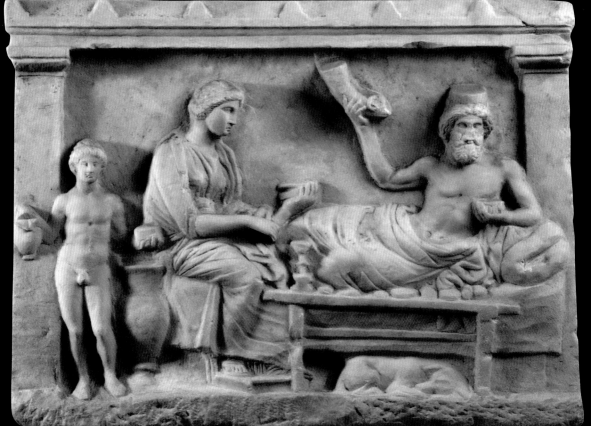

69. BANQUET RELIEF
Second half of the fourth century BCE (ca. 340)
Marble; 41.2 × 57.1 × 9.9 cm
Baltimore, The Walters Art Museum, 23.222

PROVENANCE
Spink and Son (Octagon, Winter 1966, 8); museum
purchase, 1967

SELECTED BIBLIOGRAPHY
Art Quarterly 1968, 205, 209; Hill 1968b; C. Ver-
meule 1981, 109, no. 79; Dentzer 1982, 315, 624,
no. R 498, fig. 718; Reeder 1988, 88, no. 14

The banquet scene is framed by an architectural setting typical of Greek funerary and votive reliefs: antae on either side connected by an epistyle crowned with six palmette antefixes. The two figures on the right dominate the scene. A bearded, bare-chested man on a kline reclines on his left arm supported by his mantle and two cushions. He holds a wreath in his left hand and a phiale in his right hand. Facing him on the left sits a woman dressed in chiton and himation with her feet resting on a footstool. She is taking incense tablets out of a box in her left hand, placing them with her right hand on a censer at her knee. The simple table in front of the couch holds offerings, including pyramidal cakes and a small round bottle.

Behind the woman, a nude servant has his right hand in a large volute-krater next to the couch and is likely about to pour a drink, as shown on similar reliefs. A group of four worshipers—two adults and two children—approaches the heroes from the left, right hands raised in adoration. Like the heroine, they all wear the chiton and himation.

The banquet scene is of Near Eastern origin and can be found in numerous contexts throughout the Mediterranean world. Such reliefs typically show gods or heroes, often along with worshipers, a female companion, a cupbearer, and food offerings (*theoxenia*).[1] Banquet scenes are a common form of votive reliefs for heroes in the fifth and fourth centuries BCE. The reliefs were dedicated to local heroes, whose names are often lost to us but would have been well known to the community that worshiped them in antiquity.[2]

SA

NOTES
1 See Ekroth, above 132–34.

2 For these types of reliefs, see Thönges-Stringaris 1985, 19, 52–54, 60–61; Dentzer 1982.

70. BRONZE MIRROR WITH A WOMAN HOLDING A WREATH AND A GOOSE

Third century BCE
Bronze; diameter 15.2 cm
Baltimore, The Walters Art Museum, 54.1160

PROVENANCE
Lambessis (dealer), by 1929; Henry Walters, 1929;
Walters Art Gallery, by bequest, 1931

SELECTED BIBLIOGRAPHY
Hill 1943

A winged woman (possibly Nike, the goddess of victory) rendered frontally in re-poussé adorns the cover of this large hinged mirror. She moves swiftly to the right as she glances back over her shoulder. In her left hand, she holds a swan or goose close to her body. Her extended right hand holds a wreath. The loose, flowing garment clings to the figure, revealing her body beneath. Such a mirror would have been a suitable offering to a heroine. In vase-painting Helen is frequently shown holding a mirror, an attribute that emphasizes her celebrated beauty; it also appears in vase-painting as an attribute of brides.

HAC

 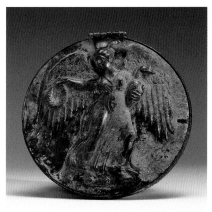

71. STATUETTE OF A HORSE

Arcadian, ca. 750–725 BCE
Bronze; 4.2 × 7 × 1.4 cm
Baltimore, The Walters Art Museum, 54.2401

PROVENANCE
E. S. David, Long Island City, New York, by 1954;
museum purchase, 1954

SELECTED BIBLIOGRAPHY
Hill 1956a; Hill 1956b; Zimmermann 1989, 93

The broad stance, bent rear legs, and extended tail of this miniature bronze horse lend this small sculpture an impression of motion. While the rest of the body is smooth, the horse's mane is indicated by a series of short, incised lines in a chevron pattern; zigzag patterns are inscribed on each cheek. The eyes are deeply recessed and may have once been inlaid with another material. Horse figurines were popular votive offerings, found at almost every known Geometric period sanctuary in Arcadia. The high cost of maintaining horses made them status symbols that indicated the wealth and high social standing of their dedicators.[1]

HAC

NOTE
1 Langdon 1993, 155.

72. TWO CORINTHIAN SKYPHOI

Seventh–sixth century BCE
Left (48.2737): height 3.5 cm, diameter 5.5 cm,
width with handles 8.1 cm
Right (48.2738): height 3.8 cm, diameter 5.9 cm,
width with handles 8.5 cm
Baltimore, The Walters Art Museum, gifts of
Mr. Richard Hubbard Howland, Washington,
D.C., 48.2737, 48.2738

PROVENANCE
Mika Skouze, Athens; given to Richard Hubbard
Howland, Washington, D.C., 1951; gift to the
museum, 1996

COMPARANDA
British School at Athens 1940; Stillwell 1984;
Cook 1997

Each of these two miniature skyphoi, or cups, bears a simple linear decoration in black glaze. These vessels reflect a trend in Corinthian pottery production of miniature vessels that seem to have been created as votives. Their small size precludes any practical function. Numerous examples of two-handled skyphoi and other vessel shapes have been found in a variety of sanctuaries; they played a role in the ritual activity at these sites.

 HAC

73. ARYBALLOS WITH A LION

Corinthian, ca. 625 BCE
Height 6.8 cm, diameter 6.7 cm
Baltimore, The Walters Art Museum, 48.2095

PROVENANCE
E. S. David, by 1957; museum purchase, 1957

SELECTED BIBLIOGRAPHY
Hill 1960

Facing to the right on this small aryballos is a lion in profile, its mouth open, surrounded by rosettes. The lion's facial features, mane and musculature are enhanced by extensive incised details. Aryballoi were used by athletes to hold oil that was rubbed onto the body before exercise or competition.[1] They often appear hanging by a small strap from an athlete's wrist in gymnasium scenes. In addition to this practical function, they were also a popular grave good and would have been a suitable votive offering in a hero sanctuary.[2]

 HAC

NOTES
1 S. Miller 2004, 14–15.
2 Payne 1931b, 290E.

74. HELMETED HEAD OF A SOLDIER

Plastic aryballos
Late sixth century BCE
6.8 × 5.1 × 6.8 cm
Baltimore, The Walters Art Museum, 48.2126

PROVENANCE
From Ephesus or Rhodes (?); Hesperia Art, Philadelphia; museum purchase, 1960

SELECTED BIBLIOGRAPHY
Hill 1961, 44–45; Biers 1984/85, 4–5, fig. 6; Albersmeier 2008, 58–59, no. 15 (A. Kokkinou)

During the Archaic period in particular (although later examples are attested), wine, oil, or perfume containers were given the shape of a human head or more rarely of a human body part or a whole body. The presence of heads of divinities (such as Dionysos and satyrs), of heroes, such as Herakles, or of ordinary women and men reflected the vessel's content and function.[1]

The Walters aryballos, a perfume container, has the form of a warrior's head. The warrior is represented in his maturity, as the presence of a mustache suggests. His wide-open eyes stare out from under his head covering, the Ionian helmet. This type of helmet is not attested in any source other than numerous series of warrior-head vases. Its noteworthy characteristics are the metopon—the semicircular band over the forehead—the separately made cheekpieces, and the unprotected area of the nose.[2]

Warrior-head vases are of eastern Greek origin, possibly manufactured in Ephesus or Rhodes. The vessels were widely distributed in several areas of the Mediterranean.[3] Their function is not known with certainty. Some scholars see them as ritual objects with funerary character—more specifically, as representations of deceased warriors; others posit that they were souvenirs.[4] Their widespread distribution suggests that they may have had different functions. An offering of this kind might emphasize the warrior qualities of the deceased, or it might imply the heroic character of his death.

AK

NOTES
1 Beazley 1929, 38–39. For the plastic vases in general, see Maksimova 1927; Beazley 1929; Ducat 1966; Biers 1980; Kozloff 1980–81.

2 Hill 1961, 45; Ducat 1966, 27–28; Snodgrass 1967, 65–66; Biers 1984/85, 2–3.

3 Ducat 1966, 26–27; Nicholls 1957, 304; Allentown 1979, 134, no. 64 (K. E. Dohan); Biers 1984/85, 5, n. 5.

4 Maksimova 1927, 24; Hill 1961, 44; Ducat 1966, 28–29; Allentown 1979, 134, no. 64.

75. CORINTHIAN HELMET (BELOW LEFT)

700–500 BCE
Bronze; 24.3 × 20.8 × 25.7 cm
Baltimore, The Walters Art Museum, 54.2304

PROVENANCE
E. Segredakis, New York; museum purchase, 1946

SELECT BIBLIOGRAPHY
Hill 1952; Snodgrass 1967 (1999)

76. BRONZE LEFT GREAVE (BELOW RIGHT)

Sixth century BCE
Bronze; 40.5 × 10.5 × 12.5 cm
Baltimore, The Walters Art Museum, 54.2336

PROVENANCE
Joseph Brummer; sale, New York, 1949, pt. 2,
lot 183; museum purchase, 1949

SELECTED BIBLIOGRAPHY
Hill 1952

NOTE
1 Snodgrass 1967 (1999), 58–59.

These two pieces of bronze armor are elements of the hoplite's panoply, which also included a breastplate, shield, spear, and sword. The nose-guard and cheekpieces of the undecorated, crestless Corinthian helmet left only the eyes and mouth of its wearer exposed. The small holes around the edge of the helmet anchored a leather lining that would have been sewn inside the helmet. This was the most common form of helmet among hoplites. The greave, or leg guard, displays repoussé ornamentation consisting of elaborate spirals on the calf and a lion's head on the knee. As with the helmet, the small holes along the perimeter secured a fabric lining. The hoplite's armor signified the social status of its owner, who was required to furnish his weapons at his own expense. It also signaled a citizen's service to the community and would thus have been a source of pride to its owner.[1]

HAC

77. DECREE RELIEF WITH THE HERO HIPPOTHOON (?)

ca. 350–340 BCE
Marble; 40 × 52.5 × 9.5 cm
Staatliche Museen zu Berlin, Antikensammlung,
Sk 808

PROVENANCE
From Athens; museum purchase, 1884

SELECTED BIBLIOGRAPHY
Blümel 1966, 80, no. 93 fig. 127 (K 113); Kron
1976, 186–87, 238, 280–81 no. 4 (= H 17); Meyer
1989, 66, 120–21, 135 n. 904, 139 n. 928, 188–91,
228–29, 290–91, no. A 89, pl. 36,1; *LIMC* 5
(1990), s.v. Hippothoon, 472, no. 20 (U. Kron);
LIMC 6 (1992), s.v. Heros equitans, 1027, no. 42
(A. Cermanovič-Kuzmanovič et al.); Lawton 1995,
145, no. 148, pl. 78

A nude male, a himation draped loosely over his left arm, leads a prancing horse by reins (once painted but now lost) held in his left hand. The figure's nudity, his size relative to the figure before him, and the presence of a horse identify him as a hero. He has a muscular body, cropped hair, and a calm, youthful face. He offers the smaller figure—a worshiper—an object that is not readily identifiable; the remaining traces suggest that it is a wreath. The worshiper raises his right hand in a gesture of adoration. He is bearded and wears only the himation, baring his chest and shoulders. On the far left stands a woman identifiable as a heroine or goddess by the parity between her size and that of the hero. She wears a chiton and a himation, which she has pulled over her head like a veil.

Horses and snakes are classical "hero markers" and often appear alongside heroes. The *hero equitans*, a hero leading or riding a horse, is attested throughout Greece in many variants. This subtle carving is likely the upper portion of a document relief, erected in agoras or other public places to apprise citizens of decrees of the state or smaller governing bodies such as demes and phyles. Every phyle had its own eponymous hero. On the basis of the horse, U. Kron has proposed an identification of the hero as Hippothoon, the son of Poseidon, nursed by a mare, and hero of the phyle Hippothontis. The relief might once have crowned an honorary decree of the tribe.[1] Accordingly, the woman accompanying the hero may be the personification of Eleusis, where the hero's cult was located.[2]

SA

NOTES
1 See Himmelmann-Wildschütz 1968, 632; also
Lawton 1995, 145.
2 Meyer 1989, 194.

78. WOMAN SACRIFICING / THREE MEN AND A YOUTH COURTING WOMEN

Attic red-figure kylix
Attributed to Makron (painter) and Hieron (potter), ca. 490–480 BCE
Height 11 cm, diameter of rim 29 cm, width with handles 36 cm, diameter of foot 10.5 cm
Toledo, Ohio, Toledo Museum of Art, Purchased with funds from the Libbey Endowment, Gift of Edward Drummond Libbey, 1972.55

PROVENANCE
Nicolas Koutoulakis, Geneva; museum purchase, 1972

SELECTED BIBLIOGRAPHY
CVA Toledo, fasc. 1 (1976), pls. 53, 54; Keuls 1983, 225–26, fig. 14.23a–b; Keuls 1985, 167–68, 223, figs. 141, 142, 204; Meyer 1988, 89 n. 13, 105–6, 124; Beard 1991, 28–30, figs. 7–8; Reeder 1995, 183–87 (cat. 38); Reden 1995, 208, pl. 5a–c; Roccos 1995, 647, fig. 2; Kunisch 1997, 179, pl. 64; Neils 2000, 216 (no. 47), 218, fig. 8.7; Dillon 2002, 39, 40, 307 n. 18, fig. 2.1; Rosenzweig 2003, 75, 76, 77, 131, fig. 63a–c; Connelly 2007, 15–16, 112, 228 n. 78, fig. 1.2, frontispiece; Toledo 2009, 73

The center of this cup depicts a dignified woman pouring a libation. She is shown with ritual equipment—altar with blood and burning sacrifice, oinochoe (wine jug), kanoun (basket to hold offerings and the knife used to kill the sacrificial animal), and thymiaterion (incense burner). She is expensively dressed in a chiton under a voluminous festival mantle.[1] On the exterior is painted a gathering that, to our eyes, could not look more unlike the pious ceremony in the tondo. Four men court four hetairai (female prostitutes, literally "companions") with gifts of flowers, ribbons, and money-bags. The women hold up the conversations with bantering gestures and music (aulos). The hetairai are as fully clothed as the woman in the tondo, but their cloaks and chitons slide as their attention wanders.

Who is the elegant woman in the tondo and what goddess or heroine is she worshiping? First, she might be a "self-sacrificing" goddess, but there is no divine attribute or name.[2] Second, she might be a priestess, either a mythical woman or a real one.[3] In Athens public priesthoods for men and women were part-time activities, not vocations. The path to becoming a priestess was based on a woman's family and wealth, which enabled her to be chosen as well as to serve.[4] It has been suggested that the contrast with the exterior is ironic social commentary.[5] Scenes painted on the underside of a kylix could be viewed by fellow diners and when the empty cup was hung from a peg, but the inside decoration was revealed to the drinker only as the red wine was drained. The juxtaposition of women of two societal worlds—party girls and a woman of a respectable family—could have been amusing.

Third, the woman might be an hetaira, perhaps even one of the women on the exterior.[6] Athenian male citizens of the Archaic and Classical periods moved freely between their households and the vibrant political, social, and commercial life of the city. An hetaira could be a prosperous businesswoman, a taxpayer, and the educated and influential companion of important men. Makron may be painting the complex world of such a woman, grateful for the blessings of Aphrodite, but in a different way than a citizen's mother, wife, or daughter. The visual message, to the men and women drinking from this cup in this woman's house, would be discreetly self-assured.

SK

NOTES

1 Roccos 1995, 646–51.

2 Connelly 2007, 104–15.

3 Reeder 1995, 185–87, suggests she is a kanephoros (basket-carrier), an adolescent unmarried Athenian maiden of good family, honored with the privilege of carrying the ritual basket in public procession. Connelly 2007 points out that the woman is not shown with a sanctuary key that would confirm religious office (16), that not all basket carriers are kanephoroi (33–39), and that the woman is making a libation onto a burning sacrifice (176).

4 Sourvinou-Inwood 1995, 114; Connelly 2007, 28–29, 166–67.

5 Reeder 1995, 187.

6 Keuls 1985, 167–68; Neils 2000, 217–18; Rosenzweig 2003, 75–77.

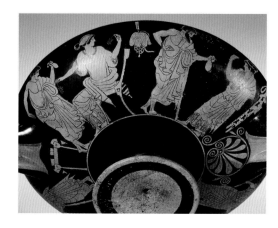

EMULATION

Heroes and heroines were inherently human; as such, they were models of behavior for the ancient Greeks. As Michael J. Anderson points out (144–173), they taught by example that rewards granted by the gods had to be earned. Heroes faced both physical obstacles and ethical challenges, which they had to overcome in order to succeed, and epics and local hero cults offered the ancient Greeks a large variety of heroes and heroines that guided them in all kinds of situations and enabled them to recognize and distinguish heroic and unheroic behavior. This section highlights several social cohorts for whom heroes and heroines served as models of behavior and by which they measured their achievements.

Like Achilles, a Greek soldier knew he had to risk his life for honor and glory. In the arts, every step of his journey is documented: he receives the armor, he girds for war, he bids farewell to his family, he fights in battle, and he returns in glory or dies heroically. The subject of the scene is often deliberately ambiguous—is the warrior depicted a hero or an ordinary mortal?—but the similarity of the visual repertoire would have encouraged identification with the hero. The popularity of these scenes also raises the possibility that they functioned in private homes in ways similar to photographs and videos today, honoring the heroic dead and commemorating those who will not return.

The strength and prowess of Herakles was a paradigm for Greek athletes in training and competition. Athletic training was an integral part of the education of Greek male youths as preparation for military service; many competed in games held all over Greece, which included demonstrations of musical ability. The games themselves were often heroic in origin: many were founded as funerary games or in honor of a local hero such as Opheltes in Nemea or Pelops in Olympia. Helen, though an ambiguous heroine, was revered for her remarkable beauty and divine birth, and she was emulated especially by brides in wedding scenes.

With the rise of the Hellenistic age, Alexander the Great and his successors appropriated Greek heroes for their own veneration and propaganda. Alexander likened himself to Achilles and Herakles, and various types of heroic representations were developed for the Hellenistic rulers based on existing models.

SA

79. WOMAN GIVING ARMOR TO A WARRIOR

Attic red-figure calyx-krater
Attributed to the Altamura Painter, 470–460 BCE
Height 35.9 cm, diameter 35.8 cm
Baltimore, The Walters Art Museum, 48.262

PROVENANCE
Thomas B. Clarke, New York, by 1924/25; sale, American Art Gallery, New York, January 7–10, 1925, no. 625; Henry Walters, 1925; Walters Art Gallery, by bequest, 1931

SELECTED BIBLIOGRAPHY
ARV² 591, no. 25; Hill 1946; Hill 1951; *CVA* Baltimore, Walters Art Gallery, fasc. 1 (1992), 16–17, fig. 4.4, pl. 20.1–4; Pantel 1992, 175; Prange 1989, A 34

This calyx-krater is sparsely but elegantly decorated, with two figures on one side and a single figure on the other. Its decorative elements consist of a band of lotus blossoms alternating with palmettes along the lip and a meander pattern below the figural scene.

On the main side of the vase, a young man on the left with a broad ribbon around his head holds a spear in his right hand and wears a cuirass decorated with stars over a short chiton. Raising his right arm, he looks over his left shoulder toward a long-haired woman dressed in a long chiton and mantle. She wears a necklace, earrings, and a diadem and presents the warrior with his armor. With her extended right hand, she offers him a helmet, while she holds a large shield with a snake device on her left side. Between them is an altar with volutes and decorative molding.

On the opposite side of the vase, a bearded man dressed in a mantle leans on a staff. He faces right, with his right arm resting on his hip, and his left arm gestures outward, as if addressing the young warrior on the other side of the vase.

Departure scenes of warriors sometimes include offerings to the gods asking for a good campaign and a safe return of the soldier to his family. Although the actual offering (normally a libation) is not represented here, the altar clearly alludes to this aspect of the preparation for battle. The presentation of armor to the young soldier has a mythical counterpart in the story of Achilles and his mother, Thetis, who gave the hero his famous set of weapons and armor.

JHC

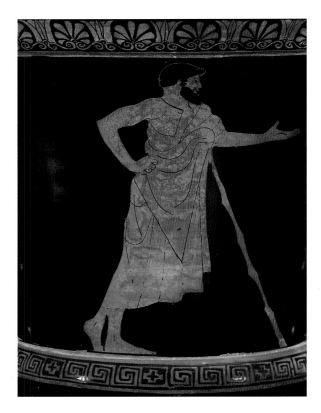

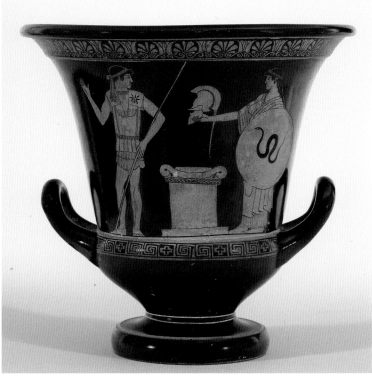

80. A WARRIOR PUTTING ON HIS ARMOR

Attic white-ground lekythos
Attributed to the Bowdoin Painter, ca. 480 BCE
Height 30 cm
Athens, National Archaeological Museum, 1964

PROVENANCE
From Eretria

SELECTED BIBLIOGRAPHY
CVA Athens, National Museum, fasc. 1 (1932),
33:1.5; Haspels 1936, 73; *ARV* 687, 218; Kaltsas
2006, 195

Rendered in profile facing right, a youthful warrior, wearing a short chiton and breast-plate, bends slightly at the waist to strap the greave he holds in both hands to his leg. He is beardless, and his curly dark hair is visible beneath his tall crested Corinthian helmet. Hanging on the wall just in front of his head is a sword. His spear and shield rest on the ground before him. The top of the scene is bordered by a meander pattern, broken by the helmet's crest and the spear. A row of black palmettes adorns the shoulder of the vase.

The armor represented is the typical weaponry of the Athenian hoplite, or foot soldier, of the late sixth century BCE. The hoplite phalanx formation obligated soldiers to rely on one another for protection, since each man's shield also guarded the soldier to his left. A celebrated example of soldiers pledging to maintain this cohesion is found in the Oath of Plateia, sworn before the battle of 479 BCE that ended the Persian wars, in which the soldiers vowed never to abandon their comrades, living or dead.[1]

HAC

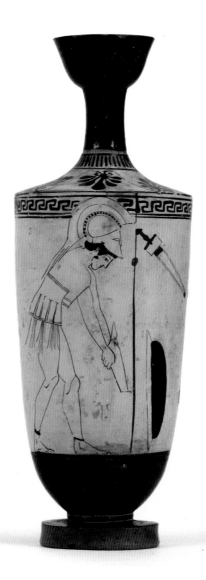

NOTE
1 Kaltsas 2006, 195.

81. A WARRIOR DEPARTING FOR WAR

Attic black-figure amphora
ca. 530–520 BCE
Height 34.5 cm, diameter 24.2 cm, width with
handles 23.7 cm
Baltimore, The Walters Art Museum, 48.224

PROVENANCE
Arthur Sambon, Paris, by 1926; Henry Walters,
1926; Walters Art Gallery, by bequest, 1931

SELECTED BIBLIOGRAPHY
Moore 1971, 78–79, 301, 306, no. A 507 bis,
pl. 39a–b

COMPARANDA
Lissarrague 1989; Shapiro 1990; Matheson 2005

NOTES
1 Shapiro 1990, 120–21.
2 Matheson 2005, 26.

On one side of this black-figure amphora, a bearded man in a short chiton is mounting a chariot while grasping the reins of four horses. Though he has no shield or helmet, his sheathed sword and spear identify him as a warrior. In front of the chariot, another bearded man holding a staff in his right hand sits on a diphros. Behind the horses stands Athena, who turns her head toward the charioteer and holds a spear in her right hand. She wears a long, patterned peplos, a snaky aegis, and a high-crested helmet.

The scene on the opposite side depicts a helmeted warrior, carrying a spear and shield and flanked by two mounted horsemen. Below the figural scene are three bands of a meander pattern, a lotus-bud chain, and black rays. Palmettes adorn the neck and the area below the handles.

The main side of the vase depicts a departure scene, in which the warrior prepares himself to enter the battlefield—a popular motif in Athenian vase-painting. The scenes vary in their iconography; some include family members offering armor, libations, and farewell gestures.[1] In black-figure examples of this motif, figures are sometimes labeled with the names of epic heroes.[2] On this vase, there are no inscriptions to identify the figures, allowing the viewer to draw comparisons between contemporary warriors and their heroic prototypes. Scenes of warriors departing tend to focus on the soldier taking leave of his family and frequently depict the soldier's father and wife or mother. The presence of Athena in this scene may refer to epic or may indicate that the warrior is protected by this armed goddess.

HAC

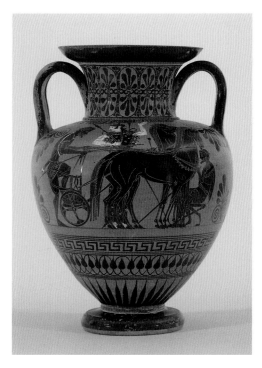

82. DUELING WARRIORS

Attic black-figure mastos
ca. 530 BCE
Height 9.3 cm, diameter of mouth 13.2 cm,
width with handles 18.2 cm
Baltimore, The Walters Art Museum, 48.223

PROVENANCE
From Vulci; Dikran Kelekian, New York/Paris;
Henry Walters, 1924; Walters Art Gallery, 1931,
by bequest

SELECTED BIBLIOGRAPHY
Hill 1946, fig. 3; Greifenhagen 1977; Albersmeier
2008, 52–53, no. 12 (A. Kokkinou)

The striking conical shape of the mastos, terminating at its base in an articulated nipple, imitates the female breast. Three thin lines at the lip and a row of black dots at the bottom frame the scenes. Beneath the row of dots is a tongue pattern of alternating purple and black.

A pair of warriors on one side of this cup engages in face-to-face combat, each holding his spear overhead in preparation to strike. The man on the left is naked except for greaves and a helmet. The bottom half of his body is rendered in profile, the top half frontally. His left arm bears a large shield, rendered so that we can see the straps that secure it to his arm. His opponent wears a short chiton, a crested helmet, greaves, and a sword strapped across his chest. An incised rosette ornaments his shield. On the opposite side are three similarly clad warriors in an analogous composition, their shields recalling those of the figures on the reverse. Two men with raised spears close in on the third warrior, who appears to lunge between the dueling pair. His helmet with a raised crest and his lack of a spear distinguish him visually from the other warriors. On each side, the sets of fighting men are flanked by men in long mantles holding staffs. A Siren fills the transitional space between the two scenes, beneath the horizontal handle.

Dueling warriors were a popular subject in Archaic vase painting. Such scenes probably depict heroic warriors from an earlier age, since hoplite warfare, which relied on large phalanxes of warriors, was the preferred mode of fighting during the period when these scenes were painted. The playful juxtaposition of male iconography with the female form of the cup may reflect a deliberate attempt to encourage the cup's user to contemplate gender, a popular topic in the symposium setting.

HAC

83. HERAKLES AND THE NEMEAN LION / WARRIORS

Attic black-figure volute-krater
ca. 525–500 BCE
Height with handles 58.5 cm, diameter 43 cm,
width with handles 52 cm
Baltimore, The Walters Art Museum, 48.29

PROVENANCE

Don Marcello Massarenti, Rome; Henry Walters,
1902; Walters Art Gallery, by bequest, 1931

SELECTED BIBLIOGRAPHY

Massarenti 1897, 2:45 (no. 29); Hill 1947, 255, pl. 61;
Brommer 1973, 118, no. 14

Beneath the meander-adorned rim of this large volute-krater is a band of figural decoration interrupted by the handles on each side. At the center of the scene on one side is a trio of warriors, each wearing a short chiton and a full panoply of armor. The central figure lunges deeply to the right as he looks back at the soldier behind him. The figure on the left prepares to plunge his raised spear into the central warrior. The third soldier, on the right, also wields a spear in his upraised right hand, poised to strike. Flanking this central pair are two women in long, decorated garments. Each raises her hands, as if to address the men or express alarm. Behind the woman on the right is a horse and young man, perhaps a groom. Beyond them are four more figures, including a naked youth with a mantle, two men with staffs, and another fully armed warrior. To the left of the central scene, behind the woman, an armed warrior mounts a chariot, as if ready to flee from the fighting. A man seated in front of the horses interrupts the sense of motion evoked by the charioteer. The two figures behind the seated man resemble those at the other end of the scene: a naked youth wearing a mantle and holding a staff or spear and a standing man in long robes with a staff.

Reminiscent of the central trio of warriors, three figures occupy the center of the scene on the opposite side, in a representation of Herakles wrestling the Nemean lion, with a youth, perhaps Iolaos, at hand offering support as he holds the hero's club. As with the composition on the other side, the figures are flanked by two female figures—a seated Athena on the right and a woman fleeing on the left. Further connecting the scenes is the depiction of charioteers mounting their chariots, which once again face seated men with staffs. A standing man with a staff frames the scene at either end.

Warriors figure prominently on both sides of this vase, which appears to celebrate the physical prowess of the central figures. The scenes highlight conduct in war and wrestling, two activities in which male citizens would have been trained and encouraged to emulate their heroic prototypes.

HAC

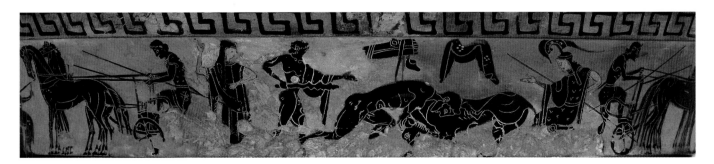

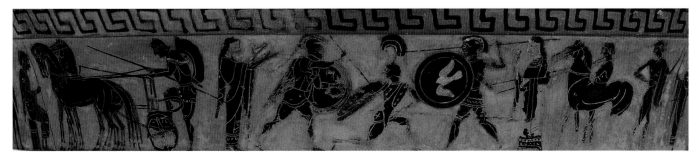

84. BATTLE SCENE

Campanian (South Italian) red-figure neck-amphora, with traces of gilding
Attributed to the Ixion Painter, ca. 330–310 BCE
Height (restored) 67 cm, diameter 23.1 cm
Los Angeles County Museum of Art, William Randolph Hearst Collection, 50.8.16

PROVENANCE
Said to be from Polignano; Giovanni Caraffa, duke of Noia (Naples, 1760s or earlier); Museum of Capodimonte; James Edwards; Thomas Hope; Henry Francis Hope Pelham Clinton; sale, Christie's London, July 23, 1917, no. 119; Viscount Cowdray; sale, Sotheby's London, December 2, 1946, no. 66; gift of William Randolph Hearst, 1950

SELECTED BIBLIOGRAPHY
Tillyard 1923, 146–49, no. 283, pl. 34, 39; Beazley 1943, 94, no. 9; Clement 1955, 21, no. 28, pls. 11a–c; Trendall 1967, 335, 337, 339, no. 799; *CVA LACMA* fasc. 1 (1977), 50–52, pls. 46, 47; Levkoff 2008, 220–21, no. 105 (A. J. Clark)

Side A of this vessel shows an unusually elaborate battle scene involving fifteen warriors fighting over the body of a fallen soldier in the center. The battle is divided among three horizontal registers. On the upper register, two warriors on the left face three on the right, each wearing a helmet and a chlamys and wielding spears and shields. In the middle, the scene is framed by two archers on either side, while a warrior in the middle, wielding an axe, is about to strike another, who is already on the ground and pleadingly raises his hand toward the aggressor. Like the archers, they wear helmets, chitons, chlamydes, and body armor but do not carry shields. A fifth warrior is trying to retrieve the body of the fallen soldier. The lower register is dominated by the warrior at the center struck by arrows, possibly from an archer on the right. He is kneeling on a rock and defends himself with a spear. Behind him, two soldiers are fighting with spears and shields. The scene likely depicts a major epic battle, perhaps (as already Johann Joachim Winckelmann suggested) the fight to recover Patroklos's body—one of the key episodes in the *Iliad*.

On side B, Eros hovers above an elegantly dressed group comprising a young man and two women. Two more women on each side are observing the scene in the middle, which has been interpreted as a wedding. The decoration on the neck is mostly destroyed: the remains of a woman facing a man in armor are discernible on the front, while palmettes adorn the back.

SA

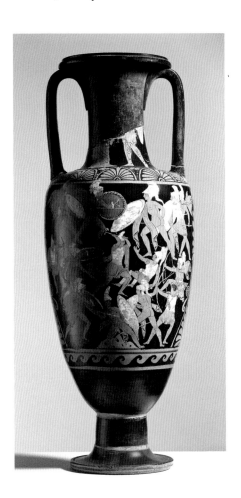

85. STELE BASE

Athenian, ca. 400–390 BCE
Pentelic marble; 67 × 61 × 58 cm
Athens, National Archaeological Museum, 3708

PROVENANCE
Discovered in Athens, near the Academy

SELECTED BIBLIOGRAPHY
Payne 1931a, 186–87, fig. 4; Richter 1959, 242,
pls. 52.6, 52.7; Langenfaß-Vuduroglu 1973, 12,
19–20, no. 15; Stupperich 1977, 162, 178, no. 151;
Kaltsas 2002, 171, no. 337

This richly decorated base was probably part of an expensive funerary monument. It would have originally supported a stele, as the opening on its upper surface suggests. The base is decorated only on its front and sides; the back would not have been visible in the monument's original location.[1]

The decorated areas show similar battle scenes, capturing the moment of victory in three combats. On the front, a rider dressed in chitoniskos and mantle, with a petasos on his head, is attacking a fallen soldier. On the left side, another rider wearing a petasos has brought his hoplite opponent to his knees. He is nude, seen from the back, with his helmet thrown down, using his shield to protect himself from the horses' hooves. On the right panel, a bearded hoplite with shield and sword, fallen on the ground, bends his head in defeat.

Riders appear in other Attic grave monuments of the Classical period, one of which was commissioned by the Athenian state to honor citizens who died heroically in battle.[2] The persons buried in such monuments would have been members of the hippeis, the cavalry, which at Athens constituted a wealthy aristocracy. The selection of a battle scene for the decoration of a grave monument commemorates the deceased as a hero, emphasizing his courage, his skills, and his superiority over his enemies. At the same time, it indirectly promotes his social class and his city.[3]

AK

NOTES
1 Kaltsas 2002, 171, no. 337.
2 Athens, National Archaeological Museum, no. 2744; see Langenfaß-Vuduroglu 1973, 11, 18–19, no. 13; Kaltsas 2002, 159, no. 313.
3 Langenfaß-Vuduroglu 1973, 10–24, nos. 10–21; Spivey 1996, 117–22.

86. HEAD OF A STRATEGOS

Athenian, ca. 430 BCE
Marble; height 54 cm
Staatliche Museen zu Berlin, Antikensammlung,
Sk 311

PROVENANCE
Cardinal Melchior de Polignac, Paris; bought
by Friedrich II (the Great) in 1742, formerly at
Sanssouci, Potsdam

SELECTED BIBLIOGRAPHY
Conze 1891, 130, no. 311

This head of Parian marble was once attached to an inscribed herm, which would likely have recorded the identity of its subject. The end of the nose has been restored; the polished finish of the face is modern. The head is turned sharply to the right. Longish, wavy locks of hair are parted over the forehead. The beard of short, curly locks was rendered with a drill. The symmetry and tidy organization of the hair and beard are typical of the Classical period.

The head depicts an Attic general, or strategos. The Athenians elected ten strategoi annually to serve one-year terms as leaders of the Athenian army, a position of high status that warranted commemoration with a portrait. Like the victorious athlete, the strategos embodied a venerable aspect of the hero, that of a warrior.

The Berlin head is reminiscent of the well-known fifth-century portraits of Perikles, the most famous Athenian strategos. In the absence of an inscription, this portrait head cannot be identified with a specific individual. Portraiture of the Classical period did not aspire to replicate an individual's specific features; rather, portraits commemorated their subject's role in public life and represented stock types: athletes, orators, and military leaders. Here the position of strategos is clearly signaled by the subject's Corinthian helmet, much as an attribute communicates the subject's identity in depictions of mythic heroes.

AS

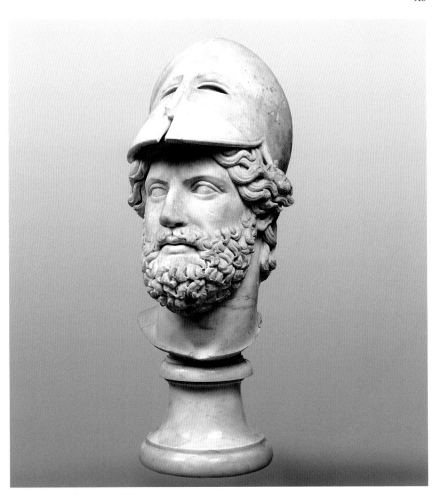

87. WARRIORS (BELOW LEFT)

Black-figure kyathos
ca. 510 BCE
Height with handle 14.4 cm, height at rim
8.1 cm, diameter of rim 10.4 cm, width with
handle 13.6 cm
Baltimore, The Walters Art Museum, 48.219

PROVENANCE
Ercole Canessa; sale, Galerie Georges Petit, 1921,
no. 36; sale, American Art Galleries, 1924, no. 52;
Dikran Kelekian, New York/Paris, by 1924; Henry
Walters, by 1931; Walters Art Gallery, by bequest, 1931

88. RUNNING WARRIOR (BELOW RIGHT)

Attic red-figure kylix
Attributed to the Colmar Painter, ca. 510 BCE
Height with handles 12.7 cm, height at rim
12 cm, diameter of rim 31.3 cm; width with
handles 39.8 cm
Baltimore, The Walters Art Museum, 48.1920

PROVENANCE
Somzée collection, Brussels; sale, May 20–25, 1901,
no. 36; sale, Hôtel Drouot, 1910, no. 146; Jerome
Stonborough, by 1940; sale, Parke-Bernet Galleries,
October 18, 1940, no. 82; Charles L. Morley, New
York; 1940; museum purchase, 1945

SELECTED BIBLIOGRAPHY
Furtwängler 1897, pl. 37, row 3, no. 2; Hill 1945; Hill
1959b, 3; Buitron 1977, fig. 7; *ARV*² 356, 61; *CVA*
Baltimore, Walters Art Gallery, fasc. 1 (1992), 43,
pl. 45.1–2, fig. 13.3

The tondo of the kylix shows a youthful warrior with long curly hair. He is nude except for his Attic helmet and holds a spear and a large round shield decorated with a horse, of which only the back is visible. He seems to be running from an enemy on the left: his head, shield, and spear are turned backward (left), while he is fleeing in the opposite direction. The artist skillfully explores the various angles of the twisted body and fits it nicely into the circular shape of the tondo. The inscription in red reads ΗΟ ΠΑΙΣ ΚΑΛΟΣ (the boy is beautiful).

The kyathos depicts a characteristic battle scene: two warriors or heroes fighting over a fallen soldier. Two bearded soldiers attack each other with raised spears and large shields decorated with white motifs and red rims. Their swords hang sheathed at their sides. The warrior on the left has knocked his opponent's helmet off his head, while his opponent's spear is pointing at his throat. In between, a third warrior has collapsed on his right knee and uses his spear and shield for support. Unlike the standing fighters in their short kilts, he wears a short white garment belted with a bow. On either side of this central scene, a warrior with a shield is driving to the right in a quadriga (a four-horse chariot).

Without identifying attributes or inscriptions, the warriors depicted could be ordinary soldiers in battle or Greek heroes fighting at Troy. The scene of two warriors fighting over the body of a fallen soldier is a familiar episode from accounts of the Trojan War; the recovery of the body and the armor of a dead comrade was crucial. Even if the warriors depicted on these vessels are ordinary Greeks, the imagery recalls the glory of the heroic warriors of the past.

SA

89. RIDERS COMPETING IN A HORSE RACE

Black-figure pseudo-Panathenaic amphora
Attributed to the Vatican G 23 Group, ca. 500–480 BCE
Height 41 cm, diameter 26.4 cm
Baltimore, The Walters Art Museum, 48.2105

PROVENANCE
St. Audries collection; sale, Sotheby's, February 23, 1920, no. 230; William Randolph Hearst, San Simeon; museum purchase, 1958

SELECTED BIBLIOGRAPHY
Hill 1959a, 181, no. 1, pls. 47.1, 47.2; C. Vermeule and Bothmer 1959, 151, no. 230; Beazley 1971, 176; Maul-Mandelartz 1990, 117, 260, pl. 30, no. PF 1; Bentz and Eschbach 2001, 184, Appendix 1, no. 146

On side A, Athena is striding to the left with a spear in her raised left hand and in her right a shield with a large snake, a popular shield device on Panathenaic vases of the late Archaic period. She is wearing a patterned garment, a high-crested helmet, and the aegis, from which several snake heads clearly emerge. Two thin columns crowned by roosters frame the scene.

The reverse shows two young jockeys in high gallop in the heat of the race. Both boys are nude and ride without saddles or stirrups, guiding their horses with their reins. The rider in the back is using the whip in his raised right hand to gain some ground on his opponent. The focus is clearly on the rider on the left, whose horse occupies the composition's foreground, its head partially obscuring the other rider. The prominence of the horse and rider, captured at a decisive moment in the race, may signal the contest's victor.

The amphora lacks the prize inscription on the front that is characteristic of small-scale copies, created for the trade and as commemorative souvenirs, of the Panathenaic prize amphoras (see also nos. 90, 96).[1] Dorothy Hill noted that the piece is stylistically and thematically close to the work of the Eucharides Painter, who painted at least three full-scale Panathenaic prize amphoras depicting two riders competing.[2]

SA

NOTES
1 For pseudo-Panathenaic prize amphoras, see Bentz 1998, 19–22.
2 See Maul-Mandelartz 1990, 105, nos. P 1–3: Toronto, Royal Ontario Museum, inv. 919.5.148; New York, The Metropolitan Museum of Art, 56.171.3 (also from the Hearst collection); London, British Museum, inv. 1836.2-24.193. An additional fragment is in Munich, Antikensammlung, inv. 8746.

90. ATHLETES

Black-figure pseudo-Panathenaic amphora
Attributed to the Vatican G 23 Group, ca. 500–
485 BCE
Height 38.1 cm, diameter 23.5 cm
Baltimore, The Walters Art Museum, 48.2109

PROVENANCE
Reportedly found in Rhodes; Sir Herman Weber;
sale, Sotheby's London, May 22–23, 1919; William
Randolph Hearst, San Simeon; sale, May 1958,
no. 5494; museum purchase, 1958

SELECTED BIBLIOGRAPHY
ABV 406; Hill 1959a, 182; Bentz and Eschbach
2001, 184, no. 148

Athena, striding in the *promachos* position, faces left, holding a round shield with the device of a boar's head and foreparts in her right hand and a spear in her left; she wears a helmet and a scaly aegis. She is flanked by two Doric columns, each topped by a rooster.

On the reverse, a discus thrower occupies the center of the composition, flanked by a trainer and another athlete. The trainer, draped in a mantle, stands on the left, looking to the right and holding a staff in his right hand and slightly raising the other. The athlete in the middle also faces right, holding the discus in his right hand, with his left hand poised high above his shoulder. The third athlete, holding a staff, looks left, while his body turns to the right. The centrality of the discus thrower suggests that the amphora was a prize in the discus competition or in the pentathlon.

Decorated amphoras were given as prizes in the Panathenaic games, held in Athens every four years as part of the festival of the Great Panathenaia. These were huge vessels, containing about forty liters (a little more than ten gallons) of oil, pressed from the olives of Athena's sacred groves. The vases usually portray or allude to the competition for which the vase was the prize on one side and depict Athena striding on the other side. The various images of the goddess are distinguished mainly by the folds and the pattern of her garments, by the device on her round shield, and by the creatures standing on the columns that usually flank her. Panathenaic amphoras continued to be painted in black-figure even after the adoption of red-figure as the preferred technique in vase-painting. Smaller versions, such as this example, were commemorative objects.

SS

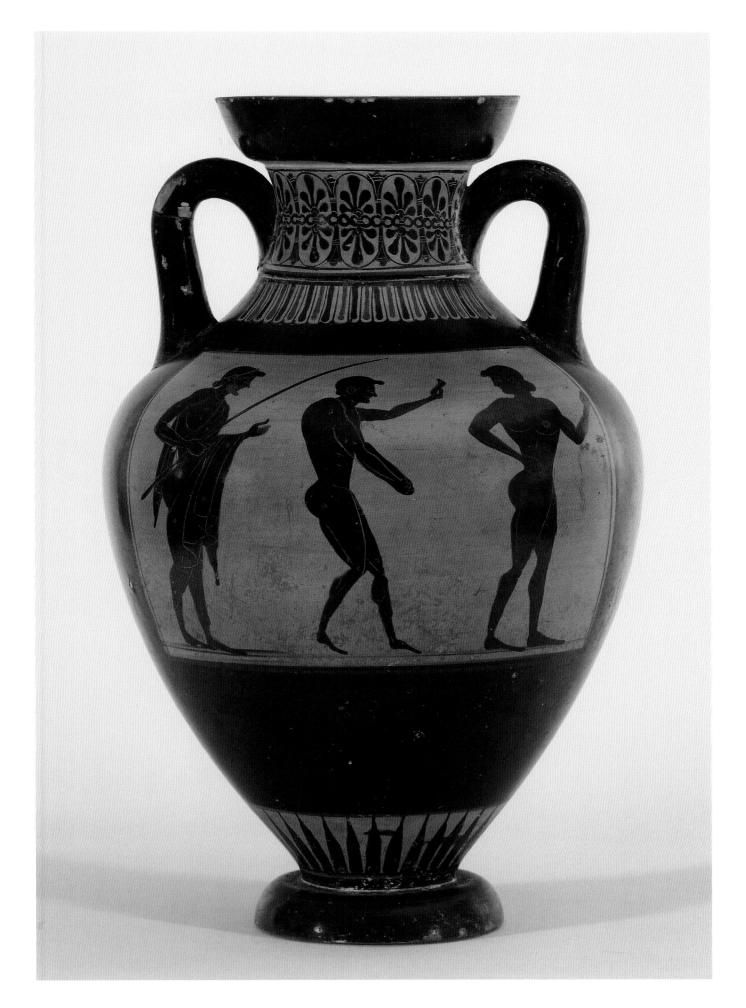

91. PENTATHLETE

First century BCE
Bronze; 17.7 × 6 × 4.1 cm
Baltimore, The Walters Art Museum, 54.699

PROVENANCE
Reportedly from Egypt; Dikran Kelekian, New
York/Paris, before 1931; Henry Walters, by 1931;
Walters Art Gallery, by bequest, 1931

SELECTED BIBLIOGRAPHY
Reinach 1924, 291, no. 7; Hill 1949, 82, no. 176,
pl. 35; Reeder 1988, 166, no. 745; Vanhove 1992,
241–42, no. 105; Albersmeier 2008, 157–59, no. 57
(S. Albersmeier)

Athletes such as boxers and wrestlers were popular subjects in bronze during the Hellenistic period. This nude athlete stands in contrapposto with the weight on his right leg. His head, which is turned to the left and faces slightly downward, seems disproportionately small. The figure holds his left arm loosely at his side, while his right arm is bent at a right angle at the elbow. The missing attribute in the right hand can be identified by the traces and through parallels as a discus, which the athlete grasped with four fingers while it lay flat on the lower arm, resting at the crook of the elbow. It identifies him as a pentathlete, so named for the five contests that the pentathlon comprised: track, discus and javelin throw, long jump, and wrestling. The figure's left hand likely originally held a javelin.

The presumed presence of two different pieces of equipment makes it likely that the athlete is not shown competing but exercising, as many depictions show pentathletes carrying their equipment during training sessions. This is further supported by the tight cap that the figure is wearing, which covers his hair. Vases show athletes in training wearing such caps, with distinct rims over the forehead and at the nape of the neck and fastened with straps tied under the chin.[1] The caps (possibly made of leather) were likely worn for protection during training.

SA

NOTE
1 See, for example, Vanhove 1992, 205, no. 67; 260,
no. 123a; 278, no. 140; S. Miller 2004, 17, 19, fig. 20; 66,
fig. 122; 73, fig. 141; Swaddling 2004, 73.

92. WRESTLERS

Second–first century BCE
Bronze, solid cast; 15.2 × 7.4 × 8.1 cm
Baltimore, The Walters Art Museum, 54.742

PROVENANCE
Henry Walters, possibly purchased from J. Brummer in 1931; Walters Art Gallery, by bequest, 1931

SELECTED BIBLIOGRAPHY
Hill 1949, 67, no. 141, pl. 30; Bieber 1955, 151, fig. 644; Brommer 1971, 25, no. 1; Havelock 1970, 147–48, no. 144; *LIMC* I (1981), s.v. Antaios 1, 809, no. 77a (R. Olmos and L. J. Balmaseda); Reeder 1988, 153–54, no. 64; Vanhove 1992, 338–40, no. 206 (M. Devillers)

Two wrestlers are engaged in fierce combat. One is striding to the right and has seized his opponent by the waist to lift him from the ground, using a hold called *meson labein* or *meson echein*, "to grab the middle" or "to have the middle."[1] The opponent is trying to pry the other's fingers loose with both hands. Both his legs are up in the air, either kicking at the legs of the standing wrestler to put him off balance or to prevent being thrown to the ground, which would end the round. The standing athlete has the clear advantage at this moment. Both athletes face downward and to the right, their faces mirroring their concentration, effort, and pain.

Wrestling was one of the most popular athletic competitions, added to the Olympic program in 708 BCE as both an independent event and part of the pentathlon. The first wrestler thrown to the ground three times lost the contest.[2] Wrestling groups were a popular subject among Hellenistic artists, providing an opportunity to explore multiple viewpoints, angles, and interactions. In some cases, it is difficult to discern whether the wrestlers depicted are ordinary athletes or Herakles and Antaios. In this case, the hair of the wrestlers is arranged in long braids and pulled up in a knot on the back of the head, which was a typical hairstyle for professional wrestlers. However, the act of lifting the opponent from the ground is taken directly from the myth of Herakles and Antaios, in which the hero had to disengage the giant from his mother, Earth, or Gaia, in order to defeat him.[3]

SA

NOTES
1 S. Miller 2004, 48.

2 On wrestling, see, for example, S. Miller 2004, 46–50.

3 For Herakles, Antaios, and wrestling groups, see V. Brinkmann, in Wünsche 2003, 178–83.

93. TORSO OF THE DIADOUMENOS

Roman copy after an original by Polykleitos,
ca. 430 BCE
Marble; 92.4 × 49.8 × 34.6 cm
Baltimore, The Walters Art Museum, 23.224

PROVENANCE
Villa Borghese, Rome (?); Stefano Bardini, Flor-
ence, by 1895; sale, American Art Association, New
York, April 1918, no. 427; William Boyce Thompson
(d. 1930); Elizabeth Seton College, New York, by
bequest, 1945; Mr. and Mrs. James E. lePere, New
York, by 1968; museum purchase, 1968

SELECTED BIBLIOGRAPHY
Hill 1970, 21–24; Hill 1968a, 1–2; Albersmeier
2008, 116–21, no. 38 (A. Surtees)

This torso is broken at the neck and across the thighs. The lower left side, the left leg, and the right leg are modern restorations. The dimensions of the torso match those of multiple marble copies of the statue-type, called the Diadoumenos, some of which exist as complete statues. The statue was also copied in small bronzes, in terracotta, and on gems.[1] These various images enable us to reconstruct the pose of the Walters torso.

The figure stands with its weight on the right leg, the left leg relaxed and extended slightly back. The raised right hip and lowered right shoulder of the torso attest to this weight distribution, which is a typical example of the classical contrapposto, contrasting tension and relaxation. The head looks down and to the right, toward the weight-bearing leg. Both arms reach up toward the head. Each hand holds the end of a fillet, or band, being wrapped around the head. The name of the statue refers to this binding action performed by the athlete in preparation for competition.

The musculature and proportions are typical of statues of athletes in the fifth century BCE, as canonized by Polykleitos, the sculptor of the original work according to literary sources.[2] Athletes before, during, and after competition were a common theme in sculpture of the fifth and fourth centuries BCE in particular. In addition to the Diadoumenos, statues show an athlete crowning himself, throwing a discus, preparing to oil his skin before a contest, and scraping oil off afterward. Many of these statues were set up as victory monuments or dedications following a victory. The right to dedicate a statue in an important sanctuary was one of the special privileges awarded to an athletic champion, indicating the high status of victorious athletes in society.

AS

NOTES
1 Hill 1970, 22 n. 4.
2 Pliny, *Natural History* 34.55.

94. CHILD BOXER

Third–second century BCE
Bronze; 8.5 × 4 × 2.2 cm
Baltimore, The Walters Art Museum, 54.1001

PROVENANCE
Reportedly from Alexandria; Madame E. Warneck
Collection, by 1905; sale, Paris, Hôtel Drouot, 1905,
no. 152; Dikran Kelekian, New York/Paris; Henry
Walters, by 1931; Walters Art Gallery, 1931, by
bequest

SELECTED BIBLIOGRAPHY
Hill 1948; Hill 1949, 74, no. 157, pl. 34; Reeder 1988,
137, no. 52

This small bronze represents a male child as a boxer. He stands facing forward, his short hair bound with a ribbon. The child's arms rest at his sides, and he stands in a contrapposto pose, his weight shifted onto his right leg and his left leg relaxed. His feet are planted firmly on the ground, and his left foot turns out slightly. His body is muscular, and his hands are bound by boxing gloves composed of leather straps with wool padding—a style popular during the Hellenistic period.

The pose and precocious musculature of the boxer's body have led some scholars to suggest that the child is Herakles. According to the Hellenistic poet Theocritus (*Idyll* 24), the child Herakles learned the skill of boxing from Harpalykos of Phanote, a son of Hermes. The subject's depiction as a boxer and his sturdy and muscular contrapposto illustrate the association of Herakles, even as a child, with adult tasks and strength. Herakles had been, from his very birth, an extraordinary infant, capable of strangling the snakes sent by Hera to kill him in his crib.

JHC

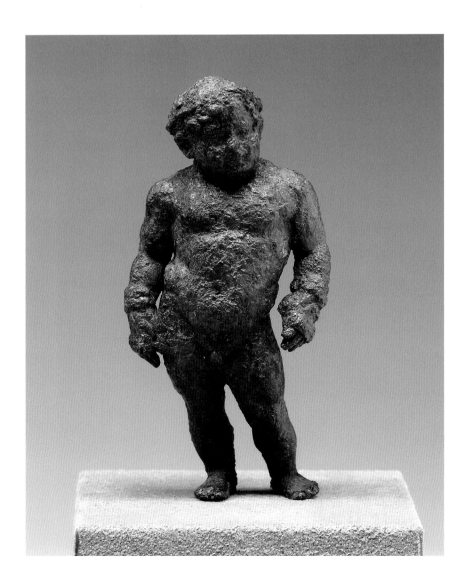

95. HERAKLES MOUSIKOS

Attic black-figure amphora
Attributed to the Leagros Group, 515–510 BCE
Height 44.15 cm
Worcester, Massachusetts, Worcester Art
Museum, Austin S. Garver Fund, 1966.63

PROVENANCE
Reportedly from the vicinity of Athens; purchased
from Hesperia Art, Philadelphia, 1966

SELECTED BIBLIOGRAPHY
LIMC 4 (1988), s.v. Herakles, 782, no. 1444
(O. Palagia); *LIMC* 7 (1994), s.v. Kyknos 1, 978,
no. 119 (A. Cambitoglou and S. A. Paspalas);
Buitron 1972; Shapiro 1984; Bundrick 2005;
Neils 1992

NOTES
1 Bundrick 2005, 161.
2 Shapiro 1984, 527.

Herakles stands upon a three-stepped bema and performs on the kithara for Athena and Hermes. He wears his lion skin but has set aside his club, which leans against the platform. Athena is fully armed, wearing a high-crested helmet and an aegis, and holding a spear and shield. Hermes, on the right, wears a petasos, winged boots, and a chlamys over his short chiton. He leans on his caduceus as he gazes toward the heroic musician. Scenes of Herakles Mousikos (Herakles the musician) were popular at the end of the sixth century BCE. These images probably refer to the Panathenaic *mousikoi agones*, or musical competitions (see no. 96); Athena's presence reflects both her association with the city and her identity as the hero's patron. However, Herakles' role as kitharode is curious, since the kithara was the instrument of Apollo. The image may have been intended to signal an Athenian rivalry with the musical competitions at the sanctuary of Apollo at Delphi.[1]

The obverse depicts the death of Kyknos at the hands of Herakles. The hero wears his lion skin over a short chiton, and its teeth, accentuated with added white paint, frame his face. Herakles lunges toward his opponent, using his left leg to hold Kyknos down as he grasps the crest of his opponent's helmet with his left hand and stabs him with a sword in his right hand. Kyknos lies on the ground, his helmet covering his face, looking outward. He holds a shield and a sword. Athena stands at far left in a chiton and himation, and on the far right is Ares, Kyknos's father, wearing a helmet and holding a shield with a tripod device. The thunderbolt above the central combat was sent by Zeus to demonstrate his support of Herakles.[2] According to the myth, Herakles killed Kyknos because he robbed Apollo of his sacrifices.

HAC

96. A MUSICAL COMPETITION

Black-figure pseudo-Panathenaic amphora
ca. 500–480 BCE
Height 44 cm, diameter 26.9 cm
Baltimore, The Walters Art Museum, 48.2107

PROVENANCE
William Randoph Hearst, San Simeon; Garrett
Chatfield Pier sale, Anderson Galleries, 1958;
museum purchase, 1958

SELECTED BIBLIOGRAPHY
Hill 1959a, 181–82, pl. 47, figs. 3, 4; Davison 1962;
Shapiro 1992b; Bentz and Eschbach 2001, 184,
no. 147; Bundrick 2005

The image on the obverse of this amphora may represent the *mousikoi agones,* or musical competitions, of the Panathenaic festival.[1] In the center of the scene, a bearded man clad in an ankle-length white chiton stands on a bema, or podium. Facing right, he holds a large seven-stringed kithara in his left hand. With his right hand, he plays the instrument, using a plectrum attached by a string. The kithara's cover hangs below. The added white paint that has been applied to the arms of the elaborate kithara simulates ivory. One man stands on either side of the bema, perhaps representing spectators, trainers, or judges of the competition.

The kithara was a highly esteemed instrument in Archaic Greece, and both Apollo and Orpheus were mythological models for human performers.[2] Herodotos (1.23–24) records the story of Arion, a highly regarded and successful kitharode who was thrown overboard from a ship by men who conspired to rob him. According to the tale, Arion was saved by a dolphin and returned to shore unharmed, which suggests that kitharodes were believed to have enjoyed the patronage of Apollo. The image on this vase finds a heroic counterpart in the representation of Herakles Mousikos, in which the hero appears as the performer, often with Olympic deities as spectators (see no. 95).

On the amphora's obverse, Athena strides to the left, wearing her characteristic helmet and scaly aegis. The goddess wields a spear and holds a large shield decorated with a soaring eagle. Two Doric columns, each with a rooster perched on top, flank the goddess. This is the standard configuration for one side of the Panathenaic amphora, which was given as a prize at the quadrennial games in honor of the patron goddess of Athens. However, the size of this vase and the lack of an inscription indicate that it was not actually used as a prize.

HAC

NOTES
1 Bundrick 2005, 160–74.
2 Shapiro 1992b, 69.

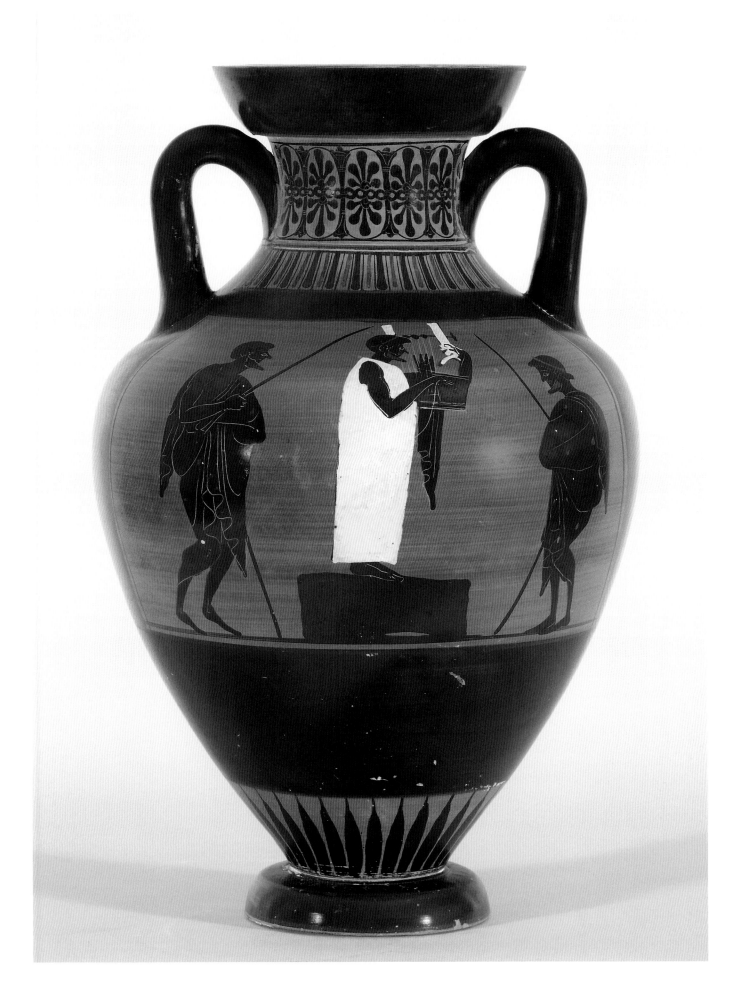

97. WOMEN AND EROTES

Attic red-figure pyxis
ca. 370–360 BCE
Height with lid 9 cm, diameter of lid 16.5 cm
Baltimore, The Walters Art Museum, 48.264

PROVENANCE
Joseph Brummer, New York; Henry Walters, 1927;
Walters Art Gallery, by bequest, 1931

SELECTED BIBLIOGRAPHY
Roberts 1977; Roberts 1978, 170–71; *CVA*
Baltimore, Walters Art Gallery, fasc. 1 (1992),
39, fig. 12.1, pl. (1453) 41.1–2

NOTES
1 Oakley and Sinos 1992, 6.
2 Larson 1995, 67.

On the lid of this pyxis are three women assisted by two Erotes, whose bodies are rendered in added white. The focus of the composition is a seated woman gazing over her left shoulder into a mirror held for her by an Eros, who appears to run toward his mistress, as do the two other women. Each of these women holds a taenia, or sash; one woman grasps a box. She looks back over her shoulder toward another Eros, who stands in a relaxed pose with one foot upon a small base, as he hands her another taenia. Lying on the ground behind this stationary Eros is an alabastron, a container for perfumes and unguents. On each side of the seated woman is a bird. The entire lid is framed by an egg-and-dot motif that is repeated on the projecting rim around the base of the pyxis. Triangular palmettes in black glaze decorate the body of the container.

The pyxis—a vase shape closely associated with women—was used to store jewelry, cosmetics, and toiletries. Scenes of women grooming and adorning themselves in their private quarters frequently decorate these vessels. This pyxis, with Erotes and servants attending a seated woman, evokes the image of a bride as she prepares for her wedding.[1] A heroic model for this type of scene might be found in the figure of Helen, celebrated for her beauty, and often closely associated with girls of marriageable age.[2]

HAC

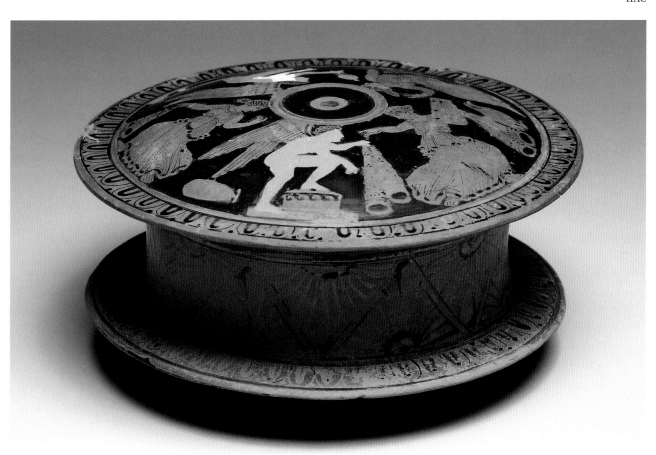

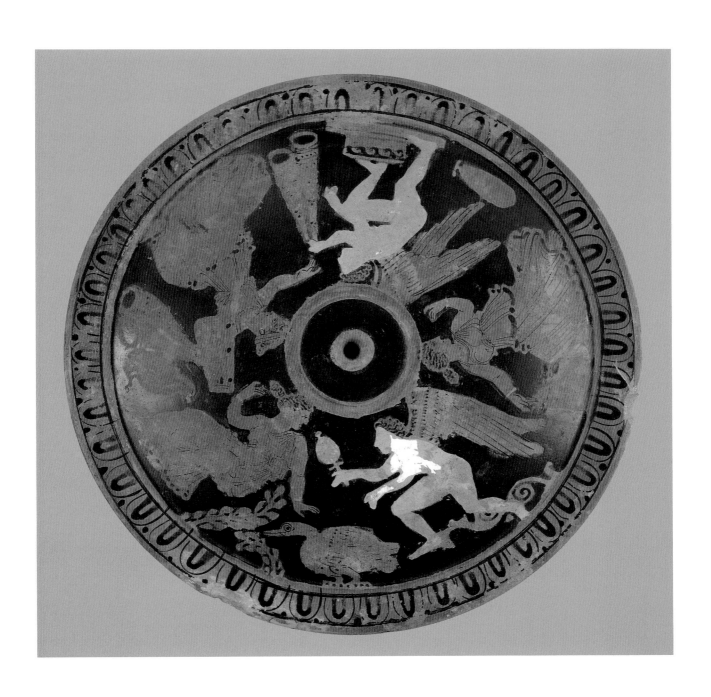

98. A WEDDING PROCESSION

Attic black-figure hydria
Attributed to the Lysippides-Andokides Group,
ca. 520 BCE
Height with top handle 43 cm, diameter 36.6 cm,
width with handles 37.3 cm
Baltimore, The Walters Art Museum, 48.33

PROVENANCE
Don Marcello Massarenti, Rome, by 1897; Henry
Walters, 1902; Walters Art Gallery, by bequest, 1931

SELECTED BIBLIOGRAPHY
Massarenti 1897, 2:34 (no. 177); Webb 1960;
Brommer 1973, 234, no. 11

The scene in the main panel of this hydria represents a wedding procession, with the bride and groom in a chariot drawn by four horses. While the groom manages the horses' reins, the woman holds her veil out in a gesture of modesty befitting the Greek bride. Behind the horses are two gods and two goddesses. Just in front of the newlyweds is Demeter, goddess of grain, who holds sheafs of wheat in each of her upraised hands. Looking back at her is Dionysos, the god of wine, who wears a wreath of ivy on his head and holds a large kantharos, his distinctive wine cup. Another figure wearing a polos on her head raises her hand toward the couple, perhaps in a gesture of greeting. At the far right is Hermes, mostly hidden by the horses. Grapevines and large bunches of grapes in the field, alluding to the wine used in celebration of the event, create a sense of crowded festivity.

At the center of the scene on the shoulder is Theseus battling the Minotaur. The hero lunges, his sword drawn and prepared to strike, as he grasps the right arm of his opponent. The scene captures this tale at the height of the action, just before Theseus slays the beast and frees his people from having to offer the Minotaur a yearly sacrifice of young Athenian children. A man and a woman stand on each side of the dueling pair. Each woman has skin rendered in added white and holds a wreath. One of these women is likely Ariadne, whom Theseus married and later abandoned; the object she holds possibly refers to a glowing wreath she gave to Theseus to guide him out of the Minotaur's labyrinth. The identity of the other figures is unclear, but they may represent companions of the Athenian hero.

HAC

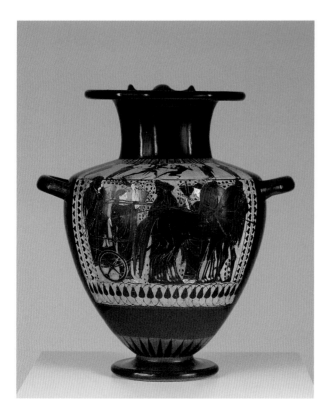

99. A WEDDING PROCESSION / A BOAR HUNT

Corinthian black-figure column-krater
Attributed to a painter in the Gorgoneion Group,
ca. 560 BCE
Height 35.1 cm, diameter of rim 31.5 cm, width
with handles 41.3 cm, diameter of foot 17.6 cm
Toledo Museum of Art, Purchased with funds
from the Libbey Endowment, Gift of Edward
Drummond Libbey, 1970.2

PROVENANCE
Reportedly from Etruria (Vulci?); Nicolas Koutoula-
kis, Geneva; museum purchase, 1970

SELECTED BIBLIOGRAPHY
Luckner 1972, 72, figs. 13, 14; Brommer 1973,
311 (no. C-5); Ebertshäuser and Waltz 1981, 61,
figs. 73–74; CVA Toledo, fasc. 2 (1984), pls. 77–79;
Toledo 2009, 68

The figural frieze on this large bowl for mixing wine and water illustrates not one but two narratives—a wedding procession and a boar hunt. The stalwart hunters, frenzied dogs, bristling spears, and massive boar convey the terrors of the wild. The stately poses and ornate clothing of the wedding guests show the blessings of civilization.

Does the hero marry the girl first or last? Does he face danger (and death?) because it is his duty to protect the people and land, or is he rewarded after victory? This vase could be read either way, or the two scenes may be independent. At the center of the wedding procession is a chariot drawn by four magnificent horses. The bride is barely visible, lifting her veil with one hand, on the far side of the bearded man holding the reins. Two more men flank the chariot, one in back and one in front. Fourteen dignified women, in pairs, escort and greet the bride.

A few black-figure vases from Corinth include names inscribed next to some figures, identifying the scenes with specific stories such as the Kalydonian boar hunt and the fateful marriage of Helen and Paris or Thetis and Peleus.[1] This scene cannot be positively identified as the Kalydonian hunt because no names are inscribed and because the heroine archer Atalanta is not present. Intriguingly, the hunter fallen and presumably dead beneath the feet of the boar is the only one of the seven hunters who is clothed, perhaps an indication of high rank. In later images of the Kalydonian hunt, this is Ankaios of Arcadia, who scorned to hunt with Atalanta because she was a woman, and boasted that he would kill the boar even if Artemis herself defended it. Ankaios, however, is described as armed only with an ax, because he had been unable to find his weapons when he set out to join the hunt.

SK

NOTES
1 E.g., Munich SH 327, pyxis attributed to the Dodwell
Painter, the lid of which illustrates a boar hunt with
hunters named Agamemnon, Alka, Dorimachos, Sakis,
Andritas, Lacon, Phidon, and Thersandros (Payne
1931b, 163, cat. 11, no. 861; Amyx 1988, 384, 565, no. 33,
pl. 86). E.g. New York, MMA 27.116, column-krater
attributed to the Detroit Painter, which illustrates the
wedding of Alexander (Paris) and Helen, whose names
are inscribed (Amyx 1988, 196, no. A-5, 562, pl. 79).
Amyx 1988, 665–66, recognizes fourteen boar hunts but
concludes, "If these scenes are meant to be heroic [i.e.,
Kalydonian], they give a very diluted version of such a
story."

100. HEAD OF ALEXANDER THE GREAT AS HERAKLES (?)

ca. late 4th century BCE
Pentelic marble; height 24 cm
Museum of Fine Arts, Boston, Otis Norcross
Fund, 52.1741

PROVENANCE

Reportedly found at Sparta; Professor W. Romaine
Newbold Collection, by 1908; Mrs. John Newbold
Hazard Collection, by 1910; Mrs. D. H. Reese
Collection, by 1927; museum purchase, 1952

SELECTED BIBLIOGRAPHY

Caskey 1910, 25–28; Sjöqvist 1953, 30–33; Bieber
1964, 52, pl. 20, fig. 39a–b; Comstock and Vermeule
1976, 80–81, no. 126 (with earlier publications);
C. Vermeule et al. 1980, 100–101, no. 5; C. Vermeule
and Comstock 1988, 110, no. 126 (with additional
published references); *LIMC* 4 (1988), s.v. Hera-
kles, 790, no. 310 (O. Palagia); Pandermalis 2004,
29, no. 8

Like earlier members of the Macedonian royal house, Alexander III, also known as Alexander the Great, claimed descent from the hero Herakles; it is less clear, however, to what extent Alexander wished people to actually equate him with Herakles. Scholars have long debated whether this partially preserved marble head wearing a lion skin headdress represents Herakles (who often appears in Greek and Roman art sporting the hide of the Nemean lion he had killed as one of his early labors) or portrays Alexander the Great in the guise of Herakles.

The Boston head, reported to have been found at Sparta, as well as a pair of comparable marble heads from the vicinity of Athens, poses a dilemma similar to that raised by the Heraklean imagery on the silver coinage issued in Alexander's name (see no. 101): during Alexander's lifetime and in the decades following his death, were images of the youthful, beardless Herakles wearing the lion skin headdress intended to be viewed as divinizing portraits of Alexander?[1]

Those inclined to doubt the association of the Boston head with Alexander point to its generalized facial features and lack of the king's characteristic leonine hairstyle. Yet the so-called Alexander Sarcophagus from Sidon (now in Istanbul), also a work of the late fourth century BCE, provides an instance in which a youthful, beardless figure wearing a lion skin helmet is probably to be identified as Alexander, despite deviating somewhat from the standard portrait iconography. Especially in ambiguous cases, the context of display would have been crucial to a viewer's interpretation, and the dearth of information about the monument to which the Boston head once belonged—whether a freestanding statue or a deeply carved relief—leaves indeterminate its identification as Herakles or Alexander.

RG

NOTE

1 On the relationship of the sculpted heads and the
coinage, see Ridgway 2001, 111–13; for illustrations of
the two heads from the vicinity of Athens, see Bieber
1964, figs. 37, 38.

101. TETRADRACHM OF ALEXANDER III WITH THE HEAD OF HERAKLES
(BELOW LEFT)

Macedonian (struck in Egypt), ca. 332–323 BCE
Silver; 17.24 g
American Numismatic Society, New York,
1947.98.326

PROVENANCE
Purchased 1947

SELECTED BIBLIOGRAPHY
Pandermalis 2004, 42, no. 11

102. DIDRACHM OF AMYNTAS III WITH THE HEAD OF HERAKLES (BELOW RIGHT)

Macedonian, ca. 393–370/69 BCE
Silver; 8.18 g
American Numismatic Society, New York,
1944.100.12165

PROVENANCE
Bequest of E. T. Newell, 1944

SELECTED BIBLIOGRAPHY
SNG ANS 8 (1994), no. 89; Pandermalis 2004, 41,
no. 6

Beginning around the early fourth century BCE, the claim of the Argead dynasty of Macedonia to have descended from Herakles was given visual expression on the kingdom's coinage. While the stately horse on the reverse of this silver coin of Amyntas III adheres to a model established by earlier Macedonian kings, the bearded head of Herakles wearing the skin of the Nemean lion as a headdress on the obverse represents a new departure.[1] Subsequent members of the dynasty introduced a more youthful, beardless version of the Herakles head. This distinctive image would become emblematic across the Greek world and beyond of the extraordinary exploits of Amyntas's grandson, Alexander III, also known as Alexander the Great. Both during his lifetime and for many years afterward, mints throughout the enormous territory he conquered struck silver coins in the name of Alexander with the head of Herakles wearing the lion skin on the obverse and an enthroned figure of Zeus on the reverse.[2]

It is sometimes suggested that the head of Herakles on the silver coinage of Alexander III was intended as a divinizing portrait of the Macedonian king.[3] While most scholars have not accepted this theory, it does seem plausible that ancient viewers would have appreciated the pictured hero not only as the progenitor of the Macedonian royal dynasty but also as a behavioral archetype for Alexander personally in his pursuit of superhuman attainments. At the very least, the image of Herakles wearing the lion skin provided a readily adaptable model for what are indisputably portraits of the deified Alexander on coins of his successors.[4]

RG

NOTES
1 For the attribution to Amyntas III, see Westermark 1989, 307–8.

2 The standard catalogue of the coinage of Alexander III is M. Price 1991; for the coin illustrated here, see no. 3964. Although the *khnum* symbol in the reverse field locates the mint for this coin in Egypt, dispute remains over the attribution to Memphis or Alexandria.

3 See, e.g., Pollitt 1986, 25–26.

4 For an overview of the development of Alexander's image on the coins of his successors, see Dahmen 2007, 10–17. On the adaptation of the model of Herakles to portraits of the deified Alexander III, see Arnold-Biucchi 2006, 34–37.

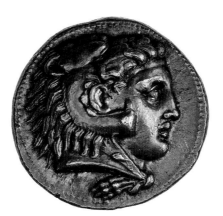

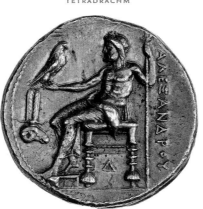

TETRADRACHM

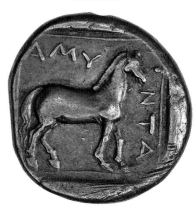

DIDRACHM

103. ALEXANDER THE GREAT WITH THE AEGIS

Alexandria (?), Roman copy of a Hellenistic original
Bronze with silver inlays; 12 × 6.5 × 3.2 cm
Baltimore, The Walters Art Museum, 54.1075

PROVENANCE
Dikran Kelekian, New York/Paris; Henry Walters, 1922; Walters Art Gallery, by bequest, 1931

SELECTED BIBLIOGRAPHY
Hill 1949, 53, no. 109, pl. 28; Reeder 1988; Stewart 1993, 422, no. 13; Parlasca 2004, 341–349, no. 5, fig. 16; Beck, Bol, and Bückling 2005, 558, no. 126 (C. Reinsberg)

NOTE
1 For the discussion of the type and for the identification as Alexander *Ktistes* ("Alexander, founder of the city"), see Stewart 1993, 243–52; Parlasca 2004; Reinsberg 2005, 226–29.

Said to be from Alexandria, this small bronze statuette depicts the youthful Alexander with long, full hair. His hair, with the characteristic *anastole*, and the shape of his face have led scholars to posit that this portrait derives from a Lysippan original, created during Alexander's lifetime. Alexander stands in contrapposto with the weight on his right leg. His right arm is raised, and he probably held a spear or lance in this hand. This statuette is of particular interest for the garment worn by Alexander. He wears an aegis shaped as a loosely draped chlamys, a type of cloak often worn by Macedonian soldiers. The aegis is embellished with incised scales and a Gorgoneion at Alexander's left breast, which is typical for this statue-type. Alongside the edge of the aegis are a number of holes, where small snakes might have been attached.

This statue-type has been linked with the Alexander Aigiochos ("Alexander wearing the aegis") mentioned in literary sources.[1] Parallels indicate that Alexander's outstretched right hand might have held the Palladion, an archaistic statue-type of Athena seized by Diomedes and Odysseus from Troy. The aegis links Alexander to Zeus and Athena, but also to the city of Alexandria, which ancient authors said was laid out in the shape of a chlamys. Like Athena for Athens, he is represented as patron and founder of Alexandria, and the aegis associates him with divine power.

JHC

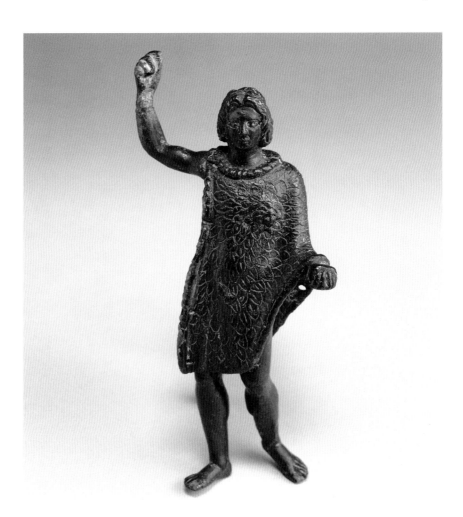

104. HELLENISTIC RULER

Second–first century BCE
Bronze, solid cast; 25 × 13.7 × 7.5 cm
Baltimore, The Walters Art Museum, 54.1045

PROVENANCE
Reportedly from Egypt; ex-coll. Matossian (?);
ex-coll. Lépine; Maison Nadaud; Henry Walters,
1930; Walters Art Gallery, by bequest, 1931

SELECTED BIBLIOGRAPHY
Reinach 1924, 311, nos. 5, 6; Hill 1949, 53, no. 110,
pl. 27; Reeder 1988, 147–48, no. 61 (with bibliog-
raphy); Stewart 1993, 430, no. 8; Albersmeier 2008,
154–55, no. 55 (S. Albersmeier)

NOTE
1 See Stewart 1993, 161–71. He lists the Walters piece
among the replicas and reversals of the Stanford Alexan-
der type (no. 8).

The practice of commissioning portraits of Hellenistic rulers with heroic or godlike attributes began with Alexander the Great (356–323 BCE), who closely associated himself with heroes like Herakles and Achilles and carefully shaped his public image. His successors in the various Hellenistic kingdoms often used Alexander's imagery as models for their own representations, which can make it difficult to identify individual rulers in portraits. Small-scale bronze statuettes became popular in Hellenistic times addition to large bronze and marble statues, often depicting the ruler in heroic nudity and with heroic or divine attributes (see also nos. 103, 105).

An example is this statuette of a muscular man with a cloak draped over his left shoulder and arm, standing in contrapposto with the weight shifted to his left leg. The man slightly turns his head and body to the right, his right arm, which likely once held a spear, raised high. His left hand holds a sheathed sword with the hilt forward, which runs along the lower left arm. The man wears a large laurel wreath with leaves sticking out in all directions from the curly hair, which is not executed on the back of the head. The broad angular face is characterized by full, slightly downward-turned lips, a thin nose, a round, prominent chin, and large, wide-open eyes (once inlaid) with thick orbital folds. The straight eyebrows are set apart as a pronounced ridge from the high forehead.

The Walters statuette has been associated with a certain type of Alexander statuette with a spear in bronze, of which several variations exist.[1] While the portrait features bear some resemblance to Alexander's portraits and coins, they are too small in scale and too generic to be conclusive for a secure identification, and characteristic traits like the *anastole* are covered by the wreath. Therefore it could be either Alexander himself or one of his successors emulating his image.

SA

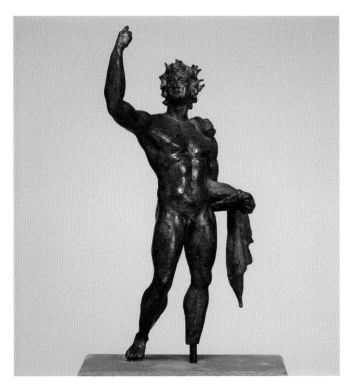

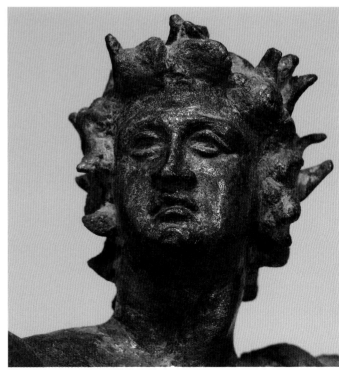

105. PTOLEMY VANQUISHING AN ENEMY

Early second century BCE (?)
Bronze, solid cast; 19.5 × 8.9 × 12.1 cm
Baltimore, The Walters Art Museum, 54.1050

PROVENANCE
Reportedly from Kharbia, northern Egypt; Dikran Kelekian, New York/Paris; Henry Walters, 1910–15; Walters Art Gallery, by bequest, 1931

SELECTED BIBLIOGRAPHY
Hill 1949, 66, no. 140, pl. 30; Kyrieleis 1975, 54–55, 173, no. E 7, pl. 43.2, 5, 6; Reeder 1988, 151–52, no. 63; Maderna 2005, 258–66 and 579–80, no. 152; Albersmeier 2008, 152–53, no. 54 (S. Albersmeier)

Two naked wrestlers are engaged in a fight with an obvious victor. The standing wrestler clearly dominates the other by trapping him between his legs, bending his right arm backward, and pushing down his head. The losing wrestler is in anguish and pain, bent down on one knee, and tries to support himself with his right hand on the ground. This group is, however, not entirely athletic in character. The facial features of both wrestlers and the attributes of the victor set them apart from normal athletes. The defeated wrestler is characterized as a "barbarian" by his facial features and the ragged hair, while the portrait features, the broad diadem, and the uraeus—the royal cobra—over the forehead identify his opponent as one of the Ptolemaic kings, the successors of Alexander the Great as rulers over Egypt. Several such groups depicting a Hellenistic king defeating an enemy are known, possibly small-scale versions modeled after large sculptural groups in Alexandria celebrating military victories of the Ptolemies.[1] In this case, the portrait features suggest an identification with the young Ptolemy V (204–180 BCE).[2]

Like the other wrestling group (no. 92), this sculpture clearly demonstrates the Hellenistic artist's ability to capture multiple viewpoints and create complex, intertwined composition. The pyramidal structure of the group stresses the dominance of the victorious ruler over the barbarian. The Ptolemies used the popularity of wrestling groups as an occasion for military propaganda, and, as indicated by the heroic nudity, they associated themselves with heroes like Herakles and his famous contest with the giant Antaios.

SA

NOTES
1 Kyrieleis 1973; Thomas 1999.
2 Kyrieleis 1975, 54f.

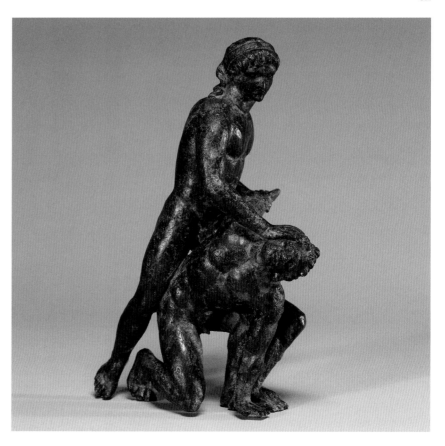

106. MEDALLION WITH BUST OF ALEXANDER THE GREAT

Roman (probably struck in Macedonia), ca. 218–235 CE
Gold; diameter 5.4 cm, weight 95 g
Baltimore, The Walters Art Museum, 59.1

PROVENANCE
Kyticas (dealer), Cairo; possible with Dikran Kelekian, New York / Paris; Henry Walters, by 1931; Walters Art Gallery, by bequest, 1931

SELECTED BIBLIOGRAPHY
Dressel 1906, 14, no. L, 68, figs. 1–2; Noe 1925; C. Vermeule et al. 1980, 103–4, no. 11, color pl. 5; C. Vermeule 1982, 63–64, pl. 5.1; Pandermalis 2004, 33, no. 12

NOTE
1 For the discovery of the Abuqir hoard, see Dressel 1906, 3–4. For a brief overview of the medallions from the Abuqir hoard with imagery of Alexander the Great, see Dahmen 2007, 36–37.

The imagery on this gold medallion represents Alexander the Great as he was imagined by his devotees living in the Roman Empire more than five hundred years after his death. Both the bust-length portrait on the obverse and the triumphal procession on the reverse draw upon Roman Imperial models and promote Alexander as an archetypal conqueror and world ruler, an ideal to which Rome's emperors could aspire.

While sharing essential features such as the upward glance and leonine hairstyle with images of the deified Alexander on Hellenistic coins, the medallion's portrait stands apart not only for its frontal format but also for its extraordinary detail and technical sophistication. Though he is dressed in armor and holding a shield and spear, Alexander's helmetless head implies invulnerability to battlefield dangers. The elaborate decoration of the shield implies the exceptional scope of Alexander's dominion: a veiled female figure, Gaia (Earth), occupies the center, surrounded by personifications of the sun and moon as well as symbols of the zodiac. The scene on the medallion's reverse shows Alexander crowned in triumph while riding in a horse-drawn chariot led by Ares, the god of war, and a helmeted female figure who may symbolize Rome.

This gold medallion and others bearing imagery of Alexander the Great were discovered in 1902 as part of a hoard at Abuqir in the Nile delta.[1] Many scholars believe, however, that they were created in or near Alexander's homeland of Macedonia and awarded as prizes or gifts at festivals celebrating the memory of Alexander, which are known to have taken place in the 220s and 230s CE.

RG

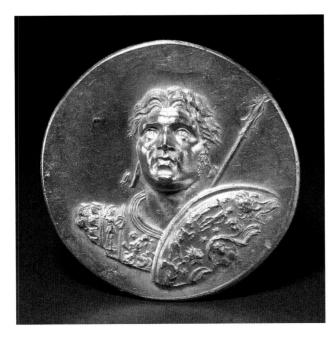

GLOSSARY

aegis: A bib or capelike garment decorated with the Gorgon's head and tassels in the form of serpents. It is an attribute of Athena and Zeus.

agora: A marketplace; the center of a Greek city's commercial and administrative activities.

Amazons: A mythological race of warrior women, hostile to men.

amphora: A two-handled storage or transport vessel for oil, wine, or other liquids.

anakalpysis: A gesture of unveiling associated with brides and marriage.

anastole: A hairstyle characteristic of portraits of Alexander the Great, in which the hair is brushed up from the forehead and parted at the center.

architrave: The beam that rests directly on the capitals of the columns, forming the lowest part of the entablature.

aryballos: A small jar, round and narrow-necked, used for holding perfume or oil.

Athena Parthenos: A (lost) monumental sculpture by Pheidias of the goddess Athena in gold and ivory, housed in the Parthenon in Athens.

aulos: A wind instrument, probably double-reeded (like a modern oboe), used most notably by the satyr Marsyas in a musical competition with Apollo.

Battle of Plateia: The culminating land battle (479 BCE) at the Boeotian city of Plateia during the second Persian invasion of Greece, in which an alliance of Greek city-states decisively defeated the army led by Xerxes I.

Battle of Salamis: A naval battle (480 BCE) between an alliance of Greek city-states and the Persians, fought in the Saronic Gulf near Athens, in which the Greek forces, led by Themistokles, defeated the Persian forces led by Xerxes I and forced the Persians' retreat to Asia Minor.

bomos: A tall square or rectangular altar associated with the Olympian gods.

Centaur: A mythical race of creatures, part man and part horse, that embodied violence and disorder. Cheiron, exceptional among the Centaurs for his culture, learning, and intelligence, was Achilles' teacher.

Chimaira: A creature composed of a lion's body, a goat's head (rising in the middle of the body) and a tail that terminated in a snake's head; defeated by the hero Bellerophon.

chiton: A lightweight one-piece garment secured with pins or fibulae.

chitoniskos: A short chiton, worn by men, commonly associated in the visual arts with heroes and hunters.

chlamys: A short cloak.

chthonian deities: Gods and goddesses associated with the earth and the underworld, as distinct from Olympian deities.

Cyclopes: A race of giants, each with a single eye at the center of the forehead.

deme: One of 139 subdivisions of Attica, originally designating divisions of land, but by the sixth century BCE functioning as political subunits of the state, enrollment in which was a condition of citizenship.

Dioskouroi: The twins Kastor and Polydeukes, brothers of Helen.

diphros: A backless stool.

Eleusinian Mysteries: A religious initiation ceremony dedicated to the cult of Demeter and Persephone, held annually at Eleusis.

Elysium: Part of the underworld and the final resting place of heroes and the virtuous dead.

embolon: The pointed projection of a warship's keel.

enagizein: Sacrifices, to gods or heroes, in which offerings were entirely burnt.

ephebe: a male adolescent who has entered his two years of military training, between the ages of eighteen and twenty.

Epic Cycle: Lost accounts of the Trojan War, comprising the *Cypria*, *Aithiopis* (by Arktinos of Miletos), the *Ilioupersis* (by Stesichoros), the *Telegony*, and the *Little Iliad* (by Lesches of Pyrrha).

Eros, Erotes (pl.): The god of erotic love and son of Aphrodite, often represented as a winged child; several such figures might appear in the same scene.

eschara: A low altar, either mound shaped or constructed of heaps of fieldstones, associated with the chthonian deities as well as with heroes.

exaleiptron: A low cylindrical container for liquids, distinguished from a pyxis by its incurving lip.

Gigantomachy*: A battle between the gods and the giants.

Herakleidai: The children or descendants of Herakles.

herm: A stone pillar with a carved head or torso, sometimes used to mark crossroads or boundaries.

heroön: Hero shrine.

himation: A cloak or mantle worn over the chiton.

hoplite: A heavily armed foot soldier.

Hydra: A fierce multi-headed serpentine water beast that lived in Lake Lerna; killed by Herakles as one of his twelve labors.

hydria: A water vessel with three handles, two for carrying and one for pouring.

Isles of the Blessed: the posthumous paradisial dwelling place of heroes.

kalathos: A basket with a flared top, used as a measure for grain; also a tall headdress in the form of a basket, associated with fertility.

kanoun: A basket used in ritual and carried by young women (known as *kanephoroi*) in religious processions.

kantharos: A drinking vessel with high vertical handles.

Kerberos: A vicious dog that guarded the entrance to Hades, often represented with three heads but sometimes many more.

kerykeion: A herald's staff, often carried by the messenger god Hermes.

kithara: A stringed instrument, similar to the lyre, played by professional musicians known as *kitharodes*.

kline: A bed or dining couch.

klismos: An elaborate chair with a rounded back.

kolpos: The blousing of a tunic, pulled up from the belt to form a pouch.

krater: A large open bowl used for mixing wine and water. Specific forms (bell-krater, calyx-krater, column-krater, and volute-krater) are named for their distinctive profiles or handles.

kyathos: A dipping vessel or ladle composed of a tapering bowl and a large looping handle.

kylix: A shallow drinking vessel with two horizontal handles.

larnax: A box or chest, often used to hold human remains.

lekythos: A tall, narrow-necked vessel with one handle used to hold oil, often associated with funerary ritual.

Leuke: *See* White Island.

Linear B: A script of approximately two hundred ideograms and syllabic signs used for writing Mycenaean Greek.

louterion: A basin for holding water used in marriage or funerary rituals.

loutrophoros: A large elongated vessel with two handles used to hold water for ritual.

Maenad: A female follower of Dionysos.

metope: The panel between two triglyphs in a Doric frieze, usually blank but sometimes decorated with painting or carving.

metopon: Lit. "forehead"; i.e., the semicircular band over the forehead of a helmet.

mnema: A sepulchral monument or burial place.

naiskos: A small nichelike construction in the form of a temple.

oinochoe: A single-handled vessel used for pouring liquids, often with a trefoil mouth.

olpe: A jug, typically with a low handle and a circular, broad-lipped spout.

Olympian deities: The twelve gods, or Dodekathon, named for their dwelling place, Mount Olympos, who ruled after the overthrow of the Titans; distinguished from the chthonic deities.

omphalos: Lit. "navel"; a stone monument at Delphi that was said to mark the center of the world.

orthostat: A large, upright stone or slab.

paian: A hymn of invocation or thanksgiving, especially to Apollo.

palaestra: A building used for exercising and practicing sports.

Panathenaic amphora: Large decorated amphora containing olive oil, given as prizes at the Panathenaic games, held in Athens every four years as part of the Great Panathenaia.

pelike: A smaller storage container with two handles.

peplos: A heavy one-piece woolen garment worn by women.

perirrhanterion: A shallow ritual water basin, usually on a stand and made of stone.

peristyle: A colonnade encircling a building or courtyard.

petasos: A hat with a wide brim, often worn when traveling.

phiale: A shallow bowl, with a raised area at the center, used primarily for libations.

phormiskos: A small, bag-shaped vessel with a narrow neck, possibly used for sprinkling water during rituals.

pilos: A rustic hat typically worn by fishermen and other outdoorsmen.

pithos: A large vessel, often partly buried, used for storage.

propylon: A structure serving as a gateway to the entrance of a sacred place or architectural complex.

prostoion: A portico that sometimes served as sleeping quarters for the sick who visited the hero in order to be healed.

prothesis: The ritual mourning period when a body is laid out before a funeral.

quadriga: A four-horse chariot.

satyr: A male companion, semi-bestial in form, of the god Dionysos.

Säulenbau. *See* tetrastylon.

skyphos: A two-handled stemless drinking cup.

sphagia: Battlefield sacrifices.

Siren: A mythological figure with the body of a bird and the head of a woman, whose song lured passing sailors to their deaths.

Sphinx: In the Greek tradition, a winged monster with the head (and often breasts) of a woman, the body of a lion, and a serpent's tail.

stamnos: A rounded vessel with a low foot and a low neck, possibly used for storage.

stele: A vertical slab of stone used for funerary or commemorative purposes.

stoa: A long colonnaded building or hall.

strategos: An Attic general, one of ten elected annually to serve as leaders of the Athenian army.

Tabulae Iliacae: Roman carved stone reliefs depicting episodes from the *Iliad* and the *Odyssey* as well as other accounts of the Trojan War.

taenia: A band or fillet encircling the forehead and temples.

temenos: A holy place or precinct.

tetrastylon: A monument consisting of four columns placed on a stepped base and linked by a roofless architrave.

theoxenia: In cult, food offerings to gods or heroes.

thesauros: A marble strong box for keeping the payments made in connection with sacrifices.

thiasos: A Dionysiac procession.

tholos: A structure composed of successively smaller rings of brick or stone.

thyrsos: A staff composed of a fennel stalk and pine-cone cap, associated with Bacchus and his followers.

thysia: In cult, blood sacrifice to gods or heroes, concluding with a meal.

tondo: The circular space, often decorated, in the interior of a kylix.

Totenmahl: Lit. "death feast" (German): reliefs showing a hero reclining at a table with food offerings and often a group of worshipers.

trapeza: A large, low tombstone in the shape of a rectangular box.

tripod: A sacrificial altar, the most famous of which was the tripod of the oracle at Delphi.

uraeus: A stylized, erect cobra, used to symbolize royal power or divine authority in ancient Egypt.

White Island (Leuke): An island located in the northern Black Sea, in legend, the posthumous dwelling place of Achilles.

zostēr: Girdle or war belt.

LIST OF ABBREVIATIONS

AA	*Archäologischer Anzeiger*	*MH*	*Museum Helveticum*
ABV	J. D. Beazley. *Attic Black-figure Vase Painters.* Oxford, 1956	*QNAC*	*Numismaticae Antichita Classiche, Quaderni Ticinesi*
ActaAth	*Acta Instituti Atheniensis Regni Sueciae*	*Rev. Arch.*	*Revue Archéologique*
AJA	*American Journal of Archaeology*	*RVAp.*	A. D. Trendall and A. Cambitoglou. *The Red-figured Vases of Apulia.* Oxford and New York, 1978–82
AK	*Antike Kunst*		
AM	*Mitteilungen des Deutschen Archäologischen Instituts, Athenische Abteilung*	*SNG ANS*	*Sylloge Nummorum Graecorum (American Numismatic Society)*
ARV²	J. D. Beazley. *Attic Red-figure Vase Painters,* 2d ed., 3 vols. Oxford, 1963.	*TAPA*	*Transactions of the American Philological Association*
Arch. Rep.	*Archaeological Reports Supplement to Journal of Hellenic Studies*	*ThesCRA*	*Thesaurus cultus et rituum antiquorum*
BaBesch	*Bulletin antieke beschaving. Annual Papers on Classical Archaeology*	*ZPE*	*Zeitschrift für Papyrologie und Epigraphik*
BAdd²	T. H. Carpenter. *Beazley Addenda: Additional References to ABV, ARV², and Paralipomena,* 2nd ed. Oxford, 1989		
BAR	*British Archaeological Reports*		
BCH	*Bulletin de Correspondance Hellénique*		
BICS	*Bulletin of the Institute of Classical Studies of the University of London*		
BMFA	*Bulletin of the Museum of Fine Art, Boston*		
BSA	*Annual of the British School at Athens*		
BWAG	*Bulletin of the Walters Art Gallery*		
Cl. Ant.	*Classical Antiquity*		
CVA	*Corpus Vasorum Antiquorum*		
GRBS	*Greek, Roman, and Byzantine Studies*		
Harv. Stud.	*Harvard Studies in Classical Philology*		
Harv. Theol. Rev.	*Harvard Theological Review*		
HR	*History of Religions*		
IG	*Inscriptiones Graecae*		
JDAI	*Jahrbuch des Deutschen Archäologischen Instituts*		
JHS	*Journal of Hellenic Studies*		
JWAG	*Journal of the Walters Art Gallery*		
LIMC	*Lexicon Iconographicum Mythologiae Classicae,* 18 vols. Zurich and Munich, 1981–99		
MAAR	*Memoirs of the American Academy in Rome*		
MÉFRA	*Mélanges d'archéologie et d'histoire de l'École française de Rome*		

ABBREVIATED REFERENCES

Abramson 1978. H. Abramson. "Greek Hero-Shrines." Ph.D. diss. University of California, Berkeley, 1978.

Abramson 1979. H. Abramson. "A Hero Shrine for Phrontis at Sounion?" *California Studies in Classical Antiquity* 12 (1979): 1–19.

Ackermann 2007. D. Ackermann. "Rémunération des prêtres et déroulement des cultes dans un dème de l'Attique: Le règlement religieux d'Axiônè (Attique)." *Études Classiques* 75 (2007): 111–36.

Adams 1987. D. Q. Adams. "῞Ηρως and ῞Ηρα: Of Men and Heroes in Greek and Indo-European." *Glotta* 65 (1987): 171–78.

Ahlberg-Cornell 1992. G. Ahlberg-Cornell. *Myth and Epos in Early Greek Art: Representation and Interpretation.* Jonsered, 1992.

Ajootian 2005. A. Ajootian. "The Civic Art of Pity." In *Pity and Power in Ancient Athens,* ed. R. H. Sternberg, 223–52. Cambridge, 2005.

Aktseli 1996. D. Aktseli. *Altäre in der archaischen und klassischen Kunst: Untersuchungen zu Typologie und Ikonographie.* Internationale Archäologie 28. Espelkamp, 1996.

Albersmeier 2008. S. Albersmeier, ed. *The Art of Ancient Greece.* Baltimore and London, 2008.

Allentown 1979. Allentown Art Museum. *Aspects of Ancient Greece.* Exh. cat., 1979.

American Art Galleries 1924. *Illustrated Catalogue of the Art Collection of the Expert Antiquarians, C. & E. Canessa of New York, Paris, Naples.* Auction cat., New York: American Art Galleries, January 25–26, 1924.

Amyx 1988. D. A. Amyx. *Corinthian Vase-Painting of the Archaic Period.* Berkeley, 1988.

Anderson 1997. M. J. Anderson. *The Fall of Troy in Early Greek Art and Poetry.* Oxford and New York, 1997.

Anderson 2003. G. Anderson. *The Athenian Experiment: Building an Imagined Political Community in Ancient Attica, 508–490 B.C.* Ann Arbor, 2003.

Andreae 1999. B. Andreae, ed. *Odysseus: Mythos und Erinnerung.* Exh. cat., Munich: Haus der Kunst. Mainz, 1999.

Andreae 2000. B. Andreae, ed. *Odysseus: Mythos und Erinnerung,* 2nd ed. Exh. cat., Munich: Haus der Kunst. Mainz, 2000.

Andreae 2001. B. Andreae. *Skulptur des Hellenismus.* Munich, 2001.

Andreae and Conticello 1974. B. Andreae and B. Conticello. "Die Skulpturen von Sperlonga." *Antike Plastik,* Lieferung 14 (1974).

Andreae and Parisi Presicce 1996. B. Andreae and C. Parisi Presicce, eds. *Ulisse: Il mito e la memoria.* Exh. cat., Rome: Palazzo delle esposizioni. Rome, 1996.

Andreae and Schepkowski 2007. B. Andreae and N. S. Schepkowski, eds. *Malerei für die Ewigkeit: Die Gräber von Paestum.* Exh. cat., Hamburg: Bucerius Kunst Forum. Munich, 2007.

Antonaccio 1993. C. M. Antonaccio. "The Archaeology of Ancestors." In *Cultural Poetics in Archaic Greece: Cult, Performance, Politics,* ed. C. Dougherty and L. Kurke, 46–70. Cambridge, 1993.

Antonaccio 1995. C. M. Antonaccio. *An Archaeology of Ancestors.* Lanham, Md., 1995.

Antonaccio 1999. C. M. Antonaccio. "Colonization and the Origins of Hero Cult." In Hägg 1999, 109–21.

Antonaccio 2005. C. M. Antonaccio. "Dedications and the Character of the Cult." In Hägg and Alroth 2005, 99–112.

Antonaccio 2006. C. M. Antonaccio. "Religion, *Basileis* and Heroes." In *Ancient Greece: From the Mycenaean Palaces to the Age of Homer,* ed. S. Deger-Jalkotzy and I. S. Lemos, 381–95. Edinburgh, 2006.

Arnold-Biucchi 2006. C. Arnold-Biucchi. *Alexander's Coins and Alexander's Image.* Cambridge, Mass., 2006.

Ashmole and Yalouris 1967. B. Ashmole and N. Yalouris. *Olympia: The Sculpture of the Temple of Zeus.* London, 1967.

Auberson and Schefold 1972. P. Auberson and K. Schefold. *Führer durch Eretria.* Bern, 1972.

Austin 1994. N. Austin. *Helen of Troy and Her Shameless Phantom.* Ithaca, 1994.

Ayala 1989. G. Ayala. "L'autel sur les monnaies antiques." *Archeologia* 251 (1989): 56–65.

Baltimore 1939. The Baltimore Museum of Art and the Walters Art Gallery. *The Greek Tradition in Painting and the Minor Arts.* Exh. cat., 1939.

Barchiesi 2001. A. Barchiesi. "Simonides and Horace on the Death of Achilles." In *The New Simonides: Contexts of Praise and Desire,* ed. D. Boedeker and D. Sider, 255–71. Oxford, 2001.

Barrigón 2000. C. Barrigón. "La désignation des héros et héroïnes dans la poésie lyrique grecque." In Pirenne-Delforge and Suárez de la Torre 2000, 1–14.

Barringer 2008. J. M. Barringer. *Art, Myth, and Ritual in Classical Greece.* Cambridge, 2008.

Baughan 2008. E. P. Baughan. "Lale Tepe: The Klinai." In *Love for Lydia: A Sardis Anniversary Volume Presented to Crawford H. Greenewalt, Jr.,* ed. N. D. Dahill. Cambridge, Mass., 2008.

Beard 1991. M. Beard. "Adopting an Approach." In *Looking at Greek Vases,* ed. T. Rasmussen and N. Spivey, 12–35. Cambridge, 1991.

Beazley 1929. J. D. Beazley. "Charinos: Attic Vases in the Form of Human Heads." *JHS* 49 (1929): 38–78.

Beazley 1943. J. D. Beazley. "Groups of Campanian Red-Figure." *JHS* 63 (1943) 66–111.

Beazley 1971. J. D. Beazley. *Paralipomena: Additions to Attic Black-figure Vase-Painters and to Attic Red-figure Vase-Painters,* 2nd ed. Oxford, 1971.

Beazley 1986. J. D. Beazley. *The Development of Attic Black-figure,* rev. ed., ed. D. von Bothmer and M. B. Moore. Berkeley, 1986.

Beck, Bol, and Bückling 2005. H. Beck, P. C. Bol, and M. Bückling, eds. *Ägypten Griechenland Rom: Abwehr und Berührung,* 258–66. Exh. cat., Frankfurt: Städelsches Kunstinstitut and Städtische Galerie 26. Frankfurt, 2005.

Bennett and Olivier 1973. E. L. Bennett Jr. and J.-P. Olivier. *The Pylos Tablets Transcribed*, 1: *Texts and Notes*. Rome, 1973.

Bennett and Paul 2002. M. Bennett and A. J. Paul, eds. *Magna Graecia: Greek Art from South Italy and Sicily*. Exh. cat., Cleveland Museum of Art. Cleveland, 2002.

Benson 1995. C. Benson. "Amazons." In Reeder 1995, 373–80.

Bentz 1998. M. Bentz. *Panathenäische Preisamphoren. Eine athenische Vasengattung und ihre Funktion vom 6.–4. Jahrhundert v. Chr.* Beiheft zur Halbjahresschrift Antike Kunst 18. Basel, 1998.

Bentz and Eschbach 2001. M. Bentz and N. Eschbach, eds. *Panathenaïka: Symposion zu den panathenäischen Preisamphoren, Rauischholzhausen, 25. 11. –29. 11. 1998*. Mainz, 2001.

Bérard 1969. C. Bérard. "Note sur la fouille au sud de l'Héroôn." *AK* 12 (1969): 74–79.

Bérard 1970. C. Bérard. *L'Héroôn à la Porte de l'Ouest*. Eretria 3. Bern, 1970.

Bérard 1972. C. Bérard. "Le sceptre du prince." *MH* 29 (1972): 219–27.

Bérard 1982. C. Bérard. "Récupérer la mort du prince: Héroïsation et formation de la cité." In *La mort: Les morts dans les sociétés anciennes*, ed. G. Gnoli and J. P. Vernant, 19–26. Cambridge, 1982.

Berger and Lullies 1979. E. Berger and R. Lullies. *Antike Kunstwerke aus der Sammlung Ludwig*, 1: *Frühe Tonsarkophage und Vasen*. Basel, 1979.

Bergquist 1973. B. Bergquist. *Herakles on Thasos: The Archaeological, Literary and Epigraphic Evidence for His Sanctuary, Status and Cult Reconsidered*. Boreas 5. Uppsala, 1973.

Bergquist 1998. B. Bergquist. "Feasting of Worshippers or Temple and Sacrifice? The Case of Herakleion on Thasos." In Hägg 1998, 57–72.

Bergquist 2005. B. Bergquist. "A Re-study of Two Thasian Instances of *Enateuein*." In Hägg and Alroth 2005, 61–70.

Bieber 1945. M. Bieber. "Archaeological Contributions to Roman Religion." *Hesperia* 14 (1945): 270–77.

Bieber 1955. M. Bieber. *The Sculpture of the Hellenistic Age*. New York, 1955.

Bieber 1964. M. Bieber. *Alexander the Great in Greek and Roman Art*. Chicago, 1964.

Biers 1980. W. R. Biers. "A Group of Leg Vases." *AJA* 84 (1980): 522–24.

Biers 1984/85. W. R. Biers. "A Helmeted Ionian." *JWAG* 42/43 (1984/85): 2–5.

Blok 1995. J. H. Blok. *The Early Amazons: Modern and Ancient Perspectives on a Persistent Myth*. Leiden and New York, 1995.

Blondell 2004. R. Blondell, trans. *Sophocles: The Theban Plays*. Newburyport, Mass., 2004.

Blümel 1966. C. Blümel. *Die klassischen griechischen Skulpturen der Staatlichen Museen zu Berlin*. Berlin, 1966.

Boardman 1972. J. Boardman. "Herakles, Peisistratos and Sons." *Rev. Arch.* (1972): 57–72.

Boardman 1976. J. Boardman. "The Kleophrades Painter at Troy." *AK* 19 (1976): 3–18.

Boardman 1978. J. Boardman. "Exekias." *AJA* (1978): 11–25.

Boardman 1981. J. Boardman. "No, No, Nausicaa." *JWAG* (1981): 38.

Boardman 2001. J. Boardman. *The History of Greek Vases: Potters, Painters, and Pictures*. New York, 2001.

Boardman 2009. J. Boardman. *The Marlborough Gems: Formerly at Blenheim Palace, Oxfordshire*. Oxford, 2009.

Boedeker 1993. D. Boedeker. "Hero Cult and Politics in Herodotus: The Bones of Orestes." In *Cultural Poetics in Archaic Greece: Cult, Performance, Politics*, ed. C. Dougherty and L. Kurke, 164–77. Cambridge, 1993.

Boehringer 1996. D. Boehringer. "Zur Heroisierung Historischer Persönlichkeiten bei den Griechen." In *Retrospektive: Konzepte von Vergangenheit in der griechisch-römischen Antike*, ed. M. Flashar, H.-J. Gehrke, and E. Heinrich, 37–61. Munich, 1996.

Boehringer 2001. D. Boehringer. *Heroenkulte in Griechenland von der geometrischen bis zur klassischen Zeit. Attika, Argolis, Messenien*. Klio Beiheft neue Folge 3. Berlin, 2001.

Bohringer 1979. F. Bohringer. "Cultes d'athlètes en grèce classique: Propos politiques, discours mythiques." *Revue des études anciennes* 81 (1979): 5–18.

Bol 1989. P. C. Bol, ed. *Forschungen zur Villa Albani: Katalog der antiken Bildwerke*, vol. 1. Berlin, 1989.

Bommelaer and Laroche 1991. J.-F. Bommelaer and D. Laroche. *Guide de Delphes: Le site*. Athens and Paris, 1991.

Bonnet 1988. C. Bonnet. *Melqart: Cultes et mythes de l'Héraclès Tyrien en Méditerranée*. Studia Phoenicia 8. Leuven, 1988.

Bonnet 1996. C. Bonnet. "Héraclès travesti." In *Héraclès, les femmes et le féminin: IIe rencontre héracléenne*, ed. C. Jourdain-Annequin and C. Bonnet, 121–31. Brussels and Turnhout, 1996.

Bothmer 1948. D. von Bothmer. "An Attic Black-figured Dinos." *BMFA* 46 (1948): 42–48.

Bothmer 1954. D. von Bothmer. Review of F. Brommer, *Herakles: Die zwölf Taten des Helden in der antiken Kunst und Literatur*, *AJA* 58 (1954): 63–64.

Bothmer 1957. D. von Bothmer. *Amazons in Greek Art*. Oxford, 1957.

Bothmer 1977. D. von Bothmer. "The Struggle for the Tripod." In *Festschrift für Frank Brommer*, ed. U. Höckmann and A. Krug, 51–63. Mainz, 1977.

Bousquet 1963. J. Bousquet. "Inscriptions de Delphes." *BCH* 87 (1963): 188–208.

Bowden 2005. H. Bowden. "Herakles, Herodotos and the Persian Wars." In Bowden and Rawlings 2005, 1–13.

Bowden and Rawlings 2005. H. Bowden and L. Rawlings, eds. *Herakles and Hercules: Exploring a Graeco-Roman Divinity*. Swansea, 2005.

Bowra 1930. C. M. Bowra. *Tradition and Design in the Iliad*. Oxford, 1930.

Bradley 2005. G. Bradley. "Aspects of the Cult of Herakles in Central Italy." In Bowden and Rawlings 2005, 129–51.

Braun and Haevernick 1981. K. Braun and T. E. Haevernick. *Bemalte Keramik und Glas aus dem Kabirenheiligtum bei Theben.* Das Kabirenheiligtum bei Theben 4. Berlin, 1981.

Bravo 2006. J. J. Bravo. "The Hero Shrine of Opheltes/Archemoros at Nemea: A Case Study of Ancient Greek Hero Cult." Ph.D. diss. University of California, Berkeley, 2006.

Brelich 1958. A. Brelich. *Gli eroi greci: Un problema storico-religioso.* Rome, 1958.

British School at Athens 1940. British School at Athens. *Perachora: The Sanctuaries of Hera Akraia, and Limenia.* Oxford, 1940.

Brigger and Giovanni 2004. E. Brigger and A. Giovanni, "Prothésis: Étude sur les rites funéraires chez les Grecs et chez les Étrusques," *MÉFRA* 116, 1 (2004): 179–248.

Brommer 1960. F. Brommer. *Vasenlisten zur griechischen Heldensage,* 2nd ed. Marburg, 1960.

Brommer 1971. F. Brommer. *Denkmälerlisten zur griechischen Heldensage,* 1: *Herakles.* Marburg, 1971.

Brommer 1973. F. Brommer. *Vasenlisten zur griechischen Heldensage,* 3rd ed. Marburg, 1973.

Brommer 1980. F. Brommer. "Theseus and Nausicaa." *JWAG* 38 (1980): 109–12.

Brommer 1983. F. Brommer. *Odysseus: Die Taten und Leiden des Helden in antiker Kunst und Literatur.* Darmstadt, 1983.

Broneer 1942. O. Broneer. "Hero Cults in the Corinthian Agora." *Hesperia* 11 (1942): 128–61.

Bruit 1989. L. Bruit. "Les dieux aux festins des mortels: Théoxénies et Xeniai." In *Entre hommes et dieux: Le convive, le héros, le prophète,* ed. A.-F. Laurens, 13–25. Paris, 1989.

Bruit Zaidman 2005. L. Bruit Zaidman. "Offrandes et nourritures: Repas des dieux et repas des hommes en Grèce ancienne." In *La cuisine et l'autel: Les sacrifices en questions dans les sociétés de la méditerranée ancienne,* ed. S. Georgoudi, R. Koch Piettre, and F. Schmidt, 31–46. Turnhout, 2005.

Bruit Zaidman and Schmitt Pantel 1992. L. Bruit Zaidman and P. Schmitt Pantel. *Religion in the Ancient Greek City.* Cambridge, 1992.

Bruneau 1970. P. Bruneau. *Recherches sur les cultes de Délos à l'époque hellénistique et à l'époque impériale.* Bibliothèque des Écoles Françaises d'Athènes et de Rome 217. Paris, 1970.

Bruneau and Ducat 1983. P. Bruneau and J. Ducat. *Guide de Délos.* Paris, 1983.

Buitron 1972. D. M. Buitron. *Attic Vase Painting in New England Collections.* Exh. cat., Cambridge, Mass.: Fogg Art Museum, Harvard University. Cambridge, Mass., 1972.

Buitron 1977. D. M. Buitron. "A Primer on Pots." *BWAG* 30, no. 1 (1977): 2–4.

Buitron 1992. D. M. Buitron., ed. *The Odyssey and Ancient Art: An Epic in Word and Image.* Exh. cat., Annadale-on-Hudson: Edith C. Blum Art Institute, Bard College. Annandale-on-Hudson, 1992.

Buitron-Oliver 1995. D. Buitron-Oliver. *Douris: A Master Painter of Athenian Red-figure Vases.* Mainz, 1995.

Bulas 1950. K. Bulas. "New Illustrations to the Iliad." *AJA* 54 (1950) 112–18.

Bundrick 2005. S. Bundrick. *Music and Image in Classical Athens.* Cambridge, 2005.

Burgess 2001. J. S. Burgess. *The Tradition of the Trojan War in Homer and the Epic Cycle.* Baltimore, 2001.

Burkert 1985. W. Burkert. *Greek Religion: Archaic and Classical,* trans. J. Raffan. Oxford, 1985.

Burkert 1987a. W. Burkert. "Offerings in Perspective: Surrender, Distribution, Exchange." In *Gifts to the Gods: Proceedings of the Uppsala Symposium 1985,* ed. T. Linders and G. Nordquist, 43–50. Boreas 15. Uppsala, 1987.

Burkert 1987b. W. Burkert. "The Making of Homer in the Sixth Century B.C.: Rhapsodes versus Stesichoros." In *The Amasis Painter and His World: Vase-Painting in Sixth-Century B.C. Athens,* ed. D. von Bothmer, 43–62. Exh. cat., New York: The Metropolitan Museum of Art. New York, 1987.

Burkert 1992. W. Burkert. "Eracle e gli altri eroi culturali del Vicino Oriente." In *Héraclès: D'une rive à l'autre de la méditerranée: Bilan et perspectives,* ed. C. Bonnet and C. Jourdain-Annequin, 111–27. Brussels, 1992.

Burnett 2005. A. P. Burnett. *Pindar's Songs for Young Athletes of Aigina.* Oxford, 2005.

Butz 1994. P. Butz. "The Double Publication of a Sacred Prohibition on Delos: *ID* 68, A and B." *BCH* 118 (1994): 69–98.

Butz 1996. P. Butz. "Prohibitory Inscriptions, Xenoi, and the Influence of the Early Greek Polis." In *The Role of Religion in the Early Greek Polis: Proceedings of the Third International Seminar on Ancient Greek Cult, Organized by the Swedish Institute at Athens, 16–18 October 1992,* ed. R. Hägg, 75–95. ActaAth 8° 14. Stockholm, 1996.

Buxton 1994. R. G. A. Buxton. *Imaginary Greece: The Contexts of Mythology.* Cambridge, 1994.

Cain 1985. H. Cain. *Römische Marmorkandelaber.* Mainz, 1985.

Calame 1998. C. Calame. "Mort héroïque et culte à mystère dans l'Oedipe à Colone de Sophocle." In *Ansichten griechischer Rituale: Geburtstags-Symposium für Walter Burkert, Castelen bei Basel, 15. bis 18. Marz 1996,* ed. F. Graf, 326–56. Stuttgart, 1998.

Calame 2004. C. Calame. "Succession des âges et pragmatique poétique de la justice: Le récit hésiodique des cinq espèces humaines." *Kernos* 17 (2004): 67–102.

Callaghan 1978. P. J. Callaghan. "KRS 1976: Excavations at a Shrine of Glaukos, Knossos." *BSA* 73 (1978): 1–30.

Camp 1986. J. M. Camp. *The Athenian Agora: Excavations in the Heart of Classical Athens.* London, 1986.

Carpenter 1991. T. H. Carpenter. *Art and Myth in Ancient Greece: A Handbook.* London, 1991.

Carpenter 2009. T. H. Carpenter. "Prolegomenon to the Study of Apulian Red-Figure Pottery." *AJA* 113.1 (2009): 2–38.

Carpenter forthcoming. T. H. Carpenter, "The Darius Painter: Text and Content" (in press).

Carter 1987. J. Carter. "The Masks of Ortheia." *AJA* 91 (1987): 355–83.

Caskey 1910. L. D. Caskey. "A Marble Head of Herakles." *Museum of Fine Arts Bulletin* 8 (Boston, 1910): 25–28.

Caskey and Beazley 1963. L. D. Caskey and J. D. Beazley. *Attic Vase Paintings in the Museum of Fine Arts, Boston*, pt. 3. Boston, 1963.

Casson 1971. L. Casson. *Ships and Seamanship in the Ancient World.* Princeton, 1971.

H. Catling 1976. H. W. Catling. "New Excavations at the Menelaion, Sparta." In *Neue Forschungen in griechischen Heiligtümern*, ed. U. Jantzen, 77–90. Tübingen, 1976.

H. Catling 1976–77. H. W. Catling. "Excavations at the Menelaion, Sparta, 1973–1976." *Arch. Rep.* 23 (1976–77): 25–42.

H. Catling and Cavanagh 1976. H. W. Catling and H. Cavanagh. "Two Inscribed Bronzes from the Menelaion, Sparta." *Kadmos* 15 (1976): 145–57.

R. Catling 1992. R. W. V. Catling. "A Votive Deposit of Seventh-century Pottery from the Menelaion." In *Philolakon: Lakonian Studies in Honour of Hector Catling*, ed. J. M. Sanders, 57–75. London, 1992.

Chamoux 1979. F. Chamoux. "Le monument 'de Théogénès': Autel ou statue?" In *Thasiaca*, 143–53. BCH Supplement 5. Athens and Paris, 1979.

Chantraine 1968. P. Chantraine. *Dictionnaire étymologique de la langue grecque*, vol. 1. Paris, 1968.

Christiansen and Melander 1988. J. Christiansen and T. Melander, eds. *Proceedings of the 3rd Symposium on Ancient Greek and Related Pottery: Copenhagen, August 31–September 4, 1987.* Copenhagen, 1988.

Clader 1976. L. Clader. *Helen: the Evolution from Divine to Heroic in Greek Epic Tradition.* Leiden, 1976.

Clairmont 1951. C. W. Clairmont. *Das Parisurteil in der antiken Kunst.* Zurich, 1951.

Clairmont 1993. C. W. Clairmont. *Classical Attic Tombstones*, vol. 1. Kilchberg, 1993.

Clay 2004. D. Clay. *Archilochos Heros: The Cult of Poets in the Greek Polis.* Hellenic Studies 6. Washington, D.C., 2004.

Clement 1955. P. A. Clement. "Geryon and Others in Los Angeles." *Hesperia* 24 (1955): 1–24.

Clement 1958. P. A. Clement. "The Recovery of Helen." *Hesperia* 27 (1958): 47–73.

Clinton 1996. K. Clinton. "A New *Lex Sacra* from Selinus: Kindly Zeuses, Eumenides, Impure and Pure Tritopatores, and Elasteroi." *Classical Philology* 91 (1996): 159–79.

Clinton 2005. K. Clinton. "Pigs in Greek Rituals." In Hägg and Alroth 2005, 167–79.

Coldstream 1976. J. N. Coldstream. "Hero Cults in the Age of Homer." *JHS* 96 (1976): 8–17.

Comella 2002. A. Comella. *I rilievi votivi greci di periodo arcaico e classico: Diffusione, ideologia, committenza.* Bibliotheca Archaeologica 11. Bari, 2002.

Comstock and Vermeule 1976. M. B. Comstock and C. C. Vermeule. *Sculpture in Stone: The Greek, Roman, and Etruscan Collections of the Museum of Fine Arts, Boston.* Boston, 1976.

Connelly 2007. J. B. Connelly. *Portrait of a Priestess: Women and Ritual in Ancient Greece.* Princeton, 2007.

Connolly 1998. A. Connolly. "Was Sophocles Heroised as Dexion?" *JHS* 118 (1998): 1–21.

Conze 1891. A. Conze. *Königliche Museen zu Berlin: Beschreibung der antiken Skulpturen mit Ausschluss der pergamenischen Fundstücke.* Berlin, 1891.

Cook 1953. J. M. Cook. "Mycenae, 1939–1952," part 3: "The Agamemnoneion." *BSA* 48 (1953): 30–68.

Cook 1997. R. M. Cook. *Greek Painted Pottery.* London and New York, 1997.

Currie 2005. B. Currie. *Pindar and the Cult of Heroes.* Oxford and New York, 2005.

Dahmen 2007. K. Dahmen. *The Legend of Alexander the Great on Greek and Roman Coins.* London and New York, 2007.

Daumas 1998. M. Daumas. *Cabiriaca: Recherches sur l'iconographie du culte des Cabires.* Paris, 1998.

Daux 1984. G. Daux. "Sacrifices à Thorikos." *J. Paul Getty Museum Journal* 12 (1984): 145–52.

Davidson 2003. J. Davidson. "Olympia and the Chariot-race of Pelops." In *Sport and Festival in the Ancient World*, ed. D. J. Philips and D. Pritchard, 101–22. Swansea, 2003.

Davidson 2007. J. Davidson. *The Greeks and Greek Love: A Radical Reappraisal of Homosexuality in Ancient Greece.* London, 2007.

Davison 1962. J. A. Davison. "Addenda to Notes on the Panathenaea." *JHS* 82 (1962): 141–42.

Davies 1977. M. I. Davies. "The Reclamation of Helen." *AK* 20 (1977): 73–85.

Dahmen 2007. K. Dahmen. *The Legend of Alexander the Great on Greek and Roman Coins.* London 2007.

Deacy 2008. S. Deacy. *Athena.* London and New York, 2008.

Demangel 1926. R. Demangel. *Fouilles de Delphes, 2: Topographie et architecture, 3: Le sanctuaire d'Athèna Pronaia.* Paris, 1926.

Deneken 1886–90. F. Deneken. "Heros." In *Ausführliches Lexikon der griechischen und römischen Mythologie*, vol. 1, pt. 2, 2441–589, ed. W. H. Roscher. Leipzig, 1886–90.

Denoyelle 1997. M. Denoyelle. *Le cratère des Niobides.* Paris, 1997.

Dentzer 1982. J. M. Dentzer. *Le motif du banquet couché dans le Proche-Orient et le Monde Grec du VIIe au IVe siècle avant J.-C.* Rome, 1982.

Deoudi 1999. M. Deoudi. *Heroenkulte in Homerischer Zeit.* BAR 806. Oxford, 1999.

Despinis 1971. G. I. Despinis. *Symvole ste melete tou ergou tou Agorakritou.* Athens, 1971.

Detienne 1989. M. Detienne. "Culinary Practices and the Spirit of Sacrifice." In *The Cuisine of Sacrifice among the Greeks*, ed. M. Detienne and J.-P. Vernant, 1–20. Chicago, 1989.

Diepolder 1931. H. Diepolder. *Die attischen Grabreliefs des 5. und 4. Jahrhunderts v. Chr.* Berlin, 1931.

Dillon 2002. M. Dillon. *Girls and Women in Classical Greek Religion.* London, 2002.

Dipla 1997. A. Dipla. "Helen, the Seductress?" In *Greek Offerings: Essays on Greek Art in Honour of John Boardman,* ed. O. Palagia, 119–30. Oxford, 1997.

Dressel 1906. H. Dressel. *Fünf Goldmedaillons aus dem Funde von Abukir.* Berlin, 1906.

Ducat 1966. J. Ducat. *Les vases plastiques rhodiens archaïques en terre cuite.* Paris, 1966.

Ducat and Llinas 1964. J. Ducat and C. Llinas. "Ptoion, sanctuaire du héros." *BCH* 88 (1964): 851–64.

Dué 2002. C. Dué. *Homeric Variations on a Lament by Briseis.* Lanham, Md., 2002.

Dunant and Pouilloux 1958. C. Dunant and J. Pouilloux. *Recherches sur l'histoire et les cultes de Thasos,* vol. 2: *De 196 avant J.-C. jusqu'à la fin de l'antiquité.* Études Thasiennes 5. Paris, 1958.

Dunst 1964. G. Dunst. "Leukaspis." *BCH* 88 (1964): 482–85.

Dyggve, Poulsen, and Rhomaios 1934. E. Dyggve, F. Poulsen, and K. Rhomaios. *Das Heroon von Kalydon.* K. Danske Videnskab. Selsk. Skrifter 7, Historisk og filosofisk 4. Copenhagen, 1934.

Ebertshäuser and Waltz 1981. H. C. Ebertshäuser and M. Waltz. *Vasen, Bronzen, Terrakotten des klassischen Altertums.* Munich, 1981.

Edelmann 1999. M. Edelmann. *Menschen auf griechischen Weihreliefs.* Munich, 1999.

Edmunds 1981. L. Edmunds. "The Cults and the Legend of Oedipus." *Harvard Studies in Classical Philology* 85 (1981): 221–38.

Edwards 1985a. A. T. Edwards. *Achilles in the Odyssey.* Beiträge zur klassischen Philologie 171. Königstein, 1985.

Edwards 1985b. A. T. Edwards. "Achilles in the Underworld: *Iliad, Odyssey,* and *Aethiopis.*" *GRBS* 26 (1985): 215–27.

Ekroth 1998. G. Ekroth. "Altars in Greek Hero-cults: A Review of the Archaeological Evidence." In Hägg 1998, 117–30.

Ekroth 2001. G. Ekroth. "Altars on Attic Vases: The Identification of *Bomos* and *Eschara.*" In *Ceramics in Context: Proceeding of the Internordic Colloquium on Ancient Pottery Held at Stockholm, 13–15 June 1997,* ed. C. Scheffer, 115–26. Stockholm Studies in Classical Archaeology 12. Stockholm, 2001.

Ekroth 2002. G. Ekroth. *The Sacrificial Rituals of Greek Hero-cults in the Archaic to the Early Hellenistic Periods. Kernos* Supplement 12. Liège, 2002.

Ekroth 2003. G. Ekroth. "Inventing Iphigeneia? On Euripides and the Cultic Composition of Brauron." *Kernos* 16 (2003): 59–118.

Ekroth 2008. G. Ekroth. "Burnt, Cooked or Raw? Divine and Human Culinary Desires at Greek Animal Sacrifice." In *Transformations in Sacrificial Practices: From Antiquity to the Modern Times: Proceedings of an International Colloquium, Heidelberg, 12–14 July 2006,* ed. E. Stavrianopoulou, A. Michaels, and C. Ambos, 87–111. Performances: Intercultural Studies on Ritual, Play, and Theatre 15. Berlin, 2008.

Ekroth forthcoming a. G. Ekroth. "Pelops Joins the Party: Transformation of a Hero-cult within the Festival at Olympia." In *What is a Festival? Rosendal, Norway, May 19–May 22, 2006,* ed. R. Brandt and J. W. Iddeng (in press).

Ekroth forthcoming b. G. Ekroth. "Theseus and the Stone: The Iconographical and Ritual Contexts of a Greek Votive Relief." In *Divine Images and Human Imaginations in Greece and Rome,* ed. J. Mylonopoulos (in press).

Ensoli 1996. S. Ensoli. "Le sirene omeriche e le sirene musicanti di età classica." In Andreae and Parisi Presicce 1996, 96–107.

Eretria 2004. *Eretria: A Guide to the Ancient City,* ed. P. Ducrey et al. Gollion, Switzerland, 2004.

Erskine 2001. A. Erskine. *Troy between Greece and Rome: Local Tradition and Imperial Power.* Oxford, 2001.

Étienne and Le Dinahet 1991. R. Étienne and M.-T. Le Dinahet. *L'espace sacrificiel dans les civilisations méditerranéennes de l'antiquité: Actes du colloque tenu a la Maison de l'Orient, Lyon, 4–7 juin 1988.* Publications de la Bibliothèque Salomon-Reinach 5. Paris, 1991.

Farnell 1921. L. R. Farnell. *Greek Hero Cults and Ideas of Immortality.* Oxford, 1921.

Fedak 1990. J. Fedak. *Monumental Tombs of the Hellenistic Age: A Study of Selected Tombs from the Pre-Classical to the Early Imperial Era.* Phoenix Supplement 27. Toronto, 1990.

Ferguson 1944. W. S. Ferguson. "The Attic Orgeones." *Harv. Theol. Rev.* 37 (1944): 61–140.

Ferrari 2003. G. Ferrari. "Myth and Genre on Athenian Vases." *Cl. Ant.* 22 (2003): 37–54.

Fontenrose 1968. J. Fontenrose. "The Hero as Athlete." *University of California Studies in Classical Antiquity* 1 (1968): 73–104.

Frickenhaus 1911. A. Frickenhaus. "Das Herakleion von Melite." *AM* 36 (1911): 113–44.

Fuchs 1959. W. Fuchs, *Die Vorbilder der neuattischen Reliefs.* Berlin, 1959.

Fullerton 1990. M. D. Fullerton. *The Archaistic Style in Roman Statuary.* Mnemosyne 10. Leiden and New York, 1990.

Funke 2000. S. Funke. *Aiakidenmythos und epirotisches Königtum: Der Weg einer hellenistischen Monarchie.* Stuttgart, 2000.

Furtwängler 1897. A. Furtwängler. *Sammlung Somzée: Antike Kunstdenkmäler.* Munich, 1897.

Gais 1978. R. M. Gais. "Some Problems of River-God Iconography." *AJA* 82 (1978) 355–70.

Galerie Georges Petit 1921. *Catalogue des tableaux anciens.* Auction cat., Paris: Galerie Georges Petit, May 30–31, and June 1, 1921.

Galinsky 1972. G. K. Galinsky. *The Herakles Theme: The Adaptations of the Hero in Literature from Homer to the Twentieth Century.* Totowa, N. J., 1972.

Gantz 1993. T. Gantz. *Early Greek Myth: A Guide to Literary and Artistic Sources.* Baltimore, 1993.

García Tejeiro and Molinos Tejada 2000. M. García Tejeiro and M. T. Molinos Tejada. "Les héros méchants." In Pirenne-Delforge and Suárez de la Torre 2000, 111–23.

Gardeisen 1996. A. Gardeisen. "Sacrifices d'animaux à l'Hérakleion de Thasos." *BCH* 120 (1996): 799–820.

Garland 1985. R. Garland. *The Greek Way of Death.* New York, 1985.

Gebauer 2002. J. Gebauer. *Pompe und Thysia: Attische Tieropfer-darstellungen auf Schwarz- und Rotfigurigen Vasen.* Eikon 7. Münster, 2002.

Gebhard 1993. E. R. Gebhard. "The Isthmian Games and the Sanctuary of Poseidon in the Early Empire." In *The Corinthia in the Roman Period: Including Papers Given at a Symposium Held at the Ohio State University on 7–9 March 1991,* ed. T. E. Gregory, 78–94. Journal of Roman Archaeology Supplement 8. Ann Arbor, 1993.

Gebhard 2005. E. R. Gebhard. "Rites for Melikertes-Palaimon in the Early Roman Corinthia." In *Urban Religion in Corinth: Inter-disciplinary Approaches,* ed. D. N. Schowalter and S. J. Friesen, 165–203. Harvard Theological Studies 53. Cambridge, Mass., 2005.

Gebhard and Dickie 1999. E. R. Gebhard and M. W. Dickie. "Melikertes-Palaimon, Hero of the Isthmian Games." In Hägg 1999, 159–65.

Gebhard and Reese 2005. E. R. Gebhard and D. S. Reese. "Sacrifices for Poseidon and Melikertes-Palaimon at Isthmia." In Hägg and Alroth 2005, 125–54.

Gill 1991. D. H. Gill. *Greek Cult Tables.* New York, 1991.

Giuliani 2003. L. Giuliani. *Bild und Mythos: Geschichte der Bilder-zählung in der griechischen Kunst.* Munich, 2003.

Glynn 1981. R. Glynn. "Herakles, Nereus and Triton: A Study of Icon-ography in Sixth-Century Athens." *AJA* 85, no. 2 (1981): 121–32.

Gow 1934. A. S. F. Gow. "ΙΥΓΞ, ΡΟΜΒΟΣ, Rhombus, Turbo." *JHS* 54 (1934) 1–13.

Grandjean and Salviat 2000. Y. Grandjean and F. Salviat. *Guide de Thasos,* 2d ed. Paris, 2000.

Greifenhagen 1977. A. Greifenhagen. "Mastoi." In *Festschrift für Frank Brommer,* ed. U. Höckmann and A. Krug, 133–37. Mainz, 1977.

Griffiths 1985. A. Griffiths. "A Ram Called Patroklos." *BICS* 21 (1985): 49–50.

Griffiths 1989. A. Griffiths. "Patroklos the Ram (Again)." *BICS* 36 (1989): 139–40.

Grubert 1975. B. Grubert. "Johann Heinrich Wilhelm Tischbein: Homer nach Antiken Gezeichnet." Ph.D. diss. Ruhr-Universität Bochum, 1975.

Guillon 1943. P. Guillon. *Les trépieds retrouvées du Ptoion.* 2 vols. Bibliothèque des Écoles Françaises d'Athènes et de Rome 153. Paris, 1943.

Hägg 1987. R. Hägg. "Gifts to the Heroes in Geometric and Archaic Greece." In *Gifts to the Gods: Proceedings of the Uppsala Symposium 1985,* ed. T. Linders and G. Nordquist, 93–99. Boreas 15. Uppsala, 1987.

Hägg 1994. R. Hägg, ed. *Ancient Greek Cult Practice from the Epi-graphical Evidence: Proceedings of the Second International Seminar on Ancient Greek Cult, Organized by the Swedish Institute at Athens, 22–24 November 1991.* ActaAth 8° 13. Stockholm, 1994.

Hägg 1998. R. Hägg, ed. *Ancient Greek Cult Practice from the Archae-ological Evidence: Proceedings of the Fourth International Seminar on Ancient Greek Cult, Organized by the Swedish Institute at Athens, 22–24 October 1993.* ActaAth 8° 15. Stockholm, 1998.

Hägg 1999. R. Hägg, ed. *Ancient Greek Hero Cult: Proceedings of the Fifth International Seminar on Ancient Greek Cult, Organized by the Department of Classical Archaeology and Ancient History, Göteborg University, 21–23 April 1995.* ActaAth 8° 16. Stockholm, 1999.

Hägg and Alroth 2005. R. Hägg and B. Alroth, eds. *Greek Sacrificial Ritual: Olympian and Chthonian: Proceedings of the Sixth Interna-tional Seminar on Ancient Greek Cult, Organized by the Department of Classical Archaeology and Ancient History, Göteborg University, 25–27 April 1997.* ActaAth 8° 18. Stockholm, 2005.

Hainsworth 1993. B. Hainsworth. *The Iliad: A Commentary,* vol. 3. Cambridge, 1993.

Hall 1989. E. Hall. *Inventing the Barbarian: Greek Self-Definition through Tragedy.* Oxford and New York, 1989.

Hall 1995. J. M. Hall. "How Argive Was the 'Argive' Heraion? The Political and Cultic Geography of the Argive Plain, 900–400 BC." *AJA* 99 (1995): 577–613.

Hall 1999. J. M. Hall. "Beyond the *Polis*: The Multilocality of Heroes." In Hägg 1999, 49–59.

Haspels 1936. C. Haspels. *Attic Black-figured Lekythoi.* Paris 1936.

Hausmann 1960. U. Hausmann. *Griechische Weihreliefs.* Berlin, 1960.

Havelock 1970. C. M. Havelock. *Hellenistic Art: The Art of the Classical World from the Death of Alexander the Great to the Battle of Actium.* Greenwich, Conn., 1970.

Hecht 1956. R. E. Hecht. "A Colossal Head of Polyphemos." *Memoirs of the American Academy in Rome* 24 (1956): 137–45.

Hedreen 1991. G. Hedreen. "The Cult of Achilles in the Euxine." *Hesperia* 60 (1991): 313–30.

Hedreen 2001. G. Hedreen. *Capturing Troy: The Narrative Functions of Landscape in Archaic and Early Classical Greek Art.* Ann Arbor, 2001.

Hedreen forthcoming. G. Hedreen. "The Trojan War, Theoxenia, and Aigina in Pindar's Sixth *Paian* and the Aphaia Sculptures." In *Songs for Aigina: Contextual Studies of Pindar and Bacchylides,* ed. D. Fearn. Oxford (in press).

Henrichs 1991. A. Henrichs. "Namenlosigkeit und Euphemismus: Zur Ambivalenz der chthonischen Mächte im attischen Drama." In *Fragmenta dramatica: Beiträge zur Interpretation der griechischen Tragikerfragmente und ihrer Wirkungsgeschichte,* ed. A. Harder and H. Hofmann, 161–201. Göttingen, 1991.

Henrichs 1993. A. Henrichs. "The Tomb of Aias and the Prospect of Hero Cult in Sophokles." *Cl. Ant.* 12 (1993): 165–80.

Hermary et al. 2004. A. Hermary et al. "Sacrifices. Les sacrifices dans le monde grec." In *ThesCRA,* vol. 1, 59–134. Los Angeles, 2004.

Hibler 1993. D. Hibler. "The Hero-reliefs of Lakonia: Changes in Form and Function." In *Sculpture from Arcadia and Laconia: Pro-ceedings of an International Conference Held at the American School of Classical Studies at Athens, April 10–14, 1992,* ed. O. Palagia and W. Coulson, 199–204. Oxbow Monograph 30. Oxford, 1993.

Hill 1943. D. K. Hill. "Ancient Metal Reliefs." *Hesperia* 12 (1943): 97–114.

Hill 1945. D. K. Hill. "Bonn or Colmar Painter?" *AJA* 49 (1945) 503–7.

Hill 1946. D. K. Hill. *Soldiers in Ancient Days.* Baltimore, 1946.

Hill 1947. D. K. Hill. "The Technique of Greek Metal Vases and Its Bearing on Vase Forms in Metal and Pottery." *AJA* 51 (1947): 248–56.

Hill 1948. D. K. Hill. "Ancient Representations of Herakles as a Baby." *Gazette des beaux-arts* 3 (1948): 193–200.

Hill 1949. D. K. Hill. *Catalogue of Classical Bronze Sculpture in the Walters Art Gallery.* Baltimore, 1949.

Hill 1950a. D. K. Hill. "The Trojan Cycle." *BWAG* 2, no. 4 (1950): 3–4.

Hill 1950b. D. K. Hill. "Two Statuettes of Hercules." *Archeologia Classica* 2, no. 2 (1950): 198–200.

Hill 1951. D. K. Hill. "A Greek Calyx Krater." *BWAG* 3, no. 5 (1951): 3.

Hill 1952. D. K. Hill. "Five Pieces of Early Greek Armor." *Gazette des beaux-arts* (1952): 309–18.

Hill 1956a. D. K. Hill. "Greek Animals." *BWAG* 8, no. 4 (1956): 2–4.

Hill 1956b. D. K. Hill. "Other Geometric Objects in Baltimore." *AJA* 60 (1956): 35–42.

Hill 1959a. D. K. Hill. "Greek Vases Acquired by the Walters Art Gallery." *AJA* 63 (1959): 181–83.

Hill 1959b. D. K. Hill. "Life in Athens." *BWAG* 11, no. 7 (1959): 2–3.

Hill 1960. D. K. Hill. "Oil Bottles for Athletes in Ancient Greece." *BWAG* 13, no. 3 (1960): 4.

Hill 1961. D. K. Hill. "Accessions to the Greek Collection, 1960 and 1961." *JWAG* 24 (1961): 39–53.

Hill 1962. D. K. Hill. "Greek Myths: The Trojan War." *BWAG* 14, no. 8 (1962): 2.

Hill 1968a. D. K. Hill. "The Diadoumenos." *BWAG* 20, no. 3 (1968) 1–2.

Hill 1968b. D. K. Hill. "New Greek Relief." *BWAG* 20, no. 4 (1968): 2.

Hill 1970. D. K. Hill. "Polykleitos: Diadoumenos, Doryphoros and Hermes." *AJA* 74 (1970): 21–24.

Hill 1974. D. K. Hill. "Chariots of Early Greece." *Hesperia* 43 (1974): 441–46.

Himmelmann-Wildschütz 1968. N. Himmelmann-Wildschütz. Review of C. Blümel, *Die klassisch griechischen Skulpturen der Staatlichen Museen zu Berlin*, in *Gnomon* 40 (1968): 630–32.

Höckmann 1985. O. Höckmann. *Antike Seefahrt.* Munich, 1985.

Hoffmann 1992–93. H. Hoffmann. "'Crocodile Love' (The Dionysian Connection): Further Studies in the Iconology of Athenian Vase Painting." *Hephaistos* 11–12 (1992–1993): 133–69.

Hofstetter 1990. E. Hofstetter. *Sirenen im archaischen und klassischen Griechenland.* Beiträge zur Archäologie 19. Würzburg, 1990.

Homolle 1901. T. Homolle. "Le temple d'Athène Pronaia." *Revue de l'art ancien et moderne* 10 (1901): 361–77.

Hooker 1950. E. M. Hooker. "The Sanctuary and Altar of Chryse in Attic Red-figure Vase Paintings of the Late Fifth and Early Fourth Centuries BC." *JHS* 70 (1950): 35–41.

Hornblower 1996. S. Hornblower. *A Commentary on Thucydides*, 2: *Books 4–5.* Oxford and New York, 1996.

Hôtel Drouot 1910. *Catalogue des objets antiques et du moyen âge / Marbres, orfèvrerie, verrerie, céramique, bronzes, ivoires, etc.* Auction cat., Paris: Hôtel Drouot, May 19–21, 1910.

Hughes 1999. D. D. Hughes. "Hero Cult, Heroic Honors, Heroic Dead: Some Developments in the Hellenistic and Roman Periods." In Hägg 1999, 167–75.

Isler-Kerényi 2007. C. Isler-Kerényi. *Dionysos in Archaic Greece: An Understanding through Images*, trans. W. G. E. Watson. Leiden and Boston, 2007.

Jacquemin and Laroche 1990. A. Jacquemin and D. Laroche. "Le piliers attalides et la terrasse pergaménienne à Delphes." *Rev. Arch.* (1990): 215–21.

Jameson 1951. M. H. Jameson. "The Hero Echetlaeus." *TAPA* 82 (1951): 49–61.

Jameson 1991. M. H. Jameson. "Sacrifice before Battle." In *Hoplites: The Classical Greek Battle Experience*, ed. V. D. Hanson, 197–227. London and New York, 1991.

Jameson 1994a. M. H. Jameson. "Theoxenia." In Hägg 1994, 35–57.

Jameson 1994b. M. H. Jameson. "The Ritual of the Nike Parapet." In *Ritual, Finance, Politics: Athenian Democratic Accounts Presented to David Lewis*, ed. R. Osborne and S. Hornblower, 307–24. Oxford and New York, 1994.

Jameson, Jordan, and Kotansky 1993. M. H. Jameson, D. R. Jordan, and R. D. Kotansky. *A Lex Sacra From Selinous.* Greek, Roman, and Byzantine Monographs 11. Durham, 1993.

Janko 1986. R. Janko. "The Shield of Heracles and the Legend of Cycnus." *Classical Quarterly* 36, no. 1 (1986): 38–59.

Johansen 1951. K. F. Johansen. *The Attic Grave-Reliefs of the Classical Period.* Copenhagen, 1951.

Johansen 1967. K. F. Johansen. *The Iliad in Early Greek Art.* Copenhagen, 1967.

Johnston 1999. S. I. Johnston. *Restless Dead: Encounters between the Living and the Dead in Ancient Greece.* Berkeley, 1999.

Kader 1995. I. Kader. "Heroa und Memorialbauten." In *Stadtbild und Bürgerbild im Hellenismus: Kolloquium, München 24. bis 26. Juni 1993*, ed. M. Wörrle and P. Zanker, 199–229. Munich, 1995.

Kaempf-Dimitriadou 1979. S. Kaempf-Dimitriadou. *Die Liebe der Goetter in der attischen Kunst des 5. Jahrhunderts v. Chr.* Bern, 1979.

Kahil 1955. L. Kahil, *Les enlèvements et le retour d'Hélène dans les textes et les documents figurés.* Paris, 1955.

Kakrides 1986. I. T. Kakridis, ed. *Ellenike Mythologia.* Athens, 1986.

Kallipolitis 1978. V. G. Kallipolitis. "He base tou agalmatos tes Rhamnousias Nemeses." *Archaiologike Ephemeris* 1978 (1980): 1–90.

Kaltsas 2002. N. Kaltsas. *Sculpture in the National Archaeological Museum, Athens*, trans. D. Hardy. Los Angeles, 2002.

Kaltsas 2006. N. Kaltsas. *Athens-Sparta*. Exh. cat., New York: Alexander S. Onassis Public Benefit Foundation. New York, 2006.

Karouzos 1923. C. I. Karouzos. "Apo to Herakleion tou Kunosargous." *Deltion* 8 (1923): 85–102.

Karouzou 1967. S. Karouzou. *Ethnikon Archaiologikon Mouseion: Sillogi glipton, Perigraphikos Katalogos*. Athens, 1967.

Karouzou 1970. S. Karouzou. "Stamnos de Polygnote au Musée National d'Athènes." *Rev. Arch.* 1970: 229–52.

Karouzou 1985. S. Karouzou. "He Elene tes Spartes: He megale prochous apo ten Analepse tes Kunourias." *Archaiologike Ephemeris* 124 (1985): 33–44.

Karwiese 1980. S. Karwiese. "Lysander as Herakliskos Drakonopnigon, 'Heracles the Snake Strangler'." *Numismatic Chronicle* 140 (1980): 1–27

Kastriotis 1908. N. Kastriotis. *Glypta tou Ethnikou Mouseiou: Katalogos Perigraphikos*. Athens, 1908.

Kavvadias 1890–1892. P. Kavvadias. *Glypta tou Ethnikou Mouseiou: Katalogos Perigraphikos*. Athens, 1890–1892.

Kearns 1989. E. Kearns. *The Heroes of Attica*, BICS Supplement 57. London, 1989.

Kearns 1992. E. Kearns. "Between God and Man: Status and Function of Heroes and Their Sanctuaries." In *Le sanctuaire grec*, ed. A. Schachter and J. Bingen, 64–99 (discussion 100–107). Entretiens sur l'antiquité classique 37. Geneva, 1992.

Kemp-Lindemann 1975. D. Kemp-Lindemann. *Darstellungen des Achilleus in griechischer und römischer Kunst*. Frankfurt, 1975.

Keuls 1983. E. C. Keuls. "Attic Vase-Painting and the Home Textile Industry." In *Ancient Greek Art and Iconography*, ed. W. C. Moon, 208–30. Madison, 1983.

Keuls 1985. E. C. Keuls. *The Reign of the Phallus: Sexual Politics in Ancient Athens*. New York, 1985.

Klinger 1993. S. Klinger. "The Sources of Oltos' Design on the One-Piece Amphora London E 258." *AA* (1993): 183–200.

Knauss 1997. J. Knauss. "Agamemnóneion phréar: Der Stausee der Mykener." *Antike Welt* 28 (1997): 381–95.

Knauss 2004. J. Knauss. "Herakles in Olympia: Mykenische Wasserbauten und die Legende von der Ausmistung des Augiasstalles." *Antike Welt* 35. 4 (2004): 25–32.

Köhne 1998. E. Köhne. *Die Dioskuren in der griechischen Kunst von der Archaik bis zum Ende des 5. Jahrhunderts v. Chr.* Hamburg, 1998.

Kondoleon, Grossmann, and Ledig 2008. C. Kondoleon, R. A. Grossmann, and J. Ledig. *MFA Highlights: Classical Art*. Boston, 2008.

Kozloff 1980–81. A. P. Kozloff. "Companions of Dionysus." *Bulletin of the Cleveland Museum of Art* 67–68 (1980–81): 206–19.

Krieger 1973. X. Krieger. "Der Kampf zwischen Peleus und Thetis in der griechischen Vasenmalerei. Eine typologische Untersuchung." Ph.D. diss. University of Münster, 1973.

Kron 1976. U. Kron. *Die zehn attischen Phylenheroen: Geschichte, Mythos, Kult und Darstellungen*. AM Beiheft 5. Berlin, 1976.

Krumme 1989. M. Krumme. *Kunst und Archäologie: Die Sammlung Brommer*. Exh. cat., Berlin: Antikenmuseum Berlin, Staatliche Museen Preußischer Kulturbesitz. Berlin, 1989.

Kuhn 1985. G. Kuhn. "Untersuchungen zur Funktion der Säulenhalle in Archaischer und Klassischer Zeit." *JDAI* 100 (1985): 169–317.

Kunisch 1997. N. Kunisch. *Makron*. Kerameus 10. Mainz, 1997.

Kunze 1999. M. Kunze, ed. *Wiedergeburt griechischer Götter und Helden: Homer in der Kunst der Goethezeit*. Exh. cat., Stendal: Winckelmann-Museum. Mainz, 1999.

Kyrieleis 1973. H. Kyrieleis. "Kathapr Ermes kai Oros." *Antike Plastik* 12 (1973): 133–47.

Kyrieleis 1975. H. Kyrieleis. *Bildnisse der Ptolemäer*. Archäologische Forschungen 2. Berlin, 1975.

Kyrieleis 2002. H. Kyrieleis. "Zu den Anfängen des Heiligtums von Olympia." In *Olympia, 1875–2000: 125 Jahre Deutsche Ausgrabungen: Internationales Symposion, Berlin 9. –11. November 2000*, ed. H. Kyrieleis, 213–20. Mainz, 2002.

Kyrieleis 2006. H. Kyrieleis. *Anfänge und Frühzeit des Heiligtums von Olympia: Die Ausgrabungen am Pelopion, 1987–1996*. Olympische Forschungen 31. Berlin, 2006.

Laguna-Mariscal and Sanz-Morales 2005. G. Laguna-Mariscal and M. Sanz-Morales. "Was the Relationship between Achilles and Patroclus Homoerotic? The View of Apollonius Rhodius." *Hermes* 133 (2005): 120–23.

Lalonde 1968. G. V. Lalonde. "A Fifth-Century Hieron Southwest of the Athenian Agora." *Hesperia* 37 (1968): 123–33.

Lalonde 1980. G. V. Lalonde. "A Hero Shrine in the Athenian Agora." *Hesperia* 49 (1980): 97–105.

Lambrinoudakis 1988. V. Lambrinoudakis. "Veneration of Ancestors in Geometric Naxos." In *Early Greek Cult Practice: Proceedings of the Fifth International Symposium at the Swedish Institute at Athens, 26–29 June, 1986*, ed. R. Hägg, N. Marinatos, and G. Nordquist, 235–46. Stockholm, 1988.

Langdon 1993. S. Langdon, ed. *From Pasture to Polis: Art in the Age of Homer*. Exh. cat., Columbia: Museum of Art and Archaeology, University of Missouri-Columbia. Columbia, 1993.

Langenfaß-Vuduroglu 1973. F. Langenfaß-Vuduroglu. "Mensch und Pferd auf griechischen Grab- und Votivsteinen." Ph.D. diss. Ludwig-Maximilians-Universität, Munich, 1973.

Larson 1995. J. Larson. *Greek Heroine Cults*. Madison, 1995.

Larson 2007. J. Larson. *Ancient Greek Cults: A Guide*. New York, 2007.

Laser 1987. S. Laser. *Sport und Spiel*. Archeologia Homerica. Göttingen, 1987.

Latacz et al. 2008. J. Latacz et al., eds. *Homer: Der Mythos von Troia in Dichtung und Kunst*. Exh. cat., Basel: Antikenmuseum Basel und Sammlung Ludwig. Munich, 2008.

Lawton 1995. C. L. Lawton, *Attic Document Reliefs: Art and Politics in Ancient Athens*. Oxford, 1995.

Le Roy 1977. C. Le Roy. "Pausanias à Marmaria (XXVIII)." In *Études Delphiques*, 247–71. BCH Supplement 4. Paris, 1977.

Lefkowitz 2002. M. Lefkowitz. "Predatory Goddesses." *Hesperia* 71 (2002): 325–44.

Leipen 1971. N. Leipen. *Athena Parthenos: A Reconstruction.* Toronto, 1971.

Lévêque and Verbanck-Piérard 1992. P. Lévêque and A. Verbanck-Piérard. "Héraclès, héros ou dieu?" In *Héraclès: D'une rive à l'autre de la méditerranée: Bilan et perspectives,* ed. C. Bonnet and C. Jourdain-Annequin, 43–65. Études de philologie, d'archéologie et d'histoire ancienne 28. Brussels, 1992.

Levkoff 2008. M. L. Levkoff, *Hearst, the Collector.* Exh. cat., Los Angeles County Museum of Art. New York, 2008.

Lezzi-Hafter 2007. A. Lezzi-Hafter, "Kinderfreund Hermes: Zu einer Kanne des Frauenbad-Malers." In ΠΟΤΝΙΑ ΘΗΡΩΝ: *Festschrift für Gerda Schwarz zum 65. Gebrutstag,* ed. E. Christof et al., 225–27. Vienna, 2007.

Lincoln 1976. B. Lincoln. "The Indo-European Cattle-Raiding Myth." *HR* 16.1 (1976): 42–65.

Lissarrague 1989. F. Lissarrague. "The World of the Warrior." In *A City of Images: Iconography and Society in Ancient Greece,* ed. Claude Bérard et al., trans. D. Lyons, 39–51. Princeton, 1989.

Llewellyn-Jones 2005. L. Llewellyn-Jones. "Herakles Re-dressed: Gender, Clothing, and the Construction of a Greek Hero." In Bowden and Rawlings 2005, 51–69.

Llinas 1965. C. Llinas. "Sanctuaire du Héros Ptoios." *BCH* 89 (1965): 914–17.

Llinas 1966. C. Llinas. "Ptoion." *BCH* 90 (1966): 936–43.

Loraux 1995. N. Loraux. *The Experiences of Tiresias: The Feminine and the Greek Man,* trans. P. Wissing. Princeton, 1995.

Lowenstam 1981. S. Lowenstam. "The Death of Patroklos: A Study in Typology." *Beiträge zur klassischen Philologie* 133 (1981).

Luce 1916. S. B. Luce. "A Red-figured Pyxis." *University of Pennsylvania Museum Journal* 7 (1916): 269–76.

Luce 1924. S. B. Luce. "Studies of the Exploits of Herakles on Vases, [1]." *AJA* 28 (1924): 296–325.

Luce 1930. S. B. Luce "Studies of the Exploits of Herakles on Vases, 2: The Theft of the Delphic Tripod." *AJA* 34 (1930): 313–33.

Luckner 1972. K. T. Luckner, "Greek Vases; Shapes and Uses." *Toledo Museum of Art Museum News* 15, no. 3 (1972): 63–86.

Lyons 1997. D. Lyons. *Gender and Immortality: Heroines in Ancient Greek Myth and Cult.* Princeton, 1997.

Maaß 2007. M. Maaß. *Maler und Dichter, Mythos, Fest und Alltag—Griechische Vasenbilder.* Bildhefte des Badisches Landesmuseum Karlsruhe 4. Karlsruhe, 2007.

Machaira 2000. V. Machaira. "He Sponde ston Eroiko kai sto Theiko Kyklo." In *Agathos Daimon: Mythes et cultes: Études d'iconographie en l'honneur de Lily Kahil,* 339–44. BCH Supplement 38. Athens, 2000.

Maclean and Aitken 2001. J. K. Maclean and E. . B. Aitken, ed. and trans. *Heroikos: Flavius Philostratus.* Atlanta, 2001.

Maderna 2005. C. Maderna. "Zum Feindbild der Ptolemaër." In Beck, Bol, and Bückling 2005, 258–66.

Maksimova 1927. M. L. Maksimova. *Les vases plastiques dans l'antiquité (époque archaïque).* Paris, 1927.

Malkin 1987. I. Malkin. *Religion and Colonization in Ancient Greece.* Leiden, 1987.

Malkin 1993. I. Malkin. "Land Ownership, Territorial Possession, Hero Cults, and Scholarly Theory." In *Nomodeiktes: Greek Studies in Honor of Martin Ostwald,* ed. R. M. Rosen and J. Farrell, 225–34. Ann Arbor, 1993.

Malkin 1998. I. Malkin. *The Returns of Odysseus: Colonization and Ethnicity.* Berkeley, 1998.

Mallwitz 1972. A. Mallwitz. *Olympia und Seine Bauten.* Munich, 1972.

Mallwitz 1988. A. Mallwitz. "Cult and Competition Locations at Olympia." In *The Archaeology of the Olympics: The Olympics and Other Festivals in Antiquity,* ed. W. J. Raschke, 79–109. Wisconsin, 1988.

March 1998. J. March, *Cassell Dictionary of Classical Mythology.* London, 1998.

March 2000. J. March. "Vases and Tragic Drama: Euripides' Medea and Sophocles' Lost Tereus." In *Word and Image in Ancient Greece,* ed. K. N. Rutter and B. A. Sparkes, 119–39. Edinburgh, 2000.

Marconi 2004. C. Marconi. *Greek Vases, Images, Contexts, and Controversies: Proceedings of the Conference Sponsored by the Center for the Ancient Mediterranean at Columbia University, 23–24 March 2002.* Leiden and Boston, 2004.

Markoe 1989. G. E. Markoe. "The 'Lion Attack' in Archaic Greek Art: Heroic Triumph." *Cl. Ant.* 8 (1989): 86–115.

Martin 1951. R. Martin. *Recherches sur l'Agora grecque.* Bibliothèque des Écoles Françaises d'Athènes et de Rome 74. Paris, 1951.

Massarenti 1897. *Catalogue du Musée de peinture, sculpture et archéologie au Palais Accoramboni,* 2 vols. Rome, 1897.

Mastronarde 2005. D. Mastronarde. "The Gods." In *A Companion to Greek Tragedy,* ed. J. Gregory, 321–32. Malden, Mass., 2005.

Matheson 2005. S. B. Matheson. "A Farewell with Arms: Departing Warriors on Greek Vases." In *Periklean Athens and Its Legacy: Problems and Perspectives,* ed. J. M. Barringer and J. M. Hurwit, 23–35. Austin, 2005.

Maul-Mandelartz 1990. E. Maul-Mandelartz. *Griechische Reiterdarstellungen in agonistischem Zusammenhang.* Europäische Hochschulschriften ser. 38, vol. 32. Frankfurt, 1990.

Mayor 2000. A. Mayor. *The First Fossil Hunters: Paleontology in Greek and Roman Times.* Princeton, 2000.

Mazarakis Ainian 1999. A. Mazarakis Ainian. "Reflections on Hero Cults in Early Iron Age Greece." In Hägg 1999, 9–36.

McCauley 1999. B. McCauley. "Heroes and Power: The Politics of Bone Transferral." In Hägg 1999, 85–98.

Merkelbach and West 1967. R. Merkelbach and M. L. West, eds. *Fragmenta Hesiodea.* Oxford, 1967.

Meuli 1946. K. Meuli. "Griechische Opferbräuche." In *Phyllobolia für Peter von der Mühll zum 60. Geburtstag am 1. August 1945,* 185–288. Basel, 1946.

Meyer 1988. M. Meyer. "Männer mit Geld: Zu einer rotfigurigen Vase mit 'Alltagsszene'." *JDAI* 103 (1988): 87–125.

Meyer 1989. M. Meyer. *Die griechischen Urkundenreliefs.* AM Beiheft 13. Berlin, 1989.

Meyer-Baer 1970. K. Meyer-Baer. *Music of the Spheres and the Dance of Death: Studies in Musical Iconology.* Princeton, 1970.

Michelakis 2002. P. Michelakis. *Achilles in Greek Tragedy.* Cambridge, 2002.

Miles 1989. M. M. Miles. "A Reconstruction of the Temple of Nemesis." *Hesperia* 58, no. 2 (1989): 131–249.

M. Miller 1995. M. C. Miller. "Priam, King of Troy." In *The Ages of Homer: A Tribute to Emily Townsend Vermeule,* ed. J. B. Carter and S. P. Morris, 449–65. Austin, 1995.

S. Miller 1990. S. G. Miller, ed. *Nemea: Guide to the Site and the Museum.* Berkeley, 1990.

S. Miller 2002. S. G. Miller. "The Shrine of Opheltes and the Earliest Stadium of Nemea." In *Olympia, 1875–2000. 125 Jahre Deutsche Ausgrabungen. Internationales Symposion, Berlin 9. –11. November 2000,* ed. H. Kyrieleis, 239–50. Mainz, 2002.

S. Miller 2004. S. G. Miller. *Ancient Greek Athletics.* New Haven, 2004.

Mitropoulou 1975. E. Mitropoulou. *Libation Scenes with Oinochoe in Votive Reliefs.* Athens, 1975.

Molyneux 1972. J. H. Molyneux. "Two Problems Concerning Heracles in Pindar *Olympian* 9. 28–41." *TAPA* 103 (1972): 301–27.

Mommsen 1980. H. Mommsen. "Achill und Aias pflichtvergessen?" In *Tainia: Roland Hampe zum 70. Geburtstag am 2. Dezember 1978,* ed. H. A. Cahn and E. Simon, 139–52. Mainz, 1980.

Moon 1983. W. G. Moon. "The Priam Painter: Some Iconographic and Stylistic Considerations." In *Ancient Greek Art and Iconography,* 97–118. Madison, 1983.

Moon 1985. W. G. Moon. "Some New and Little-known Vases by the Rycroft and Priam Painters." In *Greek Vases in The J. Paul Getty Museum,* vol. 2, 41–70. Malibu, 1985.

Moon and Berge 1979. W. G. Moon and L. Berge, eds. *Greek Vase-Painting in Midwestern Collections.* Exh. cat., Chicago: The Art Institute of Chicago. Chicago, 1979.

Moore 1971. M. Moore. "Horses in Black-Figure Greek Vases of the Archaic Period, ca. 620–480 BC." Ph.D. diss. Institute of Fine Arts, New York University, 1971.

Moore 1980. M. B. Moore, "Exekias and Telamonian Ajax." *AJA* 84 (1980): 417–34.

Moret 1984. J.-M. Moret. *Oedipe, la Sphinx et les thébains: Essai de Mythologie iconographique.* Rome, 1984.

Morgan and Whitelaw 1991. C. Morgan and T. Whitelaw. "Pots and Politics: Ceramic Evidence for the Rise of the Argive State." *AJA* 95 (1991): 79–108.

Morris 1984. S. P. Morris. *The Black and White Style: Athens and Aegina in the Orientalizing Period.* New Haven, 1984.

Morris 1988. I. Morris. "Tomb Cult and the 'Greek Renaissance': The Past in the Present in the Eighth Century B.C." *Antiquity* 62 (1988): 750–61.

Morris 2000. I. Morris. *Archaeology as Cultural History: Words and Things in Iron Age Greece.* Malden, Mass., 2000.

Morrison 1996. J. S. Morrison. *Greek and Roman Oared Warships.* Oxford, 1996.

Morrison and Williams 1968. J. S. Morrison and R. T. Williams. *Greek Oared Ships 900–322 BC.* Cambridge, 1968.

Nagy 1979. G. Nagy. *The Best of the Achaeans: Concepts of the Hero in Archaic Greek Poetry.* Baltimore, 1979.

Nagy 1990. G. Nagy. *Greek Mythology and Poetics.* Ithaca, 1990.

Nagy 1999. G. Nagy. *The Best of the Achaeans: Concepts of the Hero in Archaic Greek Poetry,* rev. ed. Baltimore, 1999.

Nagy 2005. G. Nagy. "The Epic Hero." In *A Companion to Ancient Epic,* ed. J. M. Foley, 71–89. Malden, 2005.

Neer 2001. R. Neer. "Framing the Gift: The Politics of the Siphnian Treasury at Delphi." *Cl. Ant.* 20, no. 2 (2001): 273–336.

Neils 1987. J. Neils. *The Youthful Deeds of Theseus.* Rome, 1987.

Neils 1988. J. Neils. "The Quest for Theseus in Classical Sculpture." In *Praktika tou XII diethnous Synedriou Klasikis Archaiologias, Athena, 4–10 Septembriou 1983,* 155–58. Athens, 1988.

Neils 1992. J. Neils. *Goddess and Polis: The Panathenaic Festival in Ancient Athens.* Exh. cat., Hanover, N.H.: Hood Museum of Art, Dartmouth College. Princeton, 1992.

Neils 2000. J. Neils. "Others Within the Other: An Intimate Look at Hetairai and Maenads." In *Not the Classical Ideal: Athens and the Construction of the Other in Greek Art,* ed. B. Cohen, 203–6. Leiden, 2000.

Neils 2001. J. Neils. *The Parthenon Frieze.* Cambridge, 2001.

Neils 2004. J. Neils. "Yet Another Red-figure Panathenaic Amphora." *Mediterranean Archaeology* 17 (2004): 61–64.

Neils 2007. J. Neils. "Myth and Greek Art: Creating a Visual Language." In *The Cambridge Companion to Greek Mythology,* ed. R. D. Woodard, 286–304. Cambridge, 2007.

Neils and Oakley 2003. J. Neils and J. Oakley. *Coming of Age in Ancient Greece: Images of Childhood from the Classical Past.* Exh. cat., Hanover, N.H.: Hood Museum of Art, Dartmouth College. New Haven, 2003.

Nicgorski 2005. A. Nicgorski. "The Magic Knot of Herakles, the Propaganda of Alexander the Great and Tomb II at Vergina." In Bowden and Rawlings 2005, 97–128.

Nicholls 1957. R. V. Nicholls. Review of R. A. Higgins, *Catalogue of the Terracottas in the Department of Greek and Roman Antiquities in the British Museum,* vol. 1, *Greek: 730–330 BC,* in *AJA* 61 (1957): 303–6.

Nilsson 1967. M. P. Nilsson. *Geschichte der griechischen Religion,* 3rd ed., vol. 1: *Die Religion Griechenlands bis auf die Griechische Weltherrschaft.* Handbuch der Altertumswissenschaft 5:2:1. Munich, 1967.

Nilsson 1972. M. P. Nilsson. *The Mycenaean Origin of Greek Mythology.* Berkeley, 1972.

Nock 1944 (1972). A. D. Nock. "The Cult of Heroes." *Harvard Theological Review* 37 (1944): 141–66. Repr. in *Essays on Religion and the Ancient World,* 2 vols., ed. Z. Stewart, 575–602. Oxford, 1972.

Noe 1925. S. P. Noe. *A Bibliography of Greek Coin Hoards.* American Numismatic Society Notes and Monographs 25 (1925): 12–13.

O'Brien 1993. J. V. O'Brien, *The Transformation of Hera: A Study of Ritual, Hero, and the Goddess in the 'Iliad.'* Savage, Md., 1993.

Oakley 1990a. J. H. Oakley. "A New Chalcidian Vase with the Departure of Amphiaraos." In *Akten des XIII. Internationalen Kongresses für klassische Archäologie, Berlin 1988,* 527–29. Mainz, 1990.

Oakley 1990b. J. H. Oakley. *The Phiale Painter.* Mainz, 1990.

Oakley 1997. J. H. Oakley. *The Achilles Painter.* Mainz, 1997.

Oakley 2004. J. H. Oakley. *Picturing Death in Classical Athens: The Evidence of the White Lekythoi.* Cambridge, 2004.

Oakley 2005. J. H. Oakley. "Pity in Classical Athenian Vase Painting." In *Pity and Power in Ancient Athens,* ed. R. H. Sternberg, 193–222. Cambridge, 2005.

Oakley forthcoming. J. H. Oakley. "Children in Funerary Art during the Peloponnesian War." In *Art in Athens during the Peloponnesian War,* ed. O. Palagia. Cambridge (in press).

Oakley and Sinos 1993. J. H. Oakley and R. H. Sinos. *The Wedding in Ancient Athens.* Madison, 1993.

Obbink 2001. D. Obbink. "The Genre of *Plateia*: Generic Unity in the New Simonides." In *The New Simonides: Contexts of Praise and Desire,* ed. D. Boedeker and D. Sider, 65–85. Oxford, 2001.

Ohnesorg 1982. A. Ohnesorg. "Der Dorische Peristylos des Archilocheion auf Paros." *AA* (1982): 271–90.

Osborne 1985. R. Osborne. "The Erection and Mutilation of the Hermai." *Proceedings of the Cambridge Philological Society* 31 (1985): 47–73.

Pache 2004. C. O. Pache. *Baby and Child Heroes in Ancient Greece.* Urbana, 2004.

Palagia 2000. O. Palagia. "Meaning and Narrative Technique in Statue-Bases of the Pheidian Circle." In *Word and Image in Ancient Greece,* ed. N. K. Rutter and B. A. Sparkes, 53–78. Edinburgh, 2000.

Palaima 1999. T. G. Palaima. "Kno2-Tn316." In *Floreant Studia Mycenaea: Akten des X. internationalen mykenologischen Colloquiums in Salzburg vom 1.–5. Mai 1995,* vol. 2, ed. S. Deger-Jalkotzky, S. Hiller, and O. Panagl, 437–61. Vienna, 1999.

Palaima 2008. T. G. Palaima. "Mycenaean Religion." In *The Cambridge Companion to the Aegean Bronze Age,* ed. C. W. Shelmerdine, 342–61. Cambridge, 2008.

Pandermalis 2004. D. Pandermalis, ed. *Alexander the Great: Treasures from an Epic Era of Hellenism.* Exh. cat., New York: Alexander S. Onassis Public Benefit Foundation. New York, 2004.

Pantel 1992. P. Pantel. *A History of Women in the West,* vol. 1: *From Ancient Goddesses to Christian Saints.* Cambridge, Mass., 1992.

Papadopoulou-Kanellopoulou 2001. C. Papadopoulou-Kanellopoulou. "Anachorisi tou Amphiaraou se Melanomorphi Ydria." In *Kallistevma. Meletes pros timin tis Olgas Tzachou-Alexandri,* ed. A. Alexandri and I. Leventi, 117–20. Athens, 2001.

Papalexandrou 2008. N. Papalexandrou. "Boiotian Tripods: The Tenacity of a Panhellenic Symbol in a Regional Context." *Hesperia* 77 (2008): 251–82.

Pariente 1992. A. Pariente. "Le monument argien des Sept contre Thèbes." In *Polydipsion Argos: Argos de la fin des palais mycéniens à la constitution de l'État classique: Fribourg, Suisse, 7–9 Mai 1987,* ed. M. Piérart, 195–225. BCH Supplement 22. Athens and Paris, 1992.

Parker 1987. R. Parker. "Festivals of the Attic Demes." In *Gifts to the Gods: Proceedings of the Uppsala Symposium 1985,* ed. T. Linders and G. Nordquist, 137–47. Boreas 15. Uppsala, 1987.

Parker 2005. R. Parker. *Polytheism and Society at Athens.* Oxford, 2005.

Parke-Bernet Galleries 1940. *French Furniture: Property of the Estate of the Late Jerome Stonborough, New York.* Auction cat., New York: Parke-Bernet Galleries. October 18, 1940.

Parlasca 2004. K. Parlasca. "Alexander Aigiochos: Ein Kultbild des Stadtgründers von Alexandria in Ägypten." In *Fremdheit-Eigenheit: Ägypten, Griechenland und Rom: Austausch und Verständnis,* ed. P. C. Bol, G. Kaminski, and C. Maderna, 341–62. Munich, 2004.

Polignac 1995. F. de Polignac. *Cults, Territory, and the Origins of the Greek City-State,* trans. J. Lloyd. Chicago, 1995.

Payne 1931a. H. G. G. Payne. "Archaeology in Greece, 1930–1931." *JHS* 51 (1931): 184–210.

Payne 1931b. H. G. G. Payne. *Necrocorinthia: A Study of Corinthian Art in the Archaic Period.* Oxford, 1931.

Perdrizet 1897. P. Perdrizet. "Polyphème." *Rev. Arch.* 31 (1897): 28–37.

Perdrizet 1898. P. Perdrizet. "Inscriptions d'Acraephiae." *BCH* 22 (1898): 241–60.

Petrakos 1968. V. Petrakos. *Ho Oropos kai to hieron tou Amphiaraou.* Vivliotheke tes en Athenais Archaiologikes Hetaireias 63. Athens, 1968.

Petrakos 1986. V. Petrakos. "Provlemata tes bases tou agalmatos tes Nemeseos." In *Archaische und klassische griechische Plastik,* ed. H. Kyrieleis, 89–107. Mainz, 1986.

Petrakos 1991. V. Petrakos. *Rhamnous.* Athens, 1991.

Pfister 1909–12. F. Pfister. *Der Reliquienkult im Altertum,* 2 vols. Religionsgeschichtliche Versuche und Vorarbeiten 5. Giessen, 1909–12.

Pfuhl and Möbius 1977. E. Pfuhl and H. Möbius. *Die ostgriechischen Grabreliefs,* vol. 1. Mainz, 1977.

Pinney 1983. G. F. Pinney. "Achilles, Lord of Scythia." In *Ancient Greek Art and Iconography,* ed. W. G. Moon, 127–46. Madison, 1983.

Pipili 2000. M. Pipili. "Wearing an Other Hat: Workmen in Town and Country." In *Not the Classical Ideal: Athens and the Construction of the Other in Greek Art,* ed. B. Cohen, 153–79. Leiden, 2000.

Pirenne-Delforge 2006. V. Pirenne-Delforge. "Ritual Dymanics in Pausanias: The Laphria." In *Ritual and Communication in the Graeco-Roman World,* ed. E. Stavrianopoulou, 111–29. Kernos Supplement 16. Liège, 2006.

Pirenne-Delforge 2008. V. Pirenne-Delforge. *Retour à la source: Pausanias et la religion grecque.* Kernos Supplement 20. Liège, 2008.

Pirenne-Delforge and Suárez de la Torre 2000. V. Pirenne-Delforge and E. Suárez de la Torre, eds. *Héros et héroïnes dans les mythes et les cultes grecs. Actes du Colloque organisé à l'Université de Valladolid du 26 au 29 mai 1999.* Kernos Supplement 10. Liège, 2000.

Pollitt 1986. J. J. Pollitt. *Art in the Hellenistic Age.* Cambridge and New York, 1986.

Popham et al. 1993. M. R. Popham, P. G. Calligas, and L. H. Sackett, eds. *Lefkandi II: The Protogeometric Building at Toumba,* part 2: *The Excavation, Architecture and Finds.* Athens, 1993.

Pouilloux 1954a. J. Pouilloux. *La forteresse de Rhamnonte: Étude de topographie et d'histoire.* Bibliothèque des Écoles Françaises d'Athènes et de Rome 179. Paris, 1954.

Pouilloux 1954b. J. Pouilloux. *Recherches sur l'histoire et les cultes de Thasos, I: De la fondation de la cité à 196 avant J.-C.* Études Thasiennes 3. Paris, 1954.

Pouilloux 1955. J. Pouilloux. "Glaucos, fils de Leptine, Parien." *BCH* 79 (1955): 75–86.

Pouilloux 1960. J. Pouilloux. *Fouilles de Delphes, 2: Topographie et architecture, 12: La région nord du sanctuaire (de l'époque archaïque à la fin du sanctuaire).* Paris, 1960.

Pouilloux 1994. J. Pouilloux. "Théogénès de Thasos . . . quarante ans après." *BCH* 118 (1994): 199–206.

Prange 1989. M. Prange. *Der Niobidenmaler und seine Werkstatt: Untersuchungen zu einer Vasenwerkstatt frühklassischer Zeit.* Frankfurt, 1989.

T. Price 1973. T. H. Price. "Hero-Cult and Homer." *Historia* 22 (1973): 129–44.

M. Price 1991. M. J. Price. *The Coinage in the Name of Alexander the Great and Philip Arrhidaeus.* London, 1991.

Prost 1997. F. Prost. "Délos," part 3: "Archégésion (GD 74)." *BCH* 121 (1997): 785–89.

QNAC 1986. *Numismatica e Antichita Classiche, Quaderni Ticinesi* 15 (1986): 56.

Raeder 1986. J. Raeder. *Museum Antikensammlung in der Kunsthalle zu Kiel.* Munich, 1986.

Rasmussen 2005. T. Rasmussen. "Herakles' Apotheosis in Etruria and Greece." *AK* 48 (2005): 30–39.

Ratinaud-Lachkar 2000. I. Ratinaud-Lachkar. "Héros homériques et sanctuaires d'époque géométrique." In Pirenne-Delforge and Suárez de la Torre 2000, 247–62.

Raven 1957. E. J. P. Raven. "The Leukaspis Type at Syracuse." In *Congrès international de numismatique, Paris, 6–11 Juillet 1953,* vol. 2, ed. J. Babelon and J. Lafaurie, 77–81. Paris, 1957.

Reden 1995. S. von Reden. *Exchange in Ancient Greece.* London, 2003.

Redfield 1994. J. Redfield. *Nature and Culture in the Iliad: The Tragedy of Hector.* Durham, 1994.

Reeder 1988. E. D. Reeder. *Hellenistic Art in the Walters Art Gallery.* Baltimore, 1988.

Reeder 1995. E. D. Reeder, ed. *Pandora: Women in Classical Greece.* Exh. cat., Baltimore: The Walters Art Museum. Baltimore and Princeton, 1995.

Reinach 1924. S. Reinach. *Répertoire de la statuaire grecque et romaine,* vol. 5. Paris, 1924.

Reinsberg 2005. C. Reinsberg. "Alexander-Porträts." In Beck, Bol, and Bückling 2005, 217–34.

Richter 1936. G. M. A. Richter. *Red-figured Vases in the Metropolitan Museum of Art.* New Haven, 1936.

Richter 1954. G. M. A. Richter. *Catalogue of Greek Sculpture: The Metropolitan Museum of Art, New York.* Cambridge, 1954.

Richter 1959. G. M. A. Richter. "Galenian Pottery and Classical Greek Metalware." *AJA* 63 (1959): 241–49.

Richter 1968. G. M. A. Richter. *Engraved Gems of the Greeks and the Etruscans.* London, 1968.

Richter 1971. G. M. A. Richter. *Engraved Gems of the Romans.* London, 1971.

Ridgway 2000. B. S. Ridgway. "The Sperlonga Sculptures: The Current State of Research." In *From Pergamon to Sperlonga: Sculpture and Context,* ed. N. T. de Grummond, and B. S. Ridgway, 78–91. Berkeley, 2000.

Ridgway 2001. B. S. Ridgway. *Hellenistic Sculpture,* vol 1: *The Styles of ca. 331–200 BC.* Madison, 2001.

Riefstahl 1968. R. M. Riefstahl. "Greek Vases." *The Toledo Museum of Art Museum News* 11, no. 2 (1968): 27–50.

Riethmüller 1999. J. W. Riethmüller. "*Bothros* und Tetrastyle: The *Heroon* of Asclepius in Athens." In Hägg 1999, 123–43.

Robert 1923. C. Robert. Griechische Mythologie, vol. 2: Die griechische Heldensage. Berlin, 1923.

Roberts 1977. S. R. Roberts, ed. *Ancient Pottery, Marble, and Glass.* Exh. cat., Madison, N. J.: Drew University Art Department, College Gallery. Madison, N.J., 1977.

Roberts 1978. S. R. Roberts. *The Attic Pyxis.* Chicago, 1978.

Robertson 1940. D. S. Robertson. "The Food of Achilles." *Classical Review* 54 (1940): 177–80.

Roccos 1995. L. J. Roccos. "The Kanephoros and Her Festival Mantle in Greek Art." *AJA* 99, no. 4 (1995): 641–66.

Rohde 1925. E. Rohde. *Psyche: The Cult of Souls and Belief in Immortality among the Ancient Greeks,* 8th ed. London and New York, 1925.

Rosen 2003. R. M. Rosen. "The Death of Thersites and the Sympotic Performance of Iambic Mockery." *Pallas* 61 (2003): 121–36.

Rosenzweig 2003. R. Rosenzweig. *Worshipping Aphrodite: Art and Cult in Classical Athens.* Ann Arbor, 2003.

Rosivach 1994. V. J. Rosivach, *The System of Public Sacrifice in Fourth-Century Athens.* American Classical Studies 34. Atlanta, 1994.

Rotroff 1978. S. I. Rotroff. "An Anonymous Hero in the Athenian Agora." *Hesperia* 47 (1978): 196–209.

Roux 1987. G. Roux. *Fouilles de Delphes, 2: Topographie et architecture, 17: La terrasse d'Attale.* Paris, 1987.

Royal-Athena Galleries 2008. Royal-Athena Galleries. *Art of the Ancient World, 19: Greek, Roman, Egyptian, and Near Eastern Antiquities.* New York, 2008.

Rudhardt 1992. J. Rudhardt. *Notions fondamentales de la pensée religieuse et actes constitutifs du culte dans la Grèce classique*, 2nd ed. Paris, 1992.

Rupp 1991a. D. W. Rupp. "The Altars of Southern Greece: A Typological Analysis." In Étienne and Le Dinahet 1991, 303–306.

Rupp 1991b. D. W. Rupp. "Blazing Altars: The Depiction of Altars in Attic Vase Painting." In Étienne and Le Dinahet 1991, 56–62.

Russell et al. 1999. P. J. Russell et al. *Art of the Ancient Mediterranean World.* Exh. cat., Nagoya: Nagoya / Boston Museum of Fine Arts. Nagoya, 1999.

Rutherford 2001. I. Rutherford. "The New Simonides: Towards a Commentary." In *The New Simonides: Contexts of Praise and Desire*, ed. D. Boedeker and D. Sider, 33–54. Oxford, 2001.

Rutter 2001. N. K. Rutter, ed. *Historia Numorum: Italy.* London, 2001.

Sadvrska 1964. A. Sadvrska. *Les tables iliaques.* Warsaw, 1964.

Salapata 1993. G. Salapata. "The Laconian Hero Reliefs in the Light of the Terracotta Plaques." In *Sculpture from Arcadia and Laconia: Proceedings of an International Conference Held at the American School of Classical Studies at Athens, April 10–14, 1992*, ed. O. Palagia and W. Coulson, 189–97. Oxbow Monographs 30. Oxford, 1993.

Salapata 1997. G. Salapata. "Hero Warriors from Corinth and Lakonia." *Hesperia* 66 (1997): 245–60.

Salapata 2006. G. Salapata. "The Tippling Serpent in the Art of Lakonia and Beyond." *Hesperia* 75 (2006): 541–60.

Salowey 1995. C. A. Salowey. "The Peloponnesian Herakles: Cult and Labors." Ph.D. diss. Bryn Mawr College, 1995.

Scarpi 1996. P. Scarpi. "Héraclès. Trop de mets, trop de femmes." In *Héraclès, les femmes et le féminin: IIe rencontre héracléenne*, ed. C. Jourdain-Annequin and C. Bonnet, 133–43. Brussels and Turnhout, 1996.

Schachter 1981. A. Schachter. *Cults of Boiotia, 1: Acheloos to Hera.* BICS Supplement 38. London, 1981.

Schachter 1994. A. Schachter. *Cults of Boiotia, 3: Potnia to Zeus.* BICS Supplement 38. London, 1994.

Scharmer 1971. H. Scharmer. *Der gelagerte Herakles.* Winckelmannsprogramm der Archäologischen Gesellschaft zu Berlin 124. Berlin, 1971.

Schauenburg 1960. K. Schauenburg. "Der Gürtel der Hippolyte." *Philologus* 104 (1960): 1–13.

Schauenburg 2003. K. Schauenburg. *Studien zur unteritalischen Vasenmalerei*, vol. 6. Kiel, 2003.

Schauenburg 2008. K. Schauenburg. *Studien zur unteritalischen Vasenmalerei*, vol. 11/12: *Studien zur attischen Vasenmalerei.* Kiel 2008.

Schefold 1966. K. Schefold. *Myth and Legend in Early Greek Art.* New York, 1966.

Schefold 1992. K. Schefold. *Gods and Heroes in Late Archaic Greek Art*, trans. A. Griffiths. Cambridge, 1992.

Schefold 1993. K. Schefold. *Götter- und Heldensagen der Griechen in der früh- und hocharchaischen Kunst.* Munich, 1993.

Schefold and Jung 1988. K. Schefold and F. Jung. *Die Urkönige, Perseus, Bellerophon, Herakles und Theseus in der klassischen und hellenistischen Kunst.* Munich, 1988.

Schild-Xenidou 2008. V. Schild-Xenidou. *Corpus der Böiotischen Grab- und Weihreliefs des 6. bis 4. Jahrhunderts v. Chr.* AM Beiheft 20. Mainz, 2008.

Schlesier 1991–92. R. Schlesier. "Olympian versus Chthonian Religion." *Scripta Classica Israelica* 11 (1991–92): 38–51.

Schmaltz 1996. B. Schmaltz, ed. *Exempla: Leitbilder zur antiken Kunst.* Kiel, 1996.

Schmidt, Trendall, and Cambitoglou 1976. M. Schmidt, A. D. Trendall, and A. Cambitoglou. *Eine Gruppe apulischer Grabvasen in Basel: Studien zu Gehalt und Form der unteritalischen Sepulkral-Kunst.* Basel, 1976.

Scholl 1996. A. Scholl. *Die attische Bildfeldstelen des 4. Jhs. v. Chr.: Untersuchungen zu den kleinformatigen Grabreliefs im spätklassischen Athen.* Berlin, 1996.

Schörner 2007. H. Schörner. *Sepulturae graecae intra urbem: Undersuchungen zum Phänomen der intraurbanen Bestattungen bei den Griechen.* Boreas Beiheft 9. Möhnesee, 2007.

Scullion 1994. S. Scullion. "Olympian and Chthonian." *Cl. Ant.* 13 (1994): 75–119.

Scullion 2000. S. Scullion. "Heroic and Chthonian Sacrifice: New Evidence from Selinous." *Zeitschrift für Papyrologie und Epigraphik* 132 (2000): 163–71.

Segal 1994. C. Segal. *Singers, Heroes, and Gods in the Odyssey.* Ithaca, 1994.

Seifert 2005. A. Seifert. "Heroon." In *ThesCRA*, 4: *Cult Places, Representations of Cult Places*, 24–38. Los Angeles, 2005.

Shapiro 1982. H. A. Shapiro. "Theseus, Athens, and Troizen." *AA* (1982): 291–97.

Shapiro 1984. H. A. Shapiro. "Herakles and Kyknos." *AJA* 88: 523–29.

Shapiro 1989. H. A. Shapiro. *Art and Cult under the Tyrants in Athens.* Mainz, 1989.

Shapiro 1990. H. A. Shapiro. "Comings and Goings: The Iconography of Arrival and Departure on Attic Vases." *Métis* 5 (1990): 113–26.

Shapiro 1992a. H. A. Shapiro. "The Marriage of Helen and Theseus." In *Kotinos: Festschrift für Erika Simon*, ed. H. A. Cahn, H. Froning, and T. Hölscher, 232–36. Mainz, 1992.

Shapiro 1992b. H. A. Shapiro. "*Mousikoi Agones*: Music and Poetry at the Panathenaia." In Neils 1992, 53–75.

Shapiro 1994. H. A. Shapiro. *Myth into Art: Poet and Painter in Classical Greece.* London and New York, 1994.

Shapiro 1999. H. A. Shapiro. "Cult Warfare. The Dioskouroi between Sparta and Athens." In Hägg 1999, 99–107.

Shapiro 2000. H. A. Shapiro. "Helen out of Doors." In *Periplous: Papers on Classical Art and Archaeology Presented to Sir John Boardman*, ed. G. R. Tsetskhladze, A. J. Prag, and A. M. Snodgrass, 271–75. London and New York, 2000.

Shapiro 2005. H. A. Shapiro. "The Judgment of Helen in Athenian Art." In *Periklean Athens and Its Legacy: Problems and Perspectives*, ed. J. Barringer and J. M. Hurwit, 47–62. Austin, 2005.

Shapiro Lapatin 1992. K. D. Shapiro Lapatin. "A Family Gathering at Rhamnous? Who's Who in the Nemesis Base." *Hesperia* 61 (1992): 107–119.

Shear 1973a. T. L. Shear Jr. "The Athenian Agora: Excavations of 1971." *Hesperia* 42 (1973): 121–79.

Shear 1973b. T. L. Shear Jr. "The Athenian Agora: Excavations of 1972." *Hesperia* 42 (1973): 359–407.

Sherwin-White 1977. S. M. Sherwin-White. "Inscriptions from Cos." *ZPE* 24 (1977): 205–17.

Siebert 1990. G. Siebert. "Imaginaire et images de la grotte dans la Grèce archaïque et classique." *Ktema* 15 (1990): 151–61.

Simon and Hirmer 1976. E. Simon and M. Hirmer. *Die griechischen Vasen.* Munich, 1976.

Sinn 1979. U. Sinn. *Die homerischen Becher: Hellenistische Relief-keramik aus Makedonien.* AM Beiheft 7. Berlin, 1979.

Sinn and Wehgartner 2001. U. Sinn and I. Wehgartner, eds. *Begegnungen mit der Antike: Zeugnisse aus vier Jahrtausenden mittelmeerischer Kultur.* Würzburg, 2001.

Sjöqvist 1953. E. Sjöqvist. "Alexander-Heracles: A Preliminary Note." *Museum of Fine Arts [Boston] Bulletin* 51 (1953): 30-33.

Slater 1989. W. J. Slater. "Pelops at Olympia." *GRBS* 30 (1989): 485–501.

Smith 1961. R. C. Smith. *The Ruins of Rome.* Exh. cat., Philadelphia: University of Pennsylvania Museum of Archaelogy and Anthropology. Philadelphia, 1961.

SNG ANS 3. American Numismatic Society. *Sylloge Nummorum Graecorum.* The Collection of the American Numismatic Society, part 3: Bruttium-Sicily (Abacaenum–Eryx). New York, 1975.

SNG ANS 8. American Numismatic Society. *Sylloge Nummorum Graecorum.* The Collection of the American Numismatic Society, part 8: Macedonia (Alexander I–Philip II). New York, 1994.

Snodgrass 1967 (1999). A. M. Snodgrass. *Arms and Armour of the Greeks.* London, 1967. Repr. Baltimore, 1999.

Snodgrass 1982. A. M. Snodgrass. "Les origines du culte des héros dans la Grèce antique." In *La mort: Les morts dans les sociétés anciennes*, ed. G. Gnoli and J. P. Vernant, 89–105. Cambridge, 1982.

Snodgrass 1988. A. M. Snodgrass. "The Archaeology of the Hero." *Annali dell'Istituto universitario orientale di Napoli, Dipartimento di studi del mondo classico e del Mediterraneo antico, Sezione di archeologia e storia antica* 10 (1988): 19–26.

Sourvinou-Inwood 1995. C. Sourvinou-Inwood, "Male and Female, Public and Private, Ancient and Modern." In Reeder 1995, 111–20.

Spivey 1996. N. Spivey. *Understanding Greek Sculpture: Ancient Meanings, Modern Readings.* New York, 1996.

Stafford 2000. E. J. Stafford, *Worshipping Virtues: Personification and the Divine in Ancient Greece.* London, 2000.

Stafford 2005a. E. Stafford. "Héraklès: Encore et toujours le problème du *heros theos*." *Kernos* 18 (2005): 391–406.

Stafford 2005b. E. Stafford. "Vice or Virtue? Herakles and the Art of Allegory." In Bowden and Rawlings 2005, 71–96.

Stais 1910. V. Stais. *Marbres et bronzes du Musée National.* Athens, 1910.

Stansbury-O'Donnell 1999. M. D. Stansbury-O'Donnell. *Pictorial Narrative in Ancient Greek Art.* Cambridge, 1999.

Stansbury-O'Donnell 2006. M. D. Stansbury-O'Donnell. *Vase Painting, Gender, and Social Identity in Archaic Athens.* Cambridge, 2006.

Stengel 1910. P. Stengel. *Opferbräuche der Griechen.* Berlin, 1910.

Stengel 1920. P. Stengel. *Die griechischen Kultusaltertümer*, 3rd ed. Handbuch der klassischen altertumswissenschaft 5, part 3. Munich, 1920.

Stephanidou-Tiveriou 1979. T. Stephanidou-Tiveriou. *Neoattika: hoi anaglyphoi pinakes apo to limani tou Peiraia.* Athens, 1979.

Stewart 1983. A. Stewart. "Stesichoros and the François Vase." In *Ancient Greek Art and Iconography*, ed. W. C. Moon, 53–74. Madison, 1983.

Stewart 1993. A. Stewart. *Faces of Power: Alexander's Image and Hellenistic Politics.* Berkeley, 1993.

Stewart 1995. A. Stewart. "Rape?" In Reeder 1995, 74–90.

Stillwell 1984. A. N. Stillwell. *The Potters' Quarter: The Pottery.* Corinth 15, part 3. Princeton, 1984.

Stupperich 1977. R. Stupperich. "Staatsbegräbnis und Privatgrab-mal im klassischen Athen." Ph.D. diss. Westfälische Wilhelms-Universität, Münster, 1977.

Süsserott 1938. H. K. Süsserott. *Griechische Plastik des 4. Jahrhunderts vor Christus. Untersuchungen zur Zeitbestimmung.* Frankfurt, 1938.

Sutton 1981. R. F. Sutton. Sutton. "The Interaction between Men and Women Portrayed on Attic Red-Figured Pottery." Ph.D. diss. University of North Carolina at Chapel Hill, 1981.

Sutton 1997/98. R. F. Sutton. "Nuptial Eros: The Visual Discourse of Marriage in Classical Athens." *JWAG* 55/56 (1997/98): 27–48.

Svoronos 1903. I. N. Svoronos. *To en Athinais Ethnikon Mouseion.* Athens, 1903.

Swaddling 2004. J. Swaddling. *The Ancient Olympic Games.* London, 2004.

Tagalidou 1993. E. Tagalidou. *Weihreliefs an Herakles aus klassischer Zeit.* Jonsered, 1993.

Taplin 1993. O. Taplin. *Comic Angels: And Other Approaches to Greek Drama through Vase-paintings.* Oxford, 1993.

Taplin 2007. O. Taplin. *Pots & Plays: Interactions between Tragedy and Greek Vase-Painting of the Fourth Century BC.* Los Angeles, 2007.

Thomas 1999. R. Thomas. "Zu den Ringergruppen in der Hellenis-tischen Kleinplastik." In *Gedenkschrift für Andreas Linfert: Hellenis-tische Gruppen*, 199–211. Mainz, 1999.

Thompson 1978. H. A. Thompson. "Some Hero Shrines in Early Athens." In *Athens Comes of Age: From Solon to Salamis: Papers of a Symposium Sponsored by the Archaeological Institute of America, Princeton Society, and the Department of Art and Archaeology, Princeton University*, 96–108. Princeton, 1978.

Thönges-Stringaris 1965. R. N. Thönges-Stringaris. "Das Griechische Totenmahl." *AM* 80 (1965): 1–99.

Thorn 2009. J. M. Thorn. "The Invention of 'Tarentine' Red-Figure." *Antiquity* 83 (2009): 174–83.

Tillyard 1923. E. M. W. Tillyard. *The Hope Vases: A Catalogue and a Discussion of the Hope Collection of Greek Vases with an Introduction on the History of the Collection and on Late Attic and South Italian Vases.* Cambridge, 1923.

Tiverios 1988a. M. A. Tiverios. "Archaistika I." In *Praktika tou XII diethnous Synedriou Klasikis Archaiologias, Athena, 4–10 Septembriou 1983,* vol. 3, ed. A. Delivorrias et al., 271–75. Athens, 1988.

Tiverios 1988b. M. A. Tiverios. "Peri Palladiou: Oti duo klepseian Diomedes kai Odysseus." In *Kanon: Festschrift Ernst Berger,* ed. M. Schmidt, 324–30. AK Beiheft zur Halbjahresschrift 15. Basel, 1988.

Toledo 1976. *The Toledo Museum of Art: A Guide to the Collections.* Toledo, 1976.

Toledo 2009. *Toledo Museum of Art: Masterworks.* Toledo, 2009.

Tomlinson 1992. R. Tomlinson. "The Menelaion and Spartan Achitecture." In *Philolakōn: Lakonian Studies in Honour of Hector Catling,* ed. J. M. Sanders, 247–56. London, 1992.

Touchefeu-Meynier 1968. O. Touchefeu-Meynier. *Thèmes odysséens dans l'art antique.* Paris, 1968.

Townsend 1955. E. Townsend. "A Mycenaean Chamber Tomb under the Temple of Ares." *Hesperia* 24 (1955): 187–219.

Travlos 1971. J. Travlos. *Pictorial Dictionary of Ancient Athens.* London, 1971.

Travlos 1988. J. Travlos. *Bildlexikon zur Topographie des antiken Attika.* Tübingen, 1988.

Trendall 1967. A. D. Trendall. *The Red-figured Vases of Lucania, Campania and Sicily.* Oxford, 1967.

Trendall 1987. A. D. Trendall. *The Red-figured Vases of Paestum.* London, 1987.

Trendall and Cambitoglou 1982. A. D. Trendall and A. Cambitoglou. *The Red-figured Vases of Apulia,* 2 vols. Oxford, 1978–82.

Trendall and Webster 1971. A. D. Trendall and T. B. L. Webster. *Illustrations of Greek Drama.* London, 1971.

Uhlenbrock 1986. J. P. Uhlenbrock. *Herakles: Passage of the Hero through 1000 Years of Classical Art.* Exh. cat., Annandale-on-Hudson: Edith C. Blum Art Institute, Bard College. Annandale-on-Hudson, 1986.

Vallois 1928. R. Vallois. "Bulletin Archéologique," part 2: "Architecture." *Revue des études grecques* 41 (1928): 216–17.

van Straten 1974. F. T. van Straten. "Did the Greeks Kneel before Their Gods?" *BaBesch* 49 (1974): 159–89.

van Straten 1979. F. T. van Straten. "The Lebes of Herakles: Note on a New Decree From Eleusis." *BaBesch* 54 (1979): 189–95.

van Straten 1981. F. T. van Straten. "Gifts for the Gods." In *Faith, Hope and Worship: Aspects of Religious Mentality in the Ancient World,* ed. H. S. Versnel, 65–151. Leiden, 1981.

van Straten 1995. F. T. van Straten. *Hiera Kala: Images of Animal Sacrifice in Archaic and Classical Greece.* Leiden and New York, 1995.

van Wees 2006. H. van Wees. "From Kings to Demigods: Epic Heroes and Social Change, c. 750–600 BC." In *Ancient Greece: From the Mycenaean Palaces to the Age of Homer,* ed. S. Deger-Jalkotzy and I. S. Lemos, 363–79. Edinburgh, 2006.

Vanhove 1992. D. Vanhove, ed. *Le sport dans la Grèce antique: Du jeu à la competition.* Exh. cat., Brussels: Palais des beaux-arts. Brussels, 1992.

Verbanck-Piérard 1989. A. Verbanck-Piérard. "Le double culte d'Héraklès: Légende ou réalité?" In *Entre hommes et dieux: Le convive, le héros, le prophète,* ed. A.-F. Laurens, 43–65. Centre de Recherches d'Histoire Ancienne 86. Paris, 1989.

Verbanck-Piérard 1992. A. Verbanck-Piérard "Herakles at Feast in Attic Art: A Mythical or Cultic Iconography?" In *The Iconography of Greek Cult in the Archaic and Classical Periods: Proceedings of the First International Seminar on Ancient Greek Cult, Organized by the Swedish Institute at Athens and the European Cultural Centre of Delphi, Delphi, 16–18 November 1990,* ed. R. Hägg, 85–106. Kernos Supplement 1. Athens, 1992.

Verbanck-Piérard 2000. A. Verbanck-Piérard. "Les héros guérisseurs: Des dieux comme les autres!" In Pirenne-Delforge and Suárez de la Torre 2000, 281–332.

C. Vermeule 1975. C. C. Vermeule. "The Weary Herakles of Lysippos." *AJA* 79 (1975): 323–32.

C. Vermeule 1980. C. C. Vermeule. *Greek Art, Socrates to Sulla.* Boston, 1980.

C. Vermeule 1981. C. C. Vermeule. *Greek and Roman Sculpture in America.* Malibu and Berkeley, 1981.

C. Vermeule 1982. C. C. Vermeule. "Alexander the Great, the Emperor Severus Alexander and the Aboukir Medallions." *Schweizerische Numismatische Rundschau* 61 (1982): 61–79.

C. Vermeule and Bothmer 1959. C. C. Vermeule and D. Bothmer. "Notes on a New Edition of Michaelis: Ancient Marbles in Great Britain." *AJA* 63, no. 2 (1959): 139–66.

C. Vermeule and Comstock 1988. C. C. Vermeule and M. B. Comstock. *Sculpture in Stone and Bronze in the Museum of Fine Arts, Boston: Additions to the Collections of Greek, Etruscan and Roman Art, 1971–1988.* Boston, 1988.

C. Vermeule et al. 1980. C. C. Vermeule et al. *The Search for Alexander.* Exh. cat., Washington, D.C.: National Gallery of Art. Boston and New York, 1980.

E. Vermeule 1965. E. T. Vermeule. "The Vengeance of Achilles." *BMFA* 63, no. 331 (1965): 34–52.

E. Vermeule 1966. E. T. Vermeule. "The Boston Oresteia Krater." *AJA* 70 (1966): 1–22.

E. Vermeule 1981. E. T. Vermeule. . *Aspects of Death in Early Greek Art and Poetry.* Berkeley, 1981.

Vernant 1991. J. P. Vernant. *Mortals and Immortals: Collected Essays,* ed. F. I. Zeitlin. Princeton, 1991.

Vikela 1994. E. Vikela. *Die Weihreliefs aus dem Athener Pankrates-Heiligtum am Ilissos: Religionsgeschichtliche Bedeutung und Typologie.* AM Beiheft 16. Berlin, 1994.

Visser 1982. M. Visser. "Worship Your Enemy: Aspects of the Cult of Heroes in Ancient Greece." *Harv. Theol. Rev.* 75 (1982): 403–28.

Vollgraf 1951. W. Vollgraf. "Inhumation en terre sacrée dans l'Antiquité Grecque: À propos d'une inscription d'Argos." *Mémoires présentés par divers savants à l'Académie des Inscriptions et Belles Lettres* 14, no. 2 (1951): 315–96.

Vollkommer 1988. R. Vollkommer. *Herakles in the Art of Classical Greece.* Oxford, 1988.

Wace et al. 1908–09. A. Wace et al. "Laconia I: Excavations at Sparta, 1909," part 6: "The Menelaion." *BSA* 15 (1908–9): 108–57.

Walsh 2009. D. Walsh. *Distorted Ideals in Greek Vase-Painting: The World of Mythological Burlesque.* Cambridge, 2009.

Walter 1937. O. Walter. "Der Säulenbau des Herakles." *AM* 62 (1937): 41–51.

Walters Art Gallery 1979. *Jewelry: Ancient to Modern.* New York, 1979.

Walters Art Gallery 1984. *Objects of Adornment: Five Thousand Years of Jewelry from the Walters Art Gallery, Baltimore.* Exh. cat., Baltimore: The Watlers Art Gallery. New York, 1984.

Webb 1960. M. C. Webb. "A Greek Vase Revived," *BWAG* 13, no. 2 (1960): 2-3.

Wegner 1973. M. Wegner, *Brygosmaler.* Berlin, 1973.

Welter 1941. G. Welter. *Troizen und Kalaureia.* Berlin, 1941.

West 1978. M. L. West, ed. *Hesiod, Works and Days.* Oxford 1978.

West 1993. M. L. West, trans. *Greek Lyric Poetry: The Poems and Fragments of the Greek Iambic, Elegiac, and Melic Poets (Excluding Pindar and Bacchylides) Down to 450 BC.* Oxford, 1993.

West 1997. M. L. West. *The East Face of Helicon: West Asiatic Elements in Greek Poetry and Myth.* Oxford, 1997.

West 1998. West, M. L. *Iambi et Elegi Graeci Ante Alexandrum Cantati: Editio Altera.* Oxford, 1998.

Westermark 1989. U. Westermark. "Remarks on the Regal Macedonian Coinage ca. 413–359 BC." In *Kraay-Mørkholm: Essays, Numismatic Studies in Memory of C. M. Kraay and O. Mørkholm,* ed. G. Le Rider et al., 301–15. Louvain-la-Neuve, 1989.

Whitehead 1986. D. Whitehead. *The Demes of Attica 508/7–ca. 250 BC: A Political and Social Study.* Princeton, 1986.

Whitley 1988. J. Whitley. "Early States and Hero Cults: A Re-Appraisal." *JHS* 108: (1988): 173–82.

Whitley 1995. J. Whitley. "Tomb Cult and Hero Cult: The Uses of the Past in Archaic Greece." In *Time, Tradition, and Society in Greek Archaeology: Bridging the 'Great Divide',* ed. N. Spencer, 43–63. London and New York, 1995.

Widdra 1965. K. Widdra. "Das Heroon des Phylakos in Delphi." *Marburger Winckelmann-Programm* 1965, 38–45.

C. Williams 1978. C. K. Williams II. "Corinth 1977, Forum Southwest." *Hesperia* 47 (1978): 1–39.

C. Williams 1981. C. K. Williams II. "The City of Corinth and Its Domestic Religion." *Hesperia* 50 (1981): 408–21.

C. Williams and Fischer 1973. C. K. Williams II and J. E. Fisher. "Corinth 1972: The Forum Area." *Hesperia* 42 (1973): 1–44.

C. Williams, MacIntosh, and Fisher 1974. C. K. Williams II, J. MacIntosh, and J. E. Fisher. "Excavation at Corinth, 1973." *Hesperia* 43 (1974): 1–76.

D. Williams 1980. D. Williams. "Ajax, Odysseus and the Arms of Achilles." *AK* 23 (1980): 137–45.

Winnefeld 1887. K. Winnefeld. *Beschreibung der Vasensammlung.* Karlsuhe, 1887.

Woodford 1971. S. Woodford. "Cults of Herakles in Attica." In *Studies Presented to George M. A. Hanfmann,* ed. D. G. Mitten, J. G. Pedley, and J. A. Scott, 211–25. Cambridge, Mass., 1971.

Woodford 1976. S. Woodford. "Heracles Alexikakos Reviewed." *AJA* 80, no. 3 (1976): 291–94.

Woodford 1982. S. Woodford. "Ajax and Achilles Playing a Game on an Olpe in Oxford." *JHS* 102 (1982): 173–85.

Woodford 1983. S. Woodford. "The Iconography of the Infant Herakles Strangling Snakes." In *Image et céramique grecque,* ed. F. Lissarrague and F. Telamon, 121–29. Rouen, 1983.

Woodford 1993. S. Woodford. *The Trojan War in Ancient Art.* London, 1993.

Woodford 2003. S. Woodford. *Images of Myths in Classical Antiquity.* Cambridge, 2003.

Woodford and Loudon 1980. S. Woodford and M. Louden. "Two Trojan Themes: The Iconography of Ajax Carrying the Body of Achilles and of Aeneas Carrying Anchises in Black-Figure Vase Painting." *AJA* 84 (1980): 25–40.

Woysche-Méautis 1982. D. Woysche-Méautis. *La représentation des animaux et des être fabuleux sur les monuments funéraires grecs: de l'époque archaïque à la fin du IV^e siècle av. J.-C.* Cahiers d'archéologie romande 21. Lausanne, 1982.

Wrede 1916. W. Wrede. "Kriegers Ausfahrt in der archaisch-griechischen Kunst." *AM* 41 (1916): 221–374.

Wrede 1985. H. Wrede. *Die antike Herme.* Trierer Beiträge zur Altertumskunde 1. Mainz, 1985.

Wünsche 2003. R. Wünsche, ed. *Herakles-Herkules.* Exh. cat., Munich: Staatliche Antikensammlungen und Glyptothek. Munich, 2003.

Yamagata 1994. N. Yamagata. *Homeric Morality.* Leiden, 1994.

Yavis 1949. C. G. Yavis. *Greek Altars, Origins and Typology: Including the Minoan-Mycenaean Offertory Apparatus.* Saint Louis, 1949.

Yfantidis 1990. K. Yfantidis. *Antike Gefässe: Eine Auswahl.* Kassel, 1990.

Zagdoun 1989. M.-A. Zagdoun. *La sculpture archaïsante dans l'art hellénistique et dans l'art romain du haut-empire.* Athens and Paris, 1989.

Zimmermann 1989. J. L. Zimmermann. *Les chevaux de bronze dans l'art géométrique grec.* Mainz, 1989.

trapeza, 132
triklinia, 132
tripod
 as Apollonian attribute, 42
 as cult offerings, 24, 128, 130
 Delphic, 35, 115, 222, 223, 231
 n. 3
 as prizes, 222
 as ransom objects, 202
 as shield device, 289
Triton, 190
Tritopatores, 12, 136. *See also*
 ancestor cults
Troilos, death of, 44–45, 46, 111,
 87 n. 51
Trojan Horse, 42, 43, 57 161–62,
 200, 242
Troy (film, 2004), 47
Troy, sack of, 31, 32, 40, 43–44,
 80, 91, 111, 161–62, 200,
 206, 242
Tyndareus, 37, 49, 51, 53, 148,
 176, 189, 205

underworld, 34, 40, 41, 79, 95,
 96, 97, 99, 103, 117, 118,
 130, 131, 136, 148, 155,
 157, 192, 208, 229. *See
 also* Hades, Herakles,
 labors of (s.v. Kerberos)
Underworld Painter, 71 fig. 38

Vari, cult of Dioskouroi, 252
Vatican G 23 Group (vase
 painters), 281, 282
Vatican G 43, Painter of,
 105 fig. 61
veils, 83, 186, 208, 266, 294, 295,
 301
Villa Giulia Painter, 205
Virgil, *Aeneid*, 92, 200
Vivenzio hydria, 162–63
votive offerings, in hero cults, 19,
 20, 23–24, 63, 121,
 123–24, 128, 129, 130,
 262–63
votive reliefs, 124, 129, 131, 133–
 34, 137, 138, 245, 246,
 252, 256, 258, 260

wanax (king), 12
warriors, and moral virtues,
 36–37, 150–51, 162
wedding processions, 294, 295
West Gate Heroön (Euboea), 21,
 23, 123

White Island. *See* Leuke
wrestling, 69, 121, 190, 276, 285,
 300
Würzburg 199, Group of, 183

Xenophon, *Memoirs of Socrates*,
 38, 145–47, 150

Zeus
 conflict with Hera, 32–33
 creator of race of heroes, 14
 and judgment of Paris, 149,
 150
 in Linear B tablet, 12
 parentage of heroes/heroines,
 35, 38, 49, 53, 55, 67,
 148, 155, 176, 178, 189,
 205
 rapes and abductions, 50, 72,
 102, 154
 sanctuary at Nemea, 128
 sanctuary at Troy, 42
 temple at Olympia, 33, 51, 117,
 157
 Zeus-Agamemnon, 125
 Zeus Herkeios, 80, 242
zostēr, 34, 231, 233
zugodesmon, 240

PHOTOGRAPHY CREDITS

Details

Page 1: *Medallion with Bust of Alexander the Great*, Roman (probably struck in Macedonia), ca. 218–235 CE (no. 106)

Pages 2–3 (left to right): *The Death of Priam*, attributed to the Nikoxenes Painter, ca. 500 BCE (no. 61); *Dueling Warriors*, ca. 530 BCE (no. 82); *A Wedding Procession*, attributed to the Lysippides-Andokides Group, ca. 520 BCE (no. 98)

Page 4: *The Worship of Herakles*, early fourth century BCE (no. 62)

Page 10: *Banquet Relief*, ca. 350 BCE (no. 68)

Page 30: *Achilles and Ajax Playing a Game / Herakles and Nessos*, attributed to the Toulouse Painter, late sixth century BCE (no. 39)

Page 66: *Peleus and Thetis / Achilles and Cheiron*, attributed to the Group of Würzburg 199, circle of the Antimenes Painter, ca. 520–510 BCE (no. 6)

Page 88: *Priam Ransoming the Body of Hektor from Achilles / Warriors Departing*, attributed to the Rycroft Painter, ca. 520–510 BCE (no. 22)

Page 108: *Herakles, Athena, and Hermes*, attributed to the Theseus Painter, ca. 500 BCE (no. 43)

Page 120: *Banquet Relief*, second half of the fourth century BCE (ca. 340) (no. 69)

Page 144: *Herakles and Triton*, ca. 530–520 BCE (no. 13)

Page 174: *Amazonomachy (Achilles and Penthesilea?)*, The Omaha Painter (name piece), ca. 570 BCE (no. 24)

Page 244: *Decree Relief with the Hero Hippothoon (?)*, ca. 350–340 BCE (no. 77)

Page 270: *Head of Alexander the Great as Herakles (?)*, ca. late 4th century BCE (no. 100)